GREAT
STATE

GREAT STATE

CHINA AND THE WORLD

TIMOTHY BROOK

HARPER

An Imprint of HarperCollins*Publishers*

HarperCollins books may be purchased for educational, business, or
sales promotional use. For information, please email the Special Markets
Department at SPsales@harpercollins.com.

Originally published in Great Britain in 2019 by Profile Books.

FIRST U.S. EDITION

Library of Congress Cataloging-in-Publication Data has been applied for.

ISBN 978-0-06-295098-7

20 21 22 23 24 LSC 10 9 8 7 6 5 4 3 2 1

To Fay Sims:

To misquote a poem Anne Bradstreet wrote for her husband
a year or two before the fall of the Ming, when China was still
exotic,

If ever two were one, then surely we.
If ever wife were loved by man, then thee;

I prize thy love more than whole mines of gold,
Or all the riches that the East doth hold.

There exists a paramount boundary within Heaven and Earth: Chinese on this side, foreigners on the other. The only way to set the world in order is to respect this boundary.

Qiu Jun (1421–95), quoted in Chapter 5

There are principles common to both East and West.

Xu Guangqi (1562–1633), quoted in Chapter 8

Contents

List of Maps xi

List of Illustrations xviii

Preface xx

Introduction: Ten Thousand Countries 1
Vancouver, 2019

THE YUAN GREAT STATE

1. The Great Khan and His Portraitist 17
 Xanadu, 1280
2. The Blue Princess and the Il-khan 36
 Tabriz, 1295
3. The Plague 53
 Caffa, 1346

THE MING GREAT STATE

4. The Eunuch and His Hostage 79
 Galle, 1411
5. The Castaway and the Horse Trader 109
 Zhejiang/Beijing, 1488

6. The Pirate and the Bureaucrat 139
 Canton, 1517
7. The Englishman and the Goldsmith 171
 Bantam, 1604
8. The Missionary and His Convert 201
 Nanjing, 1616

THE QING GREAT STATE

9. The Occupied 235
 The Yangzi Delta, 1645
10. The Lama and the Prince 265
 Kokonor, 1719
11. The Merchant and His Man 287
 Ostend/Canton, 1793
12. The Photographer and His Coolie 318
 Johannesburg, 1905

THE REPUBLIC

13. The Collaborator and His Lawyer 347
 Shanghai, 1946

Epilogue: One Hundred and Ninety-Three Countries 372
 New York, 1971/Quito, 2010

Notes 394
Index 427

List of Maps

1. Azimuthal equidistant projection of the globe from China.
2. The movement of the Black Death across Eurasia between the 1330s and the 1360s.
3. China under the Ming Great State.
4. Maritime connections around the South China Sea, c. 1604.
5. Manchu conquest of the Yangzi Delta, May-September 1645.
6. The territorial extent of Japan's wartime occupation of China, c. 1940.

The maps were drawn by Eric Leinberger.

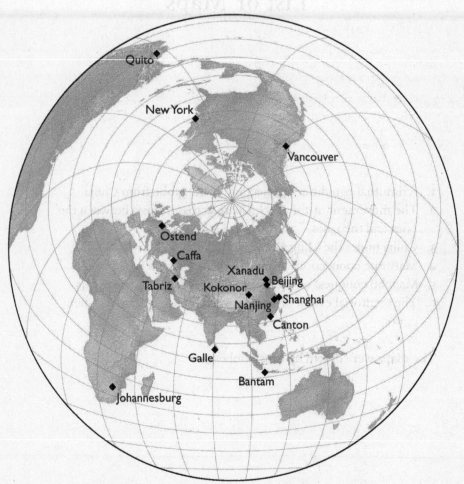

1. Azimuthal equidistant projection of the globe from China.

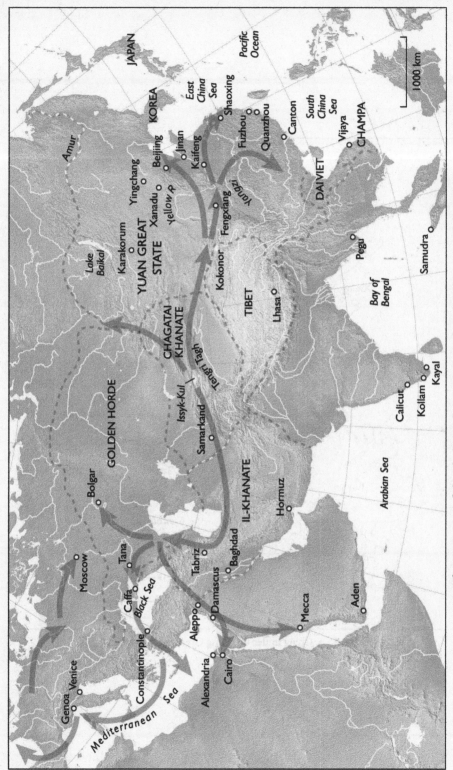

2. The movement of the Black Death across Eurasia between the 1330s and the 1360s.

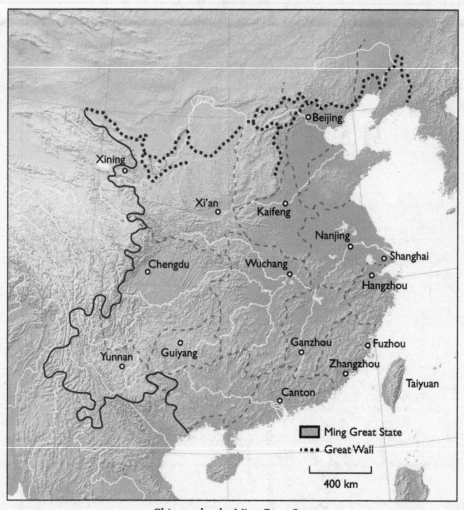

3. China under the Ming Great State.

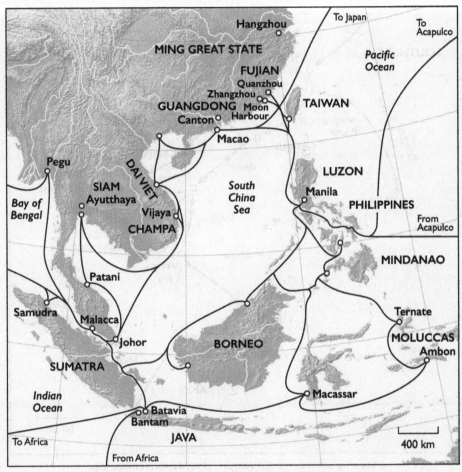

4. Maritime connections around the South China Sea, c. 1604.

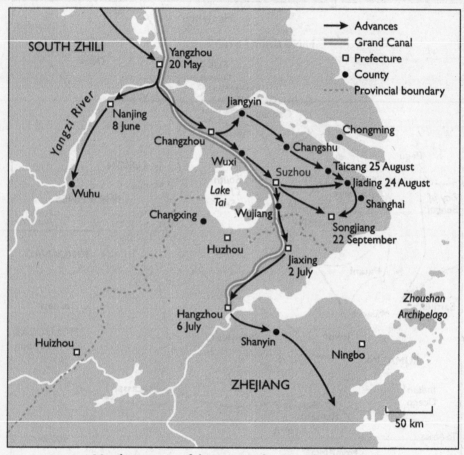

5. Manchu conquest of the Yangzi Delta, May–September 1645.

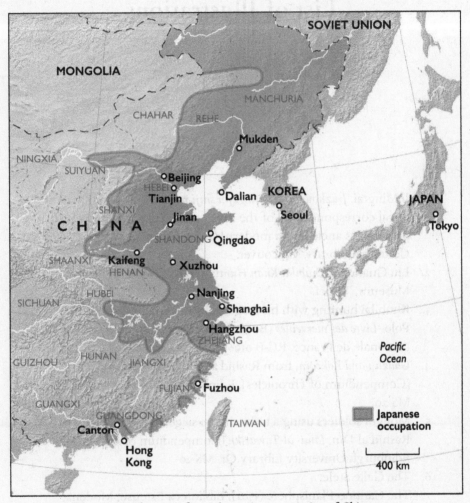

6. The territorial extent of Japan's wartime occupation of China, c. 1940.

List of Illustrations

1. Ji Mingtai, *Jiuzhou fenye yutu gujin shiji renwu* [Terrestrial map of astral correspondences of the nine provinces, with events and personages ancient and modern] (1643); University of British Columbia Library, Vancouver.
2. Liu Guandao, *Khubilai Khan Hunting* (1280); National Palace Museum, Taipei.
3. Khubilai hunting with his leopard, from a manuscript of Marco Polo, *Livre des merveilles* (Book of Marvels), 31v; Bibliothèque Nationale de France, RC-B-01969.
4. *Ghazan and Kökečin*, from Rashīd al-Dīn, *Jami' al-Tawarikh* [Compendium of chronicles], Edinburgh University Library Or. MS 20.
5. Mongol soldiers using a trebuchet in siege warfare; from Rashīd al-Dīn, *Jami' al-Tawarikh* [Compendium of chronicles], Edinburgh University Library Or. MS 20
6. The Galle Stele.
7. The Cantino Planisphere (1502); Biblioteca Estense, Modena, Italy.
8. The oceanic side of the globe made for Martin Behaim in 1492, showing Europe and north Africa on the right and Cathay on the left facing each other across the Oceanus Orientalis, the Eastern Ocean. The globe, in the collection of the Germanic National

Museum in Nuremberg, is reproduced here from Bridgman Images. The transcription is reproduced from *Encyclopedia Larousse illustrée* (Paris: Larousse, 1898).

9. Scroll painting of a Korean envoy departing from Nanjing (*c.*1410s); National Museum of Korea, Seoul.

10. Matteo Ricci and Xu Guangqi, from Athanasius Kircher, *China illustrata* (1667), Burns Library, Boston College.

11. Baptista van Doetecum, map of Bantam (1596); (public domain).

12. Suicide of Emperor Chongzhen, from Martino Martini, *Regni Sinensis à Tartaris tyrannicè evastati depopulatique concinna enarratio* (Amsterdam: Valckenier, 1661), opposite p. 44; Ghent University Library, BIB HIST.007063.

13. Portrait of the Seventh Dalai Lama (*c.* 1750–1800). Rubin Musem of Art, gift of Shelley & Donald Rubin Foundation, F1997.30.1 (HAR 380).

14. Henri-Pierre Danloux and Joseph Grozer, *Euhun Sang Lum Akao* (London, 1793); Princeton University, East Asian Studies Department, gift of Mr Wallace Irwin Jr, '40.

15. 'Instead of Flogging', *Morning Leader* (6 September 1905).

16. Torturing a bandit, from an album of punishment scenes by Zhou Peijun (Beijing, early-twentieth century); Turandot (Chinese Torture, Supplices Chinois) website, courtesy of Jérôme Bourgon.

17. Photograph of a young man undergoing torture in the courtyard of a magistrate's court after 1900.

18. Liang Hongzhi leaving his trial, Shanghai, 21 June 1946.

19. The eastern hemisphere, *Haifang tu* [map of coastal defence]; Harvard-Yenching Library, Cambridge, MA.

20. Change over time: the geographical extent of China in 1600, 1700 and 1800, overlaid on Adrien Brue, Carte générale de l'empire Chinois et du Japon (Paris: Charles Picquet, 1836); by Noel Macul, courtesy of the Vancouver Art Gallery.

Preface

Not being a writer of big books, I found the proposal of my British publisher Andrew Franklin that I write this book daunting. I prefer small craft to cruise ships. On the other hand, publishers sometimes see what authors can't, so I thank him for launching this project and hope for his sake that the boat floats.

What I have written is not a ponderous tome that slogs through eight centuries of Chinese history dynasty by dynasty – or, at least, I hope that's not what is on offer. Rather, I have tried to craft an account for general readers of how China has been in the world since the thirteenth century and what that has meant for the world and for China. I have organised the book not as an elucidation of grand themes but as a series of thirteen moments across seven centuries that reflect significant facets, to me at least, of the historical relationships between China and the world. I want to give readers a chance to see what has happened in particular, concrete situations, before asking you to think about China's relationships with the world today.

Two basic ideas drive this book. One is the recognition that China has never not been part of the world, either in the past or in our own day. We have no way to understand China if we separate it from the world. The other is that the fundamental principles guiding the Chinese state today were established not in the late third century BCE, which is where Chinese history usually goes to discover its emergence

as a unified state in a long string of dynasties, but in the thirteenth century CE, when China was absorbed into the Mongol world. The Mongol occupation had a profound impact, shifting China from the older dynastic model to a form that, following Mongol usage, I call the Great State. Without this concept we are without a key tool that is needed to understand China from the perspective of history.

The idea that China has always been entangled in the world is one that historians of China now generally recognise. In taking this approach, I write simply as part of my generation. The idea of China as a Great State, by contrast, is new and largely my own. The inspiration for this idea goes back to my mentor Joseph Fletcher, though the credit for bringing me across the threshold of this idea must go to my colleague Lhamsuren Munkh-Erdene. Perhaps the strongest prod, though, has been the burden of my own experience. In my twenties, for reasons I have never fully fathomed, I decided to study China. I thought that if I examined the far side of the world, I might make better sense of my own; but then China asserted its own questions, and I wanted to answer those. In those days, most of the frail bridges between China and the world had been swept away. I thought they needed to be rebuilt. Here in the twenty-first century, two remain still to be built. One is the bridge between the China of history and the China of now. The other is between China today and a world that has become increasingly troubled by its expansive presence. This book is dedicated to working on that first bridge in the hope that, by encountering China as it was, we might be in a better position to see China as it is.

In the course of writing this book I asked many friends for help and advice, so many in fact that I fear I will fail to name them all. So if you answered queries from me but do not see yourself in this thank-you list – Robert Bickers, Jérôme Bourgon, Liam Brockey, Timothy Cheek, Cho Young-hun, Nicola di Cosmo, Jun Fang, Monica Green, Beth Haddon, Robert Hymes, Adam Izdebski, Diana Lary, Nicolas Standaert, Nils Stenseth, Richard Unger, Paul Van Dyke and Don Wyatt – please do not be offended.

Much of this book was written while I was Agnes Gund and Daniel Shapiro Member at the Institute for Advanced Study in Princeton in 2017–18; I am grateful to the IAS for that support. I want particularly

to acknowledge the early-modern gang there, who read versions of some of the chapters: Guillaume Calafat, Alison Games, Will Hanley, Marta Hanson, Lhamsuren Munkh-Erdene, Weijing Lü, Erin Rowe, Jonathan Sachs, Silvia Sebastiani and Ying Zhang. We must all get together again soon. Subsequently, in Paris, I was given the opportunity to present four chapters in seminars at the École Normale Supérieure and the École des Hautes Études en Sciences Sociales in April 2019, for which I thank Charlotte Guichard and Antonella Romano. I wish also to acknowledge that some of the research for this book was supported by grants from the Social Sciences and Humanities Research Council of Canada.

In the background of the whole venture stands my agent, Beverley Slopen. We have worked together for over a quarter of a century, and I can't imagine how I would have got through the long writing process had she not supported me with her characteristic blend of encouragement and realism, always reminding me for whom I should be writing. For her warm support through the Herculean task of producing this book, I am forever grateful to Penny Daniel at Profile. For his enthusiasm to publish the book on my side of the Atlantic, I am grateful to Jonathan Jao at HarperCollins.

If the book reads well, the credit goes to my editor. George Sipos worked with me on a near-daily basis through the summer of 2018 to make the text better than it was. He did the work of a poet, as I expected he would.

For help with the writing and thinking, and everything else, thank you, Fay.

Introduction: Ten Thousand Countries

Vancouver, 2019

A few years ago, an enterprising graduate student at the University of British Columbia (UBC), where I work, was poking about in the geography section of the Asian Library. There, folded neatly inside a twentieth-century pasteboard slipcase, he found a Chinese wall map from the Ming dynasty (1368–1644). When unfolded, the map was impressively large, four feet wide and four and a half from top to bottom (see Plate 1). We can't say that the map was lost. It had a call number on the spine and an incomplete entry in the library catalogue, and it sat there in the open stacks for anyone to pick it up. It's just that no one had. In its day it was an ordinary object. You could have bought it for the price of a wok, or maybe 2 pounds of high-grade Philippine tobacco. Today it would fetch a shocking price, which is why, when the student showed it to the librarian, she removed it from the open stacks and locked it in the rare books room.

The map has the classic look of a Ming-dynasty production. It moulds China into a rectangular shape, on the premise that Heaven may be round but the earth is square, and it sequesters the country within the bounds of the Great Wall along its northern border. But what is it a map of, really? We look at it and see a map of China,

whereas people of the Ming would have regarded it differently, as a map not of China but of the world. Their term for such a map was *hua-yi tu*, 'a map of Chinese (*hua*) and non-Chinese (*yi*)', or barbarians, to give the latter its due resonance. Cartouches in the ocean describe foreign places from Korea and Japan to Brunei and Malacca, and text boxes in the wastes beyond the Great Wall explain who the Khitans, Jurchens, Mongols, Turks and Tibetans are. Four centuries ago this was what passed for a map of the world or, more precisely, a map of China in the world.

The more I examined this map, though, the more mysterious and elusive it became. The publisher's colophon in the bottom left-hand corner declares that it was printed in Nanjing, the secondary capital of the Ming dynasty and a major publishing centre, by Ji Mingtai [Master Ji of the Terrace of Renown] in the year *guiwei*. Chinese years are named according to a sixty-year cycle, and normally the year name is prefixed with the reign title of the emperor on the throne at the time to distinguish one *guiwei* year from the next. The design of the map reminded me of a visually very similar map I had seen published in the same city bearing the date of 1593, so I reasoned that *guiwei* was either the *guiwei* year of the Wanli reign, 1583, or the *guiwei* year of the Chongzhen reign sixty years later, 1643. Eventually I tracked down a copy in the Harvard-Yenching Library at Harvard University on which the date was printed in full: Chongzhen *guiwei*. That confirmed the date: 1643.

The 1593 map I had in mind as a precursor to the one in Vancouver was another large wall map, this one drawn by a schoolteacher named Liang Zhou. It surfaced at a Sotheby's auction in 1988 only to disappear immediately into another private collection, yet it was in the public realm long enough to be photographed and to circulate among scholars. What for me clinched the relationship between these two maps was that they carried the same subtitle: 'with human vestiges and records of events ancient and modern'. This stilted phrasing, which sounds more like advertising copy than truthful description, betrays the fact that they must share an origin, or at least a mutual influence. Their main titles are different, however. The map in Vancouver is called *The Terrestrial Map of the Astral Correspondences of the Nine Provinces*. The references to 'nine provinces' and 'astral correspondences' look back into the past by summoning up ancient

conceptions of Chinese geography. The 1593 map bears a different title, *The Complete Map of the Ten Thousand Countries between Heaven and Earth*. Unlike the 1643 map, the 1593 title declares the map to be a map of the world, which is striking, given the on-again, off-again Ming ban on contact with the world beyond China's borders. These may not look to us like maps of the world, but they have absorbed no small amount of foreign knowledge. The best sign of this on the 1593 map is the debut appearance of the Arctic Ocean complete with North Pole, details that Ji Mingtai regrettably dropped when he drew his version.

In the text printed across the top of his map Liang Zhou reveals his source for the new content to be a six-panel map of the world that had been recently engraved in Nanjing on slabs of stone so that anyone could consult it. 'For the first time', Liang proclaims, there is a map that 'allows you to understand to the most precise degree how Heaven and Earth are contained'. The author of this wonder he calls the Master from Beyond the West. Liang doesn't seem to know his name, but we do. This is Matteo Ricci, the second Jesuit missionary to enter China, in 1583, and one of the characters in Chapter 8 of this book. Here Liang's story stumbles, however, for Ricci did not actually move to Nanjing until 1598, five years after the date Liang has put on his *Complete Map of the Ten Thousand Countries of the Earth*.

Why were these dates out of order? My best guess is that Liang had to fudge his date of publication. Yes, the 1593 map was inspired by the 1598 map, but only because it wasn't printed in 1593. Liang back-dated his map to 1593 in order to obscure a fact that does not otherwise come into view, and that no one else seems to have noticed: that he was infringing someone else's copyright. The sequence of events must have been thus: Ricci's map was posted in a public place in Nanjing in 1598 or 1599, a cartographer possibly named Liang incorporated elements of that map to produce a revised version of the standard Ming map of the world, and then someone using the name of Liang Zhou came along and plagiarised this map as his own, covering his traces by messing around with the date of publication. We are unlikely ever to find the missing link between Ricci and Liang, as so many maps from this era were destroyed when the Ming dynasty fell in 1644. There is one other nice touch of mischief on Liang's map. In the oddly empty

colophon down in the bottom left-hand corner of the map appears the blunt warning: 'reprinting forbidden'!

So Liang was a pirate, but I soon discovered not the only pirate in this story. Recall that the *guiwei* date on the map in Vancouver was incomplete. A possible reason for this was the times. One of the effects of dynastic turnover was the outlawing of maps of the previous dynasty. Once the Qing army of occupation got down to Nanjing in June 1645, to own or print a map of the Ming in Nanjing was to declare allegiance to that fallen regime, and that was treason. A map publisher had to choose between destroying his woodblocks or tampering with them to remove any sign of the Ming. That blank space in front of *guiwei* could indicate that Ji Mingtai doctored the blocks so that he could keep printing his map after 1645.

As I looked more closely at the map, however, that convenient story dissolved. The reliability of the UBC map began to unravel when I noticed that the first character of the name Mingtai was not the same on the Harvard copy. Ji went from 'Terrace of Illumination' at Harvard to 'Terrace of Renown' in Vancouver. Switching that middle character *ming* ('illumination' and 'renown' are exact homonyms) would be like opening a pop-up coffee shop and hanging out a sign that read Starbukks: the inattentive customer might not notice. Once I was able to compare the two maps in detail, the map in Vancouver revealed itself to be a rather sloppy copy of the map at Harvard. My Ji Mingtai map was not by the real Ji Mingtai. Like Liang Zhou (or whoever was ripping off the real Liang Zhou, if there ever was such a person), my cartographer was committing copyright fraud.

These frauds are fun to detect, but are neither here nor there for our purpose – though they do testify to how hot the market for world maps was at the time. The point is that what became the standard 'Chinese' map of China in the last half-century of the Ming period belongs to a family tree that includes an Italian. And that's not all. In the panel across the top of the '1593' map Liang (or whoever was masquerading as Liang) explains that the Master from Beyond the West derived his map from a copperplate engraving by 'a gentleman from Ouluoba'. ('Europa' is a difficult word to bend into Chinese syllables.) Liang couldn't name this European gentleman, but we can. This is Ortelius, the great sixteenth-century cartographer of Antwerp

whose *Typus orbis terrarum* [Image of the sphere of the earth] of 1570 crowned Europe's first atlas. Having realised the potential that a European map might have for dislodging Chinese views of the world, Ricci had written back to his former teacher, now the head of the Jesuits, Claudio Acquaviva, asking him to send him a world map. The Jesuits had good contacts in Antwerp, so it was not difficult for Acquaviva to obtain a copy and send it to China where Ricci redrew it for Chinese friends.

So now we have a family tree going back four generations, starting in my local university library: from Ji Mingtai's *Terrestrial Map of the Nine Provinces with Astral Correspondences* to Liang Zhou's *Complete Map of the Ten Thousand Countries between Heaven and Earth* to Ricci's map etched on stone in Nanjing and finally to Ortelius's *Image of the Sphere of the Earth*. Two Chinese, two Europeans: some family!

Ten Thousand Countries

Ricci gave his map the title of *Complete Map of the Ten Thousand Countries of the Earth*. The idea that the world consisted of ten thousand countries was not his invention. He took the number from the *Book of Changes*, an ancient divination classic that belongs to the era of small Bronze-Age states three millennia in the past. The goal of the ruler in that era, when no unified polity that could be called China existed, was 'to bring the many things and the ten thousand countries to tranquillity'. That condition of multiplicity changed as some of these states captured enough resources and labour to destroy their neighbours. Entering the third century BCE, it was axiomatic that 'in antiquity there were ten thousand countries, whereas today they number only ten odd'. Exiting that century, all but one of those ten-odd, the Qin, was gone. Only after the ruler of Qin (the origin of our word 'China') eradicated all the other states across the North China Plain and down into the Yangzi Valley in 221 BCE did the paradigm of ten thousand countries disappear. The Founding Emperor of Qin, as he titled himself, declared that he and his descendants would rule All under Heaven as a single realm for all time. The age of ten thousand countries was over. China's era of the single mega-state, still with us, had begun.

The new norm proved to be as much a myth as a reality. Every

dynasty that conquered the country collapsed. The Qin set the worst record, disintegrating in less than fifteen years. Over the next millennium and a half, China was as often splintered among many states as it was unified. Despite the reality of recurring dynastic collapse, or indeed perhaps because of it, the idea of unity took hold and became a political ideal. With every collapse, dynastic contenders dreamed of reassembling the eastern end of Eurasia into a single realm. Some European rulers had the same dream, thinking back to the Roman Empire and wondering whether they might reconstitute it in their time, but it was an eccentric dream that burned out every time it was tried, never a norm. Even though Europe and China sustained roughly similar populations (about 120 million people in 1600) and were spread over roughly the same area (10 million square kilometres), Europe remained a patchwork of small sovereignties whereas China found itself over and over again reunified as a single state.

Matteo Ricci came from that patchwork world – never ten thousand countries, certainly, but at the time several hundred. His task as a missionary was to persuade people of a very different world to abandon their most basic beliefs and embrace an entirely different set of European Christian norms and practices. It was an amazing ask, if you think about the tenacity most people have for what they believe defines them. Ricci hoped that reason might be enough, but he needed proof. In his first year in China he started drawing maps of the world for his visitors. He wanted to show them where he came from, but he also wanted to show them that there were other ways of organising the world and other possibilities of imagining life, death and salvation – and that his way of knowing these things was better grounded in reality than theirs. He needed to dethrone the traditional cosmology positioning China at the centre of a world and relegating all other cultures to the periphery, where they sloped away from civilisation into a condition of ever more profound barbarism from where nothing good could come. What better device to disorient people and lure them away from their bearings than a picture of the world as it 'actually' was? And so Ricci invoked the ten thousand countries in the title of his map in the hope to persuade Chinese that there were more countries, quite as civilised as China, than were dreamed of in their philosophy. Ji Mingtai was not prepared to embrace the new

vision wholly and left 'ten thousand countries' off his map, but Liang Zhou was persuaded, and so were others. The idea prevailed, and the phrase 'ten thousand countries' came to be the standard term in both Chinese and Japanese for the world up to the turn of the twentieth century. Even so, the tension between one country and ten thousand remained – and is woven right through the story I tell in this book.

The Great State

In the conventional account of Chinese history, China became that one country in 221 BCE. In this book I have elected to tell this story differently. Going back two-plus millennia in the past takes us such a distance from the present that real effects become submerged by formal elements that, to me at least, are at best merely symbolic. While that transition from many countries to one was an important bar to cross, I find it more useful to focus attention on a more recent transition: the moment in the thirteenth century when the dynastic oscillation between unified realms and dispersed kingdoms ended more or less for good, and China fell under the occupation of the Mongol descendants of Chinggis (Genghis) Khan. In the wake of this second great unification China became essentially a different country. The glories of the Tang and Song dynasties preceding the Mongol invasion are indisputable, and the legacies of dynasties in the even more distant past continue to mould Chinese culture. But to this historian, looking at the long term, China today is far more the successor of the Mongol age than it is of the Qin. Some readers will not agree with me, but you don't have to agree in order to appreciate the stories I tell in this book or follow the arc of change that these stories plot.

The concept I needed to tell this new story – the Great State – is not standard fare in histories of China. Great State is an Inner Asian concept. It is not a term that Chinese today will recognise, let alone accept, but it has hugely shaped Chinese political thinking since the time of Khubilai Khan. Before the 1270s China was a dynastic state in which one family monopolised power at the centre because, so the theory went, Heaven had given that family an exclusive mandate to rule. What changed with the coming of the Mongols was the deeper conviction that this mandate entailed the right to extend the authority of that one family out across the entire world, incorporating all

existing polities and rulers into a system in which military power is paramount. This was the Great State, and this is what China became.

The concept of the Great State is a late one, emerging only in the years immediately after Chinggis became Great Khan of the Mongols in 1206. The term in Mongolian is *yeke ulus* (pronounced 'eek ooloose'), *yeke* meaning 'great' and *ulus* meaning 'state'. Once Chinggis was confirmed as ruler of the *Mongqol ulus*, the Mongol State, he began building a new, larger polity to absorb the territories that fell to his armies. By one report the term was suggested to the Mongols by former officials of the Jin Great State, a Jurchen polity that ruled north China in the twelfth century and that the Mongols destroyed in their rise to power. This new polity came to be called the *Yeke Mongqol ulus*, the Mongol Great State. The concept declares that there is nothing natural about the boundaries of a political territory, and that the goal of rulership is to enlarge the realm through conquest. This new polity is often called the Mongol Empire in English, but I prefer to stick to the Mongol term so as not to conflate this historical transformation with Europe's experiences of empire. They may be the same thing, but that remains to be proven.

Not every ruler of China since the thirteenth century has been successful in conquest, but every ruler since then has declared his regime to be a Great State. Khubilai Khan did so in 1271, announcing to his Chinese subjects that he was founding the Da Yuan, the Yuan Great State. Zhu Yuanzhang did the same when he announced the creation of the Da Ming, the Ming Great State, in 1368. And so did Hong Taiji in 1635, when as Great Khan of the Manchus he promulgated the founding of the Da Qing, the Qing Great State, which would go on to absorb the Ming in 1644. Only in 1912, with the founding of a People's State, or Republic as it is usually translated, did the Great State nomenclature come to an end in China – though it still survives, for complex historical reasons having to do with the legacy of Japanese imperialism, in Korea. The official name of South Korea, Daehan Minguk, translated literally, means the Republic of the Korean Great State.

This book is not a political history of China, but I found that I needed the concept of the Great State to frame the stories I tell of the relationships that formed between Chinese and non-Chinese over the past eight centuries. The sovereign of the Great State was endowed

with an authority that was potentially universal: those within must submit to his authority, those without must defer to it. The concept matters because it was a basic fact for those who owed the Great State allegiance as well as for those entering from zones beyond its reach. It supplied the symbolic architecture of the spaces in which Chinese and non-Chinese interacted. It coloured the terms within which they imagined who they were. It perfumed the moral air they breathed. Part of knowing you were Chinese was knowing that you stood under the canopy of the Great State. Even the pirates who stripped the ship-wrecked Koreans of their last possessions in Chapter 5 boasted that they were subjects of the Great State – they anachronistically declared that they were subjects of the Tang Great State even though it was the Ming that then ruled – so that foreigners sailing in China's coastal waters would know that fact and be awed.

Telling This Story

Everything that happens in this book took place against national backdrops, in international contexts and on global scales. In telling these tales, however, I have chosen as much as possible to focus on what happened to real people in particular local settings: on board boats moored off the Zhejiang coast in February 1488, for example. I encourage the reader to think broadly about China's relationships with the world and about how that history may shape the present, but that scaling-up is for you to do. My task is to furnish you with thirteen stories that you can use to construct that larger story (see Map 1). Rather than parade readers across seven and a half centuries down the grand avenue of Chinese history, I offer a series of intimate portraits of people, Chinese and non-Chinese alike, to exemplify how the world has mattered to China, how China has mattered to the world and how China has always been in the world – and how that may have shaped the ways in which people caught between China and the world have managed that tension and made sense of their lives.

As a result, not all the characters in this book are Chinese. In fact, in the first three chapters, which fall within the period that Chinese chronology calls the Yuan dynasty (1271–1368), Chinese are outnumbered by non-Chinese. The subject of Chapter 1 is a Mongol, Khubilai Khan, the ruler who brought China within the Mongol Great State.

Watching Khubilai in action gives us a chance to imagine the nature of the political regime that the Mongols installed in China, from which so much of China's subsequent history flows. In Chapter 2 we shift our gaze from the land to the sea and examine Mongol attempts to dominate the maritime world beyond China. We will do this by tracing Marco Polo's voyage as a member of the entourage of a Mongol princess travelling to Persia, at the end of which he returns home to Venice. In Chapter 3 we look more broadly at the Eurasian continent to revisit the old question of whether the Black Death that raged through the Middle East and Europe in the 1340s also struck China, and if so, what this reveals about China's presence in the world. Europeans and Mongols dominate this chapter, mostly because the core research on the history of the plague in China has yet to be written.

The next section of the book takes us into the period of the Ming Great State (1368–1644). Chapter 4 reconsiders some of the issues raised in Chapter 2 by examining how the third Ming emperor, imitating his Yuan predecessors, sent armadas into the Indian Ocean along the very same maritime route that Marco Polo travelled, although a century later. The main character in this story is Zheng He, the imperial eunuch whom some have elevated to the status of China's Christopher Columbus, a comparison that misses what is distinctive about his voyages. Chapter 5 opens similarly on the ocean, though in China's coastal waters rather than the Indian Ocean, where Koreans blown off course find themselves having to negotiate with a wide range of Chinese from pirates to governors in sometimes threatening face-to-face settings. This chapter is set in 1488, at a time after which imperial policy had shifted from the grand designs of the early Ming emperors to an anxious policy of reinforcing the boundaries between Chinese and non-Chinese, whether at the level of individuals or at the level of the state. The chapter also examines the trade in horses that linked the Korean and Chinese economies in this period.

Sharing a border meant that Koreans had centuries of experience managing their relations with Big Brother and knew how to tread carefully when dealing with Chinese in an official or a private capacity. Europeans had no such experience. Chapter 6 catches them at the beginning of that relationship, when Portuguese arrived on China's south coast and attempted unsuccessfully to negotiate a working

relationship with Chinese officials. Chapter 7 shifts the story of Europeans adapting to China out to the island of Java, where Chinese and Englishmen, dealing with each other for the first time, descended into mutual violence as men on each side sought to enrich themselves at the expense of those on the other. Chapter 8 considers this relationship in quite different terms by exploring the terrain of knowledge that Europeans and Chinese attempted to create between them as individuals from these two cultures found themselves having to understand each other. This is where we will find Matteo Ricci, among other Jesuit missionaries, struggling to adapt his religion to Chinese circumstances – and succeeding only when Chinese were willing to meet them more than half-way and show them how to do it.

The Ming dynasty fell to the Manchus in 1644–5. Chapter 9 recounts the shock of that experience from the diaries of several Chinese who watched appalled as the Manchus invaded and the Qing Great State moved slowly south and took over their country. If the political character of the Great State had attenuated under the later emperors of the Ming, it returned with a vengeance under the Manchus. What that conquest would mean for China was far from clear in 1645, though everyone looked back to the Mongol occupation and wondered whether that provided a useful analogy for what they were going through and what they might expect.

As outsiders, the Manchus needed help in bringing competing Inner Asian peoples to heel. Chapter 10 takes us to a Buddhist monastery in Kokonor, at the outer edge of Manchu authority, in 1719, where the emperor's son and the Seventh Dalai Lama negotiated terms of the Qing Great State's invasion of Tibet the following year. That invasion was designed to drive the Mongols out of Tibet, but the occupation led to a series of events that proved decisive for China's political position in Inner Asia, and even today sets impossible conditions for the resolution of the People's Republic's troubled relationship with Tibet.

In Chapter 11 we shift from land back to sea and return to China's slowly unfolding relationship with the West by following the attempts of a Swiss merchant to profit by trading at Canton. In the 1790s Europeans still arrived as supplicants of the Qing Great State. By the middle of the nineteenth century, that relationship flipped as the status of the Qing eroded and foreigners came and went with greater confidence.

One outcome of this flip was the export of coolie labour to the British Empire. Chapter 12 reconstructs the misfortunes of an anonymous Chinese man and his Dutch tormentor caught in the coolie trade in South Africa in 1905. But China still mattered enough, in an oddly oblique way, for the incident to help to throw the British election at the close of that year to the Liberals which, among other effects, brought Winston Churchill into Cabinet as Undersecretary of State for the Colonies.

Six years later the Qing Great State collapsed and a new generation of Chinese soldiers and intellectuals stepped forward to seize political power from the Manchus, replacing the Qing Great State with the Republic of China (1912–49). The high expectation was that the long history of foreign occupation, first by Mongols and then by Manchus, had finally come to an end; but not so. Two decades later the Japan Great State (Dai Nippon) made its first armed foray onto the Chinese mainland, and in 1937 launched military incursions against Beijing and Shanghai, marking the first steps towards the Second World War. Once again, China fell under foreign occupation. Chapter 13 takes us one year past the end of that occupation to consider the treason trial of a Chinese politician who, by choosing to collaborate with the Japanese, found himself on the wrong side of history.

The People's Republic of China was founded in 1949, vowing never again to allow China to be invaded by a foreign conqueror. That period lies beyond the reach of this book, though in the epilogue I reflect on certain continuities that reach into the century in which we find ourselves.

'What Place Is This?'
If anything has guided me through this project, it is my concern to reduce the distance that Chinese and non-Chinese are accustomed to place between themselves. Of course, there are differences that set China apart from the world that is not China. We could not speak meaningfully of China otherwise. Yet I find that we are likelier to see more by looking for bridges than by pointing out gaps. This is especially so at the present, when much of the world watches China's every move with suspicion.

The relationship has not always been so antagonistic. As the French philosopher Voltaire reminded his contemporaries, 'it is

a disgrace to the human mind for petty nations to think that truth belongs to them alone' – the 'petty nations' he is referring to here being those of Europe – 'and that the vast empire of China is given up to error'. Voltaire made this remark while fighting a rearguard action for tolerance at a time when Europeans were becoming increasingly bellicose in their relations with the world and with each other. As Europe expanded its power and the Qing Great State saw its capacities reduced, the balance of public opinion shifted. By 1818 the English Romantic Thomas de Quincey could write in his *Confessions of an English Opium-Eater* – written under the influence of the drug that came into Britain as an unintended consequence of Britain's shipping of Indian opium to China – of his fear of being 'transported into Asiatic scenes. I know not whether others share in my feelings on this point; but I have often thought that if I were compelled to forgo England, and to live in China, and among Chinese manners and modes of life and scenery, I should go mad.' That was a time when this view was treated as though he were saying something sensible.

I first went to China after finishing university in 1974. In those days China was a country largely closed to the world. I was granted entry because that condition of isolation was beginning to change. Unlike some of my fellow students on the official exchange programme, I did not expect to discover a viable alternative to Western capitalist society when I got to Beijing. There was no socialist utopia awaiting us. What I did expect to find was a place unlike any I had visited. It was. At almost every turn, it seemed, I found the fabric of social life differently woven from what I had grown up with. China became, for me, a good place from which to rethink the world. Of course, gaps and misunderstandings arose between me and those among whom I lived, but my task was to overcome them without surrendering my dignity, not to make the difference between us real and then to retreat behind it.

Still, there were odd moments when my appeal to commonality found no response. One was the afternoon I cycled from Peking University over to the Yellow Temple, which stood rather forlornly in a mixed residential-industrial zone inside the northern loop of the then newly built Third Ring Road. The Qing emperor had ordered the temple to be erected in 1651 in anticipation of the visit to Beijing of the Fifth Dalai Lama. He and the Dalai Lama were jockeying

to find the right relationship between the military authority of the Manchu Great State and the spiritual authority of the Dalai Lama's school of Tibetan Buddhism. The Manchus desperately needed the Dalai Lama's blessing if they were to dominate the vast Mongol world that stretched beyond their grasp and that looked to the Dalai Lama as its spiritual head. Political alignment with the new Qing regime could make all the difference to Manchu ambitions in Inner Asia. The happy outcome for the Manchus was that the Dalai Lama accepted the invitation to visit Beijing. A palace fit for the Buddha's highest emanation on earth was required, and so the Yellow Temple went up. I was curious to see this site of that history.

The temple was not open for visitors; it did not even have a sign saying what it was. As I approached the front gate that bright, wind-blown day, a custodian came out to meet me, a look somewhere between indifference and hostility on his face. Rather than reveal my knowledge of the temple and put my interlocutor on the back foot, I decided to take a pleasant touristy approach.

'Zhe shi shemma difarng?' I asked in my best Beijing accent. 'What place is this?'

'Zhe meiyou shemma difarng', he replied. 'This isn't any place.'

With that riposte our conversation came to an end. We were standing in front of as good a piece of evidence as any of China's richly complicated and troubled imperial past, but I belonged to the category of foreign spy and he was a low-level employee of the national security state, and nothing could pass between us. It was best for both of us if the Yellow Temple simply failed to exist. And so I let it fail, and cycled off.

That encounter was one of many I had in those through-the-looking-glass days as I tried to take in what lay on all sides and found an anxious state eager to block my view from every angle. With ordinary people I adapted my way of being to theirs, as they did to mine. I learned to speak their language and we got along. Despite de Quincey's worst nightmare, I managed to live in China, among Chinese manners and modes of life and scenery, without going mad. I encountered a country that intrigued me, and I met people who drew me into a lifetime of teaching and writing about a place on the other side of the world. This book is one possible sum of what I found.

THE YUAN
GREAT STATE

1

The Great Khan and His Portraitist

Xanadu, 1280

Let me show you one of the most impressive paintings of the thirteenth century (see Plate 2). The painting is as tall as I am, the scroll on which it is mounted even longer, and its colour scheme so vivid that the figures leap off the silk. It was done in 1280. The painter, Liu Guandao, just twenty-one at the time, did it as a commission from the court to portray his monarch, Khubilai Khan. If the result matched the Great Khan's intention, Khubilai had not been looking for the standard Chinese emperor-portrait of an inert ancestor sitting on a throne and staring dully at the painter. He wanted something dynamic. He wanted his courtiers to see him not as a figurehead but as a warrior. What better setting for such a painting than a royal hunt? Khubilai loved going out in large hunting parties. These hunts gave him and his warriors a chance to exercise the skills of war and supply meat for the Imperial Household. Just as importantly, they were occasions for Khubilai to lead his men and display himself to his subjects – to Chinese as their emperor, to Mongols as their Great Khan.

To signal that the Great Khan was in the field, Liu Guandao has given a horseman in the lower right-hand corner of the painting a *tugh*, a long pole topped by a tuft of horsehair signifying the khan's presence. To carry a white *tugh* was to come in peace. To hoist a black *tugh* was to signify war. So Khubilai was not just out hunting; he was commanding an army. And yet this is not a war scene, for his consort rides with him. Making a perfect pair with her lord, she is dressed in white to his scarlet, and has turned in the same direction to watch the archer shoot a bird on the wing. Khubilai's empress and closest adviser for three decades was a Mongol woman ten years his junior, Chabi. He looks his age in this painting, but she doesn't, and that might be because she isn't Chabi. At the time the painting was done, Chabi was already suffering from the illness that would kill her the following spring. While the woman in the painting could be Chabi re-imagined as her younger self, the realistic tone of the painting suggests to me that this might be her younger cousin Nambui, who took Chabi's place as Khubilai's consort after she died.

But this painting is not about Khubilai's relationship with Nambui. It is about his position as lord of the realm. For so important a purpose Liu Guandao needed his greatest skills as a painter. Khubilai had reached the advanced age of sixty-five, drank heavily, and had neither the strength to pull a heavily weighted bow nor the steadiness of grip to hit his target. Liu could not show him flying along on horseback loosing arrows at his quarry. Instead, he came up with several tricks to overcome this problem. One was to depict Khubilai, dressed in an enormous white ermine coat thrown over his imperial robes, twisting in his saddle to follow the action as though he were part of it. Another was to put him near but not exactly at the centre of the painting, so that the dynamic movement of the scene pivots around him. A third device, best of all, was to place him, as Liu has done, on the base line of the triangle that organises the main action of the painting. On the left side of the painting a mounted archer takes aim at two birds in flight directly above the head of Khubilai – birds that most viewers fail to notice the first time they look at the painting. Balancing the archer on the right side of the painting is a saluki hound watching for one of the birds to fall. A saluki is a sight hound and thought to see birds better than we do. Khubilai is not hunting. His bow remains sheathed in

the hands of his elderly bow-carrier behind him, but note the drooping hindquarters and tail of an animal slung behind the bow-carrier. The detail suggests that Khubilai has already bagged his quarry.

A second hunting drama takes place in the foreground, literally at Khubilai's feet. The horseman in the lower left has a gyrfalcon on his right wrist and behind his saddle has slung the kills of the hunt – one a partridge, the other an egret. The rider next to him has an even more impressive great white gyrfalcon on his wrist, its red hood over its eyes. But the most striking animal of the hunt is the one closest to the viewer. Muzzled, harnessed and tethered to the saddle, a hunting leopard is perched on a brightly striped blanket on the croup of the horse in the foreground.

Liu did not make up these details. We know of Khubilai's fondness for leopards and gyrfalcons thanks to a description one of his courtiers included in his memoir of serving the Great Khan (see Plate 3). Khubilai, the memoirist says, often 'enters the park with a leopard tethered to the crupper of his horse. When he feels inclined, he lets it go and thus catches a hart or stag or roebuck to give to the gyrfalcons that he keeps in mew. And this he does for recreation and sport.' He also reports that the Great Khan kept lynxes and even a few lions for hunting. The courtier was a Venetian. His name was Marco Polo.

Marco Polo in Xanadu

Marco Polo came from a family of successful merchants whose business dealings sent them all over the eastern Mediterranean and beyond. Although Marco was born in Venice, the family probably hailed from the Dalmatian coast across the Adriatic, the area that is now part of Croatia. Marco was not the first of his family to meet Khubilai Khan. Even before Marco's birth in 1254, his father, Niccolò, and his uncle, Maffeo, had gone out from Venice to trade, first into the Levant, then back to Constantinople, and then further east, ending up in the Mongol empire, where they met the Great Khan in 1265.

When Niccolò and Maffeo set off back to Europe, Khubilai asked them to bring back a hundred Christian scholars. Khubilai did not see them again for a decade, and when they returned to him, all they could manage was greetings from the Pope. But they did bring

someone who would go on to do more to shape European views of China than anyone, and that was Niccolò's son, Marco. Marco was seventeen when they set off from Venice for Asia in 1271. The journey ended up taking three and a half years, and only in May 1275 did they reach Shangdu, the Supreme Capital. Marco describes Khubilai's capital as 'a large city and a wealthy one'. So enthralling is his description that five centuries later, in 1798, the poet Samuel Taylor Coleridge, having dozed off while reading Polo's memoir, woke from a wondrous dream and penned one of the most famous opening lines in English poetry:

In Xanadu did Kubla Khan
A stately pleasure-dome decree.

The translation Coleridge was reading rendered Shangdu as Xamdu. Having settled on an iambic metre, however, Coleridge needed to stretch the two syllables of this place-name into three. He did it by switching out the 'm' and replacing it with 'na', coining the word we still use today to designate a magnificent place of idyllic wonders. Xanadu is incorrect Chinese, but since it has entered the English language, I shall use Coleridge's name for Khubilai's Supreme Capital in this book.

After twenty-four years travelling the length and breadth of Asia, Marco Polo eventually returned to the much smaller sea-based empire of Venice, only to get caught in one of its perennial short wars with Genoa, its competitor for control of the Mediterranean trading world. He ended up sharing a prison cell with a romance writer by the name of Rustichello da Pisa, and regaled his cellmate with tales of his exploits in Asia. Rustichello thought his stories worth writing down, and the two of them whiled away their time in prison producing a long narrative of his travels. Rustichello certainly put his mark on the book, for it reads as much like a romance as it does a description of someone's travels – and since a romance has to have a hero, the hero of the book is Khubilai Khan.

To spotlight the hero, Rustichello re-enacts in the prologue to the book the scene when Marco Polo first encountered 'the mightiest man, whether in respect of subjects or of territory or of treasure,

who is in the world today or whoever has been, from Adam our first parent down to the present moment'. Marco later describes him as 'a man of good stature, neither short nor tall but of moderate height', which rather tallies with Liu's depiction. He observes that Khubilai was 'well fleshed out' and that 'his complexion is fair and ruddy like a rose', gently acknowledging that the Great Khan was obese as well as a great drinker.

The meeting took place in the Great Khan's crowded audience hall in Xanadu. Marco's father and uncle knelt down before Khubilai and 'made obeisance with the utmost humility'. That ceremony completed, 'the Great Khan bade them rise and received them honourably and entertained them with good cheer'. After the initial exchange with Niccolò and Maffeo, Khubilai noticed Marco behind them.

'Who is this young stripling?' he asked.

'Sire,' replied Niccolò, 'he is my son, and your liege man.'

It was an ideal entrance for a young man wishing to enter the service of the Great Khan. There was nothing extraordinary about the Polos coming to serve this ruler. They were but three of many foreigners, Europeans and others, who journeyed to the Mongol empire to do business or seek employment that could be a lifetime's commitment. The Polos stayed in Khubilai's service for seventeen years before finally being sent home on a diplomatic mission, the subject of the second chapter of this book.

Polo's description of the palace and garden at Xanadu – the point at which Coleridge fell asleep – is enthusiastic. 'A huge palace of marble and other ornamental stones' consisted of many halls and chambers gilded with gold, 'the whole building marvellously embellished and richly adorned.' The palace buildings were not actually built of marble, or even faced with that stone. Chinese rarely built monumental buildings in stone. What Rustichello did was turn the white limestone of the terraces on which the palace buildings were set (fragments of which can still be seen on site) into the building material of the whole. He wanted to impress European readers with the grandeur of the hero's palace, and Venetians expected palaces to be faced with marble.

Beyond the palace's northern wall, which was also the northern wall of the city, lay an enormous hunting park 'enclosing and encircling fully sixteen miles of parkland well watered with springs and

streams and diversified with lawns' – Polo's image of the endless Mongolian grasslands. 'Into this park there is no entry except by way of the palace. Here the Great Khan keeps game animals of all sorts, such as hart, stag, and roebuck', for Khubilai 'is a keen sportsman and takes great delight in hawking for birds with falcons and gyrfalcons'. Polo then mentions the variety of hunting animals that Khubilai kept: over two hundred gyrfalcons, in addition to other falcons in even greater number. 'Once a week he comes in person to inspect them in the mew', or falcon house. The feature that stands out more than any other in his description is the magnificent yurt in the middle of the hunting park. 'It is reared on gilt and varnished pillars, on each of which stands a dragon, entwining the pillar with his tail and supporting the roof on his outstretched limbs. The roof is also made of canes, so well varnished that it is quite waterproof.' He finishes with the detail that 'it can be moved wherever he fancies; for it is held in place by more than two hundred cords of silk'. This yurt became Coleridge's pleasure-dome.

Nothing in Liu Guandao's painting indicates the particular location of the hunt he has painted. Polo tells of hunting parties out of Beijing in which the men and hunting animals numbered in the thousands, but this is not one of those. The probable location for this small excursion was the enclosed hunting park north of the palace in Xanadu that Polo describes, as Xanadu was where Khubilai spent most of his time. He only went south to his second capital late in the autumn, wintering there for four or five months before returning to Xanadu in the spring. This second capital was Khanbalik, the Khan's City, also called Dadu, the Great Capital. (We know it today as Beijing, the Northern Capital, the name it acquired in the Ming dynasty. Despite the anachronism, in this book, I refer to the city as Beijing.) Xanadu was not a summer palace to which Khubilai escaped the heat for a few months. It was his primary residence, and probably the setting in which Liu Guandao painted him.

Building Xanadu

Khubilai Khan was not in line to inherit the Mongol empire. That empire had been the creation of his grandfather, Temüjin, who in 1206 took the title of Chinggis (often spelled Genghis) and elevated

himself to the exalted title of Kaghan, or Great Khan. After him, only direct descendants within his clan, the Borjigids, forming a subgroup known as the Chinggisids, had legitimate claim to rule the Mongols. The empire was his family's personal property.

Although succession was strictly defined, that did not mean it was orderly. Unlike sedentary agrarian cultures, such as China, which favoured direct patriarchal succession from father to eldest son, nomadic cultures had a different goal in view: to elevate the most dynamic and powerful figure in the successor generation. The likeliest candidates for succession were the eldest and youngest sons, both of whom occupied important ritual positions in the family. But if neither was self-evidently the man to lead the family, they gave way or, more usually, were brutally pushed aside by a brother or cousin who, by fighting his way to the position of Great Khan, was regarded as deserving the leadership. My mentor in my early days as a graduate student, Joseph Fletcher, called this practice of brothers and cousins competing with one another bloody tanistry (succession by fratricide). Appalling by Chinese standards, it was accepted among Mongols as the best method for choosing the man most fit to rule. Bloody tanistry did not aim to replicate the ruling order; its purpose was to reinvigorate it.

When Chinggis Khan died in 1227, his four sons did not resort to fighting it out among themselves, but reached an agreement that the third son, Ögödei, should succeed their father as Great Khan. On Ögödei's death in 1251 the succession then went sideways to his younger brother's son, Möngke. When it came time for the next succession, this would prove favourable to Khubilai, as he was Möngke's next-oldest brother, and this moved him closer to the expected line of descent than if the position had gone not to Möngke but to Ögödei's son, for example. Once he became Great Khan, Möngke assigned Khubilai control over the region south-east of the Gobi Desert extending down into north China, a region previously under the control of another steppe polity, the Golden Great State of the Jurchen people.

Khubilai spent the first half of the 1250s in motion and without a permanent headquarters, but in the spring of 1256 he decided the time was right to establish his own court, a decision that hints at Khubilai's larger ambition to look towards establishing his own state. To

accomplish the huge task of building a court, he appointed a Chinese Buddhist monk named Zicong, who had been some years in his service. Zicong started by divining a propitious location, though Khubilai had already pointed him to it: the northern loop of the Luan River, which carved a path through the Mongolian grasslands before turning south-east and running into the distant Pacific. This location was far enough away from his brother's capital at Karakorum for it to be taken as simply a regional base for operations rather than be seen as a move against him. But the site already had the reputation and aura of being a capital. The Supreme Capital of the Jurchens' Golden Great State had been located here, as had the Supreme Capital of the Khitan Great State before it. Khubilai did not dare call his new city Supreme Capital (Xanadu), as the imperial pretension of that name might alarm his brother. Instead, he gave it a name that pointed towards China. He called it Kaiping: Launching Pacification.

Möngke's ambition meanwhile was to invade and conquer the Song dynasty. With that campaign in mind, he positioned brother Khubilai on the Song's northern flank, and Kaiping/Xanadu then became the base for Khubilai to support Möngke's plans. In 1259, both Khubilai and Möngke were on campaign in different parts of China when Jia Sidao, the chancellor of the Song dynasty, sent an emissary to open treaty negotiations. Khubilai had just ordered his representative to reply negatively to the Song emissary when news arrived that Möngke had died on 11 August. Suddenly the leadership of the Mongol empire was up for grabs.

The two contenders were the brothers Khubilai and Ariq Böke. Ariq Böke was favoured as the youngest, which is a position of privilege in Mongol descent. He was also the man who actually occupied the capital at Karakorum. Beating out his brother as Möngke's successor was now more important to Khubilai than continuing south into Song territory. On the same day that his general turned down the Song offer of a negotiated peace, demanding instead that the Song submit, Khubilai ordered his army to withdraw northwards. China could wait.

Khubilai spent the winter of 1259–60 in the Beijing region orchestrating his bid to succeed Möngke as Great Khan. He was delaying his return to Kaiping/Xanadu until his capital was fully in operation,

possibly also to wait out the worst of the winter weather (although Mongols did not fear the winter). Beijing may also have been a more convenient location for lining up his supporters behind the political bid he was about to make. Once spring arrived, Khubilai Khan returned north to Kaiping/Xanadu and there convened a *khuriltai*, an assembly of Mongol noblemen. He needed the blessing of a *khuriltai* if he hoped to be regarded as a legitimate contender. So too did Ariq Böke, who convened his own *khuriltai*. In Kaiping/Xanadu, Khubilai obtained the decision he wanted. The assembly elected him to be the next supreme ruler of the Mongol Great State. On 5 May 1260, after refusing election the ritually correct three times, he took the mantle of leader of all the Mongols.

Ten days later, on 15 May, his government issued a proclamation in Chinese to explain the outcome. The proclamation begins by recalling that Khubilai's ancestors had devoted over half a century to establishing an empire by force of arms, spreading Mongol rule to the four directions. Khubilai does not criticise them for failing to complete the great enterprise of state formation, noting that this was not something that could be achieved in the length of a single reign. He does, however, gently call out his elder brother, Möngke, for failing to live up to the divine signs of greatness that apparently had accompanied his investiture as Great Khan, though he is careful to blame Möngke's failure on a lack of good advisers. Now that his elder brother was dead, his princes and officials who had assembled in Kaiping/Xanadu pleaded with him that 'the great unity of the state can no longer be delayed, and the heavy trust of your sagely forebears can no longer be left unfulfilled'. So Khubilai reluctantly, or so he tells the world, agreed to what Highest Heaven commanded him to do. The subsequent war of succession with his younger brother Ariq Böke began in earnest that September and did not end until Ariq Böke's defeat three years later. His unexplained death in prison a year after that suggests strongly that bloody tanistry was at work.

Despite the continuing challenge from his younger brother, Khubilai went ahead and announced on 11 June 1260 that a new era was to be declared and a new capital put in place in Kaiping, which was formally renamed Supreme Capital (Coleridge's Xanadu) three years later. Confident of his base in the north, Khubilai now turned his

attention to the Song realm. That dynasty's continued existence was an intolerable denial of his universal rule. Besides that, success in this enterprise would be unassailable evidence that High Heaven favoured him over all other Chinggisids. But the conquest of the south proved to be a protracted affair. However brilliant the Mongols were at cavalry attack, however cleverly they learned Chinese techniques of siege warfare, the Song was not a weak state. It took Khubilai's forces fifteen hard years to overcome Song defences. The pressure on the Song through this period was enormous. Between Khubilai's rise to power and the fall of the Song capital of Hangzhou, the southern dynasty went through three emperors. The grandmother of the last Song emperor ended up overseeing the hapless eight-year-old's abdication early in 1276. Banished to Tibet, the boy emperor lived out his forty-seven-year exile in a Buddhist monastery, before eventually dying by his own hand.

The Little Ice Age

To secure his position as the Great Khan, Khubilai had to bring the Mongol world to heel and at the same time wage a campaign of conquest against the Song. He was successful on both fronts, but it was a long haul. He also had a third front on which to fight, and that was the climate. It is impossible to judge whether the wave of climate change that got under way in the 1260s helped push him to power or made it even harder to consolidate his position against those who would bring him down: both, I suspect.

We know something about environmental conditions in the 1260s because the court historiographers were required to keep a running tally of anomalies in the physical world, including extreme weather events. For just as Heaven mandated individual men to rule, so it dispensed natural disasters to put them and their people on notice of their failings. The historiographers grouped disasters into what for Chinese were the five elements: water (excessive rain, flood and snow), fire (city fires, but also the growth of miraculous mushrooms, which by spontaneously emerging were thought to express the element of fire), wood (wind damage to trees and crops), metal (droughts) and earth (problems that came out of the ground: crop failures, famines, locust infestations and earthquakes). Then they wrote out a summary list

that was preserved in the dynastic history that each dynasty wrote of the one it superseded.

Glance over these lists, and one finds that the first era of Khubilai's reign, called Established Rule (Zhongtong, 1260–63), was a mess. Famine struck in 1260. The early onset of frost for three years starting in 1261 ensured that the famine continued. Drought and locusts struck in 1262 and again the following year. In 1264, bad went to worse. North China was inundated by massive floods, which were then followed by drought, always a deadly combination. Khubilai's new realm was swiftly heading towards environmental collapse. This, it might seem, was Heaven's rebuke.

The floods caught the new Mongol rulers unprepared. Flooding was not part of the ecology of the northern grasslands. If an area was devastated, a nomadic population responded by moving on. The environment south of the Great Wall, however, did not allow for this flexibility. Farmers were tied to the land, economically as well as legally, and when the land washed away, something had to be done for them if agriculture was to be restored. In response to growing popular discontent, Khubilai went public about the disasters and issued a Renovation Edict. He reported to the people that his Muslim astronomers had detected that the stars had become misaligned, a sure sign that the natural disasters were not by chance. He stated that he took personal responsibility for the misrule that these disasters pointed to, and that he would seek to strike a new deal with Heaven by shutting down Established Rule and launching a new era. His Chinese advisers gave it the title of Ultimate Origin (Zhiyuan), from which Khubilai seven years later would derive the name of his Chinese realm: Yuan.

It is not clear how well prepared the Mongols were to rule China. A Chinese writer observed that Khubilai's court at the start of the Ultimate Origin era was a scene of pure chaos. 'The Yuan Great State received Heaven's mandate and founded a new realm in China, linking its rulers with the sage-emperors of the past', he allowed,

> yet at the start of Khubilai's Zhiyuan era, a proper court had not
> yet been institutionalised. Everyone who hoped for an audience,
> official or commoner, crowded outside his tent without
> distinction of honoured or base, high or low status. The court

monitors dealt with this annoying rabble by flourishing their staves and driving everyone off, but those they drove off kept coming back again and again.

Xanadu had not yet been domesticated to Chinese usages.

The Renovation Edict included a package of policies designed to improve state administration and ease the burdens of the people. The number of counties was reduced. The number of officers in each post was fixed, and their rankings and salaries regularised. Regular merit evaluations were imposed. Local officials were ordered to distribute state land to cultivators, cut back on unauthorised levies, curb the practice of stabling military horses in the villages, expedite legal cases, provide care for widows and widowers, bring commodity prices back to normal and submit monthly reports to the central administration. This reform was very much in a Chinese key. Khubilai probably had nothing to do with any of these policies. His Chinese advisers must have designed them in keeping with Chinese expectations of what the state should do when its administrative capacities were failing. The architect of the reform was probably his monk-adviser Zicong, for a week after the Renovation Edict was issued Khubilai ordered him to return to secular life and assume the post of prime minister.

Khubilai hoped that the reform would be enough to convince Heaven to ease up and give him a second chance. It didn't. The second year of Ultimate Origin (1265) was pretty much like the first. There were no significant floods, at least, but drought and locusts devastated the North China Plain, and the eastern zone was hit with killing frosts. The following year saw little improvement, and then drought returned to Beijing in 1268 and 1272. Locusts reappeared that year and for several years following. In 1271 the insects stripped Xanadu of vegetation. In 1273 they descended on half the realm. That same year the court recorded that frost and killing rain gripped nine places out of ten. Locusts returned in the summer of 1279, and Beijing was flooded the following year. Conditions improved briefly in the mid-1280s, but in the early 1290s temperatures across north China plummeted. By the summer of 1295, the region was in the grip of flood and famine, interspersed with drought and hail. That year, and the two that followed, were the three worst consecutive years of the thirteenth century. Looking back from

the end of the century, the last abnormally warm winter on record was in 1260. Looking forward, the next abnormally warm winter would not arrive until 1424, half a century into the next dynasty. China had become a cold place. Knowing this, we register those ermine furs Khubilai is wearing in Liu Guandao's portrait as more than signs of flamboyant extravagance. He wore them to keep warm.

China was not alone in experiencing severe cold. What Khubilai was dealing with was a new phase of global cooling that climate historians of Europe some decades ago labelled the Little Ice Age. The opening of the Little Ice Age has been flagged to the 1290s, with a slight rebound and then an even more severe collapse of temperatures in the 1310s. The Chinese documents suggest to me that colder temperatures were affecting China and Mongolia earlier than Europe. There are some scientific data for this, particularly through dendrochronology (the study of tree rings as indicators of climate change). Separate studies of tree rings of the Mongolian larch and the Fujian cypress show a reduction in growth starting in 1291, with the narrowest rings in 1295 and 1296, coinciding closely with the Mongol regime's three worst years (1295–7) of the century. What this meant for Chinese in concrete terms was that agricultural production contracted, food supply decreased and those who could migrate went south to warmer zones in hope of finding environments more conducive to agricultural production. Such migration was often at the expense of those already living there, producing inter-community and inter-ethnic tensions that shaped these areas for centuries to come.

If Chinese were subject to these climate pressures, so too were the Mongols. Falling temperatures decreased the capacity of the grasslands to support their herds. The entire dynamic that drew the Mongol Great State from Karakorum down to Xanadu, and from Xanadu down to Beijing, was a matter of both pull and push. Yes, the Mongols eyed China as a great prize to seize, but at the same time it was simply getting too cold in the north to sustain an empire. Khubilai needed to head south, and did.

The Yuan Great State
The decision to administer China from a second capital city was part of the 1264 Renovation. Xanadu remained the Supreme Capital, the

heart of the Mongol regime, but a second base of operations was ordered to be set up south of the Great Wall. We know that city today as Beijing, Northern Capital, though it did not get that name until the fifteenth century. At the time of the Renovation Edict it was called Yanjing, Capital of Yan, Yan being an ancient state in the region and its traditional moniker. Khubilai renamed it Zhongdu, the Central Capital. In doing so, Khubilai did not explain the division of labour between the two capitals. But the early onset of the Little Ice Age may have given him an inkling that the administrative challenges south of the Great Wall were going to require closer supervision and greater investment than those north of it, and that he needed to rule from both sides of the wall.

In order for it to live up to the designation of Central Capital, Yanjing had to be built up into a city worthy of the name. This was a costly undertaking, especially since the imperial structures in Xanadu were still under construction. Khubilai handed the task once again to the now former monk, Zicong. It took him five years to construct the walled city on a scale suitable to the grandeur of the regime.

As the project approached completion at the end of 1271, Khubilai issued his State Foundation Edict of 18 December. The time had come, he announced, to create a name for the realm he had created 'within the four seas', as he put it. He noted that past Chinese dynasties had used titles based on the place where the founder arose, but he deplored this practice. It staked a merely regional claim, whereas his rule was universal. Having completed the 'great enterprise' of Chinggis Khan by extending his grandfather's supremacy 'in all four directions', his realm required a 'great name' to match his achievement. To name his regime, one of Khubilai's Chinese advisers (probably Zicong) went back to a passage from the *Book of Changes* they had used in 1264 to call the new reign era Ultimate Origin. They took the second character, *yuan*, 'origin'. The new regime would be called Da Yuan, literally 'Great Yuan', though more exactly, following the Mongol nomenclature on which it was based, the Yuan Great State.

Earlier Chinese dynasties had sometimes taken the title of Great, but China was not Khubilai's model. The precedent came from his grandfather, Chinggis Khan, whose expanding realm came to be known as the Mongol Great State. By Khubilai's time, however, the

Mongol Great State was no longer the tightly unified polity it had been under his grandfather. Khubilai claimed the title the Great Khan of the Mongol Great State when he defeated Ariq Böke, but it was largely a nominal title. The political reality was that he was the ruler of his personal portion of the Mongol Great State, to which in 1271 he gave the title of the Yuan Great State. For the rest of his life he combined the formal rulership of both polities in his person, but the Yuan was really what he ruled. When, three months after the State Foundation Edict, Khubilai changed Beijing's name from Zhongdu, 'Middle Capital', to Dadu, 'Great Capital', he signalled that this would be the place from which he would rule the Yuan Great State.

It was a capital fit for the monarch of a Great State. When Marco Polo first entered the Great Capital in 1274, the year its construction was finished, he declared it to be the most impressive capital anywhere in the thirteenth-century world, and he was not wrong. The city was surrounded by a great wall, and within that city rose a second wall surrounding the palace. 'A very thick wall and fully ten paces in height. It is all white-washed and battlemented', Polo recalls. The palace within, he declares, was 'the largest that was ever seen'. The main building rested on a platform raised the height of a man, faced with what Polo thought was marble, although in fact it was a fine limestone. The platform was large enough to accommodate a terrace around the main building 'where men can meet and talk. At each face of the palace is a great marble staircase, ascending from ground level to the top of this marble wall, which afford entry into the palace.' Inside, the walls of the palace were 'covered with gold and silver and decorated with pictures of dragons and birds and horsemen and various breeds of beasts and scenes of battle'. He concludes by observing that 'the whole building is at once so immense and so well constructed that no man in the world, granted that he had the power to effect it, could imagine any improvement in design or execution'.

Polo was as impressed by the city surrounding the palace. He was amazed to see that 'the whole interior of the city is laid out in squares like a chess board with such masterly precision that no description can do justice to it'. He found the streets 'so broad and straight that from the top of the wall above one gate you can see along the whole length of the road to the gate opposite'. He had never seen a city so

densely populated 'both within the walls and without, that no one could count their number'. Not only that, but accommodations were provided for the businessmen who come 'in great numbers' to the capital. 'In every suburb or ward, at about a mile's distance from the city, there are many fine hostels which provide lodging for merchants coming from different parts.' Each nation had its own hostel. Merchants found the Great Capital attractive, he explains, 'both because it is the Khan's residence and because it affords a profitable market'. It was also a benefit that twenty thousand prostitutes lived in the suburbs, 'all serving the needs of men for money'.

Polo rounds out his generous portrait of the Great Capital by noting that a detachment of a thousand soldiers guarded every gate, 'partly as a mark of respect to the Great Khan, who lives in the city, partly as a check upon evil-doers'. But the real reason for their presence, he reveals, was that Khubilai's astrologers had prophesied a rebellion, for which reason 'the Khan does harbour certain suspicions of the people of Cathay'. Here was the predicament of every Chinese Great State: the occupied resented the occupiers, and the occupiers were always uneasy with those they had conquered. That tension never dissipated.

Ruling from the Steppe

Khubilai straddled this predicament by straddling the Great Wall. To the south lay the Chinese world that he had brought under his command after two decades of war. To the north lay the world of his birth and heritage, a world where, in the words of a Chinese writer, 'the terrain is high, the wells are deep, and the stars big'. It was the world Khubilai knew and loved best, and he was not about to abandon it to become a fixture on a Chinese throne. To manage the gap between the two worlds, he decided to inhabit both.

Every spring, Khubilai, his personal retinue and the entire upper rank of the Yuan bureaucracy trekked north to Xanadu. They remained there for seven months, and then trekked south again to the Great Capital and lived there for five. Mongols understood annual migration, but for the Chinese servants whose idea of a regime was that it should stay in one place this must have been a difficult adjustment. But they had no choice: everything had to follow the Great Khan. This included the popular annual marathon the Mongols called the

Take-Off. Where the race was run depended on where the emperor was at the time. If he was in Beijing, the starting line was at the canal wharves on the east side of the city. If he was in Xanadu, then the race started at a place just outside the city called Muddy River. The Mongols had started this tradition, but Chinese were enthusiastic to participate because the prizes Khubilai awarded in person were huge. The course was sixty miles long, and the runners were expected to cover it in six hours. The race ended at the foot of the emperor's throne, where Khubilai rewarded the winner with an ingot of silver, and runners-up with bolts of silk.

The fact that Khubilai Khan spent more time in Xanadu than he did in Beijing reminds us that the Yuan dynasty was unlike the dynasties before it or the dynasties that came after. When conventional historiography names the Yuan as a Chinese dynasty, it neglects the fact that the Chinese components of the Yuan Great State were quite outweighed by the Mongolian. The Yuan was the first major state to designate Beijing as a national capital, yet it was the secondary capital of a regime that remained based in Xanadu. Khubilai was first and foremost a Mongol Great Khan who ruled China as one part of his realm, not an emperor who brought Mongolia into the Chinese realm, as the Chinese textbook version would have it. Rather than regard Xanadu as his summer retreat, we get closer to the reality of the Yuan by treating Beijing as his winter retreat.

Khubilai kept up his annual commute until the last year of his life. The last time he left Xanadu was in October 1293. It was in Beijing that his health failed, and he died there on 18 February 1294, even as the annual preparations were under way to convey him back to Xanadu. A grandson was designated to succeed him, but a suitable ritual of succession could not be conducted in the Great Capital. He travelled north to Xanadu at the end of April and was enthroned there as the new Great Khan on 5 May 1294. Khubilai's annual commute became his, as it did every Yuan emperor's until the closing decade of the dynasty.

Khubilai's affection for Xanadu is clear in the scroll that Liu Guandao painted. The man is on horseback in his hunting park, surrounded by those he loved best: his consort, his hunters, his warriors, his hounds. But let me direct your attention to two of the riders I

neglected to mention at the start of this chapter. One is the obese and almost comical figure who sits awkwardly on his horse. He is dressed in imperial red, not as a member of the royal family but as one of the family's lifetime servants, a eunuch. He is there because Khubilai's consort could not appear in public without a gelded attendant, and the duty that day fell to this man. The most striking thing about him is his black complexion, something he shares with the rider carrying the beater pole below the imperial couple. The faces of both men are wide, their features blunt, their ears pierced with wide hoop ear-rings. Neither looks Mongol or Chinese. They are other people, though who? Andaman Islanders? South Asians? They look African to me. Chinese called them 'slaves from the Kunlun Mountains', in vague reference to lands beyond the Himalayas. The one thing we do know about the African eunuch is that he was indeed a slave, for his left cheek has been tattooed with the Y-shaped character *ya*, meaning bondservant. Here is yet another man in the Great Khan's service, though not by his own choice.

Liu Guandao was commissioned to paint the Great Khan, but by including around him the men who were there to do his bidding, Liu has produced something closer to a group portrait of the age of Mongol rule, a vision of a new China in which not one Chinese appears. And it was a new China. The Mongol conquest did not just put the country under the control of foreigners. It brought the world into China. Marco Polo, the African eunuch, the black beater, even the Great Khan himself, became part of the history of China in ways that no one standing in the shoes of the Song dynasty could have predicted – and, I would say, in ways that Chinese today are not much disposed to recognise as their own. The century of Mongol rule that Khubilai inaugurated did not just pass like a fleeting cloud across the face of an eternal China. It altered China in ways that did not disappear with the Mongols and in ways that have become hidden in plain sight: the elevation of the emperor to supreme status; the creation of a cadre of powerful servants whose duty was to obey the emperor rather than the state he ruled; the ready resort to naked power to ensure the rights of the ruler; the redefinition of moral conduct as submission to the whims of High Heaven.

The Yuan Great State modelled for China a new political framework,

a new constitution and a new relationship between ruler and subjects. It also forced China into a far more dynamic, interactive relationship with the world; indeed, it assumed that matters could not be arranged in any other way. The time would come, after the Mongols had left, when Chinese chose to deny their entanglements with the world and close their borders. But there would be no final untangling, no going back even when the going forward was not easy, as so often it was not.

2

The Blue Princess
and the Il-khan

Tabriz, 1295

She sits beside her husband on an intricately carved platform (see Plate 4). A kneeling servant presents them food on a tray. Her husband grasps a napkin in his left hand; she holds something – it is not clear what – in hers. They turn towards each other on the thick pillow that cushions them both as they converse. He is in his early twenties, of slight build, and his name is Ghazan. He is dressed in Mongol style, wearing a tight-fitting tunic with short outer sleeves and low riding boots. She is two years his elder, and her name is Kökečin Khatun, or the Blue Princess. Kökečin means 'dark-skinned' – the darkest blue of the sky – though the artist has given her the same complexion and rosy cheeks as her husband. Her full silk robe is the common hybrid of the era: long overlapping lapels and wide sleeves in the Chinese style, with the sleeves gathered at the wrist in tight cuffs in the Mongol style so that the wearer may ride a horse. Lady Kökečin's most conspicuous piece of adornment is a towering pillbox hat topped with bobbles and a long feather, a style reserved for Mongol royals. The

two women to her left wear the same style of hat but with one bobble instead of two, distinguishing them as women of elevated but lesser status than their queen.

The setting is the court of the Il-khanate in Tabriz, in the mountainous region between the Caspian and Black seas where today's Iran, Armenia, Georgia and Turkey meet. The Il-khanate was a Mongol state in Persia that had broken away from the rule of the Mongol Great Khan just prior to the rise of Khubilai. The scene could date to as early as October 1295, when Ghazan became the Seventh Il-khan, though whether the painter drew it from life or imagined it later we cannot say. Probably it was done later. It almost doesn't matter, since the components of the painting – most importantly, the people – have been arranged entirely to follow the standard format of the time for depicting a Mongol royal couple. Rather than paint the husband larger or higher than the wife, as a Chinese royal portraitist would have done, the artist places them side by side on a platform throne, the husband on our left and his wife on our right, on the same plane and equally sized. The platform is surrounded on three sides by hinged Chinese screens in carved openwork lattice and lacquered red. Following Chinese convention, the men show their feet and the women do not, even though Mongol women were not subject to the Chinese fetish for small feet that started in the Song dynasty.

The Blue Princess earned a place in this book because of her entanglement in the webs linking China to the world at the end of the thirteenth century. Politically, she sat on the Il-khan's throne because Khubilai Khan put her there. Geographically, she was in Persia because the international maritime networks of this period made the journey by sea from her home in China to Persia possible – which is to say that the Mongol Great State worked by water as well as by land. Archivally, she has survived because Marco Polo was in her entourage and on hand to tell her story. Finally, to set her experience in its organisational context, she was able to make the journey because a Persian comptroller working for Khubilai Khan back in China organised the finances that made her voyage to Persia possible – a single reference to whom is the slender thread from which hangs any indication in Chinese sources that Kökečin ever existed, or that Marco Polo ever went to China.

The Persian Comptroller

The sole reference to Kökečin's voyage in the vast Chinese historical record is linked to a man who appears in the Chinese records as Shabuding. It's a good approximation of the Mongolian pronunciation of his name, but Shabuding isn't a Mongol name. It is Persian: Šahab al-Dīn, Star of the Faith. Mongols sometimes took Persian names, but the chances are very good that this man was indeed Persian, and certainly a Muslim. The only bit of biography we have about Šahab al-Dīn's family is a passing reference in the official dynastic history produced after the fall of the Yuan to a younger brother, also in the Great Khan's service in the 1280s and also involved in maritime affairs.

Šahab al-Dīn and his brother were among the many Persians in the army of officials and functionaries, neither Mongol nor Chinese, who administered the Yuan Great State on the Great Khan's behalf. The continental reach of the Mongol Great State brought them in considerable numbers. Being untethered to either Mongol or Chinese networks, they had loyalty only to the Great Khan, which suited Khubilai. For these non-Mongol non-Chinese, he created a special registration category called *semu*: literally, 'various categories'. Most 'various' people were West Asians, but the category also included men such as the Italian Polos. In status they were one step below Mongols but one step above the peoples of north China, whom the Mongols conquered first, and two steps above southern Chinese. People of the last group were called Han after an earlier Chinese dynasty, a term still used today as an ethnic label for people we know as 'Chinese'.

Šahab al-Dīn first comes into view in the official history of the Yuan dynasty on 24 June 1287, when an official recommended that Khubilai build military installations at Shanghai and Fuzhou 'to supervise the maritime transport vessels of Šahab al-Dīn'. Šahab al-Dīn was also in charge of the Cash Treasury, which received customs duties. On 2 February 1289, for instance, we read that he forwarded to the throne the annual quota of 400 catties (530 pounds) of pearls and 3,400 taels (270 pounds) of gold from the maritime customs office in Quanzhou, the main foreign trade port on the south-east coast.

Energetic financial administrator that he was, Šahab al-Dīn was constantly under a barrage of criticism from Chinese, who objected to his zeal for increasing state revenues. One Confucian schoolteacher

even wrote to Khubilai to allege that Heaven had been so offended by Šahab al-Dīn's brutal conduct that it had unleashed earthquakes and floods. But the Persian enjoyed the Great Khan's confidence. That confidence was slightly eroded in August 1290, when he complained to Khubilai that local Chinese officials had been pilfering tax grain and proposed that the emperor reinstate what he claimed was the Song penalty for theft: cutting the culprit's hand off at the wrist. 'But that is a Muslim law', Khubilai objected. During a famine the following year, questions about Šahab al-Dīn's possible misuse of tax grain were enough to move Khubilai to order the man's wife to the capital as a hostage while her husband's case got sorted out. The charge proved to be malicious, and Šahab al-Dīn went on to weather every political storm that blew his way. He and his brother were still in imperial service as late as 1310, two emperors after Khubilai.

Launching Lady Kökečin

The connection of Šahab al-Dīn with the Blue Princess is slight, but it is from such slight connections that we catch sight of the hidden complexities of the Mongol Great State's involvements with the wider world. This is all because of the chance survival of a documentary fragment from the massive imperial encyclopaedia of the fifteenth century, *The Great Compendium of the Yongle Reign*. At 22,937 chapters, the *Compendium* was too impossibly large to print and existed only in manuscript copies, of which the last was mostly burned by British soldiers when they ransacked Beijing during the Opium Wars, though some pieces of it got carried off as souvenirs. Two Chinese historians noticed a fragment from Chapter 19,418, and brought it to scholarly notice in a one-page research note in the *Harvard Journal of Asiatic Studies* in 1945. It wasn't until 1976 that Harvard's first professor of classical Mongolian, Francis Cleaves, gave this document the scrupulous treatment it needed so that the rest of us could realise its significance. Here is the document:

On 21 September 1290, Chief Minister Ananda, Division Chief Beg Buqa, and others memorialised:

'Administrator Šahab al-Dīn submitted a statement:

"In April of this year an imperial directive was received

ordering Uludai, Abišqa, and Qoǰe to travel via Ma'abar [on the Coromandel coast in Tamil Nadu] to the domain of the Great King Arghun.

"Of the one hundred and sixty people travelling together, ninety have already received their travel expenses. As the other seventy by report have been given or purchased [as slaves] by various officials, it is requested that they not be given travel expenses or grain rations".'

There was received an imperial directive: 'Do not give them.'

The document follows the usual Chinese structure of summarising all previous documents in a paper trail before getting to the decision it presents. It starts in the mid-point of that trail by naming two officials, Ananda and Beg Buqa, who sent Khubilai a 'memorial', to use the standard term in English for this sort of communication (one did not tell an emperor anything, one only reminded him of something). In their memorial they name Šahab al-Dīn, who, in his earlier statement to them, named three men: Uludai, Abišqa and Qoǰe. Šahab al-Dīn states that they are envoys whom Khubilai sent to the Il-khan, Arghun. Nowhere else in the records of the Yuan dynasty are these three envoys referred to, but Marco Polo mentions them. He explains that these three had indeed been sent by Khubilai to Arghun, but that they had first been sent from Arghun to Khubilai, to convey the Il-khan's request for a royal wife. (Marco also names Uludai in the long rambling tale at the end of his book about Arghun's rise to power. Uludai was one of his uncle's men, but he switched sides after Arghun was captured and freed him so that Arghun could prevail over his uncle.)

The memorial from Ananda and Beg Buqa is the only whisper in Chinese sources of the Kökečin embassy, and a very faint one at that. It is worth asking why a project on this scale would pass unnoticed by the court historiographers. The answer has to do with the structure of the Mongol Great State. Khubilai was the Great Khan of that superpolity, but in practical terms he ruled over only the Yuan Great State. The Yuan and the Il-khanate (Il-khan means 'obedient khan') existed more or less independently of each other, as did the other two of the four polities that descended from the four sons of Chinggis Khan,

the Chagatai Khanate and the Golden Horde. Arghun was not strictly speaking a dependent or tributary of Khubilai, but Khubilai was his great-uncle, and that imposed certain obligations. One was that he should forward rents from lands apportioned by Khubilai's predecessor to the descendants of his brothers, which he did. This was one of the reasons to send a large embassy by sea: to forward the rents that were owed. Another obligation was that the Great Khan should provide wives for his male kinsmen, even those who ruled other states.

Arghun had approached Khubilai for this reason after the death of Bulughan Khatun, the Lady of Sable, in 1286. Bulughan had been Arghun's strong-willed, aristocratic stepmother. (Polo thought she had been his wife, perhaps because she raised his two sons, her step-grandsons.) Lady Bulughan stipulated in her will that, should Arghun wish to take a new wife after her death (he already had several), the new bride should be from her family back in China. So Arghun sent Uludai, Abišqa and Qoje to Khubilai to make the arrangement. They travelled by the trans-Asian route we call the Silk Road to present his request to the Great Khan. The Silk Road is a modern term that simplifies a complex reality of multiple overland routes connecting China to the Middle East and on to Europe. The Silk Road was less a fixed road than an itinerary, a security corridor that opened and closed and changed as political circumstances, desertification and internecine struggles dictated. As long as the safety of travellers could be maintained and the various minor potentates along the way agreed to keep it open, passage was possible. Calling it Pax Mongolica, as some historians have done, exaggerates the stability of this travel corridor, yet at least for the century of Mongol rule in China the way was more or less kept open between the Mediterranean and East China seas.

Once Arghun's embassy reached the Yuan court, Khubilai designated a princess for the purpose, and the party, together with the princess and her entourage, was sent back along the Silk Road. Coming to China, the route had been passable, but the route back was not. Eight months after setting out, the lack of security along the Silk Road forced the embassy to return. What to do?

Overland was not the only route from East Asia to the west. Marco Polo takes credit in his memoirs for proposing an alternative route for the mission. He writes that he had just returned from India, where

he had been on the Great Khan's business, when the embassy to the Il-khan found itself back in China. While Marco was in India, Uludai, Abišqa and Qoǰe had made the acquaintance of Marco's father and brother. When they met Marco and learned of his travels, they suggested to Khubilai that the embassy take the sea route to Persia, and that the Polos travel with them. The new plan coincided with the Polos' long-held desire to get leave from Khubilai to return to Venice. It was leave that he had withheld, but he finally agreed to let them go. Kökečin's embassy would go by water.

Šahab al-Dīn would have had nothing to do with this story, had the overland route been chosen again. Going by water meant that it fell to him to organise the mission and work out how to pay for it, as he was the comptroller of maritime customs. And that is how, struggling to limit what his budget had to cover of the voyage's expenses, Šahab al-Dīn came to leave a document that got excerpted in another. Without the memorial from Ananda and Beg Buqa, there would be no Chinese record whatsoever that an embassy involving hundreds of people travelled half-way around Asia on the Great Khan's business. This document not only attests that Marco Polo was indeed telling the truth about Kökečin's voyage to Tabriz but confirms that he had indeed gone to China.

By Land or Sea

When Khubilai extended his rule over China, he did not limit himself to seeking power over land only. Once he reached the eastern shore of the continent, he looked out over the water where lay further lands to conquer. The first maritime state to occupy his attention was Japan.

On 7 September 1266, Khubilai ordered two Mongol officials to carry a diplomatic letter to Japan. The dynastic historiographers considered this document so important that they included it twice: once in the record of Khubilai's reign, and once in the section on Yuan relations with Japan. The opening salutation announces Khubilai as the ruler of 'the ancient Mongol Great State' – hardly ancient at all, but he needed to position his realm as superior to that of the 'king' of Japan (he did not recognise Japan as having an emperor). He commiserated with the king about how small his country was, but then pointed out that the king should use this to advantage: 'We are the ruler of

what had been a small state from ancient times, the territory of which abutted that of our neighbours, which is why we have devoted ourselves to establishing trust and maintaining good relations.' But 'having received the clear mandate of Heaven, and having taken extensive possession of Chinese territory', his was no longer a small state but was now a Great State that was 'projecting its awe and virtue to distant quarters and foreign regions that are beyond counting'. Khubilai explained that his conquest of Korea meant that the Mongol Great State and Korea enjoyed a relationship 'as joyful as that of father and son' – speaking, of course, from the father's point of view – so why, he wondered, has Japan not sent even 'one miserable embassy' to express a desire for good relations. 'The sages regard all within the four seas as one family, so how can your failure to communicate your good wishes accord with this ideal of one family?' One family, and himself as the head. The letter closes with an unveiled threat. 'As for going to the point of resorting to arms, who would want that? You, king, should consider this.'

Japan stared down the threat and did nothing. Several more letters over the next seven years also got no response. The world took notice. Three and a half centuries later a Chinese author still recalled, with no little delight, the humiliation that this must have been for Khubilai. 'In the Yuan's most prosperous era, the foreign barbarians who sent tribute numbered over a thousand countries,' he exaggerated. 'There was none that did not come as a guest of the realm – except Japan!' Finally, Khubilai ordered an invasion in 1274. A naval force of nine hundred ships and fifteen thousand soldiers was launched. The dynastic historiographers claimed victory for the Mongols, but noted that indiscipline and a shortage of arrows had obliged the army to withdraw – which was the delicate way of acknowledging that this had been a stunning victory for Japan. Japanese records speak of a 'divine wind' (kamikaze) driving the invaders back, but recent archaeological research suggests that the defeat may have had to do with the Chinese ships being in poor condition and badly equipped.

Khubilai kept sending ambassadors, to no avail, though when some Japanese merchants in 1278 asked Khubilai to waive the restriction on buying Chinese bronze coins (which served as the international currency for small transactions), he agreed, thinking this might be an

opening for negotiations. The shogun's execution of new envoys from Khubilai in 1280 proved otherwise. This act obliged Khubilai to launch a second invasion the following year, but it too ended in disaster for the Mongols and another *kamikaze* for the Japanese. Khubilai made one more bid, in 1284, by working back channels and sending a Buddhist monk as an envoy, but the sailors charged with transporting him to Japan guessed what their fate would be. They murdered the monk and melted away.

In 1286, twenty years after his first letter, Khubilai announced that he was temporarily suspending his ambition to conquer Japan. His excuse was trouble on the southern border with Dai Viet, the Viet Great State (which Chinese called Annam, Peace in the South). 'Japan has not once invaded us, whereas right now Annam is encroaching on the border. It would be better to set Japan aside and concentrate our efforts on Annam', Khubilai wisely decided. Not wanting to be defeated on the water a third time, he preferred to have his armies advance across land. After Khubilai's death in 1294, an official proposed to his successor, Temür, that they have another go. The new emperor cryptically replied, 'Now is not the time. We will give it thought.' Which meant, do nothing and don't expect to hear from me on this matter again.

Khubilai's difficulties with Japan did not discourage him from looking in other maritime directions. As early as 1276, and with most of the Song defeated, he declared that it was time to extend conquest southward into the South China Sea, and dispatched envoys to notify rulers that he expected them to submit. Some responded. In the summer of 1279, envoys arrived from Champa (south Vietnam) and Kayal (on the Coromandel coast in south-east India) to present him with precious gifts. The Great Khan was pleased that a state as far distant as Kayal, which Chinese estimated to be 30,000 miles from China (the actual distance is less than 5,000 miles), recognised his supremacy.

By the same token, however, he was annoyed that others had not. Fifteen special envoys were sent out to make sure the rest of the maritime world paid court. One of these, Yang Tingbi, had distinguished himself in the military campaign to destroy the last resistance of Song loyalists. His remit was to proceed directly to Kollam (Quilon), the main port-state on the south-west coast of India, to negotiate

its submission. Yang set sail from Canton in January 1280, reaching Kollam three months later. The king there decided to conform to Khubilai's demand, and so sent an envoy to accompany Yang back to China and to present to Khubilai a text in Arabic declaring his submission. Almost immediately, Khubilai turned Yang around and sent him back to the region early in 1281 to take the Kollam ambassador back home and to approach other local rulers. Yang again made the passage in three months, though the treacherous currents around Ceylon blocked the final leg of the voyage. Instead of Kollam, Yang went directly west to Kayal, which had previously sent tribute, and from there travelled to Kollam overland. Local politics, however, defeated him: one leader wanted to ally with the Mongols, another didn't. Yang returned to China unsuccessful this time, but Khubilai ordered him to lead a third delegation to the region to keep up the pressure. Yang caught the monsoon in December 1282, made the passage in three months and managed this time to persuade three rulers to send envoys to China.

That was the best Khubilai could hope for from distant South Asia. His ambitions within South-East Asia were more aggressive. In 1282, he sent a naval expedition against Champa in response to the seizure of four of his envoys in a Champa port. The seizure had happened in the context of a succession crisis that had nothing to do with the Yuan, but that quickly turned into a two-year resistance that ran up a terrible toll for the Mongols. In 1293, Khubilai sent his last naval expedition, this time against Java for insulting an imperial envoy. Again, this happened during a succession crisis when rival factions tried to use the Yuan to separate advantage; again it was another embarrassing defeat.

Since geostrategic conditions did not allow the Mongol Great State to reach across the water as it had done across the land, the Yuan came to distinguish between *yi* ('barbarian') states, with which it communicated over land, and *waiyi* ('external barbarian') states. Although all foreign states should submit to Yuan authority, states 'beyond the seas' would be invited to take part in the tribute system, but would not be compelled to do so.

Sailing to Persia
The embassy conveying Lady Kökečin to Persia had first attempted to

travel by land, the zone over which Mongols were confident of asserting control. Only when that route proved too dangerous did Khubilai send her by sea. He did not expect this embassy to force maritime rulers to their knees, but he did expect those rulers to show respect to his envoys. To gain that respect meant equipping the voyage on a lavish scale, complete with crew, soldiers, diplomats and servants. Marco Polo reported that the princess's entourage alone consisted of six hundred people, a hundred of whom were female attendants. We can guess at the number of sailors. Since the flotilla consisted of fourteen ships, of which at least four or five had crews of 250 to 260 men, some 3,000 sailors must have been involved.

The larger ships had four masts and twelve sails, and could take two secondary masts as well. According to Polo's description of other vessels sailing out of Quanzhou, these ships had a single deck with at least sixty small cabins to accommodate travellers. Their hulls were divided into thirteen bulkheads for carrying cargo, which on this voyage was two years' worth of provisions. Every ship towed two or three tenders to help manoeuvre the vessel in close quarters, and the largest of these could carry up to a hundred sailors. They also had as many as ten smaller boats lashed to the sides of their hulls, to be used to fish and to ferry goods and passengers between ship and shore.

Two years was not an unreasonable estimate of how long the journey from China to Persia and back might take, but timing was everything and depended on catching the monsoon. During the winter monsoon (the word means 'season'), the wind blows from the north-east, ideal for sailing from east to west. During the rainy summer monsoon, the winds swing around and blow from the south-west, propelling sailing vessels from west to east. The winds turn from north-east to south-west at the end of April or the beginning of May, then reverse at the end of October or the beginning of November. As the winds blow, so the currents move, doubling the effect. There is regional variation in how and when the winds blow, but the larger system is constant.

To sail from China to Persia within a year it is essential to set off as soon as the winter monsoon is well established, usually in December. Kökečin's voyage seems to have set off from the port of Quanzhou a bit late, probably in January 1291. The flotilla headed south-west

across the South China Sea, calling first at Vijaya (Champa) and then continuing on past the uninhabited islands of Condor off the south coast of Vietnam towards the Singapore Strait at the south end of the Malay Peninsula. That strait is shallow and demands careful navigation. Having cleared the strait, the ships turned north-west and sailed up the Strait of Malacca towards the Indian Ocean.

Their progress was halted at Samudra (Sanskrit for 'the Seven Seas'), a maritime kingdom at the northern tip of Sumatra that we now know as Aceh. Although the local ruler had pledged allegiance to Khubilai Khan, the travellers were apprehensive about staying there for fear of cannibals. Their fear was unwarranted, but it induced them to set up a fortified camp facing the harbour protected by a moat on three sides and five watchtowers. In time, Polo says, they worked out a deal for the locals to supply them with food. The quality of the fish and the local palm wine finally won Marco over.

The reason for setting up camp at Samudra was the monsoon. The flotilla must have reached Samudra in April, too late to cross the Bay of Bengal. Once the summer monsoons set in, heavy rains, storms and a contrary ocean current make the crossing impossible. Not before September could the princess and her entourage resume their voyage, when the north-east monsoon, the 'fine season', according to the standard nineteenth-century navigation manual for the Indian Ocean, resumed. To cross the Bay of Bengal, pilots are advised to keep to the Malaysian side of the Strait of Malacca as far north as Junkseylon (now Phuket, Thailand), then turn west and steer a straight course between the Nicobar and Andaman Islands. Marco Polo confirms that this is the course they took, as he provides descriptions of both archipelagos. His outlandish tales of dog-headed Andaman Islanders and of ships being snagged by tree roots suggest that the flotilla did not land on either.

Marco Polo's record of the embassy's movements after crossing the Bay of Bengal is of little help for reconstructing Kökečin's itinerary in India. He describes places on the Coromandel coast and Ceylon (Sri Lanka) in a style that sounds more like a potted travelogue than a diary. But he must have gone to Kayal, which sits at the mouth of the Tambraparni River directly west of Colombo on Ceylon, for he describes it as a 'great and splendid city' and 'the port of call for all ships trading

with the west' as far as Hormuz. 'Merchants congregate here from many parts to buy horses and other merchandise.' He lauds the local king for maintaining strict justice, 'especially in his dealings with foreign merchants. He maintains their interests with great rectitude, so merchants are very glad to come here.' This is high praise from a merchant who understood that most port authorities were bent on siphoning what they could off trade, rather than promoting it.

Polo's account then takes the reader from Kayal around Cape Comorin and up India's Malabar Coast. Of this coastline he reports that local custom permitted seizure of cargo from ships driven off course, a view that persuaded Chinese captains to spend as little time here as possible. Anyone beaching his ship on the sand to take on cargo tried to get off in four days to avoid attack or confiscation. Once along this coast, Polo describes port-states facing the Indian Ocean one after the other without any reference to the Kökečin mission. As his list includes Zanzibar on the coast of Africa, which Kökečin clearly did not visit, it is impossible to disentangle first- and second-hand accounts and work out at which ports the embassy actually called.

One fact that Polo asserts is that the trip to Hormuz at the mouth of the Persian Gulf took eighteen months. Had he been counting from Quanzhou, where he and Kökečin embarked in January 1291, this would indicate arriving in Hormuz in June 1292, but the summer monsoon makes crossing the Arabian Sea at that time impossible. He would have had to wait in Samudra for the summer monsoon to end, so must have been counting from there. Elsewhere in his memoir Polo mentions that merchants in Hormuz were idle during the winter, waiting for the arrival of ships from India at the end of the season, so it seems that the fleet reached Hormuz in the winter of 1292–3, and that the voyage from China took two full years.

What this makes plain is that poor Lady Kökečin spent a long time on her ship. It suggests that the embassy had other tasks to perform in addition to delivering a princess. We have no way of divining what particular interests Khubilai may have had to press with any of the rulers whose ports the princess visited, but we can be sure that he would not have let slip the opportunity to remind the world of his greatness. In addition to being simply a second attempt to deliver a bride, the mission was at least an occasion for Khubilai to acknowledge the

tribute embassies that had reached him in 1280s, and also to remind the rulers of all the small states in the Indian Ocean that he remained supreme.

The Dead Bridegroom

The embassy crossed the Arabian Sea to Hormuz, at the mouth of the Persian Gulf, early in 1293, and from that port it proceeded overland to Tabriz, the capital of the Il-khanate (in today's north-west Iran). On their way there, however, they learned that Arghun had died in 1291, about the time the flotilla was in the Strait of Malacca. What then were they to do with Kökečin now that there was no bridegroom? The Il-khanate was now in the hands of Arghun's brother Gaykhatu, who had outmanoeuvred Arghun's son Ghazan and had himself declared the Fifth Il-khan. Gaykhatu took over Arghun's wives, but he had no claim on Kökečin, as no marriage had taken place. Perplexed to know how to handle the situation, the envoys sent messengers back to Khubilai for instructions. When he replied, he directed that Kökečin should not be given to Gaykhatu, probably because of a sense that the correct line of succession should not have gone to him. Gaykhatu had in any case not consulted Khubilai on the matter; so instead, the envoys were to give her to Ghazan.

At the time Ghazan was out on Persia's eastern border defending the mountain passes, probably a move by Gaykhatu to keep him away from the political centre. Once Khubilai's will in this matter was known, there was nothing Gaykhatu could do. The embassy left his court and travelled east to the city of Abhar. Polo has little to report at this point, but we can pick up the story from the history of the Mongol world compiled by Rashīd al-Dīn, a Jewish physician in the court of the Il-khan who converted to Islam and rose to the post of vizier under Ghazan's later rule. His account records the arrival of 'Qoje and other emissaries Arghun Khan had sent to the Great Khan to bring back a kinswoman of the Great Bulughan to be put in her place'. (Recall that Qoje was one of the three envoys the Il-khan had sent to China to acquire the princess, whose names appear in the document Šahab al-Dīn submitted regarding paying for the maritime embassy. The other two envoys had died en route.) 'Along with Princess Kökečin', Rashīd al-Dīn continues, 'they arrived with rarities of Cathay and China suitable for kings.' After consummating the

marriage, 'Ghazan Khan sent to Gaykhatu a tiger and several of the others gifts', which is to say a portion of the dowry sent by Khubilai, following the Mongol practice of sharing 'booty'.

The mission thus fulfilled, the Polos and everyone else returned to Gaykhatu's court in Tabriz. For nine months they waited for clearance to leave, surely an interminable wait with Venice closer than it had been in twenty-four years. At long last, the Il-khan gave them leave to depart for Venice. Gaykhatu issued them special passes reserved for emissaries of the Great Khan. These passes were thick gold tablets almost a foot and a half in length on which was written: 'In Reverence to Eternal Heaven, Let the Name of the Great Khan be Honoured and Praised for a Myriad Years.' The passes also stated that harming the bearer was tantamount to assaulting the Great Khan himself, for which the penalty was death and the confiscation of the offender's family's entire wealth. However impressive the threat, Marco knew that his safe passage really depended on what he called the 'necessary precaution' of the two hundred horsemen Gaykhatu assigned to escort them out of his realm. They rode down to the coast of Lebanon, sailed to Constantinople and from there proceeded to Venice. The voyage begun in 1291 was over, and it was now 1295.

The toll on those sent to perform the mission was huge. Of the original six hundred members of the princess's entourage, Polo reports that only eighteen were still alive at the time he departed from Tabriz. As for the hundred women among them, manuscripts differ. The standard Italian edition says that only one woman died. The manuscript in Venetian dialect, generally regarded as corrupted, has reversed the outcome to state that all but one woman died, and that the exception was Kökečin.

In the autumn of the year the Polos got home, Gaykhatu was garrotted by his own military commander. He had been unpopular for many reasons: doubts about the legitimacy of his succession mingled with accusations of wine, women and sodomy, though the tipping point for ordinary people was his introduction of banknotes printed in the Yuan style. These notes functioned reasonably well as legal tender in the Yuan, but in the Il-khanate they were unprecedented. No merchant would accept them, and the Persian economy ground to a halt. The throne at first went to Gaykhatu's cousin, but Ghazan intervened,

defeating the second usurper and taking power in October 1295. And so a few weeks shy of twenty-four, Ghazan became the Seventh Il-khan and the Blue Princess became his queen. The painting at the head of this chapter was probably done shortly after this. It survives in an illustrated copy of the history that Ghazan commissioned his vizier, Rashīd al-Dīn, to produce to celebrate the glories of his family.

By the time these events were concluded, Khubilai had been dead for a year. His grandson and successor, Temür, continued to interest himself in the affairs of the Il-khanate. This interest included sending Ghazan a seal of office in Chinese characters that reads: 'Treasure-Seal of the Kingdom that Establishes the State and Governs the People.' The language is a bit generic, suggesting that Temür's advisers did not have a terrifically strong grasp of the status of the Il-khanate or its ruler. The seal no longer exists, but we know what it says because an imprint of it appears on a letter Ghazan sent to Pope Boniface III in 1302 proposing that he join forces with the Crusades in order to drive the Egyptian Mamluks out of the Levant. That letter still exists in the Vatican archives. Ghazan knew no Chinese and would not have been able to read the seal; he would have had to ask Kökečin. That Ghazan thought it appropriate to use on his diplomatic correspondence tells us that the Mongol empire, even as its four parts drifted further from each other, still mattered in this world.

Ghazan is remembered today for tipping Persia from Buddhism to Islam. He took the name Mahmud and imposed Sufism on his subjects, eradicating Iranian Buddhism in the process. Other Mongol rulers in West Asia did the same, eventually carrying Islam with them into India as the Mughals. While conversion did not cut Ghazan off from the Mongol world, it thinned his cultural ties back east. Even so, the Il-khanate kept up diplomatic communications with the Yuan Great State during Ghazan's time and beyond, sending delegations to Beijing as late as the 1330s to maintain respectful contact.

As for the Blue Princess, she fades from view entirely. She might not have disappeared so thoroughly had she born Ghazan a son, but Ghazan was unlucky on that score. Despite having eight consorts, only one daughter survived him when he died in 1304, at the age of thirty-three, five years after Kökečin's death. His only son had died four years earlier, at the age of two. Marco Polo was more fortunate.

Five years after returning to Venice, he married Donata Badoèr in his late forties. She and their three daughters were with him when he died, along with Peter, a Mongol bondservant he had brought with him on his return voyage. His last act was to set Peter free and award him a modest legacy of 100 lire, after which Peter too disappears from view.

3

The Plague

Caffa, 1346

The realm of the Golden Horde lay to the north of the Il-khanate, over which Kökečin became queen in 1295. Of the four domains into which the Mongol empire had fissured two generations after Chinggis Khan, the Golden Horde (Altan Ord, which properly translated means 'Central Camp') and the Yuan Great State were the largest. The Golden Horde stretched west from the Chagatai Khanate (today's Kyrgyzstan) all the way to the Black Sea, while the Yuan unfolded east from the same point all the way across China to the Pacific Ocean.

Janibeg could not have become khan of the Golden Horde in 1342 if he had not been a direct descendant of Chinggis Khan. No matter how many generations separated Janibeg from Chinggis (seven, as it happens), no one became a khan without that basic qualification. Ghazan had enjoyed the same status two generations earlier, which made Janibeg his fifth cousin twice removed. It was a long span across the Chinggisid family tree, but that was how the descendants of one nomad came to rule much of Eurasia for over a century after his death. Just being a descendant wasn't enough, though. There were many descendants, and not all became khans, as Janibeg knew. When

his father died in 1341, Janibeg's elder brother took the throne. Janibeg was not in line, so the only way for him to come to power was to resort to the time-honoured practice of bloody tanistry by murdering him along with another brother. His victory in that round was accepted as a sign that he had a mandate to rule, but that didn't mean he could sit back and assume that the Golden Horde would be his for life. He needed to keep his armies in motion and make sure that the Golden Horde met no set-backs on any border, particularly the borders with non-Mongols to the north and west.

A year after seizing power, Janibeg learned of an incident in Tana, an Italian trading port on the Black Sea at the mouth of the Don River. The khans of the Golden Horde tolerated the Italians because they supplied them with the luxuries that the Golden Horde could not otherwise acquire. A Venetian merchant had insulted a Mongol aristocrat in the street. The incident was minor, but an insult to the honour of one of his own was an insult to the honour of Janibeg. Being newly enthroned meant that he had to act, even if that demanded rupturing his links to the Mediterranean economy and cutting off the flow of the goods with which he decorated his authority and awarded his courtiers. So Janibeg sent an army to punish Tana. The merchants there, mostly Venetians, responded by fleeing to the next nearest Italian trading port, 300 miles away. This was Caffa (now Feodosia) on the south shore of the Crimean Peninsula. Caffa was a Genoese port, but the long-running rivalry between Venice and Genoa (recall that it was a war between Venice and Genoa that landed Marco Polo in prison long enough for Rustichello to write down his travels) paled into insignificance compared with the threat from the Golden Horde, with whom the Genoese also traded. Robbed of the chance to redeem his honour in Tana, Janibeg sent an army the following year to lay siege to Caffa and punish all Italians, and there this story begins.

Flinging Corpses in Caffa

The siege of Caffa began in 1344 and dragged on inconclusively. Caffa was a walled port city with constant access to maritime support. The land-based Mongols couldn't impose an effective embargo to strangle the port and force the Italians to pay for their arrogance. After two years, the soldiers of the Golden Horde began to fall sick. We know

what happened next only because of the chance survival in the library of the University of Wrocław of a manuscript anthology of geographical writings that includes a memoir by Gabriele de' Mussis, a notary in the town of Piacenza in the hinterland of Genoa. He tells the story of what happened in Caffa when the soldiers fell sick, but first he lays out the larger issue: 'In 1346, in the countries of the East, countless numbers of Tartars and Saracens' – loosely, Mongols and Muslims – 'were struck down by a mysterious illness that brought sudden death. Within these countries broad regions, far-spreading provinces, magnificent kingdoms, cities, towns and settlements, ground down by illness and devoured by dreadful death, were soon stripped of their inhabitants.'

Having set out the background, de' Mussis turns to the abandonment of Tana and the flight of all the Italians to Caffa. 'Oh God!' he wails. 'See how the heathen Tartar races, pouring in from all sides, suddenly surrounded the city of Caffa and besieged the trapped Christians there for almost three years. Hemmed in by an immense army, they could hardly draw breath.' Then suddenly, unexpectedly, the besieging army collapsed. 'The whole army was affected by a disease that overran the Tartars and killed thousands upon thousands every day. It was as though arrows were raining down from heaven to strike and crush the Tartars' arrogance. All medical advice and attention was useless.'

The siege collapsed, but before the Mongols abandoned Caffa, they carried out a final act of vengeance by loading corpses into their trebuchets – a counterweight siege machine invented in China that worked like a catapult by propelling projectiles from a sling when the counterweight was dropped – and lobbed bodies into the city. It worked. Caffa was infected. The symptoms the soldiers displayed, which de' Mussis describes as 'swellings in the armpit or groin, followed by a putrid fever', appeared among the residents, setting off a panic. 'What seemed like mountains of dead were thrown into the city, and the Christians could not hide or flee or escape from them, although they dumped as many of the bodies as they could in the sea.'

The illustration of a Mongol trebuchet, which appears as Plate 5, comes from the same *Compendium of Chronicles* as the bridal picture of Lady Kököčin and Ghazan with which Chapter 2 opened. Notice

the black horsehair *tugh* that waves from a pole stuck in the top of the trebuchet: the standard of war has been raised. We cannot see what the soldiers are throwing over the city wall in this image: certainly not corpses. The traces to the bucket containing whatever is about to be thrown run out of the illustration and off the left-hand side of the page, though the scattering of half a dozen cannonballs around the feet of the Arab technician operating the device suggests what the projectiles were. This is not an image of the siege of Caffa; I offer it merely to give a sense of what the scene in Caffa might have looked like. As a biological weapon of mass destruction, it worked. 'Soon the rotting corpses tainted the air and poisoned the water supply', writes de' Mussis. 'The the stench was so overwhelming that hardly one in several thousand was in a position to escape from the remains of the Tartar army.'

The disease did not burn itself out inside Caffa. The Italians who fled from Caffa carried the infection with them. 'Some boats were bound for Genoa, others went to Venice and to other Christian areas', de' Mussis explains. 'When the sailors reached these places and mixed with the people there, it was as if they had brought evil spirits with them: every city, every settlement, every place was poisoned by the contagious pestilence, and their inhabitants, both men and women, died suddenly.' The ships sailing between the Crimea and Italy had become the conduit for the disease to enter Europe. War brought the plague to the Black Sea, but trade brought it to Europe.

Plague from the East

Europe, according to de' Mussis, was only the next chapter in a longer story of infection that had spread first across Asia. He lists all the peoples struck down by the plague. 'The scale of the mortality and the form which it took persuaded those who lived, weeping and lamenting, through the bitter events of 1346 to 1348 – the Chinese, Indians, Persians, Medes, Kurds, Armenians, Cilicians, Georgians, Mesopotamians, Nubians, Ethiopians, Turks, Egyptians, Arabs, Saracens and Greeks (for almost all the east had been affected) – that the last judgment had come.' This was a pestilence of the east, and there at the head of the list were the Chinese.

That Asia had already been devastated before Europe was only

what rumour reported, and de' Mussis had no good source for his information, but it was what Europeans believed. The rumour reached England. When the bishop of Bath wrote to his archdeacons on 17 August 1348 to warn them of the epidemic that was approaching them from the continent, he called it 'a catastrophic pestilence from the East'. It had done such damage in France 'that, unless we pray devoutly and incessantly, a similar pestilence will stretch its poisonous branches into this realm, and strike down and consume the inhabitants'. He told them to organise processions of contrition every Friday at every church in the diocese so that God might send 'healthy air'.

The English monk Thomas Walsingham also looked east. In 1348, he noted, it rained steadily from the summer solstice to Christmas; then came 'a mortality in the East among the Saracens and other unbelievers, so great that scarcely a tenth of the Saracens were left alive'. He was certain that 'it came from the East'. Robert of Avesbury wrote in the same way that 'the pestilence first began in the land inhabited by the Saracens'. An ecclesiastical chronicler in Rochester was more specific about where this happened, stating that the 'great mortality of men began in India. Raging through the whole of infidel Syria and Egypt, and also through Greece, Italy, Provence and France, it arrived in England, where the same mortality destroyed more than a third of the men, women and children.' English writers had no clear idea of where or what India was, other than it was far off in Asia, but others agreed. When Geoffrey le Baker, a clerk in Oxfordshire, asserted that this 'unexpected and universal pestilence' came 'from the eastern lands of the Indians and Turks', he was repeating what was widely believed.

Muslim observers in the Middle East were closer to events and somewhat clearer about the geography of what lay to the east. The historian Taqi al-Din al-Maqrizi, in Cairo, wrote that the epidemic started in 'the land of the Great Khan', the Golden Horde. In the Near East, by his account, the first outbreak in 1335 was in none other than the Il-khanate. Ghazan's great-nephew Abu Said was on the throne as the Ninth Il-khan at the time. Abu Said and his six children all died that November while he was on campaign against the Golden Horde. If this reconstruction is correct, the infection passed from the Golden Horde to the Il-khanate in 1335 before travelling further west. (The

infection at Caffa was still eleven years in the future.) The effect on the Il-khanate was politically devastating, for with Abu Said's death the Chinggisid line in Persia was extinguished.

Aleppo was closer to events than Cairo, and there too people looked to the east. A historian in Aleppo, Ibn al-Wardi, who was shortly to experience the plague at first hand, dying of the infection in 1349, believed that, according to what he could ascertain, the plague 'began in the land of darkness', a loose term for the 'north' and probably meant to refer to the Golden Horde. For fifteen years, he understood, the plague raged throughout the larger region, a time frame that coincides with al-Maqrizi's report that the Ninth Il-Khan died of the disease in 1335. The infection 'afflicted the Indians in India', 'weighed upon the Sind', the south-east quarter of today's Pakistan, 'seized with its hand and ensnared even the lands of the Uzbeks' in the region of today's Kyrgyzstan, 'broke many backs in Transoxiana', roughly today's Uzbekistan, 'attacked the Persians' in the former Il-khanate and 'extended its steps towards the land of the Khitai', probably not China but Qara Khitai in Eastern Turkestan. He placed one more region of Asia in the path of the plague, and that was China: 'Cathay was not preserved from it, nor could the strongest fortress hinder it.' A century later, al-Maqrizi made the same observation from Cairo. After laying low the Il-Khanate, he wrote, the plague 'spread throughout the eastern countries'. No mention of India, but 'it killed enormous numbers of people in China. Few were left there alive.'

There was one contemporary Muslim observer who travelled the length of Eurasia in the 1340s as the epidemic of the plague was unfolding. This was the quixotic and rather self-important Moroccan, Ibn Battuta. He reports skirting the edge of the plague at many locations, though not in India or China. When the plague reached Caffa in 1346, he claims to have been sailing the sea route from India to Quanzhou and back, the very route that Marco Polo took half a century earlier. The dates in his itinerary are so off, though, that if he did indeed sail to Quanzhou, he turned around and left a week later, so we can't stake too much on his non-reporting of epidemics in China. His first mention of the plague comes in the autumn of 1347, when he was passing through the Il-khanate on his way from Hormuz to Damascus. There he heard that the plague had carried off the Ninth Il-khan – Ghazan's

younger brother – and his sons fourteen years earlier. He was heading for Damascus because he had visited the city two decades earlier – just long enough to marry, impregnate and then divorce the daughter of a fellow Moroccan – and fancied finding the son he had sired. After learning that the boy had died ten years earlier, he set off for Aleppo in June 1348, but he turned around when he heard that the plague was coming. The plague passed him on his way to Damascus, and reached Jerusalem, Gaza and Alexandria in turn before he did. From Alexandria he travelled up the Nile and across the Red Sea to Mecca a year before it too was infected. At long last Ibn Battuta turned his steps for home to see his mother, only to learn that she had died in Tangier a few months earlier – of the plague.

One of the challenges in writing China into the history of the plague is that there is not a single Chinese person we can name alongside Ibn Battuta, Ibn al-Wardi and Gabriele de' Mussis who can be linked to the Black Death. We hear of Chinese dying in their millions in the far distance, but there is not one we can approach and ask what actually happened. Some Western historians of the plague have taken the observations of fourteenth-century Christian and Muslim writers as evidence of the eastern origin of the plague. Some historians of China, on the other hand, have accepted the absence of documents in Chinese as grounds for assuming that the Black Death did not go there. Given that absence of documents, a more cautious historian than I might have steered clear of the issue and not even mentioned it in a book about China's relationships with the world. If I take the plunge, it is because almost everything we thought we knew about the history of the plague is being transformed by the new technology of genome sequencing (more of which anon). Genomic research has opened a fascinating path heading into the thickets of global plague history, and I decided that it would be instructive to look down this new path, even if we can't yet see to the end of it.

The Black Death

The word 'plague' originally meant a wound caused by being struck. This became the expressive term for epidemics that struck down populations on a massive scale. Scientists today know it as *Yersinia pestis*, in honour of the Swiss biologist Alexandre Yersin, the first scientist

to isolate plague cells. Europeans at the time of the outbreak in the middle of the fourteenth century called it the Great Death. Since the nineteenth century the popular term for this epidemic has been the Black Death, though technically we call it the Second Pandemic.

The plague is a bacterial parasite of ground rodents. These rodents are the bacteria's host, and the fleas that feed on their blood are its vectors, the means by which plague bacteria move from rodent to rodent. Medical observers of the fourteenth century did not connect rodents, much less fleas, with the plague. They made other connections between those falling sick and the cosmos they inhabited. An idea of what these connections were can be gleaned from the report the Paris medical faculty wrote in 1348 at the request of the king of France, who wanted to know what was going on. Their report attributed the Black Death to a configuration of the planets that produced what they called 'corrupted air'. Thinking that the sickness invaded the body through the lungs, they were on to the form of transmission that characterises pneumonic plague, which enters the lungs from droplets in the air and breeds there. 'When breathed in', in their language, 'it necessarily penetrates to the heart and corrupts the substance of the spirit there and rots the surrounding moisture. The heat thus caused destroys the life force, and this is the immediate cause of the present epidemic.' This form of infectivity made prophylaxis difficult. 'Because everyone has to breathe, everyone will be at risk from the corrupted air', the doctors observed. Especially vulnerable were those whose bodies were hot and moist: people who engaged in 'too much exercise, sex and bathing; the thin and weak; persistent worriers; babies, women and young people; and corpulent people with a ruddy complexion'. Where the doctors of Paris were infallible was in predicting a higher mortality for the plague than for any known disease. 'Of those who succumb, few indeed are those who will escape'. In the end they had to conclude that the ultimate cause of the plague was the wrath of God. The only effective treatment was penitence, not medicine.

This wave of disease diminished in the 1350s, returned in a second wave in the 1360s and then diminished again. But the plague did not die out in Europe; it returned in short outbursts through the seventeenth century and kept the fear of the plague alive in Europe as the

worst sickness that humans could suffer. The disease then withdrew into rodent populations until late in the nineteenth century, when another pandemic broke out, this time in Hong Kong.

By the time the plague re-emerged in Hong Kong in 1894, medical science had developed new paradigms for analysing and treating infectious diseases. The technological breakthrough supporting the new paradigms was the marvellous instrument known as the microscope. The first scientist to use a microscope to see plague bacteria was Alexandre Yersin. A Swiss medical researcher who had earlier worked under Louis Pasteur on diphtheria and rabies (his doctorate was on tuberculosis), Yersin later moved to Saigon to practise the new global-scale medicine that came to be called 'tropical medicine'. In 1894 he was seconded to Hong Kong at the request of the British government to help deal with the outbreak of plague there. Yersin set up a simple laboratory and was able to isolate and identify the bacteria that caused the plague. He named it *Pasteurella pestis* in his mentor's honour, though a year after his own death in 1943 that honour was transferred to him. The scientific name for the disease is now *Yersinia pestis*, *Y. pestis* for short.

The new science in which Yersin worked recognised that the plague, while devastating for the humans it infected, was not a disease of humans. Once plague cells enter the bloodstream or lungs of a human, they reproduce at such a rate that the body's lymphatic system, its defence against infection, goes into overdrive and then collapses. Lymph nodes in the armpits and groin swell into buboes, or hard lumps, as the lymphatic system struggles to filter out the pathogen. Without the application of powerful antibiotics, the lymphatic system fails in a matter of days. This is why humans are not a sustainable host for the plague. They die quickly, and then so too do the bacteria, and unless the infection is passed on, the pathogen burns itself out. Humans are irrelevant to its natural gestation or survival, and not sustainable as a host.

By contrast, rodents can develop a limited immunity to the plague, which means that they can coexist with this parasite in a way that humans cannot. The most stable ecosystem for fleas that pass the bacteria from one animal host to another is the burrows of ground rodents, such as gophers, gerbils and marmots, though when that

ecosystem is disrupted, the bacteria can move to other rodent hosts, famously rats. With that discovery, public health authorities around the world turned their attention to exterminating and restricting the movement of rats. By 1903, Hong Kong had put in place a set of rat control measures from refuse collection to regulations requiring ships to install funnels on their mooring lines to prevent rats from climbing up or down the ropes.

It fell to Wu Lien-teh, a Singaporean doctor trained at Cambridge and Johns Hopkins universities, to determine that the plague's natural reservoir is not the rodents (such as rats) that coexist with humans, but wild rodents. Working on an outbreak of plague in Manchuria in China's north-east, Wu tracked the plague to marmots, large fur-bearing rodents that favour medium altitudes. Controlling the plague in Manchuria was thus not a matter of exterminating rats, as it had been in Hong Kong, but of quarantining plague victims and then re-instituting the natural barrier between marmots and humans, which centuries of hunting marmots for meat and fur had broken.

So that readers know how the disease progresses, I have drawn one case study that Wu Lien-teh included in his 1936 handbook, *Plague: A Manual for Medical and Public Health Workers.* The victim, C. T. Raikes, was a twenty-two-year-old medical graduate from England who went to Singapore to take up his first job at the Government Medical Service's Quarantine Station on St John's Island. While doing an autopsy on 2 May 1908 on a plague corpse transferred from Hong Kong, Raikes scratched the inside of his right wrist on the corpse's rib. Two days later he was overcome by a fever and headache. His arm began to throb, and pustules formed on the inside of his wrist, and a red line appeared extending from his wrist to his armpit. He was admitted to hospital the following morning with a temperature of 103.4°F. The following day, the lymph nodes in his right armpit began to swell, and his temperature rose to 104.7°F. The lymph glands were removed under general anaesthetic, but by the afternoon the glands under his clavicle started to swell as his immune system battled the infection. That evening, a blood test confirmed that he had plague bacteria in his bloodstream, but there was no treatment other than carbolic acid to fight the bacteria and morphine to ease the pain. On Day 5 his condition worsened, and on Day 6 his pulse became erratic. A second

enlarged lymph node in his armpit was removed. The last two days of his medical chart read as follows:

Day 8: 'At 8 p.m. his condition was a little worse; temperature 101°F, pulse 100, of fair tension. At 9 p.m. breathing became difficult, and the pulse was weaker. From this time on his condition became steadily worse. At midnight, temperature was 103.4°F, pulse 120 and weakening. He slept fitfully and had twitching of the muscles.'

Day 9: 'At 8 a.m. he muttered to himself, but was quite sensible when awake. His temperature was 104.4°F, pulse 126, respiration 48. Shortly after, he became apathetic, and passed into a condition of delirium, with incontinence of urine and inability to swallow. He did not rally from this condition, and died at 12.45 p.m.'

Raikes's attending surgeon, Dr Wray, died a week later of the same infection.

Was the Plague in China?
Yersin and Wu were certain that the disease they were treating in the 1890s was caused by the same bacteria that laid the West low during the Black Death. The buboes and fevers, and the speed and rate of mortality, appeared so similar that the two pandemics had to be related. The separate outbreaks they were dealing with were both in China, and that encouraged the idea that China had harboured the plague for centuries. Wu's handbook includes a long list of epidemic outbreaks that his assistants culled from Chinese historical sources, offered as primary evidence that the plague had a long history in China. But none of the references in Wu's list is conclusive, and since then scholars have been sceptical of reading back from our diseases and assuming we can make retrospective diagnoses of what killed our ancestors. This is why the plague tends not to make any appearance in China history books before the Hong Kong outbreak. As historian Robert Hymes, who has done the best recent work on the history of the plague in China, has written, we are faced with the problem that 'any historian who proposes that the Black Death began in China or its environs must confront an obvious question: Why do we not already know this?'

I went in search of evidence, either for or against. The biggest disappointment is the written record. The flood of despairing reports

of the mid-fourteenth-century plague found in documents all over Europe and the Middle East is simply not there. Had the plague ravaged China as the Black Death did the West, surely someone should have written about it as excitedly as their Western contemporaries did. Yet not one Chinese author has left anything of the sort. The sole source that says anything about epidemics is a source that Wu Lienteh's team culled, the corpus of official histories that each dynasty wrote for the dynasty it superseded. Each dynastic history includes a spare list of disasters that occurred during that period. This sort of record is not excited writing, nor does it make for exciting reading. Here is all there is for 1344–5, two entries in the Yuan dynastic history and one in the Ming:

> [1344]: 'Fengxiang: drought and locusts, great famine, epidemic.'
> [1344]: 'The four prefectures of Fuzhou, Shaowu, Yanping, and Dingzhou: summer and autumn, a great epidemic.'
> [1345]: 'Spring and summer, Jinan: a great epidemic.'

It is not easy to make the case that these entries indicate that the plague laid China low before breaking out in the West. Consider the locations. Fengxiang lay west of Xi'an, the old trading city in the north-west through which ran the route that led out into the trans-Asian corridor called the Silk Road. Fuzhou was the capital of Fujian on the south-eastern coast, the province from which Marco Polo and Lady Kökečin set sail and to which Ibn Battuta claimed he travelled. Jinan was in Shandong province, on the eastern side of the North China Plain south of Beijing. Three more separated locations it is hard to imagine. You could travel from each to the others, but not directly and not quickly. More promising might be their positions as points of entry or exit. Fengxiang pointed west to the Silk Road, Fujian faced the ocean, and Jinan linked north to Beijing and beyond to the Mongolian grasslands.

Even so, the distance to Europe is vast. Fengxiang to Caffa is 4,000 miles as the crow flies, and a lot farther by horseback. Left among its rodent hosts, plague bacteria can move from burrow to burrow at a rate of at most fifteen miles a year. Rodents are not long-distance travellers, unless they can hitch a ride. An infected flea might lurk in

clothing or a saddlebag, but it cannot survive the infection more than a few days. It has been suggested that plague bacteria might be able to survive in a dormant state in flea faeces and be transported over great distances, yet that seems like a tenuous thread to unroll without snapping across 4,000 miles. It is unlikely that the plague could have left China in 1345 and appeared in Caffa in 1346.

If there is a connection, it has to be earlier. And indeed we can find earlier entries on epidemics in the dynastic histories. In the years prior to 1344 there were a few outbreaks in the Yangzi Valley, but nothing as virulent as the epidemic of 1331 that struck Hengzhou, a small pre-fectural capital deep in a narrow river valley in upland south China. Mortality was extreme: the dynastic history uses the standard expression: 'nine out of ten died'. Before that, we have to go back some two decades to the years 1307–13. Shaoxing, on the coast of Zhejiang province, was struck first in a localised outbreak in 1307, but the disease returned in a great wave the following year. The official biography of the reigning emperor reports: 'An epidemic erupted on a massive scale. The dead collapsed one on top of each other. Fathers sold their children, husbands their wives. The sound of wailing thundered across the landscape to the point that no one could stand hearing it.' Another biography claims that 'almost half the population died'. At roughly the same time, Beijing was struck.

Prior to that outbreak, there is nothing in the Chinese historical record until 1232. That event, however, gives us something to work with.

Carrying Corpses out of Kaifeng

Robert Hymes has reconstructed the story of what he calls the 'best documented' epidemic in China before the seventeenth century – not well documented, but better than any other. It is an outbreak that occurred in the summer of 1232 in Kaifeng, a city on the north bank of the Yellow River. Kaifeng at the time was serving as the capital of the Jin Great State. The dynastic history records the outbreak in one meagre line, but Hymes was able to find an account of the event written by a physician, Li Gao, who seems to have been in the city when the epidemic occurred.

The epidemic struck Kaifeng while the Mongols had the city under

siege. It broke out at the beginning of June. The dynastic history states: 'over a period of fifty days, over 900,000 corpses were carried out through the city gates' for burial. That was only the official statistic, for the chronicler added this note: 'Those too poor to afford burial are not included in this number.' The physician Li Gao confirms the scale of mortality. 'Not even one or two out of ten thousand capital residents did not become sick', Li wrote. 'Those who died of their illness followed one another without end.' He counted the death toll by city gate. 'Each day at each of the capital's twelve gates, between one and two thousand corpses were taken out. This went on for almost three months.' His lower estimate matches the number in the dynastic history. Li also noted that Kaifeng was not alone in suffering from this epidemic. He named Dongping, to the east on the border with Shandong province, Taiyuan, to the north in Shanxi, and, to the west, Fengxiang, the site of one of the outbreaks in 1344. Li recorded this information not simply to be a witness of what happened but because he used it to explain why, facing such devastation, he felt obliged to formulate a new model of disease in place of the model he had been taught.

What is striking about the outbreak in Kaifeng is the implicit parallel with Caffa: a Mongol army lays siege, an epidemic flares up, massive numbers of people die. The parallelism doesn't tell us that the outbreak in Kaifeng was plague necessarily, but it does point us towards the Mongols. Could they have brought the disease?

Hymes thinks so, and has directed his attention to Kokonor (Qinghai in Chinese), in north-eastern Tibet, along the edge of which the Silk Road ran. At the start of the thirteenth century the region was under the sovereignty of the Great State of Xia, a polity founded by a Tibetan people known as the Tanguts, until Chinggis Khan decided to destroy them. It took four campaigns, starting in 1205. Eventually he achieved total victory in 1227, the year of his death. The devastation in Kokonor must have been huge. Wherever a mounted army passes, it disrupts the local ecology profoundly. Horses churn up the soil and destroy the burrows of ground mammals. Men and horses consume or ruin crops, and they decimate wild food sources by hunting. They leave carrion in their wake, altering the food chain in favour of those animals that devour carrion. The Mongol campaigns against

the Tanguts may well have created the perfect storm in which fleas infected with the plague abandoned their natural hosts and jumped to humans. That Kokonor is the natural habitat of the Himalayan marmot played a part in encouraging Hymes to come up with the hypothesis that the Mongols picked up the plague in Kokonor and carried it, five years later, down to Kaifeng. (More recent research suggests that the Himalayan marmot became a plague carrier only in recent times, but that need not have been the only host rodent for the fleas.)

The campaign against the Jin Great State was led by Ögedei, Chinggis's son and heir. His army won a string of easy victories as they came south through the Great Wall in 1231. Intriguingly, just as he was preparing to move south against Kaifeng, Ögedei fell ill. The shamans determined that it was because the destruction that the Mongol military campaigns wrought had offended 'the lands and rivers of the Cathayans', which is to say, the Chinese. Even they understood the lethal effects of disturbing the environment. We have no reason to think that Ögedei contracted the plague. He regained consciousness while the shamans were consulting, called for a drink of water and asked, 'What happened?'

The campaign resumed. By April 1232, Ögedei's forces had surrounded Kaifeng. The epidemic started six weeks later.

Was this the plague?

The Big Bang

One could say that the answer to that question doesn't matter. A medical description of what killed people on a huge scale seems unimportant beside the social fact that so many died. That way of summing up the situation used to be a fair enough attitude to take. But things have changed, thanks to recent advances in DNA research. If you stick with me for the next few pages, you will see why some historians get excited about recent breakthroughs in the research on the plague genome.

A plague bacillus is a simple single-celled organism. Like all organisms, it has DNA molecules that contain the cell's genetic material. The sum of that material, braided into the double helix of DNA, defines the organism. The building blocks of DNA (molecules known as nucleotides) are held together in pairs by one of two possible chemical

combinations. These are called base pairs, and the sequence of chemical bonds between them is what defines the organism. The sum total of that sequence in a particular organism is called its genome. To give you a sense of scale, the plague genome consists of just over 4½ million base pairs. Humans are more complicated: our genome has over 3 billion base pairs. Sequencing those base pairs is the task that genetic scientists are currently undertaking.

The genome is an organism's genetic code, the fingerprint that makes it different from every other organism. When the cell reproduces under stable circumstances, its genome is replicated: the offspring repeats the parent. There is, however, the tiniest chance that one of those 4½ million chemical combinations in the plague genome might change when reproduction occurs. There are only two possible combinations for the chemical bond holding a base pair together; genetic change occurs when one bond switches to the other. The offspring is still the plague, but it is a slightly different version of the plague. That change then becomes permanent – until the next change happens. This is what evolution is.

Once different instances of the same organism have been genomically sequenced, it becomes possible to compare them by looking for every change in a base pair (called a 'single nucleotide polymorphism' or SNP – 'snip' for short). The more instances you have, the more comparisons you can make; the greater the number of comparisons, the clearer it becomes to plot the chain of evolutionary inheritance across time. This change can be arranged in a family tree showing which instance preceded which, and which begat which. The dying out of earlier strains of a pathogen means that many intermediate evolutionary steps will be missing as the tree gets drawn. Imagine, then, the excitement caused in 2000 when a team of French scientists was able to identify a portion of *Yersinia pestis* DNA from organic material taken from the teeth of three corpses in a Black Death burial site in Montpellier. The first response was a torrent of disbelief and rebuttal, even scorn. But then other teams followed this lead, reading short snippets of what started being called 'archaic DNA' (aDNA), sequencing these fragments into longer codes and tracing the outlines of the plague's family tree.

The big splash came in 2011, thanks to the bishop of London, Ralph

Stratford. Faced in 1348 with a growing mound of plague corpses in the city, Stratford set aside a cemetery to handle the huge problem. From a third to half of Londoners died in the city's first plague, and their bodies had to be disposed of. The bishop designated a plot of ground directly north-east of the Tower of London for the purpose. The cemetery (south of Royal Mint Street and west of Cartwright Street, if you are ever in that neighbourhood) was closed in 1350. It was excavated in the late 1980s, and the remains put in storage. Then in 2011 a team of scientists led by Kirsten Bos at the Ancient DNA Centre at McMaster University announced that they had been able to sequence the genome of the pathogen that caused the deaths of these people. Not only was it clearly an ancestor of the plague, but it was not that different from plague strains that exist today: a few dozens 'snips' at most. Findings from other plague burials followed quickly and are still appearing, each new genome sequence setting off a flurry of excitement. At the time of writing, geneticists have sequenced almost forty complete aDNA genomes. Slowly a global picture of the historical evolution of the plague is taking shape.

The model currently used to organise the branches of the family tree was published in 2013 by a team of thirty-three scientists led by Yujun Cui at the Beijing Institute of Microbiology and Epidemiology. After comparing all the plague genomes that have been sequenced, archaic and modern, they determined that, some time between 1142 and 1338, the plague underwent a rapid phase of evolution, splitting into four branches and achieving an unprecedented virulence when it moved to human hosts. Cui's team decided to call this four-way split the Big Bang. The name fits, as this seems to have been the moment just after which the Black Death surged across the Middle East and Europe. That was Branch 1, which is also the plague strain that Alexandre Yersin studied in Hong Kong in 1894. Somehow it crossed the Eurasian continent between the 1340s and the 1890s. So Yersin's guess was right: he was indeed looking at the same organism as the historical Black Death. It turns out that the strain Wu Lien-teh was trying to control in Manchuria belonged to Branch 2, a Mongolian strain that has no ancestry in Europe. Both doctors were correct in believing that they were fighting the plague, but the new genomic science allows us to know basic facts of this history that were inaccessible to them.

The branch before the Big Bang is called Branch 0. How it evolved from a mild soil pathogen called *Yersinia pseudotuberculosis* several thousand years ago we may never know. But Branch 0 is turning out to be far more complicated than Cui's team realised just a few years ago, as more cases are discovered. If Kaifeng did indeed experience the plague before the Big Bang, it experienced it as a Branch 0 strain, which is to say, a strain of the plague different from what attacked Europe in the fourteenth century. Whether al-Maqrizi was right to think that the plague that devastated Cairo 'killed enormous numbers of people in China' in the fourteenth century will depend on whether Chinese scientists are able to locate and analyse Chinese aDNA. So far, no genomic analysis has been done on historical epidemics in China. Considerable work has been done there on the plague, but all of it has been back-projected from DNA findings from the twentieth century. Until that situation changes, all bets are off as to whether al-Maqrizi was on the right track. That must wait until we have the genomic evidence. Some day we will.

After Caffa
For now, all we have is the documentary record. Let me return to it one last time, not to probe the 1340s but to look at what came after. The record for the next decade is striking. Starting in 1352, China suffered at least one major epidemic every year, sometimes two, for a period of eleven years, with only two years of respite.

There were two epidemics in 1352: one in February in northern Shanxi near the Great Wall, the other that summer in Jiangxi province down in the Yangzi Valley. Epidemic returned to northern Shanxi in 1354. Beijing was hit at the same time by an infection that the sources refer to as *yili*, which is to say, a *yi* or epidemic in which a prominent symptom were *li*, surface tumours. The association with plague buboes is not hard to make. The Yangzi Valley suffered for another two years running as the *yili* spread across an ever-widening area there, infecting huge numbers of people. The year 1355 passed without a major epidemic, but 1356 saw a massive outbreak in Henan province, right in the heart of the North China Plain – exactly where Kaifeng was struck 124 years earlier. The next year, an epidemic broke out directly to the east in Shandong, and it re-emerged there two years

later. Shanxi province was struck again in 1358, and an epidemic re-emerged in Shandong the following year, 1359. That same year, there was an outbreak in the northern interior of Guangdong province, not far from the Hengzhou epidemic of 1331. In the following year, 1360, Shaoxing, the site of outbreaks between 1307 and 1313, was hit by an epidemic. The pathogen died out, but then returned in 1362.

We know these events purely from the briefest of entries in the official history of the Yuan dynasty. Other than the reference to tumours under the skin, these entries provide no record of the aetiology or symptoms connected with these epidemics. So far no other documentary material has been found that can tell us more. All we know is that a rash of major epidemics inflicted regions of China in an eleven-year wave, beginning six years after the outbreak in Caffa, and that it was on a scale that was unprecedented and not exceeded until the 1630s. Whether these epidemics were the work of local pathogens made more virulent by environmental changes or whether they were ignited by the arrival of pathogens or new strains from outside China we cannot say, though the latter strikes me as the more likely scenario.

The wave ended in 1362, six years before the Mongol Great State in China collapsed. After this decade China was still linked with Mongol polities to the west, but not at the same frequency. Whether that was enough time for the plague to slip in remains a question without answer. But the chances seem awfully good.

The Mountains of Heaven

Here is one more speculation. Rather than trying to decide whether China was the origin or the recipient of the Black Death – the 4,000 miles between China and the Crimea still loom very large – we might be better directed by looking for a source that is neither Chinese nor Middle Eastern but somewhere between the two. It seems to me that the areas deserving of a closer look comprise those places where we can still find strains of the plague that belong to Branch 0, the original before the Big Bang. Looking for Branch 0 may get us closer to the location of the Big Bang than trying to trace back from the presence of Branch 1 in the world today – which is any case is almost global.

Branch 0 did not die out in the Big Bang but continued to exist and to evolve. Scientists have identified numerous sub-branches, of

which those just before the Big Bang have been labelled the Antiqua strains. It turns out that Antiqua's current descendants are all on the Silk Road corridor along the border between Xinjiang and Kyrgyzstan. Cui's team estimated that the Big Bang occurred in Kokonor, closer to China, and that the Antiqua strains followed the Silk Road west towards Kyrgyzstan. But suppose we reverse this direction, and think of the route along which the plague travelled not as west from Kokonor, but as east from Kyrgyzstan?

A study in 2017 by a team led by Galina Eroshenko at the Russian Anti-Plague Research Institute in Saratov on the Volga River has cast some important new light on plague strains in Kyrgyzstan. Eroshenko's team has revealed a striking concentration of Antiqua strains all along the Kyrgyz side of the Kyrgyzstan–Xinjiang border, a high region the Mongols call Tengri Tagh, the Mountains of Heaven. These mountains formed something like a natural boundary between the Yuan Great State and the Chagatai Khanate. Her team has also identified what at the moment is the youngest strain of Antiqua – which is to say, the closest to us on the other side of the Big Bang. It is only two 'snips' (those changes in base pairs that mark genetic mutation) before the Big Bang. Genetically, that is really close. If we want to make an educated guess as to where the Big Bang happened, we should take a good look at the Mountains of Heaven. Perhaps this is Ibn al-Wardi's 'land of darkness', the place from which he thought the Mongols brought the Black Death to Aleppo.

There is an intriguing bit of old archaeology that rather favours the hypothesis that we should be looking in this region. The Russian archaeologist Daniel Chwolson was working in the area in 1885 when he came upon a concentration of graves at Issyk Kul, Kyrgyzstan's largest lake. One of the routes of the Silk Road passed this way, and there he found some 330 gravestones from a Nestorian Christian community by the lake. The gravestones name over 650 people who died in 1338–9. Faced with such an intense wave of mortality, Chwolson suspected an outbreak of the plague, albeit on no other evidence. What else, he asked, could have caused so many people in a small community on a trade route to succumb so quickly in one season? The date places this outbreak barely three years after the death of the Ninth Il-khan, Abu Said, and eighteen years before the outbreak at Caffa. To

switch to scientific language, was this an Antiqua strain of Branch 0? Possibly. Or was it one of the new post-Big-Bang branches that was about to go viral in Europe? More likely. The answer eludes us for now, but as we learn more, Kyrgyzstan may prove to be the place we should be looking at for the origin of the Black Death (see Map 2).

However the science gets worked out, the Mongols will always be at the centre of the story. Whether the plague moved in the saddle-bags of traders or the saddlebags of soldiers, everyone moved along the same corridors, in no small part because the Mongol states chose to keep the routes open. In the end, the capacity that had been their great advantage in warring against their neighbours conspired in their downfall, with the plague acting as the coup de grâce. At least, it was for the Il-khanate. The mobility and strategic positioning that enabled the Mongol Great State to conquer the world was also what undid it. So Robert of Avesbury was more or less right when he wrote that 'the pestilence first began in the land inhabited by the Saracens', if we substitute the Golden Horde and the Chagatai Khanate for his Saracens. Ibn al-Wardi got even closer to the truth when he wrote that the plague 'seized with its hand and ensnared even the lands of the Uzbeks and broke many backs in Transoxiana', for that put him close to the Mountains of Heaven.

China was thus not likely the origin of the Black Death. Rather, it became connected to plague reservoirs by the traders and soldiers who moved along the routes that criss-crossed Inner Asia. When or where, or whether, it arrived in China must remain open questions. For now, the best bet for finding the site of the Big Bang is in the realm of the Chagatai Khanate, the heartland of Inner Asia occupying the middle zone between the Yuan Great State and the Golden Horde. The Second Pandemic then is not a European story, or a Chinese story; it is a Eurasian one. As Monica Green, the pre-eminent historian of the plague, has phrased this way of looking, rather than treating the Black Death as an isolated phenomenon, we can see it as 'the beginning of a long shared trauma'.

The Rat at the Gate
Regardless of their genetic composition or origin, the epidemics of the 1350s and early 1360s were part of the tidal wave of destruction that

pushed the Yuan Great State towards its collapse in 1368. The onset of the wave of disease in 1352 coincided with the onset of drought. Harvests dwindled, rebels rose and the Chinggisid aristocracy could only renew itself by fighting over the succession. On the night of 20 September 1368, as Chinese rebel armies pressed towards the capital, Toghon Temür abandoned Beijing and fled north with his Korean queen, Empress Ki, and his immediate family. He announced to his court earlier that day that he was setting off on the usual imperial commute to Xanadu. But this was a fiction, and the court knew it. Toghon Temür had not made the journey for a decade, for the simple reason that the Xanadu of old was gone. At the end of 1358, two Chinese rebels, known by their alarming sobriquets of Mr Guan and the Decapitator, had swooped down on Xanadu and burned the palace to the ground. The Yuan had quickly mustered military forces to drive back the daring attack. A week later Mr Guan and the Decapitator had fled in the direction of Korea, but Xanadu was now in ruins, and it remained so. Over the decade that followed, matters went from bad to worse. Mongol kinsmen challenged Toghon Temür for the throne, and Chinese rebels calling themselves the Red Turbans rose in resistance and mounted a military threat the Mongols could not crush.

Toghon Temür's party passed through the Great Wall at Juyong Guan, the Gate of the Prime Meridian, and headed north to Xanadu. The gate was one of the glories of his reign. Toghon Temür had ordered it to be built in the 1340s as a Buddhist memorial in honour of his illustrious great-great-great-grandfather, Khubilai Khan, not just as the founder of the realm but as a *cakravartin*, a universal monarch who rules the world with Buddhist compassion. The gate was completed in 1345, the second of the two years of epidemics of 1344–5. The most remarkable features of the gate are the floor-to-ceiling inscriptions inside the archway of Buddhist prayers in six languages: Chinese, Mongolian (in Phagpa script), Uyghur (in Sogdian script, which later replaced Phagpa script to write Mongolian), Tangut, Sanskrit and Nepalese (in Lantsha script). These are texts for only priests and scholars to read, but they were carved as a permanent recitation to the Buddha affirming the Mongol Great State's support for this universal religion in exchange for his gracious protection, which by 1368 had run out.

The last thing Toghon Temür would have noticed, had he looked to his left as he exited the archway, was a large rodent dressed in Mongol robes and riding boots bulging out from the limestone's surface in a sinuous curving mass. Thrown on its back, the animal glowers up at Vaisravana, the King Who Hears All, who stomps on its gut. Vaisravana's duty was to protect the pious from evils coming from the north, hence his position at the north end of the tunnel. So who is this rodent demon dressed in Mongol get-up? It would be a nice touch for this tale of the plague if it were a Mongolian marmot, but as we know, the connection between rodents and the plague had not yet been established. No one in the Mongol royal party would have paid it the slightest attention as they rode north.

Toghon Temür spent his first winter exile in Xanadu. His health was poor, and conditions were miserable. As his safety there could not be assured, he and his court trekked further north in the spring of 1349, doubling their distance from Beijing, to a small walled city on the steppe called Yingchang. There, it was said, Toghon Temür composed a long poetic lament for all he had lost. In this poem he bewails the loss of his capital cities. He sings of Beijing as 'my Great Capital, ruler-straight and jewelled with wonders', 'so pleasantly misted in early morning when I ascended its heights'. This was the capital 'where I held in my hands the reputation of the Great State, where I surveyed Mongols from every place, where there is now no winter palace where I can winter. I have lost my Great Capital – to China.' Then he eulogises his Supreme Capital. 'Oh my Xanadu on the golden steppe, summer residence of ancient khans, my summer sanctuary on the pleasant golden steppe, the palace of cranes where Khubilai the Wise summered', and 'where I spent the summers in peaceful relaxation'. Again the same refrain: 'I have lost Xanadu entirely – to China.'

Toghon Temür was right. He had lost everything to China. But exile was not a place of safety. In 1370 dysentery erupted in Yingchang and raced through the city. That, not plague, was the bacterium that ended the life of the last Great Khan to rule the Mongol Great State from within China.

THE MING
GREAT STATE

4

The Eunuch and His Hostage

Ceylon, 1411

The fleet of the Ming Great State was spotted coming over the eastern horizon towards Ceylon in November 1410. Forty-eight great ships dominated the convoy. The smaller vessels that clustered in their wake, like goslings around a raft of geese, more than doubled that number. Count the sailors, soldiers, eunuchs and the entire support staff, and there were 30,000 men out there on the water. Word quickly spread among the islanders, and soldiers were put on high alert: the Chinese were coming.

This was not the first time. Four years earlier, an equally intimidating fleet of great ships had landed on the shores of Ceylon. This had happened at almost exactly the same time of year, some two months into the winter monsoon, when the winds out of the north-east had strengthened and the westerly current had set. It was the ideal period for sailing west across the Bay of Bengal. Additionally, the strong near-shore current off the coast of Ceylon was then running clockwise around the island, so that anything coming across the bay was swept around the south end of the island and up the west side, where the kingdom of Ceylon (or Sri Lanka, the same name differently spelled)

was most open to the world. That earlier fleet had anchored at the *kolamba* ('harbour', now Colombo) downriver from the *kotte* ('fort', now Kotte, the capital of today's Sri Lanka), where the great viceroy, Nissanka Alagakkonara, commanded fighting men in the tens of thousands to maintain the peace of the realm and secure the state against threats from Tamil states to the north.

That first encounter four years earlier had not gone well. A delegation of envoys from something that called itself the Ming Great State had come ashore with all due ceremony, their gorgeous silk robes flapping in the breeze, to propose that the king of Ceylon submit to the new emperor of the Great State. The very idea that the king should submit to a ceremony investing him with his own rightful position, on the orders of some distant emperor, was more than insulting. It implied a serious threat from outside. If he gave in to this threat, his enemies in the region would take it as a sign of weakness and move against him once these eunuchs in their fancy regalia packed up and sailed away. The delegation demanded further that the king should send an embassy to the Ming Great State to kneel before the emperor and acknowledge him as the Son of Heaven. Not only would this be a loss of face for the king, but it would also mean the virtual imprisonment of the king's ambassadors until such time as they were permitted to return home. A lesser leader might have quailed at the sight of so many ships and so many soldiers. But Alagakkonara commanded twice their number and was on home ground. Seeing no reason to cave in to this request, the viceroy spurned the overture and ordered the Chinese back to their ships. The eunuch who headed the delegation, Zheng He, decided that discretion would be the better part of valour. He withdrew with his men to their ships, leaving the imperial mission unfulfilled, and headed off to pursue diplomatic overtures to other kings on the Indian mainland.

The convoy was spotted again returning east in the spring of the following year, but the ships made no move to come in-shore. The threat to Ceylon was over, though not because Zheng was unwilling to use force when circumstances were in his favour. Chen Zuyi was a Chinese adventurer working out of the port of Palembang, Sumatra, dominating and taxing ships passing on the sea lanes of the region. Zheng refused to submit to Chen's authority. On his return journey

he led a military operation to capture Chen and take him back to China for punishment. Alagakkonara's rejection of Ming supremacy had stung, and Chen's capture was a way for Zheng to show that Ming authority would not be challenged without consequences.

Two years after that first visit, in 1408, an equally imposing Chinese flotilla came again over the eastern horizon. This time the great ships did not anchor. They sailed straight past Ceylon and headed north to India. Whether Zheng feared a repetition of the humiliation he had experienced on the previous visit or whether he was under his emperor's orders to avoid Ceylon, the island was left untouched, not just on the fleet's voyage west in the winter of 1408 but also on its eastward return the following spring. Chinese avoidance of Ceylon seemed to be a clear victory for Alagakkonara's policy of rejecting all foreign overtures.

Now, two years later, in the winter of 1410, a third armada from the Ming Great State hove into view out of the east. Would the fleet sail past, as it had the second time in 1408, or land, as it had in 1406? The latter. The fleet in fact sailed into the *kolamba*, moored and brought ashore the same delegate of four years earlier. Zheng He reiterated his request that the king of Ceylon submit to the Chinese emperor, this time with a suite of donations and lavish gifts to sweeten the demand. Alagakkonara did as he had done that first time and rejected the proposal, apparently more brusquely than four years earlier. He ordered the ambassadors to quit the island and never return. Zheng had no option but to withdraw again and sail on to India, but the matter was not settled. The affront to his dignity was an affront to the dignity of his imperial master. Three months later Zheng returned.

In the version of events he related to his emperor, which is summarised in the court diary, Zheng said that Alagakkonara 'enticed' him into the interior of Ceylon. The Chinese sources, however, are confused about the identity of Alagakkonara. There were two men of that name. The king was Vira Alagakkonara, and he ruled as Vijay-abahu VI from the capital city, Gampola, a hundred miles into the interior. The other Alagakkonara, Nissanka Alagakkonara, was the viceroy and military commander who had confronted Zheng He at the *kolamba*. He was the king's uncle on his mother's side and had distinguished himself since the 1370s by driving back several incursions

from Tamil states to the north. Had Zheng originally mistaken the viceroy for the king? When did he realise that there were two Alagak-konaras, and that the one he wanted was in Gampola?

Regardless of whether he was tricked or already had his own plan of attack worked out, Zheng He landed an armed force of some 6,000 men and headed inland to Gampola to force the 'real' Alagakkonara to come to terms with Ming authority. As Zheng's main force was mak-ing its way towards the capital, the viceroy took advantage of the situ-ation to move against the Chinese ships anchored at the harbour, now under-defended. He first dispatched his son to the fleet to demand that the Chinese hand over the gold and silver that they knew the Chinese were carrying in the ships. Expecting to be refused, he also moved 50,000 soldiers into position in preparation to attack the ships. He also sent fellers to follow the Chinese force at a distance and cut down large trees at bottlenecks along their route to barricade the road and impede a quick return to the harbour.

When Zheng got word that his fleet was under threat, he sent part of his regiment back by an alternative route to the coast, indi-cating that he had local collaborators passing him good intelligence. He guessed – correctly, as it turns out – that the viceroy would have moved most of his troops into position around the harbour to loot the ships, leaving Gampola relatively undefended. He kept back 3,000 of his men and continued on towards Gampola. When night had fallen, he ordered his soldiers to gag themselves so that they would not utter a sound and give away their positions to the capital guards. On the signal of a single gunshot (Chinese military technologists had recently developed portable firearms) they launched an assault on the palace. They captured Vira Alagakkonara – the king, that is – along with members of his family and some of his aristocrats. As soon as Nissanka Alagakkonara learned of the attack he dispatched a large army to Gampola to rescue the king. Zheng's men withstood a six-day siege inside Gampola, then burst out and fled to the coast with the king and his court. Losses on both sides were high. When they reached the fleet, they forced the Ceylonese royal party on board, weighed anchor and set sail.

This account may not be an entirely accurate description of what happened, but all we have to go on are two Chinese records: the version

of the story that Zheng He told the emperor, which was entered into the official court diary, and an account by Fei Xin, a twenty-four-year-old soldier who sailed on this voyage and left a short memoir of his adventures. Fei concluded his brief tale by declaring the outcome to have been 'a great victory' for the Ming.

Waiting for the Ambassadors

What were armed ambassadors of the Chinese emperor doing in the Indian Ocean? To answer that question, we need to bear in mind that Zheng He was not the first agent sent from China to heads of state in the Indian Ocean. This practice goes back at least to the time of Khubilai Khan, as we know from Marco Polo's voyage, but in the fourteenth century that diplomacy dwindled. The next dynasty's founder, Zhu Yuanzhang, who drove Khubilai's descendants out of China in 1368, saw himself as continuing the world-ordering vision of Khubilai, whom he called the True Man of the Steppe. Zhu was not about to step back from the role of Great Khan, and if the Yuan had been a Great State, the Ming could be nothing less. Giving himself the regnal name of Emperor Hongwu (meaning 'Martial Surge'), he simply carried on where the Chinggisid Mongols had left off. And that meant turning to the sea.

As a brand new emperor, Hongwu needed ratification that Heaven had transferred the mandate to rule from Khubilai's house to his own. Celestial portents were wanted. In their absence, international diplomatic recognition would do. Receiving envoys from foreign rulers to acknowledge his supremacy by submitting tribute might go a long way towards showing his own people that the world recognised his legitimacy, and that they should too. As Khubilai had done, Hongwu looked to the rulers of maritime Asia to confirm that he occupied the apex of the world.

During his first year, 1368, no foreign ambassadors arrived. The dynasty had just declared its founding, and rulers of lesser states may have thought it prudent to wait and see what would come of this bid. Early the following year, Hongwu lost patience. The first proclamation he sent was to the king of Dai Viet (northern Vietnam) to tell him that he expected recognition. 'Recently the Yuan capital was overcome and pacified, and all within the borders united, thus constituting

our legitimate succession. Now our relations with all, both near and far, are those of security and freedom from concerns, as we all enjoy the blessings of an era of great peace.' Having launched a new age of global harmony, Hongwu had just one worry: 'There is only the matter that you foreigners in the four directions, you chieftains and commanders, being far away, have not learned of this. I am thus issuing this proclamation so that you will be fully aware of the situation.' In other words, send your ambassadors, now. To make sure the message was received by more than Dai Viet, three weeks later the Ministry of Rites dispatched envoys to Japan, Champa (southern Vietnam), Java and Coromandel, on the coast of India. Over the next two weeks, further envoys were sent to Japan and Yunnan (which the Ming had not yet conquered, and from which it would in due course extract a large penalty measured in eunuchs – which is how Zheng He ended up in China).

In time, the desired responses trickled in. The first embassy was from Ada Azhe, king of Champa, bringing gifts of tigers and elephants. (The Ming would eventually acquire an entire stable of elephants, which would be led out on parade during court audiences.) An embassy from Dai Viet soon followed. Only later did Hongwu learn that Dai Viet and Champa were at war, and each side was jockeying with the other for support from the new dynasty: not quite the 'era of great peace' he had promised. (Emperor Yongle later launched a full-scale invasion of Dai Viet, despite his father's insistence that this was one of the fifteen countries the Ming should never invade.) A third embassy arrived in 1369 from Korea, but that was it. No other country sent envoys to celebrate the new regime.

The following spring, Hongwu dispatched another round of officials to Japan, Coromandel and Chola (south-eastern India), pointing out in his edicts to these states that Korea, Dai Viet and Champa had all sent tribute and that they should do the same. In July 1370, he enlarged the circle of summonses by inviting Java as well as the Uyghurs and other inland polities further west to fall into line. 'We wish only that the people of China and abroad all be happy in their places.' This round of prompting achieved its purpose. By 1371, all these states had dutifully responded by sending tribute. Still, Hongwu was obsessively watchful. In 1379 a tribute delegation arrived

from Champa bringing more elephants. He was not informed, learning about it only because a eunuch saw the animals outside a palace gate. His fury at not being notified of the visit knew no bounds. He accused his top officials of plotting to overthrow him and let loose a purge that, by his own estimate, put 15,000 officials to death. Recognition from foreign rulers was not just decorative diplomacy; it showed Heaven's will.

Nepoticide

Before Hongwu died in 1398, he anointed a grandson as his successor. The enthronement of Emperor Jianwen left many of Jianwen's uncles disappointed, not least of whom was one of Hongwu's sons named Zhu Di. Hongwu had posted this son to Beijing to secure the northern border against any possible threat from the Yuan Great State, which continued to exist beyond the Great Wall. Fearing that his nephew would eventually move to consolidate his power by confiscating the regional fiefs of his uncles, Zhu Di decided to take the initiative to prevent that from happening. He launched a hugely destructive rebellion, which ended four years later with the torching of the imperial palace with his twenty-four-year-old nephew, Emperor Jianwen, inside. Zhu Di then mounted the throne as Yongle, Perpetual Happiness. It was rumoured that Jianwen had escaped the flames and fled overseas, and that the expeditions Yongle sent overseas were to find him, but that only obscures what Yongle was really up to: establishing his legitimacy in terms that Khubilai Khan and his own father would have understood.

Yongle's nepoticide (the term for killing a nephew), in shocking defiance of his father's instructions for a stable succession, left him facing a legitimacy deficit of mammoth proportions. Officialdom was incredulous, the populace appalled. When officials who had served Emperor Jianwen spoke up against the coup, Yongle executed them by the tens of thousands. Mongols understood bloody tanistry when they saw it, but Chinese were less willing to tolerate this mode of succession. To make sure that history lined up behind his move, he had the court records altered to create the impression that his father had lived until 1402, that his nephew had never existed and that the succession had gone straight from Hongwu/father to Yongle/son. Jianwen

was airbrushed from the record, and two hundred years would have to pass before historians could acknowledge that the record had been doctored and that Jianwen had indeed existed. Chinese autocracy has sometimes been laid at the feet of the Mongol emperors who ruled Yuan China, but the Chinese emperors who ruled in their mould played their part, and in doing so hollowed out Confucianism's core values of obligation and reciprocity and replaced them with nothing but abject service to whoever was in power.

Like his father, Yongle turned to foreign relations to fill the legitimacy gap. Whether any delegations were on their way to submit tribute to Emperor Jianwen, we have no record. Yongle purged the official documents of the dynasty so thoroughly that all visits of foreign embassies for the years 1398–1402 have disappeared entirely. Presumably they came, and in significant numbers, to inaugurate relations with his nephew, but their presence in Nanjing has disappeared into the incinerator of national history. To kick-start an entirely new round of foreign relations on his own terms, Yongle followed his father's method of sending letters, prompting rulers of lesser states to come to Nanjing and pay their respects. If anyone needed the certification of diplomatic recognition, it was this usurper.

Within two months of taking the throne, Yongle sent instructions to the Ministry of Rites to relax the tribute system to make sure that no delegation, no matter how badly behaved, was turned away. Those who came to trade should be free to do so (and without having to pay any import duties, he later added). 'Now that all within the four seas are one family' – a polite reference to the end of the civil war he had started – 'it is proper that we broadcast widely that there are no outsiders. Those countries wishing to demonstrate their sincerity by coming to offer tribute are so allowed.' 'One family' is a term Yongle used again and again in his diplomatic correspondence. He was the ruler of All under Heaven welcoming foreign rulers into the one family of which he was the head. Under the tribute model, there were 'no outsiders'. When a regional military commissioner petitioned him at the end of that year for an order excluding all Mongols from the realm on the grounds that they were 'people of a different sort', Yongle shot back with the observations that it had been the Mongols who created racial categories, but that anyone who served him, regardless

of ethnic background, could be his subject. But the universalism of Khubilai also rang in his ears: all must submit.

A few weeks later, he ordered the ministry to send envoys to Ryukyu (Okinawa), Japan, Dai Viet, Champa, Ayutthaya (Siam), Samudra (northern Sumatra), Java and Coromandel. Every delegation carried a copy of his letter declaring that 'there are no outsiders'. Korea, Ayutthaya and Sipsongpanna (between Laos and Burma) dutifully sent envoys in 1403, but the flood of foreign dignitaries that Yongle had hoped to welcome in Nanjing remained a trickle. Six separate missions to foreign rulers went out later in 1403, laden with 'gold-spangled silk gauze fabrics and parasols, as well as patterned fine silks and coloured silks' to entice compliance.

His first big foreign relations breakthrough was Malacca. The palace eunuch Yin Qing was one of the first envoys to be sent abroad in 1403. Yin struck gold when he arrived in Malacca to call on King Parameswara. Parameswara had been the youthful ruler of Johor (today's Singapore) when he was overthrown. Barely escaping with his life, he fled up the west side of the Malaysian Peninsula and set himself up in a fishing village with a decent harbour, the spot that would become the port-state of Malacca. Yin Qing's timing was impeccable. Yongle needed a secure location from which to project Ming power into the Indian Ocean region, and Parameswara needed Great State backing to fend off his competitors. He also needed Chinese merchants in his port to build an economic base for his new regime. As a result, Malacca became the key trading entrepôt, not least because whoever controlled that port controlled all the trade moving up and down the Strait of Malacca.

Maritime diplomacy extending into the Indian Ocean required a larger transportation infrastructure to send envoys abroad, bring foreign emissaries back and then return them to their home countries on something like a regular basis. The ships involved had to be on a scale that could project an image of overwhelming power. They had to persuade all who saw them that a new Great State had indeed emerged in China, and to convince wavering heads of state that compliance rather than resistance was in their best interest. And so, on 25 May 1403, the first shipbuilding order went out. The scant entry in the court diary reads simply: 'It was ordered that the Fujian Regional

Military Commission build 137 ocean-going ships.' Five weeks later, the emperor ordered the dredging of the holding basins at Long-jiang, Nanjing's large shipyard on the Yangzi River, so as to revive and enlarge shipbuilding capacity at the capital. A month after that, he ordered that the Maritime Customs Bureau be revived to process the goods that he expected foreign tribute missions would bring to make the journey financially worth their while. Step by step, Yongle was setting up the infrastructure that would provide the Ming with the capacity to dispatch armadas as far as the Indian Ocean and bring the known world within its reach.

The Slave

The man he put in charge of the operation was not a civil or military official employed by any of the six ministries that constituted the central government. He was a slave in the Imperial Household. The Imperial Household was the inner core of the regime, the operational centre of the emperor's affairs and an agency into which the civil bureaucracy could not reach. The choice of a slave over an official harked back to the Mongol practice of keeping sensitive operations out of Chinese hands. The key service posts in the Yuan dynasty had been given to *semu*, the 'various categories' of people who weren't Chinese, people like Marco Polo. Yongle did not have a service cadre of ethnic others, but he did have a group of attendants who were utterly dependent on him: the eunuchs of the Imperial Household.

The Imperial Household used eunuchs because of the age-old, Asia-wide practice of permitting only castrated males to work within the palace administrations of rulers. Castration ensured that no child conceived within the palace precincts had any father but the ruler. No son who ascended the throne could be anyone's but his father's. Giving rulers theological status as the Sons of Heaven only intensified the need to protect succession to the next generation, since Heaven's mandate was given to one family at a time. Should a son who had been covertly conceived by a man outside the family come to the throne, the dynasty must collapse, since Heaven had not given its mandate to that bloodline. The bloodline of any woman an emperor impregnated was of no account. Most of Yongle's consorts, for example, were Koreans.

Eunuchs were demeaned not just physically: they were also demeaned in status. Their bodies were put entirely in the service of the imperial family. They worked for and at the pleasure of the emperor and his kinsmen. They lived and worked within the palace and had no work outside of it. They had no access to legal process and could not bring a suit before a public magistrate. They were socially dead, to use the language of historians of slavery. To call them eunuchs, to draw attention to their physical mutilation, at least to my mind, drapes them in a certain Orientalist exoticism. Physically they were castrated, but we get closer to what they were socially by calling them slaves.

For diplomatic operations, Yongle used slaves almost exclusively. It was inconceivable that he would do otherwise. Diplomacy was ruler-to-ruler, not head-of-state-to-head-of-state. No one could stand in for the emperor on a diplomatic mission other than a slave whose body belonged to him and who had no loyalty other than to the emperor. This is why Yongle's overseas missions were all headed by slaves. And in the history of that reign, none was more important or became more powerful than Zheng He.

Zheng had not started life as a subject of the Ming. He was born in 1371 to a Muslim family in Yunnan, at that point an independent state. It was said that his great-great-great-grandfather, a Muslim with a Persian name from Khwarezm, surrendered to Chinggis Khan in Bokhara. Zheng would have been a *semu* under Khubilai, but that term had disappeared with the Mongols. His Chinese birth name was Ma He, Ma being the generic Chinese surname of Muslims. His father and grandfather were both known by the honorific title of Ma Hazhe, signifying that they were *haji*, people who had gone on the Hajj pilgrimage to Mecca – a reminder that people in the fourteenth century were more mobile than we might realise. When the Ming invaded Yunnan, the younger Ma Hazhe died in the resistance, and his ten-year-old son Ma He was captured in 1381.

The standard fate for a juvenile captured in war was to be enslaved, castrated and put to work for life in the household of either the emperor or one of his sons. This is what happened to the ten-year-old Ma He. By random administrative chance, he was assigned to the household of the Prince of Yan, the son of Emperor Hongwu who

would become Emperor Yongle. The odds favoured his disappearing utterly into the anonymous life of enslaved service inside the princely household, but somehow he came to the attention of his master. The prince took a liking to him, and took him on campaign against the Mongols north of the Great Wall. Apparently the teenager distinguished himself in a military capacity, though it seems that his real strength lay in knowing how to organise and run complex projects. To show his favour, Yongle gave him a new surname, Zheng.

Before his assignment to lead diplomatic missions abroad, Zheng He's biggest assignment had been to oversee palace construction. He knew nothing about the sea, but he was competent and he enjoyed the emperor's trust, two qualifications that mattered far more than maritime skills. It has been suggested that Yongle took into account Zheng's Khwarezm descent and his Muslim identity, useful assets for managing political negotiations with the Muslim rulers he was about to encounter throughout South-East Asia and the Indian Ocean, though nothing in the sources confirms this supposition.

Zheng He makes his first appearance in the court diary of the Yongle reign on 11 July 1405. It is not surprising that he does not appear sooner, for he worked for the emperor, not the court. The entry reads: 'Eunuch Zheng He and others were commissioned to take imperial instructions to the countries of the Western Ocean' – the name by which Chinese called the Indian Ocean – 'and to present the kings of those countries with fine patterned silks and coloured gauze silks as appropriate.' It is a scanty reference to an operation that may have involved 62 large ships, close to 200 smaller vessels and over 27,000 men. Again, this is not surprising. The voyages were not operated out of the Ministry of Rites. They were Imperial Household enterprises, beyond the scrutiny of the civil historiographers who compiled the court diary.

Zheng He's first voyage was not intended as a one-off. Barely a week after the fleet had left China, Yongle started preparations for the second, ordering the construction of another 1,180 ships. The edict for this second voyage was issued barely eleven days after Zheng's return from the first, phrased as an authorisation for Zheng to take a delegation he had just brought from Calicut back home. Three months later, the second voyage, a fleet of 249 ships of all sizes, set off. It followed

roughly the same itinerary as the first, with the exception, as we have noted, of Ceylon. Zheng He was not to call there, as another strategy to force the king of Ceylon to obey the emperor was in development. To carry that new plan through, a third voyage was announced early in 1409, even before Zheng had returned from the second.

According to the soldier-memoirist Fei Xin, Yongle's directive to Zheng He for that voyage was to 'convey the imperial instructions and distribute presents to the king and chieftains of that country'. Knowing that the king had already refused to take instructions, Yongle inserted additional instructions into his orders: 'Presents are to be distributed to the temples, and a stone stele' – the standard term for stone tables inscribed with text – 'is to be set up to attest to their reverence toward Imperial rule.' Here was the new plan: not to beat Alagakkonara into submission, but to bring his gods under Yongle's care. Yongle was the Son of Heaven, which meant that he enjoyed Heaven's highest regard, and therefore the Buddha's – and every other deity's, for that matter. By extension, the king's submission to the Buddha confirmed his submission to Yongle, as Yongle, given his special relationship to Heaven, was the higher officiant in that religion. Zheng He had other assignments on this voyage, including delivering envoys back to their home states and picking up more ambassadors to bring back, but his main assignment was to plant the stele in Ceylon and assert Yongle's supremacy.

The passage in both directions was expeditious. The voyage set sail from the port of Changle, on the Fujian coast, in January 1410, and it was back in Nanjing in July 1411. Zheng's report in the court diary makes no mention of how or when, or where, he delivered the stele. He simply concludes the account of his adventures on Ceylon by saying that, having defeated the Ceylonese on a massive scale, he returned to China. So the question arises: what happened to the stele?

Finding the Galle Stele
The earliest evidence we have that Zheng delivered the stele as ordered is a reference in a history of the Portuguese conquest of Ceylon written in the sixteenth century. That history recounts that Portuguese soldiers waging a war against the regional king destroyed a temple complex at Dondra, on the south coast, in 1588. But in destroying it

they noted the existence of 'stone pillars which the kings of China ordered to be set up there with letters of that nation as a token, it seems, of their devotion to those idols'. The next we hear of the stele is in 1911, when Henry Tomalin, an English engineer and architect recruited from London in 1886 at the age of twenty-four, found it. Tomalin was overseeing the rebuilding of roads in Galle when it was reported to him that the road workers had turned over a huge slab of stone five feet long and five inches thick covering a culvert and noticed inscriptions on the underside.

Tomalin was the right person to inform. The Europeans who went abroad to carry out the first wave of colonial public works tended to be uninterested in the cultures in which they found themselves, even contemptuous of the world they were asked to remake. By the later decades of the nineteenth century, however, a new generation of colonial staffers – generally men of middle-class backgrounds and modest social station – had emerged to pursue careers abroad that might give them the upward mobility unavailable at home. They constructed European-style public buildings, ran large drainage projects, improved harbours, modernised roads and did whatever else was felt necessary to bring the colonies into the nineteenth century. Some were also intrigued by the ancient cultures that had once occupied the territories now within the British Empire and eager to find traces that might bridge their imperial present to a grander past.

Henry Tomalin was a prime example of this type. His first project was to decorate the front of the Galle Face Hotel in Colombo to celebrate Queen Victoria's Golden Jubilee in 1887, which he did without reference to local culture. By the time he was asked to design the Ceylon Court, the colony's pavilion at the 1893 World's Columbian Exposition in Chicago – for which he came up with an elegant building in wood influenced by his field tours of ancient ruins – he had absorbed what he considered traditional Ceylonese culture and developed a knack for adapting native forms to modern uses. Like other colonial civil engineers, he saw himself not just as part of the maintenance staff of empire, but as a custodian of a vanishing past, recording architectural remains, collecting inscriptions and recycling motifs that time, weather and colonial rebuilding were conspiring to efface. A model colony should preserve its past while also enabling

what modernity was bringing. Being from outside, as every colonial administrator was, gave Tomalin a vantage point that persuaded him to unify the diverse elements of the colony in a way that locals could not. He did this with the Ceylon Court. The pavilion was supposed to offer Americans a coherent impression of Ceylon as a single colony, rather than as an island profoundly split between Hindu-Tamil and Buddhist-Sinhalese cultures. Tomalin's solution to turn divorce into cohabitation was to install a statue of Vishnu at one end of his prize-winning building and a statue of the Buddha at the other.

When Tomalin came upon the stele in 1911, he recognised its status as a rare and important historical document, even though he had no one around him to decipher the inscriptions. The Galle Stele, as it has come to be known, has proved even rarer, more important and more contentious than he could have guessed, for on its interpretation hangs the question of whether the fifteenth-century voyages of Zheng He were acts of friendship diplomacy or missions of imperial domination.

Buddha, Vishnu, Allah

The inscriptions on the face of the stone were badly damaged and took time to decipher (see Plate 6). Not until 1933 were they fully published. The most legible of the three is the Chinese text, which fills the right-hand third of the face of the stele. It is a message from Emperor Yongle dated 15 February 1409, addressed to the Buddha.

The emperor begins his prayer to the Buddha by thanking him for exerting a 'mysterious efficacy' that had been of particular assistance to Ming foreign policy. 'Of late', he tells the Buddha, 'We have dispatched missions to announce Our mandate to foreign nations, and on their previous voyages over the ocean, Our envoys escaped disaster and misfortune, journeying safely to and fro.' Acknowledging that this must have been due to the Buddha's protection, 'We therefore bestow offerings in recompense, and do now reverently present before Buddha, the Honoured One, oblations of gold and silver, gold-embroidered and bejewelled banners of variegated silk, incense burners and flower vases, silks of many colours, lamps, candles, and other gifts, in order to manifest the high honour of the Lord Buddha. May his light shine upon the donors.' There follows an itemised list of

gifts in order of value, starting with 1,000 *qian* of gold (1 *qian* weighed roughly an eighth of an ounce, so a total of about 50 pounds of gold) and 5,000 *qian* (250 pounds) of silver, followed by the promised silk and ritual utensils and ending with scented oil (no less than 3,300 pounds), wax and incense. It was a lavish donation, and was entirely intended to be seen as such.

But who was this inscription for? Few Chinese circulated around the Indian Ocean, and even fewer would ever come by to read it. The simplest answer to the question is: no one. The text was not there to be read. It was there to signal that this was a Chinese monument announcing a Chinese presence in this place.

Two other texts fill the space to the left of the Chinese inscription. At the top is a Tamil text, representing the Vishnu end of Tomalin's dyad of Tamil and Sinhalese cultures. According to the scholar who first deciphered the text in 1933, it 'can hardly be called grammatical' and uses words attested nowhere else. This may be the effect of the translation, which was done back in Nanjing before the voyage even launched, not in Ceylon. And yet the text isn't really a translation. Instead, it transposes what the Chinese text says into a Tamil devotional context. Not a prayer to the Buddha, it is rather a prayer to Tenavarai-Nayanar, 'the Saint of the Southern Port', an emanation of Vishnu. The Southern Port, Tenavaram, is now known as Dondra. This small port on the south coast of Ceylon had been famous for centuries as an eclectic religious site. Our best witness on this question is none other than Ibn Battuta, the Moroccan traveller we encountered in Chapter 3. When he visited Dondra / Tenavaram in 1345, he reported finding both a Sleeping Buddha temple and a massive Hindu complex. He doesn't name the deity worshipped at the complex, but he does note that 'the idol carries the same name as the city', which is to say, Tenavarai-Nayanar. 'In this temple there are about a thousand Brahmins and yogis, and about five hundred daughters of the idolaters, who sing and dance before the statue every night.'

The reference to Tenavaram in the Tamil text confirms that Dondra was the location for which the Yongle stele was made. This is significant, because nothing in the Chinese text gives a location for the donation, other than to say that the gifts are being given to a generic Buddhist monastery in Ceylon. Assuming that Zheng He,

and therefore Emperor Yongle, knew that Dondra was not purely a Buddhist site but had temples to other gods, what was the emperor's intention in making offerings to both?

The only way to answer this question is to listen to how he identifies himself to the Lord of the Southern Port. After hailing the deity, he introduces himself as 'King of Great China, supreme overlord of kings, full-orbed moon in splendour'. This hardly reads like the humble address of a devotee supplicating his god. It is the voice of the supreme monarch addressing a foreign deity who has come to his notice and whom he is willing to venerate to the degree that the god meets his obligations by caring for the King's subjects.

Vishnu gets exactly the same gifts as the Buddha, though with a subtle difference. The gifts of precious metals are denominated in a local Tamil unit (*kalañcu*) rather than in the Chinese unit used in the Chinese version of the text (*qian*). As the Tamil unit weighed a third more than the Chinese unit, in real terms this transposition has the effect of increasing the value of the donations to Vishnu by a third. Was this the intention? Surely not, as that would mean that Vishnu received more than the Buddha, which would disturb the equity between the two gods. Of course, it is possible that the translator was simply looking for rough equivalents when he made his translation and didn't think it was worth fussing over the rate of exchange between *kalañcu* and *qian*. But this little glitch leaves us with a question for which we have no answer: were Vishnu and the Buddha each separately to receive the amounts listed on the stone, or was there only one gift, which the deities at Dondra, whoever they were, were to receive collectively? To put this puzzle another way, was Yongle hedging his bets by offering the gifts to both deities, hoping that at least one of them would be there to accept them?

This puzzle becomes yet more tangled when we turn to the third inscription, beneath the Tamil text. The language is Persian, the script Arabic. This combination was common at the time. Persian was the *lingua franca* among traders in the Indian Ocean, and Arabic was the *scripta franca*. This double usage reached all the way to China during the Yuan period, for we know that Ma Huan, who sailed on three later voyages and wrote a memoir of his experiences, was trained to read and write Persian in this way. It is even conceivable that Zheng

He had been taught the script as a child, though there is no evidence for this.

The rest of the stone's face bearing this third inscription is heavily damaged, but one of the fragments that survive uses the phrase 'the Light of Islam'. So this inscription was for Muslim readers, and the donation was to Allah or his saints. Yongle identifies himself as he does in the opening of the Tamil text, as 'the King of Great China', and explains that he has ordered his envoys to present offerings to thank the god of the Muslims vaguely for his 'kind favours'. The list of gifts is identical to the other two inscriptions, though again the unit for weighing precious metals has been transposed to a Persian unit (*misqal*), heavier than the Chinese *qian* but lighter than the Tamil *kalañcu*. So the same question arises here as it did with the donation to Vishnu. Was no one in Nanjing quite sure which deity prevailed at the site, and so were they content to let the donation go to whichever deity did?

Or were the inscriptions not for the deities at all, but for the worshippers? Did the Muslim merchants who passed through Dondra on their travels across the breadth of the Indian Ocean read the Arabic text and understand that the emperor of the Great State of China honours Allah? Did the Tamil merchants who operated throughout the region of South India read the Tamil text and think the emperor of China honours Vishnu?

The Tamil scholar who first deciphered the Tamil text chose to declare that the stele's trilinguality attested to 'the eclecticism in religious matters characteristic of their race'. I'm not convinced that this sort of general cultural explanation gets us very far. We would do better to think about the stele in its political context. This stone marker was a long way from China. It provided those who saw it with an unmistakable marker of who put it there, for the stele's capital consists of two five-toed dragons facing each other on either side of what is sometimes called the pearl of wisdom, and which has at times in Chinese history been interpreted as a universal symbol of religious truth that stands above sectarian differences. The dragons were widely understood as avatars of the Chinese emperor. Their presence on the top of the stone signified beyond all doubt that this was an imperial Chinese monument. That was the extent of what most who

came upon the stele would have understood. Being in three languages tripled the possibility of the emperor's message being read and understood. Whoever could read whichever inscription should know that the king of Great China was Heaven's highest priest. The stele was not a demonstration of Yongle's devotion to all deities so much as a declaration of Chinese presence within the religious geography of the Indian Ocean. Whichever deity you revered, Yongle was now the patron of that deity. Let everyone else see the dragons on the head of the stone and know that his reach was universal. No other ruler could claim such authority.

Whose Story Is This?

When Zheng He got back to Nanjing with his royal captives, he presented them to the emperor to face their punishments. Yongle's courtiers – a remarkably fawning group, even by Chinese court standards – duly clamoured for the emperor to execute the hostages for offending his imperial dignity. This clamour gave Yongle the opportunity to display the clemency of a benevolent ruler. In the language of the court diary, 'the Emperor pitied the king for his stupidity and ignorance and allowed that he and the others be released and given food and clothing'. Even so, he was not prepared to let Alagakkonara off without consequences. He declared the king deposed and ordered his Ministry of Rites to nominate someone within the royal family whom he could install as Alagakkonara's successor. Once the choice was made, the hostages were sent back to Ceylon on Zheng's next voyage, and Pakramabahu VI was installed as the Chinese puppet ruler of Ceylon. The happy result, according to Fei Xin's memoir of the voyage, was that 'all the barbarians are respectful'.

Yongle's courtiers cranked out verses congratulating the emperor on his massive victory over the barely human barbarians. His most senior adviser, Yang Rong, joined in this tide of compliant jingoism with a poem that climaxes with these lines:

> Straightaway their dens and hideouts we ravaged
> And made captive that entire country,
> Bringing back to our august capital
> Their women, children, families and retainers, leaving none,

Sweeping out those noxious pests as though winnowing chaff
 from grain.
Those lowly worms who deserved to die ten thousand deaths,
 trembling in fear,
Did not even merit the punishment of Heaven.
Thus the august emperor spared their lives
As they humbly kowtowed, grunting crude sounds
In praise of the sagely virtue of the emperor of the Ming.

Two months after Zheng presented his hostages at court, the Ministry of War petitioned the throne to approve awards and military promotions of as much as two ranks for those soldiers who had distinguished themselves in the battle of Ceylon. Not to be outdone, the Ministry of Rites did the same for its people, including doctors from the Imperial Medical Academy who had served as medics. Yongle approved the entire scheme.

Five years later, Yongle was still handing out promotions to soldiers whose fathers had died in Ceylon. Ten years after that, Yongle's grandson found himself in the position of having to reward yet more soldiers who claimed service in Ceylon. On 16 July 1426, Emperor Xuande received a report from the Ministry of Rites to say that four members of the Embroidered Guard had just returned to China. The Embroidered Guard was the elite military corps of the Ming that served the emperor and, among other duties, staffed his bodyguard. The four had been captured during the battle of Ceylon, and it had taken them fifteen years to repatriate. They had somehow managed to get to Samudra, and there were able to gain passage on a ship bringing tribute to the Ming court. The emperor duly rewarded them. 'Because these four men sailed among the distant barbarians in their sovereign's service, their parents, wives, and children knew not whether they lived or died. How terribly pitiful their situations! Confer on them clothing, paper money, and cloth and let them return to their native places to see their relatives. Only after that should they return to active duty.' Their return was yet another opportunity to glory in the Ming victory over Ceylon. It was also, though, a quiet reminder that Zheng's attack on Alagakkonara had not gone entirely in the dynasty's favour.

That is how the Chinese remember the story. Ceylonese remember

it differently. The first Ceylonese historian to reconstruct this story was Edward Perera, in a paper he read before the Ceylon Branch of the Royal Asiatic Society in Colombo in 1904. A Sinhalese journalist and barrister two years short of thirty, Perera later went on to earn the title of Lion of Kotte (Kotte, Nissanka Alagakkonara's fort, became the official capital of Sri Lanka, and is now a suburb of the city of Colombo) for his role in convincing Britain in 1917 to repeal martial law in Ceylon. Perera was also an enthusiast of Sinhalese history. This paper was but one of several studies he published on aspects of Ceylon's international past.

The Ceylonese version of the hostage-taking differs on two important points. The first is about how the succession from Vira Alagakkonara to Pakramabahu VI came about. According to Ceylonese telling, Nissanka Alagakkonara may have allowed his nephew Vira Alagakkonara to be captured as a means for him to become king in his stead. But if so, this story of ambition came with a twist he could not anticipate. When he was captured, Vira Alagakkonara left behind Sunetra Devi – who was either his young queen or a widowed daughter – and a young son. (One version claims there were two sons.) They had fled into hiding during the attack and were therefore not among the family members that Zheng seized and took prisoner to China. When, in 1414, Zheng returned Vira Alagakkonara and his retinue to Ceylon, Nissanka Alagakkonara feigned pleasure at his return but had him murdered as soon as Zheng left. He then put into motion steps towards his own coronation.

That coronation was not to be. Perera narrates the climax of this story with Shakespearian flair: 'On the seventh day of the bright fortnight of the month Wesak [April–May], 1415, on the raised stone platform facing the palace in his own city of Kotte, overlooking the beautiful tank he had built, the old warrior' – Perera means Nissanka Alagakkonara – 'clad in all the insignia of royalty, sat to receive the crown for which he had his whole life struggled. The square was filled with nobles, troops, and people.' Unbeknownst to the viceroy, the Great Priest Widagama Sami, who had connived in protecting the heir apparent, brought to the ceremony the son, now sixteen, who had been in hiding with his mother.

As Alagakkonara turned his face for the auspicious rite, the state sword, which Widagama Sami held in his hand to gird the new king, was handed to the young prince, and the head of Alagakkonara rolled into the tank below. The body of the aged hero made way for the son of Vijayabahu, and the lad of sixteen was hailed king as Sri Pakramabahu VI.

A less thrilling version of the Ceylonese story has Alagakkonara die a natural death, after which Widagama Sami brings forward the adolescent prince whom he kept in hiding until it was possible for him to come safely to the throne. However the tale was told, the right-ful heir from the Ceylonese perspective was at last on the throne as Pakramabahu VI, who would go on to be an effective ruler of the kingdom for the next half-century.

Sri Lankan historians such as Perera thus insist that the real Pak-ramabahu never went to China, implying that Chinese propagandists had simply made his installation as a puppet by Yongle a story they could live with once Pakramabahu was on the throne. Ming sources indicate that the new king was attentive to Chinese demands. In Ma Huan's account, 'the king constantly sends offerings of gems and other such precious things with men who accompany the treasure ships returning from this ocean to bring tribute to China'. His readi-ness to send gems as tribute has been taken as a sign that Pakrama-bahu was a puppet of the Ming but perhaps it signals an astute ruler willing to tolerate this fiction.

The choice of gems was clever. According to Chinese metaphysics, gems were physical manifestations of the creative force of Heaven, tangible nodes of its power. This meant that every gem that came to Yongle signified once again that Heaven was pointing to this man as its chosen appointee. Yongle received them in such volume that he then sent them on to his kinsmen as attestations that Heaven favoured him. By accepting these shining jewels – and who among them could refuse? – they conspired in the emperor's legitimacy, and so protected their place in his regime. Archaeologists have come across them in considerable numbers in the tombs of fifteenth-century Ming princes. Pakramabahu was thus able to use gems to keep the Ming happy and Ming troops off his island, and Yongle was able to pass them around

as tokens of his legitimacy. These treasures were a modest price for Pakramabahu to pay for his realm's autonomy.

But there was one treasure, the very source of legitimacy of the Ceylonese king, that could never be given away.

The Buddha's Tooth

Zheng He was not the first ambassador from China to reach the shores of Ceylon, as Marco Polo, who declared Ceylon to be 'undoubtedly the finest island of its size in the world', tells us. He records that some fifteen years before his own visit, Khubilai Khan sent three envoys to Ceylon to ask the king for what was then considered the holiest religious relic in the world, a tooth of the Buddha. That tooth, along with the Buddha's begging bowl, had been in the possession of the Ceylonese monarchy since the sixth century. Nothing was more material to the king's legitimacy than that adamantine object, which transcended the decay of the human world. Having declared himself Heaven's choice, Khubilai wanted to possess all signs of Heaven's favour, including this tooth. He also wanted the largest ruby in the world, which the king of Ceylon possessed as well, and declared that he was willing to pay 'the value of a city' for it, writes Polo. The king declined the offer. It was not so easy to resist the request for the tooth, however. The king managed that request by sending two other teeth of the Buddha, though not the one Khubilai coveted, along with a begging bowl and a tuft of the Buddha's hair. Khubilai was realistic enough to know that the gifts that reached him might not be the real things. To discourage anyone else from having this thought, he staged a huge reception outside the walls of Beijing to greet their arrival. Who then dared to suggest that these were not the genuine articles?

The story of Khubilai's attempt to acquire the Buddha's tooth a century and a half earlier was still alive in the Ceylonese imagination in 1411. According to their version, there could be no reason why Zheng He had been sent to Ceylon other than to seize their precious tooth. On the Chinese side, though, none of the sources at the time mentions the relic. The tooth does come up, however, in a long footnote to a text in the 1676 edition of the *Tripitaka*, the official compendium of Chinese Buddhist sutras. The text is the famous account by the Tang-dynasty monk Xuanzang of his travels in India in the seventh

century. Since Xuanzang mentions Ceylon, a seventeenth-century editor has attached a long note to bring the reader up to date on Buddhist matters on that island. He repeats the account in the court diary of Zheng He's hostage-taking, but then adds this extended passage:

> Fighting their way back to the coast, Zheng He and his men reached the ships that evening, bringing the Buddha's tooth relic on board with all due ceremony. The relic emitted a bright light in a most unusual manner, and a peal of thunder rumbled so loudly that people even at a great distance when they saw the lightning took cover.

Once the fleet embarked, the tooth went to work, creating such perfect sailing conditions that 'the fleet sailed on the great sea without encountering stormy winds, just as if they were walking at their ease on dry land', the standard phrase for smooth sailing. 'Fearsome dragons and dangerous sea creatures rose up before the ships but then turned back, causing no harm. Everyone on board was safe and happy.' The note ends by reporting that Zheng He delivered the relic to Yongle, who then ordered a sandalwood reliquary to be built for its display and veneration.

Is there any authority for this miracle tale? The only supporting evidence that has come to light is a letter dated 11 March 1413 from Emperor Yongle to Dezhin Shekpa, the Fifth Karmapa Lama. (Readers will be familiar with the Tibetan Buddhist lineage of the Dalai Lamas; the Karmapa Lamas constitute a different, earlier lineage within a different sect, and like the Dalai Lamas, their lineage continues to this day.) The letter appears to have been part of the diplomatic initiative that Yongle had been pursuing with Tibetan leaders to bring them within his political orbit, principally as a way to limit Mongol influence in the region. The Fifth Karmapa was Yongle's highest contact among Tibetan Buddhist leaders. The emperor had persuaded him to travel to Nanjing in 1407 to conduct a plenary mass to ease the souls of those who died in his civil war and elevate his father to the status of a bodhisattva. For every one of the eighteen days the rituals were being conducted, miraculous portents and spectacular light shows generated by *vajra* energy were reported on a scale beyond anything

Chinese had ever experienced. Everyone in Nanjing reported seeing these spectacular aerial visions in what the art historian Patricia Berger has amusingly called, with a nod to science-fiction writer William Gibson, 'an extended moment of "consensual hallucination"'. Who could deny what the emperor, in his greater wisdom, had said that everyone had seen?

Six years later, the emperor wrote his letter to the Karmapa Lama with important Buddhist news. The letter was rediscovered only in 1959 in the Potala, the seat of the Dalai Lamas in Lhasa. Yongle's message was that Zheng He had brought back the tooth relic. But he started the letter with a personal anecdote to put himself at the centre of the story: 'Once in the still of the night We were sitting in formality when several balls of light appeared in the courtyard, like moons in an empty sky, like great bright mirrors. In the largest of these could be seen Bodhi treasure-trees of many sorts.' In the midst of their flowering branches appeared an image of Sakyamuni clearly displaying his thirty-two trademark characteristics, such as his curly hair and large ear lobes. Yongle went on to describe other features of the vision, then declared that a vibrant Buddhism was the best support for an emperor's rule. To commemorate this vision, he told the Karmapa Lama that he had commissioned sculptors to carve and gild a statue based on what he had seen. The letter accompanied this statue.

At the very moment the Buddha was manifesting himself to Yongle, he tells the Karmapa, his slave Zheng He was in Ceylon fighting the Ceylonese. At this point, the letter follows verbatim the account in the footnote in the *Tripitaka*, then ties the two stories together by stating that the day on which Zheng He invited the Buddha's tooth on board his ship was the very day on which Yongle had seen the Buddha in the ball of light. The Buddha was thus blessing Yongle's succession twice over, once in his courtyard and once in Ceylon. The emperor finishes the letter by telling the Karmapa that the tooth now rests in a specially made reliquary of sandalwood and gold so that the courtiers may venerate it daily 'to generate benefits for all living beings'.

The problem with this story is the complete absence of any mention of the relic in the voyage documents, plus the absence of any other reference to there being an incisor of the Buddha in the Forbidden City. The simplest solution to the puzzle is that the tooth was

never there. The Ceylonese version of the story would appear to confirm that this was a complete fiction. Had Ceylon lost the tooth, that loss would have been decried as an outrage and featured in every account of Zheng's attack. But there is not a word about the tooth being taken. In fact, Pakramabahu, Alagakkonara's successor, had a new temple built in Kotte to house the relic when he moved his capital from Gampola. In an ode celebrating its construction, we read:

> The king caused to be built a three-storeyed palace delightful and
> beautiful to behold,
> ordered to be made a golden casket finely set with nine gems,
> encased in another golden casket shining with excellent coloured
> gems,
> and encased in yet another golden casket.

Pakramabahu's gem-studded reliquary sounds a lot more impressive than Yongle's sandalwood box, if he ever had one made. Of course, we could turn this all around and wonder whether Pakramabahu wasn't covering the loss of the tooth by creating a new fancy reliquary in a bid to generate his own extended moment of consensual hallucination. In any case, there is today in Kandy, near Gampola, a reliquary containing what everyone says is the very tooth that Khubilai wanted and didn't get.

If the story of Zheng's seizure of the Buddha's tooth was made up, then who by? The obvious candidate is Yongle, who needed Buddhist assets to keep in tight with his Tibetan allies in order to prevent the religious charisma of Tibetan Buddhism from falling into Mongol hands. But there is another source, as it turns out, and a highly improbable one: a novel published in 1597 entitled *How the Eunuch of the Three Jewels Sailed to the Western Ocean*. That might explain how the editor of the *Tripitaka* picked up the story seventy years later, but not Emperor Yongle, whose reign pre-dated the novel by almost two centuries. The answer to this puzzle lies in the Potala. It turns out that some of the documents in the Potala were faked in the eighteenth century and inserted in the archives in order to create a paper trail attesting to a historically close relationship between Tibet and the emperors of China. This seems to have been what happened. What

was discovered in 1959, then, was not a real letter from Yongle to the Fifth Karmapa Lama but a forgery. My own hunch is that the forger, who must have been conversant with Buddhist texts, lifted the passage about Zheng He's seizure of the relic from the footnote in the Buddhist *Tripitaka* – not knowing that that passage had been taken from the novel and was never true in any case. So, despite there being three texts on the Chinese side that testify that Zheng He stole the Buddha's tooth, none of this ever happened. If the tale was believed, it was because seizing relics was what rulers of Great States could be expected to do.

Colonial Monuments

Ming supremacy in the Indian Ocean was sustainable only for as long as the regime was prepared to commit the resources needed to launch these expeditions. The consumption of wood simply to build the ships was enormously expensive, and has even been credited with completing the deforestation of the hills of south-east China. But the voyages continued. The next, the fourth, ferried the hostages back to Ceylon. Two more voyages followed during Yongle's reign. On his death in 1424, the programme was suspended to halt the runaway cost of these ventures. The voyages had in any case achieved what Yongle had intended: universal recognition of his legitimacy as ruler of the Ming Great State. After some hesitation, his grandson Emperor Xuande did authorise Zheng He to lead one more voyage, in 1431. As Ceylon was on the itinerary, Zheng petitioned his new master for an edict of pacification against Ceylon, just in case the Ceylonese were no longer prepared 'to show reverence for Imperial rule', in the language of the Galle Stele. But all went smoothly. Pakramabahu received him pleasantly, and indeed continued to send embassies to Beijing until as late as 1459, when most of the other Indian Ocean rulers had abandoned the ritual. After all, by then the Ming state had effectively abandoned the Indian Ocean. It no longer prompted the rulers of coastal states to fall in line with its aspirations. Even private Chinese merchants were withdrawing to Malacca to trade from there. The venture into the Indian Ocean that had started with Khubilai Khan had finally come to an end.

The Galle Stele was the sole tangible reminder that Ming diplomacy

had reached this far. It was not the only marker of a Ming claim. Elsewhere in the South-East Asian maritime zone as well as in the Mongol and Tibetan borderlands, similarly inscribed steles sought to project Ming authority. Come the sixteenth century, however, Ming monuments in the region came to be outnumbered by another type of stone monument, a pillar known as a *pedra* or *padrão*, which Portuguese mariners erected. Like Chinese steles, these pillars bore national and religious symbols – the king's crest, the Christian cross – and were inscribed with texts declaring the presence of the Portuguese, sometimes claiming colonial sovereignty, sometimes commemorating the signing of a treaty with a local ruler allowing them to trade, as they did on Java in 1522. The earliest *padrão* that survives, dated 1482, was set up at the mouth of the Congo River. Its purpose was as much to alert men of other European states, especially Spain, that the spot had already been taken, and that Portugal had an exclusive claim to trade in the region. Chinese steles and Portuguese *padrães* were not the same thing, and yet there is a certain correspondence in the marking of claims, if not to the claims themselves. When Yongle's envoys planted a stele in the tiny state of Malacca, it was to signify the Malaccan king's obeisance to the Ming emperor and, in reciprocation, the Ming's nominal protection of Malacca. When the Portuguese set up a stone pillar there after they seized the port in 1511, it amounted to a claim of possession, unlike anything the Chinese state had ever done. That sort of claim could be resisted. When Portugese sailors raised a *padrão* on Lintin Island in the mouth of the Pearl River in 1513, Ming officials regarded this as an affront to Imperial sovereignty and immediately had it removed. The Galle Stele was taken down in its turn, though when and by whom we don't know. Someone had gone to the trouble of using it to cover a drainage channel where Tomalin found it, but we will never know who.

There is one final, curious detail to this story that doesn't make sense, and that is the location where Tomalin found it when he retrieved it from oblivion and converted it into a monument of another sort on behalf of British colonialism. The stone was never intended for Galle. Dondra was its destination, and indeed, as the Portuguese record shows, it was there in 1588. No one has been much bothered by the fact that it ended up thirty miles west of Dondra

at the small port of Galle. But what was it doing there? Galle had something of a reputation as a port, having served in earlier times as a stopping point for Arab traders sailing from the Malabar coast on the west side of India to the Bay of Bengal – just the sort who might have been able to read the Persian inscription – so it is not implausible that Zheng He might have called there. Yet none of the Chinese authors of the meagre texts from which I have extracted this story makes any mention of Galle. They all describe Dondra, noting in particular the footprint of the Buddha in a rock near the shore. By contrast, there is not a word about Galle.

My best guess is that Zheng He put it where he was told to put it, and then at some later point, some officer in charge of public works, Portuguese or British or otherwise, decided that a stone this size could be put to better use covering a culvert than reminding European colonists that Yongle's envoys had once been present on Ceylon. Today Galle no longer has the stele, merely a replica. The real stone is on display in the National Museum in Colombo, where it is situated to celebrate Sri Lanka's relations with China today. Another replica stands in the Treasure Boat Museum at the site of the old Longjiang Boatworks in Nanjing to celebrate China's Ming moment as a maritime superpower.

Tomalin's Ceylon Court had a much shorter afterlife. The wooden structure was dismantled when the world's fair closed and was sold to John J. Mitchell, Chicago's leading banker, who had it moved to Lake Geneva in Wisconsin and reassembled as a summer house. It burned in 1958 and had to be demolished, thereby ending the history of this curious strand in the circuit board linking Ceylon to the rest of the world.

The Ceylon Court and the Galle Stele belonged to very different ages, yet the one quietly shadows the other. Tomalin regarded his work as a contribution to bringing the backward peoples of Ceylon to a level of civilisation that they had once known but had long since lost. What did Zheng He think of his endeavours? He explains his view in a stele he erected in Changle, the port from which his ships set sail on the eve of his final voyage. 'When we arrived in foreign countries,' he wrote, 'barbarian kings who resisted transformation and did not show respect we captured alive, and the bandit soldiers

who recklessly looted and plundered we exterminated. As a result, the sea routes became safe and peaceful, and foreigners could use them to pursue their occupations in safety.' Both men were proud of their efforts to transform barbarism to civilisation. Installing the Buddha's tooth in the Forbidden City would have capped this story nicely, had it been true.

One Chinese historian recently declared that the Zheng He voyages deserve to be regarded as 'a major achievement in the history of Ming international relations, as well as a monumental feat in the maritime history of mankind'. Whether you want to come to that conclusion depends entirely on what you think of colonialism – which is why neither Tomalin's pavilion nor Zheng He's stele is sufficient to stand in for what really happened.

The Castaway and
the Horse Trader

Zhejiang/Beijing, 1488

Emperor Chenghua, who reigned without particular distinction for thirteen years, died on 9 September 1487. Five days before his death the court, anticipating the worst, had installed his eldest surviving son as regent. When the father died, the seventeen-year-old became emperor. His regnal title, Hongzhi, Grand Determination, came into effect at New Year. It proved to be a good tag for his reign. Despite having grown up inside the gilded cage of the Forbidden City, the young man stepped into the role with the determination that his regnal title claimed for him. He had seen the court drift under his lacklustre father and understood that a passive ceremonial emperor was not what the Ming needed. All appointments in the bureaucracy were up for review when a new man took the throne, and Hongzhi decided to use this opportunity to shake up the administration and get rid of slack officials. By spring, barges from the ministries of Personnel, Justice and War were heading south on the Grand Canal in a steady stream, ferrying home the freshly discharged. It was a dignified way

for Hongzhi to bring careers to an end. No harsh denunciations, no punishments: the dismissed were simply issued with a pewter tablet noting that their service had come to an end, then told which barge to board.

Emperor Hongzhi was also concerned to get his foreign relations onto a stable footing. As emperor, he had to receive foreign envoys bearing tribute, but there were so many of them that the costs of hosting them kept rising. These embassies were limited to a strict schedule, but they often showed up whenever they liked. This situation meant that the Ministry of Rites, which took responsibility for managing tribute relations, was constantly juggling staff and resources to manage the unpredictable flow. There were also security concerns, particularly when rowdy Tibetans and Mongols showed up. One of Hongzhi's first regulations that spring was to impose limits on the size of foreign delegations. Mongols were given the highest cap. A Mongol delegation could be as large as 1,100 men, though of this number only 400 were permitted to proceed to Beijing to present tribute. The rest had to wait at the border.

On 1 July 1488, Emperor Hongzhi received an urgent message from the border defence commander in Datong, the operational centre north-west of Beijing for managing relations with the Mongols. The commander reported that a Mongol army had suddenly appeared ten miles from the border. They had forwarded to him a letter in Mongolian from a Mongol who called himself, ominously from a Ming perspective, Great Khan of the Yuan Great State. His name was Batu Möngke, and he was just thirteen at the time. His advisers were ambitious to position him as the next great leader of all Mongols. Securing that position needed to include asserting his power vis-à-vis the Ming. Batu Möngke was not with the army that had managed to approach the Great Wall undetected, but his envoys were. In his letter he gave the emperor twenty-two days to issue permission for his envoys to cross into Ming territory and submit tribute.

The Ming found it hard to control the terms of the tribute relationship. The basic rule of the system was that when envoys from recognised states knocked at the door they should be admitted, but it could be dangerous to let them in, just as it could be equally dangerous to refuse them entry. What made the regional commander in

Datong anxious was that the request came not from one of the many groups of Mongols with whom the Ming usually dealt, but from an entity that claimed to be the Yuan Great State. 'Although these northern barbarians express the intention to present tribute, they have set themselves up as an enemy state', he warned. 'The expressions they use in seeking an edict of entry are inappropriate.' The red flag was the term 'Great State'. Once that claim was uttered, the commander reminded the emperor, 'one has to think carefully about whether they are loyal or not, whether they will be submissive or recalcitrant'. Hongzhi asked the Ministry of War to deliberate. The Ministry suggested that he just ignore the insulting implication that Mongols considered their polity to be on a par with the Ming Great State. Let them in, but put the detachment of soldiers assigned to the delegation on high alert. The emperor agreed.

Once the Mongols arrived in Beijing, they proved to be a boisterous bunch, squabbling among each other over who received the best presents and complaining when someone got more than someone else. Hongzhi gave in and told the Ministry of Rites just to hand out more presents and be done with them. This went against protocol, but staying off the moral high ground was the sensible decision. If the goal in managing foreign relations was to keep the foreigners docile when they were inside the country, and keep them out when they weren't, flexibility was an essential virtue. When dealing with Mongol barbarians, the Ministry of War assured the emperor, 'imperial authority and teachings have no effect'. Just usher them off as soon as you can.

Koreans were another matter.

The Accidental Foreigner

Four and a half months before these events, a Korean ship set sail from an island off the south coast of Korea. A storm blew up and gave the ship a severe beating. The crew, in desperation to keep their vessel from being blown over by the wind, cut down the main mast in the storm. After the worst had passed, they strung up ripped mats on a makeshift mizzen to replace the sail they had cut down, but they could not hold a course against the storm. Water was seeping in through the planks of the hull, and all hands were below deck scooping out the

water. As all the buckets had been being smashed in the storm, they cut some drums in half to use as pails. The winds died, and the ship simply drifted on a fog-bound sea.

The ship had been assigned the task of conveying home a Korean official named Ch'oe Pu. Ch'oe was no mariner, but after drifting for five days he pulled out what he calls in his diary a 'land map' – which is to say, not a maritime chart – to see whether he could help the ship's officers calculate where they were. He guessed that their location was somewhere east of the mouth of the Yangzi River. Ahead of them to the south lay the Ryukyu Islands, which we know today as Okinawa, and south-east lay the mythical island known as the Land of Women. The one heading they must avoid, he insisted, was south-south-east, for if they drifted out past the Ryukyus and the Land of Women, they were doomed to be lost in the endless ocean that lay beyond. None of this was of any help, for the ship's officers pointed out to him, 'We cannot keep track of dawn or dusk, day or night, let alone determine where the four directions lie, other than by guessing from changes in the wind. How can we determine what direction to sail in?' Ch'oe ends his diary entry for that day with the simple observation, 'They huddled together and wept'.

Two days later, they found themselves among cliff-faced islands. The men managed to get ashore and find water, but there was no place to shelter and they could only return to the ship and keep drifting. At dusk the following day, finding themselves once again among large islands, they were approached by two boats, each manned by about ten sailors dressed all in black. From their shouting, Ch'oe knew they were Chinese, so he ordered his subordinate to write a message in Chinese characters, which educated Koreans could read and write, identifying him as a Korean official and asking where they were. The Chinese replied that they were within the jurisdiction of Ningbo prefecture (south of Shanghai) in a land they called the Tang Great State. The Tang had collapsed six centuries earlier, yet that was the name that people here used.

While the Koreans looked for moorage for the night, another Chinese boat came up. Their head identified himself as Big Lin of the Tang Great State. Lin suggested that under good sailing conditions, they should be able to reach Korea in two days. After Ch'oe explained

that their ship could withstand that voyage, Lin suggested they go ashore under his escort – and that they hand over their valuables for his safe keeping. Having no valuables, Ch'oe gave Lin some rice instead, then followed his ship to the lea of an island to get out of the wind. During the second watch of the night, two dozen armed men with Big Lin at the head swarmed aboard the ship to seize anything of value they could lay their hands on. Ch'oe was stripped naked, beaten and nearly decapitated, though once it was clear the Koreans had nothing worth stealing, Lin and his gang abandoned the ship. As they did so, they cut all the ropes and threw them into the sea to make sure that this ship went nowhere.

At dawn four days later, the Korean ship was approached again, this time by six boats. They held up a piece of paper: 'We see you are "people of another type",' it read, using an ancient expression for foreigners. 'Where do you come from?' Ch'oe answered, also by writing, 'I am a minister of the Korean court. I had undertaken a tour of inspection to an island in the king's service and was hurrying back across the sea into mourning when I was blown here by the wind. I do not know this sea or to what country this land belongs.' Their answer, like Big Lin's, was that this was the Tang Great State, only now the Koreans were in the waters off Taizhou, the prefecture to the south of Ningbo: wrong direction. The Chinese suggested that he give them some pepper, a common tribute gift brought by envoys from South-East Asia in such quantity that it served as a sort of reserve currency in the early Ming – and something that pirates knew to ask for. Ch'oe explained to them that Korea did not produce pepper. They withdrew, but returned the following morning to scrounge for whatever they could lay their hands on. They also insisted Ch'oe should come ashore with them.

Were they fishermen trying to make what they could of this wind-fall, or pirates ready to drown them at the first opportunity? Ch'oe could not decide. He did realise, though, that a rash act on their part could have serious consequences later. 'We shall be falsely accused of being pirates', he told his subordinates. 'Our language, moreover, is different, so that it will be hard for us to argue our case. We might all be executed by coastguards.' Ch'oe came up with a plan. He asked the Chinese to let them eat a meal and recover; then he would go

with them. The Chinese withdrew some distance and retreated into their cabins to get out of the rain, at which point Ch'oe and his men slipped ashore and fled undetected into the wooded hills. It turned out to be the right move, because Ch'oe later learned that these men were indeed coastguards, and were trying to manoeuvre them ashore so that they could decapitate them and submit their heads as a proof that they had killed Japanese pirates – and as tokens for rewards.

At the first village the Koreans reached, the people poured out of their homes and formed a wall, staring at them. After folding his hands in greeting, Ch'oe took out a pen and explained that they were Koreans. The villagers wanted to know whether they were pirates, tribute envoys or simply castaways. Castaways, he answered. At first the villagers agreed to let them stay in a Buddhist temple outside the village, but then they changed their minds and ordered them to leave. Trudging through the night, they received the same reception every time. Driven on from one hamlet to the next, the following morning the party reached a village large enough to have a military officer. They reported to him, and at that point could begin the long procedure of being processed as what we would call illegal aliens, passed up from one level in the state bureaucracy to the next until they reached the provincial capital city of Hangzhou and received clearance to proceed under guard to Beijing for repatriation to Korea.

Koreans and Confucians

The Korean Peninsula extends over 600 miles south into what Chinese call the East China Sea. The peninsula's entire west coast faces China. The relationship between the two countries has always been unequal and therefore tense. China has taken the superior position in all matters, and Korea has had to work out what policies to adopt to keep China content and at a distance. Time and again, rulers on the continent sought to take over Korea, though Khubilai Khan was the only one to succeed.

The founder of the Ming chose not to force Kŏryo, the dynasty reigning in Korea at the time he came to the throne, to remain within his Great State, and frankly lacked the means to do so. He opted for the less expensive mechanism of demanding that it submit tribute to his dynasty. Kŏryo made efforts to demonstrate obedience, though

minor disputes over their mutual boundary marred the relationship. In 1392, partly to resolve internal disputes over how to deal with the new Ming state, General Yi Sŏnggye overthrew the king of Kŏryo. To keep China out of this coup, the very next day Yi sent a delegation to Nanjing to report the change in regime and ask Emperor Hongwu to choose a new name for his dynasty. Hongwu decided to accept Yi's takeover – there was little else he could do without invading Korea – and replied by choosing Chosŏn, the name the dynasty would use until it dissolved itself and founded its own Great State in 1897. Three years later, when the Ming founder named the states that his descendants were forbidden from invading, he put Korea on the list. The new relationship having settled, General Yi, now king of Chosŏn, adopted the pose of the model tributary, sending envoys on every conceivable occasion to make sure that the Ming had no complaints against him.

In those early years when Nanjing was the capital, Korean envoys travelled by ship to present tribute. The painting at the head of this chapter, now in the National Museum of Korea, depicts the departure of just such an envoy from Nanjing (see Plate 9). The title pasted across the top, *Sending the Envoy to Heaven's Court Home to his Country*, explains the scene. Gathered on the shore outside East of the River Gate in the outer wall of Nanjing are eight Chinese officials. Their robes identify their status. Two officials are dressed in red, the colour for those in the top ranks of the civil bureaucracy. Next in status come the three in blue, and after them the three in green. Three servants stand behind them, carrying gifts. A Korean envoy faces them on the prow of a ship, waiting for the tide to turn. The ship is probably one of the so-called 'investiture ships' built right there at the Longjiang Shipyard in Nanjing, where some of Zheng He's vessels were also constructed. The ship flies pennants in red and blue, colours traditionally used on Korean flags.

The depiction of the Chosŏn–Ming relationship is positive and generous. The officials on both sides are drawn the same size and positioned on roughly the same vertical level. This is a scene of mutual recognition and appreciation, not a staging of Korean inferiority, as it might have been. Given that the tomb of the imperial founder, Emperor Hongwu, appears squeezed in to the right of the city, and that the capital was moved to Beijing in 1420, we can date the painting

to the 1410s. The eye for local detail – this really is the finest cityscape of Nanjing from this period – suggests to me that the artist who painted it lived in Nanjing and was Chinese, or if not, was someone who was copying what a Nanjing painter had painted. It is not a fine work of art. My guess is that it was a conventional farewell gift for the man on the ship, the sort of gift that every envoy was given to take home to remind him of his journey and to give people in Korea a glimpse of Ming prosperity. Might the scroll wrapped in silk that the third servant carries be this very painting?

After the capital was officially moved to Beijing, foreign envoys travelled there rather than to Nanjing to submit tribute to the emperor. For Koreans, that meant abandoning the sea voyage in 1420 for the overland horse road via Pyongyang and the north-eastern Ming region of Liaodong. Curiously, the villagers who demanded to know who Ch'oe was suggested that one of his answers could be that he was a tributary envoy. They appear to have assumed that Korean envoys were still sailing to Nanjing. The maritime tribute route to Nanjing had been abandoned sixty-eight years earlier, yet local under-standings of how the world is disposed died hard.

Ch'oe did not get to act out the scene of easy amity that the scroll depicts. His was a harder experience. We know this because once he returned from China, he was required to submit a travel diary to the king. Every Korean envoy did this in support of Korea's effort to col-lect intelligence about conditions in their nearest and largest neigh-bour. Fortunately for us, Ch'oe was a loquacious author with an eye for details that no Chinese writer would have bothered to mention. His travel diary is the best account by far of what it was like to live in Ming China in 1488. It is also a marvellous document for understand-ing the identity predicament that Koreans faced as Confucians in the land of Confucius. Ch'oe knew that he could not expect the same greeting and send-off as the man in the painting, yet he believed that his high commitment to Confucian ideals should have bought him some slack.

Ch'oe was the strictest of Confucians in his private life, and would not have washed up on the coast of China had he been otherwise. An official of the Chosŏn court, he had been on assignment on the island of Cheju, the large island off Korea's south coast, to inspect the

tax records (local landowners were suspected of enslaving people and removing them from the registers) when news reached him that his father had died. The death of a father was the greatest crisis of the Confucian life cycle, and Ch'oe treated it that way. The father–son relationship was regarded not only as the backbone of the family but as the foundation on which the ruler–subject relationship was modelled. The Confucian rule was that the son should drop everything, return home and go into mourning, ideally by wearing sackcloth and living in a hut by his father's grave for twenty-seven months. Before he set off, Ch'oe was warned that a storm was blowing up, but his compulsion to observe mourning was so powerful that he set sail regardless and ended up drifting to China as a result.

Once in China, he wanted Chinese to know that he, not so much as an individual but as a Korean, was as Confucian as they could ever be. For him, his Confucian identity should have earned him a position of equality with members of the Ming elite. This perspective was not his alone. It was something that shaped Korea's strategy in its unequal relationship with China. Chosŏn Korea was the little country; Ming China was the great country. The only way for the inferior to manage such a hugely unequal relationship, psychologically as well as strategically, was to be seen to meet standards that matched whatever the superior set, even exceed it. Chosŏn had to be as Confucian as the Ming, and Ch'oe had to be more Confucian than every Chinese he met.

And he met a lot of Chinese as he made his way north to Beijing, people of every status who were curious to talk to a Korean foreigner. Most had never seen a foreigner before, let alone had the chance to converse with one through writing. Many were puzzled to discover that Ch'oe could not speak Chinese but could read it. 'Why', one local scholar asked at one of the inns where he and his companions were put up, 'when your books have the same writing as those of China, is your speech not the same?' It was a sensible question. There was no reason a person of the Ming should know that Koreans had been literate in Chinese for centuries, not just to read Chinese classics but also to write their own language. It so happens that four decades before Ch'oe arrived in China, the king had ordered his officials to invent an alphabet, now known as Hangul, better suited to the language and

easier to learn, but the educated elite continued to write in Chinese characters.

Ch'oe answered the man by quoting an old Chinese saying to the effect that the same wind does not blow across three hundred miles and the same customs do not obtain across thirty. 'If you wonder at the sound of my words, I wonder at yours. It is simply a matter of custom.' Rather than treat the Korean use of Chinese as something that could be explained historically, Ch'oe was eager to relegate the language difference between Korea and China to insignificance. What mattered was how civilised a foreign culture was, not how different its language. Ch'oe wanted his interlocutor to look for commonality rather than difference. 'If we share the nature that Heaven has given us, then my nature is the nature of Confucius. How can anyone object to a difference in speech?'

The charge he had to fend off most often was the suspicion that he and his men were Japanese pirates, notorious for raiding up and down the coast. In one of the early interrogations, one officer tried to catch Ch'oe out on just this point.

'Why have you Japanese come here to raid?' he suddenly asked.

'I am Korean', Ch'oe countered. 'My language is different from Japanese, and my hat and gown are of a different style. By these things you can tell us apart.'

'Clever Japanese have been known to pose as Koreans', the officer came back. 'How do we know you aren't a Japanese of that sort?'

'If you examine my documents, you will be able to tell that they are not fake.'

'But you could be Japanese who robbed Koreans to get these things.'

'If you doubt me in the slightest, order that I be sent to Beijing. One word with a Korean interpreter and the truth will be apparent.' His comment reveals that no one along this coast could speak any Korean.

The next day, a less suspicious official wanted to hear more about Korea, and asked whether Korea was ruled by an emperor, as the Ming was. Ch'oe answered with an old saying: 'In Heaven there are not two suns. How, under the same sun, can there be two emperors?' Inequality between the two rulers was the only way for Korea to survive as

an independent state next door to China. 'My king's one purpose is to serve your country devotedly', he went on to say, using the standard language of *sadae*, 'serving the Great'.

This interrogation over, others at the guesthouse then crowded around Ch'oe with their own questions. Someone supplied paper for the purpose, but Ch'oe was soon overwhelmed, at which point one of the officials passed him a note saying, 'These people are a bad lot. Do not talk with them.' Although the official view was that curiosity about the outside world should be discouraged, ordinary people were enthralled to find themselves face to face with an outsider and wanted to hear what he could tell them. When Ch'oe turned the tables and asked his own questions, though, they tended to clam up lest they be accused of passing information to a foreign spy.

If anyone was trying to pry official secrets out of anyone, it was the interrogating officials trying to get information out of Ch'oe. One deputy commander pressed him to reveal the Korean king's personal name, which no one was permitted to say or write. This would have been tantamount to revealing a Korean state secret, and Ch'oe refused.

'How can a subject speak loosely to anyone the taboo name of the ruler of his country?' Ch'oe replied.

'It does no harm when you are beyond the borders', the deputy commander suggested. This was the perfect moment to show the king, for whom he wrote the diary, that he knew where his loyalty lay and how to act accordingly.

'Am I not a Korean subject?' Ch'oe retorted with all the indignation of a loyal Confucian minister. 'Being in service, can I, by crossing the border, simply turn my back on my country and change my actions and words? That is not who I am.'

Confucius and the Emperor
The pressure to meet Ming requirements increased as Ch'oe Pu journeyed north up the Grand Canal and got closer to Beijing. Fu Rong, the officer assigned to transport him to the capital, explained that the constant line of boats from the ministries of War, Justice and Personnel passing them in the other direction were conveying cashiered officials appointed under the previous reign. Emperor Hongzhi was

demanding a level of efficiency that his father had allowed to go slack. Fu told Ch'oe that some of the officials involved in handling his party of Korean castaways had already been downgraded for being too slow in getting to the capital to report on the case.

Ch'oe declared this to be a laudable thing. 'The emperor elevates the good and dismisses the wicked', he concluded. 'The court is calm and all within the four seas is stable. Should we not give praise?'

'Quite so', Fu responded, then proceeded to tell Ch'oe that he had heard that Emperor Hongzhi had personally conducted a rite to Confucius at the National Academy just twelve days earlier. He shared this fact as yet another indication that the new emperor was determined to renovate the realm. Here Ch'oe made a curious move. From an absolute Confucian perspective, it was right that the emperor should abase himself before Confucius. From a statist perspective, however, Confucius's status relative to the emperor was clear: the emperor might honour Confucius, but he was his ritual superior. To my surprise, and possibly to Fu Rong's, Ch'oe tried on the latter position – and made the only joke in the diary.

'Does the emperor bow to the subject of a feudal state?'

The comment was a touch aggressive, and Fu pushed back. 'Confucius was the teacher for all time. How could His Majesty treat him like a mere subject?' He then explained the elaborate choreography that had been devised to manage the problem. At the point at which the emperor was expected to bow to Confucius, the chief officiant announced, 'His Majesty will bow'. As the emperor prepared to make his obeisances, a second officiant announced, 'Confucius was a criminal court judge of the state of Lu'. Acknowledging that Confucius's official post was inferior to the emperor, the first officiant then called out, 'His Majesty is excused from bowing'. As Fu explained to Ch'oe, 'the ceremony thereby honours Confucius and the Son of Heaven without slighting either'. Ch'oe was blunt enough to declare to Fu that this compromise was demeaning to Confucius, who should always be placed above the emperor. The comment must have put Fu in an awkward position, though Ch'oe gives no indication that he realised the embarrassment he caused his host, other than to note that Fu simply fell silent.

A week later, Ch'oe was put up at the official hostel for tribute

missions in Beijing. It was a busy place, with foreign envoys coming and going and Chinese wholesalers dropping in to make deals quickly enough to meet the five-day limit on emissary trade. Several days passed before the Chinese interpreter assigned to him, Li Xiang, called to give him an update on his case. When news of the shipwreck had reached the capital, Li had passed it on to a Korean envoy visiting Beijing, who immediately returned to Korea to inform Ch'oe's family that he had not been lost at sea. Ch'oe learned from Li eight days later that he could not depart until the king of Korea had sent a memorial to Emperor Hongzhi to thank him for rescuing his envoy. 'My coming here has nothing to do with affairs of state', Ch'oe complained in frustration. 'If I am returned home through the profound kindness of your Great State, I shall look up to Heaven and join my hands in prayer. I desire only to weep beside my father's coffin and hold vigil at his grave. That is what grieves me.' This was of no account to the emperor. Mourning a parent was an honourable and necessary thing to do, but it did not outweigh the correct observance of foreign relations protocol. Ch'oe's complaint is of a piece with his insistence that Confucianism expressed a universal standard that stood above the state, which rests at the core of his argument that *hua*-versus-*yi* was not a meaningful distinction between Confucians, and that Koreans, who out-Confucianed the Chinese, were just as civilised as they were.

Ch'oe had no choice but to loiter, passing the days chatting with curious Chinese who dropped by, some of whom spoke Korean. After five days, a member of the imperial bodyguard reported some trouble with his file in the Ministry of Rites. Ch'oe reiterated his complaint that his presence in China had nothing to do with state affairs, and that his obligation to mourn his father should take precedence. The procedural logjam was cleared two days later, when the ministry summoned him and told him he must appear before the emperor to give thanks. He and his party were presented with court robes for that occasion. The new robes caused another round of contention. Ch'oe insisted that his mourning status prohibited him from wearing the robe he had been given. Li was already a step ahead of his excuse.

'I discussed that today with His Excellency the Minister of Rites. For the present moment, mourning for a parent will be deemed less important than Heaven's grace', meaning an audience with the

emperor. Li returned early the following morning, 30 May 1488, to make sure Ch'oe was properly dressed for the imperial audience. He wasn't. His Confucian obligation to appear in dress appropriate to his status as a mourner prevailed over every other obligation.

Li repeated the minister's plea for him to adopt a more practical attitude to his situation. 'If you were beside the coffin, your father would be most important. Right now you are here; know only that here is the emperor.' Li noted that Ming protocol included a provision for changing out of mourning clothes temporarily to greet the emperor. 'Imperial grace must be acknowledged, but to acknowledge it, one must enter the palace, and to enter the palace, one may not wear sackcloth. It is like touching your sister-in-law's hand to save her from drowning', which was something a Confucian gentleman should never do, except in an extreme situation. 'Bow to circumstance' was his advice. Even Confucians could sometimes be permitted to adopt situational ethics.

Ch'oe held out until they reached the palace gate. Knowing who would be punished for this breach of protocol, Li grabbed Ch'oe's hat and stuck the gauze one on his head. Only after the gate was unlocked and officials started to file in between the elephants on parade did Ch'oe agree to change robes. He would play the part of more-Confucian-than-thou until the very moment when it could cause an international incident. The Koreans walked in and took their assigned position in the courtyard. They did their fifteen kowtows of thanks towards the emperor's reception hall (the emperor sat inside and was not visible to them), then filed out through a side gate, where Ch'oe changed back into his mourning clothes.

That duty fulfilled, the Koreans were cleared for repatriation. The military officer assigned to escort them home arrived the following day with his commission from the Ministry of War. Ch'oe must have been dismayed by the language of the order: 'This concerns the management of the return to their country of barbarians [yi] who ran into contrary winds.' He and his party, it seems, were still yi, despite every attempt to move themselves into the realm of hua. However much they might act to emulate the status of hua, the Koreans were for ever yi. Ch'oe finally admitted as much in his diary when he described their stay in Beijing as virtual house arrest, as indeed it was, for Ming

regulations allowed Koreans out only once every five days. 'Because the court regarded us as barbarians who had drifted across the sea, the porters who kept the gate at the guest house were ordered not to let us leave the house on our own if we had not received a clearly written authorisation or summons from a superior official, and not to let brokers or vagrants into the house to hobnob with us.' All unsupervised contact was forbidden so as to keep *hua* and *yi* apart.

The party left Beijing the following day, 4 June 1488, and began the journey overland that would convey them to Korea. The days passed less eventfully now that Ch'oe's party looked like just one more mission from Korea.

Ten days short of the border, Ch'oe had a curious conversation with a Buddhist monk, Jiemian, whose Korean grandfather had fled to the area. Jiemian explained that the region had been part of the Koguryŏ dynasty a millennium previously. China had since taken it over, yet the old customs of Koguryŏ survived. Others of his grandfather's generation had come to the area to live, but their border community felt trapped by their trans-frontier identity. 'We sacrifice regularly and do not forget our origins', Jiemian assured Ch'oe, but having crossed west into China they were unable to go back. 'Many are afraid that our country will consider us Chinese and send us back to China. Then we should be charged with having fled and lose our heads. Our hearts want to go, but our feet hesitate.'

Jiemian was among a group caught by exclusionary policies on both sides of the border. The Chosŏn side rejected Koreans who had become Chinese, and the Ming side rejected anyone, Chinese or not, who went abroad and wanted to return. We tend to associate exclusive national identities with the world of modern nationalism, but even in the fifteenth century it was possible to become stateless. Furthermore, for those who were subjects of rulers rather than citizens of a state, it was not possible to cut the bond of the subject to the ruler. Statelessness was not just a condition but a crime. To make matters worse for Jiemian, the newly enthroned emperor had ordered residents of recently built monasteries who lacked proper credentials to return to lay life. This man was one of these, both stateless and defrocked.

Ch'oe offered Jiemian neither solution nor solace. In his

fundamentalist version of Confucianism, Buddhist monks were para-sites on society, and their prayers for the longevity of the emperor were a profligate waste of resources that only enriched the parasites at the expense of the common people who laboured honestly in the fields. Put them all in the army, he said to Jiemian, where they could be of more use than they were in the monastery. Once again Ch'oe chose to shame a stranger he met on the road, this time a Korean stranger, so that he could display the moral superiority he thought should make him an equal of the Chinese.

As soon as he reached Korea, he went straight into the mourning that his accidental travels had delayed. He returned to his king's ser-vice in 1492. Fourteen years, two purges and one king later, Ch'oe Pu was executed for being on the wrong side of the faction closest to the king. Morality did not transcend politics after all.

Confucian Isolationism

Ch'oe Pu's Confucianism was of one sort: adherence to an inflexible code of ethics that bound the individual to his family and to his ruler. An understanding of Confucius of another sort can be found at this time in the writings of Qiu Jun (pronounced 'chyoh joon'). Qiu was a native of Hainan Island, as far south as you could go and still be a subject of the Ming. His near-photographic memory proved a useful skill in an education system based in part on the ability to memo-rise classical texts, yet he did not start studying for the civil service exams until he was sixteen, which was late. Eight years later, Qiu not only passed the provincial exams in Canton but was awarded the top rank in the province. He went to Beijing four times to sit the national exams before he finally passed at the age of thirty-six, ranking first in the second echelon of successful graduates. Word was that he could have made the first echelon had he not looked so dishevelled. He never reformed that aspect of his personality, living in a wreck of a house in Beijing and never bothering to master the proper Mandarin pronunciation officials were supposed to speak.

Too unkempt to be appointed to public office as a local magis-trate but too brilliant to waste in a minor administrative post, Qiu was assigned to the Hanlin Academy, the emperor's think-tank, then later moved to the National Academy as its chancellor. The commitment

that Qiu took with him to the Academy, and instilled in a genera-
tion of students, was a commitment to finding practical solutions to
the problems that troubled the realm and burdened the people. Qiu
Jun was quite as much a Confucian as Ch'oe Pu, but of an entirely
practice-oriented sort. For him, the true Confucian 'brought order to
the realm and stability to All under Heaven', to quote his favourite line
from an ancient Confucian text known as *The Great Learning*. Look-
ing outward was of far more value to everyone than looking within.
To put flesh on the bones of this ideal, Qiu organised a large-scale
research project to produce a master reference work on state policy
based on a thorough historical review of every known text. The work
that came out of this project was massive, running to 160 chapters. He
called it *A Supplement to Elaborations on the 'Great Learning'*. In essence,
it was a policy encyclopaedia for the emperor. This ambition was
admirable, but it entailed the problem of finding an emperor willing
to read it. Emperor Chenghua, under whom Qiu started the project,
was not particularly interested. But when he died in 1487 and his son
took over, Qiu suddenly had the emperor he needed.

Shortly after Emperor Hongzhi ascended the throne, Qiu pre-
sented him with his great work. Hongzhi was impressed. He autho-
rised the book for publication (it appeared the following year) and
appointed Qiu to the rank of Minister of Rites. It was an outcome
that Qiu had not particularly wanted, and a success from which he
could never escape. Shortly after receiving this singular honour, Qiu
begged for permission to retire. Hongzhi responded by elevating him
to the post of Grand Secretary, the highest post in the land. Qiu never
did get to retire and go home to Hainan Island: he died in office at the
age of seventy-five.

Foreign relations are one of the many topics that Qiu addresses
in the *Supplement*. To capture the essence of his policy preferences, I
have taken advantage of the book's structure. The book implies the
emperor as the reader with whom Qiu is in conversation. On top of
that, every topic is structured in such a way that commentaries are
laid on top of commentaries, creating a sort of virtual conversation
between Qiu and past experts. This organisation has allowed me to
transform the proposition-and-response format of the book into a
plausible conversation between the earnest new ruler and his elderly

adviser. Every quotation in the conversation that follows comes verbatim from the *Supplement*. Had Qiu and Hongzhi ever had an actual conversation on foreign policy, it would have gone something like this:

'From the time of the sage-rulers of antiquity, foreigners have stayed beyond the pale and defended themselves beyond perilous passes', Qiu explained to the emperor. 'No words can make them see reason or tame them. The only way to control them is with military force. Laws and punishments alone will not do. The way to achieve peace within the realm and beyond is to maintain high security along the border and intimidate them with force so that they do not bring disorder to China.'

'Have any of Our predecessors on the throne set a good example?' the emperor wondered.

'Earlier rulers have often been ignorant of how important it is to maintain a strict distinction between *hua* and *yi*. Some absorbed themselves in domestic affairs and paid no heed to what lay beyond the border. Others busied themselves with foreign affairs and ignored what was happening at home. And some did neither. All three positions are wrong.'

'So what should We do? We cannot simply ignore the outside world. Our authority as Son of Heaven should spread beyond the borders and transform the barbarians into civilised people. Isn't that Our role, to transform them?'

'Yes, but the sages understood that the oceans and deserts were there to ensure that foreigners remained beyond the range of interference. Never did the sages incorporate or survey their land, appoint their people to posts or try to administer these areas as if they were part of the interior. There exists a paramount boundary within Heaven and Earth: Chinese on this side, foreigners on the other. The only way to set the world in order is to respect this boundary.'

'Has Our dynasty reached the outer edge of the portion of All under Heaven that is Ours by right to rule?'

'In your minister's humble opinion, to the east and south, the sea has already set an outer limit, and there is no further to go. Although there is no sea to the west or north, mountain ranges and desolate land mark the limits, which inhospitable climates and the ferocity of their inhabitants only reinforce. These are not areas where people

should live. Possessing them would make no difference to China. Instead, hold dear the civilised land of our China and treat the rest as nothing but rubble.'

'Couldn't we rely on Our military superiority to bring these regions under Our command?'

'Your Majesty's capacity to mobilise military power already inspires foreigners with awe and obliges them to submit', Qiu replied. In his view there was nothing further to be done on that score. The emperor should confine his activism to 'the territory of the *hua* and have nothing whatsoever to do with the deserted wastes of the *yi*'.

'What about foreigners who cross the border to submit to Us?'

'That depends on why they come. If they are impoverished, we would not live up to our reputation for benevolence if we turned them away. If it is because they admire our conduct, we would not be a people of righteousness if we did not accept them.'

'What about foreigners who have been in the realm for generations?' the emperor wondered.

'History has shown that those whose forebears submitted to us generations ago out of admiration for our culture were transformed by the refined practices of this country. They have no desire to align themselves with outside forces and cause havoc within.' But Qiu was not easy about those of foreign origin. 'Should the realm slide into chaos, they might not be able to resist taking advantage of opportunities and seizing control of the dominion. Even when peace has been long, one must not become lax and not plan for the future.'

'Should We then drive all foreigners out of the realm?'

'Not those who were born and raised in the land of China. They have become people of China and have forgotten that they were once foreign. To mark them now as foreign would only unsettle them. Nor should we restrict them to their own communities, or limit the positions available to them, or require them to rule their own kind. Nor should we move them to the frontier or make them serve as envoys to their home countries.' Qiu's hope was for assimilation, though he is not quite ready to trust this process and wants size limits set. 'In a prefecture, no more than a hundred *yi* should be allowed to live together, and then no more than ten per county. That way we can break them down and transform them gradually without their even knowing it.'

This was indeed the climate that our shipwrecked Ch'oe Pu found around him in China. However well Koreans might perform as Confucians, the *hua–yi* distinction was fundamental. 'The greatest divide within Heaven and Earth is between *hua* and *yi*', as Qiu phrased it for Emperor Hongzhi. 'Chinese occupy the middle, foreigners the outside, and mountains and chasms divide them. So there is complete separation between those within and those without. This is how we will defend our China for ten thousand generations. Why would anyone choose to allow outsiders to come into the heart of our territory?' No more Great State adventures into foreign territory; no more mixing of Chinese and foreigners. Qiu's basic advice on foreign policy for the emperor was that he just leave the barbarians alone. 'When the monarch behaves appropriately and cautiously in the palace, in the court, and in the capital, then nothing need be done about the barbarians in the four directions.'

Qiu Jun was as much of a Confucian fundamentalist as Ch'oe Pu. It is just that he drew the boundary not between Confucians and non-Confucians but between Chinese and non-Chinese, and that put Ch'oe on the wrong side of the line. Despite this boundary-drawing, Qiu was more lenient when the subject of Korea came up. Unlike pretty much every other tributary state with which the Ming emperors had to deal, he declared, at least 'Chosŏn is compliant and obedient'. And for their part, this was exactly the message that the Koreans wanted China to get. The obedient are left alone.

Horses and Earthworks

Qiu Jun would not have called himself xenophobic, had that word been available to him. Xenophobia is an irrational fear of foreigners. By his own lights, Qiu was entirely rational in advising his emperor to keep foreigners at a distance, but to get to that rationality we need to think about horses.

The Ming was a state that used horses extensively but was not hugely successful at producing them. Horse-raising was part of the tax burden on farming households in north China, but the quality of the horses was poor and the cost of buying fodder often drove farmers to bankruptcy. If you wanted better horses, you bought them from the peoples north of the Great Wall, most especially the Mongols,

who knew horses better than anyone. On the other hand, the enmity between the Mongols and the Chinese, whom they had once ruled, was the very reason the Ming needed horses, to keep the nomads from crossing the Great Wall and coming back to seize what had been theirs.

Koreans were not the horsemen that Mongols were, but they did know how to raise them, and so Emperor Yongle turned to Korea for horses. In his first year as emperor, Yongle commanded the king of Chosŏn to send him a thousand horses annually. Four years later, he increased the number to three thousand. (Yongle also demanded shipments of hundreds of Korean virgins for his harem, but in the hundreds, not the thousands.) Over the next two decades, from 1407 to 1427, Chosŏn sent the Ming a total of 18,000 horses.

But Korean supply could never match Chinese demand. The Ming had no choice but also to acquire horses in large numbers from the Mongols – that is, when it wasn't actually at war with them. A year after first imposing a horse tribute on Korea, Yongle found he had no choice but to open periodic horse markets with Mongols at several locations along the border, including Xanadu. He later set a triennial quota of 14,000 horses. The trade was dressed as tribute from obedient Mongol princes, but in fact it was simply purchasing, though prices were set at a fixed rate, usually denominated in bolts of silk, for which Mongol demand was high.

Fiscal retrenchment in the Ming eventually ended the open horse markets with the Mongols, just as it eventually shut down the Zheng He expeditions into the maritime world. That left the tribute system as the only mechanism that the Ming could work to get its horses. It also provided the Mongols with the only forum in which to buy tea and textiles without resorting to smuggling or pillage, which was why the Mongols were more or less willing to go along with the arrangement. Politics controlled the exchange, but the terms of exchange could provoke a political and even military response. In 1448, the Ming court judged the prices the Mongols were charging for their tribute horses to be exorbitant, and so refused to accept the tribute mission bringing the horses. That meant no horses for the Ming, but more to the point, it meant no horse sales for the Mongols. This was not a good time to alienate this trading partner, as one of the leaders on

the steppe, Esen, was managing to bring much of the Mongol world under his unified command. Esen saw this as a *cause de guerre*, and a moment to strike.

The emperor at the time, twenty-one-year-old Zhengtong, was eager to gain for himself a military reputation to match that of his greatest ancestors, Hongwu and Yongle. His advisers had no difficulty convincing him that he should lead a great offensive campaign against Esen. So he led a massive army north through the Gate of the Prime Meridian following the route to Xanadu, which by this time lay deep in Mongol territory. The plan was for the imperial army to launch itself out onto the steppe from the border city of Datong. But in the end, the army never left Ming territory. Zhengtong's advisers realised that they had underestimated the strength of Esen's forces north of the Great Wall and decided it was dangerous to continue. They claimed to the populace that the emperor's foray to Datong had been a victory, and then sent him heading back to Beijing. When the retreating army was forty miles short of the Gate of the Prime Meridian, Esen's cavalry caught up with them at a courier station called Tumu (meaning 'Earthworks') at the beginning of September 1449. The Mongols slaughtered half the army, possibly as many as a quarter of a million men. Even more shocking, at least politically, was that they took the emperor hostage.

Esen might have pressed his advantage, but the Ming court acted quickly by installing another emperor, effectively neutralising Zhengtong's value as a hostage. Esen's ambitions were in any case directed more towards his Mongol rivals than towards the Ming. After a year, Esen saw no option but simply to return his useless hostage. Four years later, he was assassinated for daring to claim the title of Great Khan of the Yuan Great State for himself. Only a Chinggisid, someone who had descended from Chinggis Khan, could do that. Esen was not one of the family.

It is impossible to exaggerate the shock of this defeat on the Ming. Earthworks by Hongzhi's time was already forty years in the past, but Zhengtong had been his grandfather, and Hongzhi did not wish to repeat his mistakes. The history of the dynasty came to be understood as what came before Earthworks and what came after. The lesson of Earthworks was that emperors should be kept off the battlefield, and

foreigners kept as far distant as possible. The only sensible foreign policy for the Ming was to withdraw inside China's borders and stay there. Earthworks killed off the last lingering aspiration that the Ming be truly a Great State. Relations with the Mongols were suspended for two decades. As that move cut off its supply of horses, the Ming turned back to Korea. Chosŏn immediately and dutifully sent two thousand mounts.

An Everyday Foreigner

Envoys and shipwrecked officials were not the only Koreans who made their way into China in 1488. So too, it seems, did Korean horse dealers. We are on thin ice here, as no documents about private Korean traders, let alone horse dealers, crossing the Ming–Chosŏn border have ever been found, with one curious exception: a Chinese language textbook for Koreans known as *Lao Khita*. The title recalls the name that Mongols first used for northern Chinese, Khitat, their having once been subjects of the Khitan Great State. (The Mongols later switched to calling them Han, the term we use today for Han Chinese.) *Lao* means 'old' but is also used as a term of endearment among friends, even today. We could translate *Lao Khita* as *The Old Khitan*, but we get closer to the orginal intention with something like *My Khitan Buddy*, with 'Khitan' standing in for 'Chinese'.

Unlike most textbooks that present short, disconnected passages for the student to learn, *My Khitan Buddy* uses two main speaking characters whose adventures the student follows from the beginning of the book to the end. The central character is a Korean, whose name we never learn. He knows some Chinese and learns more as he travels through north China. And he is in the business of trading horses. The other main character is his eponymous Chinese buddy, surnamed Wang. The horse trader and his Chinese friend are merely characters in a textbook, not real people, but behind the colloquial conversations that make up most of the book I like to think that we can hear the voices of real people. This is what gave the textbook its lasting appeal. First composed during the Mongol era in the thirteenth century, it was rewritten in the fifteenth. In 1485, just three years before Ch'oe Pu went ashore, an instructor at the Korean court proposed to the king that *My Khitan Buddy* be adopted as an official textbook, but

he was shouted down by the elite, who prized literary Chinese and regarded the book as low-class. The result of the proposal, which I suspect reflected the appearance of a new, updated edition in the early 1480s, was that the court banned its official interpreters from using it. But everyone did.

So neither Wang nor the Korean horse trader was real, yet to my ear their dialogue allows us to listen in on real conversations, otherwise beyond recovery, that reflected how ordinary Koreans in the 1480s spoke and thought about Chinese. This is a chance to take notice of the people who lived far below the stratosphere in which Ch'oe Pu and his friends moved. Think of *My Khitan Buddy* as a bootleg recording.

The set-up of the book is this: Wang meets his future Korean friend on his trek to Beijing to sell a string of horses at the big horse market inside the south-west gate of the city. He had started out in the city of Liaodong, which meant a journey of five hundred miles. They fall in with each other just after both have passed through the Gate of the Mountains and Seas not quite half-way between home and the horse market. (Ch'oe passed through the same gate going in the opposite direction on his way home to his father's funeral.) The Korean is one of a party of four leading a string of horses. Wang opens the conversation by asking the Korean where he is coming from (Seoul), where is he going to (Beijing) and how long it has taken (over half a month). Then he gets down to the perennial question that Chinese ask foreigners who can speak Chinese: how they managed to learn the language. The Korean says he studied it at school for half a year.

'But you are Korean. Why would you want to learn Chinese?' Wang asks.

'Everyone has his own reason for doing something', the Korean replies.

'Tell me yours. I'm listening.'

'Look', the Korean replies. 'The court in Beijing rules All under Heaven as one, so everyone uses Chinese. Korean is only spoken in Korea. Once you're past the border, you're among Chinese and hear nothing but Chinese. Should someone ask me something and I can't reply, he will wonder what kind of idiot I am.' Ch'oe Pu would have agreed. Twice in his diary he compares not knowing Chinese in China

to being a deaf mute. The horse trader then admits that he started learning Chinese because his parents had made him. They thought it was a skill he would need to get ahead. The fact that the teacher in the school he went to was Chinese, and that half the students in his class were Chinese, suggests that this happened in the border region, though on which side of the Ming–Chosŏn border is never spelled out.

'How were the Chinese students?' Wang asks. 'Any bad boys among them?'

'Naturally there were some. Every day the senior boy reported them to the teacher, who beat them, but they weren't afraid of him. The Chinese boys were really badly behaved. The Korean boys were a bit better.' I think we are hearing a Korean point of view here.

The conversation then turns to horses.

'Do you know what price horses fetch in the capital?' the Korean asks.

'Someone I know just came back', Wang says. 'He told me that the prices are good at the moment. A good horse sells for over fifteen ounces of silver. A horse of second quality sells for at least ten.' The Korean is also carrying ginseng and Korean ramie, a fabric made from nettle fibres that Chinese knew as Korean cloth, to sell. After disposing of his horses and other goods, he plans to go down to Shandong province to buy silk, then sail across the Yellow Sea to Korea to sell what he buys. He reckons he can be back in Seoul by November. There he will buy more horses and ramie, and set off at New Year to repeat the cycle.

Reaching Beijing a few days later, Wang finds them an inn near the horse market outside the Gate of Martial Awe, in the south-west corner of the city. This was where the animal dealers from all over the north gathered to buy and sell through the Ming and Qing periods. After they have settled in, the innkeeper makes an approach.

'You want to sell those horses?" he asks.

'Of course', says the Korean.

'Then there's no need for you to go to the market. Just leave them here at the inn and I'll find you customers who will buy the lot.' The Korean gently puts him off by agreeing to talk about it the next day. After the innkeeper leaves, Wang advises his Korean friend to take his time. 'These horses of ours have been on the road. The journey has

worn them out and they haven't had enough to eat. They're looking a bit lean. If we take them to market now, the dealers won't give us a good price. Let's be generous with the fodder and fatten them for a few days and then see about selling them.'

'Exactly what I was thinking', replies the Korean. 'I need to go out tomorrow anyway to ask around about ginseng and ramie prices. If the prices aren't good, I plan to wait around for a while.' The next day, he and Wang go into the city to check prices. They also drop by Jiqing Shop, which handles business arrangements for Koreans in Beijing and manages postal deliveries to and from Korea. By the time the two men get back to the inn, the innkeeper is already showing their horses to two buyers from Shandong. They have a broker with them, indicating they are ready to sign a contract. The innkeeper suggests they be sold as a lot rather than one by one, and the buyers agree. Before the Korean can reply, one of the buyers, Li Wu, starts going over the horses.

'Can you tell me how old is this black horse?' he asks.

'Just look at its teeth', replies the Korean.

'I have', Li replied, 'and it's missing both upper and lower teeth, which tells me it is quite old.'

'I see you know nothing about telling a horse's age', the Korean shoots back.

Li then stands back and does a quick inventory of the herd. 'This one is blind, this one lame and this one has a crooked hoof. This one has the habit of pawing the ground, this one has a broken back, this one kicks and this one is mangy. These three are emaciated. That leaves only five good horses. How much do you want for the lot?'

'If I had to name a price, I would say 140 ounces of silver.'

'What are you thinking, asking such a price?' splutters Li. 'Just tell me how much you'll sell them for. There is no need to bargain. I'm not joking around. Just say what the price is and we can close the deal without a fuss. But don't open with such an unreasonable price. How can I come back to you with anything?'

At this point, the broker steps in. 'Gentlemen, don't bargain so hard. Both of you are wasting your time, and nothing will come of it. As the broker, I don't side with the buyer or the seller. What I would say is that if you want 140 ounces of silver, could you break that down

between how much is for the five good horses and how much for the ten inferior horses?'

Buyer and seller go another round, and then the dealer steps in again. 'All right! The five good horses are worth eight ounces of silver each, for a total of 40 ounces. The ten inferior horses are worth six ounces each, for a total of 60. That comes to a grand total of 100 ounces of silver. Do we have a deal?'

'You couldn't buy these horses in Korea for that price', moans the Korean. 'How is that an honest price? If I accept the price the broker has set for these horses, I'll be taking a loss.'

'Then what do you want?' A crowd has meanwhile gathered to watch the fun. The broker wades in again with a compromise between the two, at which someone in the crowd pipes up to say that the broker really has come up with a price that is fair.

'All right! All right!' the Korean responds. 'Let's settle the deal, though I tell you, at these prices I am going to take a loss. One more thing: don't try to pay me in low-grade silver. I want good silver.' Wang steps in to assure him Li's silver is of good quality and can be readily exchanged. The broker agrees to write up the contract, register it with the government office and pay the sales tax for the vendor. The Korean fumbles trying to calculate the tax, but finally calculates it as 3.15 ounces. He also has to pay the broker's commission of 3 per cent.

After failing to sell one of his own horses to Li Wu, Wang reminds the Korean that he has ginseng and cloth still to sell, and says he also wants to check the price of sheep, as he is thinking of investing his proceeds in sheep and taking them south to sell. At this point, as the Korean and his Chinese pal amble off to the sheep market, the reader is most of the way through the textbook. We will leave them there.

Friends and Foreigners

The Korean horse trader gets into a few scrapes as he and Wang travel towards Beijing, not because he trades horses but because he is a foreigner. One innkeeper appears in the story to say to Wang, 'These companions of yours don't look like Han Chinese, and they're not Mongols, so how do I know who they are? How do I dare let you all stay here?'

Wang springs to their defence. 'Can't you tell good men from bad? These guys are Koreans. They've just come from Korea. The officials guarding the passes and fords on the Korean side are just as strict as those on ours. Only after checking their documents and interrogating them closely do they let them across.' They may be Koreans, but there are good Koreans, as only the good ones can get across the border.

Wang then turns to the problem over which Ch'oe Pu stumbled, the gap of language. 'They are driving Korean horses to Beijing to sell', he tells the innkeeper. 'They can't speak the language of Han Chinese, so they don't dare say anything.' Wang is in effect asking the innkeeper for the benefit of the doubt. Just because Koreans are foreigners doesn't mean they can't be trusted. If you and they could talk, you would know that. And that is what the textbook promises: the ability to converse in Chinese and so to be understood in China. If the answer is language, the textbook seems to say, then the question of xenophobia vanishes of its own accord.

Of course, it could not be that simple. Earthworks reminded every Chinese of the trouble that foreigners could bring to China. And down along the coast, Japanese piracy fuelled a further level of distrust. Ch'oe and his companions got a taste of this while they were gathered around a fire that had been lit so that they could warm themselves. A man who spotted them and thought they were Japanese pirates burst in and kicked the fire apart in a fury. No foreigners should be afforded any comfort whatsoever. They should either be punished or driven off. The rumour circulating in 1488, that the new emperor had decreed exile as the penalty for divulging information to foreigners, only widened the gap of mistrust. To be fair to Hongzhi, he was concerned about the treatment of foreigners as much as he was about intelligence leaks. When he learned that Beijing residents were shouting insults and throwing things at foreigners they saw on the streets of the capital, he issued an edict ordering his subjects to leave them alone.

Fear of foreigners mattered differently depending on who you were. The horse trader wanted to be treated fairly in his commercial dealings. Ch'oe Pu wanted to be treated respectfully as a fellow Confucian. In a sense, both wanted their hosts to accept them as equals, as foreigners abroad generally do. Both asked the Ming to be a world

wider than perhaps it was. Here is how the two men put it in their own words.

Ch'oe prepared a little speech of farewell to thank a military official who had treated his party courteously: 'Though I am a stranger, and though we have known each other for not even a day, you have shown me your might, treated me generously, and taken leave of me kindly. This shows that you feel that, though my Korea is beyond the sea, yet its clothing and culture being the same as China's, it cannot be considered a foreign [yi] country.' That, at least, is how Ch'oe hoped he and his country were considered, though the directive for his return from the Ministry of Rites did not agree. But Ch'oe was determined that the distinction between hua and yi could be overcome, pitching this plea in the language of the universal Great State. 'Thanks to the unification achieved by the Ming Great State, peoples of the north and south are under one roof. As All under Heaven are my brothers, how can there be discrimination against people because they have come from afar?' Remember me not as a foreigner, he was asking, but as a friend. Live up to the pretension of All under Heaven.

Down among the men who traded horses, life was a little more straightforward and no one was yacking on about Great States. Let me give the Korean horse dealer the last word, his farewell to his pal Wang: 'Elder brother, we are going back. Please forgive me for the trouble I have caused you. You and I are the kind of people who treat all within the four seas as brothers. We have treated each other this way for several months, not once getting angry at each other. As we part now, don't say that we won't see each other again. The day may come when even solitary peaks face each other once again. Should that happen, how could we not be as close as brothers?'

'All under Heaven'. 'All within the four seas.' I would like to think that the man who wrote My Khitan Buddy once had a friend named Wang who treated him just like this. In that spirit, he gave our horse trader a good piece of advice to share with the world: 'When you make someone's acquaintance on the road, don't get into a wrangle about who is right and who is wrong. Be a good friend and don't embarrass the other guy. If you are warm and obliging, then as you travel together you will be like brothers born to the same parents. When you are on the road, support each other, look out for each

other.' Ch'oe Pu might have learned something by reading *My Khitan Buddy* – but then again, perhaps not. The lesson of getting along and treating others as equals had but a small place in the Confucian order of things.

6

The Pirate and the Bureaucrat

Canton, 1517

A handful of Portuguese ships waited at anchor out of the main current of the Pearl River below Canton, sails furled but flags flying. Captain-Major Fernão Pires de Andrade had spent two and a half years minus a week getting from Lisbon to this estuary on the south coast of China. The journey had not been direct. The year before, he had got as far as Champa (south Vietnam) when a typhoon forced him back to wait out the season in Malacca. In 1517 he managed to get away early enough in June to catch the winds that would carry him east and north to China. Now he stood off from the river courier station through which passed official communications in and out of the city of Canton, waiting for the provincial government to reply to his request to sail up to the city and go ashore.

Andrade had initially agreed to the Coastal Defence Commissioner's request that he hold his eight ships out at the mouth of the Pearl River. There he would wait for a reply to his request to land a delegation from Portugal to go to Beijing to lay a proposal to open trade

relations before the 'King of China', as Andrade called him – a request that would eventually be granted after several years. But time was passing, and every day the year moved closer to the north-east monsoon season. To have sailed this far and then have to return to Malacca empty-handed because the wheels of Chinese bureaucracy turned too slowly would be a failure too great to bear. Rafael Perestrello had made the run the year before, Jorge Álvares the year before that, and both ventures had been hugely profitable. Andrade could not turn around, but nor could he go forward as long as the commissioner held him back. To force his way up to Canton would provoke a conflict that he had no guarantee of winning, especially at this distance from a safe port and reinforcements. So he decided to put pressure on the commissioner. He hoisted his sails and made a show of leading some of his ships up the Pearl River. Fortunately, a storm forced them back to their moorage before the commissioner had to act. The commissioner did respond, though, by asking Andrade to wait a few more days. Andrade agreed, as there was little else he could do.

What Andrade did not realise was that, from the perspective of officials of the Ming, men arriving in ships by sea who were not tributaries but intent solely on private trade looked no different from pirates. The Ming understood its coastline, coastal islands and immediate coastal waters to be under its strict jurisdiction. Foreign vessels could not enter those waters without official permission. Other than ships in distress, those that did not have that permission could not land. There were voices in Canton willing to take a broader view and allow foreign vessels to come and trade under supervision. But extreme political caution was necessary when the object was to alter imperial policy, and if any altercation broke out on the coast that suggested to Beijing that local officials were not doing their jobs, it was enough to get you fired, or worse.

At last the commissioner gave Andrade clearance to proceed upriver. He also assigned local pilots to guide his ships through the Pearl River shoals that protected Canton from the sea. That short journey took the small convoy three days. Once anchored off from the courier station, Andrade ordered his gunners to do what any European fleet arriving at a foreign port was expected to do: honour their host by firing a salute with their cannon. The administration

commissioner (effectively, the governor) of Guangdong province, Wu Tingju, heard the salvo and was appalled. It would be the first of many missteps and miscalculations on the part of the Portuguese.

Dividing the Atlantic World

The elements of the plot that found Portuguese on the coast of China in 1517 first fell into place in 1493. An ambitious Genoese navigator we know as Christopher Columbus had persuaded his backers to fund his venture to sail west across the Atlantic the year before. His destination was China, and he was entirely confident that sailing due west would get him there. By 1492 sailors and cartographers understood that the world was round, and that the western coast of Europe faced the eastern coast of Asia; they just weren't sure of the earth's diameter and so could not predict how long it would take to travel to Eurasia's opposing eastern shore. It was a dangerous gamble when a safer bet, heading down the African coast, was known, but the Portuguese dominated those waters. Columbus wanted his own route to China.

That same year the German mariner Martin Behaim commissioned a globe, which he called his Erdapfel ('Earth Apple'), that showed Eurasia wrapped around roughly two-thirds of the earth's circumference, leaving a vast ocean to fill in the rest (see Plate 8). Facing Europe across the Oceanus Orientalis, or Eastern Ocean, lay the eastern end of Eurasia dotted north to south with place-names. These names, which Behaim got from Marco Polo and other travelogue writers, nicely recapitulate the history of state formations in eastern Asia from the tenth century to the thirteenth: Tangut, Tartaria, Cathaia, Thebet and Mangi. We met the Tanguts in Chapter 3. They were the Tibetan people whose Xia Great State the Mongols annihilated in the 1220s, prior to sending their armies into China. Tartaria was the name the Russians used for the Jin Great State of the Jurchens, which the Mongols also destroyed. Cathaia is Cathay, an archaic name for China derived from Khitai, the Khitan people whose Liao Great State pre-dated the Jin. Thebet is, of course, Tibet, once one of Eurasia's great empires that in 1492 was a fractured zone of competing Buddhist states. Most southerly in this scattering of place-names is Mangi, the term by which the Mongols, and their agent Marco Polo, knew the people of the Southern Song dynasty. Off the coast of Mangi, Behaim

drew a large island labelled Cipangu, a southern Chinese rendering of Ribenguo, 'the country of Japan'. By 1492 these place-names were merely memories of what Marco Polo had known or heard about, not what anyone knew existed. His *Travels,* still the best European source on what lay on the far side of the world, was one of the few books that Columbus took with him on his first voyage.

Columbus's patrons, Queen Isabel of Castile and King Ferdinand of Aragon, were joined in marriage in 1469. As co-rulers in 1479 of the country we now call Spain, they had to tread carefully with their brother-monarch in Portugal. His state enjoyed an edge in blue-water sailing, owing in part to its long Atlantic coastline, the existence of harbours able to handle maritime commerce and a long history of seagoing. Thirteen years previously, in 1479, the two monarchies of Portugal and Spain had agreed to the Treaty of Alcáçovas, a suite of four treaties that ended Portugal's bid to challenge Isabel's succession but affirmed Portuguese superiority at sea. The agreement recognised Portugal's exclusive right to navigate and trade south of the Canaries, and to take possession over all 'the lands discovered and to be discovered, found and to be found [...] and all the islands already discovered and to be discovered, and any other island which might be found and conquered from the Canary Islands beyond towards Guinea'.

Alcáçovas made sense at the time. However, once they were secure on their thrones and gaining ever greater control of Muslim-occupied areas of the Iberian Peninsula, Isabel and Ferdinand were ambitious to reach out into the maritime world to compete with their Portuguese rivals. Columbus was, in a sense, in the right place at the right time, though it still took the Genoese navigator persistent lobbying to convince their majesties to give him the financial support he needed to equip and man his modest fleet of three ships as well as the political clearance to challenge their wealthy and dangerous neighbour to the west. Key to timing was money, and that only came into the monarchs' hands in 1492. The year dawned with the fall of Granada on 2 January – Columbus was in the Alhambra that day and saw the last Muslim ruler in Iberia come out of the city gates and kiss the hands of Isabel and Ferdinand. Taking Granada from the Moors opened the way for a purge of the other unwanted aliens. On 31 March, the monarchs

signed the Alhambra Decree, expelling Jews from Spain unless they converted. Over the next four months, 150,000 Jews fled, some taking Sultan Bayezid II's offer of refuge in the Ottoman empire and travelling on ships he sent to bring them to safety in Greece and Turkey.

On 3 August, Columbus set sail, and nine weeks later he arrived in what he thought was Asia. After four months sailing among his new-found islands, he headed back east across the ocean to report his victories in a letter to his royal backers, penned on 4 March, just after reaching the coast of Spain. 'I come from the Indies with the armada Your Highnesses gave me', he began, confirming that he had achieved exactly what he had promised. His discovery of 'innumerable people and very many islands' was carried out under European protocol, taking possession of them 'in Your Highnesses' name, by royal crier, and with Your Highnesses' royal banner unfurled, and it was not contradicted'. This charade was not merely a colourful ceremonial but an enactment of the legal elements essential for assuming sovereignty over 'unclaimed land' (*terra nullius*): staging the presence of the sovereigns by standing beneath their standard and reading a declaration of sovereignty aloud to those who were being placed under that sovereignty – and noting that the new subjects raised no objection. The gesture forestalled any future legal challenge to Spain's claim to the lands that Columbus found.

After noting that these people had no conception of private property, Columbus went on in his letter to describe to his sovereigns where he had travelled. When he had got to what we now know as Cuba, he told them that he sailed along its coast for days, and there seemed to be no one. 'It was', he ventured to conclude, 'probably not an island but rather a mainland, and most likely the province of Cathay.' He had reached his destination, probably. He then painted a glowing picture of what he calls 'the Indies', a generic term for the zone of the world that, seen from Europe's eastward-looking perspective, stretched from South Asia to the islands of South-East Asia. Gold was in copious supply, he said, spices (for which the Indies were already known) abundant, cotton without limit and slaves 'innumerable' – something that Marco Polo's *Travels* had already told him he would find. He also made his famous claim that the inhabitants of the Indies believed that 'all powers reside in Heaven' and that he, his men

and his ships had journeyed to them from Heaven. 'Come and see the people from Heaven', he reports the people saying.

Now for the pitch. Despite the abundance of wealth for the taking, Columbus had spent more than he had acquired and needed to resupply his expedition. Would their majesties care to increase their investment before they saw a return on what they had already put down? Rather than plead for a small infusion of cash to carry him through a return voyage, he offered them a much bigger deal. He promised them a payout in seven years' time, which would become due on 4 March 1500. On that day, as a result of the torrent of riches that would pour into his hands, 'I will be able to pay Your Highnesses for five thousand cavalry and fifty thousand foot soldiers for the war and conquest of Jerusalem, for which purpose this enterprise was undertaken.'

The search for China was not about riches after all; it was about funding the holy war against Islam that could not end until Jerusalem had been retaken – or that, at least, is what he told his monarchs. But that was not all, for it would be followed five years later by exactly the same number of cavalry and foot soldiers. Lest Isabel and Ferdinand should miss the message, Columbus reminded them that he was offering them an incredible deal. They would gain 'all of this with very little investment now on Your Highnesses' part in this beginning of the taking of the Indies and all that they contain'. Therein lay the real heart of the deal: for the price of bankrolling him to take possession of the Indies, Spain would gain the Indies and drive the Muslims from the Holy Land. He added that there should be no delay, as there had been with his first voyage, adding with little charity: 'May God forgive whoever has been the cause of it.' To this noble plan he then added a long, embarrassing paragraph complaining about how he had spent everything he had in his seven years of service to their majesties, despite their not being all that enthusiastic, and that he expected something from them in return. Whatever they thought of his complaints, they couldn't turn down his offer – and didn't. Columbus would sail west again six months later.

Columbus's acquisitions created a new problem. The Peace of Alcáçovas–Toledo had given the Canaries to Spain, but everything in the ocean south of that to Portugal. What about whatever lay west of

those islands? Was Spain's title to these new territories secure? Rather than leave this open to a challenge from Portugal, they pre-emptively sought a judgement from Pope Alexander VI, who conveniently was from Ferdinand's state of Aragon. Within two months of hearing the news of the discoveries, the royal couple secured a papal bull, a decree issued by the Pope that had the force of law. It was a swift and potentially brilliant move.

Known by its two opening words, *Inter caetera* ('Among other matters'), this bull granted Spain full legal dominion over its new possessions. At the head of the 'works' Pope Alexander had in mind as 'well pleasing to the Divine Majesty' were the recent attempts throughout Christendom, and more particularly in Spain, to spread the Christian faith and overthrow 'barbarous nations'. Alexander noted that for a long time the Spanish monarchs 'had intended to seek out and discover certain lands and islands remote and unknown and not hitherto discovered by others' with a view to 'bringing to the worship of our Redeemer and profession of the Catholic faith their residents and inhabitants', but that they had been too preoccupied with driving Muslims out of Granada to get around to discovery. The phrasing implied that Isabel and Ferdinand had forgone benefits for Spain in order to serve the greater cause of defeating Islam, and that they therefore deserved a certain pay-off now. Drawing attention to Columbus's references to the presence of gold and spices, the Pope applauded the monarchs' determination to live up to their duty to bring their new subjects to Christianity, and then handed down his judgement: to 'give, grant and assign for ever to you and your heirs and successors [...] the aforesaid countries and islands thus unknown as well as hitherto discovered by your envoys and to be discovered hereafter, provided however they at no time have been in the actual temporal possession of any Christian owner, together with all their dominions, cities, camps, places and villages, and all rights, jurisdictions and appurtenances of the same'.

To separate Spain's new territories from the zone under Portuguese authority, which earlier papal bulls had phrased in the same sort of language, Alexander proposed that a line be drawn from pole to pole 100 leagues (which is to say, 5 degrees of longitude as measured at the equator, or about 350 miles) to the west of the Azores. Whatever

lay 'in the direction of India' and south of the Azores on the far side of that line belonged to Spain. The only limiting condition was that these lands 'at no time have been in the actual temporal possession of any Christian owner'. Aside from that, everything Columbus had found, and everything he had yet to find, was theirs.

This new judgement worried King João of Portugal. His father, King Afonso, had done the same thing in his own time, applying to Pope Nicholas V for bulls to ratify territorial claims based on early Portuguese moves out on to the ocean. In *Dum diversas* ('Until different') in 1452, Nicholas had given Afonso the right to seize territories from Muslims and other pagans. Two years later, with *Romanus pontifex* ('The Pope in Rome'), he was more specific in granting Portugal dominion over all African lands lying south of Cape Bojador (Abu Khatar) on the Moroccan coast. Portuguese mariners had first braved the shallow seas and difficult winds to round Cape Bojador twenty years earlier, in 1434 (as it happens, the year in which Lisbon received its first shipment of African slaves). By 1454 they had reached points far enough down the African coast for Afonso to make the claim.

In the face of João's objections to Pope Alexander's arrangement and the threat of war, lawyers and papal legates gathered in the town of Tordesillas near the Spanish–Portuguese border in May 1494 to work out a compromise. The new agreement explicitly divided the world being discovered between Spain and Portugal, but it moved the line from 100 leagues west of the Azores to 370 leagues west of Cape Verde. The change pushed the line west another 14½ degrees of longitude, or 950 miles. Given that mariners at the time had no reliable way to measure longitude, it would take another thirty years to determine that the line's position was at what we would measure as longitude 46°36' W, which put the eastern portion of Brazil over the line in Portuguese territory. Did the Portuguese delegation know this would happen? We cannot say, but it is not difficult to imagine that, in the course of many decades of voyages into the South Atlantic, a Portuguese ship had been blown south-west from Cape Verde and run aground on a continent of which the Spanish did not yet know.

The earliest surviving Portuguese world map to record the arrangement appears at the head of this chapter. It is known as the Cantino Planisphere, in somewhat questionable honour of the Italian, Alberto

Cantino, who smuggled it out of Portugal in 1502 (see Plate 7). The Cantino Planisphere marks the Tordesillas line in vivid blue. To either side appear the labels 'Las Antilhas del Rey de Castella' ('the islands belonging to the King of Castile') and 'Terra del Rey de Portuguall' ('land belonging to the King of Portugal'). A large chunk of South America paralleling the curve of a perfectly formed Africa protrudes across the line into the Portuguese zone. Three brightly plumed parrots perch before a landscape of marshlands and trees to prove the reality of the place. This may simply reflect the standard account of the accidental discovery of Brazil by Pedro Álvares Cabral in 1500, as he led Portugal's second expedition to India, though it is possible that the currents and trade winds had pushed a Portuguese vessel that far west earlier than 1494.

The Treaty of Tordesillas made no arrangement for what the Portuguese and Spanish were to do when they met on the far side of the globe. While the meridian drawn down the Atlantic Ocean was purely a regional arrangement to keep Portugal and Spain in separate economic zones, it had a certain influence over how events unfolded subsequently as Europeans fanned out around the world. Rather than a final settlement of claims, the Tordesillas meridian was the starting line for a race to see who could assert trade dominance where. It was the point from which, after two centuries of isolation, Europe made contact with China – and not Europe in the abstract, or England, France or Spain for that matter, but specifically Portugal. Tordesillas was one moment in the cascade of events that propelled first Vasco da Gama into the Indian Ocean, then Afonso de Albuquerque into the Strait of Malacca and ultimately Andrade to China.

Initially they knew nothing of China. The Cantino cartographer names 'Malaqua' well in advance of any Portuguese having ever reached Malacca, and south of it he indicates the tip of the Malay Peninsula, where Singapore sits today. Beyond there, however, he can only arbitrarily extend the east coast of the peninsula as a realistic-seeming coastline that runs north-east until it dribbles off the right-hand side of the map. The one reliable place-name he does insert is 'Chinocochum' or, as it was later written, Cochin China, a name by which the southern part of Vietnam, or Champa, was known. The Portuguese cartographer has located Cochin China at a river mouth

just below the Tropic of Cancer, roughly where we would put Hanoi and the Red River – surely just a lucky guess. After that, the eastern end of Asia is all *terra incognita*. No sign of China.

Portuguese mariners set their sights on Malacca, probably in reaction to hearing from Chinese merchants in India that this was the key entrepôt between the Indian Ocean and the mysterious zone of the Spice Islands that lay somewhere east of there. The first Portuguese ship to set sail for Malacca from Lisbon in 1508 carried instructions from King Manuel to find out as much about the Chinese as he could: 'when they come, and from how far; when they come to Malacca or to the places where they trade, and the merchandise they bring; how many of their ships come each year, and the form and size of their ships; whether they return in the same year they come, whether they have factors [agents] in Malacca or in any other country'. Manuel also wanted to know about their military capacities, their physical appearance, their political system ('whether they have more than one king among them'), their country's size and borders, their religion and whether they tolerated Muslim merchants, whom the Portuguese regarded as their main trade rivals in the Indian Ocean.

Malacca proved to be the key entrepôt between the Indian Ocean and the South China Sea. All shipping between the Indian Ocean and the South China Sea converged on this port. According to Tomé Pires, who was later to be Portugal's first ambassador to Beijing, eighty-four languages were spoken there. Strategically as well, Malacca was important as the choke point on that trade. Whoever controlled the port secured the routes in both directions. When, in 1511, Sultan Mahmud Shah refused to allow the Portuguese a free hand to trade in his port, Afonso de Albuquerque fired his cannon on the city until the sultan fled, leaving Malacca in Portuguese hands.

As Malacca had been a tributary of the Ming dynasty for just over a century, Mahmud sent an ambassador, Nacem Mudaliar, to Beijing to plead for help. His request for Chinese assistance in driving out the Portuguese was within the norms of the tributary system, but Emperor Zhengde's advisers were less than enthusiastic. The tribute system obliged China to come to the aid of a tributary ruler, were he overthrown, but in 1511 the Ming was not prepared to do so. Malacca was too small and too far away, besides which the navy that might

have intervened in the fifteenth century had long been disbanded. Malacca was on China's commercial map, but that was not a map in which emperors took much interest, as the general assumption was that trade overseas might enrich individuals but gave the state nothing but headaches. Emperor Zhengde in any case had other foreign-policy issues that concerned him more than a distant port, notably the planning for a campaign against the Mongols on his northern border.

It didn't help that, during his two and a half decades as the ruler of Malacca, Mahmud Shah had been somewhat hostile to Chinese merchants, confining them to their ships when they came into port, shaking them down for whatever duties he could collect and even seizing their ships when he wanted to wage war along the coast. Chinese merchants in Malacca were accordingly willing to support Albuquerque's bid to take over. In Beijing no one knew anything about Portugal other than that it lay somewhere to the west of India. Nacem Mudaliar, the sultan's ambassador, had to wait so long for the emperor's response that his wife, who had travelled with him, died in Beijing. In the end the emperor regretted the sultan's fate but chose not to intervene. Nacem Mudaliar died in turn as he was making his way empty-handed to the southern border. The most the Ming would do was give him a decent burial.

Facing no challenge from the Ming court, Portugal began sending expeditions from Malacca in China's direction. The first, led by Jorge Álvares, departed in 1513 but was prevented from landing when it reached China a year later. Moored for a time at an offshore island in the mouth of the Pearl River, Álvares sold his cargo of Sumatran pepper and erected a stone cairn to mark his 'discovery' – one of the *padrões* by which the Portuguese marked their passages through Africa and Asia noted in Chapter 4. The second Portuguese to make the voyage to China was Rafael Perestrello, who set sail aboard a Malaccan ship in the summer of 1515. Perestrello, a distant cousin by marriage of Columbus's, returned from China in a year, reputedly making a twentyfold profit on the excursion. Just before Perestrello returned at the end of the summer of 1516, Fernão Pires de Andrade set off at the head of four armed Portuguese vessels and three Malaccan transport junks.

Commissioner Wu Tingju understood that Andrade and his men

were in Ming coastal waters to trade. He called them *folangji*, 'Franks', an old word for Europeans that Chinese borrowed from Arabic. But their arrival entailed an administrative problem of category. These Franks were not named in the dynastic regulations governing the tribute system. As all foreign business was either tribute or smuggling, under what auspices could they be permitted to enter the country? Commissioner Wu too divided the world: not between Portugal and Spain but between the larger zone that Ming authority projected beyond its borders through the tribute system and what lay beyond. The outer edge of the tribute system was fluid, depending on who wanted access and who the Ming court was concerned to align with its foreign policy goals, but could Portugal be deemed a tributary of the Ming when no precedent named its existence?

Looking for Common Ground

Andrade seems to have understood the rules of the China trade. In a general sense, the rules were not all that different from the rules that every sultan sought to impose in order to maintain his authority and benefit financially from the trade that passed through his port. The difference was mainly one of administrative scale: the Ming managed relations with dozens of states through a clearly defined procedure involving state agencies. Any state making an approach for the first time had to find its way into that procedure or be turned away flat. Andrade's Chinese associates – at the very least, the Chinese working for him as interpreters and pilots – would have known what was required to make an acceptable approach. For his part, Andrade would have wished to meet rather than challenge Ming expectations, for the simple reason that he was there to make a profit, not to pursue diplomatic goals. But the gap between those expectations and his own as a supplicant foreign merchant would not have been all that wide. The Portuguese at this stage were simply another player in a maritime trading system that was understood by all parties.

None of the documents he handed to Ming officials survives, but his written request to the defence commissioner to enter China would have been in the rhetoric of tribute submission, there being no other way to phrase entering the country. Andrade would have recognised the Ming as a powerful state that regarded itself, justly, as

the legitimate hegemon of the region. The only way to advance his interests as a trader was to approach the hegemon respectfully. He would have been conscious that the dignity of the king of whom he was a subject should not be slighted and acted accordingly, but only ever as an inferior party in whatever relationship that might emerge between his king and the Ming emperor.

Regardless of what Andrade pressed for, the fact that the Ming state would have viewed his request to trade as a petition to cross an international boundary situated his arrival within a formal diplomatic framework. This is why the defence commissioner with whom Andrade lodged his first request could not allow him to proceed upstream without explicit state authorisation. To do otherwise would have been grounds for immediate impeachment for failing to defend the border. Upriver in Canton, Commissioner Wu Tingju for his part had to cleave closely to official protocol and keep the court informed of every step while the regional authorities evaluated whether to allow his party to land or to turn it back out onto the ocean.

As soon as he heard the cannon salute, Wu knew he had to act. He could have ordered the Ming navy to drive Andrade off, but he didn't. Instead, he ordered him ashore and dressed him down sharply on three counts. First, he should not have proceeded upriver until expressly commanded to do so. This amounted to entering Ming territory without authorisation and could be construed as a hostile act. Second, he came with flags flying. To hoist the flag of another ruler in Chinese waters was regarded as a direct challenge to Ming authority. Third, and worst of all, Andrade had fired cannon shots. There was no Chinese protocol that permitted the use of cannon fire to signal a welcome or serve as a gesture of respect. The gesture could only be regarded as hostile, or at least as a warning. This is precisely what the Ming coastguard had done when Andrade first approached in August. They fired shots intended not to hit the arriving ships but to put them on notice and gauge their response. Andrade responded appropriately, not returning fire but displaying every sign that his expedition came in peace.

The cannon shots gave Commissioner Wu an excuse, were he looking for one, to reject Andrade. Intriguingly, he didn't. Andrade handled the situation well by apologising, though the apology had

almost nothing to do with what Wu did next, which was to send his request up to Beijing. For Wu had his own interest here. He believed that foreign trade could benefit the state by being detached from the limitations that tribute diplomacy imposed. Let trade be trade. This was a radical idea in the context of the time. The logic of the tributary system was that China should interact with the world beyond China as though it sought only to dispense order, and its tributaries only to seek that order. Gifts should be exchanged to cement the bonds between superior and inferior, not to gain benefit, and especially not for China to gain benefit at the expense of those who came as supplicants to its court. Once the ritual exchange of gifts at court was done, envoys might be permitted to trade on the side, but as a sign of indulgence and not as a business incentive. Foreigners could trade only on those terms; to do so on any other was to engage in smuggling.

The idea of separating maritime trade from diplomatic exchange, as a few officials in the south were doing just at this time, contradicted the terms of the tribute system. It was a fundamental adage of Ming statecraft that the state should work to ensure the physical and moral well-being of the people, but not to exploit possibilities to increase its revenue. The foundation of the state's fiscal income was revenue from land taxes. This provided a limited financial base for the regime, but it was generally considered adequate to meet the needs of the people and the state. Commerce was also taxed, but at a level so modest (between 3 and 10 per cent) as to constitute only a minor line item in the state budget. The tribute system did not contribute to the state budget; indeed, the cost of covering the expenses of diplomatic missions far exceeded what the court received in gifts and payments. Officials in south China, however, were well aware of the profits that foreign trade could earn. They could see that trade produced a significant infusion of wealth that benefited the coastal economy – and surely filled their own purses as well. If properly monitored and taxed, that trade potentially could also benefit the realm. Allowing that to happen meant detaching foreign trade from the tribute system, and as the Ming founder had forbidden his descendants from altering the basic institutions of the dynasty, this was a tall order. Nevertheless, some officials were willing to try.

The institutional fabric for conducting trade and diplomacy was

complex. Foreign envoys arriving at China's shores were handled by an agency called the Supervisorate of Maritime Trade. Early in the fifteenth century, this agency passed to the control of the eunuchs, who constituted a parallel administration responsible not to the government but solely to the Imperial Household. The eunuchs' mandate was to protect the interests of the emperor, particularly his financial interests, which is why they worked to win control of the duties levied by the Supervisorate of Maritime Trade. Diplomacy was managed by the Ministry of Rites, which oversaw the protocol governing Ming relations with foreigners. The eunuchs were involved only to the extent that tribute embassies were required to enter the Forbidden City and present gifts to the throne. Border security was under the jurisdiction of the Ministry of War.

As most tribute missions arriving by ship landed on the coast of Guangdong province, the day-to-day business of trade and diplomacy was the responsibility of officials posted there. To describe the regional arrangements briefly, the provinces of Guangdong and Guangxi, its neighbour to the west, were under the supervision of a viceroy (a civil bureaucrat) and a grand defender (a eunuch). Beneath them, leadership at the provincial level was split three ways among three different commissions. The administration commission oversaw civil affairs, the surveillance commission acted as the local watchdog for the central government, and the military commission handled military and policing operations. The three commissioners were obliged to work in concert to deal with major issues. Problems arising from relations with seaborne foreigners tended to land on the desk of the administration commissioner, unless there were breaches of the peace, in which case the military commissioner could also be involved.

The first moves in the direction of treating maritime trade as a revenue generator may have come from the eunuch administration. As the emperor's personal servants, the eunuchs had a reasonably free hand to run the affairs of the Imperial Household as they chose and to side-step troublesome precedents if that were to the benefit of the privy purse (as well as themselves). This was particularly so during the reign of Emperor Zhengde, who preferred fishing or playing soldiers to attending to the intricate management of state affairs. The eunuchs were only too happy to facilitate his whims, and the chief eunuch

under Zhengde, a powerful figure by the name of Liu Jin, enjoyed a free hand in managing palace matters until corruption charges caught up with him. The source of those charges is complicated and began with an incident that came to involve eunuchs in the spring of 1509. Several ships from Siam were discovered moored off the Guangdong coast. The sailors claimed that the winds had blown them off course, an excuse to cover the fact that they were there to trade with Chinese counterparts and were doing it without written authorisation as tribute envoys. What to do with them? The provincial commissioners passed this problem up to their immediate superiors at the supra-provincial level and let the grand defender and viceroy decide. They advised the throne to show leniency to sailors who were far from home and to permit the ships to unload their cargo. But they should be required to pay an import duty on these goods. The funds collected would be put into the southern regional military budget, which had to bear the cost of controlling smuggling.

This minor arrangement would have constituted a powerful precedent to allow foreign trade to expand under state supervision, had no one objected. But someone did. According to the unsympathetic account in the official court diary, known as the *Veritable Record*, Xiong Xuan, the eunuch director of the Maritime Supervisorate in Canton, 'figured that he could intervene in the matter and obtain great benefits, and so memorialised a separate request to the Emperor'. Xiong supported the proposal but requested that the supervisorate be given the authority to collect duties on irregular cargoes. The Ministry of Rites strenuously objected. The ministry was willing to support a partial lifting of the maritime trade ban, but argued that the eunuchs' role in the supervisorate was to oversee the management of tribute embassies, not get involved in revenue collection. Emperor Zhengde decided to side with the ministry. He chastised Xiong for overstepping his authority, recalled him to Nanjing and replaced him with another eunuch, Bi Zhen. The eunuchs had lost the first round.

Bi's mandate was to adhere to the ministry's directive to limit the supervisorate's responsibilities to tribute affairs. Seventeen months passed, and then in August 1510 he asked the emperor for permission to let the supervisorate take over the levying of duties on non-tribute-bearing vessels: exactly what his predecessor had asked for. Bi's

argument was perfectly mercenary. He noted that not just the grand defender and the viceroy but also the provincial commissioners were managing the highly profitable revenue from these ships to the benefit of their budgets. He wanted the revenue diverted into the Imperial Household stream. His communication to the throne was passed to the Ministry of Rites for an opinion. Again the ministry objected. 'The function of the Supervisorate of Maritime Trade is to manage local products brought as tribute. Merchant ships and other foreign ships forced by the winds to seek safety and anchor along the coast are not included within the original purview of the imperial orders. Regulations should not be meddled with.' The Ministry of Rites could always be counted on to block eunuch initiatives, as it regarded these as undermining the proper administration of the realm. Whatever motivated the ministry's opposition, the emperor sided with precedent, confirming that the system should return to what the status quo had been before Xiong had tried to take over import duties in March 1509.

If the second round too went to the ministry, it was in part because of other noise in the system. The editors who recorded the emperor's decision on Bi Zhen's request in the *Veritable Record* end it with a note that 'Liu Jin had sought private gain from Bi Zhen and had thus falsely stated that this practice had a precedent.' The editors felt free to make this undocumented observation about Emperor Zhengde's chief eunuch because just two weeks later the emperor ordered the arrest and execution of Liu Jin on the charge of plotting to overthrow him. That charge was probably excessive, though it was a good way of sealing a verdict against him. What is entirely true is that Liu Jin had been running the largest corruption racket of the dynasty, squeezing everyone who reported to him or over whom he had any control. His massive scheme of kickbacks and intimidation had corrupted and demoralised the entire state bureaucracy for years while Emperor Zhengde looked the other way. Finally, he could look away no longer. Liu's arrest and gruesome penal torment – he was subjected to the death penalty known as death by a thousand cuts, which in his case was to be applied slowly over a period of three days, though to general disappointment he died on the second day – was the most popular decision Zhengde ever made.

The Liu Jin factor may explain why Bi Zhen sent in his request, which went against his explicit orders not to collect revenue. Liu was shaking him down, and he had to deliver. But we shouldn't reduce the issue of taxing foreign trade to eunuch corruption or the endless struggle between eunuchs and civil officials. The point is that a sea-change was under way on the south coast. More ships were ferrying an ever greater volume of commercial goods in and out of China, and officials in south China were struggling to work out how to manage the state's monopoly on both maritime imports and diplomatic con-tacts to benefit the state.

The next step in the vexing issue of maritime trade arose four years later, in 1514, when Assistant Commissioner Chen Boxian sent Emperor Zhengde a memorial accusing his superior by two grades of letting maritime trade get out of hand. His boss was none other than Commissioner Wu Tingju. Why Chen made this dramatic move against Wu we may never know. Perhaps it was simple career advance-ment: cut down your boss so that you can move into his place. Chen starts his memorial to the emperor by sketching the trade situation as it looked from Canton. He mentions Malacca, Siam and Java, and then dismisses the value of the products coming from these places as 'nothing but pepper, sappanwood [highly valued as a dye and a phar-maceutical], elephant tusks, tortoise-shell, and such like'. Not being 'daily necessities such as cloth, silks, vegetables, and grain', they were wasteful extravagances of which a soberly managed economy had no need. Chen then notes the shift under way: 'Recently, the admin-istration has been permitted to levy taxes according to the value of the goods, and there has been open trade.' The concession to the Sia-mese sailors in 1509 had in fact turned into a new policy, and in Chen's view the effects were not good. 'This has resulted in thousands of evil persons building huge ships, privately purchasing arms, sailing unhin-dered on the ocean, illicitly linking up with foreigners, and inflicting great harm to the region. This must be stopped at once.' The official behind this dreadful state of affairs, Chen declared, was none other than Wu Tingju.

The emperor did as he usually did when such accusations arrived in Beijing out of left field. He asked for an opinion, and directed that request again to the Ministry of Rites because of its responsibilities

for diplomatic protocol. The ministry responded on 27 June by supporting Chen, insisting that foreign ships arriving outside the tribute regulations should not be taxed – because they should not be allowed to land in the first place. 'All evil persons who continue to collude with the foreigners', the ministry added darkly, 'should be punished.'

Tribute and Trade

What had Commissioner Wu done to draw Chen Boxian's fire? That depends on how we understand the man. From traces he has left in the official documentary record we know he was in service for close to four decades, starting late in the 1480s as a county magistrate and rising slowly through the ranks to several vice-ministerships early in the 1520s. But that record alone was not enough to suggest his place among the remarkable men that every generation of the Ming dynasty called forth. Wu was a striking character in his own right, notoriously careless of his dress and, as his official biography in the dynastic history rather candidly puts it, 'with a face like a split melon'. He was utterly fearless, indifferent to the reactions of others and not afraid of taking action when action was required. That meant regularly falling foul of important people, from eunuchs up to the emperor, though he also had the support of important figures at the top of the government to survive the many attacks he suffered.

Wu's name comes up most often in official documents of the 1510s in connection with Chen's attack, becoming a flash point for opponents of those who advocated reforming foreign trade practices. Three years after Chen's memorial, for example, another official in south China referred back to Chen's attack in 1514, complaining that Wu 'had argued that it was plausible that benefits were to be gained and so requested that all ships be received. The viceroy, regional inspector, and minister of revenue were all deluded, and so his proposal was approved.' Four years later, another hostile official sought to lay all the subsequent difficulties with the foreigners in Guangdong province at the feet of Wu Tingju. He claimed that Wu was willing to let any ship land so long as he could tax it in order to make up for shortfalls in provisions for the local military. 'As a result', this official declared, 'foreign ships continually come into our coastal bays, foreigners live among us in our cities' – Japanese were the most feared and hard to

detect – 'and the laws are flouted and coastal defence neglected.' He capped his accusation with the charge that Wu's policies facilitated foreign espionage. Spies come and go so freely that 'our domestic routes are becoming increasingly familiar to them'. Those fearful of the outside world spent a decade blaming whatever they didn't like on Wu Tingju.

Did Wu champion the idea of separating trade and diplomacy? Although the traces of his career are not sparse, he seems to have left no writings of his own. There is an appreciative biography in the local gazetteer of Shunde county, south of Canton, where he held his first official posting as a county magistrate after passing the metropolitan exams in 1487. That source remembers him with great fondness as a tall, unkempt man whose word could be trusted and whose acts produced results, judgements that the court historiographers in the next dynasty inserted into his official biography. During his tenure as magistrate he revitalised the county, swept away objectionable popular practices and resisted the attempts of his superiors to solicit bribes – which may be why he languished in his first post for nine years instead of the standard three before being promoted. Wu was back in Guangdong province as an assistant commissioner in 1505. He was rotated out to Jiangxi, the province to the north, where he organised several campaigns to rid the province of bandits, but returned to Guangdong as Right (Junior) Administration Commissioner. So he spent most of the first twenty-five years of his career in Guangdong, and must have been reappointed there in post after post because he was seen as having a good understanding of the challenges of administering the region.

None of this explains Chen Boxian's attack on Wu Tingju. The emperor agreed with the Ministry of Rites and approved Chen's recommendations. Oddly, however, Wu remained in post: not only that, but he was promoted to Left (that is, Senior) Administration Commissioner within a year. Despite his open advocacy for a more liberal trade policy, he appears to have enjoyed sufficient support at higher levels to protect him. Perhaps a share in the profits that trade brought helped him make his case.

Wu Tingju was again the target in May 1515, when the Ministry of Rites forwarded a memorial complaining that the judgement the

previous year limiting foreign imports to tribute envoys was not being enforced. The ministry phrased the situation somewhat elliptically by complaining that 'those who were supposed to carry out the orders have let things continue as before'. It does not actually name Wu, though his role is implied. However, this time the ministry enlarged its complaints and claimed that 'the grand defender profited from [illegal traders] and relaxed the prohibitions a little'. The grand defender of Guangdong and Guangxi from 1506 to 1514, a long tenure in such a post, was the eunuch Pan Zhong.

This is curious. Was Wu Tingju in cahoots with a corrupt grand defender? This seems unlikely. Wu had a long and public history of resisting the eunuch establishment that went back to his time as magistrate of Shunde county. In one incident, he blocked a move by his superiors to build at public expense a family shrine for a powerful eunuch who was a native of the county. In another, he refused a bribe from a eunuch posted in the Maritime Supervisorate, which led to his being thrown in prison on the pretext that he had overstepped his authority in another matter. When he returned to Guangdong as an assistant commissioner in 1506, he came into conflict with none other than Grand Defender Pan Zhong, accusing Pan of twenty crimes. Pan counterattacked, and Wu was arrested and sent to Beijing to be punished by none other than the hated chief eunuch Liu Jin. Liu had him exposed in a wooden cangue – a type of movable stocks clamped around the neck of the criminal – in front of the offices of the Ministry of Personnel for almost two weeks. The ordeal could have killed him, had his younger brother not stayed by his side the entire time. Wu survived, physically and politically, but he could not be posted back to Guangdong so long as Pan remained grand defender. Not until the eunuch retired in 1514 could Wu be moved back to the region.

How then did the incorruptible Wu Tingju and his arch-enemy, the eminently corruptible Pan Zhong, end up on the same side of the maritime trade issue, at least as the Ministry of Rites saw matters? The only way to resolve this puzzle is to suppose that Pan had been relaxing restrictions on foreign trade in order to steer benefits to the Maritime Supervisorate, and that Wu Tingju continued the same policy when he returned to Guangdong in 1514, not to benefit the eunuchs but to ensure that the duties collected on imports be properly

allocated to the provincial budget. The politics surrounding Ming foreign trade policy in the 1510s were complicated. There was no single common view that everyone shared, though the recurring protests against Wu suggest that the faction opposed to his more liberal view of trade was having to stem a wider tide of opinion than just the views of this one man.

To reach the sort of conclusion that Paul Kennedy did in *The Rise and Fall of the Great Powers* that 'Ming China was a much less vigorous and enterprising land that it had been under the Song dynasty', or to complain about 'the sheer conservatism of the Confucian bureaucracy', whatever that might be, is to polarise the past rather than view it historically. Ming China was not beset by lassitude and conservatism; it was a lively political space in which informed people disagreed greatly over the appropriate institutional context for maritime trade. Even the Ministry of Rites, which was effectively the chief source of foreign policy analysis within the Ming government, vacillated in its opinions. Though the flux did not ultimately lead to the sorts of policies that European states adopted *after* the sixteenth century, there is neither the need nor the justification to fall back on stereotypes about the Chinese state being hostile to trade or Chinese officials being on the take, even if sometimes they were.

This was the context into which the Portuguese arrived, a context of which they were utterly unaware, and on which they would have a regrettable impact.

'It Was All Wu Tingju's Fault'

The first Portuguese voyages to Canton in 1514 and 1515 did not reach the notice of the Ming court. The first reference to Franks in the *Veritable Record* comes on 15 June 1517, a month before Andrade's ships appeared at the mouth of the Pearl River. It appears as an appendix to a larger directive on maritime trade. The directive orders are as follows: 'that ships from foreign countries sending tribute and carrying trade goods be taxed at twenty per cent, a portion to be forwarded to the capital and a portion to be locally retained to meet military expenses'. Diplomacy and trade are not being pulled apart so much as being treated as parallel categories. The text then goes on to declare that 'this is entirely in keeping with the old regulations, and no one

shall use recent regulations to obstruct it'. This is assuredly not true, as the 'old regulations' were carefully imprecise about import duties. Citing conformity with old regulations was a rhetorical device not uncommonly used to camouflage just the opposite. The order did not open the border to foreign trade by non-tribute-bearing missions, but it did recognise the revenue value of allowing missions to import full cargoes. Zhengde's administration was half-way to a full revision of maritime trade policy.

The imperial historiographer who edited the *Veritable Record* has inserted an appendix giving some historical background. He notes that natives of Guangdong and Guangxi had before 1517 been involved in private trade in foreign goods. He dredges up all manner of familiar tropes to complain that the locals 'linked up with the distant foreigners and tribute bearers in order to scheme for profits, beguiling people into absconding, kidnapping or purchasing boys and girls, coming and going as they pleased to the general harm of the people'. All bad. The editor then mentions Chen Boxian's attack on Wu Tingju in 1514, and from there introduces the Portuguese: 'Within a few years, the troubles with the Franks started. Vice-Commissioner [of Maritime Defence] Wang Hong put forth all his efforts to eliminate or capture them, and was just able to defeat them.' The editor is referring forward to a subsequent naval stand-off in 1522, which we shall get to shortly. 'As a result, the annual expenditure on ship-building and gun-casting for defence has been crushing. Also, because of the Franks, all the foreigners whom we are duty-bound to receive were blocked and their cargoes could not get through, causing inestimable harm.' The entry ends with the now standard complaint: 'It was all Wu Tingju's fault.'

The editor inserted this brief account of Commissioner Wu and the Franks into his commentary on the 1517 directive because he regarded the directive as a change in policy in response to initiatives being taken by regional officials in Canton. He was also retrospectively aware that the Portuguese had arrived just after the moment when an attempt to ease trade restrictions was being launched. The Franks' arrival did not set the process going, but it did produce consequences that would derail what Wu and others were trying to do. In the summer of 1517, before Andrade sailed into view, the change was tentative, despite the

new directive. It was not clear which way the Ming state would go on maritime trade. To recap what we barely know on the basis of slight references in the documentary record: Commissioner Wu Tingju had been persuasive in opening up trade around 1514, Chen Boxian and others were counselling limitation in 1514–15 (just as Portuguese vessels started to arrive), and between that date and 1517 the court was vacillating as to which course to take, though the drift seemed to be in the direction of trade liberalisation. The crisis had not yet come.

And then, two months after this first reference to the Portuguese in the *Veritable Record*, Fernão Pires de Andrade's fleet arrived on the Guangdong coast and requested permission to land as a tribute mission. Andrade, of course, had no idea what game was afoot. To his credit, he took his cue from Wu, apologising and explaining that his cannon shots were courtesies by which he as a ship's captain showed his respect to China. This was all Wu required. Apology accepted, Wu put procedures in place that would allow Andrade the opportunity to put Portugal's case for recognition as a tributary of the Ming before his superior, Chen Jin, viceroy of Guangdong and Guangxi. Chen was not an easy touch. His earlier career in bandit suppression gained him such an evil reputation that the locals made up a little ditty in his honour: 'Local bandits? Let 'em be. Local soldiers? Murder me.' But Chen and Wu got on – Wu had also distinguished himself previously in bandit suppression – and Chen was willing to let the application for tributary status go forward. The idea that the king of Portugal was seeking to subordinate himself to the emperor of China was, at least for the Portuguese, a fiction, but at this opening stage in the Ming–Portugal relationship it was a harmless one, as its sole practical repercussion was to permit trade to go ahead. Viceroy Chen agreed to forward the request to Beijing, and together with the eunuch grand defender submitted a memorial to the throne.

Andrade assumed that diplomatic matters were moving forward satisfactorily, but this is not the impression one gets from the short fragment from Chen's memorial excerpted in the *Veritable Record* on 11 February 1518, four months later. Chen observes in this document that Franks have never been listed among the foreign maritime countries to the south, and moreover that the delegation carried 'no written credentials from their own country' identifying them as representatives

of the king of Portugal. His delicately phrased conclusion on the basis of these two pieces of evidence is that the delegation applying for tributary status 'cannot yet be trusted. We have detained their envoys and request instructions.' Perhaps this was careful prevarication on Chen's part, extending conditional trust to the Portuguese in front of him but leaving himself a way out should Beijing decide otherwise. Chen may have been sympathetic to Commissioner Wu's attempts to allow foreign trade to grow, but he did not want to be the one to open the door to tributary recognition. If that were to happen, the decision had to come entirely from the court.

'Detained' perhaps over-translates the Chinese term *liu*, which means simply 'allowed to stay' – though it also connotes the sense of not being allowed to leave. Andrade was allowed to stay, but also allowed to leave when he had to. He unloaded his cargo, sold it to local merchants, then set off before sickness, probably malaria, took any greater toll on his crew. He left behind an ambassador, Tomé Pires, with an entourage. Three years passed before Pires and his men were given leave to depart from Canton and make the long journey north by river, portage and Grand Canal to put King Manuel's case before Emperor Zhengde.

Portugal as a Tributary of the Ming

The initial reception at court of Chen Jin's memorial had not been favourable. The *Veritable Record*, after quoting the passage about not yet trusting the Franks, reports that the emperor referred the case, yet again, to the Ministry of Rites for deliberation. The ministry responded quite quickly, advising that the embassy be sent home and their gifts to the throne be returned to them. The fact that the incident is reported in the *Veritable Record* on 11 February 1518 implies that an edict to this effect was issued that day. But then the documentary record falls silent. There is nothing to indicate what, if anything, happened as a result. Nothing, it would seem. Two and a half years passed before the matter rose again to the attention of the compilers of the court diary, when a passing comment in the *Veritable Record* in October 1520 implies that Zhengde had not responded to the ministry's request for an edict of exclusion. So the issue had not been settled, despite the ministry's position. The official Portuguese request for tributary

status was still active. Tomé Pires was still in Canton, waiting; which is to say some within the Ming administration, like Commissioner Wu, were still working to accommodate the growing pressure from abroad on the Ming to trade.

While the issue was stalled at court, other Portuguese arrived on the Guangdong coast, engaging in conduct that did not warm Chinese to their cause. Notorious among them was Simão de Andrade, the brother of Fernão Pires de Andrade and captain of the next mission in 1519. As the first Chinese historian of Sino–Portuguese interaction put it in the 1930s, Simão de Andrade 'soon committed a series of outrages which completely destroyed the amicable relations between the Portuguese and the Chinese established by his brother, and even turned the Chinese into deadly enemies'. What T'ien-tsê Chang here terms 'outrages' included performing an execution on Ming territory and blocking other ships from landing before the Portuguese had sold their cargo. By the time the court was willing to re-hear arguments on the case for granting tributary status in January 1521, the mood for liberally re-interpreting the laws had shifted. At issue in this next round of debate was not purely whether the Ming should recognise a new tributary state, still less whether the court should entertain new regulations governing foreign trade. Discussion revolved entirely on the record of Portuguese conduct. The touchstone for judgement or, we could say, the lightning rod of conflict was none other than Portugal's seizure of Malacca ten years earlier. But the arguments on this point were not uncomplicated.

The censor Qiu Daolong became the moderate voice in this round. He insisted that no recognition could be given to Portugal until the still outstanding appeal for help from the sultan of Malacca was sorted out, though he remained vague as to what that might entail. He suspected that this would require a military solution, and realised that the Ming state was unlikely to project its military power so great a distance. Qiu's view was not a categorical refusal of Portugal's request, however, for he concluded his statement on the matter with this policy recommendation: 'that their tribute be refused, that the difference between obedience and disobedience be made manifest, and that they be advised that, only after they have returned the territory of Malacca [to its ruler], will they be allowed to come to court to offer tribute.' In

other words, the door for accommodation should be left open. Earlier in his career Qiu had served as magistrate of the same county near Canton, Shunde, where Commissioner Wu had held his first post, and was similarly praised in local records for his virtuous administration there. This is hardly a coincidence: the experience of administering a coastal county in Guangdong must have exposed him, as it did Wu, to the complex world of maritime trade that was invisible to most of his contemporaries.

Another censor, Heh Ao, took a harsher view. Heh stated that 'the Franks are infamous for their cruelty and guile, and their weapons are better than those of all other foreigners'. Recalling Fernão Pires de Andrade's cannon salute, he noted that 'the sound of their guns shook the city and suburbs'. Then he went on to explain: 'The persons they left at the courier station violated the ban on communication, while those who came to the capital were fierce and reckless and vied for supremacy. Now, if their private ships are permitted to come and go in trade, it will certainly lead to fighting and injury. The calamities in the south will be endless.' Censor Heh wanted a final solution to the leaky southern border: expel all foreigners not connected to tribute missions and restore the original rules of the system. If there was anyone to blame, it was, of course, Wu Tingju, though Wu had been promoted elsewhere in the country by this time.

The surprising response from the Ministry of Rites, especially in light of its decision back in 1518 to send the Portuguese packing, was to side with Qiu. The entire matter hinged on the status of Malacca – though whether the Portuguese ever fully understood this is unclear. Portugal might be recognised, the ministry advised, once a thorough investigation of the Malaccan situation had been carried out. It too felt obliged to take a retrospective swipe at Wu Tingju and stress the need to tighten border security, but it asked for no further measures. At no point, then, earlier or later, was action taken against Wu Tingju, despite his recurrent demonisation. The possibility of opening maritime trade had not yet been crushed, and the ministry was hedging its bets on the issue. If anything, it was suggesting that the final issue was not the integrity of the tribute system: it was border security.

The incident that brought this long diplomatic meander to an end was entirely fortuitous: the death of the emperor on 20 April 1521. The

first effect, as always when an emperor dies, was to suspend government business. Embassies to the deceased emperor were sent home, and new embassies would not be accepted until there was a new emperor to receive them. This particular succession was not straightforward, for Zhengde had died without issue. It was decided that the throne should pass from Zhengde to his younger cousin, enthroned as Emperor Jiajing (r. 1522–66), but the transition turned into a political mess, effectively suspending court business for half a year. The succession veered towards a crisis, polarising the court so severely that no one had the time or energy to think about revising trade policy. To make matters worse, the new thirteen-year-old emperor, who had grown up deep in the interior of the realm, had no grasp of maritime issues, and no interest in them either. Pires's embassy was sent back to Canton, and the Portuguese who were involved in trade there were ordered to leave the country. That order was backed by military force. Portuguese ships that did not leave the area found themselves under attack from the Ming navy under the command of Maritime Defence Vice-Commissioner Wang Hong whom, as we noted earlier, the *Veritable Record* singled out for praise. The two sides were evenly matched in technology, but the Chinese outnumbered the Portuguese and blockaded their ships. Sea battles ensued. Eventually some of the Portuguese vessels broke through the blockade and returned to Malacca, stranding Pires's embassy in Canton.

The following summer a second Portuguese embassy arrived to seek a treaty of friendship, but Beijing was not inclined to give the request a hearing. The Ministry of Rites advised the throne to regard the Portuguese as pirates and spies and to 'drive them away quickly so that they do not enter the borders'. As for Malacca, the ministry had to admit that nothing could be done. A Ming naval expedition to force Portugal to return Malacca to the ousted sultan was out of the question, although as late as 1524, Jorge de Albuquerque warned the king of Portugal that there was a danger that a Ming fleet might sail to Malacca to drive the Portuguese from the base. A century earlier that could have happened, but not in 1524. By then the Ming was a Great State in name only, not in ambition. It kept within its borders, and there was no obvious reason why it should do otherwise.

Closing the Coast

In 1525, Emperor Jiajing shut down the coast: not just the Guangdong coast but the entire coast of China. No ship of more than one mast could set sail. The ban allowed small fishing vessels to ply their trade close to the coast, but that was the extent of legal maritime activity. Tribute embassies from foreign rulers bearing official authorisation could still land, but no other foreign ships could approach the coast. A viceroy appointed in 1529 to oversee Guangdong and Guangxi provinces tried to revive the argument for reopening trade, estimating that it could yield a monthly customs revenue of several tens of thousands of ounces of silver, but the relaxation of trade restrictions he won applied only to tribute missions. The coast was closed and would stay closed for another forty-two years until the emperor who imposed the ban died.

The officials in Canton who had been attempting to ease the restrictions on maritime trade prior to the 1525 ban were not arguing that trade should be free. Ming officials across the board understood that international trade should be conducted in relation to foreign policy as a state monopoly. Goods coming into the country should be restricted by type and amount, and traders who had no diplomatic standing, at least by proxy, should be kept outside the system. In the 1510s a shift had been under way, a shift towards recognising that maritime trade might legitimately have a revenue logic as well as a diplomatic logic. Trade would remain a state monopoly, but a monopoly that served the state by contributing to its fiscal well-being, not just to its status.

This view should not have surprised any Europeans of the time, least of all the Portuguese, for whom maritime trade also functioned as a monopoly under state supervision. Indeed, not until the nineteenth century could European mariners operate free of government monopolies. The problem, other than simple greed, was the Alexandrian mindset (if I may call it that in honour of the author of *Inter caetera*), extending centuries into the European past, which regarded the world as available for religious conquest. If the Portuguese misjudged the situation once they reached Canton, it may have been because of their relative success with lesser states around the Asian littoral. Only when they reached China were they in the presence of a state that exercised a monopoly that it expected foreigners to observe,

and that had the naval capacity to enforce that observance. The Ming did discover that the Portuguese had some advantage in marine gunnery, but the weapons gap in 1517 was not such as would cripple China's capacity to defend itself. And thanks to an enterprising police officer named Heh Ru, who captured some of the Portuguese guns, the Ming soon acquired Portuguese cannon technology. The military commander of south China asked the court in May 1524 for permission to learn the casting technology to manufacture similar weapons in both Canton and Nanjing, and was not only given clearance but allowed to put Heh Ru in charge of the project.

Portuguese misconduct was not uniquely responsible for altering the direction in which Ming maritime policy was moving. The decision to turn away from open trade came about in relation to pre-existing policy conflicts internal to Ming politics. But in politics, timing is often everything. Resorting to violence, as the Portuguese did at Malacca and on the China coast, was spectacularly mistimed. Violence earned them profitable windfalls in some places around the Indian Ocean and the South China Sea, but it did not win them entry into trade with the Ming. Indeed, it had precisely the opposite effect. When Jiajing's successor did eventually agree to reopen Canton for foreign trade, he specifically singled out the Portuguese for exclusion. The Portuguese managed to acquire a toehold for their China trade on the tiny peninsula of Macao in 1557 and operate trade between there and Japan profitably for a century, but they were never granted formal status by the Ming. A certain evil reputation lingered. A century later, Chinese were still talking about how badly the Portuguese had conducted themselves in Malacca. As one well-informed author wrote in 1617, Malacca was a dangerous place. First, there were the huge saltwater crocodiles: 'they bite whomever they encounter, causing instant death'. Then there were the black panthers in the hills: 'they can change into human shape and slip into the markets in broad daylight'. Then comes the punch line: 'Together with the Portuguese, these are rightly called "the three dangers of Malacca".'

Another unanticipated consequence was the impression of Chinese foreign relations that the ban projected to the world. Shutting out the Portuguese has been treated as the original sin of Chinese foreign policy, sufficient to prove the claim that the Ming was lost in

a haze of 'consciously anachronistic grandeur' that prevented it from responding intelligently to the coming of Europeans. Ming Chinese were caught 'gazing abstractedly out from the Flowery Kingdom with a kind of measured dignity', as one florid writer put it in 1970. They were lost in 'a fine, Chinese, obscurantist dream. The hostile world was more or less successfully excluded for the time being as China prolonged that intensely national reverie, a sleeper reluctant to wake to the morning of the world's reality.' This is all hilarious nonsense, dressed up in anachronistic remnants of anti-opium rhetoric from the nineteenth century. It is easy for us to laugh at this language – less easy when it comes to spotting the legacy of suspicion that has returned in full force today: that China operates an arrogant foreign policy; that the Chinese state is inherently hostile to foreign trade; that it favours monopoly over free trade; that it imposes unfair disadvantages on its trading partners; and that any sign of deviation from this posture must be attributed not to policy debate but to factional interests and, of course, corruption, eunuch or otherwise. Some of these accusations may stand up, but they flow from a deep well of misunderstanding.

What is clear from this chapter is that Chinese trade policy in the sixteenth century was fluid, but, more than that, that it was sensitive to shifts going on in the world beyond China's borders. Trade in itself was neither good nor bad: its virtue or vice depended on whether its promotion generated conflict or minimised it. Some Ming officials – most notably, Commissioner Wu Tingju – saw the benefits for state revenue, which could be used to strengthen his government's capacity to impose greater security along the south coast. Others saw only the violence and disorder that foreign sailors brought to China's shores and could see no gains in trade sufficient to offset these losses. The court's decisions were based on insufficient knowledge and short-term anxieties, but this is usually how states make decisions. The irony is that the Portuguese disrupted both foreign trade and diplomatic relations – unintentionally to be sure, but the effects were real – by derailing a policy shift that could have put trade between China and Europe on a very different footing. But we should be careful about putting the two parties in opposite camps. What the Ming state did to protect its borders and interests in the 1510s was not all that different from what European states were doing at the time. Had armed Chinese

ships appeared at the edge of its coastal border, the Portuguese crown would have acted no differently in defending its monopoly on maritime trade arriving in its ports. So Ming China is not really the counter-example to Europe that some have supposed it to be. If there was significant difference between them in maritime policy, it emerged only after the eighteenth century, as the global structure of empires shifted and rapid advances in military technology gave European states the means to enforce unequal terms of trade.

Emperor Jiajing may have imagined that he was protecting the dynasty when he closed the coast in 1525, but he also placed the Ming – again unintentionally – at a serious disadvantage. So long as there was no contact, except for smugglers, it was impossible for people of the Ming to learn what was going on in the wider world. This was a bad time to step out of global contact, as one European state after another moved out onto the seas to build empires, each trying to move ever closer to China. While borders confined Chinese, frontiers lured foreigners: a world divided by yet another line, and not as straight as Alexander's.

The Englishman and
the Goldsmith

Bantam, 1604

At the end of the first watch, after checking that the East India Company (EIC) compound was secure for the night, Edmund Scott climbed the stairs to his bedroom. It was 5 June 1604, and he was headed for sleep upstairs in the English house in Bantam on the island of Java. An hour later, one of the nine Englishmen under his command rushed up to announce that the place was on fire. 'Oh this word Fire!' he wrote later in his memoir. 'Had it been spoken near me either in English, Malay, Javan, or Chinese, although I had been sound asleep, yet I should have leaped out of my bed: the which I have done some times when the men in our watch have but whispered one to another of fire.'

Scott was an agent of a company formed in 1600 when Elizabeth I handed a group of London merchants a charter to trade with Asia. The company's First Voyage, as it was called, carried Scott and twenty-two Englishmen to Java in 1603. Scott had paid the handsome sum of £200 as a share in the new company to secure the privilege of a place

on the voyage. They were assigned the task of setting up a base of operations, a 'factory' in the language of the time, from which the company intended to engage in trade throughout the region. Bantam, at the western end of the island of Java, was then a port city of 40,000 – roughly two-thirds the size of Amsterdam and possibly the largest city in South-East Asia. As the two men who outranked Scott died in their first six months, the leadership of the factory fell to him. He acquired property for the company in a suburb on the east side of the city where the other foreign merchants, mostly Chinese, lived. The house he built, six metres wide and twelve metres long, was regarded as the finest private building in Bantam. It was meant to impress, to set the English apart from everyone else. The upper storey had a gallery, dining room, kitchen and bedrooms, while the lower storey served as the goods storehouse. Several smaller outbuildings, including a pepper house, were arranged around a pond in the centre of the property, which was enclosed on all sides by a wooden fence and a ditch.

The watchman told Scott that he had 'felt a strong funk of fire' but couldn't find where the fire was burning. Scott raced down to join in the search. One man remembered the rat hole they could never manage to seal up behind a trunk in the kitchen, and when they pulled the trunk away from the wall, they saw a plume of smoke waft out of the hole. Scott rushed downstairs and threw open the doors to the storehouse, 'whereat came out such a strong funk and smoke that had almost strangled us: this smoke, by reason it had no vent, was so thick, that we could not perceive whereabouts the fire was'. Of immediate danger were the two kegs of gunpowder just inside the door. They were already hot to the touch, but Scott and his men rolled them out and stashed them away from the house. When they went back into the warehouse, their candles guttered for lack of oxygen. Only by tying twelve great candles together into a torch could they produce enough light to see their way into the smoky darkness and remove the goods stored there. By this time, the commotion had attracted the notice of Scott's Chinese neighbours. Scott needed their help and let them in.

'Why don't you break a hole in the roof and pour in water?' one of the Chinese merchants suggested. Scott said no. He feared that opening a hole overhead would vent the fire, which 'would have flamed up

to the thatch before we should have gotten half water enough: and when we had a fire over our head and under foot, and all the houses round about us, it had not been possible to have saved the worth of one groat'.

'Then let us knock down the walls. Much faster', another proposed. Scott feared that would turn the rescue into a free-for-all scramble for the company's goods. He wanted them to go in and out of the storehouse door so the rescue would be orderly, and so that he and his second-in-command could keep track of the bundles coming out and make sure none was quietly thrown over the fence to the Chinese on the other side.

Scott suddenly remembered £1,000 in gold he had concealed in a chest in his bedroom. This he could not afford to lose, so he rushed back to rescue the chest, intending to throw it in the pond. Once he got to his bedroom, however, he decided to leave it where it was. When he looked into the dining room, he found several Chinese tearing up the floorboards to break through the brick ceiling of the warehouse beneath. Suspecting their intent was pillage, he chased them out roughly. Then he went back outside and handed out forty tickets to those helping to empty the warehouse, promising to pay them next morning at the rate of one piece of eight (peso) per person. He thought that was generous for half an hour's work, though they grumbled that they were saving him from an enormous loss and should receive a better reward.

Once all the bundles had been pulled out and the fire quenched, Scott surveyed the scene. 'Our house and yard lay like a small town that had been newly sacked by the enemy, and goods lay, some half burnt and some trodden in the mud and dirt, and what with fire and water, much was spoiled.'

The answer to how the fire had started arrived next morning. An English surgeon plying his trade in Bantam showed up to share a conversation he had had that morning with a Dutch patient, who told him that a Chinese bricklayer said that Chinese had set the fire. The surgeon asked to see the room in the warehouse where the heat and smoke had been most concentrated. After looking about, they discovered a small hole in one of the floorboards. Scott stuck a stick through the hole and could not touch bottom. He called for an axe and pried

up the board. Directly underneath was a tunnel that ran south in the direction of the Chinese inn across the fence. One of the Englishmen dropped down into the hole and saw that it was big enough for men to carry goods from the warehouse out to the neighbouring property.

Scott collected three of his men and slipped around to the inn. He posted one of them at the door to prevent an escape, then he and his two other companions rushed in and grabbed the three men they found in the first room. Two more men in the next room escaped through the back door before the English party could seize them. Scott took his three captives back to the English compound, clapped them in irons and then set off for the court of Bantam to demand justice.

We know about this episode from the memoir Scott published the year after he returned to London in 1605, *An Exact Discourse of the Subtilties, Fashions, Pollicies, Religion, and Ceremonies of the East Indians*. The book is vastly entertaining for its tales of the troubles the English had in trying to penetrate the Asian market, but it is also filled with fascinating information about the lives and travails of Chinese working overseas. Chinese merchants kept detailed records, but no records from Bantam survive. We have only European accounts from which to tell their story. Scott's vision is skewed by his own blindnesses and anxieties certainly, and yet without accounts such as *An Exact Discourse* we have no way back to that community.

Terms of Trade in the South China Sea

Bantam was a central node in an extensive trading system that had emerged in the preceding decades to trade goods around the South China Sea and beyond. It was a trade to which Europeans were not initially essential, though their aggressive pursuit of markets in the region and the supply of precious metal that they brought to pay for their purchases gave them an ever greater role in shaping the market, and eventually in dominating its upper layers. By the time Scott arrived in 1603, the Portuguese had Macao on the south coast of China, the Spanish had Manila on the island of Luzon in what they called the Philippines and the Dutch had just recently established a presence in Bantam. What had been an intra-Asian trading system had become an international one.

Bantam was favoured with a large natural harbour and by its location just inside the Sunda Strait, which leads between Sumatra and Java into the southern zone of the South China Sea and further east to the Spice Islands (see Map 4). The city was laid out in three sections along the waterfront, each with its own market square. Its middle section was the royal precinct, surrounded by a brick wall on which cannon were mounted at intervals. The large public square in the city centre was where the king convened the royal council and presided over the law court. It also hosted a morning market. The king's palace stood on the south side of the square, the residence of the shāhbandar, or port master, was on the east side and the mosque was on the west. The rest of the walled city was taken up by the residential compounds of the nobility (see Plate 11).

The other two sections of the city, also palisaded, formed wings across the narrow river channels on either side of the royal precinct. To the west lay the Pacinan, literally 'China-town'. Scott notes that in the time he was there most of the houses and warehouses in the Pacinan were being rebuilt of brick to withstand the constant outbreaks of fire. Since it was the practice of Islamic port cities to allocate separate quarters for foreigners, not only Chinese but Dutch and then English as well were directed to locate their houses there. This explains why Scott had Chinese neighbours. The eastern wing of the city was formed around the Karangatu market, which the English called the Great Market. This was where most of the import/export trading in rice, sugar and aromatics, as well as the sale items of everyday use from fruit to knives, was conducted. The wholesale pepper trade was handled separately outside the market's eastern palisade because of its rank smell. Chinese, Bengali and Gujarati merchants set up their stalls within the market and handled most of the bulk trade.

A city of multiple communities, Bantam drew traders and labourers from all over East and South Asia. The Chinese were the predominant community of traders and skilled labourers. They controlled trade to most of the rest of East Asia and were also the producers of local commodities. They grew the pepper in the hills, harvested it and transported it down to the city. They were Bantam's farmers and building contractors, brewers and cooks, tailors and furniture makers, pilots and sailors.

What enabled Europeans to buy their way into the trading networks that ran in and out of Bantam was the great windfall of Spanish silver from their colonies in Mexico and Peru. The effect of the flood of American silver with Europe and Asia was to change the South China Sea economy from a fairly loose network of seasonal trading to an integrated system of regular commodity exchange. European demand for Chinese commodities, combined with the capacity of the Chinese economy to absorb large amounts of silver, made Chinese merchants central to the entire system. Without their participation, what we might call the global economy of the early modern world could not have taken form.

The Ming court, as we saw in the previous chapter, had been reluctant to allow private trade between Chinese and foreigners. Emperor Jiajing's ban in 1525 on coastal trade remained in place as long as he lived. An attempt to revive the three maritime customs posts along this coast in 1561 to respond proactively to what was happening out on the oceans got up to ministry level, but no further. Only when Jiajing died in January 1567 could his son, Emperor Longqing, ease the ban. The end of the prohibition was uncannily well timed, coinciding with the rise of American silver coming onto the world market. As silver found its way to the Philippines, Thailand, China, the Moluccas and Japan, among other locations, the South China Sea trade networks were transformed into an international economy linking the region to places as far flung as Madagascar, Mexico and Madrid. Without either of these changes, Edmund Scott would not have been in Bantam in 1604, nor would most of his Chinese counterparts, for that matter. The Europeans brought the silver, the Chinese the commodities.

The Ming court's refusal to allow foreigners to trade on Chinese soil meant that foreign trade had to take place offshore. The exception was Macao, a long thin spit running out into the ocean where, as of 1557, the Portuguese were informally permitted to come ashore to repair their ships. Chinese sources of this period are silent about Bantam, but they have rather a lot to say about Macao. This was China's first foreign trade city, and it attracted a huge Chinese population. Everyone from silversmiths to prostitutes flooded into Macao looking to make a living. Rampant smuggling fuelled great anxiety in official circles, however. Not a few officials and private gentlemen slipped into

Macao to see what these foreigners were all about – and were amazed by the bustling city they found there.

Wang Linheng, an official posted to Canton at the turn of the seventeenth century, heard that 'as many as ten thousand families have moved to Macao, which amounts to a population in excess of a hundred thousand'. Wang may never have spoken to a European, but he took a keen interest in them. In the book of memoirs he compiled shortly before his death in 1603, he devoted one of its eight sections to what he could find out about them. 'The foreigners from the Western Ocean have deep-set eyes and prominent noses, bald heads and curly whiskers', Wang began. 'They dress themselves in flowery clothing, the handiwork so fine as to catch the eye. When they talk, it comes out as *chengli gutu* and is completely incomprehensible.' (Unable to transcribe the sound of Portuguese, Wang here was borrowing a Han-dynasty transcription of the Hun title 'Son of Tengri', his way of saying that their speech was gobbledygook.) Of six Dutch sailors the Portuguese had taken hostage and handed over in 1601, Wang heard that 'their hair and beards were entirely red, the eyes were round, and they stood over three metres in height'.

What most caught Wang's eye, though, was European craftsmanship. Everything they ate and used, he declared, was of the finest manufacture. When a eunuch tax inspector passed on to him a tray of a dozen cakes and a bottle of wine he had received from foreigners, Wang was fascinated. He saved the bottle for later, but tasted the cakes and was impressed that each was differently flavoured and ingeniously decorated, suggesting a skill beyond anything a Chinese confectioner could make. He even noticed the finely patterned linen napkin draped over the tray, 'skilful in the extreme' and quite beyond anything Suzhou weavers could make. Wang also commented on the realism of European paintings and statues, which suggests he visited the church of St Paul in Macao, the ruins of which still stand today. He repeated with amusement the anecdote of a friend who thought the statues were living people and went up to speak to one of them. Wang also mentioned hearing an organ, a virginal and a chiming clepsydra, presumably in the church, and marvelled at the skill of artisans who could make such machines.

Wang understood that trade lay at the heart of these marvels.

He wrote that European ships arrived in April or May to trade, then went on to Japan and other places in East Asia looking for business and loading cargo to take back. The capital involved was enormous. He mentions watching three ships sail up to the mouth of the Pearl River, each of which, he claims, 'forwarded 300,000 ounces of silver to the tax inspector' – the one who sent him the cakes and wine – 'upon which they were permitted to enter the city and trade with the common people'. This wealth amazed him, but it troubled him too. The foreigners were supposed to keep their ships downriver at Macao and leave Canton as soon as the annual trade fair was over. 'Over time, however, the laws have become lax' as foreign merchants bribed Chinese officials to turn a blind eye to smuggling. 'We are unable to exercise the full letter of the law to control them, so for the moment they just do as they please.' He noted that some officials wanted to keep the trade within the limits set by the central government, yet 'the foreigners have so much silver that the profits from a single visit are many tens of times the costs, so that it is impossible to forbid the trade'. Wang did not advocate shutting the trade down, but the opportunity for corruption worried him.

No Chinese in Bantam has left us his impressions of the foreigners. What we know is whatever the English and Dutch thought to write down, though they wrote from their perspective as uneasy competitors in this market. 'The Javans and the Chinese from the highest to the lowest are all villains and have not one spark of grace in them', Scott wrote in a moment of pique, 'and if it were not for the Shāhbandar, the Admiral, and one or two more, there were no living for a Christian amongst them without a fort or very strong house, all of brick or stone.' Yet Scott also offered sympathetic glimpses of his Chinese business partners, the men with whom he bought and sold, who stored goods for him and passed on information about local politics: 'our friends', he called them at one point. But *An Exact Discourse* is not so much about those men. It is about the endless difficulties of operating in a hostile environment, the conflicts that he as head of the factory had to manage and the never-ending efforts he had to make to ensure that the English would be treated and judged fairly. His publisher advertised the book as a treatise on the 'fashions, policies, religion, and ceremonies of the East Indians, as well Chinese as

Javans', and a lot of such ethnography found its way in, but *An Exact Discourse* is really a morality tale on the importance of staking out the moral high ground by celebrating what Scott felt to be an innate English capacity for upholding the rule of law.

Justice Territorial and Extraterritorial

Scott's concerns concerning law arose in part because Bantam was deep in a political crisis that at the time he arrived had been twenty years in the making. The crisis was the result of the city's commercial success. That success brought a large influx of traders and labourers, mostly men, at first from communities all over the region – Chinese forming by far the largest group – but eventually from places as far away as northern Europe. The presence of these incomers both enriched and threatened the soil-based nobility, who looked to merchants to provide them with their needs and luxuries but not to compete with them as social equals. In time, though, it was from the ranks of these people, who brought literacy, numeracy and the organisational skills needed for trade, that the royal family recruited administrators for the realm. The old aristocracy was unhappy.

As such men moved into the upper levels of the state, the distinction between local nobility and foreign-origin experts became blurred, although everyone still knew who was *pangeran* (the local elite) and who was *ponggawa* (administrators from commercial backgrounds). The regent in Scott's time was a *pangeran*, but the previous regent had been *ponggawa*. (Three years after Scott's departure, the *ponggawa* clique, unhappy with having lost the regent position, had him killed, but could not secure the next appointment for one of themselves as the post went to the king's uncle, again a *pangeran*. The uncle was able to resist *ponggawa* attempts to oust him through to the 1620s, though as a result the *ponggawa* faction abandoned Bantam for Jakarta. The Dutch moved with them, and then capitalised on the new circumstances to turn Jakarta into their colonial base, side-lining Bantam. But that outcome lay in the future.) Scott appears to have been unaware of the depth of this conflict. I mention it because it must have shaped how the court responded to the matter of the fire in his compound on which Scott sought judicial action.

Bantam being a crowded city of wooden and bamboo buildings

thatched with straw, the penalty for arson, according to 'the law of the country', was death. Scott went to the court the day after the fire to demand that such justice be done. The king at the time was Abdul Kadir, a boy of twelve when Scott first met him. (Impressively, Abdul Kadir managed to remain king until his death 1651.) The most powerful person at court was his widowed mother, Nyai Gede Wonogiri. Scott sought her out from time to time for special favours, though always at a price. The public affairs of state were handled by a regent, a *pangeran* named Camara who had married Abdul Kadir's mother, probably in a deal to secure his authority. Scott dealt often with two other figures of authority. One was Ngabehi, commander of the king's galleys, head of his security and the person to whom foreigners went to sort out their affairs. Scott refers to him as 'our very good friend'. The other was the shāhbandar, a Persian term widely used throughout the monsoon world to designate the port master who met every ship and imposed duties. Both were *ponggawa*, the latter said to be a Tamil.

The fire in the EIC storehouse was not the first time Scott had brought a legal matter to the court. The previous summer his men had caught a Javanese slave setting fire to a thatched roof upwind of their compound in the hope that arson would cause enough confusion for him to steal from the property. (Most Javanese in Bantam were slaves, bound to the *pangeran* and *ponggawa* lords.) Scott had delivered him to Ngabehi for punishment. Ngabehi had passed the arsonist on to the king, but no punishment followed as the slave's master was one of the king's friends. The *pangeran* regarded themselves as above the law, even the king's. Later, in another context, Ngabehi observed to Scott that 'the notables here are a sort of beggarly poor men, and would seek the spoil of all such merchants as you, which come thither to trade. If you had not had a strong house, and kept especial good watch, they would have cut your throats long ago.' This was the warning of a *ponggawa* against the *pangeran*, though it is not at all clear that Scott understood what he was being told.

The same Javanese man was again a suspect shortly afterwards, this time in connection with the killing of a Dutchman. The Dutch went to the court clamouring for the man to be executed. There were two problems: one was that they had no proof that he did it; the other

was that death might have been the penalty for murder in Europe, but not in Bantam. This difference put the Dutch in the position of demanding that the regent apply territorial justice but pronounce an extraterritorial sentence.

Extraterritoriality is a legal arrangement allowing foreigners to be subject to their own laws, even when they find themselves in a territory subject to different laws. The concept is still with us, a common example being diplomatic immunity. Whether a ruler could apply local law in matters pertaining to the affairs of foreigners would grow to become a major obstacle to relations between European traders and Asian rulers right down to the nineteenth century, most conspicuously during the Opium Wars, when Britain pressed China to grant formal extraterritorial status to British nationals, releasing them from the unilateral jurisdiction of Chinese courts. This exemption from Chinese law ended only in 1943, when Japan renounced its right of extraterritoriality in China – an empty gesture, given that a third of China was under Japanese military occupation at the time, but it had a certain popularity among Chinese and shamed Japan's enemies into making the same concession.

In fact, local rulers were often willing to hand off certain legal functions to foreigners in matters where there was broad agreement between the provisions of territorial and extraterritorial law: theft, for example. Shortly after Scott arrived in Bantam, the king told the commander of the First Voyage that 'whosoever he took about his house in the night' – that is, apprehended for having snuck in – 'he should kill him'. After four or five house invaders were shot, 'we lived in reasonable peace and quiet'. The king saw no need for him to exercise justice in this matter, even though the thieves were his subjects; he left it to the English to deal with. Their remit was eventually broadened to include permission to chase thieves not just out of their compound but anywhere in the Pacinan, the western section of the city.

It was not unusual for a ruler to transfer the authority to punish a subject who had committed a crime abroad to the ruler who was sovereign in the jurisdiction where the crime was committed. Tokugawa Ieyasu, the general who in 1600 founded that last great shogunate in Japan, notified rulers in South-East Asia that if any Japanese within their jurisdictions committed offences, they should 'punish them

immediately according to the laws of your country'. By granting foreign rulers the authority to punish Japanese, Tokugawa was waiving extraterritorial privilege. The entitlement the English enjoyed was different: the king invested them with territorial authority in defence of the English factory in Bantam, but not necessarily in other matters of legal jurisdiction. What the Dutch asked of Camara, the king's uncle, in their homicide case was different again: that the territorial authority impose an extraterritorial punishment on a subject for a crime committed within that territory. The possibility that such variation could be tolerated is a measure of the legal pluralism that became common in places where people were thrown together and had only limited recourse to an external sovereign authority.

Camara responded to the Dutch by moving the discussion to general principles and asking what rules they thought should apply.

'When you come to a country to trade', he asked, 'do you bring the law with you, or are you governed by the laws of the country you are in?' This was the crux of the matter, and an issue of some concern to the regent. Would the Dutch accept his authority as legal arbiter? Perhaps surprisingly, given the later history of European colonialism, they did.

'When we are aboard our ships, we are governed by our own laws', the head of the Dutch delegation answered. This principle of bringing the laws of your territory with you while on the ocean continues to be standard practice today. 'But when we are ashore, we are under the laws of the country we are in.' The Dutch were not yet seeking extraterritorial privilege – the right not to be governed by the laws of the territory in which they sojourned – as they later would.

'Well then, I will tell you the law of our country, and it is this', Camara stated. 'If someone kills a slave, he must pay 20 pieces of eight', referring to what had become the standard trading currency in the region, Spanish pesos minted in Mexico; 'if he kills a freeman, 50 pieces; if a gentleman, 100 pieces.' (Note that foreign trade was so much part of daily life by 1604 that the most widely recognised currency was Spanish.) European law knew this penalty as bloodwit (or weregild), though the practice had disappeared some three centuries earlier. The Dutch were unhappy with this law. In their legal culture a death merited a death, but they could not impose that locally.

Accepting territoriality, they demanded the regent sign a statement regarding these prices. But they shaded their acceptance of territoriality by refusing to accept the payment that was due to them. They presented it as a matter of honour, but it was also a tacit refusal to accept fully the jurisdiction of Bantamese law.

The following April, the English were embroiled in their own case of murder involving foreigners. The case centred on a man Scott identifies as a 'mulatto', a term used at the time for someone of mixed European (white)/Asian (black) parentage. The term is quite out of fashion today (though it was still a category in the 2000 US Census), but I use it for want of knowing enough about him to re-describe the man in our terms. What Scott tells us is that he was a Christian from the trading port of Pegu, on the east side of the Bay of Bengal, who had grown up among Portuguese. He had arrived in Bantam from Siam on an English ship and was staying at the East India Company house. He ran into a fellow countryman from Pegu who had just arrived as a crewman on a Dutch ship from Patani. They went out drinking and bumped into an officer from the second man's ship, also intoxicated, who ordered the sailor back on board. When the man from Pegu refused, his superior struck him for insubordination. The mulatto Christian, being 'somewhat tickled in the head with wine', went home to get a rapier and a knife and returned to confront the Dutchman, bringing another friend, a slave of the shāhbandar who had grown up in Manila. The mulatto argued with the Dutch officer and stabbed him, then in his drunken craze stabbed his Pegu friend. He would have killed the shāhbandar's slave as well, had the man not run off. On his way back to the English house, the mulatto stabbed the next person he met, a Javanese.

Before he died, the stabbed officer identified his attacker as a black Englishman. Fellow Dutch officers descended on the English compound demanding blood. In the Dutch view, the mulatto was a non-territorial person and therefore need not be tried by the law of the territory. They feared that bloodwit would arise and so block the penalty they wanted, which was the man's death. Scott did not like being pressed by the Dutch on the matter. Rather than assert extraterritorial jurisdiction, he wanted the Bantamese court to handle the case, not least because the shāhbandar would have an interest in it, though 'if

he had slain no more than the Javanese, he should not have died for that'. When the Dutch returned the next day demanding the culprit, Scott led them all off to the court.

The regent had heard the story by the time they arrived, so Camara got right to the point, demanding 50 pieces of eight for the dead Javanese. That went nowhere when the Europeans reminded him of the document he had signed setting that price as the bloodwit for a freeman, not a slave. Scott also pointed out that if the prisoner forfeited his life, that penalty cancelled out the lesser penalty of bloodwit.

'I have nothing to do with Hollanders who are slain,' Camara replied, 'nor with your laws. You might agree among yourselves, but for the Javan, the King must and will have money.' The price, he declared, should be 50 pieces.

'I would rather deliver the guilty party to you', Scott replied, 'so you should have man for man. You might save his life if you will.' Scott knew this was not going to go anywhere. He realised that 50 pieces was a modest demand, and that the regent could do more harm to the English if he did not pay that amount. The Dutch erupted at Scott's suggestion that the regent might allow the prisoner to live. 'He should die, even if there were no more men in the world', one insisted. Scott replied that this was within his discretion, not theirs, though he said this to annoy them. He had already decided that the man had to die, given 'that the deed was so odious before God and Men, and that I feared the blood of those Christians that were murdered would cry out to God from the earth for vengeance against me.'

Fearing the argument might turn violent, Camara sent the king out and told the Europeans he had other business to attend to, though to expedite the matter he would accept the posted price of 20 pieces of eight. The Dutch wanted to pay so that they could then claim the prisoner and execute him. Scott insisted that he should pay and retain custody of the prisoner. Realising now that Scott would execute the man, the Dutch gave in. When two of the Dutchmen told him that he should make the man suffer when he killed him – 'he should have the bones of his legs and arms broken, and so he should lie and die', declared one, 'or else have his feet and hands cut off, and so lie and starve to death', insisted another – Scott replied that 'he shall die the ordinary death of the country, and no other': execution without torment.

Scott took the mulatto back to the company house, telling him that as a Christian he should prepare himself for death, for he was to be executed the following morning. The mulatto spurned his advice. A Christian Arab who knew Spanish and had come to Bantam on a Dutch ship overheard their conversation. He sat down with the man and talked to him about the mortal seriousness of his offence and the infinite mercy of God, should he repent. Scott marvelled at the Arab's persuasion. 'Within one half hour he brought him to be the most penitent that ever I heard in my life.'

Scott then had to book the executioner. The man who did the job had come to him a week earlier for a gratuity. He had executed a Chinese counterfeiter guilty of coining false pieces of eight. The Dutch had followed the case closely and had given the executioner 2½ pieces of eight as a reward. The man thought Scott should show the same appreciation. Scott had refused, saying that the case had nothing to do with him, but had promised to pay double if he should ever have need of his services. Declaring that an Englishman was always as good as his word, he now agreed to pay him 5 pieces of eight to dispatch the mulatto. That payment meant that Scott could keep his promise of a gentle death if the mulatto confessed, which he did. The executioner had put the counterfeiter to a gruesome death, but for the mulatto Scott gave him his own knife and asked him to do the job in one stroke, which he did, 'for belike he dreamed I should have more work for him shortly'.

Scott's argument – that the mulatto could be punished only once by either bloodwit or the death penalty, but not twice by both – did not in fact prevail. By paying the mulatto's bloodwit, Scott was free to execute the man according to English law. As the man had killed three men under three different jurisdictions, though, he could theoretically be punished according to the legal remedies of all. For the Javanese, bloodwit was paid and no further action was taken against him. For the Dutch ship's officer, he was sentenced to death. As for his fellow Pegu native, no one seems to have cared. Despite his status as a Dutch employee, the Dutch made no claim on his behalf. What determined the entire process, from extraterritorial custody to extraterritorial penalty, was the mulatto's status as a Christian and an English employee. Had the murderer been Javanese, Bantamese law would have prevailed.

Dispensing English Justice

Two months later, Scott found himself asking for territorial justice from the Bantamese court but having to dispense it himself. He had three Chinese suspects for the fire in custody: the man known to reside at the neighbouring property (it seems his name was Sawwan, from later evidence Scott obtained), a Chinese from Jortan (now Srivijaya, further east along the coast of Java) and a third man. He knew others were involved, and he wanted them all brought to justice. The first thing he did was send his second-in-command to Camara 'to certify him how the case stood, and to desire him that they might be sought out, and have justice done upon them, which he promised should be done'. Before the morning was out, the king's secretary arrived and vouched for the third as a kinsman, insisting the man knew nothing of the matter and that he would return him for justice if evidence to the contrary came forward. Scott had to let him go. No one protested that Sawwan was innocent, but several Bantamese approached Scott to speak on behalf of the man from Jortan. Disinclined to release another suspect, Scott promised that the man would be well treated and released if nothing was proved against him, as indeed he eventually was.

Camara did not arrive until the following day, which annoyed Scott and led him to suspect, incorrectly as it turned out, that he had a hand in the matter. Scott took him down into the tunnel to show him what had been done, and demanded justice. Camara told Scott he was on his own. He could mete out whatever justice he saw fit, as neither man in custody was Bantamese. Camara suspected the man from Jortan was innocent, but he left that determination too up to Scott. He could execute him if he liked. Scott wanted to avoid the public outrage of executing an innocent person, but more to the point he wanted the regent to show that he would back the English when injury was done to them. But to no avail: Scott had to dispense his own justice.

Scott needed Sawwan's confession before he could execute him. Under torture, Sawwan confessed and named his accomplices. He and Uniete, the proprietor of the inn, were the architects of the plan. Hynting and Boyhie he named as the main diggers, but neither of the two men Scott had apprehended on site was involved. This confession was not enough for Scott. He worried that Sawwan and the others

had been put up to this trick by 'some great men of the country, or the rich Chinese', who wanted to see the English factory fail. He tortured the man again, but reported that Sawwan 'roared out and said, he would accuse no man that was not guilty, how much soever we did torment him'. The English were not the only ones who understood what justice required.

That afternoon, however, Sawwan withdrew his confession, and Scott was back where he started: with no substantial evidence. He decided on a different tactic, offering to spare Sawwan's life if he would repeat what he had confessed under torture. He did so, though Scott suspected he was holding something back. He gave up on learning anything more and ordered the man to be put to death the following morning. Scott gives Sawwan the last word. As he was being taken out to his execution, a crowd of Javanese gathered outside the English compound to watch him die. (Chinese did the same when the execution of a non-Chinese was announced; some had appeared earlier for the mulatto's execution, hoping to have the satisfaction of watching an Englishman die and disappointed when he turned out not to be white.) As Sawwan was borne out of the compound, he addressed his audience. 'The Englishmen are rich, and the Chinese poor, so why should we not steal from the English if we can?' Scott includes this comment as evidence that the local Chinese and Javanese 'hated us for our goods'. The lack of trust here was as much between rich and poor as it was between Chinese and English.

The day after Sawwan's execution, Ngabehi delivered to Scott a second man, a goldsmith suspected of starting the fire. Ngabehi had succeeded in getting him to confess to coin-clipping (shaving bits off the edges of silver coins) and counterfeiting (mixing tin and other cheap metals into the silver), but not to starting the storehouse fire. Ngabehi could have executed him on those charges, but instead handed him over to Scott to show the English that he, whether as head of security or as a *ponggawa*, was willing to act to protect their interests. When the goldsmith refused to say anything, Scott turned again to torture. His description of what his men did to the suspect – burning, cutting, drilling, crushing and exposing the man's body to be eaten by ants – makes for one of the most gruesome passages in Jacobean literature. The process so appalled the Bantamese soldiers Ngabehi assigned to

protect the English compound that they pleaded with Scott to shoot the goldsmith and be done with it. Scott piously replied that 'in our countries, if a gentleman or a soldier had committed a fault worthy of death, then he was shot to death'. Someone who was neither did not enjoy that privilege. By the end of the day, however, Scott was defeated by the man's silence. He had the man tied to a stake, and then ordered a mixed party of Englishman and Dutchmen to shoot him to pieces.

Scott acquired his third suspect by bribing the Bantamese authorities holding him. Boyhie was already known to the English for stealing the EIC commander's sword, and had been punished for it. Scott expected to have to put Boyhie to torture to get a confession, but the man was ready to confess, for which he earned a swift end, a single knife thrust to the heart. Boyhie identified the mastermind as Uniete, the brewer next door, and his partner, Sawwan. He admitted that he and Hynting, whom Sawwan had already named, were the main diggers, but he also fingered Utee, Iccow, Laccow, Onygpayo and Hewscancow. Utee by this time was dead, stabbed for sleeping with a woman he shouldn't have. Iccow and Laccow had fled to Jakarta and were beyond reach. Onygpayo and Hewscancow were protégés of two *pangeran* and therefore untouchable. As for Uniete, the brewer had fled to the hills, but starvation that winter drove him back to Bantam, where he was seized by a wealthy Chinese and handed over to Scott. Preoccupied with dealing with the arrival of EIC ships at that moment, Scott followed the traditional Bantamese penalty of summary execution, which Camara confirmed by consulting the *qadi* or Sharia judge attached to the court. 'Had the situation been otherwise', Scott notes, 'he should have died nothing so easy a death as he did.' Camara closed the case by awarding the EIC the brewer's property.

Trade and Sovereignty

These struggles for justice mattered to Scott. His was the smallest of the legal communities jostling in Bantam for recognition by the others. Throughout his memoir, Scott insists that what set the English apart from all other sojourners in Bantam was that 'we never put up [with] the least wrong that was offered either by Javans or Chinese, but always did Justice our own selves: And that when the Protector

did wrong us himself, it was known that we did not spare to tell him of it soundly.' Outnumbered by every other sojourning group and outcompeted by the Dutch, the English had only their reputation, whether for firmness or justice, to keep their operation alive.

Though Scott presented his handling of judicial quandaries as principled, much about the legal outcomes depended on shifts in circumstances and even mood. Scott's solutions should be seen as instances of the sort of improvisation that went on in every Asian port in which merchants from distant lands engaged in trade. One-time exchanges could leave no footprint, but sustained commerce required infrastructure and institutions. Port facilities had to be available, goods stored, residences set up, trading partners wooed and sexual partners engaged. At every stage, claims had to be made and defended, procedures agreed on and recourse sought from some authority when those claims and procedures were overlooked or denied. A port that hoped to benefit from trade had to provide conditions for managing legal disputes, even if the chief condition was to offload legal responsibility on an extraterritorial basis.

The presence of many trading communities entailed, at the same time, the presence of many legal communities, each operating according to standards and penalties that it took to be correct and necessary, but which others possibly did not. When the conflicts between communities could be managed, we might call this legal pluralism. When they could not, legal anarchy might be the better description. Whatever solution was found depended on who was able to prevail in the exercise of sovereign power.

An instance of this problem arose on 9 September 1604, when the regent issued a proclamation barring Chinese merchants from selling pepper to other foreign merchants – in this case, meaning the Dutch and the English. As pepper was the top trade commodity for both groups, blocking them from buying it was tantamount to shutting down their operations. The reason for the proclamation had to do with loans that the Dutch had given to the regent in a bid to buy favoured access to the local market. They were pressing Camara for repayment, so his scheme was to force the Chinese wholesalers to sell their stocks to him in the king's name and to no one else. He would then pass the pepper on to the Dutch to repay the loans. Outraged

at being cut out of the market, Scott went to Wonogiri, the king's mother and Camara's wife, demanding that this proclamation be rescinded. She called Camara in and let Scott make his case, which he did in the language of treaty obligations between two sovereigns. He reminded Camara that the previous regent had exchanged letters with Queen Elizabeth confirming the right of English merchants to trade at the port. A promise made by a head of state could not be arbitrarily rescinded.

'Would you now cause the King's word, the Queen's, and all theirs, to be broken?' Scott demanded to know. 'Kings must keep their words,' he went on, 'or else they were no kings.'

Impugning the honour of the king was a dangerous move on Scott's part, but he was as desperate to buy pepper as Camara was to clear his debts. Scott then went further by telling Camara about the war between England and Spain in 1585, in which many thousands of lives were lost. 'It is well known to all nations', he boasted, 'that we did not only burn and spoil at home, but also came into those parts of the world, and took away his subjects' goods, the which you yourself can witness.'

Scott was in no position to assume sovereign authority and threaten the violent reprisal of the English state. The royal charter of the EIC, which Elizabeth signed on the last day of 1600, declared the merchants to be 'a body corporate and politick and capable in law to have, purchase, receive, possess, enjoy and retain lands, rents, privileges, liberties, jurisdictions, franchises and hereditaments of whatsoever kind, nature, and quality so ever they be'. Be that as it may, the company was not an agency of the state, nor had the state delegated its sovereign authority to the company. Implying that it had, however, was a device in Scott's toolkit for conjuring up the English throne's protection of his activities in Bantam.

Scott performed a similar conjuring move on one other occasion. The most celebrated day in the Elizabethan calendar was 17 November, known as Ascension or Coronation Day. (Elizabeth ascended the throne that day but was not actually crowned until 15 January.) On Coronation Day in 1603, Scott flew the flag of St George from the top of the company house, dressed the meagre ranks of his fourteen men in red and white scarves and headbands, and marched them up

and down to the beat of drums and gun volleys. One of his purposes for doing this was to distinguish Englishmen from Dutchmen, and it seemed to work, for he reported that street children ran after the marching men crying, 'Englishmen are good, Hollanders are nothing!' The noisy volleys that were part of the following year's celebrations, in 1604, were so impressive that a rumour went around that the English had trained parrots and monkeys to fire the guns, since by then disease had eroded their numbers to only ten.

Scott was able to note the shāhbandar's reaction to the anniversary spectacles. He 'greatly commended us for having our prince in reverence in so far a country'. The demonstration of this was the point of the exercise for Scott, but it was also the problem: at such a distance, London was far away and his sovereign out of effective reach. The reality was that Scott was in Bantam at the pleasure of the king of Bantam, not the queen of England. How unlike the auspices under which Marco Polo worked in China. The Polos arrived with letters from Pope Gregory X, not to borrow the Pope's authority but to use his recommendation to become the Great Khan's men. Factors of the EIC made a very different bid: not to enter the service of a new lord, but to invoke the sovereign protection of the English crown. Company merchants were more than just traders on their own account. The next step, which Spain had already taken in the Philippines, would be to overthrow local sovereignty and replace it with their own. The Dutch did just this in 1619 by establishing a second factory further east along the coast in Jakarta. Eight years after that, they overthrew the ruler of Jakarta and established themselves as the sovereign power in the region, replacing the open port with a closed colony. At that point, colonialism took over from exchange. Elizabethan England, however, was not yet ready for such an enterprise.

Nor was Ming China. Merchants who sailed from China did so illegally, for the only people authorised to leave the country were those the emperor sent abroad for diplomatic purposes. The Ming state had no interest in providing support, much less in allowing Chinese to act as sovereign proxies. We have a record of one delegation sailing from Fujian province to Manila to investigate what Chinese merchants, who were there in the tens of thousands, were up to. The delegation went under the orders of the eunuch tax inspector of the province,

not the emperor. Its arrival in Manila on 23 May 1603 alarmed the Spanish authorities there, who feared that the Ming might be planning to invade the Philippines. Governor Pedro de Acuña accepted the delegation's letters of introduction, but was alarmed when the visitors displayed their insignia of office while under Spanish jurisdiction, and even more alarmed when the delegation convened a court the following day to hear cases brought forward from within the Chinese community. Acuña regarded these acts of extraterritoriality as unacceptable, and sent the delegation back to Fujian as soon as he could.

The consequences of this visit proved to be dire. Anxious for their safety, the Spanish launched several unpopular initiatives: demolishing Chinese houses close to the city wall, registering Chinese sojourners, collecting weapons, and dragooning Chinese labour to dig a moat around their city. Tensions rose through the autumn until competing rumours that the Chinese were going to rise up and kill all the Spanish, and vice versa, sparked violence on 4 October 1603. The Chinese hugely outnumbered the Spaniards, but the Spaniards had arms and native recruits. Some twenty thousand Chinese died, and those who were captured were bound to galley service.

Emperor Wanli was appalled by the news of the massacre, though he was ambivalent about whether Chinese who had left the country deserved his concern. He handed off the problem to the Provincial Administration Commissioner Xu Xueju. Xu wanted to launch a punitive expedition, but he got no support for this from Beijing. All he could do in the end was to send a letter of protest to Acuña, which did not reach him until March 1605. Not unlike Scott, Xu felt that only in his own country could justice adequately be done. He demanded that the Spanish authorities repatriate those Chinese stranded by the violence and compensate Chinese merchants for their losses. Once this has been done, 'there will be amity between this kingdom and that, and merchant vessels will sail there every year'.

Commissioner Xu used the same communication to complain about Dutch ships nosing about in Chinese waters and asking for them to be withdrawn, not realising that the Spanish and the Dutch were in mortal competition. He then closed his letter with a threat. Should justice not be done, the emperor would dispatch a thousand ships manned by Chinese and their tributaries. It was an empty

threat, but one he, not unlike Scott, had to make in order to project the sovereign rights of his ruler beyond the Ming border. It is hard to imagine Xu finding a thousand ships and enough sailors to man them. Emperor Wanli had launched a maritime fleet on that scale in 1592 to turn back the Japanese invasion of Korea, but that intervention had been to defend a loyal tributary at the tributary's request, not to secure the interests of Chinese merchants abroad. Even more remarkably, Xu went another step and explained that in the wake of the invasion the island of Luzon would be divvied up among the participating tributaries as their reward. This vision of mobilising an East Asian hemispheric alliance to wage war on Beijing's behalf was utterly unprecedented, and never put into operation. Acuña did not reply, and no further official correspondence passed between the Ming and the Philippines. The Chinese in Bantam and elsewhere had only themselves on whom to rely.

The Manila massacre occurred while Scott was in Bantam, just half a year before the arson incident. Scott makes no mention of it in *An Exact Discourse*, but he would certainly have heard about it. As would the Chinese in Bantam. What happened in Manila would have been on everyone's mind in 1604. (In 1740, the Chinese in Jakarta would suffer the same fate at the hands of the Dutch as the Chinese in Manila had; but that is another story.)

Finding Law in Piracy

Scott's legal battles were part of a much larger process having to do with the early phase of developing the law of the sea and international law more generally, and not just in an abstract sense but via a direct material connection. The connection lies in the £1,000 in gold that Scott had hidden in his bedchamber. This stash was not the simple accumulation of the company's ongoing business transactions, but came from one particular sale of pepper to one particular Dutchman before he sailed back to Amsterdam and into the Admiralty Court to defend his right to his cargo.

Jacob van Heemskerck had set sail from Amsterdam for the Spice Islands in April 1601 to buy pepper, as well as to challenge Portugal's monopoly over the spice trade. When the Dutch had first sailed into South-East Asia in the 1590s, the Portuguese pursued a vigorous

campaign to drive them out. Violent incidents hardened both sides. One of the worst was the incident from which Wang Linheng heard about red-haired Dutchmen three metres tall. Those sailors had been under the command of Jacob van Neck, whose ships had been blown by a gale towards the coast near Macao and who had sent two parties ashore, one of eleven men (including a Chinese pilot) and one of nine, to declare their peaceful intention and request resupply. The Portuguese captured both parties and refused to assist Van Neck. When Chinese officials got wind of this, they demanded the Portuguese hand them over, since these men had been taken within Chinese territory. The Portuguese half-acceded by sending six of the men, who were chosen because they knew only Dutch and therefore could not communicate with the Chinese. The officials could not make head nor tail of the incident and simply handed them back to the Portuguese to do as they wished. Of the original Chinese pilot and nineteen Dutchmen, only three survived. Six were executed and eleven (including the Chinese pilot) were drowned at sea.

Van Heemskerck learned of this atrocity when he reached Bantam in February 1602. Four Chinese brought the news from Macao to a Chinese merchant known as Lakmoy, who had traded with Van Heemskerck's brother in Bantam six years earlier and had saved his life when Portuguese attempted to murder him. After loading five of his ships with pepper to send back to Amsterdam, Van Heemskerck spent the next six months trolling around the Spice Islands to seek revenge for his murdered compatriots and steal Portuguese pepper if he could. He ended up in Patani, a busy port city on the east side of the Malay Peninsula, and there struck up a friendship with Raja Bongsu, the brother of the sultan of Johor (now Singapore). Johor was in a stand-off with the Portuguese over their high-handed tactics, so Van Heemskerck saw an opportunity to collude in the capture of the next Portuguese ship that passed through the Strait of Johor. He sailed south to the cluster of islands lying off Johor, where he ambushed the *Santa Catarina*, an enormous 1,400-ton Portuguese carrack en route from Macao to Malacca. Van Heemskerck cornered his prey off Johor on 23 February 1603. After enduring a day's precise bombardment designed to incapacitate the carrack without sinking it, the Portuguese captain surrendered. It was a skilful capture. The

hugely valuable cargo was undamaged, and deaths were few. Over 800 crew and passengers were taken hostage, all safely repatriated to Malacca.

Van Heemskerck sailed the *Santa Catarina* with the rest of his fleet down to Bantam. The passage was difficult, and he lost one sloop to pirates, but the convoy finally arrived on 20 June 1603. The *Santa Catarina* yielded a cargo of Chinese manufactures and processed materials: silk, velour, fragrant wood, granulated sugar, copper, medicinal plants, camphor, musk balls, furniture, gold bars and sixty tons of porcelain. Van Heemskerck spent four months in Bantam refitting his ships for the voyage home and used some of the captured gold to buy 5,000 sacks of pepper, 1,000 of which Scott sold to him. This was how £1,000 ended up being in his bedroom when the fire broke out. Van Heemskerck set sail from Bantam on 14 October 1603 and reached Amsterdam the following summer. The public sale of the cargo set a record, netting an amount equal to half the paid-in capital of the Vereenigde Oostindische Compagnie (VOC), the Dutch East India Company – and over twice the capital of Scott's EIC.

Portugal regarded the seizing of the *Santa Catarina* as piracy and sued in the Admiralty Court in Amsterdam for the return of the ship and its cargo. The judges were Dutch and so, of course, handed down a judgement on 9 September 1604 that declared both ship and cargo to be legitimate war booty. Although the VOC won the case, it recognised the shakiness of its legal claim to loot, given that technically Portugal and the Netherlands were not at war. Five weeks after the judgement was given, the company's directors sent a letter to a promising law student asking him to formulate a sound legal opinion in support of their claim. The student they approached was the roommate of the younger brother of one of the directors. Huig de Groot was not yet famous under his Latin moniker of Hugo Grotius, but he was brilliant and not a little ambitious, and he embraced the commission with gusto. For a young man looking for an entry into the Dutch political elite, this was a splendid opportunity.

The VOC wanted a short opinion delivered quickly. Instead, two years after receiving his commission, Grotius delivered *De jure praedae* (On the law of booty), a monumental tome setting VOC conduct in relation to a selective body of historical legal texts. Grotius argued

his defence of the VOC in three ways. First, Portugal had no legal right to exclude the Dutch from trading in Asia. Basing their claim on the Treaty of Tordesillas was flawed, inasmuch as that treaty had been declared solely on the authority of the Pope, who had no standing in the matter. Second, Portuguese violence against Dutchmen amounted to acts of war. In arguing this point, Grotius reconstructed the seizing and murder of Dutch sailors off Macao in 1601 from Dutch testimony, noting that the 'chief magistrate of Canton' investigated the case. He concluded that the Portuguese had, without provocation, 'treated the Dutch nation and Dutchmen as enemies, waging public war against them in the Orient'.

Grotius's third argument was the most far-reaching: that freedom to trade was an inherent right. When that right was arbitrarily abridged, a state or its agent had the right to enforce that freedom. This meant that ships engaged in trade should be permitted to sail anywhere they chose. This part of *De jure praedae* was extracted and published in 1609 under the title of *Mare liberum*. This argument entailed a much greater one: that no ruler has the right to abrogate the rights given by natural law. Grotius raised this to the general principle that rulers are not above the law. As he phrased it: 'Kings have no more power against [laws] than have the common people against the decrees of the magistrate.'

In relation to the *Santa Catarina* case specifically, Grotius argued that the Portuguese had no right to interfere with Dutch sailors, and no right to impose exclusive contracts on Johor. Johor and Holland had therefore acted correctly in seizing the ship and its cargo as war booty. To the EIC, the Dutch claim that they were seeking to keep the seas open rang hollowly, since the Dutch were doing everything they could to run them out of the Spice Islands, just as the Portuguese had tried to do to the Dutch. In fact, the EIC responded to Grotius's challenge by mounting its Eighth Voyage precisely to test the Dutch claim that the seas were free. Not surprisingly, they found that they weren't. At every turn, the Dutch so harassed the English and threatened their trading partners that Scott's little outpost in Bantam could not flourish. The company would before long withdraw from the region, only to return in force in the eighteenth century to build an empire based on three-way trade among Britain, India and China.

The Death of a Goldsmith

Scott had called the man he tortured to death a goldsmith. We think of a goldsmith as someone who makes things of gold, but it is worth asking what Scott meant by the term. In the language of his day, goldsmith and silversmith were interchangeable. Most European languages did not even have different words. French, for example, only has one word for both: *orfèvre*; Italian, likewise. In England a goldsmith was also a person with whom one entrusted funds, something like a banker. Scott was writing for an English readership who may have understood goldsmith in a more general sense than someone who works only in gold. Whatever the man was, we have only what Scott tells us, and he says nothing specific about him beyond that his profession meant that he knew how to work fire, the agent for breaking into the storehouse.

Although gold figures in Scott's story as the medium in which Van Heemskerck paid for his pepper, the standard precious metal for buying and selling high-value commodities at the time was not gold but silver. A century earlier, according to Tomé Pires, Bantam operated in two media – copper cash (technically, bronze) for small-denomination transactions and gold for large – but that era was over. The flood of Japanese and American silver into the South China Sea had replaced gold. So there is a good chance that the man was a silversmith, and that Scott construed him as a goldsmith to align him with his readers' (or even his own) sensibilities. In this capacity, he sat at the unstable centre of commodity exchange. Money was supposed to stabilise the market, but it required trust. This was why sovereigns minted silver and had it stamped with the monarch's name or head. Wang Linheng knew these pieces of eight (pesos) as 'Spanish silver' and was curious that they bore the image of the Spanish monarch. In China, by contrast, only cheap bronze coins were minted, but they were stamped only with the regnal era, never the emperor's image. Silver was left as bullion and not minted into coins. Transactions were conducted by engaging a silversmith to weigh the amount of raw silver needed. Sometimes the silver was cast into ingots of standard weight, but this was more to store the silver rather than to make it easily transferable. The fact that the goldsmith had admitted to counterfeiting and clipping coins before Ngabehi turned him over to Scott suggests that

indeed 'goldsmith' is not the word we would use for him. Most of his work would have been in silver.

Silver was a troubling presence in the Bantam economy. It was a commodity in its own right, its price vulnerable not just to its own supply and demand but also to the supply and demand for copper. Just a month before the fire, for instance, a Chinese ship coming from Fujian unexpectedly sailed into Bantam after the end of the winter trading season. Bronze coins were always in demand throughout South-East Asia and also made for good ballast, and the ship unloaded a huge supply. Article 246 of the Ming Code made exporting copper cash punishable by a beating of a hundred strokes plus confiscation of ship and cargo, but no one really seemed to care. The sudden arrival of these coins drove down the local value of bronze and pushed all the silver out of the market, since no one could trust the exchange rate. The shāhbandar, for one, had held pepper past the season, hoping to sell it at a big mark-up, but until the value of silver resettled, no one was going to part with it to buy his stock.

Silversmiths operated at the centre of this fluctuation in the value of silver. They stood to benefit from the fluctuation but also were exposed to scapegoating when the market veered or crashed. Scott's 'goldsmith' knew what he was doing, and knew as well that whatever he said would not save him from Scott's wrath. The only power left to him was to withhold the one thing that Chinese and English law agreed was needed: a confession. Neither system of justice could determine guilt without a confession. Tormenting the suspect was one way to get it, though both systems shared anxiety that a forced confession could be false. By choosing silence, the goldsmith deprived Scott of the thing he needed to show the world at Bantam that he had the right man and that he had maintained the highest standards of justice in obtaining the necessary evidence of his guilt. The goldsmith's refusal to speak left Scott empty-handed. What should have been a trial became a show trial, leaving Scott with no option but to put the man he had mutilated out of his misery. And he may have decided to let the Dutchmen in on the final act as a way of dispelling the charge that the English were uniquely unjust.

Here is what I believe the goldsmith might have said to himself, even if he didn't say it to Scott:

The plan was brilliant, and kept getting better, at least at first. To hide the digging, Uniete agreed to build the two brewing sheds along the Englishmen's fence, one to brew liquor and the other to serve it. Because the land in the Pacinan is low and soggy, we had to dig a well to drain off the water that kept pooling in the tunnel. The brewery was the perfect cover for handling the water. You can't serve liquor without making it, and you can't make it without water. Sawwan had the great idea of planting a garden along that side of the property, so if they asked, we could say that we dug the well to water the plants. Tobacco was a particularly clever choice, because it grew fast and filled the space nicely, screening the entire operation.

We aimed the tunnel for the back corner of the house. All went well until Boyhie and Hynting tried to tunnel up through the floor and discovered the building was not resting on soil but had a solid wooden floor. The only way to get through was to saw, but people were in and out of there all the time and would have heard the noise. Besides, the English are on constant patrol around their grounds. Sawing and drilling would give the game away.

Of course you can't saw through the boards, I told them. But you can burn your way through. You want to get a good-quality wax candle to do this. The brighter the flame, the hotter the fire. I should know: I melt gold and silver for a living. Put the burning candle up close to the underside of the floor, let it scorch the wood, and then take the candle away as soon as the board starts smoking, otherwise the English will smell it. Then do it again. Take all the time you need, I told them, do it gradually. Just don't burn the place down with everything in it. Once we burn through, up we go.

The night we burned through the floor, the candle went out three times. I had to keep relighting it. Then the flame caught something in the room above us. That was not part of the plan. It was too hot to enlarge the hole, and the smoke was building up, so we scrambled out and watched the compound. Suddenly the alarm was sounded, and a new plan occurred to me. If we weren't going to crawl in through the floor, maybe we could walk in through the front gate in all this confusion.

The English boss was worried about losing his silk, though he didn't know which to be more worried about, fire or theft. But he

took the chance of theft in the face of the more immediate threat of fire. I entered the storehouse with the first group of rescuers, making it look like I was trying to drag out the bundles, but I had something else I was looking for. I had heard that the Dutch had paid for their pepper in stolen gold. If I could find that while the Englishmen were busy with the fire, I would be a rich man. I reckoned there would also be a large stash of silver, though I found out later that they had buried their silver in jars in another outbuilding.

The gold was not in that first room. It might be in the room where we started the fire, but we had to delay the English from getting in there until we had a chance to get a good look first. Uniete said, if we can't go through the door or the floor, what about the ceiling? We reckoned we could slip upstairs and no one would pay any attention, so up we went with two of the others. We got to the room we figured was over the back end of the storehouse and started prying up the floorboards. But we didn't get very far. The English boss burst into the room, yelling and waving his sword, so we made off down the stairs.

I mixed in with the guys emptying the storehouse. By then, the English were dragging out the bundles of silk. I looked around quickly but saw no sign of the gold, though at that point I don't know what I could have done even if I had found it. There was no point waiting around to find out what would happen next. It was time to run. I can't believe Sawwan stayed at the brewery. Even if they never found the tunnel under the floor, where did Sawwan think they would start looking if not right next door?

Hiding in toilets worked until Ngabehi's men found me. When that ship came in from Fujian a month ago, I knew how badly the shāhbandar got burned holding pepper, and figured the Admiral might be in the same position. I wondered whether he might try to use me to move silver in his direction. But he's too close to the Englishmen, too afraid of them. I could have put my talents to his service. But he condemned that other Chinese silversmith to death two months earlier on the charge of counterfeiting, so I was more use to him as a pawn in his dealings with the English.

I'm to be handed over to those wolves today. The Englishmen pretend to be just, but they are men without conscience who will do what they will do. They will get nothing out of me.

8

The Missionary and His Convert

Nanjing, 1616

Word reached the priests at midnight that the Ministry of Rites had issued a warrant for their arrests. It was the night of 30 August 1616 in the city of Nanjing, and they could expect their arrests within the next day or so. Only two of them – an Italian, Alfonso Vagnone, and a Portuguese, Álvaro Semedo – were named in the warrant. At fifty, Vagnone was the eldest in the house; Semedo, at thirty-one, was the youngest. The ministry was not aware that two other Italians, Niccolò Longobardo and Giulio Aleni, also lived at the residence. Semedo was ill and confined to bed, so the other three busied themselves with putting the house in order, gathering up precious items and sending them to the nearby home of a Chinese convert for safe keeping. It was decided that Longobardo and Aleni, unknown to the ministry, should slip out of Nanjing at dawn to seek help from a friend in the Ministry of Works who was posted to an office two days' journey north of Nanjing. Vagnone and Semedo remained behind to wait out the order.

Three officials in the Ministry of War called that morning to advise them to sell the house and leave the city as soon as possible, for their own safety. Their ministry did not have the authority to issue an arrest warrant, though it might be ordered to execute one. The authority to arrest or banish a foreigner lay with the Ministry of Rites. War was charged with the more mundane tasks of providing protection and transportation for foreigners, but Rites controlled diplomacy and pro-tocol, and Rites was making a move. The three sympathetic officials from War wanted to give the Europeans a head start.

That evening, a squad of soldiers from the city ward was stationed around the residence to prevent their escape. The following morning, three officers arrived to carry out the arrest of Alfonso Vagnone and Álvaro Semedo, and to conduct a search for evidence against them. By all accounts, the arrest was courteous on both sides. The officers spent much of the day on their search but turned up nothing to incriminate the Europeans other than the fact that they were indeed devotees of the Christian religion. The delay conveniently gave Vagnone enough time to send a Chinese Christian named Donatus with a message to Longobardo and Aleni, informing them how matters stood. Donatus was swift enough to catch up with them, deliver the message and return before nightfall. The officers took only Vagnone, leaving the ill Semedo behind but under guard. Two domestic servants living in the Jesuit residence volunteered to accompany Vagnone to gaol. The party went first to the residence of the censor who had ordered the arrest, presumably to report on what had happened and explain why Semedo was not being brought into custody. Whatever they had to sort out, it took two hours, during which time Vagnone waited in the street, exposed to the curiosity of passers-by. Once the officers had finished their business with the censor, they re-emerged and led Vagnone to gaol.

Many charges against them were bundled together, but the heart of the matter was that these foreigners were not official envoys from their rulers. There were protocols for receiving tribute envoys, but these men had entered China without having received such clearance. That they were in China to speak of matters of Heaven – which could be construed as infringing on the divine authority of the emperor – only made the illegality of their status that much more offensive.

The four priests were missionaries of the Society of Jesus, which had been founded in 1540 with the goal of promoting spiritual renewal within the Church. The Jesuits distinguished themselves by their education and their dedication, and were mobilised by the king of Portugal, among other European monarchs, to ensure the spiritual health of Christians abroad. The idea of organising missions to convert foreign rulers followed. By the turn of the seventeenth century the prize that many dreamed of was the conversion of the emperor of the Ming. Early in the 1580s, two Italian Jesuits, Michele Ruggieri and Matteo Ricci, obtained permission to set up a mission outside Canton. Ruggieri did not remain in China long, but Ricci stayed until his death in 1610, spreading the Christian word by whatever means he could, including printing world maps, as we saw in the Introduction.

When the crackdown came, six years after Ricci's death, the eighteen Jesuits (including six Chinese) elsewhere in the realm soon learned of the arrests. Choosing discretion, they disappeared from public view. Chinese converts proved to be less discreet. One Chinese Christian in Nanjing was so incensed at the arrest, and so prepared to suffer for his faith, that he paraded through the streets of Nanjing carrying a banner declaring his adherence to Christianity – for which he was arrested and held in prison for a year before being brought for punishment.

When the officers who arrested Vagnone and Semedo made their report to the Nanjing Vice-Minister of Rites Shen Que, he was furious with how lax they had been. It had been his initiative that had brought the law down on the Jesuits, and his intention was not to give the foreigners a soft warning. He wanted them out of the country. So he immediately ordered the arresting officers to return, seize Semedo and carry out a more thorough search of the Jesuit properties, including a garden outside the city that supplied the residence with food. They did so, but found nothing in any of these locations to expose the Jesuits as spies. In the main residence they did find a pair of terrestrial and celestial globes, nineteen maps and a folding screen displaying Ricci's map of the world, but these all seem to have been European maps, not Chinese, and therefore of no threat to state security. Nothing else the officers found indicated that these men were engaged in anything other than the practice of their religion.

Vice-Minister Shen had more than the Europeans in his sights. He wanted the message of non-toleration of this foreign teaching to reach the Chinese who collaborated with them. Accordingly, the officers arrested not only Semedo but also a Chinese Christian living at the Jesuit residence, a young novice who had come up from Macao to study there, four domestic servants and four other Nanjing Christians who had turned up at the residence to find out what was going on. By the end of the day on 2 September, fifteen men associated with the Christian mission were in prison. More arrests were to follow. Whether Shen's initiative would be extended to the entire realm remained to be seen. This was what Shen wanted, but his crackdown lacked a key element. He had submitted a memorial to Emperor Wanli calling for the expulsion of all Jesuits from the realm, but he had received no reply on the matter. Shen had gone ahead with his purge without permission from the throne. It was a daring move to push his agenda forward, and did not go unnoticed. Others stepped forward to argue against what Shen was doing. The spokesman on the side of toleration was Xu Guangqi, known to his fellow Christians by his baptismal name of Paolo.

For and against Europeans

Paolo Xu was surprised when he heard about Shen's attack on the Nanjing Christians. Xu hailed from Shanghai and had spent the three years before this summer home on sick leave. He had only just returned to Beijing when the news reached him. In a letter home to his son in August, he wrote that he had always regarded 'Uncle Shen', using a familiar term of respect, as 'a friend of theirs' – which is to say, a friend of the very small number of Chinese Christians in government service. Xu had converted in 1603 under the influence of Matteo Ricci. The following year he had broken through the barrier of passing the national exams and become a Presented Scholar. Recognised for his maturity (he was already forty-four), his breadth of knowledge and his expertise in certain areas of state policy, Xu had been appointed to the Hanlin Academy, the think-tank providing advice to the court. The appointment kept him close to Ricci until the Italian died (see Plate 10), and was the first of the string of appointments to central institutions that kept him in Beijing for his entire career.

Shen was three years Xu's junior but had passed the Presented Scholar exams a dozen years earlier, which is why Xu called him 'uncle'. Shen too had gone into the Hanlin Academy, and their stints there had overlapped. They had become friends, although friends who agreed to disagree over many issues without falling out. Shen had been promoted out of the academy to the Ministry of Rites while Xu was off on sick leave, and Rites gave him the perch from which he launched his attack.

Xu had not seen this coming. 'Now all of a sudden he has changed his attitude', Xu wrote to his son. 'I can't understand why.' What also puzzled Xu was how Shen, who was vice-minister in the Nanjing branch of the ministry, had managed to get the Beijing branch of the ministry behind the persecution. Presumably he would have had to do that before he got the ball rolling in early July with his memorial to Emperor Wanli outlining the threats he saw the Jesuits as posing to both the security of the country and the authority of the emperor. But that ball rolled nowhere, since by the end of August there was still no response from the throne. Within a few weeks of returning to work, Xu took up his pen and composed a memorial to the emperor opposing Shen's proposals point by point.

By reading the two memorials side by side, we can imagine how the disagreement between the two officials might have unfolded, had Shen and Xu been able to debate their positions before the throne. Here is how it might have gone:

Shen opens the debate. 'Barbarians from a distant land have entered the capitals illegally and are secretly injuring Your Majesty's kingly influence. Suddenly Alfonso Vagnone and Manuel Dias are in Nanjing and Diego de Pantoja and Sabatino de Ursis are in Beijing.' (Shen has mistaken Semedo for another Portuguese priest, Manuel Dias, who was in south China at the time and had never been in either capital.) 'Yet other foreign priests are in provincial capitals and prefectural cities. This ministry is charged with ensuring that the prohibitions against subverting orthodoxy are strictly maintained. These people seek to subvert truth. Simulating good actions, they agitate and deceive the people. I humbly beg Your Majesty to clarify and enforce the laws, so that the people's hearts will be made correct and public morality upheld. I ask for their arrest and expulsion.'

Paolo Xu responds. 'I first found out that the Ministry of Rites wanted to expel Diego de Pantoja and other of Your Majesty's envoys from the Far West from a report in the Beijing Gazette.' This was the monthly digest of government policies and appointments that officials all over the country read to keep abreast of what was going on at court. 'Unlike the ministry officials, I have actually discussed philosophy and astronomy with these foreigners. As a matter of fact, I have been talking with them for years, so I am well acquainted with them and their doctrines. If Your Majesty's envoys are found guilty, how can I hope to escape the ministry's condemnation?'

Shen wants to target the Jesuits for what he regards as their noxious foreign influence on Chinese customs and values, but his hook is the technicality that they were not envoys bringing tribute to the Chinese throne. 'After the dynasty was founded, barbarians from the four quarters came to demonstrate their respect for the throne. Our realm has repeatedly emphasised the distinction between barbarians and Chinese. In the *Collected Statutes* are listed the names of tributary states, the amount of their tribute and the schedule for bringing it, according to which tallies are issued. For those whose names are not recorded and who do not have tallies, there are laws against crossing China's border posts. There are also laws about watching closely for spies. The desire of distant peoples to acknowledge righteousness by coming to us is laudable, and the court is capacious enough to accept all without exclusion. Yet topography forms naturally bounded regions, setting frontiers between them and us. Each country has its appointed place, and its people should remain there.'

'But foreigners have been coming to China for millennia', Xu objects. 'Some have even rendered great service to the state. It didn't matter that they came from afar.'

'But think of such foreigners as An Lushan, who entered China only to plunder and rebel', rejoins Shen, recalling the famous Sogdian military leader of the eighth century who served the Tang dynasty on its northern flank but later rose in revolt. 'Some at the time saw through him, but their warnings came to naught, to our endless regret. How

could loyal officials not be alarmed by these barbarians? Honouring and encouraging them will only bequeath vast calamity to the future.'

Rather than pursue this line of argument, Xu shifts to the Jesuits' religious purpose for being in China. He attempts to clear the way by pointing to the vast influence that Buddhism has had as a foreign religion in China. 'Buddhist temples and pagodas are all over the empire, and Tibetan lamas still come to China. Even Muslims, despite their theological errors, also have been freely tolerated, building mosques wherever they choose. Earlier emperors who desired to improve the people and transform customs commended these foreigners who came a great distance.'

Far from bringers of calamity, Xu insists, 'these envoys, who have enjoyed Your Majesty's support for seventeen years, are followers of the sages. In their deportment and in their hearts they are wholly free from anything that could excite suspicion. Their doctrines are most correct, their regimen most strict, their learning most extensive, their knowledge most subtle, their hearts most true, their views most steady. Their own people regard them as one in a thousand, nay, one in ten thousand.'

Shen has no interest in discovering moral value in the foreigners' teachings. The ineradicable problem for him is that they are foreign and therefore a threat to the Confucian moral order. They cannot be trusted to act in China's interest. Accordingly, their presence in China must be seen always as a political threat. 'They come from a country they call the Great Western Ocean. Your August Majesty is the sole ruler of All under Heaven within and beyond the seas, which is why our country is called the Ming Great State. How can these barbarians also speak of a Great West? Especially now that they claim they are naturalised, how dare they speak of two "greats" and oppose each to the other?'

Xu knows that Shen has misconstrued the Great West. It seems that Matteo Ricci himself coined the term to distinguish their Great West from the lesser West, which was India. He does not bother to respond to the charge, instead pointing out that there are 'more than thirty countries in the West Ocean region, where they have practised their teaching for a dozen centuries'. The effects of that teaching, not where its practitioners come from, are what is important. 'Greater and lesser care for each other, and superior and inferior seek each

other's security; nothing dropped on the road is lost, and the gates are not barred at night. They have been at peace and well governed for a long time. The only anxiety of the inhabitants of their countries is that they should not fall into error and sin against Heaven.'

'But they name their religion the teaching of the Lord of Heaven', objects Shen. How can they lay claim to Heaven when the emperor of China is its son? He is Heaven's highest priest and closest link. 'This is why, when an imperial edict goes out, it always concludes with the phrase, "Respect Heaven!" Yet these barbarians, by falsely talking about a Lord of Heaven, suggest that there is something higher than the emperor. This confuses the people. How will they know whom to follow?'

This accusation puts Xu in a difficult position. He has to leave the foreigners room to claim that they serve Heaven without allowing them to be manoeuvred into opposition to the emperor as its son. He does so by making the service of one the service of both.

'It is because they serve Heaven and cultivate the self that they have travelled thousands of miles from the West. Having heard that the teachings of the sages of China are also entirely dedicated to cultivating the self and serving Heaven, they realised that their principles corresponded with ours. Accordingly, in spite of the difficulties and dangers by land and by sea, they desired to come here. They wish to confirm the truth so that all might realise High Heaven's love of humankind and devote themselves, as they do, to practising loyalty, filial piety, compassion and love. All their injunctions are in the highest degree compatible with the principles of Heaven and human feeling.'

But of what use is all that to China? 'If we want a far-sighted plan for ruling the world in peace, we already have it in the teachings of Buddhism and Daoism, which have long spread throughout the realm to supplement Confucianism', declares Shen. 'This combination is enough for upholding public morality. Magicians and soothsayers do nothing but stir up the common people, which is why the Ming Code bans their sort.' (Shen is referring here to Article 197, which prescribed a beating of a hundred strokes should a soothsayer be invited into the home of an official to predict the dynasty's fortune. The article is not a good fit with Christianity, but citing it was a clever way to implicate officials such Paolo Xu, who patronised the Jesuits and brought them into their homes.)

Xu dodges Shen's bid to introduce legal reasoning by going two steps back to the Buddhists. Yes, they were permitted to enter China, but as far as Xu is concerned, they have failed to deliver on their mandate to supplement the otherwise perfect teachings of Confucianism. The problem with Confucianism, widely acknowledged by those interested in more than rote-learning, is that its teachings 'affect only outward conduct and cannot touch human feelings. The more restraints you place on people, the more deceit and guile multiply. For every law enacted, a hundred evil practices spring up, to our endless disappointment.' On this front, Buddhism has made no difference. 'The Buddhists use heaven and hell to make people avoid evil and do good, yet in the eighteen centuries since Buddhism came from the west, the ways of the world and the hearts of the people have not been transformed. They have contributed nothing to the great wisdom of the Ming in the two and a half centuries since the dynasty was founded.' Christianity offers a far more effective programme. 'On whom should the people depend? Whom shall they follow?' Xu asks. He answers his own question: 'If we want people to do good, we should use the envoys' programme of serving Heaven. Only this can supplement Confucianism, support the practices of our scholars and correct the teachings of Buddha. Were the Lord on High worshipped as reverently as are the Buddha and Laozi, and were Your Majesty's envoys received as generously as the priests of those two religions have been, the imperial teachings would flourish and the principles of rectitude achieve a degree of perfection that exceeds every age since ancient times.'

Shen argues back that the religion of these foreigners produces exactly the opposite effect. 'I have heard that the foreigners say there is no need to sacrifice to ancestors because the worship of the Lord of Heaven is enough to attain heaven and avoid hell. This instruction deceives the common people and sows confusion. Buddhists and Daoist priests already use doctrines of heaven and hell to encourage people to fulfil their obligations to each other. How will the common people know whom to follow, especially when the gentry throw in their lot with these foreigners! Those who follow them forget the importance of paying due respect to the great unity of China.'

Here Shen circles back to his core anxiety: that whatever the Jesuits do or teach in China, it could undermine the unifying authority of

the Great State. The real threat is political as well as moral. Before he makes his final argument about the political dangers of foreign influence, he launches an attack on the scientific theories and methods – he calls them 'treacherous absurdities and wild boasts' – that the Jesuits have brought from Europe to correct the flawed astronomical calculations on which the Chinese calendar depends. He doesn't trust the results. 'They go against the model established by the ancient sages, so are they obeying or obstructing the way of Heaven? They say they have come to China yearning for our culture, but do their arguments really follow our kingly way? Even if their astronomical concepts were the same as China's, your servant would still be concerned that their methods differ from those conferred by the emperors and preserved by the sages, producing conclusions that are not in accord with ours.'

Xu simply dismisses the entire issue with the quip, 'As for calculating the imperial calendar, this has little bearing on the case.' Xu knows whereof he speaks. He tells the emperor that he has discussed cosmology and astronomical mathematics at great length with the Jesuits. He even co-translated the first chapter of Euclid's *Elements* with Matteo Ricci (with whom he appears in the illustration at the head of this chapter, Xu on the right and Ricci on the left, drawn half a century after Ricci's death to celebrate their collaboration). Xu knows that Shen is way out of his depth and leaves him there to flounder.

For his final argument, Shen turns to the accusation of treason. To get there, he suggests that the emperor follow the money. 'Whenever country bumpkins are fooled into following their teachings, it is because they hear that the barbarians have ample resources, which they pay out on an individual basis. They declare that the teachings of the Lord of Heaven help people in this way. The avaricious and foolish, having something to gain, believe them. The deceit they harbour in their breasts is especially detestable.' He further suspects the foreigners of cheating Chinese in their financial dealings, but it is the nexus between money and local complicity that disturbs him. 'They claim to have come from a place that is twenty-five thousand miles away from China and yet their resources keep coming, so who supplies them? What credentials do they use that gives them passage through customs stations? Why have the officials in charge and the customs soldiers allowed them to pass without interrogation?'

This line of attack obliges Xu to fend off several challenges from several angles. To the charge that the foreigners appear to have a covert channel to the outside world, he responds by pointing out that this is because of their situation. 'The foreign priests have left their families and do not engage in lucrative occupations, so of course they must accept contributions.' But lest this admission be used to prove that they have been taking money from Chinese, he explains that all their support comes from the Far West. This is a problem, he agrees, but not the problem that Shen thinks it is. 'The vagaries of winds and waves, of robbers and pirates, mean that they are often in distress.' Unable to access the very resources Shen thinks they have, the foreigners might have been tempted to turn to Chinese for support, but have never done so. 'During the twenty years since their arrival, they have not received from the people a single thing, not a single coin, lest they be accused of obtaining it by deceit or fraud.' In fact, Xu proposes that the state should take over their support, as it does for every foreign envoy coming to China. This would allow the foreigners to cut their communications with Macao, resolving the charge of espionage.

Shen's complaint about covert financial support is not really about money, though; it is about the fact that the priests are able to receive support from a foreign source without the Chinese government knowing anything about it. Not only have the foreigners entered China without proper authorisation, but they receive funds in exchange for who knows what sensitive information. In addition, they are using this money to buy support from Chinese. His final plea: 'Let the regulations be strictly upheld so that, from now on, people of this sort will no longer be able to barge into China illegally. By applying the full force of the Code of the Ming Great State, our security will be tight and their traces will be hard to cover. The realm will be at peace for ten million years and no unexpected worries will arise.'

'I am junior in rank to the vice-minister', Xu responds, 'and would not presume to contradict him, yet I, Your Majesty's minister, have fasted and performed the requisite purifications before coming forward to lay the envoys' case before the throne. I too was once filled with suspicion, but after years of careful examination and inquiry, I have come to see the truth these men bring. Were there the slightest shadow of doubt that they might be of no advantage to China,

I would not care whether they were sent away. But nothing can surpass the learning of these foreigners for attaining the goals of perfect government and great peace for the realm.' With that preamble, Xu lodges his request: 'Should Your Majesty issue a statement distinguishing their learning as a value to the realm, the hearts of people and the ways of the world will soon be seen to undergo a steady change. Every law will be upheld, no command opposed. There will be no unfaithful officials in the capital or the provinces, and everyone will be worthy of employment in Your Majesty's service. Your Majesty's sacred person will enjoy perfect felicity, and the realm will be eternally at peace for ten thousand generations.'

Ten thousand generations versus ten million years: such was the language of Ming lobbyists addressing the emperor. Emperor Wanli, however, was not interested. He did nothing in response to Shen's memorial. Allegedly he scribbled 'so noted' at the bottom of Xu's memorial (the original no longer exists) indicating that he had read it, but did nothing further. Shen would launch two more rounds of denunciation through the autumn. Not until the winter would the emperor respond.

The Great West

Had the emperor paid attention, he would have learned that there was a distant place variously called the Great West, the Great Western Ocean or the Far West. It was either one country or over thirty countries. From Xu's testimony, it was a place that was at peace and well governed, where greater and lesser cared for each other, where superior and inferior sought each other's security, where nothing was stolen and the gates were not barred at night, where the sole worry of ordinary people was whether they measured up to the standards that Heaven expected them to meet. It lay to the west of China, further west than India, and the voyage from there to here was 25,000 miles.

The Jesuits, who styled themselves 'scholars from the West', were the authors of this vision. The key figure in creating it was the second Jesuit to enter China, the man who came to define the accommodative approach the Jesuits would take in China, the Italian priest Matteo Ricci. His Chinese friends referred to him as 'the person from *Tai xi guo*', the Country (*guo*) of the Furthest (*tai*) West (*xi*). Shen Que was

right to catch the parallel with *Da Ming guo*, the Ming Great State. Ricci's address projected the notion that there was a West Great State that was a distant mirror image of the Ming Great State. The parallel created both the comfort of familiarity and the disturbance of a competitor. When speaking of Europe, Ricci did not himself mystify the continent into a single state that sat at the far end of the world as a sort of counterpoise to the Ming. He made clear that Europe, unlike China, was divided into many countries. The ambiguity lies in the fact that the Chinese language does not regularly distinguish between singular and plural. *Guo* is 'country' or 'countries', depending on the context. The reading habit of Chinese, having no context for Europe, would have been to read it in the singular. It seemed that there was a Great State in Europe, and Ricci was its representative. It seemed too that this was a misperception Ricci was happy to accept.

A lesson the early Jesuits quickly learned was that most people of the Ming at the end of the sixteenth century were fully ensconced in a worldview that they could not imagine abandoning. The common people had Buddhism and Daoism, ancestor worship and any number of local deities and hearth gods with which they lived day to day. Their beliefs were like the air they breathed: simply there. Where there was some doubt and breaking of ranks was among the educated. Some Confucians refused to have anything to do with these religions – Xu being one of these. Others happily accepted a division that gave Confucianism oversight of outer moral conduct and Buddhism authority over inner spiritual life. In the language of the age, which both Xu and Shen invoked, Buddhism was regarded as a supplement to Confucianism. It was an understanding that Shen accepted and Xu rejected, but it actually helped the Jesuits. To Confucians who were Buddhists, they could explain that Christianity was a better supplement than Buddhism, while to Confucians who were opposed to Buddhism, they could offer Christianity as the supplement that didn't interfere with their fundamental principles, and indeed could support them – just as Xu tried to explain to the emperor.

So the West was a general location, a specific place and possibly its own Great State in which a great religious teacher had arisen, as well as being a treasury of technical knowledge. This knowledge embraced mathematics, astronomy, geography, cartography,

surveying, agricultural science, medicine, ballistics, time-keeping, prismatics and the other fledgling sciences of the Renaissance, in all of which the Jesuits were well trained. This set of knowledge soon became known as *xixue*, Western Learning. Much of that learning fit together with Chinese practices of science and technology, but it was coded in terms of principles that were unfamiliar to Chinese ways of thinking, and thus stood apart as a coherent body of knowledge that could be named and distinguished by its place of origin, the distant West that the Jesuits represented. How could this knowledge become Chinese?

A Bolt of Lightning

The Jesuits did not pit theological and scientific truths against each other. For them, European technical knowledge of the natural world was Christian knowledge, and therefore suitable as a bridge to lead from the secular to the religious. By sharing their knowledge of the physical universe, they hoped to lead their more educated interlocutors to knowledge of the divine mind that had conceived this universe. Interested Chinese did not, however, necessarily form the same connection. Some did, Paolo Xu notably among them. For many, though, the new knowledge – geometry, for example – did not appear to require a theological element. For the Jesuits, God could not be taken out of equations, even if for others he could. Still, the Jesuits' approach to communicating modern scientific knowledge was always with this second purpose in view: to show the properties of the world to be expressions of the intentionality of God's creation and from there lead to a belief in this God.

Take lightning, for example. When Ricci wrote this sentence in Chinese – 'Hearing the reverberation of a thunderclap, people see lightning strike a dead tree' – he could do so without much fear of being misunderstood. The description tallied with everyone's experience. Cultures might disagree about whether lightning produced thunder or vice versa, but they could happily agree on the notion that lightning could strike the earth and destroy what it hit. Beyond that simple fact, though, misunderstanding could arise, as it did when Ricci went on to observe that lightning 'did not necessarily strike villains'. With that comment, lightning was no longer a simple physical fact. It

became an intentional act by which Heaven punished evil people. Suddenly the conversation turned from physics to metaphysics, overlaid with ethics. Most cultures before the discovery of electromagnetism linked the destructive force of lightning to the idea that the gods used lightning to punish the wicked, so perhaps it was not so awkward for Italians and Chinese to have this conversation. Once he got down to the theoretical models available to him, however, Ricci had considerable work to do to get these models to make sense. For what was the earth, and what was Heaven, and what was the deity dispensing lightning as a punishment for wickedness, and what relationship might that deity have with the gods with which Chinese were familiar?

Most who venture into a new culture avoid such complicated issues. Ricci recognised the value of being tactful rather than confrontational in his teachings, but a mission was a mission. He was in China to explain to Chinese why their metaphysics was mistaken, why their theology was wrong and how a Christian understanding of the cosmos yielded a more correct view. A missionary seeking entry into another culture needs to identify gaps in understanding that can create opportunities for teaching. Ricci was alert to such gaps, using differences to bring his message through the cultural barrier between his Europe and Paolo Xu's China.

How, for example, did Heaven and earth stand in relation to each other, so that an act in Heaven could strike the earth but not the other way round? Catholic theology understood the earth as the centre of a series of concentric spheres, the outermost of which was Heaven. (Jesuits in Europe were paying keen attention to the new discoveries of Johannes Kepler and Galileo Galilei, which seemed to show that the sun, not the earth, was the centre of the system, but they were not in a position quite yet to revise Papal cosmology.) Rather than start from Heaven, a fairly universal concept about which every culture had its own ideas, Ricci started from the earth. The toughest concept was that the earth was round, though there was space in traditional Chinese cosmology for this idea. Size was also a challenge. Ricci had to explain that the earth was far bigger than Chinese thought, and he could make an argument from his own experience. He told his Chinese friends that his journey half-way round the world had covered a distance of over 32,000 miles (a distance he later adjusted down). For

those who wanted proof, he showed them how you could use Euclidean geometry to measure the size of the earth.

Another of Ricci's lessons about the earth was that it was populated by a great many countries: 'ten thousand' in the Chinese phrasing. The world maps he published in Nanjing about 1598 and in Beijing in 1602 visualised what this new concept of the world might look like, and some Chinese were fascinated. These were not explicitly Christian maps of the world. He limited their Christian content to two cartouches around the Mediterranean, one in Judea, noting that 'the Lord of Heaven was born in this place, so people call it the Holy Land', and the other by Italy, explaining that 'the king of moral transformation [the Pope] does not marry and devotes himself entirely to practising the teachings of the Lord of Heaven in Rome; the countries of Europe all acknowledge him'. His purpose was not just to show a neutral representation of the world, however. It was to encourage Chinese viewers to consider the possibility that there were other, better ways of imagining the world. That purpose seems to be woven into the description of Europe Ricci includes on his 1602 map:

This is the continent of Europe. There are over thirty countries, all of which employ the laws of the former kings [which is to say that they are monarchies]. No heterodoxy is adhered to, and only the holy teachings of the Lord on High who is the Lord of Heaven are revered. Officials are of three grades. The highest propagate the teachings, the next judge and order secular affairs, and the lowest devote themselves exclusively to military matters. The land produces the five grains, the five metals, and the hundred fruits. Wine is made from grape juice. The artisanate is skilled. There is nothing about astronomy or principles of things that is not thoroughly comprehended. People by custom are sincere and trustworthy and value the five ethical relationships. Material accumulation is great, the relationship between lord and minister vital and productive. States have mutual dealings with each other in all seasons. Merchants travel throughout All under Heaven. From China, it is over 25,000 miles. In ancient times, there was no contact between them, but now there has been interaction for close to seventy years.

Embedded in this short text are some of the bits of information Paolo Xu fed to the emperor in his defence of the Nanjing Jesuits: that there were over thirty countries in Europe, that their states were ancient monarchies, and that Europeans enjoyed high levels of social trust. Emperor Wanli may have already studied Ricci's map. We know he ordered a copy through intermediaries, so possibly he had read the cartouche describing Europe that we have just read. If so, then Xu was merely reminding the emperor of what he already knew, and perhaps trying to nudge him back to the curiosity that had at first disposed the emperor to let Ricci enter Beijing. Wanli did not respond to his appeal as Xu hoped he might, but at least he held back from authorising Shen Que to remove all Jesuits from the realm.

The Convert

Paolo Xu was open to learning about the world from which Ricci came in a way that Shen was not. His curiosity may have had something to do with his being from Shanghai. Shanghai was not then the cosmopolitan centre it is today. It was a backwater, a place of no advantage for someone trying to climb the ladder of promotion. Shanghai was a recent county, formed only in 1292 because the Yangzi River had by then deposited enough sediment to push the coastline out far enough to require giving this featureless mud flat a name (Shanghai means 'Approaching the Ocean') and administrative status. Shanghai grew quickly on the strength of cotton-weaving and commerce, so much so that the county had possibly half a million people by the time Xu was eleven, when its north-west portion was lopped off to form a second county. In the sixteenth century an educated cohort was becoming established, though no tight group of families was able to dominate the social landscape, leaving room for entry for ordinary boys such as Xu.

Its coastal location meant that Shanghai was exposed to the wave of piracy that overwhelmed the region in the 1550s, thanks in no small part to Emperor Jiajing's closing of the coast in 1525. Japanese demand for Chinese goods was so strong, and so frustrated, that both Chinese and Japanese smugglers took to pillage to compensate for the lack of opportunity to trade. Shanghai inhabited its own unique space compounded of commerce, maritime trade, smuggling, coastal violence and a fairly open social structure.

Xu was born into this world in 1562, to a family of modest means. His father, orphaned at the age of five, had been left a small inheritance and managed to support his family through a mix of market gardening and petty trading that was characteristically Shanghaiese. As a native of Shanghai, arguably Xu's imagination was shaped by the ocean that lay beyond the mouth of the river flowing through the city. The memories of his childhood that he recalled later in life had to do in one way or another with the ocean: the pirate tales his father's friends loved to tell; the typhoon when he was four that knocked down gates and buildings; another when he was nine that drowned nine people and countless livestock; the tidal wave that poured over the sea wall and submerged thousands when he was twenty; and the typhoon that same year that capsized the vice-magistrate's boat as he was going upriver to the prefectural capital, drowning the man. In a later reminiscence, he recalls sneaking pictures of battles into his schoolbooks to pore over them when he was supposed to be reading the classics. Once, when a pirate attack was rumoured, Xu was one of the young men involved in planning the city's defence. But he understood well that the other side of piracy was trade, and the military strength needed to counter piracy could only be dealt with at the level of state policy. As he puts it in a later policy paper, prohibiting trade is 'like damming water that has to flow. Drain it via the main channel and it will not flood. But when you block the main channel there will have to be side drains, and when you block the side drains it will overflow in all directions.' To make his point explicit, he explains that 'tribute trade is the main channel, private trading is the side drains, and the disaster of 1552' (referring to pirate attacks in general) 'is a case of overflowing in all directions. One cannot dam without allowing release.'

These conditions were driving some Chinese to places such as Macao, Manila, Japan and Bantam in order to profit from pent-up demand among foreign merchants. Xu would come to learn more about this emerging trading world as his contacts with Europeans grew; he would later even visit Macao to see for himself. But it was his experience growing up in Shanghai, before Europeans were yet a major presence in regional maritime trade networks, that got him to the idea that what he called 'the way of mutual profit' was the only

way to manage foreign relations and foreign trade along the coast. 'By trading, both sides profit; by not trading, both sides are harmed.' It was a realistic assessment, though tough to get past the moral guardians who wanted to quarantine China against the threats, opportunities and influence of the outside world. But this takes us slightly ahead in Xu's biography.

In his youth, Xu got the standard education in the Confucian classics designed to produce candidates for the state examination system. Despite the challenges of making ends meet, his family was able to afford to educate him through his teenage years. (Xu's two siblings were girls and did not require the expenses of an education.) Xu had to enrol in another jurisdiction outside Shanghai in order to earn his first degree of *shengyuan* or Student (think of *shengyuan* as analogous to a BA). He was not quite nineteen, a respectable showing but not the sign of a literary prodigy. Getting to the next step, the triennial provincial examinations that conferred the status of *juren*, Elevated Person (analogous to an MA), eluded him for a long time. Over the next fifteen years, he sat every round of provincial exams but two. He finally passed in 1597. To become a *juren* at thirty-five was not exceptionally old, but not so young either. Then it took him seven more years to get to Presented Scholar (roughly equivalent to a PhD).

To support his family through these long lean years, Xu turned to teaching. A peripatetic career as a teacher took him to the city of Shaozhou in Guangdong province. Shaozhou was the site of the second Jesuit mission in China, after the first one, west of Canton, was shut down by popular protest. In the summer of 1595 Xu stopped in at the mission and spoke to Lazaro Cattaneo. Neither man recorded the encounter, but Cattaneo would have done what he could to engage his visitor's attention, possibly showing him the first edition of Matteo Ricci's world map, his first glimpse of the West. Two years later, Xu went up to Beijing to sit the Elevated Person exams in the capital rather than in Shanghai, possibly because the odds of passing were better there. And indeed he passed. He stayed on for the Presented Scholar exams the following year, hoping to pass the two twice in quick succession, but that did not happen. He went home to Shanghai, discouraged.

Three years had to pass until the next chance to sit the national

exams. And so in 1600, he travelled from Shanghai up to Nanjing with a plan to devote several months there to preparing for his second attempt. Before going north, he decided to call on the Jesuits now ensconced in Nanjing. There he met Matteo Ricci for the first time. Ricci gave Xu a basic outline of Christian theology and probably a taste of European science. A connection was kindled. Xu then went up to Beijing to fail the Presented Scholar exams for a second time, returning home in defeat. Another three years passed, and he set off once again to try his luck. He again stopped in Nanjing to see Ricci, but the Italian had gone north two years earlier to set up a church in Beijing. His replacement was a Portuguese priest named João da Rocha. Xu must have already resolved to commit himself to the foreigners' teaching before arriving in Nanjing, for he asked Da Rocha to catechise him and accept him into the Church. Da Rocha did so, baptising him as Paolo. Xu then went north, sat the exams and, as if in response to his conversion, passed.

Xu spent the next two decades in the Hanlin Academy working on policy questions. Political tensions at court occasionally obliged him to withdraw to an experimental farm he set up east of Beijing, but every time he returned it was to the centre. Spending his entire working life in Beijing allowed him to provide the Jesuits with cautious tactical support when necessary. It also put him in position to promote various schemes to mobilise the Europeans' technical knowledge in astronomy and ballistics on behalf of the Ming. Xu's residence in the capital gave them time to collaborate on a range of projects that included translating Euclid's *Elements* into Chinese. Euclidean geometry laid out the principles needed to aim a cannon, so this translation was not merely an academic exercise. Xu's watchword was practicality. Anything that helped him improve the capacity of the Ming state to repair weaknesses within and withstand threats from without, especially the threat of Manchu invasion from the north-east (hence the interest in sighting cannon), was a thing he wanted to learn. Ricci taught the new sciences because they demonstrated God's presence in the world as well as reinforcing his image as a man of wisdom and authority; Xu learned them because they might prove of practical value for the task of ensuring the survival of the dynasty he served.

Bashing out translations of Euclid was only a small part of the learning that went both ways. What the two men did, more than anything else, was simply talk: about religion, history, science, China and the world. Ricci later published two of his talks with Xu as part of a book of conversations under the title *Ten Talks of an Eccentric*, based on Zeno's *Paradoxes* of the fifth century BCE. These conversations cannot be taken as transcripts of real chats, but they reveal Ricci's method: to manufacture a West that conformed to Christian morality.

Conversations

Ricci starts by asking Xu about something he has noticed. 'In China, gentry and commoners alike have a phobia about the afterlife. Bring it up in conversation, and they steer clear. Why is this?'

'Because life after death is nothingness! It is darkness! How can even a man of wisdom deny it?' Xu turns the question back to Ricci: 'How is it in your country?'

'There is nothing clearer to every living person than the certainty of death. The only thing that is not certain is when death will come', Ricci replies. But death is always approaching, and Ricci illustrates this with the metaphor of a voyage. 'When a traveller sails on the ocean, he sits, stands, sleeps and eats on the boat, as though he has stopped somewhere and is not going anywhere. And yet day and night his body keeps moving. There is not a moment's pause, and in fact everything goes forward.' Ricci is here recalling his own experience sailing to China, one that Xu can appreciate even without having had the experience himself.

'How sound your wise comments are', Xu replies. 'The common view today has it that if one turns all his thoughts and words and deeds to goodness, then he will become good. But if one is constantly thinking of the afterlife as evil, he will look upon the world with a vicious mind and a vicious tongue.' For Xu, this is why Chinese do not like to talk about death. The prospect of annihilation will only induce people to behave badly, so it's best to avoid the subject.

'Not so', Ricci responds. Anticipating the afterlife should have the opposite effect, of encouraging people to abandon evil and pursue good. It is the journey of life that is difficult, not the end. 'Understand, good sir, that the Son of God gave us this world as a temporary

residence, not as a place to live for ever, so we should take All under Heaven as a temporary inn, not a permanent home.' To underscore his point that life is ephemeral, Ricci cites a passage from Strabo's *Geographika* of the seventh century BCE, where it is recorded 'that there is a bird on the banks of the Nile that is born when the sun rises and dies when the sun sets, so that its greatest age can only span one day. How is this any different from the brevity of a hundred years for us?' But did such a bird ever exist? Chinese readers had no way to judge.

To express the precariousness of life, Ricci describes a china shop, creating a scenario that would have been unfamiliar to Europeans, as Chinese porcelain was only just starting to appear there, but that made complete sense to Chinese. 'If you go into a china shop and look at the pieces, you will see they are of different size and thickness. Suppose you were to ask the shopkeeper, "Which of these will break first?" He cannot say, "The thinnest will break first and the thickest break last." Nor can he say, "The porcelain you take out first will break first and the porcelain you take out later will break last." All he can say is, "The one that hits the ground first".' Ricci does not locate the shop in a specific time or place, so there is no danger that his readers will take this parable as a description of life in Europe.

Then he tells Xu about Sparta. 'By custom the people of this country do not regard life and death as two separate things. It is common practice, even among the women, to treat death lightly and value righteousness. Their history tells of a mother whose son died fighting off bandits. The person who came to report his death expressed his condolences, saying, "How sad to have a son die for his country." She calmly replied, "I gave birth to my son for this day. He has lived out the life that was his."' Ricci ends the story with the ambiguous comment that there may be sorrow in this life, but 'far greater may be the sorrow that comes after death.' By embedding a Christian message in a pre-Christian time and place Ricci encourages his Chinese readers to imagine a West that is culturally consistent with that message two millennia in the past.

Here the conversation ends, but Xu returns the following day to continue where they left off. 'What you brought up yesterday really is a matter of desperate urgency. I was shocked by what you said. Is it possible to avoid this fate, I wonder? Could you please go over your

argument again and explain it step by step, so that I can write it down to keep as a warning to be vigilant?'

Ricci is happy to do so, walking Xu through the misjudgements that arise from ignorance, desire, fame, pride and fear, illustrating each with parables. For ignorance he turns to the sea, sketching a scenario that would have been familiar to Europeans who have travelled to China, less so to a land-bound Chinese. 'When beginning a voyage, the chief officers of a ship must have a rutter and a map', Ricci explains. A rutter is a handbook in which sea routes are recorded as a series of directions and distances from one place to the next along the route. Chinese and Europeans both used rutters, though we do not know whether Xu had ever seen one. Ricci would have, given his shipboard travels from Europe. He explains how pilots determine a ship's position at sea by working from the last known position and deducing their current position on the basis of distance covered and angle travelled – a procedure known as dead reckoning. 'They keep track of how far they travel each day, and so know the distance they have travelled. Positioning themselves in relation to what is behind them, they know what lies ahead and turn the rudder accordingly.' Ricci then presents the message: 'Our progress along the road of life is like this. By keeping track of the past and reckoning our location in relation to the endpoint of our life, we can know what to do in this life.'

For some anecdotes he turns to history, telling Xu about Alexander the Great and about the twelfth-century Egyptian Saladin, who 'was the overlord of seventy countries'. For others he turns to the Bible. He mentions the 'ancient sage' Master Peleg, in the eleventh chapter of *Genesis*. According to the Hebrew Bible, Peleg lived to the age of 239, an example of someone who was able to put off death for a long time. He then goes on to the next story in *Genesis* about the Tower of Babel. To both these stories, however, he adds additional details. He tells Xu that Peleg lived in a graveyard for six years in order to make himself fully conscious of his own death, and then that 'the people of Babel sited their graves outside the doors of their homes so that they see them whenever they leave or enter'. Neither detail is mentioned in the Bible. Ricci was under no obligation to stick to the biblical versions of Christian stories or not to adorn these stories to enhance their impact, but he gives Xu no point of reference outside them. What he

says about Peleg and Babel simply happened. They had entered Xu's register of facts about Europe.

Then there is this parable of the two rivers: 'In the Western Region, there are two rivers close to each other. When people drink the water from one, they laugh themselves to death and cannot stop. When they drink from the other, they stop laughing and are cured of the affliction.' The moral of this story? 'The water that causes people to laugh themselves to death is the worldly pleasure that deludes and harms the mind. The water that stops the laughing and cures the affliction is contemplation of what comes after death.' Ricci's message is clear, but it comes wrapped in a parable that Chinese readers would not necessarily have understood as fiction. They knew that unknown lands stretched off into the far distance beyond China's western border. Out there, they could now suppose on the basis of this testimony from the Master from Beyond the West, lay these two strange rivers.

At the end of this conversation Xu exclaims: 'Everything in these stories is entirely to be trusted! These are indeed a great supplement to the teachings of this world.' Some Confucians might allow Buddhism to supplement Chinese values, but for Xu the real supplement was Christianity. 'From now on, I know how to prepare for death. Most people do this by looking for a solid coffin and divining for a propitious site to bury it. How perverse of them not to realise that we will receive strict judgement before the throne of Heaven.'

'Perverse indeed!' agrees Ricci. 'A coffin may not collapse of itself, but Heaven will collapse it no matter how thick the wood is. Giving your relatives a good burial arises from admirable human sentiment, but that is no reason to neglect their souls.'

What was Xu to make of any of this? Parables did not have the canonical status in China that they did in Europe, where Aesop, Jesus and many others used them regularly. Chinese knew how to tell stories to make a point, but their canonical stories tended to come from history and were therefore understood as having a basis in fact. By setting his parables in Europe, Ricci easily elicited the wrong reaction from Xu. He knew that he was being instructed in Christian theology, but he naturally also assumed that he was learning about Europe, a subject of which he was an eager student. He had no ready basis on which to filter Ricci's fiction from Europe's history.

Paolo's Europe

These conversations had many readers. Ricci composed eight more conversations with other Chinese friends, all of whom he names, and published them in his *Ten Talks of an Eccentric* in 1608. Ricci's point was not to show how logic can reduce every sound claim to absurdity, as Zeno did in his *Paradoxes*: it was to shake Chinese readers out of their philosophical complacencies. The book did reach readers, for he later wrote to his superior in Rome to tell him that his *Ten Talks* had been reprinted several times and circulated more widely than any of his other publications.

Ricci cannot entirely be faulted for fictionalising. As a missionary his purpose was to convert Chinese to a religion that would lead them to salvation, as he saw it, and he used whatever methods he could think of to communicate the excellence of his worldview. It is not surprising that he ended up exoticising the Great West as a land of marvels, and at the same time idealising it as a place where people of extraordinary virtue and sobriety embodied Christian teachings in their daily lives. But much was presented as though it were real, and not just parables. When telling Xu about Babel, for instance, he adds that, 'as a rule, people in the several hundred countries in the Western Region that share my teaching bury their dead inside cities, lest they forget to prepare for death'. A significant detail that emerges from this comment is that the Great West is made up of hundreds of countries. This fact would have struck Chinese, who lived in one country that received visiting tributaries from at most two dozen. The West was such a different world, yet it was not entirely as he described it. His teaching was not universal. Nowhere does he mention the divide between Christians and Muslims, nor between Catholics and Protestants. The Great West was a deeply divided, violently conflicted place. Ricci needed Europe and China to be similar enough to argue that Christianity could be accepted in China as it was in Europe. But he also needed Europe to be a better place than China so that it could attest to the superiority of his religion. That meant presenting Europe as other than it was, and no one in China could say differently.

Another discrepancy arose. What Europeans came to know about China was so much greater than what Chinese knew about Europe. This discrepancy was in large part thanks to the Jesuits being on

site and able to observe China at first hand, but it also had much to do with ordinary Europeans who were starting to circulate in ever greater numbers through East Asia as sailors and traders and who brought back versions of China they picked up offshore from Chinese and others who had been to China. This discrepancy in knowledge would dog China's relationships with the West down to the twentieth century. The West developed an entire branch of scholarship devoted to studying China known as Sinology – this became my field of study as an undergraduate when I became a bit bored with studying English literature – whereas China did not have what might have been called Europaeology. Chinese could not easily get to Europe and therefore had no opportunity to acquire first-hand knowledge. They could only learn about the West from the Europeans who came to them, though most lacked even that opportunity. Early Chinese knowledge of Europe was limited to what Europeans with vested interests told them or wrote down for them, and in language and parables that could be difficult to understand or credit. Some elements of European knowledge were absorbed, as we saw from the maps that Chinese cartographic publishers were turning out during these years. But Chinese knowledge of Europe was incomplete, blocked or filtered at every point of contact, and that put Chinese at a disadvantage.

The picture of Paolo's Europe – Ricci's Far West – was thus shaped by Ricci's relationship with China as the foreigner, the distant outsider whose acts and motives were suspect, yet who had knowledge of the world that Chinese could not access. The impact of this difference comes out poignantly in Xu's preface to his translation of a treatise on the use of the Archimedean screw for irrigation written by Sabatino de Ursis, one of the Beijing Jesuits Shen Que called out during the Nanjing persecution. Xu quotes Ricci as telling him that he had 'passed through upwards of a hundred countries' to reach China from Europe, and by comparison with what he had seen elsewhere, China was distinguished by its rites and music. It was a canny compliment, for Confucianism regarded rites and music as the highest arts of civilisation. 'China thus deserves top rank among all countries within the seas', he observed. But the compliment then paved the way for Ricci to be blunt about China's weaknesses, for he went on to say, 'I also note that most of its people are impoverished, and that as soon as they

encounter a flood or drought, the roads are littered with corpses.' Ricci had lived through the great Ming famine of 1587–8, as well as the lesser drought of 1598–1601 and the floods of 1603–4. He had seen how environmental disasters could overwhelm the country, and believed that European technology could help alleviate the suffering of the people.

For Xu, this external perspective was immensely encouraging. Although China met one European standard only to fail at another, the larger assumption underlying the split judgement was that China was not fundamentally different from the rest of the world and could benefit from the knowledge that lay beyond its borders. Ricci's conviction, which Xu reiterates at several points in his writings, was that 'there are principles common to both East and West'. This conviction came up, for instance, in a conversation he had with Ricci about the importance of water-lifting technology in Spain. Ricci took it as axiomatic that 'when the people are prosperous, benevolence and righteous conduct follow' and saw no reason why that principle should not apply in China was well. The sociology may sound a bit simplistic, but it was what Xu wanted to hear. His passion as a statecraft Confucian was to improve the welfare of the people. Rather than exhort the people to be moral, he preferred to furnish them with the conditions under which they will naturally become so.

Xu's attitude on this point put him somewhat at odds with the more speculative wing of contemporary philosophers, whose eyes were on higher things. Xu's eyes were on the physical world around him. Despite his willingness to accept the mysteries of Christianity, Xu did not regard 'Western learning' as an escape from the reality of 'this world', a term Ricci constantly used to depreciate the importance of this life compared with the next. What won him over to the Jesuits was the mechanistic model of the universe they used to infer scientific knowledge from their observations of the physical world. Armed with that approach, a person with high purpose and the right analytical tools could engage productively in work that benefited the security of the state and the prosperity of the people. If Ricci, in this case, insisted that Spanish irrigation techniques had been shown to benefit public welfare, Xu saw no need to construct an elaborate argument about morality following concrete experience to justify borrowing

them (Confucian moralists would have objected in any case). Xu just wanted to get on with what needed to be done. If something were true in the West, it was true in China, and no further proof was necessary. The world could be only one place.

The essential unity of creation was, of course, Ricci's message as a missionary: that the world was one place under the Christian God. And so, to some extent, he and Xu were at cross purposes, Ricci using the science of nature to demonstrate the grounds for faith, and Xu using science to see the Ming Great State through hard times. That difference did not much matter at the time. Xu was busy with the tasks at hand, and Ricci took the long view that China would eventually become a Christian land. Both projects would fail, though not for want of trying.

Expelling the Europeans

In embracing the commonality of East and West, Paolo Xu was a citizen of more than his own age. But the revelation of commonality was not a discovery that everyone welcomed or even tolerated. Shen Que was hostile to the idea, and Xu was surprised and disappointed by Shen's attack. They had disagreed about Christianity earlier, when they were colleagues in the Hanlin Academy and Xu was still a recent convert. Xu suspected some other matter was entangled with the attempt to expel the Jesuits, but couldn't get to the bottom of it, according to the letter he wrote to his son. 'To say abruptly that they are spies: what sort of thing is this, waiting until they have lived in the capital for seventeen years and then mentioning it?' Xu also tells his son that rumour had it that Wanli too was puzzled by Shen's denunciation and had asked one of his eunuchs, 'Why is there so much talk about the wise ones from the West?' To which the eunuch was supposed to have replied, 'We have always heard that they are good people.'

The Jesuits were in part the authors of their own exposure. They had regular contact with the outside world, when it was understood that anyone who moved permanently to China should end all foreign contact. Why were they corresponding with Macao and receiving money, if not for some nefarious purpose tied to the interests of the countries from which they had come? Then they were devoted to an

authority higher than the emperor. They might celebrate the emperor as the Son of Heaven, but their loyalty, it was understood, was first to Heaven. Chinese had had enough experience of unsuccessful regimes in which Buddhist monks had exercised undue power to value separating church and state, yet the separation was to be understood as a subordination of the one to the other, not as a competition between them. Any religion that implied it occupied a place equal to or above the emperor was doomed to suppression.

Then there was the outlandishness of what the Europeans claimed about the realm they came from. When Shen complained in his memorial about the Europeans' doctrines containing 'inaccurate and boastful absurdities', he was not entirely wide of the mark. Living to the age of 239? Drinking from a river and dying of laughter? A continent of several hundred countries? Did greater and lesser really care for each other? Was nothing lost that was dropped on the road? Were the gates always left unbarred at night? How could they be trusted to tell the truth about the Great West? Was there really a West Great State equal to the Ming Great State?

Xu's defence of the Europeans was not enough to parry all the attacks that Shen and his associates continued to pile up through the autumn of 1616. After Shen filed a third memorial, on 7 January 1617, Emperor Wanli at last responded. Perhaps he was persuaded by Shen's concern that 'in recent years suddenly crafty barbarians have been coming from afar'. Whatever argument finally snagged his attention, on 3 February 1617, the emperor issued the edict authorising the Jesuits' expulsion, though it was not quite the stern condemnation that Shen wanted. Instead, following the cautious language of a report on the matter submitted by the Ministry of Rites, the emperor speaks of the Europeans in two registers, as missionaries and as foreigners. As missionaries – heterodox sectarians, from the Chinese point of view – they 'subvert the truth, mislead the people and engage in open propaganda to spread barbarian ways in China'. Despite his willingness to follow Shen on this point, the emperor did not regard religious propaganda as 'constituting an immediate danger'. That required no action on his part. As foreigners, however, they 'reside in the provinces, slip about unnoticed and disclose conditions within China to other maritime powers', and that could be construed as a threat. Every foreigner

was potentially a spy. 'This has a bearing on our military decisions and constitutes a truly serious danger.' This is why he ordered that the two Jesuits in Nanjing should be banished from the realm, and not just them, but the two Jesuits in Beijing as well.

The expulsion of the two missionaries in Beijing – a Spaniard, Diego de Pantoja, and an Italian, Sabatino de Ursis – came as a surprise to those who were not in Shen's camp. Pantoja had lived in the capital since 1601 and de Ursis since 1607. Both had assisted Matteo Ricci in spreading the Christian religion, but they had also provided services to the court. These services included geographical surveys, astronomical calculations and, in Pantoja's case, teaching four eunuchs to play the spinet, which Ricci had presented to the court to entertain the emperor. There had heretofore been no indication that their presence in the capital was problematic. When Ricci died in 1610, the emperor granted Pantoja's request for a burial site. Wanli himself mentions this grant in the opening preamble of his edict, where he explains that he had admired Ricci's moral character (though he had declined to meet the man), but that since Ricci's death he had become concerned that 'followers have increased in number by the day, and their activities have became more perverse and secretive'. Chinese rulers have always been anxious about religious activities among the people that go on out of sight of the state. Who knows what dubious things they get up to? The anxiety was enough to persuade Wanli to banish the Europeans who had served his court, in Pantoja's case for over fifteen years.

It seems that Shen was vindicated and Xu ignored. But not quite. The emperor's command actually reads: 'It is ordered that Alfonso Vagnone and others, for setting up a teaching [i.e., a religion, in our terms], deluding the people and working unfathomable schemes, be sent to the tribunals of Canton and ordered to return to the West. As for Diego de Pantoja and others, let them also be sent back to their countries.' This expulsion was limited to four people: two in Nanjing and two in Beijing. Nothing was said about Jesuits elsewhere in the country. The Ministry of Rites wanted them all expelled, but that was not what the edict granted. There were two other Jesuits in Beijing at the time, Francesco Sambiasi and Niccolò Longobardo (who had evaded being rounded up by slipping out of Nanjing the previous

summer). Not being named, they remained untouched, though they chose to lie low by living with a convert in Hangzhou. The edict had blown a chill wind over mission activities. Despite the change in climate, as long as the Europeans still in China stayed out of the public eye for the present, they were left alone.

In Nanjing, Vagnone and Semedo were put through further rounds of questioning, especially about covert contacts with Macao. Shen Que himself headed one of the tribunals, insisting that Semedo, who was still ill, be carried in on a plank to face him. Shen told them they both deserved the death penalty, but had been spared by the emperor's clemency. This was not actually the case, as the edict of expulsion did not indicate that any capital crime had been committed, but Shen wanted them thoroughly intimidated. Shen ordered the relatively light punishment of ten strokes with a bamboo rod, though even he excused Semedo. It took a month for Vagnone's wounds to heal.

On 30 April, the day they were expelled from Nanjing, Vagnone and Semedo were confined to wooden cages and manacled, and in that fashion carried out of Nanjing by two officers and eight soldiers. Wooden cages were normally prescribed for prisoners being taken to their deaths; this was Shen's way of reminding the missionaries that death was what they deserved as far as he was concerned. The prisoners' destination was Canton, a month's journey to the south. For the first five days, they were not allowed to leave the cages. After that, their guards allowed them out for meals and sleep, but they had to get back in the cages when they travelled. The point was not to prevent them from fleeing: it was to humiliate them in full public view.

Meanwhile, Pantoja and de Ursis were required to leave Beijing for Canton, where they joined their Nanjing confrères. All four were put through another round of questioning, and another set of reports were written to show the Ministry of Rites that the order for expulsion had been properly executed. Canton then had to hold them back for eight months before delivering them to Macao until they knew that a ship was leaving that could take them back to Europe. Once the four were deposited in Macao, however, not one of them did as the emperor ordered. They remained in Macao. The two from Beijing ended their lives there, Pantoja in 1618 and de Ursis in 1620. But a year after de Ursis's death, Semedo adopted a different Chinese name and

went back in; Vagnone followed shortly afterwards. (Both would die natural deaths in China many years on.)

Shen Que was still politically prominent in the early 1620s and still adamantly opposed to letting Jesuits into the country. When Emperor Wanli died in 1620, Paolo Xu proposed to the new emperor that the court hire Portuguese gunners from Macao and bring in Jesuit priests as technical advisers, and Shen predictably objected. But once he was forced from office in 1622, the bridge that Xu and the Jesuits had opened between China and the West reopened. Still, there would be limits to what traffic that bridge was allowed to carry. Perhaps if Xu had become Chief Grand Secretary before 1632, when he was seventy, and had not died the following year, the terms under which the Jesuits entered China might have been altered. The threat of the Manchus on the northern border was more pressing than the presence of a few Europeans. When the Manchus finally invaded and brought the Ming to an end in 1644, they readily accepted the Jesuits as technical advisers. The new rulers were able to keep them inside the court, captive to their service. Knowledge of the West became a privilege their new masters kept for themselves. For most Chinese, the Great West was a distant and unknown place.

And yet fragments crossed the barrier. In Paolo Xu's final year, when he was Chief Grand Secretary, you could wander through the market at Beijing's City God Temple and find what the author of a guidebook to the city called 'things brought by envoys from the Western Ocean'. These things included all manner of foreign objects from places as far-flung as Tibet and Europe. The West, wherever it was, had become a catch-all for whatever was foreign and far away. And there, mixed in among these exotic items you could find at the market, were statues of 'Yesu'. Amazingly, the author of the guidebook knew who Jesus was when he saw him, and he seems to have assumed that his readers would do too. Shen Que had complained that these missionaries were not 'envoys from the Western Ocean'. Xu had insisted they were. The guys running the stalls in the market didn't care either way.

THE QING
GREAT STATE

9

The Occupied

The Yangzi Delta, 1645

On 25 April 1644, Emperor Chongzhen found himself almost alone in the Forbidden City. He had ascended the throne seventeen years earlier as a sixteen-year-old. Now, at thirty-three, he was on his own. The rebel general Li Zicheng, the Dashing Prince, had led his army through the Gate of the Prime Meridian, breaching the region's last line of defence and descending on the capital. Two days earlier, he had invited Chongzhen to submit to his protection. At a final cabinet meeting the following day, the emperor's advisers could not agree on how to proceed in the face of such bare-faced treason, but Chongzhen decided that he would not surrender to these rebels. He smuggled his sons out of the palace, then gathered the remainder of his family the following morning.

First he ordered his empress to commit suicide so that she would not fall into the hands of the rebels. He may then have asked his consort and his two daughters to do the same. They possibly quailed, for he took a sword and stabbed them. Princess Kunyi died instantly, but Princess Changping lingered on with a severed arm. The emperor then turned his back on this bloody scene and left the palace by the

north gate, climbing Coal Hill behind his residence. What happened next comes in many versions. In one, a servant found Chongzhen's body dangling from a branch of a tree, his sash knotted around his neck. In another, the servant found him at the foot of a tree, either cut down by a loyal servant or, some said, by someone who had strangled him. One version of the story insists that a scrap of paper was found by the body. 'Son of Heaven', it said, not in Chongzhen's own hand. Another has it that he left a suicide note: 'I die unable to face my ancestors in the underworld, dejected and ashamed. May the rebels dismember my corpse and slaughter my officials, but let them not despoil the imperial tombs or harm even one of Our people.'

For the Dashing Prince, this was a convenient death. He was not left with the awkward complication of how to deal with the captured emperor of a fallen regime when his own ambition was to take that man's place. Chongzhen's death, apparently by his own hand, opened the path he was bent on taking. But the Dashing Prince was not a complete fool. He was only too keenly aware that his military position vis-à-vis his rebel competitors – and more to the point, the huge Ming army defending the Gate of the Mountains and Seas against a powerful Jurchen army – was not strong. Nevertheless, he mounted the throne, declared the founding of a new dynasty and dispatched an army to the Gate of the Mountains and Seas to see if he could destroy the last power of the Ming. But when a combined force of Ming and Jurchen soldiers defeated the ill-disciplined army he sent against them, the Dashing Prince abandoned Beijing and let his brief dynasty dissolve. He survived for a year on the run, dying eventually at the hands of a village militia.

No Chinese drawing of the events of Emperor Chongzhen's last morning has survived; probably none was ever made. The lack of visual material did not discourage the publisher of Martino Martini's *How the Tartars Laid Waste to the Chinese Kingdom* from commissioning an illustrator to produce thirteen illustrations of events in his book about the fall of the Ming. The sixth in the series combines Chongzhen's killing of his womenfolk and his suicide on Coal Hill (see Plate 12). The illustrator had nothing to go on, so he pictured the palace as an Italian villa and put Ottoman-style turbans on the heads of the men, since turbans were the signature headgear of Orientals. Martini

himself would have known better. A member of the Jesuit mission to China, he had been there at the time the Ming fell, albeit in Hangzhou rather than in Beijing. Shortly after returning to Europe, Martini arranged with a publisher in Antwerp to bring out his *History of the Tartar War* in 1654. The book became an instant best-seller in Europe, with editions appearing in half a dozen languages that same year in Cologne, Amsterdam, Delft, Paris, Madrid and Lisbon, and the following year in London. When the illustrated edition appeared in Amsterdam in 1661 under a revised title, Martini was back in Hangzhou. That edition sold well, if the large number of copies still in existence are anything to go by. It is unlikely that Martini ever got a chance to see or correct the illustrations. He died in Hangzhou that summer.

It made sense that Martini was in Hangzhou in 1644. As the capital of Zhejiang province, it was one of the half-dozen most important cities in the region Chinese called Jiangnan, 'South of the River'. Anchored to the prosperous Yangzi River delta, Jiangnan was the heart of the late-Ming economy, the centre of its culture efflorescence and a fertile ground for the Jesuit mission. Despite the earlier expulsion of the Jesuits from Nanjing, Jesuit missionaries and their Chinese communities remained active across the Yangzi Delta, notably in Hangzhou and Shanghai. Converts here had the resources to withstand pressure from unsympathetic officials and to keep the new religion alive. As Martini narrated his version of the fall of the Ming from South of the River, so will I.

Portents

Dong Han was a lad of sixteen living in the city of Songjiang, another of the half-dozen key cities on the Yangzi Delta, when, in his words, 'all within the four seas became a seething cauldron'. Rebellions had arisen in the parched north-west, Jurchen armies had moved right up to the Great Wall and local order was breaking down. Fearing the worst, he recalled, in the sporadic memoir he kept of his experiences: 'we fled the chaos and shifted from place to place until we ended up to the east of the Mao Lakes', some thirty miles west of Shanghai and roughly twice that distance north-east of Hangzhou. 'Though our hovel of a few rooms was dilapidated, it was enough to keep out the wind and rain. There we watched by day and chanted by night, cut off from everyone.'

The Dongs were an educated family, but not a wealthy or prominent one. They lacked the resources to act at the political level. All they could do, as disorder threatened, was to flee Songjiang – cities were always a target – and hole up in an out-of-the-way rural location where the worst of the chaos might pass them by. Cut off from the news-sheets printed in prefectural capitals such as Songjiang, rumour became their only source of information. Over the course of 1644–5 the rumours became more and more harrowing. Dong kept a record.

In Linqing, the main river harbour on the Grand Canal south of Beijing, rumour had it that a family hoarding sacks of beans against the time when food would run out opened the sacks to check on their hoard, only to discover that the beans now looked like human heads: 'heads of old people, of young people, some with faces that looked as though they were crying, and also some that looked female'. Although within a few days the beans went back to looking like beans, this was not a good sign. Nothing would stay as it was, Heaven seemed to be saying, and heads might roll.

Further south on the bank of the Yellow River, Dong heard about a vision of a walled citadel that appeared in the sky. 'Nothing was missing', he heard tell – the extravagant castle simply shone there, visible to all through the afternoon, and then after four hours it vanished into thin air. Out near the coast in the city of Huaian, a tree in one of the city's main temples wept 'tree tears' for three days. Closer to home, he heard about a ship with a hundred refugees on board sailing from Suzhou that was struck by a tornado a hundred miles out to sea. As the gale-force winds did their worst, a horde of blue-faced demons twenty feet tall swarmed the vessel. Only two passengers, clinging to the wreckage, survived to tell the tale.

Word of abnormal births became regular grist to the rumour mill. A horse in Dong's prefecture laid an egg the size of a goose. A chicken egg hatched a chick with three legs. But these abnormalities were mild compared with monstrous human births. On Chongming Island in the mouth of the Yangzi River, a woman gave birth to thirteen still-born babies, each six inches long. In Songjiang, a woman delivered a child with horns and three eyes, two of them open and the middle one closed. In both cases, the creatures were destroyed – the three-eyed newborn killed, the thirteen foetuses thrown into the sea.

The natural world became so disturbed that birds sensed the chaos. Strange white swallows (white was the colour of mourning) were found nesting on Songjiang's eastern city gate. A swarm of owls gathered one night on the roof of Songjiang's Drum Tower, where the hours of the watch were beaten through the night, hooting so loudly that they drowned out the drum. They sounded, to Dong's ears, 'like the weeping of tens of thousands of ghosts'.

Other stories started coming in as the Jurchen invaders approached the delta. One told of the brilliant officer Zhang Jirong who rode up to an inn outside Nanjing in full armour at a head of a small detachment of horsemen, calling for wine and food, only to disappear when an old man arrived at the same inn lugging Zhang's body from the battlefield. The legendary strongman of Shanghai, General Qiao, committed suicide rather than be captured or killed, but re-emerged from his tomb a month later, spluttering unintelligibly, to cudgel his son to death for choosing to submit to the conquerors – 'by which time', Dong noted with disappointment, 'ordinary folk were ready to submit as obedient subjects'. Who was in the right, and who in the wrong? Who should live, and who die? Not all victims found justice or revenge, though the three-eyed newborn from Songjiang did. He appeared to his father in a dream as a full-grown warrior in golden armour, vowing revenge. And he got it too: when the city of Songjiang fell to an army disguised as loyalist rebels on 22 September 1645, both parents died in the slaughter.

Dreams, resurrections and demons; omens, abominations and visions. The wall between the human world and other worlds was breaking down. This was the daily fare for the people of the Ming who lived and died through the long year of 1644–5 as army by army, city by city, the Ming dynasty collapsed as the Jurchen armies of occupation moved south. These years were so terrible that many, such as Dong Han, kept diaries or wrote memoirs of the troubles they experienced so that these memories would not be lost, and so that later ages would learn from their struggles and not become complacent enough to allow a disaster on this scale to happen again.

Disorders of Nature

Unlike the youthful Dong Han, Chen Qide [pronounced chee-duh]

was in his seventies when the disasters of the 1640s fell upon Jiangnan. Chen was a teacher who lived in Tongxiang, less than 50 miles from the Dongs. He could claim no great achievements during his career, but he left two detailed accounts of the years just prior to the death of Emperor Chongzhen. These survive only because a descendant included them in a slim volume of Chen's homilies on how to live an ethical life, published under the innocuous title of *Simple Words Handed Down To Instruct*. Only one original of this local publication survives today. Reading his account, we learn that the monstrosities and portents Dong Han so eagerly collected were not a sudden aberration but the flotsam that washed into Jiangnan on a flood tide of calamity that had been flowing for some years.

Chen Qide frames his account of the misery of those years by starting with his childhood in the 1570s, when the child-emperor Wanli was on the throne, 'when the harvests were bountiful, and the people prosperous. A peck of rice cost only 3 or 4 cents, and so if you wanted to ferment some to make wine, you threw away the dregs. Beans and wheat were fit only to feed oxen and swine. You could go from house to house and everyone had all the fresh fish and choice cuts of meat they needed.' That was normality for Chen, against which subsequent life failed to measure up. 'People reckoned that this prosperity would go on for ever and acted accordingly. How were we to know that people's hearts would give way to debauchery and that Heaven would deplore this overabundance?'

Misrule by the eunuch faction at court in the 1620s 'angered Heaven above and was resented by the people below', so conditions through the 1630s deteriorated, reflecting Heaven's dissatisfaction. Yet the natural world was not thrown into anything like the crisis that arrived in 1640. 'Heavy rains fell for weeks and months on end. Compared with floods of 1588, the flood waters were at least two feet deeper. As far as you could see in all directions was a great swamp. Boaters poled their way among beds and couches, and fish swam through wells and stoves.' Here he is quoting old popular images to describe the complete inundation of communities in the worst floods. 'Those whose houses had upper storeys resorted to them as boltholes, while others either scrambled onto their roofs or climbed up onto terraces. Everyone woke each morning to wonder whether they would survive until

evening.' The price of grain climbed out of reach of most people. When the flood waters receded, 'farmers from the neighbouring prefecture fanned out across the fields of ours looking for sprouts, fighting over them as though these were rare commodities. This went on until early September; only then did they boat away.'

The following year, 1641, was worse. The disasters of that year started with a drought that expanded rapidly. 'The rivers ran completely dry. The price of a hundred litres of grain leapt from two ounces of silver to three', an unheard-of price.

Even though the spring wheat harvest was double what it had been in earlier years, it was not enough to feed everyone. Some ate chaff, some chewed bran, some resorted to eating weeds and tree bark. A respectable family that could feed every member two meals of flour gruel a day could be said to enjoy great good fortune. The vast majority had to get by on only one meal. Husbands abandoned wives, fathers abandoned sons, everyone fleeing in a different direction in hope of surviving. Merchandise accumulated in the markets for want of buyers. When those who could have used these things calculated the price, they could only walk away.

The poverty went from general to extreme.

The moneylenders closed up shop, but in any case people ran out of things to pawn. They called out to Heaven, but Heaven did not answer. They pleaded with the city's gatekeepers, but the gatekeepers did not let them pass. Those who courteously pled for help in the morning by evening were crawling begging on their knees. Once someone slipped and fell, it was like being sucked out on a roaring tide with no way to save oneself. Some were still holding onto a few extra grains of rice when they fell dead in their tracks. How could a person of humanity not weep to see this?

From the drought flowed other disasters. First locusts descended on the fields, stripping the land of its last vegetation. Then sickness

followed: first dysentery, then an illness so virulent that 'five or six out of every ten homes were infected'. Those who had not set aside coffins for their own burials 'could do nothing but let the flies be their mourners and the vines and rushes become their tombs. Who knows how many people simply abandoned their dead and fled to distant places?' The epidemic withdrew through the winter months but struck again in May, this time at a rate of 'eight or nine of every ten households'. In many a stricken household no one escaped infection. 'It became impossible to find a family, even with as many as twenty members, in which one person did not become ill, still less one in which one person remained completely healthy.' Disposing of the corpses became an insoluble problem. 'Once the coffins were full', Chen writes, 'corpses had to be wrapped in straw. Once the straw was gone, they were simply abandoned. Bodies piled up outside the doors of homes.' Local benefactors in Tongxiang banded together to set up plague cemeteries to dispose of the urban dead. 'Great holes were dug in the mud and filled with the corpses, sometimes fifty in one grave, sometimes sixty or seventy. In less than three months, fifty or sixty of these mass graves were filled.' Physicians found themselves without remedy or relief for this sickness. As a result, Chen reports, 'even quacks and charlatans were on constant call. The more death stalked us, the better their business grew.'

Tongxiang was not alone. What Chen Qide witnessed in his home county was replicated all up and down the Yangzi River and all across north China as colder temperatures (starting in 1629) and drought (starting in 1637) plunged the country into conditions worse than anything in a millennium. By 1639 famine was widespread, in many locations running for several years in a row. Famine districts suffering from drought were most vulnerable to locusts. They also tended to be where epidemics broke out, fitfully in 1639 and 1640, and then with gale force in 1641. For the next three years, in local chronicle after local chronicle, the same parade of events unfolded: no rain through the spring and summer of 1640, a plague of locusts in July, rain in August to germinate the buckwheat but frost in September to strike it down, famine in November, cannibalism in December, followed in the spring of 1641 by disease outbreaks that annihilated seven of every ten families and in some locations wiped out entire villages.

This sequence repeated itself later that summer, as locusts appeared in September, followed by famine and again by epidemic in 1642 and again in 1643.

The last major outbreak, in the spring of 1644, swept across the North China Plain and raced down the Grand Canal as far as South of the River. An eyewitness in Suzhou prefecture, Xu Shupi, wrote in his private memoir that the pestilence (*wen*) first broke out in Beijing and then descended on the Yangzi Valley in the opening month of the year. He reports that those who contracted the disease coughed up blood, and after presenting this symptom immediately died. Locally it was called 'bitter melon *wen*' because the clots of blood that victims vomited were said to be the size and shape of bitter melons. Xu also noted that it was a summer disease. The people responded by hiring shamans and paying for vastly expensive ritual performances at shrines to Wenshen, the God of Pestilence, in the desperate hope of assuaging his unfathomable wrath. Wu Youxing, a local doctor, could hardly blame them. The *wen* epidemic conformed to no known pattern, persuading him to abandon the old idea that diseases are latent in the body and erupt only when seasonal change veers off course. This *wen*, he insisted, was not linked to distortions in the seasons but invaded the body from outside and displayed a degree of toxicity beyond any other ailment. Wu was puzzled as to how to analyse it. 'Unable to see its form, unable to see or smell it, how can we perceive it? How can we know about it? Its onset has no set time, and its vector has no set direction.' Wu believed that 'the pestilence enters through the nose and mouth'. His only remedy was betel nut combined with magnolia and cardamom.

Genomic analysis that would allow us to identify the pathogen that appeared in so many places to devastating effect has not yet been done. Even without that confirmation, though, the virulence of the epidemics in this period (70 per cent was the common estimate of mortality) suggests the plague. A local record of 'a strange disease' east of Beijing reports that 'mortality was eight or nine out of ten, and friends and relatives did not dare to pay each other visits of condolence'. The rate of infection was shocking. 'Entire families were wiped out, with none to bury them.' There are also a few records of plague-like symptoms. Xu Shupi, just cited, called the *wen* of 1644

the 'swellings pestilence'. He didn't have a word for buboes, but described these swellings as 'blood clumps'. In the province west of Beijing a local chronicle records that a 'great epidemic' broke out in the autumn of 1644. 'The victims first developed hard lumps below the armpits or between the thighs' – suggestive of lymphatic buboes – 'or they coughed up blood mucus and died before they could take medicine.' One name for it was '*tantou* sickness'. *Tantou* means to stick your head out to see what's going on, but it could equally describe a hard swelling pressing up from under the skin, an image characteristic of plague buboes. Helen Dunstan, the first China historian to investigate these epidemics, judged these references to be 'near-conclusive' evidence that this was the plague. Until geneticists are able to isolate aDNA from this epidemic and sequence their genomes, hers remains the best assessment of the data.

If this was the plague, China was not alone, for the pathogen also erupted in cities all across the western end of Eurasia in roughly the same period: in London in 1625 (40,000 dead), in Venice in 1630 (50,000), in Nuremberg in 1632 (30,000), in Cairo in 1642 (1,800,000), in Barcelona in 1651 (15,000), in Moscow in 1654 (200,000), in Naples in 1656 (150,000), in Amsterdam in 1663 (50,000 dead) and again in London in 1665 (over 100,000), to mention but a few of the outbreaks. Plague scientists have not yet been able to agree as to why the plague returned to Europe in these years. Some argue that the plague re-infected Europe from Inner Asia, others that the bacteria had found ecological niches within Europe and re-emerged from there under the particular conditions that this phase of the Little Ice Age created. Which of these explanations suits the case of Ming China we cannot say until we know whether the outbreaks there were in fact the plague.

The chances are good that it was the same disease, for climate indicators show that China and Europe were experiencing much the same stressful conditions at either end of the Eurasian continent. The historian Geoffrey Parker has summoned evidence of climate strain all over the world to show that, starting in 1629, climate underwent a massive shift that touched most places on the globe. The bad weather struck Europe that year, beginning with excessive rains and then turning to drought. The following year, north India experienced total drought that lasted into a second year. The harsh conditions eased

somewhat in the 1630s, then returned with a vengeance in 1640: no rain in the Mexico valley between 1640 and 1642, stunted tree growth in the Americas from 1640 to 1644 (Massachusetts and Chesapeake bays froze over, as did all the rivers along the east coast of North America), the River Nile at its lowest level ever in 1641, and the rice harvest in Indonesia failing in 1641 and 1642. According to Parker's analysis, some places were more effective at mitigating the stress of climate change than others. States that had the infrastructural capacity to protect or even shift their food sources did better than those that lacked that flexibility.

The Ming Great State should have been a good candidate for surviving environmental crisis on the grand scale. It enjoyed the advantage of a well-articulated administrative system, and was able to attract talented men to work on its behalf. The weak link for the Ming, it has been argued, was its failure to maintain the state courier system by which the central government was able to maintain contact with every part of the realm. Budget shortfalls in the 1620s led to the closure of courier stations in less heavily populated and travelled regions. As the men who operated the courier system were military, closing stations meant unemployment for able-bodied soldiers – the Dashing Prince being one of these. As these soldiers-turned-bandits took matters into their own hands, they became strong enough to pick off the administrative system's more isolated nodes, now exposed and undefended, one by one. As drought and cold swelled the ranks of their followers, these rebels gained control of large northern reaches of the realm within the Great Wall. The armies of the Ming fought back where they could against the armies of the rebels, but beyond the wall, other armies waited.

One Man's Response

On 8 February 1644, the date of the lunar New Year that year, Qi [pronounced Chee] Biaojia started the first page of his new diary. The year 1644 was a *jiashen* lunar year, traditionally considered one of the worst in the sixty-year cycle by which Chinese kept time. Qi noted that local diviners had already warned everyone not to undertake anything of importance that day. But Qi had things to do. He had gone out on his barge on the morning of New Year's Eve to deliver rice from the Qi

family storehouse to his cousins, asking them to distribute it to poorer members of the clan so that no Qi should starve – and so that every Qi should remain loyal to the family in these hard times. That afternoon he had invited a neighbour to come and collect rice from the same storehouse to distribute to the village poor. The hungry were a powder keg in dangerous times. These duties done, he stayed home that evening and all the next day. New Year's Day dawned clear, a nice break after the bad weather of the previous few days. Even so, Qi spent New Year at home, forgoing the usual celebrations of calling upon friends and relatives. He travelled no further than his very large garden. He practised military drill with his household servants after lunch to keep them on the alert, but they remained on the property.

Qi lived south-east of Hangzhou, in Shanyin county, at the edge of the trouble that was brewing across the Yangzi Delta, and also in places further north. The previous three years had been the worst in the living memory of anyone in Shanyin. The drought, famine and epidemics that had devastated the region had struck Shanyin as well, and banditry had been the predictable result. Qi was preparing for catastrophes greater than those he had yet survived, drilling the villagers and distributing relief grain to keep people calm and on side. Normally, a gentleman of his status should not have been scurrying about his home village keeping order. He was a famous scholar and high-ranking official who should have been employing his talents in a provincial or national post. But his career had been uneven, though not untypical in this difficult era. He had passed the provincial exams at the precocious age of sixteen, and the national exams at twenty, marking him as a rising star. An assistant prefect at twenty-one and a capital censor at twenty-eight, he gained the attention of the earnest but somewhat unimaginative Emperor Chongzhen. But Qi was more a man of principle than he was a politician. Such a disposition is not ideal if you are a censor, as your job is to point out failings in the administration. Having crossed top Beijing officials one too many times, he had asked to retire at the age of thirty-two on the pretext of having to go home to care for his ageing mother.

For the next nine years he stayed at home, pursuing local projects on behalf of his community and engaging in public philanthropy. By the time he was called back to serve in Beijing, it was 1642 and rebellion

had become almost endemic in the north. No one from the south was going north to take up appointments, but Qi did. If the vocation of the Confucian was to aid the people, his highest duty was to serve his monarch when that service was commanded, as it was now. But Qi found the political environment in the capital impossible for getting anything done. Those with power used it only to gain more, and lesser officials had either to help them to their plunder or to stand aside. After barely a year in office, Qi petitioned to retire again, this time at the age of forty-one. The central administration was barely functioning in these difficult times, but his petition was granted. He went home to Shanyin.

We know more about Qi Biaojia than we do about most of his contemporaries because of his diaries. Whether in office or at home, Qi wrote something almost every day. There was nothing remarkable about his keeping a diary. Many people did. What is remarkable is that fourteen years of his diaries survived into the twentieth century, when they were first published as a record of what had happened in the final years of the Ming.

The day after New Year, when the most inauspicious day of the year had passed, Qi got back into motion. It was raining, but he went out to offer prayers at the local shrine and at the Buddhist temple, acts he would normally have performed on New Year. The next morning, he visited his ancestors' graves, as one did at the beginning of each year. He then spent the afternoon planting trees on the embankment along the edge of his estate. That evening he led his household militia out on night patrol along the same embankment. When he got back, an urgent message arrived, informing him that a friend who had stepped up to organise local defence in Jinhua, the neighbouring prefecture to the south, had ambushed a gang of bandits and beheaded them. The following morning, Qi went back to drilling the militia. That afternoon they gathered at the lineage shrine for combat practice. In the evening, another friend from Jinhua dropped by to tell him that his county had fallen to bandits and that he had had to move up to the city of Hangzhou. He asked whether Qi could spare any militiamen to help out in this emergency. Everyone was asking everyone for help.

The banditry in the Yangzi region was disturbing, but more dangerous to the realm were the rebellions rocking the north. Peasant

armies had been surging across north China intermittently for over a decade, and several rebel leaders were positioning themselves as candidates for emperor. The Dashing Prince was preparing to ascend the throne. Qi was too preoccupied with local woes to refer to these matters in his diary until 18 March, when he wrote that a friend 'came by to see me and tell me all about the bandits of the Dashing Prince entering Shaanxi province'. That same day, a letter arrived to tell him that his request to extend his leave of absence for medical reasons was being processed. Even in this disordered time, the machinery of government kept turning.

In his entry for 5 May, Qi reveals a change of heart. Regardless of the political mess in Beijing, his highest duty was to serve his emperor. 'Because of what is going on in the north-west', referring to the rapidly growing rebellion of the Dashing Prince, 'I have made my decision.' What you tell your diary is often not the final word, for two days later he asked a close friend to come over and help him make this decision. The change of heart about his decision of two days earlier may have been prompted by a visit earlier that day from someone sharing the newest information about the rebellion. The Dashing Prince had defeated the Ming forces sent against him and was now moving in three separate columns towards the capital. Beijing was under high military alert.

As Qi settled his family's affairs in preparation for returning to service, the unusually hot weather started getting to him. On 16 April, he had already written: 'Very hot, like the middle of summer.' On 7 May, he changed his phrasing from 'very hot' to 'extremely hot'. A bit of rain fell over the next few days, but there had been no serious rainfall for five weeks. All he could do in this heat was lie down – and worry that another drought might be in the making. The following day he started preparing to travel to the capital to report for work. The day after, though, he learned that some court officials in Beijing were proposing that Emperor Chongzhen should abandon Beijing and move the government south to the secondary capital in Nanjing. Qi's trip back into government service might prove to be shorter than he had planned.

News of disaster started to reach him in bulletin after bulletin. The day after setting out, Qi received a letter to say that the Dashing

Prince's forces were in Shanxi only and not yet near Beijing. But the next day, 11 May, he received yet another letter reporting that rebel forces had surrounded Beijing, and recalling an imperial audience on 31 March at which Emperor Chongzhen had wept at his powerlessness. Three days later, though, a friend received a letter from a relative in Beijing to report that no, the Dashing Prince's army was not yet in the Beijing region, but that yes, officials were clamouring to move the capital south to Nanjing – and that the emperor refused to retreat. As Qi headed north across the Yangzi Delta, the news got worse and worse: this commander dead, that city fallen, the capital under threat. His local colleagues began discussing the idea of commuting the annual grain tribute to cash in order to raise funds for the military, but the lack of rain was driving up grain prices, leaving those without grain hungry and those with land unable to pay their taxes.

Qi pressed on to Wuxi, the next city up the Grand Canal northwest of Suzhou. There he paused for a week, discussing with friends whether it wouldn't be wiser just to go home and prepare for the coming disaster. In the end, though, he decided that he was dutybound to serve his emperor, and so he set off on the final leg of his journey to report for service. Two days later, still short of Nanjing, he received his official letter appointing him governor-general of Jiangnan, effectively the Yangzi Delta and its hinterland. It was an extraordinary appointment, even for someone who had been a capital censor. Qi was not just being brought back into service: he was being asked to bear the burden of rescuing the entire region. He had suddenly become the new hope of the regime.

Three days later, on 1 June, events in the north caught up with him. He learned that five weeks earlier, on 25 April, Beijing had fallen to the rebel army and that the emperor he was sworn to serve, Chongzhen, had committed suicide. This news had reached Nanjing the day before, and senior officials there were gathering to decide on the succession. They chose the Prince of Fu, Chongzhen's cousin and the third son of Emperor Wanli. There was enormous irony in this choice. Wanli had desperately wanted this boy to succeed him, and had fought a long, losing battle with his bureaucracy to abandon the dynastic rule of primogeniture and put his favourite son on the throne. An entire generation of officials had successfully blocked Wanli's moves to put

the Prince of Fu on track to become emperor, and Wanli had died in 1620 knowing that he had failed. Now here was the next generation of officials doing just what Wanli had wanted.

Qi was not in on the decision about the succession, and he is a bit guarded in his diary as to whether he thought the succession had been handled correctly. There was another prince who might have been selected, but the vote went in favour of the Prince of Fu. Some of Qi's fellow officials were blunt in their opposition. At the meeting that Qi did not attend, the Minister of War, Shi Kefa, who the following May would lead the Ming's heroic last stand at the city of Yangzhou, north-east of the capital, bluntly listed seven factors that disqualified the prince from becoming emperor: he was corrupt, licentious, drunk, unfilial, vicious to inferiors, unstudious and interfering. Qi mentioned none of these charges in his diary, but he did worry on paper that old splits in the bureaucracy around disqualifying the prince a quarter of a century earlier could undercut the new regime. He voiced the fond hope that old battles could be forgotten to gear up for the challenges that were coming.

Three days later Qi reached Nanjing. The following day, Nanjing was officially redesignated the main capital of the dynasty, and the Prince of Fu made his entry. Two weeks elapsed while preparations for his enthronement were made, at the end of which the prince ascended the throne as Emperor Hongguang. By this time Qi had already left Nanjing on an inspection tour of the Yangzi Delta to help him draw up plans for countering the Dashing Prince's rebellion. He read about the enthronement in the *Capital Gazette*, the official government newssheet.

And then the entire situation shifted as events took an utterly unexpected turn.

Invasion

On 20 June 1644, Qi picked up the first rumour that a 'barbarian chieftain', as he called him in his diary, had entered through the Gate of the Mountains and Seas, the eastern terminus of the Great Wall where it touches the coast. Other rumours flooded south in quick succession: that the Dashing Prince had sent an army against this chieftain; then that the barbarians had defeated his force in a battle east of Beijing;

then that the capital had been 'restored' by the invading barbarians; then that the barbarians had seized the throne.

Qi's 'barbarian chieftain' was a Manchu prince named Dorgon. To bring him into the story, we need to go back to his remarkable father, Nurhaci, the unifier of the Jurchen peoples. The Jurchens had seized north China in the twelfth century during the Song period and founded the Jin (or Gold) Great State, ruling the region until Chinggis Khan and his sons destroyed them. Later, after the fall of the Yuan, the Jurchens had reasserted their independence from the Mongols but without cohering strongly enough to re-emerge as a political force until the sixteenth century, under Nurhaci. Employing the same tactics of force and persuasion that other steppe leaders before him had done, Nurhaci succeeded through the 1580s and 1590s in bringing the Jurchens under his leadership and also in gaining the upper hand over several Mongol groups as well. He was able to gain recognition from the Ming as a border vassal in 1589, and then used that recognition against contending leaders north of the Great Wall to build his empire, all at the Ming's expense. In 1609 he stopped sending tribute to Beijing without actually revoking his tributary status, thereby positioning himself in an ambiguous fashion between subservience and defiance. Defiance won out as Nurhaci declared himself Great Khan of the Jurchens in 1616. Two years later, he abandoned his vassalage to the Ming, and three years after that, in 1621, he seized the city of Shenyang, which had served as the headquarters of Ming operations in the north-east since 1592. Four years later he declared Shenyang his capital. He was on a steady course towards founding a Great State but died the following year, just short of that goal.

Steppe polities, as we have seen, tremble at times of succession, but his eighth son, Hong Taiji, handled the moment successfully. He had proven his bravery and determination in battle, but more to the point he had demonstrated administrative skill. Indeed, over the next few years he constructed a central administration that was able to manage the many ambitious components of his father's regime. In the course of building the alliances this new polity needed to strengthen itself in the region, Hong Taiji fostered a relationship with the Fifth Dalai Lama, whose own strategic alliances were positioning him as the leading Buddhist cleric in Tibet. The mutually beneficial outcome

of this relationship was that the Fifth Dalai Lama had the backing of the most powerful rising state in Inner and East Asia, and Hong Taiji gained for his father posthumous recognition as a manifestation of Manjusri, the fearsome Buddhist deity who used the sword of truth to defeat illusion and bring the people to the Buddhist dharma. To signal the rise of his polity and his people, Hong Taiji adapted the name of Manjusri in 1635 to create the ethnonym of Manchu. The following year, 1636, he had the confidence to declare the close of the Jin Great State and the founding of the Qing Great State.

The Manchus (to back-date their name before it was actually given to them) were as vulnerable to changing environmental conditions as the Chinese. Close research on this question remains to be done, but colder temperatures and drought appear to have challenged the Manchu polity in what came to be called Manchuria. A semi-nomadic economy requires fodder for its horses, and fodder is highly sensitive to changes in climate. But the Manchus were not purely a horse culture. They also engaged in agriculture. That said, the main agricultural producers in Manchuria were actually Chinese migrants who had fled to the region over the preceding decades in search of land. Hong Taiji sought to incorporate them so as to enlarge his regime's food supply and develop a tax base. Some in fact became 'Manchus', while others were incorporated into Nurhaci's armies, or 'banners', and came to be known as 'Han bannermen', a special category from which not a few advanced into the upper echelons of the regime. Manchuria being further north than China, its agriculture was even more exposed to changes in climate. The slightest fall in temperatures could reduce the growing season and therefore the northern limit of grain agriculture. Farmers working at that northern limit had to abandon their communities and move further south, in search of places within Manchuria where the growing season was long enough for their millet and wheat to reach harvest.

The timing of the first major Manchu incursion through the Great Wall in 1629 coincides uncannily with the environmental shift that year. Hong Taiji may not have explicitly been looking for land to the south, but the weakening of his capacity to extract food from north of the Great Wall must have become obvious quite quickly. He wanted to test Ming defences, but he also needed to loot food and other

supplies to continue building his regime. It was a beneficial foray, for among the supplies he looted were cannon. The Manchus also brought back cannoneers and, through them, knowledge of the new technologies that Ming officials such as Paolo Xu (whom we met in an earlier chapter) were adapting from Jesuit knowledge of European gunnery and combining with existing Ming practice. Further forays continued through the 1630s and the early 1640s, strengthening the Qing at the expense of the Ming. By 1643 Hong Taiji had assembled a large army just beyond the Gate of the Mountains and Seas and was poised to strike.

The Ming was not the only Great State against which Hong Taiji was in play. In his zone beyond the Great Wall a number of polities were vying for anything from survival to ascendancy, including the Yuan Great State. For Chinese, the Yuan Great State had disappeared in 1368, but for Mongols, it was still part of the constellation of power among leaders contending for supremacy. Chief among these Mongol contenders was Ligdan Khan, the Great Khan of the Yuan Great State who claimed descent from Chinggis Khan. Although Ligdan Khan had been ineffective in subordinating other Mongol princes to his rule, and was resented for trying, his status nevertheless blocked Hong Taiji's path. But Ligdan Khan's defeat by Hong Taiji in 1632, followed by Ligdan's death two years later, and Hong Taiji's acquisition of the seal of Chinggis Khan a year after that, were essential steps that he needed to take to found the Qing Great State, and declare himself Great Khan in 1636. His overtures to the Dalai Lama had been part of the larger strategy he was following to prevent any challenger arising from the ranks of the Mongols to claim the title of Great Khan, in that case by appealing to Buddhist legitimacy.

Despite, or because of, this success, twenty-eight Mongol lords across the Mongolian steppe, anxious about the rise of the Qing Great State on their south-east quarter, convened an assembly in 1640 to develop a common plan to deal with the altered international situation created by the meteoric rise of Hong Taiji. The outcome was a document they called the Great Code. Signatories of this treaty agreed to refrain from armed assault on greater or lesser states within the Mongol world. The penalty for doing so was invasion by a joint force of the other signatories and confiscation of half the possessions of the

ruler who contravened the agreement. Monastic communities of all religious affiliations were also protected with the same provisions, in effect enshrining religious toleration across the Mongol world. The intention behind the Great Code was to arrange inter-state matters in such a way that no hegemonic sovereign could emerge. What the Great Code sought to create, as the Mongol historian Lhamsuren Munkh-Erdene has put it, was 'a commonwealth of independent principalities with a common legal system and collective enforcement'. In effect, it proposed to spell the end of the Great State in Inner Asia.

But the next Great State had already arisen, in the shape of the Qing. Because of this, the Great Code of 1640 could not achieve what it had originally been designed to do. The failure of the Great Code to bring about a new inter-state system contrasts with what happened in Europe starting four years later, the year the Ming dynasty fell, when representatives of state under the Holy Roman Empire held the first of the meetings that led to the Peace of Westphalia in 1648. The Great Code imagined the principles of sovereignty, legal equality and non-interference differently from Westphalia, but one could argue that something analogous was happening at both ends of Eurasia at roughly the same moment.

Hong Taiji's death in 1643 could have caused the growing Qing Great State to splinter, given the readiness of the Mongols to resist; but it didn't. His sons were minors, but he had several capable brothers to keep the ship of state moving forward. Nurhaci's fourteenth son, Dorgon, might have resorted to bloody tanistry to challenge the succession to his nephew and make himself the next Great Khan, but he didn't. Instead of seizing the succession for himself, he let the succession go to Hong Taiji's ninth son, Fulin, and set up a regency in which he quickly established himself as the senior regent. Tough and decisive and never one to step back when he had taken a step forward, he guided the Qing Great State's invasion of the Ming, and then oversaw the latter's dissolution. (He will also be for ever remembered as the man who forced Chinese men to adopt the Manchu tonsure and to wear their hair in a pigtail.)

The turning point in this history, the events that turned the former Jurchens into the continent-conquering Manchus, came when news reached the defending Ming army that the Dashing Prince had

captured Beijing and that Emperor Chongzhen was dead. Wu Sangui, the general in charge of the army, used back channels via Chinese who had gone over to the Manchus to strike an agreement that the two armies would join forces to retake the capital and re-establish the Ming. In return for their support, Wu promised Dorgon that the Manchus would be hugely rewarded for that service. But with Chongzhen dead and the Dashing Prince already gone before the combined army reached the city, the city presented a political void: one that Dorgon stepped into. He declared on behalf of his nephew that the Ming was dead; long live the Qing. Faced with such a powerful, well-organised force, China submitted to this fate. There was nothing anyone could do other than flee south and hope to find somewhere to get a foothold strong enough to push back against the occupation.

The Qing Great State Moves South

The Qing Great State sent its first notice to the Ming court in Nanjing on 18 July 1644. It was an open letter from Dorgon to the people of the Yangzi Valley seeking their friendship. The letter spoke of the Manchus having rescued China for the benefit of All under Heaven, and of having generously rewarded upright Ming officials throughout the north who had welcomed them. The officials who had flocked to the Nanjing regime under the Prince of Fu had acted correctly, the letter said, but they should now open discussions with the Manchus about the way forward.

Dorgon set two conditions for these discussions: that the leaders in the south 'should do no wrong against this dynasty', meaning the Qing, and that they 'should feel gratitude for our continuing what was cut off'. It was the rebels, not they, who had destroyed the Ming dynasty. They had simply stepped in to take control of the situation, and had established a legitimate successor regime, albeit ruled by Manchus rather than Chinese. Then came the warning: a country with two rulers can never be stable. Should the officials of the former Ming not align themselves with the new dynasty, it might be necessary for the Qing to send its Great Army south to 'bring all under one rule', which is to say, unify the realm under the Manchus' command.

Nanjing's response was to send a peace mission to see what sort of settlement could be negotiated that would allow the Ming to continue.

There was an obvious precedent, involving the Jurchens themselves, from whom the Manchus descended. The Jurchens had coexisted for a century with the Song, their Jin Great State controlling the north while a reduced but still viable Song continued in the south. The first task for the peace mission was to choose someone to lead the delegation. The governor of Nanjing, Zuo Maodi, volunteered for this challenging and sensitive task. He had a personal reason for doing so: his mother had died in Tianjin while the hostilities were under way, and he wanted to return to arrange for her funeral. The goal of the mission, though this was not made public, was to accept the existence of the Qing Great State, but beyond the Great Wall. The Ming would thank the Manchus for stabilising the situation in the north and would pay whatever price they set to retreat back north of the wall.

The delegation took leave of the emperor on 7 August and headed north under an armed guard of 3,000 soldiers. But when Zuo reached Beijing in October, he found he had lost control of the terms of the visit, and any hope of inviting the Manchus to withdraw north of the Great Wall. He was told to dismiss all but a hundred of the delegation's soldiers, and then, embarrassingly, to lodge in the Foreign Envoys' Residence, as though the Southern Ming were just another tributary calling on the new dynasty. And he was not allowed to present his communication from Emperor Hongguang directly, but had to send it through the Ministry of Rites. According to the historian Frederic Wakeman, who over three decades ago reconstructed the history of 1644–5, events had overtaken the delegation. Qing success had convinced Dorgon that the Manchus could occupy what they had invaded, and that it was already time to move to the second stage of the invasion: conquering the south. Plans were already in place to 'bring all under one rule'. The Manchus had no interest in permitting a Southern Ming regime to survive. A separate Han-Chinese state was no longer thinkable. Invasion by now had become conquest, and conquest meant taking not just part of the realm but all of it.

Zuo was granted two interviews with the Chief Grand Secretary, a Manchu named Ganglin. At the first meeting, Ganglin castigated Zuo and his delegates for being among 'the disloyal ministers of Jiangnan' who had failed to come to the defence of Emperor Chongzhen. He also assured Zuo that the Qing had already dispatched its Great Army

towards Jiangnan. Between the first and second interview, Fulin, the child Great Khan, entered Beijing for the first time to be ceremonially installed as Emperor Shunzhi. Events had moved far past Zuo. There was nothing he could ask for or achieve, beyond requesting permission to return south. This was granted, and the party departed. However, when the top military man in the delegation secretly defected, Dorgon ordered that Zuo and his men be seized en route and brought back to Beijing. Upon their return, Dorgon commanded Zuo to serve the Qing. Zuo refused, for which he and five other envoys were executed. From the Qing perspective, there was no legitimate regime within the borders of China other than their own. The Ming no longer existed. There could be only one Great State, and that Great State, the Qing, had installed itself in Beijing.

The Great Army was not quite on its way to Jiangnan in October, as Ganglin claimed, but the next month the southward offensive began. Progress was slow, but eventually the forces of the Qing reached the Yangzi River in May 1645. Nanjing fell in June, and the rest of Jiangnan collapsed, city by city, through that summer and autumn.

Drought

Although the events of 1644–5 can be narrated as a sequence of political and military events, we already know that there is another way to tell this story: through the lens of climate change. This version emerges as a secondary theme in Qi's diary through the summer and autumn of 1644 as the prospect of sending the Manchus back north was collapsing. It started in June, when Qi was fully preoccupied with the immense task of reimposing order across the Yangzi Delta. A remark in his diary on 23 June hints at this second story. Qi was travelling south-east by barge towards the heart of the Yangzi Delta and found his progress hindered because there simply wasn't enough water for the barge. The Grand Canal was almost dry.

Qi's first order of business the following day was to deal with a local uprising by serfs bound to some of the big estates. That afternoon, after meeting the local gentry to discuss security, he led them out on foot – as a sign of their humility before Heaven, and their concern for the suffering of the local people – to perform a ceremony to pray for rain to relieve the severe drought that gripped the region.

Four days later, he conducted another rain ceremony in the main Daoist Temple in Suzhou. 'Heavenly rain' fell two days later, he wrote, but it was not enough to relieve the drought. Continuing east, his barge once again dragged on the bottom because there was not enough water in the canal. Qi assured himself in his diary that a big rain the following day must signal the end of the drought, but such was not the case. Two days later he prayed at the rain altar of another county. The following day a crowd gathered at the county border to block his inspection tour and plead for relief from the drought. After that, once again, his barge ran aground on the bottom of the canal, forcing Qi to switch to a lighter vessel with a shallower draught. The following day he arrived in Songjiang, Dong Han's city, where he walked in humility to the temple of the city god to pray for rain, not just once but twice. There was a light sprinkle after the second set of prayers, but not enough to make any difference. Three days later he was praying for rain in a Confucian temple in yet another county.

And so it went on. Roughly every second day, Qi was out in public presiding over a ceremony imploring Heaven to send rain, to almost no effect. 'The urge for rain is so very great', he notes in his diary on 27 July, 'yet the rain we get is never very much.' The intense summer heat only made everything worse. Riots broke out in Shanghai and nearby towns. In August, at the strategic point where the Grand Canal meets the Yangzi River, barely seventy miles downriver from Nanjing, the regional military commander (and former protégé of the Dashing Prince) Gao Jie was on the edge of mutiny. Qi moved his operations up to that area to defuse the crisis and get General Gao back on side.

Still the drought continued. The only technology available to Qi was prayer. In a letter home on 29 September, he asked his friends to set up an altar at every major crossroads to pray for rain. Five days later, he wrote in his diary that every religious institution in Jiangnan, regardless of sect affiliation, had set up a rain altar for daily prayers. At last there came a sign, it seemed, that Heaven was listening. A statue of Guanyin, the Buddhist goddess of mercy, was found floating to the surface of a nearby lake. The miraculous statue was retrieved and carried to a Buddhist monastery by people who begged the resident monk Dingmu to pray to it for rain. Qi went to see Dingmu several times to support his effort. No matter how many times Dingmu prayed, however, no rain

fell. The coming change of season changed the nature of the danger, however, for should rain come at the time of the rice harvest in October, the result would be a calamity. The only hope for saving the meagre rice crop that had survived the drought, and that was still standing in the fields waiting to be harvested, was for no rain to fall. On 9 October, Qi ordered that all prayers for rain be temporarily suspended until after the harvest so as not to spoil the crop.

But now the time had come for Qi to report to Emperor Hongguang on his progress with gathering the autumn grain tax. He had to report not only that he could not collect this year's tax but also that he could not collect next year's in advance either, something that the court had ordered him to do to meet the military emergency. He asked that the region be forgiven its tax obligations, for the simple reason that the farmers could not pay them. A week later, he heard from a friend at court that the court in Nanjing was not happy with his performance and was considering transferring him to another position. He had been concerning himself too much with the people without lining up political support for his moves. Two days after that informal notice, an imperial edict arrived. It turned down his request that the region be forgiven its taxes. Qi carried on for another five weeks, but realised that his position had become untenable, so he petitioned to retire for health reasons.

Emperor Hongguang answered that his case would be referred to the Ministry of Personnel (which was an indirect 'No'). Qi petitioned a second time. He received no response to this request, but on 5 December read in the *Capital Gazette* that his request had been turned down again. So he wrote a third request. At last he was called back to Nanjing, and there, on 26 December, learned, again from the *Capital Gazette*, that his replacement had been appointed. His duties were over. Qi mentions nothing in his diary about being cashiered, only this: 'When I left for Nanjing, I travelled through rain and snow. Since then it has rained and snowed without a break, so that now the water in the canals flows again.' Qi caught the irony of his dismissal, which came just as the drought had finally started to ease. 'It has been over six months since the rain stopped in June', he wrote to himself – exactly the length of his tenure as governor-general. The drought had ruined his brief return to his career. A man more skilful

at playing court politics could have rescued himself by spinning his achievements and undermining his opponents, but that was not Qi. He had been no good at politics when he was in Beijing, and his political survival skills had not improved when he went to Nanjing. He was fated to fail.

The Jiangnan drought that brought Qi Biaojia down was not the chance misfortune of a single year, nor local to his corner of Eurasia. Since 1629, China had been subject to the same wave of colder temperatures and, for the most part, drought that had overtaken the entire northern hemisphere and that would carry on for several decades, pushing much of the world into a vicious cycle of agricultural shortfalls, peasant flight and administrative collapse. For the Ming there was no relief, making the last fifteen years of the dynasty the worst period of environmental stress that China had experienced for a millennium. Each environmental shift became yet another wedge opening the gate to disaster.

Death, Life and Regime Change

For those who experienced the Manchu occupation, which in a few key locations was breathtakingly brutal, the arrival of soldiers was but one more manifestation of the cosmic disorder that had overwhelmed China for as long as Emperor Chongzhen had been on the throne. On the day of his suicide, he had no idea of who would replace him. He thought that he was half a day ahead of the peasant rebels thirsting for his blood, with just enough time to spirit his sons out of the capital before the rebels arrived and then to end his own life as a humble sacrifice to appease Heaven. He knew that a Manchu army was massed on the far side of the Great Wall, but he could not have guessed that they, rather than the rebels, would replace his Great State with their own. Most last emperors knew when they were about to lose their dynasty and to whom, but Chongzhen had no way of knowing he was the last emperor of the Ming. His suicide on 25 April 1644 was meant to secure the future of his dynasty, not empty it out. But events slipped past him faster than he could know.

A year later, Qi Biaojia also ended his own life, but on a different basis. Like Emperor Chongzhen, he had initially understood that he was acting to save the dynasty from Chinese rebels, only to find that

the ultimate enemy lay not within the Great Wall but beyond it – and worse, that that enemy was better organised and better led than the rabble the Dashing Prince had pulled together. As the Great Army swept south to Jiangnan (see Map 5), the general commanding the invasion force sent a letter ahead of the army to Qi, inviting him to join the regime. The day after he received the letter, Qi noted in his diary entry for 20 June 1645 that he knew exactly what was at stake: that to refuse to serve was to forfeit his life. In the entry two days later, he observes that both he and his wife were too ill to flee. After that, he writes nothing about his predicament, other than to jot down that he is still reading the official history of the Southern Song, which he had been reading all spring, in search of guidance as to how to act as his own dynasty headed towards extinction. The Confucian official always had the option of realising that Heaven had withdrawn its mandate from his emperor, and that this vacancy meant the installation of a new one. Whether that required serving the new ruler was a difficult call, and one nearly impossible to get right. In his last entry, dated 24 July 1645, he notes that some family and friends had written urging him to go to Hangzhou and meet the new commander, insisting that he could do so without having to take office and so protect his reputation. Qi Biaojia disagreed with their assessment of his choices. Two days later, he drowned himself in a pond.

As for Chen Qide, recorder of the famine and plague in Tongxiang county, there is no record of what happened to him beyond 1642. But then he was just a local scholar, not important enough for anyone other than the members of his family to notice when he died.

The one author we can follow into the Manchu era is Dong Han, chronicler of end-of-the-age portents. In the summer of 1645, Dong and his family abandoned their rural retreat in the belief that they stood a better chance of escaping the violence spreading across the Yangzi Delta by returning to the city of Songjiang. They may have known that the leader of Songjiang had decided to coordinate a resistance movement all across the Yangzi Delta from the city. When that resistance collapsed, the locals withdrew inside the city walls to withstand a siege and hope for reinforcement. When a small army of men in red turbans appeared below the walls on 22 September 1645, the defenders assumed that these soldiers had rallied to their cause and

come to their rescue. They opened the gates to admit them, only to discover that these were soldiers of the Qing Great State who had disguised themselves as rebels. They flooded the city, acting as occupying armies always do.

Dong's parents did not survive the fall of Songjiang, but their teenage son did. By this point, loyalism to the fallen Ming was fast becoming no longer a reasonable option. Scattered loyalist forces held out further down the coast and then later retreated for a last stand in the far south-west corner of the realm, but most accepted that Heaven had transferred its mandate. Despite desperate letters to the Pope to rally support for the regime in Europe, the Ming would not come back. There was nothing for young men such as Dong to do but accept the change and make the best of things. There was no point following their emperor in suicide. One simply went on living under the occupation as best as one could, adjusting to its demands for their loyalty. Dorgon's order that Chinese men should shave their foreheads and grow pigtails was enough to drive some into rebellion, but it was not enough to unseat the new rulers. (A parallel command requiring Chinese women to stop binding their feet, a custom the Manchus found repulsive, went nowhere.)

Dong Han made the transition by choosing to collaborate with the new regime. Even though his parents died in the dynastic transition, the family ethics of Confucianism did not constrain Dong from serving the new regime. He had never taken a degree or held office under the Ming, and that was good enough. He could serve the Qing without compromising a prior loyalty. He regretted the fall of the dynasty he had been born under, and wrote with satisfaction that the tombs of the Dashing Prince's father and grandfather had been dug up and desecrated. But he returned to his studies and worked his way up the ladder of the Qing Great State examinations, eventually winning the top degree of Presented Scholar in 1661. Dong more than made his peace with the new regime.

But nothing is ever that simple. Ambivalence laces the memoir that Dong wrote late in life, though you have to look carefully to find it. He published the book under the innocuous title of *Superfluous Notes from Water-Mallow Village*, clearly chosen so that the book might slide past the notice of the government censors. By the time he published

it in 1678, the Manchus had become vigilant about preventing any Ming loyalist sentiments or references to uncivilised 'barbarians' from seeping into print, and violent towards anyone deemed guilty of such actions. Living authors were rounded up and tortured into confessing their treason, and posthumous authors were exhumed and chopped into pieces for insulting the new regime.

The book is where Dong wrote down his account of the portents and evil omens with which this chapter opened. Despite the obvious atrocities committed in the name of the Qing, he is careful to skirt the high politics of the era and avoids making any criticism of the new masters whom Heaven sent to restore order in a disturbed cosmos. But there is one moment when a private opinion breaks free from the ranks of his disciplined thoughts. It comes in a detailed review of a Jesuit geography of the world published in Chinese. Dong takes strong issue with some of the facts in this geography. How could it have taken Columbus an entire month to sail across the Atlantic Ocean? (In fact, it took longer.) How could the Aztecs have mistaken Cortes and his cavalry for creatures in which human and horse had fused as one? How could Magellan have travelled 100,000 miles to circumnavigate the globe? Was Europe really 30,000 miles by sea from China? He is also offended by the claim that the world contains ten thousand countries. The world could not possibly be that big, and any author who peddled this nonsense was intent only on deluding Chinese. At the close of his review, Dong sums up his contempt with this comment: 'To allow these little monks' – meaning the Jesuits – 'to come from across the ocean and bring their heterodox doctrines into the Chinese realm' (he uses the term Zhonghua, 'the *hua* of the Central State'), 'and then to permit them to build residential temples and to support them with lavish official salaries, is to delude people's minds and cause them to turn their back on the true Way.' He sounds like Shen Que asking the emperor to kick the Jesuits out of Nanjing.

But when Dong rounds off his harangue by exclaiming, 'Who is responsible for this?' it is not exactly clear whom he seeks to condemn after all. Are the Europeans his target, or is it the Manchu imperial family that invited the Jesuits to enter the palace and serve them? Dong's diatribe against the Jesuit geography lambasts the Europeans for bringing such nonsense, but he may also have had the Manchus in

his sights for failing to protect the realm against these outlandish and dangerous ideas. However we construe his attack, he was speaking in the voice of his age. The teachings of the Jesuits had once persuaded a man who had reached the highest post in the land, but Chief Grand Secretary Xu Guangqi was dead, and no one of his stature would speak again on the Christians' behalf. Nor would the Ming return.

10

The Lama and the Prince

Kokonor, 1719

There are two things you need to know about the Dalai Lama. The first is that he is a reincarnate, the return to bodily form of a lama, or religious teacher, in a line going back to Sonam Gyatso in Lhasa in the sixteenth century. He returns not by some inexorable law of reincarnation, as the theory of karma obliges the rest of us to do, but by choice. The Dalai Lama has already completed the task of moral perfection and could long ago have elected to enter Nirvana and not come back to us. But he does, life after life, out of his commitment to lead all people to Enlightenment. At least, that is how those who believe that souls are never extinguished but return again and again to this world understand his importance. He is the closest being to the Buddha any of us will ever meet.

The tangka painting that appears in this book as Plate 13 is an official portrait of Kelsang Gyatso, the Seventh Dalai Lama, the person at the heart of the story I tell in this chapter. It was probably painted in the second half of the eighteenth century, during or just after his lifetime (he died in 1757). Primarily a portrait of this one man, it is also a group portrait of some of his more important previous appearances

in the world, including as a rabbit (a favourite figure in Indian folk tales) in the top right-hand corner. At the top of the tangka is Sakyamuni Buddha himself, and in what looks like a thought bubble directly over his head, Avalokitesvara, the Buddha of Compassion, of whom the Dalai Lama is a particular incarnation. The figures below him are his more recent emanations. Directly below him are the two most important, the Fifth Dalai Lama and, below him in turn, the Third. All wear the yellow hat that distinguishes the Gelug School of Tibetan Buddhism from other schools

The second thing you need to know about the Dalai Lama is that, though his spiritual ancestry extends back to the Buddha, his lineage is relatively recent. It emerged only in the sixteenth century as the result of a pact with the Mongols. The man who brought this about was Altan Khan, the Golden Khan. A direct descendant of Khubilai, Altan Khan forged the Western Mongols into a unified polity and posed a constant threat to the Ming Great State – that is, until the Ming bought him off in 1571. It was in the years leading up to this arrangement, when Altan Khan was in his mid-sixties, that he turned to a prominent Buddhist monk in Lhasa, Sonam Gyatso, as his spiritual teacher. Sonam Gyatso held back from accepting Altan Khan's patronage for a few years, lest his compliance turn into a Mongol takeover of Tibet, but he eventually agreed to travel from Lhasa to meet the Khan on common ground.

Their first encounter may have been in the north-east grasslands of Tibet at Kokonor, the Blue Lake (Qinghai, in Chinese), a zone where Tibetans and Mongols have overlapped for centuries (and where Chinggis Khan's troops may have disturbed the local ecology sufficiently to unleash an epidemic of the plague on China in the thirteenth century). Sonam Gyatso agreed to become Altan Khan's teacher of Buddhism. In return, Altan Khan assumed the financial and military responsibilities of being his chief patron. To secure the relationship in Buddhist terms, Sonam Gyatso declared Altan Khan to be not just a descendant but a reincarnation of Khubilai Khan – the Mongol Great State was back – and declared himself to be a reincarnation of Khubilai's chief Tibetan adviser, Phagpa. Theirs was a religious relationship, to be sure, but it was also an alliance, a two-way deal that extended Mongol power into Tibet while at the same time bringing

the Mongols under Tibetan spiritual authority. Altan Khan responded in kind by bestowing on Sonam Gyatso a Mongol title, Dalai Lama, Oceanic Teacher. Sonam Gyatso declined to assume the exalted position of lineage founder, accepting the title only on condition that he be considered the Third Dalai Lama after his teacher, deemed the Second, and his teacher's teacher, the First. His teacher's teacher features in the bottom right-hand corner of the Seventh Dalai Lama's collective portrait, where he is seen depicted wearing the distinctive yellow hood of the Gelug School.

The deal between Tibetan priest and Mongol patron proved resilient, weaving Tibetan and Mongolian history together for the next two centuries. The Mongols are no longer a world power, but the Dalai Lama, now in his fourteenth incarnation, continues to dominate the religious landscape of Tibet and Mongolia. A good deal, at least for Tibet, though it would draw that land into China's orbit in ways that no one at the time could have guessed.

Now that you know these two things about the Dalai Lama – reincarnation and affiliation with the Mongols – there are two things you need to know about Tibet.

The first is that Tibetans consider Tibet to be its own place, not a place that is part of another. Tibet has a long history, rising in the seventh century to be counted as one of the six great world-empires of medieval Eurasia. Tibetans have a keen sense of a distinctive identity based on this history. Since then, Tibet's fortunes as a Himalayan kingdom have depended on the skill with which its leaders have managed relations with the powerful states surrounding them. In matters of religion, Tibetans have tended to look south to India, the source of Buddhism, but in political terms they have had to direct their gaze north and east to the Great States of Inner Asia and China. The alliance with Altan Khan and the rise of the Dalai Lama lineage belongs to that context.

The second thing you need to know about Tibet, which follows inexorably from the first, is that Tibet's political autonomy has proven almost impossible to secure. The low point of that history, for Tibetans today, was the Red Army invasion in 1950, when the People's Republic of China moved to secure the region as part of its territory and, having conquered it, to divide it up among three provinces so

as to weaken its territorial coherence and self-identity. These interventions, sustained by an unrelenting message to PRC citizens that Tibet is part of their fatherland, have turned most Chinese against the idea that Tibet is, or ever has been, an independent country. Tibetans understand where Tibet ends and the world begins, and China is part of the world; Chinese understand where China ends and the world begins, and Tibet is on their side of that line.

A Meeting in Beijing

This chapter pivots on a conversation that took place in 1719 between the Seventh Dalai Lama, pictured above, and Prince Yinzhen, the son of his most powerful patron. The conversation was a set piece of formal diplomacy, as we shall see, yet it cleared the way for the Manchu military invasion that followed, an intervention that proved crucial to setting the terms of the Sino-Tibetan relationship. The conversation did not have to bring China and Tibet to a point of no return, but that is exactly what it did. To understand why this conversation could have such significance, though, we need to go back to another meeting sixty-six years and two Dalai Lamas earlier.

The Third Dalai Lama and Altan Khan laid the foundation of Mongol patronage and the ascendancy of the Gelug School, but the architect of the relationship that placed Tibet in China's orbit was the Fifth Dalai Lama. Like the Third, he had a powerful Mongol patron in the person of Gushri Khan, born to the Khoshot Mongols (the most powerful of the four Mongol groups) in 1582: precisely the year in which Altan Khan died.

Unlike the Third, however, the Fifth Dalai Lama lived in a real world in which his patron was falling under the shadow of a new Great State. The Fifth was alone among the early figures in his lineage in being able to match spiritual training with administrative capacity and a canny sense of diplomacy. When a new political force, the Manchus, emerged far to the north-east of the Mongols, he looked to that horizon and weighed his options. He understood the benefit of having a second powerful patron, especially one so far away and unlikely to interfere in his affairs. He also understood that the Jurchen khan who founded the Qing Great State in 1636, Hong Taiji, needed his assistance to bring the Mongol world under his sway. In fact, the game

had already started while the Fifth was still a child, when Lhasa sent an exploratory delegation to the Jurchens (as they were called before they took the name of Manchu) to assess this newly arisen power. In 1639 Hong Taiji responded by sending the Fifth Dalai Lama the first of several letters inviting him to visit Manchuria and propagate Buddhism among the Manchus.

The distances were great and the negotiations protracted. As it turned out, Hong Taiji died before his final letter reached Tibet, but the invitation still stood. In 1649, five years into the Qing occupation of China, the Dalai Lama finally accepted. It was arranged that he would travel to visit Hong Taiji's son, now Emperor Shunzhi, not in the old Manchu capital in Manchuria but in Beijing, the new capital of the Qing Great State. There were lengthy preparations on both sides. Emperor Shunzhi ordered the building of a monastery on the site of a temple from the era of the Liao Great State to serve as the Dalai Lama's residence in Beijing: this is the Yellow Temple that I tried to visit in 1975. From Lhasa, the Dalai Lama orchestrated a campaign designed to turn his journey into a diplomatic campaign that would carry him to important locations throughout the Mongol world to strengthen his authority among the Mongols. He set out in 1652, and everywhere he went, people along the route flocked to be in his presence and receive his blessing. Four thousand Mongols came out to greet him in Kokonor, twenty thousand made donations in the Ordos, and twelve thousand received his instruction at Lake Taika, to mention only a few of these congregations. Donations were lavish. Half of what was given to him he turned back to local projects and redistributed as gifts to those who came to see him. The other half went back to Lhasa.

When the Dalai Lama's party reached the Great Wall, the Manchus took control of the visit. Emperor Shunzhi's elder brother greeted him outside the wall at the head of a column of 2,000 soldiers on horseback and a band playing a noisy fanfare of welcome. The Tibetan was not whisked through the wall immediately, however, as the two sides had to work out the diplomatic protocol that would govern the Dalai Lama's meeting in Beijing. Would he and the Manchu emperor be presented to each other as equals, or would one be placed above the other? The Tibetans might fancy that the Fifth should be higher than

Emperor Shunzhi, but the reverse was the likelier arrangement. The Fifth was not so naïve as to misunderstand the extent of his authority. He was coming before the new leader of the Great State that now ruled China. The chances of being squeezed into the status of a tributary envoy were dangerously high, and he hoped to avoid that; but what further he could hope for was not clear. The Chinese officials advising Emperor Shunzhi on Chinese diplomatic protocols were intent on casting the Dalai Lama as a tributary, not as a diplomatic equal. No resolution to this issue was achieved, but the Dalai Lama decided to cross the Great Wall anyway.

When the two did finally meet, in 1653, the fourteen-year-old emperor departed from the script his Chinese advisers had arranged for him and switched to Manchu protocol, which called upon the secular ruler to honour his spiritual master. He rose from his elevated throne when the Dalai Lama entered the audience hall and descended the steps to greet him as an equal. The formal record states that he followed what his advisers had told him should happen, but in fact he acted in a way appropriate to receiving the most revered religious leader in Asia. In religious terms, he recognised the Fifth Dalai Lama as an emanation of Avalokitesvara, the god of compassion, and the Dalai Lama recognised the emperor as an emanation of Manjusri, the god of wisdom. That day in 1653 was a meeting of the gods: Avalokitesvara acknowledging Manjusri, Manjusri greeting Avalokitesvara. As for their actual conversation, we have no record. But that was of no significance. What mattered was that priest and patron had found each other.

Reincarnates and Other Successors
Avalokitesvara would meet Manjusri again sixty-six years later, in other bodies. To fill in those bodies, it is worth considering what options existed for transferring the charisma of power in this part of the world. Every culture has its protocols for managing this task.

Where the youngest son succeeds to the headship of the family, the arrangement is called ultimogeniture. This was the Mongol tradition, though they also had the tradition of tanistry, which recognised that sons may compete among themselves. Chinggis Khan tried to discourage his sons from falling into a round of bloody tanistry, fearing

that that would cause the empire he had created to break apart. His sons managed to postpone that looming eventuality for a generation by agreeing that the succession should go to Ögedei, the second youngest son.

The Chinese had a different set of protocols, which favoured the eldest son: a practice known as primogeniture. Zhu Yuanzhang opted for this principle, anointing his eldest son to succeed him as second emperor of the Ming. When that son died, Zhu named that son's eldest son as the heir apparent. That plan did not work out well. Within four years, as we know from Chapter 4, Zhu's fourth son, the man who became Emperor Yongle, overthrew his nephew in a classic bout of bloody tanistry and seized the succession for himself and his line, not his eldest brother's.

The Manchus came from Mongolian traditions. Nurhaci did not succeed to power but rose to it by unifying the Jurchens and refounding the Jin Great State in 1616. By the time he died a decade later, not all of his fifteen sons were still alive to compete for the succession. The second youngest, Dorgon, was rather favoured to become the next Great Khan, but the prince who manoeuvred himself into the post was Nurhaci's eighth son, Hong Taiji, who went on to found the Qing Great State in 1636. When Hong Taiji died in 1643, the succession might have gone to Dorgon, but instead it was decided that the throne should pass to Hong Taiji's ninth son. This was Emperor Shunzhi, whom we have just seen meeting the Fifth Dalai Lama. Shunzhi died in 1661 of smallpox, a disease to which few Manchus developed immunity, so the next succession was a practical one. It was decided that his third son, Kangxi, aged only seven at the time, should be put on the throne for the simple reason that he was the only one of Shunzhi's four sons who had contracted smallpox and survived. Kangxi's immune system was excellent, and he set a record of sixty-one years on the throne.

By the time Kangxi died in 1722, not a few of his twenty-four sons who had survived to adulthood had disgraced themselves in one way or another, but enough candidates remained to prompt worry of a chaotic succession. Prince Yinzhen, who will feature in this chapter, was one of the candidates, but since he was absent from Beijing when his father died, his elder brother quickly stepped in and became

Emperor Yongzheng. Yinzhen did not dispute the succession, but Yongzheng did not trust him or his brothers. He stripped Yinzhen of his noble rank and placed him under house arrest. Yinzhen was careful not to protest. After Yongzheng died in 1735, he was released, and two years later his princely rank was restored. He then lived on, his earlier honours intact, until he died just three days short of his sixty-eighth birthday.

All these variations on patrilineal succession from Yuan to Qing testify to the common understanding that the realm is the property of a single family, and rulership that family's prerogative. But there are other ways to arrange succession. Tibetan Buddhism opted for a vastly different solution: reincarnation.

The doctrine of reincarnation supposes that a soul is never extinguished. It migrates from body to body, life after life, as it makes its way on the epochal journey towards spiritual perfection. Good deeds speed you along the way, and bad deeds hold you back. Physical characteristics and property may pass from father to biological son, but spiritual identity passes without regard for whose sperm or womb are involved. Rather than allow biology to control succession, Tibetan Buddhism in the sixteenth century began increasingly to adopt reincarnation as a principle for organising succession to high lamaships.

The ultimate goal of reincarnation is not to enjoy eternal existence but to earn the spiritual perfection of Buddhahood. The consequence is entry into Nirvana, which is the only way in Buddhist theology to escape from the suffering of birth and death. But a perfected being can also elect to postpone Nirvana and return to the world to aid others in their escape from suffering: that being is called a bodhisattva. And that was what the Fifth Dalai Lama, Gushri Khan and Emperor Shunzhi all were. For the latter two, this was a sort of special recognition of the virtue they had earned by prevailing against competitors, rather than a true reincarnation. If Emperor Kangxi was an emanation of Manjusri, he was so purely by virtue of his patrilineal succession from Emperor Shunzhi. The only true reincarnate was the Dalai Lama.

To the extent that the Seventh Dalai Lama was the reincarnation of the previous Dalai Lamas in his portrait, so too he inherited their problems. The apparent randomness of reincarnation was designed to prevent any single family from monopolising power, but the process

of identifying the reincarnate was as vulnerable to politics as any auto-cratic succession. The Seventh's problems went back to the death of the Fifth Dalai Lama, positioned directly beneath him in the group portrait, in 1682. The Fifth's chief minister chose not to let the world know he had died, announcing instead that the great lama had gone into deep meditation and was not to be disturbed. The minister clearly had no wish to see a succession take place any time soon, as that was likely to deal him and his people out of the game (as eventually did hap-pen, when he was shunted aside and murdered in 1705). But he under-stood the inexorability of succession and on the side quietly located the Fifth's reincarnation, putting him in training until, at the age of fourteen, he could be installed in the Potala as the Sixth Dalai Lama.

Curiously, the Seventh's portrait does not include the Sixth. Why is he not there? Art historians have speculated that there must have been another tangka, possibly featuring the Eighth Dalai Lama, that depicted the Second, Fourth and Sixth, to match the tangka we have showing the First, Third, Fifth and Seventh. I'm dubious. Even know-ing who was the Sixth would become a problem, for there would be more than one.

The Sixth Dalai Lamas

The Sixth Dalai Lama located by the chief minister was named Tsang-yang Gyatso, and he had two strikes against him. The first of these was not of his own making. Because he had been selected in secret, many suspected that the minister had controlled the process to his own advantage. The other problem, however, was his entirely. He does not appear to have been disposed to play the role handed to him. He was a poet, and the verses he wrote expressed as much dedication to contemplating the female body as they did to contemplating the truths of Buddhism. A Dalai Lama was an exalted spiritual being, and only he could assess the means he chose to enlighten the people, but even that rationalisation was a stretch too far.

Doubts about the status of the Sixth opened a window for politi-cal opportunists. Gushri Khan's grandson, Lhazang Khan, stepped up. Lhazang Khan had come to power by killing his brother and needed legitimacy if he was to persuade the Khoshot Mongols that he deserved to be their ruler. Like his grandfather Gushri Khan, he

turned to Lhasa. Sensing the weakness of the Sixth Dalai Lama's position, he made a bold move by placing Lhasa under military supervision and compelling the Sixth to abdicate. He declared Tsangyang Gyatso to be illegitimate and installed a puppet, born Pekar Dzinpa, in his place. Conveniently for Lhazang Khan, the deposed Sixth died while on his way into exile in Kokonor.

Lhazang Khan's strategy backfired. Whatever doubts there may have been about the first Sixth's suitability for the post, Tibetans regarded him as 'our' Dalai Lama, not to be interfered with. The second Sixth had a respectable reputation, having entered the great monastery of Drepung at thirteen as a novice and then gone on to study at the medical college in Lhasa. But the question was not his personal qualities but his identity: was he really the reincarnation of the Great Fifth? Rumours began to circulate that the young man was actually Lhazang Khan's son, a charge that cannot be proven. Despite this, Lhazang Khan was able to convince the next highest personage in the Gelug School, the Panchen Lama, to ordain the young man. But this gesture increased rather than eased doubts, for the Panchen Lama was the head of a competing lineage within the Yellow Hat sect and might have an interest in undermining the authority of the Dalai Lama. Had Lhazang Khan been able to win the propaganda battle, installing his own Dalai Lama could have been a deft move, but his interference in the reincarnation had been too obvious for most people to accept his puppet as the real Sixth.

Lhazang Khan's position was further weakened by a verse the first Sixth wrote in 1706 on his journey to exile and death predicting his rebirth:

White crane, lend me your wings.
I will fly no farther than Lithang,
And from thence return again.

Lithang lies far to the north-east of Lhasa, beyond Lhazang Khan's control, and this region was where senior Tibetan lamas went to search for his reincarnation. The boy they found was Kelsang Gyatso, the young man with whom Prince Yinzhen was to meet before long, the lama in the centre of the picture.

We know from the account of Ippolito Desideri, an Italian Jesuit missionary who was in Lhasa at the time, that the news of Kelsang Gyatso's discovery sparked great excitement in Tibet, spawning hope that Lhazang Khan might be forced to give up his fraudulent Sixth Dalai Lama and concede instead that this child was the Seventh. In fact, Lhazang Khan did just the opposite. He sent some lamas to examine the boy to determine 'whether the said child really was the late Dalai Lama now born again'. According to Desideri, the lamas reported back to Khazang Khan that he was. Loath to switch Dalai Lamas again, Lhazang Khan ordered the boy to be held in a secure location and not to be brought to Lhasa.

The Jesuit understood that Lhazang Khan got Emperor Kangxi to agree to this arrangement, but the Manchu sources tell a different story. The day Emperor Kangxi learned that Lhazang Khan had replaced the original Sixth Dalai Lama with his own candidate, he declared that 'Lhazang Khan is not to be trusted'. Nonetheless, he chose not to challenge the replacement, since to do so would have been costly and destabilising. But Lhazang Khan's move was a flare on the horizon and had to be watched. When word reached Emperor Kangxi that a young boy in Lithang had been recognised as the Seventh Dalai Lama, he ordered him to be installed in Kumbum Monastery in Kokonor, but not in conspiracy with Lhazang Khan. That move put the young lama where his officials could keep an eye on him, to prevent him from being used as a joker in some Mongol game of thrones and also to keep him in reserve, in case he should prove politically useful in a future contest with Lhazang Khan. It was not the course of reincarnation that troubled Emperor Kangxi, but what others might do to use it to his disadvantage.

Enter the Zunghars

To complete the scene leading up to the meeting between the Seventh Dalai Lama and Prince Yinzhen, we need to bring one more party into play. This was the powerful confederacy of Western Mongols in Eastern Turkestan (Xinjiang for Chinese) known as the Zunghars. The Zunghars constituted a new Mongol political formation. Their clan name appeared for the first time only in 1697. Fiercely independent, they found themselves in a long stand-off with the Cossacks to the

north, the Manchus to the east and eventually the Khoshot Mongols of Lhazang Khan.

Eclipsed early in the eighteenth century, the Zunghars rose again under a ruler named Tsewang Rapten. He had been involved in the politics surrounding the appointment of the first Sixth Dalai Lama in the late 1690s, so that when Lhazang Khan announced that a new Sixth had been installed, he saw an opening to make a move. To throw Lhazang Khan off guard, he gave him his sister in marriage and invited Lhazang's eldest son to marry his adopted daughter. When Emperor Kangxi heard of these overtures, he immediately recognised their significance. He cynically observed that the Zunghar leader was 'using his love for his son-in-law as a pretext to keep hold of him', effectively turning Lhazang Khan's son into a hostage. 'Is it possible that things can stay as they are without anything happening?' Kangxi wondered aloud.

Kangxi was right. Tsewang Rapten was setting up an elaborate plan to force the Khoshot Mongols out of Lhasa and take over the patronage of the Dalai Lama. The key to the plan was Kelsang Gyatso, the Seventh. Tsewang Rapten would have his army capture the young lama and then convey him in triumph to Lhasa, driving out Lhazang Khan and the discredited Khoshots. In 1717 he put the plan into action. The first step was to send an army of 6,000 Zunghar soldiers under the command of his cousin Tsering Dhondup into Tibet from the north by way of a rarely travelled route through the Kunlun Mountains. The second was to send a rapid-deployment mobile unit of 300 horsemen to Kumbum Monastery to kidnap the Seventh Dalai Lama. The first part of the plan worked perfectly; the second did not. Not only did the Zunghars fail to grab the boy, but they revealed to the Manchus their intention of seizing control of Tibet, though now without the means to do so. Meanwhile, Lhasa fell easily as the lamas who had tired of the Khoshot Mongols were prepared to welcome the Zunghars. Lhazang Khan was killed, and his army of occupation was driven out. But the Zunghars had nothing else to offer. They thought of trying to make use of the Panchen Lama, as Lhazang Khan had done, not by bringing him in to bless yet another Dalai Lama but by manoeuvring him into a position of supreme spiritual authority. But the Panchen Lama was based in another city to the west, Shigatse, and

had almost no support in Lhasa. The upshot of their bungling was that the Zunghars were regarded as simply another occupying army, pillaging at will. Everything went downhill from there.

Emperor Kangxi had looked the other way over Lhazang Khan's intervention in Tibet, but he could not afford to ignore what the Zunghars were doing, especially as their attempted kidnapping had infringed on what he regarded as the territory of the Qing Great State. The only possible response was full-scale military invasion.

It took a year to assemble a force sufficiently large to invade Tibet. But the campaign was a complete failure. The Zunghars destroyed the army that the Qing sent against them. Stung by this defeat, Kangxi ordered a second invasion. The commander he put in charge was none other than his son Prince Yinzhen. Kangxi gave him an army of 300,000 troops and the title of Supreme General Who Pacifies the Far Regions. This venture was not to be allowed to fail. An important component of securing the conditions for the second campaign was making sure that the Tibetan Buddhist establishment was onside. For this reason Kangxi sent Yinzhen to meet with the Seventh Dalai Lama on 10 May 1719 at the Kumbum Monastery in Kokonor.

The Meeting in Kokonor

To honour Emperor Kangxi's sixty-sixth birthday, the monks of Kumbum Monastery decided to hold a week-long marathon of sutra-chanting starting on 4 May 1719. Marking the imperial birthday was an occasion for the Yellow Hat sect to show itself to be the spiritual protectors of this emanation of Manjusri. The chanting was intended to generate sufficient merit for the emperor to rule for ten thousand years, as the saying went (though Kangxi went on to live for only another three). When the ceremony was concluded in the afternoon of 10 May, the lamas paraded out past the main statue of the Buddha, then prostrated themselves before forming up in long lines down each side of the pathway leading from the main hall to the abbot's residence. Emperor Kangxi's fourteenth son, Yinzhen, was expected.

Yinzhen was not simply out for a visit to Kumbum Monastery on this day. He was calling on the young Tibetan monk who was said to be the Seventh Dalai Lama. The lamas of Kumbum Monastery, most of whom were Mongols, had assembled at the gate to greet the prince

and his retinue with drums and horns. The retinue included Yinzhen's three younger sons (all three of whom would die before they reached maturity, victims of either smallpox or other childhood diseases). First the prince and his sons bowed to the Buddha, then they were escorted to the meditation hall where Kelsang Gyatso was to meet them. The lama emerged to greet them as they arrived. He asked after the health of the emperor and then draped a kata, a white silk scarf, around the necks of each of his guests in the traditional Tibetan gesture of welcome. Speaking to each in turn, he led them gently by the hand into his chamber. After the lama took his seat on the elevated meditation platform at one end of the hall, the audience began. We know what passed between them thanks to Yinzhen, who wrote out the gist of their conversation and reported it back to his father.

'When I set out to come here', Yinzhen began, recalling his departure from Beijing two years earlier, 'my imperial father ordered me to come and greet you.' The prince does not bother to explain the delay in calling on the lama, but gets right to the point.

'I do not know whether you, Khubilai Khan, are or are not the real Dalai Lama.' ('Little Khubilai Khan' was the title by which Mongol lamas addressed him.) 'But since everyone here calls you Dalai Lama Khubilai Khan, I come before your throne, Khubilai Khan, and prostrate myself accordingly.' This was the issue that the prince had been sent to decide: was this monk really the Dalai Lama? Yinzhen has just said that he would treat him as such for the moment.

'General and Prince,' Kelsang Gyatso responded, 'You are the son of the Great Imperial Manjusri Bodhisattva, and thus are a bodhisattva yourself. I am just a child: how can I receive your prostrations? I would ask you, Prince, to come up and sit with me.' With these few words, Kelsang Gyatso recalled the exchange that had taken place sixty-six years, one emperor and two Dalai Lamas earlier, when the Fifth Dalai Lama met the prince's grandfather, Emperor Shunzhi.

Yinzhen dodged the implication that he was in line to inherit his father's status as a bodhisattva – which was to say, his father's status as emperor. Imperial succession was a subject about which no one whispered anything in public. Instead, Yinzhen went back to the theme with which he began, that it would be appropriate for him to treat this young man as though he were who he claimed to be. 'You, Khubilai

Khan, have donned monk's robes and endlessly perform Buddhist rites in the service of the Yellow Teaching', he noted. 'Accordingly I must respect the imperial command by devoting myself to the rites that are due to you.'

'General-Prince, you are the host', the monk replied. Technically this was true. This part of Kokonor was then under Qing rule. The nearest hub of Qing administration, the city of Xining, lay barely a dozen miles from Kumbum Monastery. More to the point, Kelsang Gyatso had been under the protection of the Qing state for several years. This was why he offered to defer to the prince's status, saying, 'I really should not receive prostrations from you.' Then in a flawless reprise of that first meeting with Emperor Shunzhi sixty-six years earlier, Kelsang Gyatso descended from his throne. 'As this is in fact the command of the Great Sage-Ruler, I wish to speak to you standing.' He thus received the prostrations of the prince and his three small sons standing rather than sitting, as a gesture of respect for his guests. He then led them to a low platform where they could sit and chat more informally.

The conversation ran the usual polite gamut of whether the prince had had a smooth journey to Xining, and whether he felt comfortable in this new environment. To this Yinzhen responded by asking the lama whether he had settled in comfortably since coming to Kumbum four years earlier. He replied that he had, 'thanks to the goodness of the Great Sage-Emperor and the compassion of the Three Jewels [Buddhism]'. Small talk finished, the conversation could turn at last to the business of the visit.

'Do you know what brings me here?' asked Yinzhen.

'I am just a child without education or instruction', Kelsang Gyatso replied. 'How could I know? But if I were to think about it, it must be that the General-Prince, following the weighty command of the Great Sage-Ruler, has deigned to make your appearance here at the frontier so that hereafter the Yellow Teaching can be quickly re-established and the people can for ever live in peace and take pleasure in their livelihoods.' Kelsang Gyatso was clearly aware of the massive military intervention that the Qing state was preparing to mount beyond Kokonor. More than that, his comment indicated that he was on side with the Manchus' plan to intervene in support of the Dalai Lama's lineage and what he regarded as the well-being of the Tibetan people.

With that, the business part of the meeting was over. Yinzhen had what he came for. Tea and sweets were served.

The interview ended with Kelsang Gyatso wishing the emperor longevity many times over. He presented Yinzhen and his three sons with Buddhist statues, relics, prayer beads and horses, a hundred for the prince and ten for each his sons, plus ten camels for Yinzhen. The prince in turn presented his gift to the Buddha: 1,500 ounces of silver, a substantial sum. In his report to his father, Yinzhen was careful to declare that this was not a private gift to the lama but a gift purely for the Buddha. (Personal gifts to Kelsang Gyatso were sent by honour guard the following day: one bolt each of yellow brocade and red brocade woven with dragons, and seven rolls of silk.) Little Khubilai Khan then accompanied the prince and his sons to the front gate of the meditation hall and saw them off, as was fit for honoured guests.

Emperor Kangxi was satisfied with the report when it reached him. 'Noted', he penned in his usual clipped fashion at the end of the memorial. But he followed that note with a warning for Yinzhen: 'Those who come from the west to prostrate themselves before this Khubilai Khan are extremely numerous, so don't neglect to be vigilant on this score and to report back to me if you hear anything.'

As for Little Khubilai Khan, he had done well to act the part that history had given him. He had shown appropriate respect to Yinzhen and flawless deference to the prince's father. He had also expressed satisfaction at the campaign Yinzhen was leading to restore the Yellow Hat sect to its position of ascendancy. This was high diplomacy in Inner Asia – and an impressive performance for an eleven-year-old.

The Manchus in Tibet

Emperor Kangxi agreed the boy could be mobilised for the coming campaign – exactly as the Zunghars themselves had hoped to do. The Manchu forces would carry the Seventh Dalai Lama with them to Lhasa and install him in the Potala. To verify the legitimacy of his position as well as the support he enjoyed from the Manchus, the emperor sent him a seal of office confirming that he was indeed the Dalai Lama. The seal, though, confirmed him as the Sixth Dalai Lama, not the Seventh. Perhaps this was in error, or perhaps it let the Manchus hedge their bets on how the succession would get sorted out. In

a sense, it didn't matter. If Kelsang Gyatso was the Seventh, then in his previous life he had been the Sixth. The error was later corrected.

The campaign advanced in two columns. While a combined Manchu–Mongol force set out from Kokonor with the Dalai Lama, a second force under General Galbi pushed west from Sichuan. The distances the campaign faced were daunting. According to eighteenth-century sources, the journey from Kokonor to Lhasa was anywhere from 1,200 to 1,700 miles, depending on which routes were open. The route from Sichuan to Lhasa was even further, at 2,000 miles. The Zunghars readied themselves to meet the first column but were unprepared to fend off the second. Galbi's army pushed its way through the weaker defences to the east of Lhasa and reached the city first. 'With nary an arrow lost', as one Manchu commander put it in an official commemoration of the victory, 'the fleeing mob of bandits scudded like clouds from morning to night without finding any escape, and so we gained complete victory.' As for the Tibetans, 'young and old lined both sides of the route, bowing and bearing food and drink to welcome the royal army.' Galbi made a short speech on his arrival in Lhasa declaring that Emperor Kangxi had sent him to bring peace to the region, and the people were rapturous. 'The tribesmen danced and the roar of their joyful shouts shook heaven and earth.' This is a Manchu perspective, but it was probably close to what the popular response to the invading army was.

Ippolito Desideri, the Jesuit missionary under the protection of the Khoshot Mongols and therefore no friend of the Zunghars, confirmed the popular response. He allowed that the Zunghar general, Tsering Dhondup, was 'among the best captains of that barbarous nation for his experience in combat and his unflagging valour', yet 'after heavy fighting, the Zunghars were defeated and the insolent usurper-general fled with a handful of followers into the great western desert'. In his official account, General Galbi reported the flight of the Zunghars in much the same terms: 'Tsering Dhondup, depleted in food and arms and at the extremity of exhaustion, slunk away like a rat.' Desideri was suspicious of Manchu intentions, but even he had to admit, in his characteristically backhanded way, that the new Dalai Lama was given a 'rapturous reception by these superstitious people'.

Manchus and Tibetans alike were satisfied that the Zunghar

occupiers had been forced out, but beyond that point of agreement they diverged. The Tibetans expected the Manchus to withdraw, their task accomplished, but the Manchus were not so ready to leave the future to chance. Part of the invading force remained in Lhasa for two years, then was reduced to a garrison of 1,900 soldiers, enough to dissuade any Mongol adventurer from slipping in and stirring the pot once again. Tibetans viewed the reduction as a normalising move that would eventually release them from direct Manchu supervision. That hope would prove to be an illusion.

Desideri believed he knew how this new arrangement between Tibet and the Qing Great State would work out. He understood that the Qing had a stake in Tibetan affairs. 'The Emperor of China had grave reasons for anger', he conceded calmly. 'First the attempted invasion of his Empire by way of Kokonor, without provocation or reason' – referring to the Zunghars' attempt to capture the Dalai Lama – 'and secondly the treacherous seizure of the kingdom of Tibet and the murder of Lhazang Khan, his friend and near relation.' Desideri did not have his facts quite right. Lhazang Khan was not Emperor Kangxi's bosom friend, nor were they related by kinship. But he saw the writing on the wall that his Mongol patrons must have seen, which was that the Qing Great State had arrived to stay. As he concluded at the end of his account, Tibet 'was thus subjugated by the emperor of China in October, 1720, and here his descendants will probably continue to reign for many centuries'. As indeed they did until the last Manchu emperor abdicated in 1911, and as China still does today.

What Followed

The history of Tibet since the 1720s has for Tibetans been a long and winding struggle to achieve greater autonomy from Beijing. The first attempt came in 1723, when a cousin of the murdered Lhazang Khan attempted to stage a comeback of Khoshot power in Lhasa, allegedly with the support of the Seventh Dalai Lama. The Qing Great State had just passed to the rule of a new emperor, Prince Yinzhen's tough elder brother, Emperor Yongzheng. He responded with his characteristic vigour. He had no intention of allowing Tibet to slip into other hands, and sent a punitive expedition from Kokonor into Tibet to drive out the Khoshots, in the process annihilating Tibetan opposition

and laying waste to monasteries suspected of supporting the Kho-shots. 'The war was one of the bloodiest', notes a modern scholar. 'All who made a stand were killed. All the provisions and property of the people had disappeared. All the lama monasteries were destroyed or burned down. The depredation of the country was wicked and ruth-less, the destitution of the people tragic.'

Rumour following the suppression suggested that Emperor Yong-zheng intended to cancel the arm's-length relationship and bring Tibet under direct administration. This fear seemed to be realised when Manchu officials arrived to take charge of Tibet's affairs. To strengthen the Manchu grip on Kokonor, the emperor in 1725 elevated its north-east portion to the status of prefecture. The next year he brought Tibetan dependants of the Khoshots under direct Manchu supervision. The following year, lest Tibetan monastic power revive as a countervailing force, Yongzheng confiscated all the seals that Tibetan lamas in the region had received from the Ming court and imposed a limit on the number of acolytes a lama could have, setting the maximum number at one.

These measures intensified manoeuvring within the Tibetan polit-ical elite. Members of the Lhasa faction around the Seventh Dalai Lama who were opposed to Manchu control found themselves pitted against a pro-Manchu faction based around the Panchen Lama in Shi-gatse. This competition led in 1727 to the assassination of a powerful Shigatse aristocrat. Fearing that Tibet was spiralling out of his grip, Emperor Yongzheng launched another military force into Tibet in 1728 to repress the Lhasa faction. By this point Tibet was only one of his headaches, for the Zunghars were again on the rise. To prevent a threat coming from that quarter, Yongzheng had to neutralise Tibet. At the start, his second campaign was quite as brutal as the first, but before the army reached the Lhasa Plain, Polhané, a Shigatse noble-man who had risen to power under Lhazang Khan, launched his own stroke against Lhasa, weakening the faction around the Dalai Lama. By the time the Manchu army reached Lhasa, Polhané had everything under control.

Emperor Yongzheng decided Polhané was someone he could work with and left Tibet in his hands, albeit under the close supervision of two high Manchu officials and a garrison of two thousand Manchu

and Mongol soldiers to ensure there would be no further disturbance. Suspecting the Seventh Dalai Lama was complicit in the struggle, the emperor wanted him and his politically active father out of Lhasa. The initial plan was to transport the Dalai Lama to Beijing, ostensibly to re-enact the tie created between the Fifth Dalai Lama and Emperor Shunzhi, but the emperor suspected that might strengthen the Seventh's authority. Instead, he sent him into internal exile first in one location and then in another. When Yongzheng died, in 1735, the exile was cancelled and the Seventh Dalai Lama was permitted to return to the Potala. But Polhané's continuing supremacy meant that the Dalai Lama's political power was much reduced, and that any dream of resurrecting something like the power of the Great Fifth evaporated.

A Chinese civil official appointed to the region in the mid-1740s affirmed the belief that Emperor Yongzheng's measures had brought about Qing supremacy in Tibet. 'We have now brought the area back onto our map', he wrote. 'By breaking the lamas' support for the Khoshots, weakening Kokonor, and driving off what lies outside and defending what is within, matters have finally been suitably arranged.' Emperor Yongzheng had done what needed to be done. 'Blocking and exterminating the Tibetans', he boasted, 'was, you could say, a once-in-ten-thousand-year achievement.'

From the Tibetan perspective, however, the Manchus' final solution was simply a fuse for ongoing instability. Dissent continued. As soon as Polhané died, in 1747, another wave of conflict erupted in Lhasa. The Zunghars again became involved, hoping to shape the situation to the disadvantage of the Manchus. Alarmed by these developments, Manchu officials had Polhané's son assassinated to prevent any strong core from reappearing among the Tibetans. This act in turn provoked the officials' own assassination, along with the massacre of some hundred Chinese living in the city. Yongzheng's successor, Emperor Qianlong, ordered yet another military intervention. Once opposition within Tibet was again suppressed, Qianlong decided to deal with the Zunghars once and for all. In 1755 he launched a three-year campaign to destroy the Zunghars. By the end of the campaign in 1757, Qianlong's armies had reduced the Zunghars from over half a million people to perhaps 200,000, half of whom then perished in the devastating smallpox epidemic that the Manchu soldiers brought in

their wake. The genocide was on a scale such that today there remain only about 15,000 people who claim Zunghar ancestry.

For Tibet, the consequence was devastating, and conclusive. That conclusion was spelled out when the Panchen Lama, the second in the Yellow Hat hierarchy, was invited to travel to Beijing in 1779 to have an audience with Emperor Qianlong. This was a good moment for the Panchen Lama to act, as the Seventh Dalai Lama had died in 1757 and the Eighth would not be born until 1808, an unusually long hiatus in the reincarnation of the Panchen's superior. The encounter of the Panchen Lama and Qianlong was not a meeting of equals. It was not a re-enactment of the Fifth Dalai Lama's encounter with Emperor Shunzhi, nor even of the Seventh Dalai Lama's conversation with Prince Yinzhen. It was pure submission. The Panchen Lama went down on his knees and kowtowed to the emperor, laying not just himself but Tibet at the emperor's feet. The gesture acknowledged that the Qing Great State now commanded all of Inner Asia.

Sumpa Khanpo, a disciple of the Panchen Lama, wrote seven years later this was the outcome that had to be. He insisted that Emperor Kangxi had 'brought the people of Kokonor under his power and bound the good relationship of the Chinese and Mongols with a golden cord'. He noted that that golden cord had frayed under Emperor Yongzheng (left unnamed, of course) because the Manchus had failed to respect the contributions the Khoshot Mongols had made to protect the Seventh Dalai Lama, but it was repaired when his master went to Beijing. For the disciple, the Panchen Lama's submission signified not that Tibet had been stripped of its authority but that it had gained a place within the Qing Great State. There were, he insisted over and over again, 'two laws' (the state law of Beijing, and the religious law of Tibet) and 'three countries' (China, Tibet and Mongolia). With this formula, he sought to imagine an arrangement that placed Tibet within China without causing it to disappear. But that was the hopeful view from Inner Asia. The view from Beijing was not that there were two laws and three countries. There was only the emperor's law and only the Qing Great State. And so, largely, matters remained this way until the Qing unravelled and was dissolved in 1912.

The disappearance of the Qing Great State severed the priest–patron bond between the Dalai Lamas and the Qing emperors in a

way that Chinese Republicans neither comprehended nor credited. For Tibetans, as indeed for Mongols and Uyghurs of the New Territories, the political relationship with the Qing Great State had come to an end. Even before that end, the Thirteenth Dalai Lama had attempted to secure allies – Mongolian, Russian, even British – in the closing years of the failing Qing in the hope of restoring Tibetan autonomy, but without success. In 1912 the revolutionaries declared that the Chinese Republic was the successor to the Qing Great State. Of the regions the Manchus had colonised, only Outer Mongolia managed to break free from the suction of Chinese nationalism. Tibet could not engineer its exit from the new Republic, but was largely left on its own during the chaotic decades that followed. With the invasion of Tibet by the People's Liberation Army in 1950, China made its move to reimpose its active sovereignty over the territories of the old Great State. What the current Dalai Lama, the Fourteenth, has called 'the foreign occupation' of Tibet continues to this day.

The Merchant and His Man

Ostend, 1793

The *Etrusco* was making its way up the English Channel on 15 July 1793, one day out from the Belgian port of Ostend, when a British naval cutter slipped alongside. Britain was at war with France that summer, and the British navy was enforcing an embargo. A ship in the English Channel not flying the Union Jack was liable to seizure if its papers were not in order. The captain of the *Etrusco* had reason to be anxious. The ship was a legal mishmash not untypical of the era: built in the United States, sold in Calcutta, registered under the name of another vessel, owned nominally by a Venetian from Istria, flying the flag of Tuscany, commanded by an Englishman, carrying goods for merchants of at least four nationalities and funded by creditors of at least three. Navigating a world of monopolies, the ship's manifest came in several versions, depending on who might want to see it. Oh, and there was also a Chinese passenger by the name of Lum Akao.

The men on the *Etrusco* had learned of this war only when they reached St Helena, a lone island in the middle of the South Atlantic where ships sailing to and from Asia regularly called for water and supplies. When they had left Macao on New Year's Day with a hold filled

with sugar, the two countries had been at peace – though, unknown to them, Britain declared war that very day. The war into which the *Etrusco* sailed was a delayed outcome of the French Revolution in 1789, which had put France at odds with every other European state, and two years later, when the French National Assembly revoked the monarchy, violently at odds. Relations with the Austrian Empire, the other major power on the European continent, soon reached breaking point. Rather than let the 'Impérialistes', as the French called them, make the first move, France declared war on the empire in 1792. Other states were drawn into the conflict, eventually including Britain, which declared itself in alliance with the Austrian Empire.

The *Etrusco* was flying a flag of the Austrian Empire, of which Tuscany was then a part, so that was good. But then, as now, flags of convenience were often flown, which meant that in war they could not be taken at face value. No British warship could allow a merchant vessel, regardless of its flag, to sail past without checking its papers to determine who owned it, whose cargo it carried and where it was heading. The *Etrusco* had already been intercepted for this reason several times as it made its way up the North Atlantic.

It was vulnerable on two counts. First of all, the ship was under the command of an English naval officer on leave at a time when all naval officers had been recalled for service. Home Popham had learned his craft as a junior officer in the British navy in the war with the American colonies, rising to the rank of lieutenant. Demobilised and put on half-pay after Britain abandoned that war, he had had no desire to hang around doing nothing to advance his career, so he went over to Ostend, a location that placed merchant vessels conveniently beyond British regulations. He nosed about for a command, found one and petitioned the Secretary of the Admiralty in 1787 for leave 'to go to the East Indies to follow my private affairs'. The Secretary was not enthusiastic but gave in after Popham's second petition, agreeing only on condition that he stay out of any region in which the East India Company (EIC) had an interest, and also that he clear his presence in Asia with the company.

Popham did neither. Instead, he sailed off to India in a ship called the *Etrusco* to do business exactly where he wasn't supposed to – in the waters where the East India Company operated. In Calcutta, he ended

up selling his ship in a dodgy deal to some Americans in exchange for a larger one, the *President Washington*, which he promptly renamed the *Etrusco*, probably to obscure the fact that any ship had changed hands. Besides, calling his vessel 'the Tuscan' was a great way to appear to be at arm's length from English interests. To keep up the pretence, he hired a Tuscan as ship's mate, replacing him later with an Istrian (Istria then being under the Austrian Empire). For a time, Popham moved cargo around the Bay of Bengal, the deepest pocket of the East India Company, then sailed to Macao, where he found European merchants eager to fill the hold with commodities and sail with him back to Europe to make their fortunes.

What was in the hold was the *Etrusco*'s second point of vulnerability. A third of the cargo belonged to Jean-Baptiste Piron-Hayet, a French merchant based in Macao and trading in Canton. Another third belonged to another merchant with a French name, Charles de Constant. Constant was in fact Swiss, but he had gone to Canton as chief agent for the French East India Company. He had quit the previous year, when the company closed its Canton agency as part of a radical attempt to avert financial collapse (which came anyway in 1794). He now worked on his own account. Yet carrying so much cargo under two French names would catch the attention of any British inspector.

Despite these handicaps, Popham was a nimble operator who knew all the rules and was deft at denying basic facts when the facts did not agree with his objective. Every time a British officer boarded his ship, Popham had been able to use argument and the force of his personality to convince the inspector that the ship sailed without offending Britain either by the laws of war or by the laws of monopoly. And he did so again on 15 July, when the naval ship challenged his vessel in the English Channel. It helped that his ship was destined for Ostend, as Belgium lay within the Austrian Empire. But what helped on the one hand could hurt on the other, for the agency handling the shipment in Ostend was an English merchant house, Robert Charnock, notorious for using devious methods to get around the EIC monopoly. Fortunately for Popham, your average junior British officer was unlikely to know that, as indeed the young lieutenant who boarded the *Etrusco* did not. The two men had a long conversation, brother officer to

brother officer, and then the lieutenant returned to his cutter, satisfied that the *Etrusco* was not a prize of war and could proceed to Ostend.

The *Etrusco* reached port the following day without further incident. The voyage was over. No sooner had the ship dropped anchor than Home Popham had himself rowed ashore. He had left a young wife in Ostend, and had not yet met the son they had conceived on the night of his departure two and a half years earlier. Whether Charles de Constant, the Swiss merchant who sits at the centre of this chapter, went ashore too is not recorded. After a long voyage he would surely have wanted to feel dry land beneath his feet. If he did go ashore, Lum Akao, the merchant's man, would have gone with him, setting foot on European soil for the first time. Few were the Chinese who had done that.

When the *Etrusco* reached Ostend, they would no doubt have seen the British frigate *Brilliant* at anchor in the harbour, but the ship had passed muster so many times already that no one gave it any thought. But that night, under cover of darkness, a lieutenant from the *Brilliant* led an armed party to board and declare the *Etrusco* seized for His Majesty George III as a prize of war. The history that got Lum and the *Etrusco* to Ostend was nothing in length compared with the legal battle that ensued over whether the seizing of the Chinese goods on board was legal, and whether restitution was due when it was found that it wasn't. The case would take fifteen years to work its way through British courts.

A Chinese in Europe

Four months after arriving at Ostend, Lum Akao had his portrait painted in London. I discovered the painting while visiting Princeton, in a chance conversation with Sue Naquin, a long-time colleague and friend. When I happened to mention that I had been reading the memoirs of Charles de Constant, she remembered an inquiry she had received years earlier while she was chair of the Department of East Asian Studies. A Princeton alumnus had brought in an old print that had been in his family. It showed a Chinese man, and he was curious whether anyone in the department could shed light on who he was. After some digging, Sue discovered that he was Lum Akao, Constant's servant. By way of thanking her for the interest she had taken, the

owner donated the print to the department. It hung in her office for years. In recent years, curators at the university art museum judged the print too valuable to be left hanging on a wall, and condemned it to be encased in bubble wrap and put into storage.

When I got to see it, I noticed that in small print it included a credit for the painting from which it had been made: 'H. Danloux Pinx't', which is to say, 'painted by H. Danloux'. I assumed that the original had long ago disappeared, but by searching the internet I found the painting on which it is based, now in a private collection in Ireland. Although I have seen this original in a digital copy only – always a far cry from the real thing – the reproduction is enough to tell me that, while the Princeton print is good, the original is extraordinary.

The sitter is shown against a background of sky, looking beyond the painter's right shoulder, his brow well lit, his eyes clear and his lips parted. There is some slight suggestion in his face that he is not entirely at ease and perhaps a bit self-conscious about posing. Sitting to have your portrait painted was an experience foreign to most Chinese in the eighteenth century. Portraits were for the famous and the great, emperors and princes, high officials and famous literati. Think back to the portraits that opened the first two chapters of this book. For ordinary people, the only portraits they knew or saw were portraits of the dead or about-to-be-dead – what we call ancestor portraits. Sitting for Henri-Pierre Danloux in his studio in Leicester Square would have been a novel experience for Lum Akao, yet only one more in the parade of novelties that had been his life since he first started working for this European fourteen years earlier.

The portrait is a fine piece of work. Measuring a yard in length and twenty-eight inches across, it is large enough to extend to the subject his full dignity without seeking to monumentalise him and overwhelm the viewer. European artists unfamiliar with Asians found modelling Asian facial contours challenging, especially the eyes. Chinese eyes were not part of their training curriculum, yet Danloux has managed the epicanthic fold of the upper eyelid with skill. But the painting is more than just a good likeness: it is a sympathetic rendering. The slight parting of his lips and the multiple planes of light on his face impart a sense that this is a living, breathing person. The blackness of the clothing is a bit sombre, but the soft pastels tinting

the clouds behind the sitter add warmth and buoyancy to the presentation. Nothing in the painting questions or takes away from the dignity of the sitter. No attempt is made to exoticise Lum or to put him in a category apart. He may not look the way we do, and he may dress out of fashion from the perspective of a European viewer in 1793, but essentially he is one of us.

The painting stands out in Danloux's *oeuvre*. His trademark style was darker, more theatrical, at times overly decorative – very much in the eighteenth-century mode. Not this portrait. Aside from the use of a cumulus clouds backdrop as a device Danloux repeated in his portrait of the Duc de Berry three years later, the painting is not like anything else in his repertoire. No fancy clothes, no props, no dark shadows – just the man himself, posed out of doors, in Chinese dress and cap, but otherwise unadorned. There is nothing hasty or inattentive about the work. Quite the contrary; the complex geometry of light and shadow that Danloux has used anticipates painting in the nineteenth century more than it looks back to the conventions of the eighteenth, at least to my eyes. Danloux is not experimenting with a new style so much as trying to find a manner to capture his sitter without relying on the standard props, whether heroic or domestic, that tended to clutter European portraiture at the time. Whether Danloux was too pleased with Lum's portrait to part with it or simply could not find a buyer, the painting remained in his collection when he returned to Paris in 1801. When Danloux died in 1809, the painting went to his son, and it was still in his possession as late as 1860.

Danloux had arrived in London a year before Lum and Constant did, an escapee from the French Revolution after it had turned to violence. Since this upheaval deprived him of the aristocratic clientele on whom he had relied for commissions, he set up a studio in Leicester Square and chased portrait commissions in London for several years before moving to Scotland to do the same. When Constant arrived in London, he and Danloux made contact. They may have known each other from one of Constant's extended sojourns in Paris, though being European émigrés from the French Revolution may have brought them together in any case. I suspect that prior acquaintance and a shortage of funds led them to the notion that they could turn the mild sensation Lum created in England to their advantage.

Lum may have been the only Chinese in London in 1793, and hence a figure of considerable curiosity. He even came to the attention of George III. Their paths crossed when the king was walking in Hyde Park, a happenstance that Constant probably orchestrated in his bid to gain attention and build contacts with London's commercial elite. Charmed by the encounter, the king allegedly shouted, 'What? What? Chinaman! Chinaman! How do you do? How do you do?' Constant reported that Lum bowed and murmured deferentially, 'Qing, qing', meaning 'As you please, as you please'.

Lum's visibility must have encouraged the idea of producing a print that could be sold to a curious public. Danloux painted the portrait and then arranged for Joseph Grozer, an engraver whose workshop was also in Leicester Square, to produce a mezzotint from the portrait. Unlike a conventional print, made by etching a copper plate, a mezzotint used a more sophisticated technology of roughening and polishing the plate to create finer tonal shadings than the cross-hatching employed in the earlier technology. Grozer reduced the painting to one-fifth of its original size in order to make it economical to print. He added a panel at the bottom of the image giving the identity of the sitter and crediting Danloux as painter and publisher. The panel includes a dedication: 'To Mr. Charles Constant de Rebecque this plate is dedicated by his most humble and devoted servant, H. Danloux.' The print also bears a subtitle: 'The Chinese arrived at London in 1793.'

The full caption reads: 'Euhun Sang Lum Akao', or 'Lum Akao of Euhun Sang' (in Mandarin, 'Lin Yajiu of Xiangshan'). Xiangshan was the native place of many Chinese who went to Macao to work, and sometimes abroad. The title not only fits the image, but corresponds to the Chinese title, which appears in the top left-hand corner. The five characters are legible, but just awkward enough – two strokes in the first character are incorrect, and the vertical line at the bottom of the second is too long and prominent – to suggest that this is not the handiwork of someone who has studied Chinese calligraphy. The result is respectable for a novice, hardly surprising for someone with Danloux's trained eye and hand. Writing characters on a painting was normal practice in Chinese painting, but it was unknown on European portraits of the eighteenth century. In Europe the sitter's

name appears on the frame, never within it. It was Danloux's way of acknowledging that Lum came from another culture.

A European in China

If Lum was a curiosity for Londoners, Constant was a 'ghoul' (*gwailo*) for Cantonese. Europeans were not quite so rare in Canton as Chinese were in England, but each regarded the other, when seen on the observer's own home ground, with emotions that could range from amusement to disgust. He who wandered on the other's home turf had to be prepared for the hostility that fear of the other can breed, especially when that fear has been instilled since childhood.

To be a European engaged in the Canton trade was to live in two places: Macao and Canton. Portugal had gained the lease of Macao, a tiny peninsula at the mouth of the Pearl River, in 1557. By the eighteenth century, it was still the only place adjacent to China where Europeans could live. Europeans and Chinese had traded informally there and elsewhere around the estuary of the Pearl River until 1684, when the Qing opened Canton to supervised foreign trade. Foreigners were permitted to rent premises outside the city walls for their trading needs and could reside there during the summer trading season, but during the rest of the year they had to winter 100 miles downriver at Macao.

Constant first sailed to Macao in 1779, at the age of seventeen, and would sail twice more over the course of his career in China. His enormous archive of papers and diaries, now housed in the Geneva Library, includes a diary of his third visit, which he wrote in the form of letters to friends. In one of these letters, dated 20 September 1789, he expresses his delight at coming into sight of Macao and finding himself 'returning to the country where I passed the most wonderful years of my youth and where I knew I would find again such good, old friends'. In the same letter he describes Macao as

> very dazzling and very agreeable. This peninsula consists of
> several hills among which the city sits irregularly as though in
> an amphitheatre. The whiteness of the buildings obscured by
> the foliage of beautiful trees and the mix of Chinese buildings,
> European churches, and pretty homes make for a very lovely
> effect. One disembarks on a huge panhandle in the form of a

semi-circle, along which runs a beautiful wharf that serves as
a promenade. The movement of European and Chinese boats
coming and going adds to the beauty of the whole.

Macao was a Portuguese city with a Portuguese governor. After
the Qing appointed a magistrate there in the mid-eighteenth century,
however, the Portuguese could no longer keep the city to themselves
and were obliged to permit entry to anyone who arrived. Accord-
ing to Constant's count, the European population of Macao in the
later years of the century exceeded 2,000, all of them male but for
the governor's wife. Add to that the Chinese women who served and
cohabited with the Europeans (and who were all nominally converts),
and that number grew to 7,000 'Christians'. That community was far
outnumbered by the 25,000 Chinese men who worked in Macao and
whose labour was essential for the city to function. Twelve to fifteen
hundred African slaves completed the tally of the city's population.
Despite their small number, the Europeans dominated the port.

Like most Europeans, Constant went to Macao as a sojourner
intending to stay however long it took to make his fortune. He started
as an apprentice for the Imperial Asiatic Company of Trieste. This was
one of the lesser-known East India or Asiatic companies state-man-
dated to operate monopolies trading to China. Constant had hoped to
go in service of the French Compagnie des Indes Orientales but was
unable to secure a position. He was the son of a reasonably prominent
Geneva family of noble lineage but moderate wealth, which meant
that Constant started out in life with some connections and opportu-
nities, but he had to work to benefit from them. His family moved him
around a great deal when he was young, an itinerary that included a
two-year stint outside London when he was fourteen. By the age of
sixteen he could speak four languages well and knew how to conduct
himself in unfamiliar settings. Genevans came to staff companies all
over Europe, but the Imperial Asiatic Company was as good as he
could manage at the time. He had one big disadvantage: he was never
more than lukewarm about the idea of making a killing in business.
He liked the thought of having enough to be able to return home in a
respectable state to settle in a comfortable family setting, but he was
never single-minded enough to pursue riches at any cost.

The Imperial Asiatic Company of Trieste operated as a monopoly of the Austro-Hungarian (Habsburg) Empire. At the time Constant was taken on, this was the latest avatar of a company that had maintained but a short and fitful presence in Canton. Despite its name, Constant's company operated not out of Trieste but out of Ostend. It claimed Trieste in order that it could come under the Habsburg umbrella as its official company trading in Asia. Working for 'the Imperials', as the English called them, was not the steady prospect Constant had hoped for. Once he got to Macao, the company found itself in financial straits back in Europe. It sent no ships, and as a result there was no business to transact, especially for a seventeen-year-old newcomer. Effectively stranded, Constant decided to abandon his post, though he had to borrow money to pay off his debts before he could leave in February 1782. While he was en route to Europe, the company reorganised and sent two ships to China, though Constant had no way of knowing that until he got back to Europe. As there was no Imperial ship on which Constant could take passage back to Macao, he hurried to England to pick up a ship leaving from Margate that flew the Imperial colours on the strength of having hired an Italian captain of convenience. Its real captain and officers were former EIC men – another English ship evading the monopoly.

Once he was back in Macao, Constant wrote his brother a letter revealing his unhappiness at having returned. 'Here I am again in my prison', he wrote. 'I am surrounded by people without principles, without morals, not at all sociable, and who think of nothing except how to make a fortune and who don't much trouble themselves over how and through whom they make it.' To his own rhetorical question – 'Could fortune ever compensate for the awful moments that I pass and will pass, perhaps for a long time, in this sad country?' – Constant answered, 'I don't believe so.' After a burst of speculative activity, the Imperial Asiatic Company collapsed under the weight of its debts and declared bankruptcy in 1785. Constant was released and sailed home on the next winter monsoon with no wish to return. Once back in Europe, though, his prospects were no better than they had been in Macao. When the Compagnie des Indes Orientales, briefly suspended, went back into operation, it offered to send him for his third stint in China as its agent. Going back at this level meant that he could be

comfortably installed as the second-in-command of the French factory. He decided to give fortune another chance.

Macao was where Constant met Lum soon after arriving the first time in 1779. On that occasion he wrote home to say, 'I have a servant just for me. He is eleven and is called Akao. He is intelligent, gentle, and cheerful.' The two young men became close. Constant left Lum behind when he returned to Europe in January 1782, but on his second arrival in Macao, Constant was delighted to discover Lum waiting for him among the men on the wharf looking for work and took him back into service. He writes of Lum in a letter home as 'the domestic who had been in my service previously and whom I could say I had raised', but otherwise says little about him in his writings. A second separation followed when Constant returned to Europe, and a second reunion when he arrived back in Macao to run the French factory. When the *Etrusco* sailed in January 1793, Constant could afford to take Lum with him.

Lum was not Constant's only Chinese companion. Macao was a world of foreign men, but it was also a city of Chinese women whom the Portuguese bought from China as orphan girls and raised as Christians in Macao. Like most European men, Constant took advantage of the arrangement. 'The Portuguese regard it as a work of piety to buy Chinese children and raise them in the Christian religion', he wrote to friends. 'The price of Chinese children is not high, especially during the famines that frequently devastate that empire, even in the best provinces. Girls are the preferred choice, because they are better assured of making a living as prostitutes.' The man who took a temporary wife, or *nyonya*, was obliged to support her as he would a real wife, though it was understood that the financial bond between them dissolved when he left. Constant's first *nyonya* was Josefa. When he returned in 1789, he learned that a Danish merchant had taken her on in the same capacity, so later that winter he contracted the services of another Chinese convert. Her Chinese name is not recorded, but her Portuguese name was Gratia Barrada. Gratia more than fulfilled the terms of her contract, nursing Constant through a long illness midway through his third stint in Macao from which he might not have recovered without her care.

The Canton Experience

The Europeans who sailed to Canton to trade found themselves entering a highly organised trading system. The bigger merchants with whom they dealt worked for licensed *hong*, or companies. These *hong* merchants enjoyed official authorisation to carry on this trade, a privilege for which they paid through the nose to the Imperial Household. The Europeans had to base themselves in Macao, and came upriver during the summer trading season to conclude trade deals. Banned from entering the city itself, they had to reside in the so-called Thirteen Factories along the Canton waterfront just beyond the south-west corner of the city. These 'factories', which initially the *hong* merchants constructed at their own expense, provided a combination of residential and warehouse space to house the Europeans and their goods during the trading season. Constant described them as 'not so wide but very deep' – well over a hundred yards in depth – 'and divided into sections separated by little gardens and a wide passage down the middle. Their fronts are adorned with galleries on the upper floor, some supported by columns and others that form arcades ornamented with pilasters.' Initially not large enough to receive the entire cargo of a ship, they were expanded over time to the point that some could store the cargo of upwards of four ships.

The only amenities for those stationed in the Thirteen Factories were the Chinese businesses that were allowed to open along two lanes running back from the river. The original shopping lane, Hog Street, ran by the English factory. It was joined in 1760 by a second, China Street, which flanked the French factory during Constant's first sojourn, though the French company later moved three doors west of China Street and the Americans took over the site and built their own factory there in 1800. Bored foreigners could buy personal necessities and souvenirs in the shops crowded along these two alleyways, and eat and drink, or get into brawls in the taverns if the mood took them, which it often seemed to. Chinese knew China Street as Jingyuan Jie, the Street for Keeping Those from Afar Calm, a name entirely without ironic intention. This common phrase expressed the official goal of foreign policy, which was to keep foreigners – by definition always potentially a source of trouble – content and thereby reduce to a minimum any threat they might pose. Most foreigners remained within the conclave set up for them.

Constant preferred Macao to Canton. He only occasionally ventured out into the city, and was never comfortable when doing so. 'It is not at all pleasant to leave the quarters frequented by Europeans to satisfy one's curiosity', he confided in a letter, in which he then revealed that he never went into Chinese neighbourhoods without an armed guard. 'Even though one takes a soldier with him to make an impression on the populace, one is soon surrounded by a great crowd who throw stones, etc., and threaten you with injuries.' Not all Europeans experienced Canton in such negative terms, but Constant was unable to manage face-to-face interactions with equanimity. He had brought with him certain Enlightenment expectations, fed by Voltaire and other authors, that the Confucian order placed Chinese on an altogether higher plane of rationality and morality than Europeans. Instead, Constant found himself dismayed and disgusted by conduct that, he complained in a letter home, 'belongs more to a nation of savages than a people renowned for their degree of civilisation'. Lum Akao seems to have been the only Chinese he excused from this judgement.

Constant resolved his confusion by switching from Voltaire to Montesquieu, from the idea of China as an enlighteed monarchy to the contrary view, increasingly popular back in Europe, of China as a land of despotism. If Chinese acted badly, he believed, it was because despotism had blocked Chinese from being able to live up to the values of their culture. 'One must not forget that despotism permits society no moral pleasures', he writes in December 1789. 'Men compensate for this by searching for and gratifying themselves with the pleasures of the senses, which they take in secret and in silence.' His choice of language was not accidental. Despotism was on everyone's mind at the time, for this was the language of the French Revolution. Constant goes back to the same language in a letter a few weeks later, singling out the contempt that Qing officials displayed towards ordinary people and the debasement that common people were expected to display towards the state, as evidence of despotism at every turn. 'Let me be clear about what follows by saying that contempt is the predominant sentiment of all despotic governments, and obligation the most efficacious means for keeping in containment a people so numerous in a country that is as vast as China.'

Constant's critique of Qing despotism to some extent reflected his own difficulties in making his way in China. For Constant, despotism was the political condition that produced monopolies and stifled free trade. 'Monopolies, companies, and closed corporations are so much to the taste of despots', he argued. 'Every partisan of monopolies', he insisted, 'is a partisan of despotism.' China was not the sole target of his wrath. He applied the critique equally to the East Asia companies for which he had worked and from which he had gained nothing. Only by doing away with monopolies would Europe save itself from sliding more deeply into despotism. Revolutionary opinion in Europe agreed with him. The French were the first to cancel their East India company, and in time the other European companies were also disbanded as public opinion in the nineteenth century embraced the call for free trade.

The Emperor's Interest

At the distant head of the Canton system was the man who most profited from it, the Manchu emperor. That man – seventy-eight years old, and fifty-four years on the throne at the time Constant was writing – was Emperor Qianlong. His grandfather Kangxi had set the record for the longest occupation of the throne: sixty-one years. When Qianlong hit the sixty-year mark six years later, he decided that it would be inappropriate to surpass his grandfather and so formally retired from office, though he held the reins until his death four years later. I dwell on his age and the length of his tenure to make the simple point that this man, who proved himself to be a competent monarch within the rules of the Manchu occupation, had been around so long that the interests he and his coterie represented were deeply vested. His favourite, a Manchu bodyguard named Heshen, rose to such a height that he has been given the distinction of being named the most corrupt man in Chinese history, and probably the richest man in the world by the time he was obliged to commit suicide straight after his master died in 1799.

Constant had nothing against Emperor Qianlong and was keen to see the monarch in the flesh. When a plan was hatched to send a party of Europeans to Beijing to congratulate the emperor on attaining his eighty-first year (a lucky number), Constant leapt at the chance. The

journey was aborted because of objections by the British over proto-
col, but he still wrote in a letter to his friends: 'You will understand
the joy with which I would have accepted such a proposal.' Constant
nonetheless understood that the frustrations he faced in Canton
flowed from the fact that the Canton system existed to support the
Imperial Household, and that the officials with whom he dealt were
obliged to use the system to funnel as much silver as possible into
the emperor's purse. That burden fell heavily on all parties, though
hardest of all on the Hong merchants. To engage in the Canton trade
was an enormous gamble, given the burden of paying off the Imper-
ial Household. For many Hong merchants it ended in bankruptcy at
best, or exile at worst.

To ensure his cash flow, Emperor Qianlong kept a close eye on the
officials he appointed to the key positions in the system: the provin-
cial governor and the customs commissioner, whom the Europeans
knew as the Hoppo (literally, 'Finance Minister') or Quanpou ('Cus-
toms Minister'). When Constant arrived in Macao in 1779, Qianlong
had combined the Hoppo and the provincial governor in the person
of Li Zhiying. Despite his Chinese-seeming name, Li was a Manchu
attached to the Imperial Household – exactly the sort of person the
emperor wanted in key posts. Like the Mongol emperors, who had
used foreigners of 'various categories' to run a parallel administration
in their private interests, or the Ming emperors, who pursued their
goals through emasculated slaves, the Qing emperors ran their private
operations through imperial clansmen and Chinese bondsmen, and
kept them out of the reach of civilian administrators. So Li Zhiying,
like Marco Polo in the Yuan or Zheng He in the Ming, was a cog in
the mechanism by which the emperor ruled without having to defer
to his official bureaucracy.

Li Zhiying lost his governorship during Constant's second year but
was kept on as customs commissioner for another three so that he
could make good his debt to the Imperial Household, which ran to
hundreds of thousands of ounces of silver. Dismissed from service
in 1784, he spent the remaining decade of his life paying it off. The
historian Kent Guy has reconstructed Li's debts and determined that
the entire edifice of corruption rested on taxing tea, for which for-
eigners paid in silver. The result of this squeeze from above – 'the

Chinese emperor methodically taking his cut of the supposedly ill-gotten gains of his ever resourceful minions rather than holding them to a moral standard', as Guy nicely puts it – was a degradation of office that utterly negated 'the ideological image of an emperor who was a center of moral and political authority'. The income was terrific but the dangers were even greater, for an emperor without moral authority made himself and his dynasty vulnerable to challenge from within and contempt from without. By the end of the nineteenth century, Europeans regarded the emperor of China as a joke, and Chinese regarded him as a liability, a foreign occupier who could be dispensed with so that Chinese could get on with the task of ruling China.

But I run ahead of the story. Though European merchants chafed under this financial administration, Li Zhiying was no better or worse than any other Hoppo. When another Manchu, Mudeng'e, replaced Li in February 1784, the Europeans used his installation to invite him to a meeting to consider changes in the rules of the Canton game. Rarely did the Europeans act as one, for they were at least as much each other's competitors as they were fellow Europeans, but they wanted relief from the extra burdens the system imposed, especially ones that struck them as purely arbitrary. They wrote out a list of ten requests and asked Mudeng'e to meet with them to discuss their concerns. He agreed, and the meeting took place on 27 October 1784 aboard one of the European ships at anchor at Whampoa, an island just downriver from Canton beyond which the larger foreign ships could not proceed. As none of the European merchants was fluent in Chinese, they engaged Jean-Charles-François Galbert de Rochenoire to translate on their behalf. Galbert, who had arrived in Canton at the age of eight with his father, had learned Chinese without formal instruction. He worked for the various East India companies as they rose and fell, though he preferred to present himself as interpreter for the king of France. It is thanks to him that we have a record of the meeting with Mudeng'e.

The meeting opened with Galbert introducing the Europeans in attendance, distinguishing each by nationality. He explained to Mudeng'e that he was merely the interpreter, and that the views he was about to express were those of the delegates and not his own, and then went one by one through their complaints. Mudeng'e was

at ease, responding to each point as it was raised and showing himself willing to review and revise the measures and procedures the Europeans found burdensome or offensive, though only after he had had time to read through and consider the full list of their complaints after the meeting. The language on the European side stressed 'la liberté du commerce'. The concept had no particular meaning in the Chinese context. An artisan or merchant was free to sell his wares as he chose, but that did not add up to so grand a concept as *liberté*.

What the Europeans wanted from Mudeng'e was nothing so abstract as freedom, though. They wanted relief from the financial burdens that the Canton system imposed. Some of these burdens were built not so much into as around the rules of the system. And out they tumbled. The system required the foreigners in Canton to sail out to Macao annually, but the tolls and fees they had to pay to do that had more than tripled in the previous four years. The lesser officials who assessed the values of cargoes for tax purposes falsified their weight and quality. They were limited to two sampans when loading cargo in Canton, which made the process slow and costlier than it need be. In every case, Mudeng'e promised relief in the most benign manner. 'As for using more than two sampans for loading your vessels', he replied to the third demand, 'that can be accommodated without difficulty. You could ask three or even four without that being too great a request on your part', he added graciously.

Galbert moved on to a tougher issue, the management of Chinese debts. Chinese merchants were chronically undercapitalised and thus hampered from acquiring goods ahead of the trading season at reasonable cost. To make advance purchases, they turned regularly to the European merchants to float advances well before the goods were delivered. Surprisingly, it turns out that the Canton system ran on European credit, not Chinese. That meant that when a Chinese merchant went bankrupt, his debts to the Europeans could be huge. Lest these debts cause the trade to collapse, Emperor Qianlong insisted that the other Hong merchants had to take over his debts and repay the Europeans at an annual rate of a tenth of what they were owed. The problem with this solution was that the money to make those repayments was levied from the foreigners in the form of new entry and exit duties. The upshot of this arrangement was that the

Europeans were paying the repayments that they received on their debts, in effect, paying themselves out of their own revenues. The foreigners objected to this arrangement, not least because most of the outstanding debt was to the English company, and the French, Swedes, Danes and Dutch saw no reason why they should be paying off the Chinese debt to their chief competitor.

'I understand', was the Hoppo's less than useful reply.

After going through several other matters, Galbert presented the final item of business, which was that the Hoppo should agree to receive a copy of the list of their demands to ensure that there were no misunderstandings. Galbert added, as a goad, that the list 'will be sent abroad to the various courts of Europe as testimony to the zeal with which we have sought to represent their interests'. It would be treated as something of an international memorandum of understanding, implying the hint of pressure from foreign heads of state. Mudeng'e was unprepared, indeed unauthorised, to engage in diplomacy with other states, so he hedged.

'As I am on board a ship, I can give you no undertaking at present, but I will do so if these gentlemen so desire, either in their respective factories or, if they prefer to do so as a group, in the English factory. So long as the requests that you have made are not contrary to the laws, I will reply in writing article by article and give you justice.'

It was a skilful performance on the Hoppo's part, and would amount to nothing, not just because 'the mandarins refuse nothing but accept nothing', as Constant put the situation in another context, but because of an issue of sovereign jurisdiction more pressing than a trade memo.

The Justice of Capital Crimes

Less than a month after the meeting with Mudeng'e, an event intervened to destabilise the accord that the meeting might have generated. On 24 November 1784, the *Lady Hughes*, a British vessel, arrived at Whampoa. To announce its arrival, it followed the standard European protocol of firing a cannon salute. Unbeknownst to the gunner, George Smith, a small boat carrying officials out to the ship was approaching under his firing port. As Smith had already fired two shots without incident, he assumed that no one was in his firing range.

But his third shot hit the sampan, killing one man instantly and fatally injuring a second. In European law these deaths would be considered accidental homicide, but in Chinese law they were capital crimes. The commander of the *Lady Hughes* was loath to hand Smith over to the Chinese authorities and insisted that he would mete out justice himself on the basis of English law, which he understood pertained on board a ship at sea. Smith's surrender, however, became the condition for unloading the ship's cargo. Facing financial disaster at neither selling his cargo nor acquiring Chinese goods, the captain caved in to the request and handed Smith over. On 8 January 1785 he was executed by what Chinese law considered the least stringent form. He was garrotted.

Though legal under Chinese law, the execution offended the Europeans. The *Lady Hughes* incident became the front end of a wedge of distrust and contempt that would drive Europeans and Chinese further and further apart, polarising them not as people from different places but as adherents of fundamentally incompatible cultural and moral systems. From that moment on, difference was no longer simply a matter of Chinese doing things one way and Europeans another in a world in which there were many ways of doing things. The chasm that separated Chinese from Europeans could not be crossed, and should not be crossed. It marked China, in its institutions as well as in its essence, as a zone where the basic standards of civilisation did not apply. Portions of this attitude were already finding voice when Constant first reached China, but the hostility – and an indifference to defusing this hostility – grew over the period of his three sojourns.

By his third stint in China and still unsuccessful in the trade, Constant indulged extravagantly in this opinion. His contempt for officials – whom, to vent his frustration, he at one point called 'my ladies mandarin' – was deeply felt, largely because as senior French agent he had to deal with them on a regular basis.

Nothing strikes a European who arrives in China as much as the impediments and obstacles that he meets at every turn. The detailed surveillance that the mandarins exercise over us, the contempt with which they treat us, the slowness with which they issue permission to depart or arrive, because of which they

oblige us at every moment to have to ask for the most ordinary
things as well as the most indispensible, irritate us and drive us
to lose all patience, especially as they do not react to our anger
except with the iciest of looks, the greatest insouciance, and the
most insulting contempt.

And yet Constant never quite gave up on China. The country fascin-
ated him even as it irritated. Perhaps his relationship with Lum Akao
helped to soften his hostility. So when the prospect suddenly emerged
of going to Beijing for the emperor's birthday, Constant was ready to
leap at the chance. Even if he had to go in the guise of an envoy bear-
ing tribute from France, he did not mind. He wanted see the country
with his own eyes, and this would let him do it, on top of which 'this
fascinating voyage would have been at the expense of the Chinese
government', which Chinese protocol allowed for tribute missions.
The plan collapsed when the English began to worry about the proto-
col of prostrating themselves on the ground before Qianlong, which
Qing custom required and English custom found abhorrent. Constant
blamed the scuttling of the expedition on the head of the English
factory, 'a man without curiosity, without spirit and filled with stupid-
ity, who under the pretext of the difficulties that arranging protocol
would pose, refused to send a delegation'. Unable to get around the
objections of the English, the officials who had proposed to present
the emperor with a delegation of exotic foreigners abandoned the
project entirely.

The problem of how to greet the emperor was in fact resolved the
year Constant sailed back to Europe, when the Anglo-Irish diplomat
George Macartney led the famous trade mission from George III to
Emperor Qianlong to seek a liberalisation of the trade regime at Can-
ton. The solution was for an image of George III to be set up in the
direction in which Macartney faced when he went down on one knee
to Qianlong, so that his prostration could be construed as a gesture
to his own monarch. Constant got word of the plan for this English
embassy to the emperor before he left Canton in January 1793, and
a month later while on the voyage home penned a perceptive essay,
'Some Ideas on the Embassy of Lord Macartney to China'. He pre-
dicted that the embassy would fail to achieve anything. Of course,

Qianlong's officials would expertly confound his every attempt to bring about change, but the real problem was that Macartney could not possibly know how to persuade Qianlong to change the status quo, which, from the emperor's point of view, was in China's favour.

> Experience has proven many times that appeals brought by Europeans who speak Chinese very well and are not afraid to explain their positions clearly have achieved nothing but make our sort appear even more deplorable. I cannot stop myself from adding that the impatience natural to Europeans, the confidence that gives them naturally their superiority over Asiatics, combined with the equanimity, haughtiness, and the sluggishness of Chinese, will not contribute to removing the obstacles of which I have noted only a very few.

In Constant's jaded opinion, Macartney was on a fool's errand.

Constant ends the essay with a list of what a commercial treaty between China and the European states should include. His simplest demand was for an end to all monopolies. But his most strongly felt proposal was the establishment of a judicial tribunal consisting of the heads of the European factories and an equal number of Qing officials. He wanted the tribunal to be guided by a new statute dealing with capital cases, while leaving the Qing the right to administer punishment. Rather than judicial extraterritoriality, which is what would come after the Opium Wars, he wanted a new set of joint agreements that would enable Chinese and Europeans to work together.

The requests that Macartney later presented to the viceroy in Canton in November 1793 raised most of the same issues that Constant did, and tended to propose much the same solutions. Where they differed was over the administration of justice. Rather than anything so radical as setting up a joint tribunal or writing laws, Macartney limited his request to asking for Qing officers not to be permitted to seize substitutes when an English suspect escaped. George Smith could easily have escaped with the connivance of the captain of the *Lady Hughes*, but that would have left the English in the position of having to turn someone else over. We might conclude that the conundrum of two different legal systems was beyond Macartney's solving. But Constant

took a tougher view – against the British, not the Chinese. 'George Smith', Constant reveals, 'was not British.' He was from India and had adopted an English name. If the Chinese were one guilty party in the *Lady Hughes* affair, the British were another. Constant charged them with 'being in the habit of regarding Indians as beings of another type that the noble European may sacrifice for silver'. The EIC eventually gave in to the Chinese demand to hand Smith over not just because financial interest trumped justice but also because their disrespect for other races made it easy to give in. Constant then went on to indict the entire European community on this point, not just the British. 'We were the cause and executioners of the death of an innocent man', he concluded.

Sailing from Canton

Charles de Constant was a keen observer of the Chinese scene in Canton, but he was not there for that purpose. He was there to facilitate French trade with China. All went well at first. He was able to sell the entire of cargo of the French company's ship on which he had sailed – a matter of particular pride, as agents were often unable to clear all the merchandise that was delivered to the factories in Canton. He was then able to fill the hold with Chinese merchandise and have it ready to sail by early December. By the end of the following year his listless and useless superior at the French factory stepped down, leaving Constant in charge. He immediately set about rebuilding the relationship with Pan Youdu, the Hong merchant with whom his predecessor had fallen out. He must have done so brilliantly, for when he proposed that a new factory be built for the French Company, the Imperial Company having taken over the old one, Pan agreed.

Constant had one employee, Jean-Baptiste Piron-Hayet, an apprentice who turned out to be completely unschooled in the business of commerce but whom Constant found to be 'of a character so gentle, cheerful, and easy-going' – curiously, these are exactly the qualities he said he admired in Lum – that he was 'untouched by worries, and philosophical by temperament'. The two young men were able to work together to re-establish the reputation and credit of the French Company in Canton. Once the company ship was off and there was little to do until the next season, Constant set about dealing on his

own account by borrowing money for various ventures. These went well enough for him to think that it might just be possible to make a modest fortune after all. And then the company for which he worked collapsed when, in April 1790, the Revolutionary leadership in France cancelled the company's trading privileges. Cut adrift, Constant saw in the arrival of the *Etrusco* two and a half years later an opportunity to put a deal together to rescue himself, and potentially to profit greatly. The French Revolution had driven the value of French currency down and commodity prices up. Now was the time to make a fortune.

In normal times, Constant would have filled the *Etrusco* with tea, the everyday beverage of most Europeans. Chinese tea exports had grown by 50 per cent between 1775 and 1793, and British consumption had increased fivefold over the same period. Constant did indeed include tea on the *Etrusco*, but not much. We know this from the property depositions that Constant and Balthazar Georgi, Popham's Istrian flag captain, drew up after the ship was seized at Ostend. Georgi chose tea as his main personal export, stowing almost 94,000 pounds aboard.

Instead, Constant had barely a third of Georgi's amount, just under 29,000 pounds. If tea was not the commodity on which Constant was gambling, neither was it silk, nor porcelain, nor any other manufacture. Constant put his money on sugar. Sugar was Europe's largest import in the eighteenth century. What Constant was banking on was the French Revolution, which had so disturbed the European economy that sugar was in short supply and high demand, commanding prices to match. He was confident of the price of sugar staying high, though whether this was an astute choice was never tested, since his sugar was confiscated and taken to London – which had no need of Chinese sugar. Trade would never make Constant's fortune.

Opium

In 1600 the English crown had chartered the EIC to concentrate mercantile resources for the huge expense of trading half-way around the world, and to protect those who pooled their resources from competitors outside the company. By 1795 the entire structure of global trade had changed, and many – not least, Home Popham – felt that the monopolistic protections that were needed two centuries earlier to concentrate capital and provide hope of return no longer did anything

but hamper the growth of Europe's trade with Asia. But Parliament, facing inflation and still in shock over the effects of the French Revolution, was in no mood to change the status quo. It voted to extend the company's monopoly for another twenty years. But recognition of the need for some opening of trade convinced Parliament to permit the EIC to issue licences to individuals to trade in commodities that the company was barred from handling.

This separate channel, which had already been operating for some time, was known as the 'country' trade, indicating trade between countries in Asia as distinct from trade between Asia and Britain, which remained the company's monopoly. The country trade was exactly the niche into which Popham inserted the *Etrusco*, at least until he decided to sail back to Europe with an Asian cargo that he hoped to get by the watchful eyes of the EIC and the British navy.

Much of the country trade trafficked in the regular commodities that flowed among Asian ports. One of these commodities was sugar, which was shipped to China from Taiwan and from South-East Asia. So there was nothing particularly noteworthy about the *Etrusco* taking on board a cargo of sugar. If the EIC did not usually handle sugar, it was because prices in Europe were generally not high enough to yield the profits that traffic in other Asian goods did. Britain had in any case developed more efficient sites of sugar production in its Caribbean colonies, with which the company had no need to compete. But there was one commodity that was beginning to circulate surreptitiously in the hands of country traders, a commodity the company did not ship, especially not to China, which had criminalised its possession and outlawed its trafficking as early as 1729. That was opium.

China was not a significant producer or consumer of opium until foreign imports started creating demand. The EIC initially banned its merchants from handling the drug, so as not to excite the protests of Qing officials and disturb the Canton trade, but trade in opium became quite lucrative and the pressure to take advantage of the new market grew. By 1773, the company enjoyed a monopoly over the purchase of opium in India, and by the end of the eighteenth century it had put in place an entire system of production and distribution that was hugely profitable. It was, however, banned from actually shipping the drug to China to sell. That was where the country traders filled an important

gap – and why the East India Company Act of 1795 was quite happy to augment the company's business by authorising the country trade.

Constant could not see what was coming – the rise of opium as the chief commodity sold to China in the nineteenth century to pay for tea – but he was aware of opium's commercial potential and its profitability, especially as it remained illegal. As he did with many topics on which he felt informed, he wrote an essay on the subject. His approach in the essay wavers between detached scientific interest and close commercial advice. The opening reveals succinctly this double interest: 'Opium should be freshly made, thick, of a blackish colour, not at all dry and not at all wet; it should be sticky. Too long on board a ship and it ferments, which alters it considerably and dries it out. When that happens, the loss is 30 to 35% of the value it would have had were it of top quality.' Constant then turns to his main topic, the market for opium in China. Despite the illegality of what he calls 'this pernicious merchandise', Chinese use had gradually moved from recreation to necessity, and so officials were willing to tolerate its import at a rate of 'four or five cargoes annually either at Macao or Canton'. Although import was a capital crime, 'one runs no risk of getting into trouble, as the mandarins close their eyes to the trade'. His main advice is not how to get around the officials but how to protect yourself from your buyer. 'Sell it on board ship, and always take ready cash. Never sell on credit even to people you know well, for the Chinese are not unaware that with this sort of contraband, the seller has no recourse to justice, nor the option to expose the cheater to public scorn. One should always be anxious that they not be tempted to abuse this advantage.'

As Portugal did not allow opium traders to deal at Macao, any inbound opium ship had to drop anchor in a harbour five miles along the coast and wait there for an official pilot to be dispatched from Canton to bring it up to Whampoa. 'Forty-eight hours usually suffices to clear the formalities', Constant notes, though this may not be time enough to sell the ship's load of opium, packed as it was in fairly cumbersome 200-pound chests.

Captains with opium cargoes can invariably come up with pretexts to extend their stay and trade their merchandise, either

with the Portuguese or with the captains of the Chinese junks stationed nearby to meet the ship's needs. The usual tricks are to claim distress because of the loss of a mast or some other mishap suffered during a long voyage, a situation demanding extraordinary assistance and consequently a lot of time, or to declare that one would happily set off except that the strength of the current or the lack of wind does not allow one to leave.

His two final warnings: 'Make sure your sales are always in cash', and don't let Portuguese get involved in the deal.

The problem with opium as a commercial commodity, Constant believed, was that it was not viable in the long term. As demand rose, so did supply, and then prices fell. Over his years in Canton, he had seen the price of opium diminish by half. 'This is a branch of trade that will always decline', he concluded. Constant was also alive to the negative effects of opium use. He concludes his essay with the observation that

the use of this drug is extremely pernicious. Those who use it at first do so for the agreeable sensations they feel, but one quickly acquires the taste, the taste becomes a habit, and the habit degenerates into an irresistible need that leads to premature death. One sees the sad victims of the opium passion who at thirty years of age carry all the marks of decrepitude and an air of stupefaction that is only too real, as their memory and their intellectual faculties are completely blunted.

Constant was not convinced that opium was the commodity of the future, though he had to admit 'that conditions may change in ways that we cannot foresee today'. Which is exactly what happened. Rather than allow the trade in opium to dwindle, the EIC decided to invest hugely in its production and distribution at about this time. When consumption exploded in the second quarter of the nineteenth century, the British were there to benefit.

In terms of short-term economic gain, at least for the hundreds of Britons importing the drug to China, the thousands of Indians producing it for the Chinese market and the tens of thousands of Chinese

distributing it to consumers, opium was a brilliant investment. But the biggest winner was the British Empire. Because Britain had been buying tea at an increasing rate through the eighteenth century, with the bill rising every year, and every year costing Britain more in silver than it could possibly earn back in sales to China, selling opium to Chinese offset the endless loss of buying tea from them. But using opium to balance payments on Sino–British trade wasn't the full story. There was another link in the chain, and that was American cotton.

Britain's Industrial Revolution was built on cotton textiles. To keep the mills of Manchester running, Britain needed a secure supply of raw cotton. India had proved not to be as reliable a supplier as the EIC had hoped. To fill the gap, Britain turned for its raw materials to cotton plantations in the United States. What opium provided was the liquidity for Britain to buy American cotton. To reduce the connections to their simplest: British plantations produced opium in India, the opium was shipped and sold in China, the silver that paid for this opium was shipped to the United States to buy raw cotton, which was shipped to England to manufacture cloth, which was shipped to India (where the company had been successful in suppressing the native cotton textile industry), the proceeds of which then bought more opium. Britain went to war twice in what are called the Opium Wars to expand the opium market in China, in 1839 and again 1856, each time to good effect, if 'good' means greater business profits. Not until the turn of the twentieth century, when Chinese were growing their own opium, was Britain persuaded to get out of the opium trade. In the long term, Constant was right: dealing in opium was 'a branch of trade that will always decline'. What he couldn't realise was for how long the Chinese market for opium would continue to grow. Not until the mid-twentieth century was the Chinese state able to eliminate opium consumption, though the global narco-economy of the twenty-first century is undermining that achievement all over again.

Prize and Restitution
During the autumn of Lum Akao's brief popularity in London, Popham and Constant made efforts to recover the *Etrusco* and its cargo, though Popham was soon back in service with the navy overseeing inland navigation to support the British army on the continent, and

out of Ostend, no less. Their agent in Ostend, Robert Charnock, filed the case on their behalf. The judgement that came down in November 1796 was entirely on the crown's side. The flag captain Balthazar Georgi and his servant were awarded £1,035 for their lost property, but otherwise the ship and everything in it were declared lawful prize under the laws of war. Constant and Popham appealed against this judgement to the Commission of Appeals in Prize Causes, and the case dragged on. The process took two years, during which time the ship and its cargo were sold at auction at knock-down prices.

The Lords Commissioners eventually decided that cargo belonging to Constant, as a Swiss national trading into a port under the jurisdiction of a British ally, was not legally forfeit to the British crown. On 26 November 1798 they declared that Constant was entitled to his property, assessed at one-third the value of the cargo. They also awarded a third as much again to a Canton merchant, Shi Zhonghe. This award is telling. It reveals that Europeans were not the only investors in this trade. Sadly for Shi, he had died in prison under torture a year and a half earlier, as interrogators tried to get him to reveal non-existent caches of hidden wealth to pay back his spectacular debts to the EIC and his tea suppliers, to say nothing of his arrears in import duties. Shi's collection of clocks and watches worth more than £60,000 hardly made a dent.

The question of whether the *Etrusco* had defied the EIC's monopoly by sailing to Asia in the first place the Lords Commissioners left for another day. That day finally arrived five years later, in August 1803. Their lordships decided that it had. Popham had no claim against any of the assets of the voyage. The ship and his share of the cargo belonged to the king. Popham had unlawfully enriched himself while his country was at war, and they dismissed the technicalities Popham put forward to claim his innocence. A further judgement two years later awarded Mark Robinson, the officer on the frigate who seized the *Etrusco*, £2,450 to cover the expenses involved in the seizure – though no portion of the cargo, as was usual with prizes of war.

Three years later, in March 1808, what remained of the case went before the House of Commons. On the issue of whether the commander and merchants of the *Etrusco* were guilty of smuggling cargo into France in defiance of the Anglo-Austrian alliance, Parliament

declined to make a finding. The House limited its work to the matter of deciding how to award the £39,000 left in the voyage's account. Constant was judged to have proved his claim that a third of the cargo belonged to him, and was awarded £12,000 – revealing that no payment had actually been made in the wake of the judgement of the Lords Commissioners in his favour a decade earlier. Only in 1808 was he able to recoup his losses, and then not at a level that would have matched his profits, had he been able to land his cargo of sugar and sell it fifteen years earlier. Georgi's award of £1,035 was also confirmed, indicating that he too had not yet been paid. The biggest surprise was for Popham. He was awarded £10,000, plus a further £15,000 in two payments over the next twelve months. The exoneration threw opposition members of the House into apoplexy, but the case was closed with a final cringe-worthy speech from the Advocate-General, who simply lied about the extent of the EIC monopoly and the ownership of the cargo and declared that there had been no smuggling at all. This outcome was certainly helped by the fact that in the election just prior to Parliament's judgement, Popham's party, the Tories, had returned to power.

It also helped that public opinion was on Popham's side. Since returning to England, he had distinguished himself as a commander in the British navy and all past and present sins were excused. Although officially censured for abandoning his maritime position in the South Atlantic without Admiralty approval during the war, he basked in the reputation of having made the right tactical move at the right time, making his insubordination justified. He was so much the war hero that a sentimental Tory like Jane Austen could compose this bit of doggerel in April 1807 for the amusement of her friends:

> Of a Ministry pitiful, angry, mean,
> A Gallant Commander the victim is seen;
> For Promptitude, Vigour, Success, does he stand
> Condemn'd to receive a severe reprimand!
> To his Foes I could wish a resemblance in fate;
> That they too may suffer themselves soon or late
> The Injustice they warrant – but vain is my Spite,
> *They* cannot so suffer, who never do right.

The Last Portrait

As a refugee from the French Revolution, Henri-Pierre Danloux knew that he lived at the end of an era. His portrait of Lum Akao, the last of the sympathetic portraits of Chinese that European artists painted over the course of the seventeenth and eighteenth centuries, put him at the end of another, an era in which it was possible to produce a thoughtful rendering of a Chinese person. It was the moment when Chinese were on the cusp of European re-evaluation. No longer would they benefit from the curiosity and even admiration of the Enlightenment. The feedback from Europeans who had gone to Canton to make money was persistently negative. The tales they brought back of corruption, of officials refusing to abide by agreements and of people whose habits they judged uncivilised opened a channel of condescension and contempt that became a flood in the wake of the Qing's defeats in the nineteenth century. There would be nothing to admire about China and no one to credit as an equal. Lum Akao was the last.

I like to think of Danloux's portrait of Lum Akao as an *hommage* to Lum's culture. The inclusion of Chinese calligraphy and the exclusion of background clutter suggest that Danloux had seen Chinese paintings and wanted to put Lum within a Chinese frame: not the facetious decoration that Europeans knew as Chinoserie, but Chinese art on its own terms. Constant had nothing to say on the subject of Chinese art, but there was art on the *Etrusco*. In the inventory of his confiscated goods, Georgi, Popham's Istrian mate, lists 'a large and very rare collection of Chinese paintings on paper, water colours, beautifully executed, consisting of animals, flowers, fruits, insects of China, and Chinese Emperors from the first origin, their gods and idols'. Georgi may have had a taste for Chinese art, though more likely he was banking on there being a market for such rarities in Europe, where the differences Chinese art presented still caught the fancy of buyers.

Once his portrait had been engraved and printed at the end of 1793, Lum Akao slips from view. By the time Constant went home to Lausanne in 1794, Lum was no longer with him. Presumably he returned to Macao, for what attraction could Europe have held for a Chinese man? But though Lum disappeared from Europe, his image lives on. Copies of Grozer's print are still in circulation. One comes up at auction

every year or two. A copy in good condition sold in 2014 for £850, far above its original value. At least one of Constant's ventures made a profit, though not one from which he could benefit.

The Photographer
and His Coolie

Johannesburg, 1905

On 3 November 1906, the Beijing police sent a message to the British vice-consul, C. Kirke, to say that the body of a murdered European had been found in a city street. There were no registration papers on the body, but several letters in his pocket identified the victim as Henry John Pless. The police presumed the man was British and asked the British Legation to take charge of the body and sort out the man's affairs.

(Pause here briefly. This message, regardless of its content, is all the evidence you need to realise that China's relationship with the world had changed hugely since Charles de Constant and Lum Akao sailed away at the end of the eighteenth century. Now there were Europeans roaming the streets of Beijing, foreign diplomats carrying out their tasks and a police department quite capable of contacting these diplomats directly without going through the emperor. The rules of the game had changed utterly.)

Kirke did not know anyone by the name of Pless. British subjects

living or sojourning in Beijing were expected to register with the Legation, but a quick look in the files did not reveal anyone currently registered by that name. He sent a telegram of inquiry to his nearest colleague, L. Hopkins, the British consul in Tianjin. Hopkins responded the next morning that no one named Pless had registered in Tianjin. But Hopkins did say that he already knew about the murder from a US citizen named Comstock, an agent for an American tinned goods company. Comstock had employed Pless as his sales agent in Beijing and was anxious lest a consignment of tinned goods Pless was storing for him in his house go missing. Comstock also informed Hopkins that the house in question belonged to Pless, which raised the problem of foreign ownership. Foreigners were not legally allowed to conduct business or own property in Beijing, so the deed for the property had been made out in the name of Pless's servant – 'in his Chinese boy's name', as Comstock's colonial turn of phrase had it. The property and whatever tinned goods were stored there might revert to the servant if someone in the diplomatic corps did not intervene. Comstock wanted to go up to Beijing immediately to recover his goods, and Hopkins sought out Kirke's direction. Kirke replied the same day, advising that Comstock should come immediately and remove whatever property he claimed as his own.

The British soon learned that letters written in Dutch had been found in Pless's pockets. So Pless may not have been British after all. Kirke sent a query to the Netherlands Legation, but the Dutch consul declared that his office had no record of the man, nor did he show any enthusiasm about taking over responsibility for sorting out the dead man's affairs. As far as the consul was concerned, since Pless had not registered as a Dutch citizen, he could remain in British hands. Kirke had no choice but to give the corpse the benefit of the doubt. He arranged for the man to be buried in the British cemetery in Beijing. For the moment, Pless would be deemed British.

A search of Pless's house divulged little as to his identity. His possessions were modest. Aside from simple household furnishings and a limited wardrobe, the search turned up a bundle of photographs, two photograph albums and other odds and ends. There was next to no cash, and no records of financial dealings. After the cost of the funeral was charged against assets, Pless's estate was worth $4.18.

The first breakthrough to discovering who Pless was came towards the end of December, when the Consulate-General in Shanghai wrote to Kirke, informing him that Pless had registered there as a British subject in 1897 and again in 1898. A further search through the files of the Beijing Legation revealed that Pless had indeed registered there as well, in 1903 and 1904, though not subsequently. As none of the registrations provided next of kin, Kirke decided that the Dutch connection was the one to follow, and wrote to the British consul in Amsterdam for help in tracing him. The consul wrote back in April 1907, confirming that Pless had been born in the Netherlands on 9 February 1875. He had moved to London in the 1890s looking for work, passing himself off as a British subject. With this successful imposture, Pless insinuated his way into the army of minor functionaries and commercial agents who staffed the British colonial network of agents and employees abroad. At that point he disappeared from Dutch records, only to re-emerge in British records in Shanghai in 1897 as a British subject.

For a Dutchman to work his way into the lower ranks of Britain's imperial project was not unusual. For him to be murdered in the streets of Beijing was. Judging from the papers of the Beijing Legation now preserved in the Foreign Office files at the British National Archives at Kew, this was the only murder Kirke had to deal with in 1905. Foreigners in the capital were better protected than they had been five years earlier, when militias enjoying the covert backing of the Qing court had launched an all-out attack on foreigners as well as on Chinese who collaborated with them, especially Chinese Christians. Dubbed the Boxers because of their training in traditional martial arts, these men had besieged the foreign embassies in the Legation quarter in Beijing through the summer of 1900. In response, eight nations landed a coalition force on the coast east of Beijing to secure their embassies and relieve the siege. Punishments were harsh, and the casualties on the Chinese side were high.

The Qing government fled west to escape the invading force. During the two years of this self-imposed internal exile, Beijing was under foreign military occupation. Even before the court returned in 1902, the Empress Dowager Cixi, the emperor's great-aunt and *de facto* ruler, permitted officials to begin a series of reforms to bring

Qing institutions more into line with international standards. These reforms, which came to be known as the New Policies, included, among other initiatives, ending the old civil service examinations, setting up military training academies and police schools, and creating a Ministry of Foreign Affairs.

With this return to a new normalcy, foreigners looking for business opportunities began arriving, despite the xenophobic riots just a few years earlier. Henry Pless turned out to be one of these men, though he trailed a far more complex past than Kirke at first realised.

Extraterritoriality

The presence in Beijing of foreign consuls and a salesman for an American tinned goods company would have been unthinkable ten years earlier, and unimaginable when Charles de Constant was in China. Permission to install a permanent legation had been one of Macartney's requests to Emperor Qianlong in 1793, and that had gone nowhere. That situation did not change until 1842, in the wake of the First Opium War, but then it changed hugely.

The Treaty of Nanking (Nanjing) signed that year is known for ending the Canton trade system and granting Great Britain perpetual possession of the island of Hong Kong. (In 1898, Britain negotiated a ninety-nine-year lease on a further portion of territory, which it duly surrendered, along with the island, back to China in 1997.) But historically the most important article of the treaty is the second, which opened Canton, Shanghai and three other ports to foreign trade. There, Emperor Daoguang agreed, 'British subjects, with their families and establishments, shall be allowed to reside, for the purpose of carrying on their mercantile pursuit, without molestation or restraint'. Queen Victoria agreed by the same article to 'appoint superintendents, or consular officers, to reside at each of the above-named cities or towns, to be the medium of communication between the Chinese authorities and the said merchants'. By these two conditions, the Qing brought itself more into conformity with what had become standard practices of trade and diplomacy in the nineteenth century. The emerging global order that these standards supported was based on the idea that people should be able to trade where and in what commodities they liked, and that states could not impose restrictions on that trade.

When Hugo Grotius published *Mare liberum* in 1609, he may not have coined the term 'free trade' – he actually spoke of 'free seas' – but he certainly understood the principle, and that principle had now come to dominate the international order.

Free trade is not as innocent as it sounds. In practice, the doctrine has only ever arisen when stronger states insist on access to the goods and markets of weaker states. It is certainly true that, as Chinese nationalists like to point out, the signing of treaties and the opening of treaty ports in China were achieved at gunpoint, the stronger forcing the weaker to submit. That acknowledged, open markets had become such a basic principle of international relations by the mid-nineteenth century that it could be said that Britain was simply demanding that the Qing meet international standards, and not attempting to encroach on Chinese sovereignty. Britain wanted to shore up conditions for the benefit of private British trade, not set up more colonies to manage. This change was not so much driven by politics; it was more that politics had become the servant of economics.

Even extraterritoriality – the right to be subject to the laws of one's home country, not of one's host country – was as much economic as it was political. The execution of the gunner on the *Lady Hughes* in 1785 still rankled as a matter of principle, but also as a discouragement to commerce, if such things could happen to foreigners who went to China to trade. The British side was accordingly concerned to insert terms into the treaty to prevent the repetition of such unfortunate outcomes. The principle is implicit in Article I, by which the two parties reciprocally granted the subjects of the other 'full security and protection of their persons and their property within the dominions of the other'. Here too, this provision did not infringe on Qing judicial authority so much as bring the Qing in line with European practice, which recognised diplomatic immunity. The article structured this concession as a reciprocal obligation, though frankly the notion that Britain was bound to protect Qing subjects in British territories just as the Qing was bound to protect British subjects in China was pure fiction. There were very few Qing subjects in the British Empire. But that too was about to change.

The Global Labour Market

The global economy in the eighteenth century had been based on buying commodities in one place and selling them in another, and taking advantage of the price differential between the two. This sort of trade continued in the nineteenth century, but the organisation of production changed. Rather than buy cash crops and industrial raw materials from producers, merchants took over production in order to control costs and increase supply. Agricultural commodities such as sugar cane, tobacco, cotton, opium and, later on, tea, coffee and rubber came increasingly to be produced on plantations. Similarly, the mining of industrial raw materials, especially precious metals and diamonds but also tin, was taken from the hands of small-scale producers and concentrated in large mining concerns. This transformation brought about a need for labour that led to the emergence of a global labour market under colonial conditions.

Chinese had been going abroad to earn cash wages in South-East Asia since at least the sixteenth century. By the seventeenth, they were leaving annually in the hundreds of thousands. Most laboured for Chinese entrepreneurs, to whom they were often bound by kinship or native place. In the 1840s, the flow began to increase, thanks to the opening of treaty ports. In the growing colonial economies of Britain, France and Spain, not just in Asia but also in the Caribbean and in South America, the demand for cheap labour was high. The push of poverty at home was ready to respond to the pull of the global economy. In Chinese they were called *kuli*. The terms means 'hard labourer', though in fact 'coolie' was coined from a Tamil word, *quli*, meaning 'payment'. A coolie was a labourer who worked for wages, usually low.

Labour trafficking, when it began early in the nineteenth century, was carried out beyond the scrutiny of the Qing state. Not until the Peking Convention of 1860, signed at the end of the Second Opium War, did the Qing permit Chinese to take employment abroad. Qing officials worked with British and French diplomats in 1866 to draw up an emigration convention allowing Chinese labourers to work abroad under contract, though only so long as that contract was not coerced. Though the agreement was never ratified, it came into use, so that for the first time in history Chinese had the legal right to leave the country to work abroad. What made the 1866 convention so different from

earlier ad hoc arrangements is that it obliged the Qing to recognise the right to return. That had always been the sticking point. It wasn't that hard to leave to China without authorisation, but if you returned, you faced capital punishment. Because labour abroad was criminalised at the moment of return, the only way to go home was to sneak back in. Many simply chose never to return to China.

Decriminalising emigration was the Qing's concession to the growth of the global market in labour. As this was the great era of industrialisation, it might seem counter-intuitive that the need for semi-skilled labour should rise as the global economy industrialised, but industry depended on raw materials that, in the nineteenth century, could be extracted or harvested only by hand: ore for the production of iron and precious metals, cotton for textiles, cane for sugar production, the building of track beds and the laying of tracks for railway transportation. In every industry, labouring by hand was the first stage of the process. And in every industry, costs were determined in large part by the cost of that labour: the cheaper, the better. Qing China, with its weak agricultural economy, its exploding population and the push factors of rebellion and natural disasters, became an obvious source for cheap labour.

Cheap labour, however, was vulnerable to abuse. Word soon got back to China of the harsh conditions under which the coolies who went overseas worked. The men who laboured abroad were not only poor but also lacked the legal or financial means to protect themselves against exploitation by their bosses or to defend themselves from the hostility of local people who regarded their arrival as evidence of a scheme to drive down their wages or deprive them of work (which it usually was). The Qing government was not indifferent to their plight. Hearing of the mistreatment of Chinese labour in Cuba, for instance, the Qing dispatched a commission of inquiry to Havana in 1874. The commission interrogated Chinese labourers working in the sugar industry. Four-fifths said they had been kidnapped or tricked into service. Upon arrival in Havana, they had simply been sold into slavery, with no possibility of ever terminating their labour contracts. The Qing had to intervene, and did so both abroad and at home. Abroad, Qing officials negotiated for better conditions for Chinese. Back home, they got involved in regulating the recruitment process.

Labour recruitment, as it turns out, was the world in which the murdered man, Henry Pless, was deeply involved. Pless was a labour contractor, and a notorious one, for Chinese coolies going to the mines in South Africa.

'The Price of Gold'

Eight months prior to the murder, another labour contractor who called himself Major A. A. S. Barnes had written a letter to the British vice-consul in Zhifu, a small treaty port on the Shandong coast, to complain about Pless. Major Barnes worked for the Transvaal government as its emigration agent in Zhifu. The Transvaal was a British colony that, five years later, joined the merger that formed the Union of South Africa. Barnes had been hired a year earlier in connection with a scheme to hire Chinese to deal with a labour shortage in the gold mines in South Africa. The flight of mine labour had been among the effects of the Boer War (1900–02), with neither white nor black miners willing to return even after the hostilities were over. In desperate need of labour, the mining companies along the Rand – as the Transvaal mining region of Witwatersrand was called for short – joined together in 1904 to bring Chinese labourers to South Africa. The scheme involved appointing emigration agents in several coastal Chinese cities. These agents were charged with hiring native recruiters to entice Chinese to volunteer for work abroad. The incentives were signing bonuses and promises of good conditions and high wages. Recruitment in south China did not go well, but recruitment in the north did. Between 1904 and 1906, Zhifu and Tianjin served as the two main points through which labourers going to the mines of South Africa passed. By September 1905, 44,565 Chinese were working on the Rand. The goldrush town of Johannesburg was its centre.

In his letter to the British vice-consul in Zhifu, Barnes complained that Pless was alleged to have committed an 'act of cruelty on one of the Mines in the Transvaal'. Barnes was writing 'in the hopes that it may be possible for something to be done to bring the matter home to the man Pless'. He was giving mine labour recruiters a bad name, and Barnes wanted the vice-consul to put Pless under a warning. To back up his charge, Barnes enclosed a typed copy of a highly partisan

newspaper article from the *Transvaal Leader* dated 20 January 1906 under the headline 'Nailed Down: The Latest "Chinese Lies"'.

The subject of the article was one of the biggest news stories in England in the autumn of 1905, though Kirke and the rest of the consular staff in China appear to have missed it: the use of flogging to punish Chinese miners in the Transvaal, particularly at a mine called the Nourse Deep. This use of torture – properly 'torment', since it was not used to extract information, only to enforce discipline – had first come to the attention of the House of Commons that summer. The journalist who broke the story was Frank Boland of the *Morning Leader*, one of the Liberal newspapers in London. 'The Price of Gold', published in the 6 September 1905 edition of the *Morning Leader*, was the first in a stream of articles, some by Boland and some by other journalists, exposing the issue and putting Pless front and centre.

Boland was reporting from Johannesburg, and 'The Price of Gold' was based on visits he had made to local mines. Nourse Deep was less than four miles from town. If you take the metrorail today from Johannesburg Park Station, it is located under the warehouse tract on your right between the George Goch and Denver stops. In this article, Boland described the forms of corporal punishment that were used to control the Chinese miners. Victims were flogged by being held flat on the ground by two or three policemen while being beaten on the buttocks by another policeman 'with a strop of thick leather on the end of a three-foot wooden handle'. Fifty-six men were punished in this way during the first quarter of 1905. At the Witwatersrand Deep, victims were made to kneel on the ground and were beaten on the shoulders with a bamboo stick. At the Nourse Deep, Chinese policemen beat the thighs and leg tendons of anyone who failed to drill thirty-six inches on his shift. Not everyone in the mining industry agreed with this method of raising production. At the Nourse Deep, the 'Chinese controller', the term for the white labour boss in charge of the Chinese miners, 'refused to thrash the coolies unless they had committed some crime' and eventually resigned in protest over this practice. Not until London ordered an end to the flogging did the practice cease.

Mistreatment, however, did not end. These beatings were replaced by other forms of torment, which Boland characterised as 'well known in the Far East'. One of these was

to strip erring coolies absolutely naked, and leave them tied by their pigtails to a stake in the compound for two or three hours. The other coolies would gather round and laugh and jeer at their countryman who stood shivering in the intense cold. A more 'refined' form of torture was to bind a coolie's left wrist with a piece of fine rope, which was then put through a ring in a beam about 9 ft. from the ground. This rope was then made taut so that the victim, his left arm pulled up perpendicularly, had to stand on tiptoes. In this position he was kept, as a rule, for two hours, during which time, if he tried to get down on his heels, he must dangle in the air hanging from the left wrist.

This image was so powerful that the Morning Leader had its cartoonist capture the scene for readers on 6 September 1905 (see Plate 15). The stark sketch is imaginary in every detail, including the clenched fist of defiance, but the threatening shadows in the background, almost African in shape, make it difficult to know how to respond: with sympathy for the victim's plight, or fear of what might he now do?

The torment of miners, particularly of the 'head boys', as they were called, drove some Chinese to desertion. Having nowhere to go, they lived by preying on local farmers. British mine owners and managers, Boland averred, should be ashamed of employing methods on Chinese that they would not dare use on white miners. At the same time, though, Boland was not above resorting to certain stereotypes about Chinese coming from a culture in which torture was the only reliable method of social control. This double sense is there in the cartoon. Although the article it accompanied condemned the use of such methods, the image prompted readers to recall that such bodily torment was 'well known in the Far East', as Boland put it, implicitly shifting the blame to the Chinese for working under such conditions. The caricature resonated with popular opinion. Opium addiction (ironically, a creation of British trade), the binding of women's feet, ignorance and hostility towards the outside world and a sadistic fondness for torture (or so it was supposed) made China a pariah and Chinese unworthy of civilised treatment. Liberal opinion was nonetheless appalled at the treatment Chinese miners were receiving and

demanded that the British government put an end to these practices in the colony.

The mining establishment in South Africa rejected Boland's portrait of conditions in their mines. They commissioned counter-articles in what Boland snidely called 'the capitalistic dailies' in South Africa to question his integrity and discredit his allegations 'by means of cheap sneers and fancy headlines'. Undaunted, Boland pressed on with new allegations. In an article written five days after his first, entitled 'More Horrors by Yellow Serfs', Boland reported that flogging was still common at some mines, despite the order to stop. He also introduced his readers to yet another 'Chinese method of torture', which policemen in the French mines were using to control their workers. This device was 'a kind of yoke about 2½ ft. square, made of 2 in. wood, which is fastened about the necks of the coolies'. The French took their model for this device from the Chinese cangue, a large wooden board fastened around the neck as a type of movable stocks for tormenting and publicly shaming Chinese offenders. The French were thus thought to be using a 'Chinese' practice on Chinese men, that being the only form of discipline they thought Chinese could understand. Transposing the cangue from its judicial context in the Qing to the zone of private enterprise, however, would have been regarded as an outrage in China. Boland concluded 'More Horrors by Yellow Serfs' by pointing out that, after six months in the mines, the Chinese were still being paid at the probationary rate of one shilling per day, not the minimum wage of two. Even though workers brought forward 'just representations' on this matter, these were summarily rejected. Part of the problem was that some Chinese controllers 'still do not know more than 20 words of Chinese'. Boland acknowledged that gambling and opium were driving some Chinese to financial ruin, but he maintained that the blame lay with the whites, not the Chinese.

Boland's articles ignited a journalistic storm. The *Indian Opinion*, a Johannesburg weekly published in both English and Hindi, ran articles on the controversy as it developed. On 9 September, a young Indian lawyer who had moved to South Africa in 1893 to practise law, and who had relocated ten years later to Johannesburg, took up the issue. Not yet known to the world as Mahatma, Great Soul, as he would be later when he campaigned to end British rule in India, Mohandas

Gandhi joined in the general condemnation of the miners' mistreatment. Gandhi did not get his facts about Chinese mine labour on the ground in Johannesburg, however, but took them from an article in the London *Daily Express* that recycled what Boland reported down to the last detail. In his article Gandhi named the perpetrator, sounding Pless out in Hindi as 'Place'.

> Mr. Place, who had experience of conditions in China, introduced a practice that is prevalent there. He had the offending Chinaman stripped, then had him tied with his pigtail to a flag-pole standing in the compound, and made him stand there for two to three hours, however biting the cold or scorching the sun. Then Mr. Place ordered other Chinamen to make faces at the offender. Another punishment was to tie a thin rope to the offender's left hand; the rope was then passed through a ring in such a way that the man was suspended with his toe just touching the ground and kept thus for two to three hours.

Gandhi's interest in the mistreatment of mine labour is not surprising. For years he had been fighting discrimination against Indians working in South Africa, demanding that they be treated as equals in the eyes of British law. He did not necessarily regard indentured Chinese miners as having the same legal entitlements as long-settled 'British Indians', as he called his confrères, but if Chinese had no protection under the law, Indians could find themselves in the same position. What Gandhi was confronting, as he well understood, was the fundamental contradiction of colonial regimes: the need for abundant cheap labour to process the raw materials that colonies delivered to the metropole, but an unwillingness to incorporate that labour into colonial society. As he pointed out in an editorial in the *Indian Opinion* a month earlier, Indian labourers in particular were a boon to the economy. 'The men who come out give great satisfaction, and the bread and butter of thousands of Colonists depends very largely upon a steady inflow of indentured labour from India.' The fact that they were 'indispensable to the welfare of the economy' meant that 'the noise that we find here about the Indian being an undesirable citizen

is largely hypocritical or selfish.' Gandhi does not make the point, but much the same could be said of the 'noise' about the increasing presence of Chinese labour. It was work that no one else was willing to do, but work that was essential to the prosperity of the mining economy that sustained South Africa.

'Slave-Driving on the Rand'

These front-page stories were a thorn in the side of the Tories. The government regarded the use of torture as 'abhorrent' but sidestepped any clear acknowledgment that it was being practised, asserting that 'no effort shall be spared to render even the suggestion of such a charge impossible'. Such carefully worded declarations failed to quell popular suspicion that the denials issued by the mining companies were fraudulent. Christian social activists fanned the controversy by linking the practices of British mining companies to the issue of slavery, and demanding, in the words of the president of the Baptist Union, that 'our country would soon remove into outer darkness the men who had disgraced the English name and English justice'.

Given the sensitivity of public opinion, especially among working people, to the issue of slavery, the activists could not have chosen better. The banning of slavery in Britain in 1833 had been a huge landmark for those committed to reforming the worst aspects of the capitalist system. Britain had been behind some countries in this, but ahead of others – including, famously, the United States. The reliance of the American cotton economy on slave labour made Americans in the south loath to give up this asset, leading to four years of civil war before Congress was able to abolish slavery in 1865. Other countries followed suit, some more slowly than others. The last were those most dependent on slave labour: Cuba in 1886 and Brazil in 1888.

What no one anticipated was the impact that the abolition of slavery would have on China. As country after country banned the practice, industries that had depended on slave labour, such as cotton and sugar, were desperate to find an affordable substitute. William Martin, an American missionary and translator working in China, deeply concerned what this meant for Chinese, wrote in his memoirs in the 1890s: 'The time had now come for yellow to take the place of black at the behest of anti-slavery sentiment.' To illustrate the problem, Martin

quoted a Chinese fable about a king who, pitying an ox about to be sacrificed, ordered a sheep to be sacrificed instead, which was merely trading one life for the other. With black slaves no longer acceptable, surrogates had to be recruited in other forms. China – impoverished, overpopulated and under-regulated – was poised to emerge as the new supplier of cheap labour to replace slaves.

Calling the Chinese slaves contained a barb, however, for in liberal opinion, those who chose to submit to slavery were objects of contempt. The views aired in the *Morning Leader* were thus at war with themselves, some articles making torture the problem, others criticising the policies that had allowed the Chinese to come to South Africa in the first place, and some implicitly blaming the Chinese. Although the thrust of popular agitation was against the practices of British mine owners, it was mixed with misgivings about the 'attendant dangers and evils' entailed in bringing Chinese labourers to South Africa, Chinese being 'such horrible, repulsive-looking creatures'.

In the face of this controversy, the Foreign Labour Department of the Transvaal felt that it had to stem the flow of negative publicity. Unable to deny that mistreatment had occurred, the department decided to single out a notorious incident in which Pless strung up a Chinese miner in his living room and insist was isolated and not part of regular discipline. To make its case, the department obtained an affidavit from Alexander McCarthy, a hospital attendant at the Chinese Hospital operated by the Nourse Deep, and distributed it to all the newspapers in Witwatersrand. It was the version that appeared in the *Transvaal Leader* in January 1906 that Barnes sent to the British vice-consul in Zhifu.

According to the affidavit given under oath before a justice of the peace on 15 November 1905, McCarthy explained that he was a boarder at Pless's house and had been present on 10 June 1905 when Pless tormented the coolie. McCarthy did not know what the Chinese man had done to deserve the punishment, but could report that Pless had told him, 'I will make an example of this fellow, and I will photograph him tied up, "for fun" or words to this effect.'

Pless first dunked the man in cold water, then put him in hot water. McCarthy objected to this treatment, concerned that it would induce pneumonia, but Pless did not desist.

He then tied the coolie, stripped naked, by his wrists to two large nails on the door in his dining room, tied his pigtail up to his hands, and then tied his feet. Whilst he was tied up, Pless brought food at meal hours and placed it on a chair in front of the coolie where it was impossible for him to get at it. Pless kept the coolie tied up from 7 o'clock at night until 11.15 a.m. the following morning, and then released him and allowed him to return into the compound.

The new element that McCarthy's affidavit introduces is that Pless did not just torment the miner, but took photographs of the man as he hung from his wrists. McCarthy testified that Pless sent the negatives to a shop in the town of Cleveland to be developed, though he wouldn't reveal the name of the shop when asked. McCarthy ended his testimony by noting that 'Pless remarked to me on one occasion, that the photographs he had taken would be useful to him on his return to China, and that he would make something out of them; further, that he intended writing a book – with the photographs for illustrations – on "Slave Driving on the Rand".'

The Foreign Labour Department of the Transvaal misjudged popular reaction to this affidavit. The department somehow thought that it would refute the 'Chinese lies' in circulation and show that Chinese torture was not systematically practised at the mines, and that Boland had inflated a minor incident in the home of one Chinese controller into a 'notorious case'. In fact, the article had exactly the opposite effect when it went out to newspapers beyond the Rand, eliciting further horror at what was going on there.

Politics in the Imperial Metropole

At some point between stringing up the Chinese coolie on 10 June 1905 and being found murdered in Beijing on 3 November 1906, Pless left South Africa and returned to China. Midway between those two dates, Major Barnes complained that Pless was giving labour recruiters a bad name. Other than that, Pless disappears from the story.

So who was Henry Pless? Vice-Consul Kirke had little to go on, but we have more, for Pless can be found in the records of the Chinese Maritime Customs Service, an agency of the Qing government

operated on its behalf by largely British civil servants. According to his Memorandum of Service, 'Harry' Pless was a British citizen born in London in 1875 – of which, as we know, only the date might be trustworthy. He had gone out to China as a ship's steward in 1897 and been taken on as 'outdoor' staff, the lowest category of employment for foreigners. Pless was hired first as a 'watcher' in Shanghai and then as a 'tidewaiter' in Tianjin to meet incoming ships and inspect cargo. He was sent back to Shanghai after the Boxer Rebellion and promoted to tidewaiter first class, but then left his job on 1 October 1903 and disappeared from all public records until the incident in the Transvaal.

It was the British election of 1906 that brought Pless to the world's attention. The Conservative Party had been in power since 1895 in a coalition government. The horrors of the Boer War five years later persuaded many Britons that the government had sacrificed British lives purely to protect British mining interests in South Africa. The main issue in the 1906 election, however, was protectionism versus free trade. The Tories wanted to impose tariffs to protect British industry. The Liberals took the opposite view, contending that this would only lead to other states erecting tariff barriers and closing markets for British products. They called instead for free trade to ensure that British goods would be able to enter all markets. This was a position that won strong support from the industrial working class. What energised that support, though, were the reports of the cruel treatment of Chinese miners – which is how Pless's name came up. As reports filtered back to Britain about the low wages and poor conditions under which Chinese labourers worked, public anger turned against the government that had sponsored this solution to the labour shortage in South African mines. The Liberal Party saw an opening and went on the attack. Frank Boland's reports from South Africa might have stirred only casual interest had it not been for the political context in which the story played back in Britain. In speeches in the lead-up to the election, four out of five Liberal candidates raised the issue of Chinese labour, whereas Conservative candidates did their best to evade the issue, referring to it only when the audience forced them to.

The torment of Chinese miners was a combustible political issue, however, for the emotions that Chinese labour incited did not always flow in favour of the Chinese but could spill in other directions. It

was understood that Chinese would work for lower wages than anyone else, and so the prosepect of Chinese labour taking white jobs in South Africa set off a certain racist anxiety among British working men. They worried that the same could happen to them, that big business might bring in Chinese coolies to overwhelm the domestic labour market and take away their jobs. A widely used political placard during the election showed a 'cosmopolitan financier' leading a line of Chinese coolies while John Bull dozed. A Liberal spokesman was shown crying from the wings: 'Was THIS what we fought for?' Lloyd George made the threat even more palpable by conjuring up the threat of Chinese replacing Welsh workers.

If the British working class was fairly united in viewing the manacling and flogging of Chinese in South Africa with repugnance, it was because it reminded them of slavery. The victory of the anti-slavery movement had been their great achievement, and they regarded the return of labour slavery on workers' rights as a threat to their union rights at home. A government that colluded in the policy of enslaving Chinese was a government that the working class could not trust. Although Conservatives charged the Liberals with being hypocrites, taking advantage of an arrangement that the British government had never actively supported, they were not able to defuse the issue. All you had to do was project a slide of a Chinese man at a political rally, one analyst observed, and you could arouse 'an instantaneous howl of indignation' against the Conservatives. By the end of December 1905, just a week into the election campaign, you could march in a political parade or show up at an election meeting dressed as a mock Chinese in pigtails and handcuffs, and everyone got the reference.

But the solidarity of British working men with Chinese miners in South Africa did not hold. By the end of the election campaign, the meaning of this Chinese dress-up pantomine had flipped. A Liberal election poster issued late in the campaign to swing undecided voters reprinted the line-of-Chinese cartoon with a more precise caption: 'South Africa for the Chinese'. Humanitarian outrage over the brutal treatment of the miners had transmogrified into fear that Chinese were being transported to South Africa to take over British jobs. The Tories could be blamed for trade protectionism, but that was a rather abstract notion for most voters; much better to blame them for

bringing in Chinese to rob British working men of their livelihoods. It was a remarkable about-face.

And it worked. The Conservative coalition lost to the Liberals under this pressure – a loss in which the report of Pless's photograph of the hanging man played no small part. The Conservatives thought this terribly unfair. Their government had wanted to eliminate indentured labour in South Africa but worried that this would precipitate the collapse of the mining industry. They felt that using the charge of 'Chinese slavery' had been a dirty tactic, even going so far as to reprint the cartoon in the *Morning Leader* as evidence of a rigged propaganda campaign. When Winston Churchill gained his first cabinet post as Under-Secretary for the Colonies in the new Liberal government, he found himself in the awkward position of having to manage the issue without crippling the mines in the Transvaal and also without letting popular indignation blow back on his government. He rose in the House of Commons on 22 February 1906 to declare that the conditions under which the Chinese worked, however deplorable, did not in fact amount to slavery in a legal sense, but that steps would be taken to bring the practice to an end. Galled by this declaration after months of catcalling about Chinese slavery, Joseph Chamberlain, the new leader of the Conservative opposition, accused Churchill of having won his seat by having 'a gang of men dressed as Chinamen accompanied by some agent got up as a slave-driver' parade 'in every street in his constituency'. This sort of political theatre had been used in other ridings, but Churchill was able to deny the charge on the spot. A party official in his riding wrote to him the following day confirming that no such tactic had been used in his constituency.

Was this slavery? At least one colonial official in Johannesburg regarded the charge as nothing but electoral politics. J. W. Jamieson had worked as a British consular official and commercial attaché in China for over fifteen years before being seconded to South Africa in 1905 to take over the Foreign Labour Department and try to get the situation in hand. It helped that Jamieson could speak and read Chinese, and that he brought two subordinates, Purdon and Mayers, who were fluent as well. As he writes in a long letter to two colleagues back in China on 11 June 1906, he arrived in Johannesburg 'at the psychological moment when everything was going to hell'. Facing a somewhat

unruly labour force of Chinese men who had chosen mine labour
over unemployment and rural poverty at home, he was personally in
favour of what he called 'Quarterdeck or Orderly room justice, to be
administered in the compounds by my Inspectors', but was blocked
from using military discipline by the Liberal victory. Instead, the new
government 'substituted the most elaborate forms of British judi-
cial procedure. All sentences are liable to revision by Judges of the
Supreme Court, who quash them freely.' He confessed that 'I myself
have been had up by a coolie for illegal detention and arrest, and sen-
tenced to a fine of £10, and the payment of costs between Attorney
and client. You can easily image the loss of face that ensued.' The
issue, as Jamieson saw it, was not his personal reputation. It was the
effect this judgement had on his shaky authority over the men. 'My
whole sway over this small Army of 50,000 is based on bluff, or call it
prestige, and any derogation thereof has the most disastrous results.'

Jamieson acknowledged that there had been abuses before he
arrived, but these had been curtailed. In his view, 'this experiment of
introducing Chinese into a Colony' – as he puts it, 'one of the very
greatest ever undertaken' – was a success and could have worked, had
the Liberal government not tied his hands. The heart of the problem
was not Chinese conduct, in his view, but the fact that the colony was
'saturated with the idea that the white man is the only human being
whom God intended to breathe the breath of life'. Jamieson was in no
position to alter white prejudice, but he was in a position to manage
the labourers in ways he thought fair and effective. 'There is very the
little the matter with the Chinese', he wrote to his friends. 'They have
proved themselves an undoubted economic success, they have noth-
ing to grumble about, and if only they would leave off gambling with,
and buggering, each other, they would be all right.' As for the 'so-
called outrages' that Chinese have committed, they 'are far fewer than
those committed by whites or blacks, of which, of course, the outside
world hears nothing'. His main complaint about his labourers was
that they squandered their pay on what he called 'idiotic purchases'.
'Only today I came across two, who had bought two air balloons and
had doubtless paid a shilling each for them – they ride in cabs to an
extent that would break me and generally toss their money about, in
the most openhanded way'. Whatever issues were in play, slavery was

not one of them. The Chinese in Johannesburg were 'far less slaves than the ordinary Tommie or bluejacket and are infinitely freer than the British merchant seaman', Jamieson assured his friends. 'In conclusion', he ends his letter, 'believe nothing you hear or still less what you read with regard to the South African slaves'.

What finally cancelled the experiment, as Jamieson feared it might, was the charge that the miners were having sex with each other. This was hardly surprising in a work force of 50,000 men and no women, but the practice was sufficiently offensive to Victorian morality to excite universal public condemnation. The radical wing of Churchill's own party took up this issue and used it to bring down the scheme. Forced to respond to the allegation that the Chinese in South Africa were becoming 'habituated to practices that have always been held in deepest detestation by our race', Churchill had to commission an inquiry into sodomy among the miners. He received the report in November, but judged its findings too sensational to publish. Still, the whole process served its purpose. It obliged the Liberal government to end the use of Chinese labour in South Africa the following year, when the newly elected government of Transvaal decided that black and white miners living there were sufficient to enable the mines to operate.

And so the scheme evaporated, and with it the fortunes of everyone involved, miners and recruiters alike. Of the losses the Chinese suffered no record survives, but there is a trace of the consequences for one of the Englishmen. It lies in a hastily scribbled note dated 29 May 1906 in the private papers of British consular official James Lockhart in the Scottish National Library. The note reveals that the Transvaal Emigration Agent who first brought the name of Henry Pless to the attention of British consular staff was ruined by the failure of the program. 'I hate to go', Major Barnes wrote, but I am 'mentally obviously so broken down that a change is necessary'. He thanked Lockhart for recommending him for the job – 'the only happiness I have ever known' – and told him that he had decided to cut his losses and book passage for somewhere else in the Empire in the hope of starting afresh. Vancouver, as it happens.

We today have little sympathy for men like Barnes and Pless who staffed the lowest ranks of imperial administration. They were agents

of British colonialism, to be sure, but they might also be thought of as victims of what the correspondent for *The Times* called 'the first attempt made since modern capitalism began to move labour from place to place'. Hiring Chinese was a scheme 'arranged by capital for the interests of capital alone'. The men at the bottom simply tried to make the best of it, and often failed.

Photographing a Chinese Body

None of this might have happened, had the story remained in the realm of words, but what caught the attention of the British public was the widely circulated image of Pless's victim in the *Morning Leader*. The cartoonist who created this image overlaid it with so much anti-Chinese visual rhetoric – the subject impoverished, degraded, pigtailed, disturbingly subhuman – that without the context in which it appeared, we would be hard-pressed to tell that the intention was to stir our sympathy, not to excite our scorn. European newspapers had been filled with derisive caricatures of Chinese in the summer of 1900, when foreign troops had landed on Chinese soil to drive back the Boxer Rebellion and protect the foreign legations in Beijing. Every newspaper reader had learned that this was what Chinese were supposed to look like. Perhaps the cartoonist had no other way to signal a 'Chinese'.

Something else is going on in this cartoon, though. It taps an underground spring that had been running beneath the European notion of China for over a century, in which two ideas were conjoined. One idea was that Chinese used forms of corporal punishment that Europeans no longer tolerated and regarded as deeply uncivilised. The other was that Chinese were incapable of understanding justice unless it was dispensed using these forms of physical degradation. The erasure of these penalties from European penal practices had occurred as recently as the mid-nineteenth century, yet the erasure had been so complete and declared so absolute that Europeans no longer thought of their civilised selves as capable of acting in these vicious ways. Qing law still tolerated the use of such practices, in part because it chose not to incarcerate criminals except on a temporary basis. If there were no prisons to punish the guilty, the only choices were beating or exile, and that is what the Qing Code prescribed. These practices were in

the process of changing at the time Pless took his photograph, but Europeans were unaware of the change. This trick of timing meant that Europeans could condescend to Chinese while praising themselves, and thus consign the entire odious history of physical degradation to the other side of the world.

British readers were already familiar with the Chinese use of torment. It comes up in the memoirs of members of the Macartney embassy of 1793. The official artist on that mission, William Alexander, was encouraged by a London publisher to produce a portfolio of drawings to show European audiences scenes of what China looked like. The book, *The Costume of China*, presents the reader with a curious land in which the strangest punishment was the cangue. It was followed by an even more popular book, *The Punishments of China*, by George Mason. Mason had worked in India but had once visited Canton, where he had acquired simple paintings of everyday scenes that Chinese artisans cranked out as souvenirs for visiting Europeans. Many scenes were anodyne, but they could include pictures of torment, torture and execution in order to satisfy prurient Western curiosity. The original Chinese paintings are highly artificial productions in which carefully delineated figures are arranged on blank backgrounds in a sort of sanitised ethnography (see Plate 16). By bringing them before a European audience, Mason transformed these stock images into scenes not only exotic but all too real. This, the pictures claimed, is what Chinese do.

The Punishments of China not only sold well but also created expectations of what exotic Chinese practices, including bodily torment, looked like. For their part, painters in Canton and Beijing kept up a steady production of such scenes to satisfy the demand of foreign visitors, which is why these paintings survive in great numbers in Western museums today. These visual expectations were so strongly established that when Europeans arrived in China armed with cameras, they already knew what they wanted to photograph. So Pless snapped the Chinese man he was tormenting in his house, he knew what sort of image he wanted to capture. The sight of a Chinese body in torment made sense to him before he took the picture.

Physical suffering is not easy to capture on film, and was even harder to capture when cameras first became available in the second half of

the nineteenth century and were costly machines that required con-
siderable technical training to operate. Taking pictures required bright
lighting, long exposures and, on the part of those whose pictures were
being taken, frozen poses. Casual shots of everyday life were beyond
its capacity. Cameras were the tools of professional photographers,
not recreational toys for amateurs. By the turn of the twentieth cen-
tury, however, the technology had been so improved and simplified
that cameras were becoming mass-produced commodities. Costs
went down, shutter speeds increased and portability went up, and
amateurs of all classes took up photography as a pastime. They filled
their frames at first with faces and landscapes, and then increasingly
with scenes in which not everything and everyone had to stand still.
They looked for events to photograph, and used photographs to place
themselves alongside those events, at least as spectators, and more and
more as actors. And what more spectacular event could the photogra-
pher be present at than a beating or, even better, an execution?

The suppression of the Boxer Rebellion in 1900 may have been the
first major international military event in which the effects of con-
quest were photographed. Army photographers worked alongside
military sketch artists to record defence posts overrun, landscapes
bombed and combatants slain. Once the conquest was complete,
they could then produce images of the processes of the justice that
Europeans demanded be done. From there, they went on to capture
scenes from the everyday business of Chinese penal justice, such as
the photograph included in this book of a young man under physi-
cal restraint in a magistrate's courtyard (see Plate 17). The posture is
different from the cartooned character in the *Morning Leader*, yet he
bears the same ragged signs of poverty, physical distress and humili-
ation. We need to be cautious about taking a photograph like this at
face value. Many such photographs were staged, probably for a fee,
so that foreign photographers could create images that corresponded
to their idea of 'China' and that they might then be able to sell to
publishers for book illustrations or postcards. The dejection of the
people in the background of this photograph, though, persuades me
that this young man has indeed been caught and strung to a crosssbar
to force a confession.

Far worse than this were the photographs that foreign soldiers

posted to the legations in Beijing took of the public executions at Caishikou (Vegetable Market), a dusty intersection outside the southwest gate of Beijing, not of Chinese rebels by foreign soldiers, but of Chinese criminals by Qing executioners. With the click of a shutter, foreigners could capture scenes of 'Oriental depravity' of which Thomas De Quincey in his day could only have dreamed, and reproduce them wherever a photography studio set up shop. Most shocking were the photographs that foreigners took of criminals undergoing the notorious process of 'death by a thousand cuts'. The condemned was taken to a public place and, under the supervision of judicial officials, stabbed and dismembered in a sequence of pre-established steps. The last man to be put to such an execution, a Mongol guard named Fuzhuli who killed his master, died at Caishikou on 9 April 1905. The photographs that a French soldier took of the event still exist in the form of gruesome postcards that could be sent home in the mail.

We don't have to know whether Pless ever attended a Qing interrogation or execution to know that he had seen Chinese paintings and European photographs in this register. He would not have staged his torment of the Chinese miner in the way he did, nor would he have imagined photographing the man, had he not seen them. What his purpose was, and who he planned to show them to, we can only guess. McCarthy said that Pless told him he intended to take them back to China and 'make something out of them', but what? Was it to show labour recruits what would happen to them if they did not do what he ordered them to do? To impress the labour recruiters who wanted some assurance that Pless was a man to get things done? Or something else altogether?

There is no evidence that Pless ever printed the picture that the cartoonist imagined. We know only that the British vice-consul's staff found bundles of photographs in Pless's house when they went to sort out his affairs after his murder. Surely if these photographs had included snapshots of a naked Chinese man being tormented, some comment would have been registered with the vice-consul. Or perhaps not. Perhaps no one cared enough about this abruptly ended life to look further. The intriguing question is whether Pless was murdered by someone who wanted to get even with him. But the murder was left unsolved. We will never know.

Why this incident matters to the history of China's engagement with the world is its unexpected reach. Pless was not interested in influencing the British election yet a garbled version of his story got to the floor of the House of Commons in February 1906. In a tirade against Churchill, Joseph Chamberlain rose to complain at length that the Liberal Party had exploited the revelations of torture to swing the election. To press home his point that the Liberals had tricked the British public into thinking Chinese mine labourers were virtual slaves, Chamberlain held up an anonymous book of which no copy seems to have survived. This book, which he declared was 'widely circulated during the election', argued that Chinese coolies were treated as slaves. Chamberlain speculated aloud that it could have been written by the *Morning Leader* reporter Frank Boland, or if it wasn't Boland, it could have been 'by a man whom I should unhesitatingly describe as a great scoundrel, that is Mr Pless, who confessedly hung up and tortured a Chinaman for a whole night that he might photograph him next morning for a book he was writing'. Here is an amazing twist to the story. Pless had indeed claimed that he was writing a book called 'Slave Driving on the Rand', but he hadn't actually written it, so far as we know. To Chamberlain, Pless was just another journalist who had staged the entire affair so as to cost the Conservatives the election. Chamberlain was so wide of the truth that, for the first time in this book, I am at a loss for words.

Anticipating that this issue would come up, Winston Churchill had already done due diligence by inquiring of the Transvaal government whether Pless should be extradited. He was thus able to inform Chamberlain that the Transvaal government had reported 'that there was no ground for the institution of proceedings on the evidence supplied, but it was thought desirable by the Secretary of State to institute legal proceedings in this case, if at all possible'. In the end, no legal proceeding was launched. In any case, Pless was already back in China, recruiting coolies or taking orders for tinned goods, unscathed by his notoriety in London.

The irony of the story from a Chinese perspective is that, just two months before Pless took photographs of a coolie in the Transvaal, Chinese jurists in Beijing succeeded in getting 'death by a thousand cuts' abolished. Shen Jiaben, the official in the Ministry of Justice who

led the effort to get rid of this extraordinary form of execution, voiced his opposition not by appealing to vague humanitarian principles. His objection was that the penalty did not actually appear in the Qing Code and, further, that no precedent for dismemberment existed anywhere in the classical tradition. 'Death by a thousand cuts' was not a Chinese penalty after all. 'How could something like this have been deliberately instituted?' he demanded to know. His answer was: the world outside China. Dismemberment was a barbarian practice that a nomadic people who had invaded China a millennium earlier had brought with them. This should have been a touchy argument for Shen to make, given that the Qing Great State was ruled by the Manchus, interlopers from beyond the Great Wall, but somehow that awkward link did not get in the way of his campaign to get rid of this punishment.

In the end the deciding factor was not whether 'death by a thousand cuts' could or could not be found in ancient Chinese traditions. That was just a useful narrative for making the case against it. The real impulse was the situation in which Chinese found themselves after the Boxer Rebellion. Foreigners were arriving in large numbers, they had the freedom of the streets and they brought their cameras with them. Had it not been for the Boxers, photographs of gruesome punishments would not have been circulating abroad, driving China even farther down the scale of global civilisations. Best to remove what Shen called 'irregular punishments' from public view by banishing them altogether. Even the Manchu court could see the sense in this reform. This is why Fuzhuli's execution on 9 April 1905 was the last dismemberment in Chinese history. Later that month, the penalty was abolished.

How uncanny that Pless should have staged his little scene of torment at home in Johannesburg just as the Qing was getting rid of corporal punishment in its bid to find acceptance among the civilised nations of the world. But men like Pless were not ready to let that heritage go. It gave them the edge they needed over the people they wanted to control. Nor were postcard publishers ready to give up their market in these sadistic sights. Postcards of Fuzhuli's death postmarked as late as July 1912 were still being mailed off to Europe after the Qing Great State had fallen and its legal regime dissolved. The era

of China as a land of physical torment had ended, yet the image of China as a realm eternally cruel, backward and without justice lived on in the Western imagination. Chinese were groping their way forward, but others were stuck in the past.

THE
REPUBLIC

13

The Collaborator
and His Lawyer

Shanghai, 1946

Turn to Plate 18. A newspaper photographer took this photograph on 21 June 1946 outside the Shanghai High Court. Turned away from us, dressed in a traditional scholar's gown, is Liang Hongzhi. He has just heard the judgement condemning him for treason. Two policemen lead him from the courtroom, while a third restrains Liang's young wife as she tries to approach her husband. In the background, bystanders from one of the most closely watched trials of 1946 look on. To most Chinese today, Liang Hongzhi is unknown. A minor politician during the Republican era (1912–49), he drifted on and off the public stage without ever gaining a starring role. More to the point, he has been banished from Chinese memory for having committed the worst sin of modern Chinese politics: collaborating with a foreign power. Such a person could only be forgottten.

The judgement delivered against Liang on 21 June was based on an indictment on eleven counts that made Liang personally responsible for the collaborationist regime he ran from 1938 to 1940, the first

'national' regime under Japan's sponsorship, and for his role in the subsequent regime that replaced his, in which he served at cabinet level from 1940 until the end of the war in 1945. The first three counts – creating an army to support Japanese security forces, operating rail lines to move men and *matériel* for the Japanese army and allowing Japan to monopolise the inland waterways – were charges of aiding and abetting the invader. The next five counts in the indictment had to do with directing the economy to Japan's benefit by imposing grain controls, setting up the China Renaissance bank to issue a national currency, diverting the revenues of the China Customs Service, taxing the people harshly and peddling opium (that hangover from the nineteenth century) to drain the people's wealth and weaken their resistance. The final three counts condemned him for participating in the creation of the Reorganised National Government (RNG) in Nanjing in 1940 under the leadership of Wang Jingwei to counter and compete with the National Government, under Chiang Kai-shek (Jiang Jieshi), holed up in Chongqing far up the Yangzi River during the war. Chiang, the dour Methodist generalissimo, and Wang, the handsome charismatic revolutionary, had been long-time competitors for the leadership of Sun Yat-sen's Nationalist Party. They split in 1938 over the question of whether it was better to wage a prolonged and devastating war of resistance against the Japanese or to negotiate a peace.

Now that the war was over, the party that survived claimed its victory. The war crimes tribunal, however necessary for re-establishing the principle of justice, became a theatre for acting out that claim. Compared with Wang Jingwei and Chiang Kai-shek, Liang Hongzhi was a bit player, a holdover from another era. If his story is worth telling, it is because he embodied the pressures and contradictions of the era almost perfectly. Nothing he did was conceivable without the world in which China found itself from the mid-1930s to the mid-1940s, caught in that horrendous global drama we call the Second World War. Given the untrammelled aggression to which states of that difficult era resorted, Liang was not the only leader, in China or elsewhere, who collaborated. He may have looked to Japan for the survival of his regime, but Chiang looked to the United States, and Mao Zedong, running a Communist insurgency in the north-west, looked to the Soviet Union. Collaboration was not ultimately the

issue; everyone collaborated with someone. The issue was the future: what did it look like, and who should dominate it?

The standard account of the war highlights countries fighting for their survival against foreign states, and many were indeed facing just such existential threats, but many struggles were also internal. Collaboration is the issue that best exposes these struggles. The reality behind Japan's invasion of China in 1937 was not China divided against Japan so much as China divided against itself.

From Great State to Republic

The foreign state best able to take advantage of China's internal divisions was Japan. By the twentieth century, Japan was China's most important neighbour (arguably it still is). In the nineteenth century, both Tokugawa Japan and Qing China had found themselves facing a radically changing world. The leaderships of the two states responded in different ways and so found themselves on paths that diverged profoundly. What the Qing Great State had regarded as nuisances seeping in from the world around it, Japan had seized as opportunities. An early revolution in Japan in 1868, dressed up as a restoration of the monarchy, opened the way for a massive project to study the European models of politics, economy and war that had overwhelmed the nineteenth-century world so that Japan would not be overwhelmed in turn. While China succumbed to threats and treaties, Japanese watched from a distance and resolved that that would not be their course. Being just that much further from Europe, Japan had the minor advantage of being able to remain isolated during the key decades in the second quarter of the nineteenth century when the Europeans and Americans were so intent on opening China, and thus in a position to anticipate changes that would have to come. Famously successful at adapting to the new technologies and institutions on which the Western world thrived, Japan raced forward to become the first industrialised nation in Asia. That industrialisation, which motored the rapid expansion of European military power, enabled Japan to build Asia's first modern army and navy, tools it would use first against China and then Russia.

Given the difficulties the Qing had had dealing with the shocks of the nineteenth century, politicians and theorists of the China that

emerged from the carapace of the Great State in 1912 knew it was necessary to adapt China to the new rules of the Western international order but lacked a common leadership to guide and unify this process. Some Manchus had thought it might be possible to create a version of constitutional monarchy to protect the continuation of the imperial family, but events quickly outran them, and in a moment of poorly managed crisis their Great State collapsed late in the autumn of 1911. A republic was declared to replace the old empire. That declaration did not produce the unity of purpose or direction that some of those who gathered in Nanjing for the founding of the Republic on New Year's Day 1912 might have hoped. The putative leader of the revolution, Sun Yat-sen, was in Denver when he heard the news of the brief uprising against the Qing and barely made it back to China to be present at the Republic's inauguration. He was soon pushed aside by the men who commanded the troops. The republican dream quickly dissolved into the reality of warlords and the political cliques that aligned with them. This was the context of Liang Hongzhi's entry into politics in the early 1920s. By 1927, however, Chiang Kai-shek had fought his way to supremacy in central China, and his Nationalist Party was able to assert a national presence that would dominate politics for the next decade, leaving no place for the old clique politicians such as Liang in the new dispensation.

From Encroachment to Occupation

While China stumbled through these decades of transition from Great State to Republic, Japan went through a series of coups that militarised the regime and, in the 1930s, delivered the government to the army. The two great obsessions of the Japanese army in that decade were to expand Japan's control of off-island resources and to prevent the expansion of Russia in its direction. The coordinated pursuit of these two objectives led Japan to intensify a series of encroachments on China that it had begun as early as 1895.

In that year, at the end of a short war with the Qing, Japan had caused China to surrender its colony on the island of Taiwan by treaty. The campaign of steady encroachment continued step by step as Japan seized more and more territory and influence from China: in Korea, in Shandong and finally in Manchuria in 1931. This campaign

was based on the logic of economic expansion that European imperial powers had exploited to great benefit. It was also impelled by the global depression of 1929, which hit Asian industries severely. The newspaper editor Takaishi Shingorō thought he was striking a note of reason in 1938 in his book *Japan Speaks Out* when he patiently explained to English-speaking readers that 'in order to live, Japan must be given ample opportunity for her legitimate national progress and expansion', the same rationale that European imperial powers had once cited for their expansionism. 'What Japan is seeking is only freedom and opportunity for peaceful economic expansion', Takaishi averred.

Japan's last major act of encroachment before the 1937 invasion was to set up in north-east China a state called Manchukuo under the nominal leadership of Puyi, the Manchu who had been the last child-emperor of the Qing. The League of Nations rapped Japan on the knuckles for perpetrating this fraud, declaring the new state to be nothing more than a puppet of Japan. But unlike the United Nations subsequently, it had no tools to impose any consequence for committing that fraud. The only thing the League of Nations' condemnation achieved was Japan's withdrawal from the League.

The invasion in 1937 was not launched with the intention to occupy China. Japan landed forces to pressure Chiang Kai-shek to surrender certain elements of the Republic's economic sovereignty so that Japan could enhance its strategic and economic position in China. The first assault was against Beijing in July, the second against Shanghai in August. By applying pressure at these points, Japanese leaders believed that Chiang would have to come to the bargaining table. They wanted Chiang to recognise the legitimacy of the new government in Manchukuo. They also wanted to be able to appoint economic advisers at all levels of the Chinese administration. As the Foreign Minister, Hirota Kōki, stated in September: 'The basic policy of the Japanese Government aims at the stabilisation of East Asia through conciliation and cooperation between Japan, Manchukuo, and China for their common prosperity and well-being.' He accused China of 'ignoring our true motive'. China having 'mobilised her vast armies against us, we can do no other than counter it by force of arms'. Hirota too acted as though he were being utterly reasonable. Under the circumstances, he said, Japan had no choice but to 'take a resolute attitude

and compel China to mend her ways. Japan has no other objective than to see a happy and tranquil China.' In his book, Takaishi went even further, describing Japan's intervention not just as countering China's 'vast armies' but as fighting 'purely for the sake of self-defence – in defence of vital interests which are inalienable parts of Japan's national life'. This was the official posture behind which Japan hid its aggressive self-interest. Certainly no Chinese saw matters that way.

The idea that military intervention would bring Chiang Kai-shek's government into line with Japan's national interests was the first of the many miscalculations that would draw Japan and China, and finally Japan and the world, into war. The defence of Beijing collapsed quickly, but the defence of Shanghai did not. Chiang's soldiers held out against the assault for over two months, but they could not hold out indefinitely against the military weight the Japanese army brought to bear. Still Chiang did not negotiate, nor did the National Government turn against him. A month later, the Japanese army seized the capital of Nanjing in a move intended to force the Chinese government to capitulate. It didn't. Instead, adamant in its refusal to give in to Japan, it moved west by stages up the Yangzi River (see Map 6). The capture of the capital, known in English as the Rape of Nanjing, became an immediate symbol of the atrocities Japan committed in this war. The accounts from this atrocity have never been settled, at least in the Chinese view, leaving a troubled legacy that still continues to haunt the China–Japan relationship.

Realising that the original plan to force Chiang or someone else to the bargaining table would not work, the Japanese cabinet gave its armies in China permission to set up local administrations to replace the Nationalist government in the areas they occupied. Once the Prime Minister, Prince Konoe, declared on 16 January 1938 that Japan would no longer consider working with Chiang Kai-shek and his people, the larger task emerged of creating provisional regional governments with a view to assembling a new national regime. The challenges to this project were formidable, and obvious. Atrocities had been widely committed against Chinese civilians, infrastructure had been badly damaged and the economy was in ruins. On what grounds and with what promises could Japan possibly imagine gaining the compliance either of the elite or of ordinary people? They

could not do so by installing Japanese administrators. If they were to have any legitimacy, at least in the eyes of world observers, though hopefully in the eyes of Chinese also, the occupation regime had to be led by Chinese. Japan did not want a repetition of the feeble hoax of Manchukuo. It wanted something that could pass as a legitimate sovereign government in order to parry international condemnation that it had occupied China. (Germany was less averse to seizing territory and incorporating it into the German state, yet it would later do the same across Europe, setting up compliant local administrations under the supervision of Nazi agents, sometimes directly, sometimes at arm's length.)

The Chinese government responded to Prince Konoe's declaration almost immediately by announcing that any organisation sponsored by Japan would be deemed illegitimate, its mere existence treated as an infringement on Chinese sovereignty. More than that, it published a list of people who, because they worked with the Japanese, were considered fair game for assassins. This was the moment at which Liang Hongzhi stepped into the story.

Creating the Reformed Government

To be fair to Liang, he did not make the approach. That came from the Special Service Department of the Central China Area Army, the Japanese force occupying the Yangzi Delta and its surrounding region. After a week of discussion, the Special Service drew up a plan for creating a 'national' regime in Nanjing. Colonel Usuda Kanzō was put in charge of approaching prominent political figures to see who might be willing to work with Japan.

Liang's name was not at the top of his list, and it took weeks of discussions with more attractive candidates before Usuda got to Liang. Before that happened, Liang had left for the neutrality of Hong Kong, though this may have been because one of the other men Usuda approached had been assassinated by Chinese agents. However, Liang was in touch with old associates who were in touch with the Special Service. By the second week of February 1938, he was back in Shanghai putting together a leadership team. At the end of that week he and two associates met the head of the Special Service, Harada Kumakichi, and pledged to float a regime on behalf of the Japanese army.

A secret Special Service document produced in mid-February admitted concern about 'what kind of people they will muster and what kind of organisation they will select for the regime' and stressed that, whoever was chosen, 'continuous direction and intense support from within will be needed to lend substance' to the new regime.

The group around Liang met on 19 February together with Special Service agents assigned to the group to hammer out a political programme and a founding manifesto. A Special Service progress report the following week stressed that Liang's Japanese advisers understood how important it was for his regime to appear legitimately Chinese and have credibility with the people it ruled. That Japan was so obviously the elephant in the room was never mentioned, and it was decided that it could not be named. The political programme committed the new government to achieving 'peace in East Asia', 'peace' being the Japanese code word for the colonial domination of other Asians. It vowed to pursue economic cooperation with 'a friendly country', a reference everyone understood. The manifesto looked back at what had happened in the previous half-year and charged the Nationalists with engaging in scorched earth tactics and with 'collaborating' with the Communists. 'Truly there has been no government as evil as this in the entire history of our China', it declares. For that reason, a group of colleagues 'motivated by righteous anger' have stepped forward 'to rescue the nation from calamity, to replace the old with the new and revive the fate of the nation'. The new regime's sole mandate was 'to restore territorial sovereignty to the prewar situation and return to cordial relations with our neighbour so that the people of our country can avoid the disaster of war'. The new government would nonetheless 'continue to preserve the friendships we already have with the European and American countries'. Fifty years earlier, no ruler in China would have bothered making such a claim; now it was *de rigueur*. The age of Great State elevation above other states was over.

That done, the Special Service sent a report to Tokyo two days later on the proposed new regime. Tokyo did not respond. The documents were re-sent the following day; still no answer. As the days went by, the silence from Tokyo became deafening. It was quickly becoming clear that the cabinet would not rubber-stamp the proposal. After a week of waiting, Colonel Usuda sent his chief assistant to find out

what was going on. Tokyo was taking a very different view, in part because of international pressure. The Foreign Minister, Hirota Kōki, had affirmed to the British ambassador in Tokyo in January that the Japanese Government 'had no desire to encourage the creation of a number of "autonomous" governments', and that the government's hope was that a single government would emerge to rule over a unified China. But that was not what happened.

Unfortunately for Liang and his backers, the Special Service Department in Beijing was busily setting up its own regime. Tokyo was not about to ratify both. The Special Service working with Liang declared that the new regime in Beijing was less than the 'Government of China', and that 'the Government of the Republic of China' – their bid – 'reserves the right to rule the Republic of China'. So a second discussion had to take place between the Beijing and Nanjing armies to deal with the turf war that had emerged. Some quick revisions were made, and on 10 March Tokyo gave Usuda its approval to go ahead with a Nanjing regime.

The following day, Tokyo sent naming instructions. The new regime could be called a Republic, but it couldn't be the Republic of China *tout court*. The name had to be qualified in some way so that it did not appear to be claiming to be the government of all China, which had not yet emerged. Three possibilities were floated: Government of the Republic of China in Nanjing, Provisional New Government of the Republic of China and Reformed Government of the Republic of China. Liang and his group did not want the first, as it made them sound like a regional government. They did not want the second, because provisionality built into its name its own self-destruction. That left the third. 'Reformed' was taken from an ode in the ancient *Book of Poetry* to describe the Zhou dynasty under the ideal rule of King Wen. The classical resonance was fine. The problem, from a Chinese perspective, was the modern resonance. The Japanese had already used the term in the wake of the coup of 1868 that had set Japan on its new course (usually translated into English not as the Meiji Reform but as the Meiji Restoration). But no other option was on the table, so Reformed Government it was.

The Reformed Government held its official inauguration on 28 March 1938, albeit without appointing a president. Liang wanted the

title but was not given it; nor was anyone else. Japan held the position in reserve in case some truly prominent person came along to fill the post. Liang was technically the head of the Executive Office, and that made him head of state, as close to a presidency as he could ever hope to achieve. A Nationalist agent working undercover in Shanghai at the time expressed popular opinion when he reported of the new leadership that, 'in terms of the credit they have within society, all are bankrupt'. But Charlie Riggs, an American employee of the University of Nanjing who had lived through the Japanese assault on that city in December 1937, took a broader view. Although some working for the regime were 'mediocre crooks who are willing to make what they can out of any situation', he did allow that some of the top echelon were 'men of ability', and that there were a few honest men 'who feel that they can do good for China by keeping the control of the Reformed Government out of the hands of the crooks, and who secretly hope for an opportunity to return it sometime to National control'.

In the end there was little to gain from collaborating. Whatever Liang gained would diminish very quickly. From the start it was apparent that the Reformed Government was a temporary solution while Japan waited for something better to emerge. That Japan was serious about recruiting a top Nationalist leader became clear in October, when Prince Konoe reversed his earlier declaration about not negotiating with the Nationalists, and proposed instead that Japan and China should form an equal partnership to build what he called a New Order in East Asia. The only thing that stood in the way of creating this New Order was Chiang Kai-shek. Jettison him and Konoe would be happy to work with the Nationalists to create a solution – the term 'New China' was put about – that could satisfy both parties. The Special Service began to prepare the ground for working with the Nationalists. Japan would even consider reviving Sun Yat-sen's 'Three Principles of the People', his reworking of Abraham Lincoln's 'of the people, by the people, for the people' for a Chinese audience. Liang would have regarded as repugnant this return to the superficial claptrap of modernity that he thought his regime had dismissed, but the power to decide these matters was not in his hands.

It may have been the ever-rising costs of the occupation, economic as well as military, that had persuaded Konoe to revise his strategy in

China. But it also mattered that he was listening to his chief adviser on China matters, a journalist named Ozaki Hostumi. Ozaki was telling him that Japan's chief obstacle in China was nationalism. 'He can find it in the Nationalist-Communist collaboration', Ozaki pointed out. Not just there, but 'he can find it in the leaders of the puppet regimes'. In his estimation, 'nationalism is what has enabled China to keep fighting with all her weakness. It is to be found not just at the state level but also at the individual level.' The earlier Japanese contempt for Chinese nationalism had gone, at least in the more liberal quarter of the Japanese political establishment. It turned out that Ozaki was an ardent Communist who had worked with the German journalist Richard Sorge, an underground agent for the Soviet Union, during the early years of the war. Sorge had set up a spy ring in Japan, and Ozaki was his main asset. (Ozaki's most significant intelligence, that Japan had no intention of invading Siberia, influenced Stalin to move Soviet forces out of the east for the Battle of Moscow in the winter of 1941. By stymying Hitler's eastern campaign, Ozaki arguably changed the course of the Second World War in Europe.) Ozaki was finally exposed in 1941 and executed in 1944 in the only civilian treason case that Japan prosecuted during the war.

But Ozaki had been right to give Prince Konoe the advice he did about China. The Chinese were not going to submit to Japan unless the Japanese army beat them into it. In that struggle, the Japanese were not outgunned but they were outnumbered. Occupation was an endless and ultimately futile strategy, though it would take until 1945 for the nightmare (for both sides) to end.

The big break for Japan came when Wang Jingwei slipped out of China at the end of December 1939 and declared that the war should end. At last, someone with presidential stature had come onto the scene. Liang's Japanese handlers all turned to Wang as the solution to their problems. From that point until Wang inaugurated the Reorganised National Government in March 1940, Liang became simply a placeholder. To save face, Wang gave him the post of Minister of Control. In other circumstances, this was a position to put fear into colleagues, since the Control agency ran surveillance on the regime's personnel. But the power of the Control Office depended on the political standing of its minister, and Liang had next to none.

The Arrest

By the summer of 1942, as word filtered into the occupied zone about the first American victories in the Pacific war, it became clear to most in Nanjing that Japan would be defeated, and that Chiang Kai-shek would return. Those who could make contacts with Chiang's regime did so, knowing that this might help them once the occupation had failed. After Wang Jingwei died during surgery in 1944, the arrival of the end felt like only a matter of time. Even so, Liang accepted a promotion to serve as the head of the legislative arm of the government. But then the last hope that the regime might be able to survive died with the surrender of Germany on 7 May 1945. Japan was alone and doomed.

On 16 August, the day after Japan announced its surrender to the United States, Liang was called to a meeting of the top regime figures in Nanjing to declare formally the dissolution of the Reorganised National Government. When he entered the hall, an old friend, Chen Qun, was sitting in a chair on the far side of the room. Liang greeted Chen by name, but Chen only stared vacantly, as though he had no idea who was speaking to him. Worried that his friend had suffered a stroke, Liang went over and spoke softly to him using his childhood name. Only then did he realise that the man was weeping silently. Liang recalled that Chen had once vowed to him that 'in life we will work together, in defeat we will die together'. That moment of defeat had come. The most anyone in the collaborationist regime could hope for was that the returning government would just leave them alone, but surely this group understood that this was too much to expect. That evening Chen wrote several farewell notes. One was to Chiang Kai-shek, explaining that he had collaborated to prevent China from falling to Communism. One was to Liang, urging him to commit suicide. He himself waited until morning. The pistol he intended to use was taken from him, but he had kept a poison pill a Special Service officer had given him at his request should the time ever come when he would need it. The time had come. He knew what would happen to them all, and could not endure the humiliation of a public trial or execution.

In spite of the vow to live and die together, Liang chose to take his chances. He fled to Shanghai and started nosing about for contacts

with Chiang. His best line of connection was through Ren Yuandao, a close colleague in Suzhou who had served as Pacification Minister in the Reformed Government. Liang took his young wife with him to Suzhou to make the necessary overtures, with the intention of returning home to Shanghai once an understanding had been reached. But that would prove difficult. Chiang felt personally offended by anyone who had taken service under the Japanese. In Liang's case, this was compounded by the fact that they had been on opposite sides of so many issues since the 1920s. Chiang might aid a friend, or someone he might think was useful to him, but Liang was neither.

Also not in his favour were the four sets of regulations promulgated through the autumn of 1945 to guide the judicial handling of collaboration cases. The first set, issued in September, identified six categories of people in leadership positions who could be prosecuted by virtue of their posts. The fifth category, political leaders in puppet governments, clearly included someone like Liang, so he was marked from the beginning. The general principle determining culpability was 'communicating with the enemy for the purpose of opposing China'. Communicating with Japanese in and of itself was not a crime, but it was when that communication served Japan's advantage, and therefore the disadvantage of China. Punishments could be lightened if evidence was brought forward that the accused had acted in ways that helped the resistance or protected individuals who would otherwise have been harmed by the Japanese, but that evidence had to be presented. Simply claiming that this is what one had done during the war was not good enough.

Liang was arrested in due course and put in a military detention centre in the Shanghai suburb of Nantao with some five hundred other suspects to await the political and judicial decisions that had to be made before the trials could start. Finally, on 1 April 1946, the order came down from the Military Statistics Bureau that the trials should begin. The Provincial High Court in Suzhou was first off the mark. Within the first few weeks, it tried and convicted three of the top figures in the Wang Jingwei regime, including Wang's widow. These prosecutions fuelled a strong public appetite for the overdue settling of scores. The Shanghai High Court was a little slower to begin hearing collaboration cases, in part because seventy-one prisoners in Nantao,

including Liang, were transferred to Ward Road Gaol and added to its already large docket. Two weeks passed before the first trial opened.

Seven weeks after that, it was Liang's turn for judgement. He was by far the most prominent collaborator yet to appear in a Shanghai court, and so his case attracted huge public interest. It was still early enough in the treason trials for doubts not to have set in about the process and pace at which the trials proceeded. And no one expected Liang to be found innocent. The only question was how seriously his political roles during the occupation would be judged, and how heavy a sentence the court would impose. The case attracted much attention, especially as the newspapers published a transcript of each day's proceedings. People wanted to know what Liang would say, and how the court would respond to his claims.

The Trial

The trial opened on 5 June. The procurator took Liang through a straightforward series of questions concerning his background, including his non-involvement in Chiang Kai-shek's government, then turned to the regime he headed for two years in the late 1930s.

'How long did it take you to discuss setting up the Reformed Government?'

'It was very short. The Reformed Government was founded on 28 March 1938'.

'Did the Japanese side at this time invite you to organise it?'

'No. The Japanese knew of our intention to organise a government and came calling'.

The denial was plausible, though Liang was well aware that the Japanese were recruiting and had played to that opportunity. In fact, he then admitted that his group had made the first contact, through the offices of 'someone who was fluent in Japanese'.

The procurator asked him briefly about the internal structure of the new regime to demonstrate to the court that this was indeed a fully fledged regime, then turned to the question of decision-making. Liang admitted that he chaired the Policy Deliberation Council, where the key decisions were made, but insisted that 'the Council was an executive body, not a political body'. His intended message was that he was merely an administrator and had not acted with any political intentions.

The procurator then turned to several elements of the Reformed Government that pointed to an adversarial relationship with the Nationalists. One was the revival of the old five-barred flag, which the Nationalists had superseded. Liang explained that this was so that citizens flying the Chinese flag wouldn't get into trouble with Japanese soldiers. He was also able to point out that his regime's flag had been designed by none other than Sun Yat-sen. Another issue the procurator raised was that the Reformed Government established the Pacification Army in 1939, putting the one regime in armed opposition to the other. Liang downplayed the significance of having a sizeable army by saying that a great majority of soldiers had simply surrendered to his side. It wasn't that war had been waged.

The procurator shifted to financial affairs, then to Liang's role in founding and administering the RNG, and finally to his collusion with Wang Jingwei. With this line of questioning, Liang could move to safer ground by insisting, quite truthfully, that he had had no real part in Wang's regime.

'How many times did you meet with Wang Jingwei when he came to Shanghai?'

'He came to see me once, I returned the visit once, so altogether we met in Shanghai twice.'

'Did you hold a meeting in March 1940 in Nanjing with Wang Jingwei and Wang Kemin?'

'Yes.'

'Did you discuss the bogus National Government's general outline and the organisational regulations for the bogus Central Political Commission and the bogus North China Political Council?'

'Yes, but in reality it was only to hear Wang Jingwei's report. We certainly did not decide on anything.'

The procurator then wanted to know the extent of Liang's role in this government.

'Did you serve in the Wang government as president of the Office of Control?'

'Yes.'

'How many officials did the Office of Control have?'

'The officials numbered over thirty.'

'What impeachment cases did you prosecute?'

'The biggest impeachment case was against officials who embezzled grain. Wang Jingwei later fired several officials in the Legislative Office and the Control Ministry, but we did not participate in their deliberations.'

'Were you appointed president of the bogus Legislative Office on 20 November 1944?'

'Yes.'

'What laws did you establish during your tenure as president of the bogus Legislative Office?'

'I did not establish any laws at the time. All I did was to look over one or two sets of administrative regulations.'

The procurator then shifted his line of questioning to the circumstances surrounding Liang's surrender to the Nationalist Government, which he called not his surrender but his 'confession'. Liang stated that he sent it on 15 July 1945 via a friend to Dai Li, the infamous head of what was called the Bureau of Statistics. The Bureau was the military intelligence arm of the Nationalist Government, and Dai Li arguably the most powerful man in the regime after Chiang himself. His unexplained death in the crash of a US plane in March 1946, just weeks before the trials began, deprived many a collaborator of a witness to verify a claim to have gathered covert intelligence during the occupation. When asked at the close of the session whether he had anything else to say on his own behalf, Liang stated that he had started working underground for Dai Li as soon as he came to power and had continuously fed reports on the situation of the Japanese back to Chongqing throughout the war.

The trial resumed at 3:00 p.m. on 14 June. The courtroom was packed. Judge Liu invited the prosecution to open with a statement. Gesturing to a thick stack of files he had on the table in front of him, the lead prosecutor declared that the court had ample evidence of Liang's role as an official in the service of illegitimate organisations, starting with the Reformed Government and continuing with the RNG, and that these roles constituted criminal activity. He then entered into evidence a stack of documents that he argued supported the prosecution's allegation that the purpose of Liang's regime was to oppose the government of Chiang Kai-shek. Judge Liu glanced over these documents and then passed them to Liang to verify. Liang

went through them one by one. Aside from a few demurrals on minor points, he accepted them as faithful evidence of what he had done during those eight years. But he regarded none of this material as threatening his defence, because he had a different story to tell.

Now it was his turn.

In Defence of Collaboration

Liang opened his statement defending what he had done during the Japanese occupation by declaring that his original motive for organising the Reformed Government had to been to 'preserve the fundamental essence of the country'. China could be occupied and torn apart, but it would never disappear so long as someone continued to nurture this essence. That is the role he took on at the critical moment in the winter of 1938 when China was on the verge of extinction by a foreign power. The China that Liang wanted to protect was not just any China, however. It was the China he believed the Nationalist Party had compromised with its confused modernism and irresponsible autocracy. Liang noted a second motive for coming forward to form a regime, and that was to relieve the suffering of the people.

Liang next stressed that he had been unhappy about having to 'obey the enemy', but circumstances simply made any other course impossible. He could have avoided this humiliating compromise by abandoning the people to their suffering and the country to its virtual destruction. If he did not, it was because avoiding those outcomes was more important than the temporary accommodations he had to make to Japanese power. Then came the core of his interpretation of what he had done. Forming an administration in the occupied zone did not constitute opposition to the Nationalist Government. It was a means to the ends to which he devoted himself: to preserving China and alleviating the people's suffering. He admitted to having made a state visit to Japan, but that gesture should be construed in the same fashion, as a formality that had to be gone through in order to continue in his role as a protector of China. He added in this regard that he did not negotiate any international agreements on that trip. It was all surface and no substance.

In the final section of his opening statement, Liang offered an interpretation of his role in Wang Jingwei's regime that was different from

the prosecution's. The prosecutor had laid more stress on Liang's relationship with Wang than on his own regime, so that what he had done during the Reformed Government was not the main charge. Liang decided this could work to his advantage if he could show, first of all, that he had been powerless under Wang Jingwei, and second, that he had assumed that whatever Wang had done, he had done it as an agent of the National Government. He believed that Wang had been sent to open a second front against Japan, not that he had gone over to the Japanese side. It was a disingenuous interpretation. He could surely have seen quickly enough that this was not the case, but it served him as a way to suggest that his point of reference was always the Chiang regime; that by working with Wang he was working for Chiang. Conspiracy theorists like to think that Wang Jingwei had a secret agreement with Chiang, and that his regime in Nanjing was in fact a covert operation to weaken Japan's position in China, but no evidence that this was the case has ever come forward. And Wang was conveniently dead by the time the trials were conducted and could not be called to the stand.

After Liang finished his statement, the court recessed. The trial resumed nine days later. At this point, Liang turned over his defence to the best-known trial lawyer in Shanghai, Zhang Shizhao. Zhang was famous for arguing controversial cases, and notorious for winning them. Although lawyering was not regarded as a respectable occupation, Zhang's reputation was such that it wove him into the highest echelons of the political elite, Nationalist as well as Communist. (His daughter would later marry Chairman Mao's first foreign minister.) Liang could not have chosen better.

To make sure that his argument was properly phrased and correctly understood, Zhang submitted a written defence. It is an eloquently written document, a masterpiece of legal and cultural reasoning. Zhang presented two arguments as to why the court should not pursue Liang to the full extent of the law. One was rooted in the law the court was called on to interpret. The other was based outside the law.

To make his first argument, Zhang opened by setting the context. Consider, he proposed, the options available to an educated gentleman who was not a member of the Nationalist Party when Japan occupied China. There were three. The first choice was to join the non-aligned

resistance and move west with the Nationalist Party's government. The second was to withdraw from all public activity, 'to close the gate and sweep the walk', to invoke the classical trope. The third was to realise that one could not simply stand aside and do nothing in circumstances this terrible, that one had to act on the promptings of one's moral conscience, regardless of the self-sacrifice that such action might entail. These choices were not a matter of indifference, Zhang insisted. Those who fled west liked to declare that they would never have done what those who remained behind did. But this could be a very self-serving attitude. Many who stayed behind did so because they could not bear to see the Chinese people left without a government, and had the wisdom and capacity to act in their protection.

Now that Japan had been defeated, Zhang understood that people had a natural desire to put the whole experience behind them, particularly the hardships that those under occupation had suffered. This attitude had unfortunately crept into the way in which the regulations governing the war crimes trials were being interpreted. He pointed in particular to the third article, where concessions are permitted for those whose actions 'were of benefit to the people'. The only 'people' that a collaborator could possibly have benefited were the specific people under occupation, not some general national body. If the regulations instructed the court to examine the benefits that a collaborator conferred on the people, the court could not choose to set aside what the collaborator had done to improve the lives of those under his jurisdiction.

Zhang argued that there was no basis for alleging that collaborators who contributed to social stability in the occupied areas were undermining the policy of resistance. The stability they provided benefited the people. The National Government may not have benefited from a collaborator's work, but the government was not the people. He asked the court to recognise benefit where benefit had been provided, without regard to political questions. When killing and deprivation made the lives of the occupied intolerable, anything that eased their suffering was a benefit, and therefore worthy of notice and mitigation of sentence.

At that point, Zhang Shizhao shifted to the more general problem that has haunted all post-conflict war crimes trials: can justice be

achieved in a climate of revenge? Zhang accepted that laws against treason must be strictly enforced when a country is under siege, as a warning to potential traitors that they can expect to be punished for their conduct. Now that the conflict was over, there were strong reasons, both moral and practical, to favour leniency over strict adherence to the letter of the law. He started by offering a legal precedent from the Han dynasty, but then turned to jurisprudence arising from the trial of collaborators in Vichy France, naming two who worked in Marshal Pétain's government against whom charges had been dropped in order to show magnanimity and heal the wounds of the war. Offering amnesty was far better than continuing to rehearse the terrible memories of what had happened. The foreign occupier had gone. Reconciliation should be the order of the day.

Having set out his general arguments, Zhang Shizhao turned to the man he was tasked to defend. Liang was from an old official family whose political fortunes had ebbed with the passing of the dynasty it had served. He was someone whose reputation was less for politics than for poetry. He had gone into politics somewhat late in his career and had distinguished himself as a man of talent. The biggest mark against him was that he had followed a political course that was not the course taken by the Nationalist Party. Zhang worked this in Liang's favour in two ways. Not being a party member meant that someone of his talents was excluded from the National Government. It also meant, however, that Liang was at no point under the discipline of the party. He was free to make the choices he made and could not be charged with having gone against party discipline or party policy. Party members who were in court on the charge of having served Wang Jingwei's government rather than Chiang Kai-shek's were indeed in a vulnerable position, but Liang was not. Zhang insisted that at no point did Liang declare himself openly to be the enemy of either the party or its government. His collaboration had been benevolent, guided solely by good intentions and not for his own gain. Never did he use his power to the detriment of the people. This brought the defence back full circle to the criterion that Zhang had raised at the beginning of his defence, that Liang had used his position to bring benefits to the people who fell under his jurisdiction, and his conduct had never contradicted this motive.

Within the limited jurisprudence that existed in Chinese law at the time, Zhang Shizhao's defence was masterly. What was difficult for him to establish was the idea that it could be legitimate to serve a regime that coexisted with, and therefore by implication competed with, another national authority. Division was a weak claim against unity.

When the Shanghai High Court handed down its sentence on 21 June, its judgement followed the prosecution's story in every detail. The court accepted nothing in Liang's or Zhang's defence to mitigate the charges. It stressed Liang's involvement with Japanese agents when he and associates, including his old friend Chen Qun, put together the Reformed Government. It regarded his return to the political stage in early 1938 as simply a power grab, with no mitigating circumstances. The court made the point that he could not be treated as some local merchant who came forward to organise a self-government committee in order to re-establish a semblance of order in the midst of local chaos. He was there purely to satisfy his own desire for power. The court confirmed all the original charges about assuming state sovereignty, organising a military, taking over customs and signing agreements with the Japanese that gave away the control of the railways, communications, the salt monopoly and banking. It found his conduct treasonable when he helped pave the way for Wang Jingwei's government. He had continued to hold office even under Wang when he could have done otherwise, and accepted promotion to the presidency of the legislature after Wang was dead. There could be no doubt that he had served the interests of the enemy. Liang stood condemned.

The next move in his defence was to appeal to the Supreme Court. The basic charge – that he had spent the eight years of the war working in the interests of the conquering power – was not one he could turn aside. The public record was clear. Accordingly, he did not try to challenge the facts of his collaboration in his appeal to the Supreme Court. Instead, his strategy was to draw out certain details in the story to alter their meaning, to accept the charge of collaboration but to show that, even so, he had acted honourably. Yes, he had served in the collaborationist regimes, but he had done so to rescue the people and protect the country. Yes, he had signed agreements with the Japanese,

but he had done so to recover rights that would otherwise have been lost. Yes, the Japanese had commandeered grain and carried off cultural treasures, but he had resisted these moves and had been able to recover some of what was lost. Yes, he had sat on Wang Jingwei's Political Council, but he either did not attend, or, when he did, said nothing. Finally, even though, yes, he did stay on past 1940, he acted in ways that favoured the National Government in Chongqing. He must have known that the Supreme Court would not overthrow the verdict of the High Court, but he could hope that it would take account of his motives when passing sentence.

His strongest argument was this: if the Reformed Government had not taken on the burden of administering the occupied zone, that part of the country would have ended up under the direct rule of Japan. He and his government had placed themselves between the Japanese and the people so that China would not be absorbed into Japan's control. Having created that barrier, he simply did what he could to provide the services and benefits that a government provides its people. Political competition with the National Government did not enter into it. If he printed bank notes, it was not to drive out the notes of the National Government but simply to provide people with legal tender, and then only to the sum of 3 million *yuan*, which was not enough to count as 'flooding the currency market', as the prosecution had put it. If he had changed the flag, it was merely to prevent confusion when Japanese had to distinguish their allies from their opponents.

Liang may have been trying to claim too much innocence for everything he had done, especially before a sceptical court. In 1645, the collaborators prevailed. In 1946, they could not.

Postwar

The Supreme Court handed down its judgement on Liang's appeal on 18 October 1946. It was worse than he could have imagined, and harsher than the Shanghai High Court's judgement had been. The court opened its statement with a roll of righteous thunder:

> Clearly the Center had set out a policy of resistance, and yet the
> accused went ahead and organised a bogus regime to implement
> the policy directives of the enemy army; clearly our country had

a sovereign leadership, and yet he went ahead and ingratiated himself with the enemy leaders in order to gain personal benefits; clearly the national flag was the white sun on the blue sky, and yet he went ahead and hoisted the five-barred flag to signal his opposition; clearly the people were ardently moved to resist, and yet he went ahead and tried to turn them into a populace obedient to the enemy and their puppets.

No ambiguity there, no hesitation about whether a second centre of political authority might have been possible under conditions of military occupation. Liang's regime, by collecting taxes for the cause of the Japanese occupiers and by publishing statements that challenged and denied the authority of the National Government, had acted against the only sovereign authority in the country. The Reformed Government had not just failed to assist the resistance; it had actively blocked it. The court quoted the passage in the regime's manifesto about scorched earth tactics, not to review Liang's motivations but to show that his policies had hampered the ability of the National Government to lead the resistance against Japan. As for Liang's argument that his regime prevented the railways, communications channels, banking and salt administration from falling into Japanese hands, the Supreme Court dismissed this as entirely beside the point. The only point against which anything could be measured was the fact that Japan's policy of invasion had been designed and pursued to incorporate the Chinese economy into its own by converting it entirely to Japan's needs. Liang had done nothing to divert Japan from that purpose.

The Supreme Court was not persuaded by the claim that Liang had thought Wang Jingwei was working in collusion with Chiang Kai-shek's regime. A sign of the court's exasperation was that it lapsed at that point into a rhetorical question to express its amazement. 'How could the accused possibly offer that misunderstanding as a defence for cooperating with Wang from beginning to end, for becoming president of the Legislative Office after his death, and for continuing in office right up to the moment that the Japanese surrendered?' The only way Liang might have been allowed to escape some of the charges was if he had resigned after his regime was folded into Wang's. And that he did not do.

Throughout not just the appeal but the entire process, the court did not hear the arguments for the defence. At one obvious level, the court was judicially deaf because it was not insulated from political influence. It was an agency of the regime that created it. The Nationalist government appointed its justices, funded its operations and projected the constitutional legitimacy from which it produced the post-war legal subject. For that reason, like every other post-war tribunal, the court could only deliver what the Indian justice at the Tokyo trials, Radhabinod Pal, disparaged as 'uneven justice', protecting the victors and punishing the defeated. No one accused of collaborating with the enemy could appear before this court and receive an impartial hearing of the sacrifices he believed he had made or the wrongs he felt he had suffered. That ideal eluded the Shanghai bench, as it eluded every other post-war tribunal.

It would have been surprising if it had been otherwise. The losses, sufferings and injustices of the war had been extreme. From that perspective, the trial of Liang Hongzhi was no worse than any of the other trials held at the end of the war. In some procedural respects, it was better. Laws and regulations were consulted, rules of procedure and evidence followed, arguments framed using judicial logic, and appeals accommodated as part of normal process. Even if Liang entered the courtroom with no hope of vindication, he and his lawyer were at least allowed the opportunity to state a case in his defence. The court of public opinion was as stacked against him as the bench before which he stood, and it would have been factitious to complain about unfairness on that account. The lead Japanese lawyer for the defence at the Tokyo trial had made just this bid in the opening session a few months earlier, requesting that the tribunal disband itself. That move was immediately thrown out. Justice of some sort, however flawed, had to be done.

Shanghai was not alone in holding post-war trials. They were held everywhere, and it is worth asking why. What was gained? They were less about re-establishing the rule of law than about creating what Tony Judt has tagged as 'the postwar'. The Second World War ended in 1945, but the postwar went on. This was an era in which the victors who had prevailed, sanctified by the sacrifice of those who had worked and fought for that victory, could not be questioned. This

condition lasted for decades, perpetuated through curricula and public entertainment in an almost endless loop of self-congratulation that brooked no alternative. The Gaullists in France, the Communists in China, the Nationalists in Taiwan, and the list could go on: the war gave them the right to impose their terms on the people they ruled.

On 6 November 1946, Liang made his last court appearance. The court affirmed his guilt and handed down a death sentence. The sentence was carried out by firing squad immediately after the court adjourned. It wasn't enough to secure the newly restored regime. Three years after Liang's execution, the Nationalist Government fled to Taiwan and the Chinese Communist Party claimed its inheritance as China's postwar successor regime. The postwar era lasted longer in some places than in others. In China, arguably, it hasn't ended.

Epilogue

One Hundred and Ninety-
Three Countries

New York, 1971/Quito, 2010

Three millennia ago, the people of the North China Plain gazed out
on a world of ten thousand countries. Through the course of the first
millennium BCE, that number gradually dwindled to several dozen,
then to ten-odd, then to one. When Matteo Ricci entered the Ming
realm and showed Chinese his map of the world, he revived the old
memory of ten thousand countries. That world, he said, did not lie
in the distant past but was here and now. The phrase stuck. Right to
the end of the nineteenth century, 'ten thousand countries' was the
term Chinese and Japanese used to name the wider world. It was a
reality both recognised and resisted, as the nineteenth-century draw-
ing of the eastern hemisphere in Plate 20 suggests. The world was
indeed divided into many countries, named and bounded, yet the larg-
est, undisturbed by internal division, was the vast realm covering the
eastern third of Eurasia, highlighted in a pale wash of imperial yellow.
This was the Qing Great State at its most expansive, claiming an All
under Heaven that extended outwards to absorb adjoining countries
such as Korea as though the principle of ten thousand countries did

not quite apply to this part of the globe. The map is merely decorative, and we shouldn't try to read it too closely. The Netherlands is the size of Germany, France has incorporated Italy, Africa is utterly incoherent and Taiwan is coloured as though it were not part of the Qing Great State. The map's main impression is that a unified Qing occupies the largest share of a fractured world.

The countries of the nineteenth century did not begin to number ten thousand, a theoretical maximum the world has never reached. Today we count them according to the United Nations tally. At its inception in October 1945, the UN had fifty-one founding members. By the time I first went to China in October 1974, that number had climbed to 138. As I write this epilogue in 2019, forty-five years later, the UN has 193 member-states. There is a good chance that more will follow as protectorates, former colonies and artificially amalgamated states left over from earlier political arrangements gain national status.

China was there at the founding, not just as one of the original member-states but as the holder of one of the five permanent seats on the Security Council. These five seats were reserved for the chief victors of the Second World War. The new institution was to be their attempt to restructure the world to prevent anything like that war from happening again. China's inclusion recognised the extraordinary sacrifices Chinese made in the common cause of the Allies against Germany and Japan. Until 1971, that seat was occupied by the Republic of China (ROC), the regime of the Nationalists under Chiang Kai-shek that retreated to the island of Taiwan when the Communists swept the country in 1949. Chiang lost China but not the seat on the Security Council. The Republic continued to be 'China' in the eyes of the United Nations until 25 October 1971, when the UN General Assembly passed a motion introduced by Albania to transfer the seat to the People's Republic of China. The motion passed and the PRC took its place three weeks later. Twenty-two years of isolation, in part self-imposed by Mao Zedong after seizing state power in 1949, in part imposed by the US when the two countries went into a proxy war in Korea in 1950, had ended.

One of China's first gestures to reconnect with the international community after 1971 was to set up student exchange programmes. This was how I got to China three years later, a tiny pawn in the game

that started the current chapter in China's relationships with the world.

Two Chinas

The one thing on which both the ROC and the PRC agreed in 1971 was the so-called one-China policy. There could not be two Chinas. This was not a UN rule, but a rule on which both Chinas insisted. Two years later, both East and West Germany were admitted to the UN on the same day as separate member-states (they became a single member in 1990). The same protocol was used in 1991 to admit both North and South Korea, though these two continue to hold separate seats in the General Assembly. In both cases, the decision as to whether the parties continued as two or became one was left up to them. This is not a discussion that the one-China policy could tolerate.

Much has changed since 1971, especially in Taiwan, where most people now regard themselves as Taiwanese, not Chinese, and view the one-China policy as exactly what it is: a remnant of an earlier colonial era. Politics has followed public sentiment, and in 2002, the government of the Democratic Progressive Party (DPP) officially abandoned the one-China policy for a one-China, one-Taiwan policy, or 'one country on each side', as it was phrased in Chinese. The policy was suspended in 2008, when the Nationalist Party returned to power, but with President Tsai Ing-wen's victory for the DPP in the 2016 election, the government went back to regarding Taiwan as an independent and sovereign country. Tsai's government has not yet abandoned the name of China, adopting the official name of the 'Republic of China (Taiwan)'. At least in a linguistic sense there are still two Chinas in the world. This is not purely a language game, though. For President Tsai to take the full step of renaming the country 'Taiwan' *tout court* could trigger a military invasion, something the PRC has threatened to do should her government make any move, in the language of PRC leader Xi Jinping, that would 'thwart' Chinese sovereignty on the island. Since Tsai's victory, Xi has gone on the diplomatic offensive to undercut her government, pressuring Panama in 2017, and the Dominican Republic in 2018, to switch their recognition of 'China' from Taiwan to the PRC.

The use of military force to resolve the issue would put the PRC

in contempt of the principle affirmed in the preamble to the Charter of the United Nations 'that armed force shall not be used, save in the common interest'. It would also be in defiance of Article 1 of the Charter, which calls on member-states 'to bring about by peaceful means, and in conformity with the principles of justice and international law, adjustment or settlement of international disputes or situations which might lead to a breach of the peace'. These are UN rules, not China rules, yet the China rules have been surprisingly effective at overriding the UN rules, such that the UN itself deems Taiwan to lie within the jurisdiction of the People's Republic, when clearly it doesn't, and not to recognise it as a functioning state, which clearly it is. Taiwan's goal at the UN now is not to retake the China seat but to be given one of its own. Taiwan solicits members of the General Assembly for support for its application, while the PRC lobbies other members to deny the application.

The proliferation in recent decades of tiny post-colonial nations as new members has created a hunting ground for patrons in search of votes, with both Chinas continuing actively to dig further and further down that list for clients. Consider the two smallest UN members. In 1999, the Polynesian island-state of Nauru, then with a population of 10,000 (now just over 11,300) on eight square miles of land, became the 187th – and territorially smallest – member-state of the UN. The following year, the neighbouring island-state of Tuvalu became the 189th member. Larger than Nauru by 2 square miles, Tuvalu holds the distinction of being the member-state with the smallest population, with some 200 fewer residents than Nauru. Both were under British colonial domination in the nineteenth century, and then were swept into the Second World War in 1942, when Japan built a runway on Nauru and the US did the same on Tuvalu. Subsequently placed under UN trusteeship, through the UN Special Committee on Decolonization, both gained independence: Nauru in 1968 and Tuvalu in 1978.

In the late 1970s, the ROC established diplomatic ties with both new states. In 2002, however, Nauru switched recognition to the PRC in exchange for $130 million. Three years later, Nauru went back to recognising the ROC after receiving a better offer from Taiwan. According to US diplomatic cables exposed by WikiLeaks in 2011, this arrangement included off-book funding of Nauruan government

officials and payments to voters. The competition between the two Chinas continued, becoming so intense that in 2007, according to an article in the *New Statesman*, Nauruan President Ludwig Scotty was 'allegedly accosted by a horde of screaming Chinese officials who tried to drag him on to a plane to Beijing just as he was boarding one bound for Taipei'. As the journalist who reported this story summed up the situation, 'no nation is too tiny for China and Taiwan to squabble over'. But size doesn't matter. Every member-state, no matter how small, has a vote in the General Assembly, and should the motion ever get to the floor of the General Assembly, Taiwan can count on both Nauru and Tuvalu to vote in support of its membership in the UN, at least for the moment.

These diplomatic games are embarrassing minor footnotes in the history of China in the world. What gives them expressive power is the utterly disproportionate relationship between two tiny atolls with a combined population of just over 20,000 and a mega-state of 3.7 million square miles and a population in excess of 1.4 billion. But that is the world we have constructed.

Great Powers

The one-China, two-China problem exists thanks to the enduring fixation on unification as a Chinese ideal. It is an ideal that every regime since the Yuan Great State has had to declare as its guiding light. As we learned in the Introduction to this book, maps in this era were drawn to stand as 'evidence that, not in a thousand years – nay, not in ten thousand generations – have the Nine Provinces been unified on so grand a scale'. This was patently not true for the Ming Great State, and Ji Mingtai, or whoever was pretending to be Ji Mingtai, knew it. Not to make the claim, though, was to doubt the very legitimacy of the Ming ruling family. No Great State could be anything but the greatest state in history. By the same token, no Great State could decline to claim supremacy in a world of ten thousand countries. There was no room for two Great States, just as there is no room for two Chinas.

Although I prefer to highlight sameness, in this matter Europe's history has been so different. Powerful monarchs seeking to dominate the continent have risen over time, but they have also fallen. The principle of the equality of states implied by the Peace of Westphalia

was observed as often in the breach as in the maintenance, but at least since the seventeenth century, that has been the ethical foundation on which Europeans have understood their political order to rest. This changed in the nineteenth century as the rising imperial regimes asserted themselves as Great Powers. The term emerged in that century to tag states that had strengthened themselves economically and militarily to the point that they could pursue policy goals without having to compromise with the demands of other states. The self-determination of Great States was based not on legal principle, as it is in the UN system, but on material capacity. This was the context in which Great Britain campaigned to press the Qing to accept its free-trade regime, not by diplomatic means but through the series of armed incursions we call the Opium Wars. Britain was a Great Power, and the Qing was not, and Qing defeat was taken as confirming that claim. The same logic came to drive Meiji Japan, which increasingly referred to itself as the Japan Great State, to pressure first the Qing and then the Republic to submit to its demands. At the turn of the twentieth century – with Taiwan in the hands of Japan as a result of Japan's short war with the Qing in 1895, and Beijing for two years in the hands of a coalition army of eight foreign states, including Japan, following the suppression of the Boxer Rebellion in 1900 – the Qing was on no one's list of Great Powers.

The regime of the Great Powers was altered by the two Great-Power struggles we know as the First and Second World War. Whatever those wars did to alter the balance of power among the pre-eminent states, they had the more lasting effect of bringing formal colonialism to an end. The end of the Second World War became the tipping point for decolonisation. In 1945, three-quarters of a billion people found themselves in non-self-governing territories. Some of the Great Powers, notably Britain and France, were unprepared for being stripped of their colonial possessions, but the tide of public opinion was against them. The UN Security Council had been structured in such a way as to protect the interests of the largest states, but even that body could not interfere with the dismantling of colonial empires. Although the process was slow, the UN Special Committee on Decolonization oversaw the transition one by one of former colonies to national status, and in some cases to membership of the UN.

In the early 1960s, the UN was still sufficiently unified in its purpose to allow the principle of self-determination in Article 1 of the Charter to prevail over the interests of the former Great Powers. The stream of newly decolonised states has rather dwindled in the past two decades. Decolonisation is now more the exception than the norm, and requires extreme circumstances to go ahead. The most recent new member of the UN, South Sudan, became the 193rd member in 2011 by separating from Sudan. Sudan was a classic colonial creation, first under British suzerainty, then under joint British–Egyptian supervision. Independence in 1956 did not succeed in creating a viable state but propped up the sub-colonisation of the Dinka and Nuer peoples of South Sudan under an Arab majority in the north. Sudan descended into a brutal civil war that was resolved only when the UN became involved and brokered a deal to separate South Sudan from the north. Unintentionally, the lesson for other sub-colonised peoples, of whom there are still many, was that only violence could secure a path to independence.

Today, no civilian toll is large enough to guarantee the outcome of decolonisation. The permanent members of the Security Council, China included, have learned how to wring their hands in public over human suffering, but to look firmly away when the spectre of decolonisation threatens their national interests. In our own time, the spectacular failure of the Security Council to do anything effective since 2011 to de-escalate the brutal civil war in Syria or to protect civilians caught in that conflict stands as the most egregious recent evidence that no one escapes unless the Great Powers agree to allow that to happen. Without their colonial possessions, France and Britain have dwindled to the status of small powers and no longer matter much in the politics of the Security Council. Those politics are now dominated by the world's three most powerful states: the New Great Powers, if you will. Russia has its set of clients, the United States has a different set of clients and each vetoes the other's motions, China is assembling its own band of supporters. Cleaving religiously to a policy of non-encroachment on state sovereignty – in this case, the sovereignty of the Bashar al-Assad regime – China has voted consistently to do nothing for Syria.

The three New Great Powers, all super-states, have one thing in

common: they are products of colonial expansion. Russia grew to over 6 million square miles by expanding eastward across the Asian continent. The United States acquired its 3½ million square miles by expanding westward across North America. (So too did Canada, but its small population disqualifies it from Great Power status.) China is no exception. Just slightly larger than the United States, it ranks as the third-largest country in the world on the strength of colonial expansion westward across Asia, in a move that is almost a mirror image of Russia's expansion eastward (see Plate 19). Some insist that China has never been a colonial power that grew at the expense of other states, but, to state the bleeding obvious, it is simply not possible to create a country on this scale without conquering and absorbing territory that was once under other jurisdictions. What is curious about Chinese expansionism compared with the other four permanent members of the Security Council is that China's enlargement since the Mongol invasion has been driven primarily by the non-Chinese who conquered it. China became a mega-state not by conquering others so much as by being conquered by others. What the Mongols and Manchu ruling families of the Yuan and Qing Great States wrought, the Chinese ruling families of the Ming, the Republic and the People's Republic have chosen to perpetuate.

This history is invisible to most Chinese today. Patriotic education teaches them that their 'fatherland' occupies a space that is, and always has been, completely and naturally Chinese. This is how nationalists, as opposed to historians, think. For historians, the perspective is time and the dynamic is change. Nothing that is has always been so. Whatever national space was brought into being when the magic wand of 'revolution' in 1949 was waved, it had to come from somewhere. It had to be brought into being, and then given a false history.

Colonialism Today

There are many nations in our world that have not attained the autonomy of South Sudan, Nauru or Tuvalu. In the China zone, Mongols, Uyghurs and Tibetans come first to mind. What they see when they look at China is not a fatherland but the presumptuous inheritor of a colonial regime that disappeared when the Qing Great State collapsed in 1912. Here are a few brief glimpses of that history from their point of view.

In Mongolia, the Eighth Jebstundamba Khutuktu, chief lama of the Gelug School of Tibetan Buddhism in Mongolia and Mongolia's head of state when the Qing Great State collapsed, declared independence at the end of 1911. Mongolians saw no reason to continue obeisance to the Chinese state that emerged to replace it. It was only after Russian intervention in 1920 and 1921 that Outer Mongolia had the means to defend its sovereignty against China. This state continued to exist primarily as a Russian client until the collapse of the Soviet Union in 1989. Inner Mongolia, the portion of Mongol territory that is now a province of China, briefly seized political independence in 1945 after the collapse of the Japanese military control of the region, calling itself the Inner Mongolian People's Republic. That hopeful experiment lasted for two months until the Chinese Communist Party official, Ulanhu, arrived to dissolve this new regime and bring it into China. Ulanhu was rewarded for his loyalty to the party in his later years by being made the highest-ranking Mongol in the party hierarchy. Since his death in 1988, Inner Mongolia has remained in the hands of his family. His son Buhe took over the governorship of Inner Mongolia six years before his father died, and now Buhe's daughter Bu Xiaolin holds the post. Control there has been so tight, and the Mongol population so swamped by Chinese immigration, that Mongol nationalism can find expression only among expatriates.

East Turkestan, which Uyghurs also call Uyghurstan, is the region Chinese call the New Territories (Xinjiang). The Turkic population of the region has been Muslim since before the collapse of the Mongol Great State, and that religious identity continues to dominate their consciousness of who they are. The Qing-appointed governor of the New Territories fled when the dynasty fell in 1911. This might have created an opening for state formation, but his Chinese subordinate immediately took control and in March 1912 delivered the New Territories to the Republic. Uyghurs thus had no chance to exercise self-determination in the way the Mongols did at the end of the Qing. The dream of independence is still alive, fuelled since 2001 by what China calls its 'anti-terrorist measures' to stop the wave of Islamic radicalisation that had taken hold in other countries of the region. This repression, and the racial discrimination on which it rests, provoked indignation and widespread rioting in 2009. The PRC responded with

a crackdown and widespread arrests. That response intensified in 2016 with the imposition of a still ongoing programme that the new governor calls 'de-extremification', a core feature of which has been to concentrate Uyghurs in 're-education camps' to cleanse them of anti-party or anti-Chinese sentiments. Over a million Muslims – well over 10 per cent of the region's adult Uyghur and Kazakh population – were interned between 2017 and 2018.

The case of national non-self-determination in China familiar to most people is Tibet. Tibet came to lie within what the Qing Great State regarded as its legitimate jurisdiction in the eighteenth century, as we know from Chapter 10. You can find it on the map at the head of this epilogue: the red dot labelled Xizang south-west of Sichuan and just over the border from India. When the Great State sent an army into Lhasa in 1910 to make sure that the Thirteenth Dalai Lama did not waver in his submission to Beijing, the Tibetans turned to British India, until then a palpable threat, for support. When the Qing Great State disappeared in 1912, Tibet's ministerial council informed the British viceroy that, the Qing having collapsed, 'we have decided to separate altogether from them'. But no new patron came forward to act on its behalf. Tibet could only take advantage of the Republic's weakness and hope for a better solution to come along. The solution that arrived in 1950, however, was not Tibet's choice. Instead, the newly founded People's Republic sent in its army to secure Tibet as part of its sovereign territory. When the Chinese Communist Party sent the army in again in 1959 to suppress opposition to Chinese rule, the current, fourteenth, Dalai Lama, Tenzin Gyatso, fled to India. Even though the UN General Assembly passed resolutions in 1960, 1961 and 1965 condemning China for failing to respect the Tibetan people's right to self-determination, nothing has changed. The Dalai Lama is still in India, still seeking a non-violent resolution to this conflict.

Wang Lixiong, a prominent Chinese writer who has disagreed publicly with the party's goals and methods in Tibet, has called China's effort to impose 'long-term stabilisation' an act of cultural imperialism. What Tibet needs, he has argued, is 'national articulation', which hinges on the understanding that Tibet is a nation. 'National articulation is not simply about repeating one's history or acting out one's traditions. More important is the expression of what the

nation's people feel, think and demand from their present realities.' This approach has proved impossible under the current domination of China, which, in Wang's phrasing, 'has categorically suppressed Tibetan self-articulation. The empire seeks to control all forms of expression so that all transgressions are punished.'

If most Chinese are blind to their country's imperialism in Tibet, it is because a potent brew of Communist ideology and Confucian superiority has taught them to see themselves purely as imperialism's victims, not its perpetrators, as though the one must exclude the other. That China might have caused 'national humiliation' for any other state or people other than itself is beyond the capacity of most Chinese to imagine. Half a century of colonial policies designed to weaken non-Han ethnic identity, from the relocation of Han Chinese into minority regions to dilute ethnic populations, to residential schools for students and forced re-education for adults, have failed to make the problem go away. Ironically, it is the UN system of upholding currently existing countries that keeps this domestic source of instability alive and festering.

Since 1949, the only significant challenge to the territorial integrity of the PRC has been Taiwan. As long as the one-China policy remains alive and the PRC regards Taiwan as an inalienable part of its territory, its frustration with Taiwan's ongoing independence generates instability for which the only permanent solution appears to be military invasion. From China's perspective, that solution is not a matter for international comment: an invasion would be entirely an internal response to a domestic issue by a competent state authority. The world is unlikely to react positively, but whether there are any consequences will depend on the politics of the parties involved. Nauru and Tuvalu might speak out on behalf of Taiwan, but then again they might not. No one, other than itself, loves a Great Power, but no weak state wants to find itself on the wrong side of Great Power vengeance.

Neo-Colonialism

While domestic colonialism is an ongoing source of instability for the PRC, another is the condition that the Ghanaian political philosopher and one-time president Kwame Nkrumah called 'neo-colonialism'. Nkrumah was active in the movement to decolonise Africa through

the 1950s and 1960s. He coined the term to make sense of something that he as an anti-colonialist had not expected to happen, which was this: Africans saw off their colonial masters, put leadership in the hands of their own people and set about building their economies for their national benefit, but found that most of the problems of colonialism still plagued them. Decolonisation was followed not by autonomy but by an even deeper dependence on the global economy, over the terms of which they had no control.

Neo-colonialism in the 1960s was not like the original colonialism of direct occupation. The era of governors dispatched from distant metropolitan centres was over. What replaced it was a system of arm's-length financial obligations that allowed the decolonised to enjoy the trappings of an independent state while its economy, and thus its political policies, were directed from outside. Nkrumah was in the Marxist camp, so he indicted American capitalism, with its use of loans and exclusive contracts, as the economic system guilty of infringing on African liberation. But other cases would show that Soviet socialism was just as vulnerable to this critique.

Colonialism in this register did not require a cadre of colonial masters to oversee. It relied mainly on financial transactions, especially loans that proved too expensive and too difficult to pay back, leading to an intensified supervision through anonymous entities such as banks and joint enterprises. Foreign capital could thus exploit resources without making any significant contribution to local development. And so the gap between rich and poor nations after decolonisation only grew. Nkrumah was guardedly optimistic, insisting that neo-colonialism 'represents imperialism in its final and perhaps most dangerous stage'. But the decades since his time have shown the condition to be tougher to escape than he imagined.

The Power of Debt
China first became deeply involved in Ecuador in the first decade of the twenty-first century. Through that decade, China's oil consumption doubled. (It would surpass US domestic consumption of crude oil in 2017.) Venezuela and Brazil were already supplying the China market, but Ecuador was emerging as a possible further source. The opportunity to gain a foothold in Ecuador came after the US-trained

economist Rafael Correa took office as president in 2007 and the following year threatened to default on the country's foreign debt of $3.2 billion. PetroChina (the China National Petroleum Corporation) stepped in with a loan of $1 billion in a comprehensive deal to stave off financial collapse and tap Ecuador's petroleum resources. Subsequently, the China Development Bank and the China Export-Import Bank provided eleven loans totalling $15.2 billion. To secure this credit, Correa in 2010 signed a sovereign immunity waiver permitting Chinese lenders to seize almost any asset, other than military and consular, should Ecuador fail to meet its debt payments. The arrival of Chinese financing was so swift that in 2011 Reuters, exaggerating only slightly, described Ecuador as 'a wholly owned subsidiary of China'. By 2013, Quito was securing three-fifths of its government financing from China, in exchange for which China was collecting nine-tenths of Ecuador's oil exports. As Nkrumah predicted, 'Control over government policy in the neo-colonial State may be secured by payments towards the cost of running the State.'

The agreement worked well enough while the money flowed from China to Ecuador, but the arrangement began to generate difficulties. One was opposition from native groups whose land was being drilled for oil. Correa had undertaken an initiative with the Yasuní people in 2007 to suspend oil extraction on their lands in perpetuity in return for payments from the international community. The plan was hugely undersubscribed, and the pressure to keep oil flowing to China persuaded Correa to cancel the initiative in 2013. Correa left office in 2017, but disputes over that decision are still being sorted out.

A second difficulty was beyond Correa's control, though it is latent in any financial contract tied to commodity futures: the price of a barrel of crude oil, valued at $80 in 2011, fell to $35 in 2016. Given that the cost of extracting Amazonian oil at the time was about $39 a barrel, Ecuador in 2016 was losing $4 a barrel just to produce the stuff. Since its debt to China was in dollars, not barrels, the burden became twice as expensive to carry. The price has since climbed almost halfway back to its 2011 figure, but the deal remains vulnerable to market fluctuation. Ecuador's indebtedness to China today amounts to over two-fifths of its gross domestic product, and its oil exports are sewn up until at least 2024. The new president, Lenín Moreno, is seeking

to renegotiate the terms of the deals that Correa signed. He has also asked where a signing bonus of $69 million, which was exposed by the leak of the Panama Papers, ended up. Correa currently lives in Belgium, his wife's native country, and is hoping to avoid extradition to face charges that may or may not prove to be entirely political.

If Ecuador defaults on its Chinese loans, as Venezuela has been on the verge of doing for several years, China will face a massive financial loss. But as China generally responds to debt losses by writing off the debt or offering bigger loans, this problem can be delayed as long as it is flush with cash. In addition, the debt enables China to dominate decisions in Quito. Andes Petroleum, a wholly owned subsidiary of PetroChina, gained two new oil concessions in the indigenous rainforest in 2015. The following year, China obtained at least three mining concessions. China is thus in a position to push the protection of indigenous lands off the national agenda. The PRC can also expect its client to support it in other contexts, such as voting on its side at the UN. The election in June 2018 of María Fernanda Espinosa Garcés, Ecuador's foreign affairs minister, as president of the UN General Assembly should not be reduced to Ecuador's China connection, but it cannot be divorced from it either. Again, Nkrumah's prescience is striking: 'The rulers of neo-colonial States derive their authority to govern, not from the will of the people, but from the support which they obtain from their neo-colonialist masters.'

What follows when the loans can no longer be paid back? For a hint of what this future might look like, we can turn to Sri Lanka. Just sixty miles east of where Henry Tomalin found the Galle Stele on the south coast of Sri Lanka lies the small port of Hambantota. The 2004 tsunami devastated the region, but the town has made a comeback by building a new container port funded by China. Ecuador's debt slide has been measured compared to that of Sri Lanka, which under former President Mahinda Rajapaksa and his three brothers took on loan after loan almost without scrutiny. The political value of Sri Lanka to China is undeniable, given China's determination to counter India's influence throughout South Asia. The port of Hambantota gives China a central node in the Indian Ocean from which it can compete for shipping contracts, warehouse commodities, gather intelligence and run military operations (Chinese naval submarines

have already called at the port) – in short, from which it can protect its newly acquired interests.

The construction company that won the contract to build the port is a Chinese company called China Harbor. Investigators recently discovered that it diverted at least $7.6 million to the president's associates in 2015 to make sure that he would be re-elected, though he surprised Sri Lanka and the world by losing. (China Harbor has since been banned from contracts in Bangladesh after trying to bribe a Ministry of Roads official with $100,000 in cash. Its parent company, China Communications Construction Company, had already been excluded from bidding on contracts over its corrupt practices in the Philippines.) With the change in regime in 2015, the Sri Lankan government tried to renegotiate the terms of the loans, but having to spend $12.3 billion of an annual national revenue of $14.8 billion to service its debt loan gives Sri Lanka no room for manoeuvre. The solution in 2017 was takeover: China closed out roughly $1 billion of that debt in return for Sri Lanka signing over 70 per cent of the equity of Hambantota to China on a ninety-nine-year lease.

When historians of China hear about ninety-nine-year leases, it is hard for us not to think of the terms by which Great Britain secured Hong Kong in 1898 and the official hoopla around its return in 1997. (Hong Kong government bureaux were ordered in 2018 to stop referring to the recovery of Hong Kong as its 'return', so as to create the impression that it had never left the fatherland.) The players at the table have changed, but the methods have not, and the only benefit to Sri Lanka has been a bit of local infrastructure and the enrichment of corrupt politicians. Again, Nkrumah: 'The less developed world will not become developed through the goodwill or generosity of the developed powers. It can only become developed through a struggle against the external forces which have a vested interest in keeping it undeveloped.'

Neo-Hegemony

China's relationships today with the other 192 countries are not what they were in the past, however many countries there were then. Nor are the stories that some Chinese want to tell about how to make sense of China's new position in the world. Some propose that it is time for

China to abandon the rules of the UN system and follow a uniquely Chinese vision of the world, the vision they call *tianxia*. *Tianxia* – All under Heaven – was originally an idea of the Zhou dynasty that the emperor should rule all of his territory under the mandate of Heaven. He was Heaven's proxy, ordering everything that looked up to Heaven for guidance. There lay realms beyond his rule, but they were so far beyond the edge of anything that Heaven looked down upon that nothing would be lost by leaving them beyond the pale of civilisation. As the Chinese state became the Great State, there was potentially no place to which the ruler could be indifferent, no people who could be left beyond the apartheid regime of *hua* and *yi*. His rule was universal and all must submit. But then, the Great State had no further use for the distinction between *hua* and *yi*. That was merely a cultural distinction, not a political one as it had been back in the Zhou dynasty when all this was getting worked out.

The new vision of an East Asian international order has inspired some commentators in China to revive the old imperial language of *tianxia* – All under Heaven – as a model to guide China's correct relationships with the world. As the emperor was once the Son of Heaven, so now China under the Communist Party is Heaven's designate to oversee an international hierarchy extending downward from itself, the most powerful state in the system, to the least. The model dismisses the Westphalian idealisation of inter-state relations, which holds that all states are autonomous entities relating to each other as equals. Westphalia is with us today in the language of the United Nations Charter. Article 1 speaks of 'the principle of equal rights and self-determination of peoples'. Article 2 insists on 'sovereign equality' and the reservation of matters of 'domestic jurisdiction' from the interference of other states. These principles are arguably an extension of the peculiarly Christian tenet that everyone is equal in the eyes of God. Western jurisprudence has implicitly adapted this tenet in building itself on the principle that everyone is equal before the law. Legal and diplomatic equality are not always respected in practice, but equality is the ideal towards which Western systems are formally disposed.

The proposition that states should be arranged in a hierarchy suspends upholding the ideal of equality, however fictional it might be

in practice, in favour of bowing to the reality of imbalance that prevails across the world system. Hierarchy solves the problem of imbalance by recognising that no two members of the system hold the same position. Every relationship between any two states is either of superiority or inferiority. The Confucian ethic celebrates the virtue of orderly imbalance. Within a Confucian system of social relations, who you are is determined by who is above you and who is below. The same logic shapes the vision of a *tianxia* international order. The superior state expects deference from the inferior state, in return for which the inferior state expects the superior state not to interfere in its affairs.

This ordering may be a realistic way to harmonise social as well as inter-state relations, putting an end to the conflict that inter-state equality is presumed to feed, but it finds little traction in the moral system underpinning Westphalia. True harmony emerges from equality, not from inequality. It is otherwise merely the submission of the weak to the strong. But again, the Confucian mind regards this as an acceptable price to pay for global stability.

Earlier I found it helpful to borrow Kwame Nkrumah's term 'neo-colonialism' to identify what I see happening in countries where China is driving up debt. I think I need a different term to highlight what is at stake in the new world order that is being heralded, and the term that comes to mind is 'neo-hegemony'. Political theorists will recognise the echo of Antonio Gramsci's theory of 'hegemony'. While imprisoned under Mussolini during a war he would not outlive, Gramsci coined the term to express the surprising power that ideology can have to create a feeling among ordinary people that their social and political subordination is simply common sense. States benefit from broadcasting this sort of common sense that matters are as they should be, persuading citizens that nothing, including their own subjection, needs to be changed. What is 'neo' about today's neo-hegemony is the remarkable ease with which autocratic state leaders all over the world tell their citizens the most preposterous lies and have them believed. This is not a hegemony of force, but a hegemony of willing compliance.

The Chinese Communist Party has been active in this vein, churning out a steady stream of moralistic language to produce a Gramscian

hegemony of ideas favourable to the policies of the ruling elite. Two ideas are key to the party's bid for neo-hegemony. One is the idea that the Westphalian principles of equality and non-interference are inimical to economic prosperity. Prosperity requires stability, and stability requires hierarchy. The other is that people throughout the world will be better served by leaders who defer to China's national interests. Whether the passing of the Pax Americana will be a good thing is too early to tell, but whether replacing it with a Pax Sinica will benefit the self-determination of states and peoples throughout the world remains an open question. The Chinese Communist Party certainly seems to think so. My disadvantage as a historian is always noticing that the emperor's new clothes aren't what he says they are. The language of 'friendly cooperation', 'mutual benefit' and 'shared prosperity' that drapes Chinese foreign-policy statements is eerily reminiscent of the slogans that Japan offered to China and the rest of Asia when it went to war in the late 1930s. Japan in those days was in search of a decidedly non-neo military hegemony, but it too tried to use the balm of language to make it seem good.

It is difficult to assess where the 'win-win' promises of China's bid for neo-hegemony will lead, at the level either of principle or of practice. The record thus far, at least viewed from the Westphalian corner, is not promising. Consider what can happen at the level of individuals. Huseyin Celil is a Uyghur who believed that the interests of Uyghurstan would be better served if it were not under the military occupation of the PRC. Imprisoned on the one-size-fits-all charge of terrorism and fearing for his life, Celil escaped into Kyrgyzstan in 1994. He ended up in Turkey, where the UN High Commission for Refugees recognised him as a refugee. Under its obligations under the UN Convention Relating to the Status of Refugees, Canada granted him refugee status in 2001 and, later, citizenship. While Celil was in Uzbekistan with his wife to visit her relatives, he was seized on 26 March 2006 by Uzbek police and handed over to Chinese agents to take back into China. China's nationality law, which is loosely in line with global norms, allows Chinese to naturalise as citizens of another country, though on condition of losing Chinese citizenship. Not in Celil's case. Chinese courts continued to treat him as a Chinese citizen and declined to give him access, as international law required, to

Canadian consular support. Celil was sentenced to fifty years' imprisonment for espousing separatism. If that law were enacted in Canada, two million people, mostly Québecois, would be in jail. In 2016 the Communist Party reduced his sentence from life to twenty years, but he is still there.

China's bid for neo-hegemony encourages this sort of defiance of international legal standards. The same has happened in its stand-off in the South China Sea with all its maritime neighbours. The UN Convention on the Law of the Sea has mechanisms to deal with the problems of jurisdiction that have arisen. Although China is a signatory to the law, it refuses to have its claim tested before the International Tribunal for the Law of the Sea: again, Chinese rules, not UN rules. The Philippines brought its case against China to the Permanent Court of Arbitration in The Hague in 2015, and the following year secured a judgement in its favour, yet China refuses to recognise the authority of the court, or indeed of any international body, preferring instead to rely on unilateral military action. Chapter 6 of the UN Charter enjoins members to resolve conflicts by 'negotiation, enquiry, mediation, conciliation, arbitration, judicial settlement, resort to regional agencies or arrangements, or other peaceful means'. That's quite a shopping list, and yet not one of these options has China tried. Of course, the PRC is not the first country to hold an international court in contempt, but its decision to do so – to declare, in effect, that it is not subject to international law – over an issue for which there are recognised mechanisms of dispute resolution bodes ill for the future of the UN system, if a neo-hegemony of unilateralism becomes global common sense.

Whether the current 'Belt and Road' (or 'One Belt, One Road') initiative provides a gentler, friendlier vision of this neo-hegemonic future remains to be seen. This hastily contrived formula uses the language of a train and road 'belt' across the Eurasian continent and a maritime 'silk road' via the South China Sea and the Indian Ocean (which is a bit confusing, given that the Silk Road was a land route). This language was floated in 2013 as an umbrella for the global wave of large infrastructure investments that China was making to improve its access to foreign markets and to lessen the exposure of its oil imports to interdiction – precisely the objectives that drove Japan to bomb

Pearl Harbor and invade South-East Asia in 1941. There is nothing about the project that defies UN principles. For China, constructing physical links to two-thirds of the world's population is a smart, if expensive, move to enlarge its markets. Container loads of tomatoes from Chinese farms in Xinjiang, largely operated without Uyghur labour, now get to Italy fast enough for processing plants there to be able to pulp and can them to sell as fresh 'Italian puree', to the ignorance of consumers.

There is no obvious neo-hegemony built into the plan, yet Chinese state bank funding is intensifying debt dependency and corruption in poorer countries throughout the region. The Maldives, Mongolia, Djibouti, Montenegro and Laos, among others, carry debt repayment loads of well over two-thirds of their GDP. All have seen their debts soar since 2016 because of loans contracted under the Belt and Road Initiative. Hambantota is part of this story. Who can say what the raising of the Chinese flag alongside the Sri Lankan flag at the port on New Year's Day 2018 will come to signify? I was more struck at the time by a local news story from Hambantota that caught my eye because it mentioned Galle, the site of the stele in Chapter 4. A local resident, Ruwan Siriwardane, admitted that he was happy that the building of the port would bring business to his town, but he was worried about the impact of a surge of international visitors. 'We fear that the peace and quiet of Hambantota will be disturbed', he said, speaking for his neighbours. 'None of us wants to see Hambantota become a commercialised town like Galle.'

This inkling of neo-hegemony on the horizon puts me in mind of an essay that Owen Lattimore published half a century ago, when China's future role in the world was in question. Lattimore, the great scholar of Inner Asia whom the American government, under the leadership of Senator Joseph McCarthy, harassed as an 'instrument of Soviet conspiracy', wrote this essay to help readers puzzle through the options facing Mongolia, a small country caught as it was (and still is) between China on one side and Russia on the other. To illuminate Mongolia's options, he offered a distinction between colonies and clients that is still useful today. Colonies and puppet states – even Liang Hongzhi's regime during the war – 'dream of nationalism'. Despite the terrible compromises they make, even the colonised can still

aspire 'to become completely separate from the controlling power'. Satellites and client states, by contrast, exist because the political elite choose to attach their country to another. The client's goal is not to separate: it is to enjoy the benefits of attachment by following its patron's directions, agreeing with whatever win-win views the patron espouses and doing whatever it takes, including 'repatriating' former citizens that its patron wants seized, to ensure that the benefits the patron has promised keep flowing.

China is not the only state to use debt dependency to secure the compliance of state elites in satellite polities, but that is hardly a persuasive defence. Escalation of debt to this scale leaves the economic sovereignty of weak states utterly exposed to China's choices, without a gunboat or an aid worker in sight. It is too early to say whether these undertakings will lead to an erosion of democratic politics, the greater corruption of elected officials or a vitiation of the liberal order that the UN system has sustained since 1945. But they do appear to be creating what one expert has termed a 'growing structural bipolarity of the world order' between one regime of international norms, based (however messily) on laws and rights, and the new regime of authoritarian norms that disdains the mechanisms of international law. The danger of this round of neo-hegemony, not just for China but for the world, is that it is designed to boost the current global rise in neo-autocracy, beyond which lies war.

It is far too early to declare outcomes. That is not the historian's task. I would rather close this book with a simple exercise in historical perspective. Take a map from a century ago and compare it with a map of today. Parts of the world that were there then are not there now. Now go back two centuries. You will find that the differences are even greater. Go back another two centuries – say to Matteo Ricci's map, the grandparent of Ji Mingtai's map with which I opened this book – and almost nothing as we know it today is there. Now go in the other direction. Imagine what a map a century from now will look like. You can't, because the only thing we can know for sure is that, if they still make maps, the world will not look as it does today.

Who knows what countries there will be, what shapes they will have, what names they will be called? It is unlikely, for example, that the stilted Bolshevik name of the People's Republic of China will have

any rhetorical utility a hundred years from now. But then, who knew that the Great State would have a seven-century run? As for the United Nations, assuming it still exists, we can be certain that the number of member-states will not be 193. We might like to think that the total will have risen as more former colonies join Nauru, Tuvalu and South Sudan in the General Assembly. But the number could go the other way as well, as Ecuador, Sri Lanka and any number of the others sink under the tsunami of debt funded by our spendthrift ways and disappear into other political formations.

Unthinkable? Every tale I have told in this book was unthinkable before it happened. Who in 1974, when I set off for China, could have predicted what the world would look like today and not got it wrong? There is no end to the surprises in store for us and for those who come after us. What tales they will tell we cannot even begin to imagine. The only two things we can know for certain is that China's relationships with the world will continue to change, and that we are not at the end of anyone's version of history.

Notes

Notes to the Introduction

The maps referred to in the Introduction are, in order of appearance:

(1) 'Ji Mingtai', *Jiuzhou fenye yutu gujin renji shiji* [Terrestrial map of the astral correspondences of the nine provinces, with human vestiges and records of events ancient and modern] (Nanjing, '1643'); University of British Columbia (UBC) Library.

(2) Ji Mingtai, *Huang Minga fenye yutu gujin renshi shiji* [Terrestrial map of the astral correspondences of the Imperial Ming, with human vestiges and records of events ancient and modern] (Nanjing, 1643); Harvard-Yenching Library, Cambridge, MA.

(3) Liang Zhou, *Qiankun wanguo quantu gujin renji shiji* [Complete map of the ten thousand countries between Heaven and earth, with human vestiges and records of events ancient and modern] (Nanjing, '1593'), private collection; published in *The Library of Philip Robinson*, pt 2: *The Chinese Collection* (London: Sotheby's, 1988), p. 76.

(4) Matteo Ricci, *Kunyu wanguo quantu* [Complete map of the ten thousand countries of the earth] (Beijing, 1602). The copy in the Bell Library at the University of Minnesota is posted at https://www.lib.umn.edu/bell/riccimap.

(5) Abraham Ortelius [Abram Ortel], *Typus orbis terrarum* [Image of the sphere of the earth], from his *Theatrum orbis terrarium* [Theatre of the sphere of the earth] (Antwerp: Gilles Coppens de Diest, 1570).

Matteo Ricci's impact on Chinese cartography has been examined in Cordell Yee, 'Traditional Chinese Cartography and the Myth of Westernization', in J. B. Harley and David Woodward (eds), *The History of Cartography*, vol. 2, pt 2 (Chicago, IL: University of Chicago Press, 1994), pp. 170–86.

For references to 'ten thousand countries' in the classics, I have quoted James Legge (trans.), *The Yi King* (1899), p. 213, and Stephen Durrant et al. (trans.), *Zuo Tradition* (Seattle, WA: University of Washington Press, 2016), vol. 3, p. 1875. For other references see: James Legge (trans.), *The Shoo King* (*The Chinese Classics*, vol. 3), pp. 523, 526, 534; John Knoblock (trans.), *Xunzi* (Stanford, CA: Stanford University Press, 1988), vol. 2, p. 135; and Burton Watson (trans.), *Records of the Grand Historian of China*, vol. 1 (New York: Columbia University Press, 1971), p. 492.

I am grateful to Lhamsuren Munkh-Erdene for his analysis of the concept of the Great State, especially in his 'Where Did the Mongol Empire Come From? Medieval Mongol Ideas of People, State and Empire', *Inner Asia* 13:2 (2011), pp. 211–37. For more on this concept, see my 'Great States', *Journal of Asian Studies* 75:4 (2016), pp. 957–72.

'It is a disgrace to the human mind': Voltaire, *Chinese Catechism, Dialogues and Philosophic Criticisms* (New York: Peter Eckler, 1918).

'Transported into Asiatic scenes': Thomas De Quincey, *Confessions of an English Opium-Eater* (London: Taylor and Hessey, 1823), p. 169.

Notes to Chapter 1

On the portrait of Khubilai Khan, see Chen Xiaowei, '"Yuan shizu chulie tu" liuchuan kaolüe' [Brief investigation on the provenance of 'Khubilai's Hunting Portrait'], *Zhongguo guojia bowuguan guankan* 2016:6.

Events and documents from Khubilai Khan's early years have been taken from the official dynastic history, *Yuan shi* [History of the Yuan] (Beijing: Zhonghua shuju, 1976), pp. 63–8, 3688–94. For readers interested in his life, still the best biography is Morris Rossabi's *Khubilai Khan: His Life and Times* (Berkeley, CA: University of California Press, 1988).

The quotes from Marco Polo's memoir have been taken from Ronald Latham's translation, *The Travels of Marco Polo* (Harmondsworth:

Penguin, 1958), pp. 39–40, 108–13, 121–30, 153. When consulting the original text, I found it convenient to rely on the French manuscript in the Bibliothèque Nationale (MS fr. 5631), published in six volumes by Philippe Ménard as *Le Devisement du monde* (Paris: Droz, 2001–09). Of the voluminous secondary literature on Polo, I benefited most from reading Simon Gaunt, *Marco Polo's Le Devisement du monde: Narrative Voice, Language and Diversity* (Woodbridge: D. S. Brewer, 2013). Catching Marco Polo's errors is an old sport. For the two poles in that debate, see Frances Wood, *Did Marco Polo Go to China?* (London: Secker & Warburg, 1995), and Hans Ulrich Vogel, *Marco Polo Was in China: New Evidence from Currencies, Salts and Revenues* (Leiden: Brill, 2012).

'In Xanadu': Ernest Hartley Coleridge (ed.), *The Complete Poetical Works of Samuel Taylor Coleridge* (Oxford: The Clarendon Press, 1968), vol. 1, p. 297. Coleridge read the passage from the extract of Polo's account published in Samuel Purchas, *Purchas his Pilgrimage* (London, 1613).

'The mightiest man': Polo, *The Travels*, p. 113.

'Enclosing and encircling fully sixteen miles of parkland': Polo, *The Travels*, p. 108.

'The great unity of the state can no longer be delayed': *Yuan shi*, p. 63.

Khubilai Khan's Renovation Edict: *Yuan shi*, p. 99.

Khubilai Khan's State Foundation Edict: *Yuan shi*, p. 138.

'The Yuan Great State received Heaven's mandate': Tao Zongyi, *Nancun chuogeng lu* [Notes after the ploughing is done, 1366] (Beijing: Zhonghua shuju, 2004), p. 17.

The studies of Mongolian larch and Fujian cypress are mentioned in Bruce Campbell, *The Great Transition: Climate, Disease and Society in the Late-Medieval World* (Cambridge: Cambridge University Press, 2016), pp. 198–208.

'The terrain is high, the wells are deep, and the stars big': Huang Bian, *Yitong lucheng tuji* [An atlas of the routes of the unified realm] (1570), reprinted in Yang Zhengtai, *Mingdai yizhan kao* [Studies on the courier system of the Ming dynasty] (Shanghai: Shanghai guji chubanshe, 2006), p. 239.

On the Take-Off race, see Tao Zongyi, *Nancun chuogeng lu*, p. 19.

On the history of blacks in China, see Don Wyatt, *The Blacks of Premodern China* (Philadelphia, PA: University of Pennsylvania Press, 2011); see also his 'The Image of the Black in Chinese Art', in David Bindman et al. (ed.), *The Image of the Black in African and Asian Art* (Cambridge: Harvard University Press, 2017), pp. 295–324.

Notes to Chapter 2

On Kökečin's voyage and her reception in Tabriz, see Marco Polo, *The Travels*, pp. 42–5. For a useful account of Polo's maritime journey, see Philippe Ménard, 'Marco Polo et la mer: le retour de Marco Polo en occident d'après les diverses versions du texte', in Silvia Conte (ed.), *I viaggi del milione* (Rome: Tiellemedia, 2008), pp. 173–204.

On Šahab al-Dīn, see Song Lian, *Yuan shi*, pp. 298, 311, 319, 322, 325, 326, 336, 338, 339, 345, 346, 352, 364, 528, 2402–3, 4050 and 4572; on his younger brother, known only by the Chinese rendering of his Persian name, Hebashi, see pp. 252 and 528. Šahab al-Dīn's memorial was first noticed, and printed, in Yang Chih-chiu and Ho Yung-chi, 'Marco Polo Quits China', *Harvard Journal of Asiatic Studies* 9:1 (1945), p. 51. On this document, see Francis Cleaves, 'A Chinese Source Bearing on Marco Polo's Departure from China and a Persian Source on his Arrival in Persia', *Harvard Journal of Asiatic Studies* 36 (1976), pp. 181–203. His translation of the document is found on pp. 186–7.

Khubilai's 1266 letter to Japan: Song Lian, *Yuan shi*, pp. 111–12, 4625–6.

'Japan has not once invaded us'; 'Now is not the time': Song Lian, *Yuan shi*, p. 4630.

On Yang Tingbi, see Song Lian, *Yuan shi*, pp. 214, 245, 250, 4669–70; on the Yuan attack on Champa, pp. 3152–3. On Mongol initiatives in southern India, see Roderich Ptak, 'Yuan and Early Ming Notices on the Kayal Area in South India', *Bulletin de l'École française de l'Extrême-Orient* 80 (1993), pp. 137–56; Tansen Sen, 'The Yuan Khanate and India: Cross-Cultural Diplomacy in the Thirteenth and Fourteenth Centuries', *Asia Major* 19:1–2 (2006), pp. 299–326. On Mongol initiatives in South-East Asia, see Derek Heng, *Sino–Malay Trade and Diplomacy from the Tenth through the Fourteenth Century* (Athens, OH: Ohio University Press, 2009).

'In the Yuan's most prosperous era': Xie Zhaozhe, *Wu zazu* [Five

offerings] (Shanghai: Shanghai shudian, 2001), ch. 4. For the recent archaeological evidence on the Mongol fleets sent to invade Japan, see James Delgado, *Khubilai Khan's Lost Fleet: History's Greatest Naval Disaster* (London: Bodley Head, 2008).

On the navigation of the Singapore Strait, for which outsiders had to rely on local pilots, see Peter Borschberg, 'Remapping the Straits of Singapore? New Insights from Old Sources', in his *Iberians in the Singapore-Melaka Area (16th to 18th Century)* (Wiesbaden: Otto Harrassowitz, 2004), pp. 93–130.

The navigation manual cited for information on the monsoons is Alexander George Findlay, *A Directory for the Navigation of the Indian Archipelago, China, and Japan* (London: Richard Holmes Laurie, 1878), pp. 5–6, 26, 51–2. On the monsoon winds in the Bay of Bengal, see Sila Tripati and L. N. Raut, 'Monsoon Wind and Maritime Trade: A Case Study of Historical Evidence from Orissa, India', *Current Science* 90:6 (25 March 2006), pp. 864–71.

Coastal polities on the Indian Ocean thrived to the extent that their rulers encouraged maritime trade; see Sebastian Prange, *Monsoon Asia: Travel and Faith on the Medieval Malabar Coast* (Cambridge: Cambridge University Press, 2018).

'Qoje and other emissaries Arghun Khan had sent to the Great Khan': Wheeler Thackston (trans.), *Classical Writings of the Medieval Islamic World: Persian Histories of the Mongol Dynasties* (London: I. B. Tauris, 2012), vol. 3: by Rashiduddin Fazlullah, p. 427.

On the attrition of the Kökečin mission, see Polo, *The Travels*, p. 44. The standard Franco-Italian edition of Polo's manuscript does not include this passage; see Marco Polo, *Le Devisement du monde*, ed. Joël Blanchard and Michel Quereuil (Geneva: Droz, 2019), pp. 32–3. On Kökečin's death, see Anne Broadbridge, *Women and the Making of the Mongol Empire* (Cambridge: Cambridge University Press, 2018), p. 286.

Notes to Chapter 3

I could not have written this chapter without the guidance of Monica Green. Her edited volume, *Pandemic Disease in the Medieval World: Rethinking the Black Death* (Kalamazoo, MI: Arc Medieval Press, 2015), is an inspiration for anyone venturing into this field. For further developments since that book, see her 'Climate and Disease in Medieval

Eurasia', *Oxford Research Encyclopedia of Asian History* (2018). Before the new research, Mongol specialists preferred to downplay the association between the Mongols and the Black Death: e.g., Peter Jackson, *The Mongols and the Islamic World: From Conquest to Conversion* (New Haven, CT: Yale University Press, 2017), p. 408.

The opening image is from Rashīd al-Dīn, *Jami' al-Tawarikh* [Compendium of chronicles], Edinburgh University Library Or.MS 20. It is examined in David Rice, *The Illustrations of the 'World History' of Rashīd al-Dīn*, ed. Basil Gray (Edinburgh: Edinburgh University Press, 1976), pp. 146–7. As Rice points out, in the original text it serves to illustrate an attack in 1003, not the siege of Caffa.

Gabriele de' Mussis's plague memoir has been translated in Rosemary Horrox, *The Black Death* (Manchester: Manchester University Press, 1994), pp. 14–26, though I have modified her translation to meet the narrative purposes of this chapter. De' Mussis is the only author to describe the trebuchet incident. The original text has been long lost, but was copied into a manuscript of geographical accounts that ended up in the library of the University of Wrocław. For one assessment, see Mark Wheelis, 'Biological Warfare at the 1346 Siege of Caffa', *Emerging Infectious Diseases* 8:9 (September 2002), pp. 971–5.

The comments of English authors on the plague's origin are from Horrox, *The Black Death*, pp. 64, 66, 70, 76, 80, 112.

The case of Dr Raikes is reported in Wu Lien-teh et al., *Plague: A Manual for Medical and Public Health Workers* (Shanghai: National Quarantine Service, 1936), pp. 516–17.

Report of the Paris medical faculty: Horrox, *The Black Death*, pp. 161, 163.

Public health regulations in Hong Kong: *Ordinances of Hong Kong for 1903* (Hong Kong: Hong Kong Government, 1903), pp. 124–7.

On al-Maqrizi, see Stuart Borsch, *The Black Death in Egypt and England: A Comparative Study* (Austin, TX: University of Texas Press, 2005), pp. 1, 4, 136n. 23.

'Began in the land of darkness': Michael Dols, 'Ibn al-Wardi's *Risalah al-naba' 'an alwaba*: A Translation of a Major Source for the History of the Black Death in the Middle East', in D. K. Kouymijian (ed.), *Near Eastern Numismatics. Iconography, Epigraphy, and History: Studies in Honor of George C. Miles* (Beirut, 1974), p. 448.

On Ibn Battuta and the plague, see Ross Dunn, *The Adventures of Ibn Battuta: A Muslim Traveler of the 14th Century* (Berkeley, CA: University of California Press, 1986), pp. 266–78; Ibn Battûta, *Voyages*, ed. C. Defremery and B. R. Sanguinetti (Paris: La Découverte, 1982), vol. 3, pp. 356–9.

'Any historian who proposes that the Black Death began in China': Robert Hymes, 'Plague in Jin and Yuan: Evidence from Chinese Medical Writings' (unpublished).

The aDNA research from the East Smithfield cemetery is described in Ewen Callaway, 'The Black Death Decoded', *Nature* 478 (2011), pp. 444–6. The original report is Kirsten Bos et al., 'A Draft Genome of *Yersinia pestis* from Victims of the Black Death', *Nature* 478 (2011), pp. 506–10.

For the Big Bang, see Yujun Cui et al., 'Historical Variations in Mutation Rate in an Epidemic Pathogen, *Yersinia pestis*', *Proceedings of the National Academy of Sciences USA*, 110:2 (2013), pp. 577–82.

For Chinese records of epidemics in the mid-fourteenth century, see Imura Kōzen, 'Chihōshi ni kisai seraretaru Chūgoku ekirei ryakkō' [Brief investigation of Chinese epidemics recorded in local gazetteers], *Chū-gai yiji shinpō* 1233 (1936), pp. 14–15; Zhang De'er et al. (eds), *Zhongguo sanqian nian qixiang jilu zongji* [Compendium of Chinese meteorological records of the last 3,000 years] (Nanjing: Jiangsu jiaoyu chubanshe, 2004), pp. 539–46.

The biggest, albeit accidental, impact of the 1331 epidemic was historiographical, for William McNeill assigned this episode a pivotal role in his masterly global history of the plague, *Plagues and Peoples* (New York: Anchor Press, 1976). Unfortunately, the researcher McNeill hired to comb through Chinese sources mislocated the 1331 epidemic to the North China Plain. Ninety per cent mortality in an upland prefectural seat might have killed 10,000 people, but unleash the same statistic on the North China Plain and it produces mortality in the millions. This error led McNeill to propose that the Black Death started in Burma before 1320 and then moved north to lay waste to China in 1331 before making its its way west to Caffa (pp. 162, 297); not so.

On the Kaifeng epidemic, see Robert Hymes, 'A Hypothesis on the East Asian Beginnings of the *Yersinia pestis* Polytomy', in Monica Green (ed.), *Pandemic Disease in the Medieval World: Rethinking the Black Death*, pp. 285–308.

'Over a period of fifty days': Tuotuo (ed.), *Jin shi* [History of the Jin] (Beijing: Zhonghua shuju, 1975), p. 387.

'What happened?': Igor de Rachewiltz, *The Secret History of the Mongols: A Mongolian Epic Chronicle of the Thirteenth Century* (Leiden: Brill, 2004), vol. 1, p. 203.

'Beginning of a long shared trauma': Monica Green, 'On Learning How to Teach the Black Death', *History, Philosophy and Science Teaching Note* (March 2018), p. 19, on-line at www.hpsst.com/uploads/6/2/9/3/62931075/2018march.

On Toghon Temür's final flight, see David Robinson, *Empire's Twilight: Northeast Asia under the Mongols* (Cambridge, MA: Harvard University Asia Center, 2009), pp. 285–6.

On the Gate of the Prime Meridian, see Jirō Murata (ed.), *Chü-yung-kuan: The Buddhist Arch of the Fourteenth Century A.D. at the Pass of the Great Wall Northwest of Peking* (Kyoto: Faculty of Engineering, Kyoto University, 1957), 2 vols.

Notes to Chapter 4

The principal sources on the third Zheng He expedition are the court diary of the Yongle reign, known as the *Veritable Record* (*Ming taizong shilu*), and accounts from two men who sailed on the voyages, Ma Huan, translated by J. V. G. Mills in his *Ying-yai Sheng-lan*, *'The Overall Survey of the Ocean's Shores' [1433]* (Cambridge: Hakluyt Society, 1970), and Fei Xin, translated by the same scholar in his *Hsing-ch'a sheng-lan: The Overall Survey of the Star Raft by Fei Hsin*, ed. Roderich Ptak (Wiesbaden: Harrassowitz, 1996). The history of the Zheng He expeditions has been recounted many times. Louise Levathes provided the first popular overview in *When China Ruled the Seas: The Treasure Fleet of the Dragon Throne, 1405–1433* (New York: Simon and Schuster, 1994). The most sensible account of Zheng's voyages is Edward Dreyer, *Zheng He: China and the Oceans in the Early Ming Dynasty, 1405–1433* (New York: Longman, 2007). For a sound assessment of these expeditions, see Tan-sen Sen, 'The Impact of Zheng He's Expeditions on Indian Ocean History'. Serious readers are advised to avoid anything written by Gavin Menzies.

On Zheng's attack on Gampola, see *Ming taizong shilu* 116.2a-b; translated in Geoff Wade (trans.), *Southeast Asia in the Ming Shi-lu: An*

Open Access Resource (Singapore E-Press, National University of Singapore, http://epress.nus.edu.sg/msl/466), Record 771. For the Ceylonese account, see Edward Perera, 'Alakéswara: His Life and Times', *Journal of the Ceylon Branch of the Royal Asiatic Society* 18, no. 55 (1904), pp. 281–308, and Edward Perera, 'The Galle Trilingual Stone', *Spolia Zeylanica* 8 (1913), pp. 122–32. For Fei Xin's account, see J. V. G. Mills, *Hsing-ch'a sheng-lan: The Overall Survey of the Star Raft*, ed. Roderich Ptak (Wiesbaden: Harrassowitz, 1996), pp. 63–5. For the history of Ceylon, I have relied on K. M. de Silva, *A History of Sri Lanka* (Berkeley, CA: University of California Press, 1981).

The role of legitimacy in driving early Ming foreign relations is argued in Timothy Brook et al., *Sacred Mandates: Asian International Relations since Chinggis Khan* (Chicago, IL: University of Chicago Press, 2018), pp. 64–70.

'Recently the Yuan capital has been overcome': *Ming taizu shilu* [Veritable record of the reign of Emperor Hongwu], 37.23a.

Envoys sent abroad in 1369: *Ming taizu shilu*, 38.11a, 39.1b; Hongwu's letter to Ada Azha: *Ming taizu shilu*, 39.2b; Hongwu's messages of March and July 1370: *Ming taizu shilu*, 50.7a–b, 53.9b.

'People of a different sort': *Ming taizong shilu*, 134.4b.

A brief biography of Henry Tomalin appears in Arnold Wright, *Twentieth Century Impressions of Ceylon: Its History, People, Commerce, Industries and Resources* (London: Lloyd's, 1909), p. 122. The colonial government produced a guide to the Ceylon Court: *World's Columbian Exposition Hand Book & Catalogue: Ceylon Courts* (Colombo: H. C. Cottle, 1893). For a challenge to the widely repeated British claim that Ceylon was a 'model colony', see Margaret Jones, *Health Policy in Britain's Model Colony: Ceylon (1900–1948)* (New Delhi: Orient Longman, 2004).

The Galle inscriptions were first translated and published in S. Paranavitana, 'The Tamil Inscription on the Galle Trilingual Slab', *Epigraphica Zeylanica* 3 (1933), pp. 331–41. For the Portuguese reference to 'the kings of China', see p. 334.

'The idol carries the same name as the city': Ibn Battuta, *Voyages* (Paris: La Découverte, 1997), vol. 3, pp. 266–7.

'Straightaway their dens and hideouts we ravaged': Levathes, *When China Ruled the Seas*, p. 115, cited from the first chapter of Yang's *Yang*

Wenmin gong ji [Collected writings of Master Yang Wengong] (1515), though I have been unable to find the original. For an apology accepting the Chinese claim that the military action was 'purely defensive', see C. J. [Chung-jen] Su, 'The Battle of Ceylon, 1411', in Department of Chinese, University of Hong Kong (ed.), *Essays in Chinese Studies Presented to Professor Lo Hsiang-lin* (Hong Kong: Chinese University of Hong Kong, 1970), pp. 291–7.

'All the barbarians are respectful': Mills, *Hsing-ch'a sheng-lan*, p. 65.

Awards for survivors of the battle of Ceylon: *Ming taizong shilu*, 118.3a–b, 120.1a–b, 180.1b. Return of the four Embroidered Guard soldiers: *Ming xuanzong shilu* [Veritable record of the reign of Emperor Xuande], 18.4b.

'On the seventh day of the bright fortnight': Perera, 'Alakéswara: His Life and Times', p. 294.

On gems in the tombs of fifteenth-century princes, see Craig Clunas, 'Precious Stones and Ming Culture', in Craig Clunas and Jessica Harrison-Hall (eds), *Ming China: Courts and Contacts 1400–1450* (London: British Museum, 2016), pp. 236–44.

Marco Polo on the tooth relic: *The Travels*, pp. 258–9, 284.

'Fighting their way back to the coast': Su Bai, 'Lasa Budala gong zhuyao diantang he kucang de bufen Mingdai wenshu' [The main buildings and some Ming documents held in the Potala Palace in Lhasa], in his *Zangchuan fojiao siyuan kaogu* [Studies in the history of monasteries of Tibetan Buddhism] (Beijing: Wenwu chubanshe, 1996), p. 213; translation adapted from Tansen Sen, 'Diplomacy, Trade and the Quest for the Buddha's Tooth', in Clunas and Harrison-Hall (eds), *Ming China: Courts and Contacts 1400–1450*, p. 35. Sen accepts the argument that the footnote was inserted in the Northern Edition of the *Tripitaka*, the compendium of Buddhist sutras that was produced shortly after Yongle's death, though the passage has not actually been found in any copy prior to the Jiaxing edition of 1676. I was pleased to discover, after my own investigations, that Edward Dreyer also found the tooth relic story fictional; see his *Zheng He*, p. 69.

On the Fifth Karmapa's visit to Nanjing, see Patricia Berger, 'Miracles in Nanjing: An Imperial Record of the Fifth Karmapa's Visit to the Chinese Capital', in Marsha Weidner (ed.), *Cultural Intersections in Later Chinese Buddhism* (Honolulu, HI: University of Hawai'i Press,

2001), pp. 145–69. For 'an extended moment of consensual hallucination', see p. 161.

'The king caused to be built a three-storeyed palace': Edward W. Perera, 'The Age of Srí Parákrama Báhu VI (1412–1467)', *The Journal of the Ceylon Branch of the Royal Asiatic Society of Great Britain & Ireland*, vol. 22, no. 63 (1910), p. 17.

The full title of the 1597 novel about Zheng He is *Sanbao taijian xia xiyang tongsu yanyi* [The popular tale of how the eunuch of the Three Jewels sailed to the Western Ocean].

Yongle's continental steles include the Yongning Temple stele, near the mouth of the Amur River, in Chinese, Mongolian and Jurchen, dated 1413 (now in the Arsenyev Museum in Vladivostok), and the two Gautama Monastery steles in Amdo, bilingual in Chinese and Tibetan, one dated 1408, the other 1418. For a brief account of Yongle's steles, see Aurelia Campbell, *Architecture and Empire in the Reign of Yongle, 1402–1424* (Seattle, WA: University of Washington Press, forthcoming), pp. 6–7, 264, 273–8; also Johannes Lotze, 'Mongol Legacy, Language Policy, and the Early Ming World Order, 1368–1453', PhD diss., University of Manchester, 2016, ch. 3. On Portuguese stone pillars and their possible connection to Chinese markers, see Michael Keevak, 'Failure, Empire, and the First Portuguese Empire', in Ralf Hertel and Michael Keevak (eds), *Early Encounters between East Asia and Europe: Telling Failures* (Abingdon: Routledge, 2017), pp. 175–6.

Arab traders in Galle: Xavier de Planhol, *L'Islam et la mer: la mosquée et le matelot, VIIe–XXe siècle* (Paris: Perrin, 2000), p. 98.

'When we arrived': the text of the Changle stele of 1431 is translated in Dreyer, *Zheng He*, pp. 195–9.

Notes to Chapter 5

On Batu Möngke, see *Ming xiaozong shilu* [Veritable record of the reign of the Hongzhi emperor], 14.13a–b. His biography, listed under his title of Dayan Khan, can be found in Christopher Atwood, *Encyclopedia of Mongolia and the Mongol Empire* (New York: Facts on File, 2004), p. 138.

Quotations from Ch'oe Pu have been freely revised from John Meskill's fine translation, *Ch'oe Pu's Diary: A Record of Drifting across the Sea* (Tucson, AZ: University of Arizona Press, 1965). For the original text in Chinese, I have consulted the most recent Korean edition,

by Pak Wŏn-ho, *P'yohaerok* [Record of drifting across the sea] (Seoul: Korea University Press, 2006).

'We cannot keep track of dawn or dusk': Meskill, *Ch'oe Pu's Diary*, p. 37; Pak, *P'yohaerok*, p. 356.

'Why have you Japanese come here to raid?': Meskill, *Ch'oe Pu's Diary*, p. 55; Pak, *P'yohaerok*, p. 370.

'Does the emperor bow to the subject of a feudal state?': Meskill, *Ch'oe Pu's Diary*, p. 115; Pak, *P'yohaerok*, p. 422.

The five-day limit on foreign emissaries wishing to trade at the hostel: *Wenxing tiaoli* [Itemised questions on law], cited in Huai Xiaofeng (ed.), *Da Ming lü* [Code of the Ming Great State] (Beijing: Falü chubanshe, 1999), p. 386.

On Ch'oe's Confucian universalism, see Sixiang Wang, 'Co-Constructing Empire in Early Chosŏn Korea: Knowledge Production and the Culture of Diplomacy, 1392–1592', PhD diss., Columbia University, 2015, pp. 153–9.

'My coming here has nothing to do with affairs of state': Meskill, *Ch'oe Pu's Diary*, p. 125; Pak, *P'yohaerok*, p. 432. On the repatriation of Korean castaways from other states in the region, see Kenneth Robinson, 'Centering the King of Chosŏn: Aspects of Korean Maritime Diplomacy, 1392–1592', *Journal of Asian Studies* 59:1 (February 2000), pp. 109–25.

'This concerns the management of the return to their country of barbarians': Meskill, *Ch'oe Pu's Diary*, p. 131; Pak, *P'yohaerok*, p. 436.

Ch'oe's interview with Jiemian: Meskill, *Ch'oe Pu's Diary*, p. 146; Pak, *P'yohaerok*, p. 453.

Qiu Jun's biography appears in *Qiongzhou fuzhi* [Gazetteer of Qiongzhou prefecture] (1619), 10b.9a–17a. For a biography in English, see Chi-hua Wu and Ray Huang, 'Ch'iu Chün', in L. Carrington Goodrich and Chao-ying Fang (eds), *Dictionary of Ming Biography* (New York: Columbia University Press, 1976), pp. 249–52.

Quotations from Qiu's *A Supplement to the Elaborations on the 'Great Learning'* have been taken from the 1488 edition of *Daxue yanyi bu*, 132.15b–16b; 143.1b–19b; 144.2a–b, 8a–9a; 145.2b. I am grateful to Leo Shin for making available his translation of Chapter 143.

'Chosŏn is compliant and obedient': Qiu Jun, *Daxue yanyi bu*, 145.21a.

On the Mongol–Ming horse trade, see Frederick Mote and Denis

Twitchett (eds), *The Cambridge History of China*, vol. 7: *The Ming Dynasty* (Cambridge: Cambridge University Press, 1988), pp. 264–8, 317–19; on the Tumu incident, see pp. 322–5.

The conversation between Wang and the horse trader has been adapted, with revisions, from Svetlana Rimsky-Korsakoff Dyer, *Grammatical Analysis of the 'Lao Ch'i-ta'* (Canberra: Australian National University Press, 1983), pp. 305–25, 407–25. The use of a wrong character in the name of Shuncheng Gate, the site of the Beijing livestock market, turning Obedient Reception (the Mongols insisted that they had obediently responded to Heaven's mandate when they conquered China) into Obedient City, suggests that the new edition post-dated by several decades the renaming of the gate to Xuanwu in the 1440s, long enough for the correct characters to have dropped from public memory. On the renaming, see Sun Chengze, *Tianfu guangji* [Wide-ranging account of the Heavenly precinct] (Beijing: Beijing guji chubanshe, 1983), p. 41; also Tan Qian, *Zaolin zazu* [Date grove miscellany] (Jinan: Qilu shushe, 1997), p. 575.

'These companions of yours don't look like Han Chinese': Dyer, *Grammatical Analysis*, p. 371.

'Though I am a stranger': Meskill, *Ch'oe Pu's Diary*, p. 65; Pak, *P'yohaerok*, p. 377.

'Elder brother, we are going back': Dyer, *Grammatical Analysis*, pp. 493–5.

Notes to Chapter 6

Portions of this chapter appeared in 'Trade and Conflict in the South China Sea: China and Portugal, 1514–1523', in Lucia Coppolaro and Francine McKenzie (eds), *A Global History of Trade and Conflict since 1500* (Basingstoke: Palgrave Macmillan, 2013), pp. 20–37.

On Fernão Pires de Andrade's arrival in China, see T'ien-tsê Chang, *Sino–Portuguese Trade from 1514 to 1644: A Synthesis of Portuguese and Chinese Sources* (Leiden: Brill, 1933), pp. 32–68. For a colourful account of Tomé Pires's failed mission to the Ming court, see Nigel Cameron, *Barbarians and Mandarins: Thirteen Centuries of Western Travelers in China* (Tokyo: Weatherhill, 1970), pp. 131–48.

King Manuel's instructions: Chang, *Sino–Portuguese Trade from 1514 to 1644*, p. 33.

Eighty-four languages spoken in Malacca: cited in James Fujitani, 'The Ming Rejection of the Portuguese Embassy of 1517: A Reassessment', *Journal of World History* 27:1 (March 2016), p. 90.

On Emperor Zhengde's maritime policies, see Zheng Yongchang, *Lai zi haiyang de tiaozhan: Mingdai haimao zhengce yanbian yanjiu* [The challenge from the ocean: studies on changes in Ming maritime trade policy] (Taipei: Daoxiang chubanshe, 2004), pp. 113–14.

On Xiong Xuan and Bi Zhen, see *Ming wuzong shilu shilu* [Veritable record of the reign of Emperor Zhengde], 48.1b–2a (23 March 1509), 65.8b–9a (1 September 1510). Some of the translations from the *Veritable Record* have been taken, and freely modified, from Geoff Wade, trans., *Southeast Asia in the Ming Shi-lu: An Open Access Resource*, accessed between 4 and 15 June 2018. In most cases, the Chinese text can also be found in Chiu Ling-yeong (Zhao Lingyang) et al. (eds), *Ming shilu zhong zhi dongnanya shiliao* [South-East Asia in Chinese reign chronicles] (Hong Kong: Xuejin chubanshe, 1976), pp. 475–94. Some of this history is recounted in Chang, *Sino–Portuguese Trade from 1514 to 1644*, p. 31.

On Wu Tingju, see *Ming wuzong shilu*, 113.2a (27 June 1514), 149.9b (15 June 1517), 194.2b (13 Jan. 1521); Chiu, *Ming shilu zhong zhi dongnanya shiliao*, p. 479; *Shunde xianzhi* [Gazetteer of Shunde county, 1853], 21.3b–4b; *Guangdong tongzhi* [Gazetteer of Guangdong province, 1853], 7.23b, 25a, 36b; Zhang Tingyu, *Ming shi*, pp. 5309–11, 8221, 8430. The sources contradict each other on dates, so it is difficult to be as precise as one would like in reconstructing Wu's biography.

'Those who were supposed to carry out the orders have let things continue as before': Zhang Tingyu, *Ming shi*, p. 5310.

'The grand defender profited': *Ming wuzong shilu*, 123.4b (2 May 1515).

Pan Zhong: *Guangdong tongzhi* (1853), 7.19b; Zhang Tingyu, *Ming shi*, p. 5309. Subsequent to the events narrated in this chapter, Wu stood up to another powerful eunuch in an incident in the Nanjing region in 1522 (*Ming shi*, p. 5310).

'Ming China was a much less vigorous and enterprising land': Paul Kennedy, *The Rise and Fall of the Great Powers: Economic Change and Military Conflict from 1500 to 2000* (New York: Random House, 1987), pp. 7–8.

'It was all Wu Tingju's fault': *Ming wuzong shilu*, 149.9a–b (15 June 1517).

'Local bandits? Let 'em be': Zhang Tingyu, *Ming shi*, p. 4962.

'No written credentials': *Ming wuzong shilu*, 158.2a–b (11 February 1518).

Zhengde's failure to respond to the ministry's request for an edict of exclusion: *Ming wuzong shilu*, 191.1b–2a (23 October 1520).

T'ien-tsê Chang on Andrade: Chang, *Sino–Portuguese Trade*, p. 47.

'That their tribute be refused': *Ming wuzong shilu*, 194.2b (13 January 1521). This and the following passage are also translated, with some commentary, in Chang, *Sino–Portuguese Trade*, pp. 51–2.

Qiu as magistrate of Shunde: *Shunde xianzhi* (1853), 21.5a.

Response from Ministry of Rites siding with Qiu: *Ming wuzong shilu*, 194.3a (13 January 1521).

For a brief account of the politics of the Zhengde–Jiajing succession, see Brook, *The Troubled Empire*, pp. 98–100.

'Drive them away quickly': *Ming shizong shilu*, 4.27b (31 August 1521). On Portuguese spying in Canton, see Chang, *Sino–Portuguese Trade*, p. 44; on Afonso's request, p. 58.

An account of the conflict with the Portuguese from the Chinese side appeared in the *Veritable Record* a year later, when the emperor confirmed death sentences on Portuguese captured in the battles; *Ming shizong shilu*, 24.8a–b (6 April 1523).

New viceroy argues for opening trade in 1529: *Ming shizong shilu*, 106.5a (7 November 1529); Chang, *Sino–Portuguese Trade*, pp. 73–4.

On the Portuguese monopoly on their maritime trade, see C. R. Boxer, *The Portuguese Seaborne Empire, 1415–1825* (New York: Knopf, 1969), pp. 48, 60–62.

On Heh Ru, see *Ming shizong shilu*, 38.13a–b (15 May 1524), 154.7b–8a (7 October 1533). Heh's extraordinary promotion to the position of assistant county magistrate in Nanjing was probably tied to this development, as a reward for capturing the cannon. In 1533 Heh Ru earned another extraordinary promotion, from the unranked position of assistant county magistrate to the ranked post of vice-magistrate in Beijing. The correct romanisation of Heh is He; I have altered it to avoid confusion with the English pronoun.

The three dangers of Malacca: Zhang Xie, *Dongxi yang kao* [Study

of the eastern and western sea routes] (Beijing: Zhonghua shuju, 1981), p. 67.

'Gazing abstractedly out from the Flowery Kingdom': Cameron, *Barbarians and Mandarins*, pp. 129, 131. It is a bit unfair to single out Cameron here. He makes a sincere effort to get his reader to understand the Chinese side of Sino–Western relations, and I learned a great deal from the book when it was published. His verbiage was simply what passed for reasonable rhetoric in the popular press in 1970.

Notes to Chapter 7

The map of Bantam by Baptista van Doetecum (1598) is preserved in the Bodleian Library, University of Oxford, MS Mason K229 28r.

Quotations from Edmund Scott are from his *An Exact Discourse of the Subtilties, Fashions, Pollicies, Religion, and Ceremonies of the East Indians* (London: Walter Burre, 1606); the arson incident begins on p. E1. I have converted his Old Style dates and standardised his spellings to modern usage. The Hakluyt Society reprinted Scott's book in *The Voyage of Sir Henry Middleton to the Moluccas, 1604–1606* (London, 1943), pp. 81–176, though that edition is incomplete. Scott's biography after Bantam is sketchy.

Michael Neill, *Putting History to the Question: Power, Politics, and Society in English Renaissance Drama* (New York: Columbia University Press, 2000), p. 300, proposes that Scott published the book 'to advertise the cause of the company', but as he fell into a long dispute with the EIC after returning, it seems likelier to me that he published it as a testament to his service to the company, for which he had not been adequately rewarded. This issue must have been sorted out, for Scott was elected an auditor of the company later in the 1610s. After that he disappears from the record. An Edmund Scott and Agnes Losse are listed as parents of Anne Scott, who was born in Reading in 1609 and died in Barnstable, MA, but I have not determined whether he is our Edmund Scott.

The best treatment of Bantam in this period is Romain Bertrand, *L'Histoire à parts égales: récites d'une rencontre Orient–Occient* (Paris: Seuil, 2011). For the political background in Bantam, see Claude Guillot, 'Une Saison en enfer: Scott à Banten, 1603–1605', in Denys Lombard and Roderich Ptak (eds), *Asia Maritima: Images et réalité 1200–1800*

(Wiesbaden: Harrassowitz, 1994), p. 34. On the Chinese community on Java, mostly after 1604, see Marie-Sybile de Vienne, *Les Chinois en Insulinde: Échanges et sociétés marchandes au XVIIe siècle d'après les sources de la V.O.C.* (Paris: Les Indes savanates, 2008). On the archaeological remains, see Halwany Michrob, 'A Hypothetical Reconstruction of the Islamic City of Banten, Indonesia', M.A. diss., University of Pennsylvania, 1987, pp. 110–40.

The centrality of Bantam as a node in the Chinese trading network in the South China Sea in the decade of the 1600s is reflected in the Selden Map, an extraordinary Chinese maritime chart that, I have argued, was drawn there about 1608; see my *Mr Selden's Map of China: The Spice Trade, a Lost Chart and the South China Sea* (London: Profile, 2013), pp. 169–73.

'As many as ten thousand': Wang Linheng, *Yuejian bian* [The (hundred-tael) sword I brought back from Guangdong] (Beijing: Zhonghua shuju, 1987), pp. 91–3. Wang's testimony is puzzling, as I cannot find any record of his service in Canton in Chinese sources.

'Whosoever he took about his house in the night': quoted in Samuel Purchas, *Hakluytus Posthumus, or Purchas his Pilgrimes* (Glasgow: MacLehose, 1905), vol. 2, p. 431; repr. in *The Voyages of Sir James Lancaster* (London: Hakluyt Society, 1940), p. 115.

'Punish them immediately according to the laws of your country': cited in Adam Clulow and Tristan Mostert (eds), *The Dutch and English East India Companies: Early Modern Asia at the Centre of the Global Economy* (Hong Kong: University of Hong Kong Press, 2018), ch. 8, n. 36.

On the role of law in the creation of the colonial world, see Lauren Benton, *The Search for Sovereignty: Law and Geography in European Empires, 1400–1900* (Cambridge: Cambridge University Press, 2010), esp. pp. 3–8, 24–7. I disagree with Michael Neill's suggestion (*Putting History to the Question*, p. 279) that Scott was insisting on enjoying an exclusive claim to administering justice. I see him as more concerned with developing legal standing with the Bantam court.

Pope Gregory X's letters to Khubilai Khan: Polo, *The Travels*, p. 39.

On the Manila massacre of 1603, see José Eugenio Borao, 'The Massacre of 1603: Chinese Perception of the Spanish on the Philippines', *Itinerario* 23:1 (1998), pp. 22–39. The 1605 letter to Acuña is translated in E. H. Blair and J. A. Robertson (eds), *History of the Philippine Islands*,

vol. 13 (Cleveland, OH: Arthur H. Clark, 1904), pp. 287–91. On Dutch ships (under the command of Wijbrand van Waerwijck) nosing about in Chinese waters, see Zhang Tingyu, *Ming shi*, pp. 8434–5.

On Van Heemskerck, see Marina van Ittersum, *Profit and Principle* (Leiden: Brill, 2006), pp. 1–52; also Peter Borschberg, *Hugo Grotius, the Portuguese and Free Trade in Asia* (Singapore: NUS Press, 2011).

On the dispute over the cargo of the *Santa Catarina*: Hugo Grotius, *Commentary on the Law of Prize and Booty*, ed. Marina van Ittersum (Indianapolis, IN: Liberty Fund, 2006), p. 540; on the Dutchmen killed at Macao, pp. 279–84; on Lakmoy, pp. 275, 282.

On the use of gold as a medium of exchange, see Tomé Pires, *The Suma Oriental of Tomé Pires*, ed. Armando Cortesao (London: Hakluyt Society, 1944), p. 170.

The torture of the goldsmith, as also his silence under torture, has troubled numerous commentators. In an essay introducing the concept of 'the new historicism', using literary analysis to approach historical texts, Stephen Greenblatt called up this story to probe the limits of the historicist approach. Greenblatt suggested seeing the goldsmith's refusal to speak as a gesture of anti-colonial resistance, yet what shocks us and what shocked readers in 1606 are not the same. As Michael Neill has observed in *Putting History to the Question* (p. 294), scenes this gruesome were regularly enacted on the London stage. What distressed Greenblatt was that reading about a body in pain could create a kind of sadistic pleasure in the reader, thereby sabotaging his argument for the need for imagination in reconstructing the past. Greenblatt's unsatisfactory escape from this conundrum was to declare that, in the face the goldsmith's 'uncanny, unimaginable, perhaps heroic' silence, the historian had no right, 'after all this time, finally to compel him to speak'. In *The Hypothetical Mandarin: Sympathy, Modernity, and Chinese Pain* (Oxford: Oxford University Press, 2009), p. 50, Eric Hayot proposes that Greenblatt falls victim to the stereotype of the suffering Chinese that didn't yet exist at the time Scott was writing. Greenblatt thus ends up treating the goldsmith as just another colonised 'Oriental', not as a man who understood the losing bargain he was in. Richmond Barbour accepts Greenblatt's charge of sadism in his '"The English Nation at Bantam": Corporate Process in the East India Company's First Factory', *Genre* 48:2 (July 2015), p. 175,

but misrepresents the torment as 'vengeance'. The violence of the scene, to my mind, expresses Scott's near-desperation at being unable to manage the affairs of his factory, not something as abstract as 'vengeance' or as personal as 'sadism'.

One final note on the goldsmith: Neill believes him to be Hynting (or Hinting), identified as a digger with Boyhie, but Scott does not actually name him as such.

Notes to Chapter 8

The joint portrait of Matteo Ricci (on the left) and Xu Guangqi (on the right) at the head of this chapter comes from Athanasius Kircher, *China illustrata* (Amsterdam, 1667).

Some of the ideas and material in this chapter were first aired in my essay 'Europaeology? On the Difficulty of Assembling a Knowledge of Europe in China', in M. Antoni Ücerler (ed.), *Christianity and Cultures: Japan & China in Comparison, 1543–1644* (Rome: Institutum Historicum Societatis Iesu, 2009), pp. 269–93.

The arrest of the Nanjing missionaries is presented in Edward Kelly, 'The Anti-Christian Persecution of 1616–1617 in Nanking' (PhD diss., Columbia University, 1971), pp. 43ff. The main events of the persecution are listed in Ad Dudink, '"Nan gong shu du" (1620), "Po xie ji" (1640), and Western Reports on the Nanjing Persecution (1616/1617)', *Monumenta Serica* 48 (2000), pp. 133–265.

Xu Guangqi is the subject of Catherine Jami, Pieter Engelfriet and Gregory Blue (eds), *Statecraft and Intellectual Renewal in Late Ming China: The Cross-Cultural Synthesis of Xu Guangqi* (Leiden: Brill, 2001); see Ad Dudink, 'Xu Guangqi's Career: An Annotated Chronology', pp. 399–409, for a skeletal biography. I have also relied on Liang Jiamian, *Xu Guangqi nianpu* [Chronological biography of Xu Guangqi] (Shanghai: Shanghai guji chubanshe, 1981).

'"Uncle" Shen': Gail King (trans.), 'The Family Letters of Xu Guangqi', *Ming Studies*, 31 (1991), pp. 24–5.

The opposing memorials of Shen Que and Xu Guangqi are translated in Edward Kelly, 'The Anti-Christian Persecution', pp. 277–82, 294–302; these translations I have extensively altered. For Xu's original text, see Xu Guangqi, *Xu Guangqi ji* [Collected writings of Xu Guangqi] (Shanghai: Shanghai guji chubanshe, 1984), pp. 431–3.

Article 197 of the Ming Code: Yonglin Jiang (trans.), *The Great Ming Code* (Seattle, WA: University of Washington Press, 2005), p. 117.

'Like damming water that has to flow': Xu Guangqi, *Xu Guangqi ji*, p. 37.

The dialogues between Matteo Ricci and Paolo Xu in Conversations 3 and 4 of *Jiren shipian* appear in Zhu Weizheng's edition of Ricci's collected Chinese-language works, *Li Madou zhongwen zhuyi ji* [Matteo Ricci's collected writings and translations in Chinese] (Hong Kong: Xianggang chengshi daxue chubanshe, 2001), pp. 515–34. The earliest study of *Jiren shipian* is Pasquale d'Elia, 'Sunto Poetico-Ritmico di *I Dieci Paradossi* di Matteo Ricci S.I.', *Rivista degli Studi Orientali*, 27 (1952), pp. 111–38. This essay consists primarily of translations of the prefaces by Zhou Bingmo and Wang Jiazhi and the opening verse summary of the book's contents. I am grateful to Nicolas Standaert for sending me a copy of this essay. Matteo Ricci has been the subject of several biographies; the best are Jonathan Spence, *The Memory Palace of Matteo Ricci* (New York: Viking, 1984), and R. Po-Chia Hsia, *A Jesuit in the Forbidden City: Matteo Ricci, 1552–1610* (Oxford: Oxford University Press, 2010).

'That there is a bird on the banks of the Nile': Zhu Weizheng (ed.), *Li Madou zhongwen zhuyi ji*, p. 518.

'In the Western Region, there are two rivers': Zhu Weizheng (ed.), *Li Madou zhongwen zhuyi ji*, p. 526.

'China thus deserves top rank among all countries within the seas': quoted in Xu Guangqi, *Xu Guangqi ji*, p. 66.

'Principles common to both East and West': Xu's preface to Sabatino de Ursis, *Taixi shuifa* [Hydraulic methods of the Far West] (1612), in Xu Guangqi, *Xu Guangqi ji*, p. 67.

'To say abruptly that they are spies': Gail King (trans.), 'The Family Letters of Xu Guangqi', p. 25.

Emperor Wanli's edict is translated in Kelly, 'The Anti-Christian Persecution', pp. 85–6; for the Chinese text, see *Ming shenzong shilu* [Veritable record of the reign of Emperor Wanli], 552.1a–6.

On the impact of Shen's fall from power, see Gregory Blue, 'Xu Guangqi in Europe', in *Statecraft and Intellectual Renewal in Late Ming China*, pp. 40–41.

Statues of Jesus in a Beijing market: Liu Tong, *Dijing jingwu lüe* [A

brief guide to sights and things of the imperial capital] (Beijing: Beijing guji chubanshe, 1980), p. 166.

Notes to Chapter 9

The image of the suicide of Emperor Chongzhen referred to in this chapter appears opposite p. 44 in Martino Martini's *Regni Sinensis à Tartaris tyrannicè evastati depopulatique concinna enarratio* (Amsterdam: Valckenier, 1661); it is reproduced courtesy of Ghent University Library.

Dong Han's catalogue of portents appears in his *Chunxiang zhuibi* [Superfluous notes from Water-Mallow Village] (1678), reprinted in the second collection of *Shuoling* [Storybells] (1799), preface, 1.2b, 7a–8a, 9a–11b, 26b–27a. Dong later incorporated this book into the larger collection of his writings, *Sangang shilüe* [My brief understanding of the Three Bonds], reprinted in the fourth series of *Siku weishou jikan* [Collection of books not included in the Four Treasuries] (Beijing: Beijing chubanshe, 2000), vol. 29. For more tales from the fall of the Ming in Jiangnan, see Lynn Struve, *Voices from the Ming-Qing Cataclysm: China in Tigers' Jaws* (New Haven, CT: Yale University Press, 1993).

Chen Qide's descriptions of the disasters in Tongxiang are recorded in his *Chuixun puyu* [Simple words handed down to instruct], 16a–20a; reprinted in *Tongxiang xianzhi* [Gazetteer of Tongxiang county] (1887), 20.8a–10a.

The litany of disasters from the drought of 1640 to the locusts of 1641 has been adapted from *Caozhou zhi* [Gazetteer of Caozhou subprefecture] (1674), 19.20b–21a, reporting from Shandong province.

For a panorama of the global climate crisis, see Geoffrey Parker, *Global Crisis: War, Climate Change and Catastrophe in the Seventeenth Century* (New Haven, CT: Yale University Press, 2012). Plague outbreaks noted in European cities are referred to on pp. 83–5, 287, 294, 333 and 617.

'Bitter melon *wen*': Xu Shupi, *Shi xiaolu* [Notes on trivial knowledge], 4.9a–b (also 4.26b–27a), repr. in *Hanfen lou miji* [Private texts from Hanfen Tower] (Shanghai: Shangwu yinshuguan, 1916), pt 1, vol. 8. On the *wen* epidemic in the north, see Hu Wenhua and Ding Danian, *Yunzhong zhi* [Gazetteer of the Cloud Realm (Datong prefecture)] (1652), 12.20a.

Wu Youxing's study of the *wen* epidemic in Suzhou is examined in Marta Hanson, *Speaking of Epidemics: Disease and the Geographic Imagination in Late Imperial China* (Abingdon: Routledge, 2011), pp. 96–102; I have altered her translations, purely for literary reasons.

'The victims first developed hard lumps': quoted in Helen Dunstan, 'The Late Ming Epidemics: A Preliminary Survey', *Ch'ing-shih wen-t'i* 3:3 (November 1975), pp. 19–20. For a later, more thorough, survey of the north China evidence that tags these outbreaks to the plague, see Cao Shuji, 'Shuyi liuxing yu Huabei shehui de bianqian' [The spread of bubonic plague and social change in north China], *Lishi yanjiu* [Historical research] 1997:1, pp. 17–32.

The diaries of Qi Biaojia were published as *Qi Zhongmin gong riji* [The diaries of Qi Biaojia] (Shaoxing: Shaoxing xian xiuzhi weiyuanhui, 1937). I have relied mainly on his *Jiashen riji* [Diary of 1644]. For a study of Qi's philanthropy during the 1641 famine, see Joanna Handlin Smith, *The Art of Doing Good: Charity in Late Ming China* (Berkeley, CA: University of California Press, 2009).

Shi Kefa's seven reasons for disqualifying the Prince of Fu are listed in Huang Zongxi (ed.), *Hongguang shilu* [Veritable record of the Hongguang reign], reprinted in his *Huang Zongxi quanji* [Complete writings of Huang Zongxi] (Hangzhou: Zhejiang guji chubanshe, 1986), vol. 2, p. 3.

The peace mission of Zuo Maodi is discussed in Frederic Wakeman Jr, *The Great Enterprise: The Manchu Reconstruction of Imperial Order in Seventeenth-Century China* (Berkeley, CA: University of California Press, 1985), vol. 1, pp. 403–11.

Qi Biaojia records his last days in *Yiyou riji* [Diary of 1645], in his *Qi Zhongmin gong riji*. His final entry of 24 July appears on p. 23b.

On the fall of Songjiang, see Wakeman, *The Great Enterprise*, vol. 1, pp. 671–2.

Desecration of the tombs of the Dashing Prince's father and grandfather: Dong Han, *Chunxian zhuibi*, 1.2b–3a.

'Who is responsible for this?': Dong Han, *Chunxian zhuibi*, 2.15a–b.

Notes to Chapter 10
This chapter grew in part from my earlier essay, 'Tibet and the Chinese World-Empire', in Stephen Streeter et al. (eds), *Empires and Autonomy:*

Moments in the History of Globalization (Vancouver: UBC Press, 2009), pp. 24–40.

On the history of Sino–Tibet relations, see: Elliot Sperling, 'Early Ming Policy toward Tibet: An Examination of the Proposition that the Early Ming Emperors Adopted a "Divide and Rule" Policy toward Tibet', PhD diss., Indiana University, 1983; Zahiruddin Ahmad, *Sino–Tibetan Relations in the Seventeenth Century* (Rome: Istituto Italiano per il Medio ed Estremo Oriente, 1970); and Luciano Petech, *China and Tibet in the Early XVIIIth Century* (Leiden: Brill, 1950).

For a recent study of the role of the Dalai Lama in Manchu–Tibet relations, see Peter Schwieger, *The Dalai Lama and the Emperor of China: A Political History of the Tibetan Institution of Reincarnation* (New York: Columbia University Press, 2015).

On the Fifth Dalai Lama's journey to Beijiing, see Gray Tuttle, 'A Tibetan Buddhist Mission to the East: The Fifth Dalai Lama's Journey to Beijing, 1652–1653', in Brian Cuevas and Kurtis Schaeffer (eds), *Power, Politics, and the Reinvention of Tradition: Tibet in the Seventeenth and Eighteenth Centuries* (Leiden: Brill, 2006), pp. 65–87.

The meeting of Yinzhen and the Dalai Lama is based on the report Yinzhen wrote for his father, Emperor Kangxi, two days later; it is preserved in *Kangxi manwen zhupi zouzhe quanyi* [Complete translation of Kangxi's vermilion rescript memorials in Manchu] (Beijing: Zhongguo shehui kexue chubanshe, 1996), doc. #3366. As Yinzhen's name was a perfect homonym for his elder brother's, when that brother was enthroned as Emperor Yongzheng, Yinzhen was required to change his name to Yinti to avoid sounding out the emperor's name whenever his was spoken. Yinzhen is also known as Prince Xun, a title he later received from Emperor Qianlong.

'Is it possible that things can stay as they are without anything happening?': *Qing shengzu shilu* [Veritable records of the Kangxi emperor], 259:4b; quoted in Gu Zucheng (ed.), *Ming-Qing zhi Zang shiyao* [Historical outline of Ming and Qing policies to control Tibet] (Lhasa: Xizang renmin chubanshe, 1999), p. 136.

For the distance from Xining to Lhasa, see Yang Yingju, *Xining fu xinzhi* [New gazetteer of Xining prefecture] (Xining: Qinghai renmin chubanshe, 1988), p. 564; William Rockhill, 'Tibet: A Geographical, Ethnographical, and Historical Sketch', *Journal of the Royal Asiatic*

Society of Great Britain and Ireland (January 1891), pp. 101, 106. I have calculated the distance from Sichuan to Lhasa from the distances Rockhill gives on pp. 33, 40, 45, 54, 64 and 69.

For the passages quoted from Ippolito Desideri, see *An Account of Tibet*, pp. 168, 171. On Desideri, see Sven Hedin, *Southern Tibet, 1906–1908* (Stockholm: Lithographic Institute of the General Staff of the Swedish Army, 1917), 1:278–9, 3:10–14. Desideri's account may be 'one of the best and one of the most reliable ever written on Tibet' (1:279), and he was 'a sharp and conscientious observer' (3:14), but his political observations are unreliable, as Petech notes in his *Selected Papers on Asian History* (Rome: Istituto Italiano per il Medio ed Estremo Oriente, 1988), pp. 218–19; see also his *China and Tibet in the Early XVIIIth Century*, pp. 50, 54.

'With nary an arrow lost': from the text of a stele inscribed by the Manchu general Xiluntu, reprinted in Zhang Yuxin (ed.), *Qing zhengfu yu lamajiao* [The Qing government and lamaism] (Xuchang: Xizang renmin chubanshe, 1988), p. 290.

'Tsering Dhondup, depleted in food and arms and at the extremity of exhaustion, slunk away like a rat': Galbi, 'Pingding Xizang beiwen' [An epigraphic record of the pacification of Tibet], in Zhang Yuxin (ed.), *Qing zhengfu yu lamajiao*, p. 290. Desideri understood Tsering Dhondup died in flight, whereas in fact he made it home. A Russian envoy visiting Zungharia some years later found Tsering to be a powerful Zunghar leader – and on bad terms with Tsewang Rapten, the cousin who had sent him into Tibet; Petech, *China and Tibet*, 34, n. 4. For the larger context of the Qing conquest of Central Asia, see Peter Perdue, *China Marches West: The Qing Conquest of Central Eurasia* (Cambridge, MA: Harvard University Press, 2005).

'The war was one of the bloodiest': Louis Schram, quoted in Warren W. Smith Jr, *Tibetan Nation: A History of Tibetan Nationalism and Sino–Tibetan Relations* (Boulder, CO: Westview Press, 1996), p. 125.

On the Qing campaign of 1728, see Shu-hui Wu, 'How the Qing Army Entered Tibet in 1728 after the Tibetan Civil War', *Zentrale-Asiatische Studien* 26 (1996), pp. 122–38.

'We have now brought the area back on to our map': Yang Yingqiu, *Xining fu xinzhi*, pp. 54, 122, 385–6.

'Brought the people of Kokonor under his power': Sumpa Khanpo's

1786 history of Kokonor, translated into English by Ho-chin Yang as *The Annals of Kokonor* (Bloomington, IN: Indiana University Press, 1969); see especially pp. 29, 37–54. Sumpa Khanpo's biography is given in S. C. Das, 'Life of Sum-pa Khan-po', *Journal of the Asiatic Society of Bengal* 58:1, no. 2 (1889), pp. 37–9.

'The foreign occupation': Dalai Lama XIV, *The Spirit of Tibet: Universal Heritage*, ed. A. A. Shiromany (New Delhi: Allied Publishers, 1995), p. 135.

Notes to Chapter 11

Charles de Constant left his massive archive of manuscripts, letters and notes to the Geneva Library on his death in 1835. These have been catalogued as *Archives de la famille de Constant* (Geneva: Odysée, 2016). The best studies on Constant are Louis Demigny (ed.), *Les Mémoires de Charles de Constant sur le commerce à la Chine* (Paris: SEVPEN, 1964), and Marie-Sybille de Vienne, *La Chine au déclin des lumières: L'expérience de Charles de Constant, négotiante des loges de Canton* (Paris: Honoré Champion, 2004). The year Demigny published his study of Constant, he also published his magisterial three-volume work on the Canton trade, *La Chine et l'Occident: Le commerce à Canton au XVIIIe siècle, 1719–1833* (Paris: SEVPEN, 1964). I have also relied on the edition of Constant's diary-letters published as *Terres de Chine: Nouvelle Compagnie des Indes, 1789–1790: 11 lettres commentées* (Montélimar: Armine-Ediculture, 1998). These were first published in Philippe de Vargas (ed.), *Récit de trois voyages à la Chine, 1779–1793* (Peking, 1939).

On the Canton trade system, see Paul Van Dyke, *The Canton Trade: Life and Enterprise on the China Coast, 1700–1845* (Hong Kong: Hong Kong University Press, 2005). The same author provides a useful history of the Thirteen Factories in his article 'The Hume Scroll of 1772 and the Faces behind the Canton Factories', *Revista de Cultura* 54 (2017), especially pp. 84–8.

'Euhun Sang' is the Cantonese pronunciation of Xiangshan. The county was renamed Zhongshan in 1925 in honour of native son Sun Yatsen, who died that year. Sun was given the Japanese surname of Nakayama – Zhongshan in Chinese – as a pseudonym while he was in political asylum in Japan in his early thirties; this is the name by which he is best known to Chinese today.

'To go to the East Indies to follow my private affairs': quoted in Hugh Popham, *A Damned Cunning Fellow: The Eventful Life of Rear-Admiral Sir Home Popham* (Tywardreath: Old Ferry Press, 1991), pp. 29–30.

'Returning to the country': *Terres de Chine*, pp. 25, 26.

'Here I am again in my prison': *Mémoires*, p. 53.

'I have a servant just for me': *Mémoires*, p. 49.

'The domestic who had been in my service': *Terres de Chine*, p. 26.

'The Portuguese regard it as a work of piety': *Terres de Chine*, p. 75. Josefa and Gratia Barrada are mentioned in Vienne, *La Chine au déclin des lumières*, pp. 70, 72.

'Not so wide': *Terres de Chine*, p. 38.

'It is not at all pleasant to leave the quarters': *Terres de Chine*, p. 45.

'The Chinese emperor methodically taking his cut': Kent Guy, *Qing Governors and their Provinces: The Evolution of Territorial Administration in China, 1644–1796* (Seattle, WA: University of Washington Press, 2017), pp. 321–3.

Galbert's transcript of the discussion with Mudeng'e in 1784 is included as an appendix in *Mémoires*, pp. 449–53.

'The mandarins refuse nothing but accept nothing': *Mémoires*, p. 425.

Constant on the *Lady Hughes* affair: *Mémoires*, pp. 420–21; also p. 398. Demigny notes a French source that thought Smith might have been a Filipino.

'Nothing strikes a European who arrives in China': *Terres de Chine*, p. 35.

'A man without curiosity': *Terres de Chine*, pp. 77–8.

Constant expressed his views of the Macartney mission in a text entitled 'Quelques idées sur l'ambassade du Lord Maccarteney à la Chine' ['Some ideas on the embassy of Lord Macartney to China'], in *Mémoires*, pp. 413–31.

Macartney's lists of requests to the viceroy: Macartney to the EIC, 22 January 1794, 'Entry Book of Letters Written by Lord Macartney in China to the East India Company', Morrison Collection MS40, Toyo Bunko, Tokyo.

'Of a character so gentle, cheerful, and easy-going': *Mémoires*, p. 75, n. 2.

Constant's essay on opium: *Mémoires*, pp. 204–7.

'Judgement of the Lords Commissioners of Appeals in Prize Causes': quoted in Popham's appeal of 24 October 1803, in *The Naval Chronicle for 1808*, vol. 19 (London, 1808), pp. 315–16.

Shi Zhonghe appears in the court records under his father's name, Skeykinqua, used as the name of his firm. On Shi, see Kuo-tung Chen, *The Insolvency of the Chinese Hong Merchants, 1760–1843* (Taipei: Academia Sinica, 1990), pp. 298–306. I am grateful to Paul Van Dyke for bringing this and other studies of the Canton trade to my attention. For the amounts given in pounds sterling, I have converted silver taels to Spanish dollars at a rate of 5:7, and Spanish dollars to British pounds at a rate of 5:1.

Jane Austen, 'On Sir Home Popham's Sentence', in David Selwyn (ed.), *The Poetry of Jane Austen and the Austen Family* (Iowa City, IA: University of Iowa Press, 1997), p. 7.

Recent sales of the Grozer print: Galerie Bassange, Berlin, 28 November 2013; Bloomsbury Auction House, London, 2014; Chiswick Auctions, London, 13 October 2015.

Notes to Chapter 12

The opening cartoon appeared in *The Morning Leader* (6 September 1905), p. 3, under the heading, 'Instead of Flogging'.

The documents on Pless are in files FO 562/1–2, National Archives, Kew: telegram from Hopkins to Kirke, 4 November 1906; telegram from Kirke to Hopkins, 4 November 1906; letter from Hopkins to Kirke, 21 November 1906; undated inventory of the personal effects of Henry John Pless; letter from Consulate-General, Shanghai, to Vice-Consul, Peking, 29 December 1906; letter from British Consulate, Amsterdam, to Vice-Consul, Peking, 13 April 1907.

Documents relative to the emigration of Chinese labourers in the nineteenth century may be found in Irish University Press Area Studies (ed.), *British Parliamentary Papers: China*, vol. 4: *Correspondence and Returns Respecting the Emigration of Chinese Coolies, 1854–92* (Shannon: Irish University Press, 1971).

On the rise of coolie labour in the nineteenth century, see Harley Farnsworth MacNair, *The Chinese Abroad, Their Position and Protection: A Study in International Law and Relations* (Shanghai: Commercial Press, 1926), pp. 212–35. On the use of Chinese labour in the Transvaal, see Persia Crawford Campbell, *Chinese Coolie Emigration to Countries*

within the British Empire (New York: Negro Universities Press, 1923), pp. 161–216. On the recruitment of Chinese for mine labour, see Norman Levy, *The Foundations of the South African Cheap Labour System* (London: Routledge and Kegan Paul, 1982), chs 13–14, and Peter Richardson, *Chinese Mine Labour in the Transvaal* (London: Macmillan, 1982), ch. 3. The most recent study of Chinese mine labour in South Africa, which situates the issue in a broader perspective, is Rachel Bright, *Chinese Labour in South Africa, 1902–10: Race, Violence, and Global Spectacle* (Basingstoke: Palgrave Macmillan, 2013).

William Martin on slavery: W. A. P. Martin, *A Cycle of Cathay; or China South and North, with Personal Reminiscences* (Edinburgh: Oliphant, 1896), p. 383.

For anti-Chinese caricatures from the Boxer Rebellion, see Frederic Sharf and Peter Harrington, *The Boxer Rebellion: China, 1900: The Artists' Perspective* (London: Greenhill Books, 2000), and Jane Elliott, *Some Did It for Civilisation, Some Did It for Their Country* (Hong Kong: Chinese University Press, 2002).

The 2 shilling wage is noted by Dr MacNamara in the summary of debate in the House of Commons for 23 February 1906 in *The Times*.

'No effort shall be spared': 'Mr. Lyttelton and Chinese Labour', *The Times* (27 September 1905), p. 6.

'Our country would soon remove into outer darkness': 'Savoring of Slavery's Days', *The Morning Leader* (4 October 1905), p. 1.

'Outrages on the Rand', *The Morning Leader* (6 September 1905), p. 1.

Frank C. Boland, 'The Price of Gold', *The Morning Leader* (6 September 1905), p. 1.

Frank C. Boland, 'More Horrors by Yellow Serfs', *The Morning Leader* (2 October 1905), p. 1.

Frank C. Boland, 'Chinese Outrages', *The Morning Leader* (16 October 1905), p. 1. Further down the column, the newspaper ran a short article entitled 'Opium Traffic on the Rand' to remind readers of the vices that Chinese could get up to.

Gandhi's editorial on Chinese mine labour appears in E. S. Reddy, 'Gandhi and the Chinese in South Africa', Occasional Paper of the National Gandhi Museum (New Delhi, 2016), p. 19. His editorial on Indian labour, 'Indentured Indians in Natal', appeared in *Indian Opinion* 3:31 (5 August 1905), p. 1.

The testimony of Alexander McCarthy appeared in the weekly edition of the *Transvaal Leader* for 20 January 1906; it is enclosed with a letter from the Vice-Consul, Peking, to the Netherlands Legation, Peking, 9 July 1907; FO 562/1.

Pless's record of service with the Maritime Customs: 'Memo of Service, Chinese Maritime Customs, Revenue Department, Foreign Staff, Outdoor: Harry John Pless': Chinese Customs Archives, Number Two Historical Archives, Nanjing. On the career path of outdoor staff in the Maritime Customs, see John Pal, *Shanghai Saga* (London: Jarrolds, 1963), p. 57, and Robert Bickers, *Empire Made Me: An Englishman Adrift in Shanghai* (New York: Columbia University Press, 2003), p. 8.

On the Chinese coolie issue in the 1906 election, see A. K. Russell, *Liberal Landslide: The General Election of 1906* (Newton Abbot: David and Charles, 1973), pp. 64–9, 78, 102–8, 126, 196–8.

'The first attempt made since modern capitalism began' is taken from *The Times* on the eighth day of polling.

Chamberlain's charge against Churchill: *The Times* (23 February 1906), p. 5. Chamberlain was obliged to withdraw the accusation a week later, though he stuck by his insistence that 'mock Chinamen' had appeared in other ridings, as had posters of 'Chinamen manacled': 'I find that I was mis-informed as to the action taken in your Division in reference to the question of Chinese Labour, and that no mock Chinamen paraded in your constituency although they appear to have been present in some neighbouring Divisions. As regards posters, Mr Gibbons, Hon. Secretary of the Conservative Club, Cheetham Hill Road, states that a large placard representing a gang of Chinamen manacled was posted outside the Tower Liberal Club, Cheetham, and also at the Committee Rooms Cheetham Hill Road'; quoted in Randolph Churchill, *Winston S. Churchill* (Boston, MA: Houghton Mifflin, 1967), vol. 2, pp. 167–8.

Jamieson's and Barnes's letters dated 1906: James Stewart Lockhart Papers, ACC 4138/1/k (Miscellaneous Letters, mainly 1900–1911), Scottish National Library.

Report on sodomy: Churchill, *Winston S. Churchill*, vol. 2, p. 184.

'Trick of timing': see Timothy Brook, Jérôme Bourgon and Gregory Blue, *Death by a Thousand Cuts* (Cambridge, MA: Harvard University Press, 2008), pp. 25–7.

George Mason's images of Chinese punishments appear in his *The Punishments of China, Illustrated by Twenty-Two Engravings* (London: William Miller, 1801).

Photographs of the execution of Fuzhuli, including postcards, can be found at the website 'Chinese Torture / Supplice Chinois', at http://turandot.chineselegalculture.org.

Churchill's comment in Parliament 'that there was no ground for the institution of proceedings': *The Times* (24 February 1906), p. 5.

'How could something like this have been deliberately instituted?': quoted in Brook, Bourgon and Blue, *Death by a Thousand Cuts*, p. 89.

Notes to Chapter 13
This chapter does not directly address the toll of human suffering that the Japanese invasion of China unleashed, which goes a long way towards explaining the popular disgust with figures such as Liang Hongzhi. For a portrait of that suffering, see Diana Lary, *The Chinese People at War: Human Suffering and Social Transformation, 1937–1945* (New York: Cambridge University Press, 2010). For the larger political and military context, see Hans van de Ven, *China at War: Triumph and Tragedy in the Emergence of New China* (London: Profile, 2017).

'In order to live': Takaishi Shingorō, *Japan Speaks Out* (Tokyo: Hokuseido, 1938), pp. 9, 41.

'The basic policy of the Japanese Government': Hirota Kōki, quoted in *The Truth behind the Sino–Japanese Crisis* (Tokyo: Japan Times & Mail, 1937).

'Mediocre crooks who are willing to make what they can': Charlie Rigg's comments appear in the diary of Albert Stewart, reprinted in Kaiyuan Zhang, *Eyewitnesses to Massacre: American Missionaries Bear Witness to Japanese Atrocities in Nanjing* (Armonk, NY: M. E. Sharpe, 2001), p. 322.

For Ozaki Hotsumi's comments, see John Boyle, *China and Japan at War, 1937–1945: The Politics of Collaboration* (Stanford, CA: Stanford University Press, 1972), pp. 192–3.

Regulations on the punishment of collaborators are found in Zhu Jinyuan and Chen Zuen, *Wang wei shoushen jishi* [Records of the investigations of the Wang Jingwei puppets] (Hangzhou: Zhejiang renmin chubanshe, 1988), pp. 145–8, and Nanjing shi dang'anguan [Nanjing municipal archives] (ed.), *Shenxun Wang wei hanjian bilu* [Records of

the investigation of the Wang Jingwei traitors] (Nanjing: Jiangsu guji chubanshe, 1992), vol. 2, pp. 1490–94.

The reconstruction of Liang Hongzhi's trial is based on reports in the Shanghai newspapers *Shen bao* and *Wehui bao* on 6 July 1946. A partial transcript of the resumption appeared in *Shen bao* on 15 July. A full transcript of the trial is preserved in the Academia Historica in Taiwan, Record Group 010.20/1208, File 013.11/2110. I am grateful to Luo Jiurong for her generosity in sharing the notes she took from this file.

On the strengths and limits of the Shanghai High Court trials, see Timothy Brook, 'The Shanghai Trials, 1946: Conjuring Justice', in Academia Historica (ed.), *Postwar Changes and War Memories* (Taipei: Academia Historica, 2015), pp. 127–55.

On Pal's concept of 'even justice', see Timothy Brook, 'The Tokyo Judgment and the Rape of Nanking', *Journal of Asian Studies* 60:3 (August 2001), p. 695.

On the idea of the postwar, see Tony Judt, *Postwar: A History of Europe since 1945* (New York: Penguin, 2005).

Notes to the Epilogue
The hemisphere at the start of this chapter appears at the head of a long scroll from the nineteenth century, when the Qing was actively part of the world, depicting the coast of China entitled *Haifang tu* [Map of coastal defence]; Harvard-Yenching Library, Cambridge, MA. The map survives in many versions.

On China's veto in the Security Council to protect Syria on the grounds that to do otherwise would infringe its 'judicial sovereignty', see the discussion on a draft resolution to refer Syria to the International Criminal Court at the 7180th meeting of the Security Council (22 May 2014): https://www.un.org/press/en/2014/sc11407.doc.htm. On China's refusal to support resolutions in November 2017 and April 2018 to determine responsibility for the use of chemical weapons, see https://news.un.org/en/story/2018/04/1006991 and https://www.un.org/press/en/2017/sc13072.doc.htm; all documents retrieved 15 August 2018.

WikiLeaks report on Taiwanese payments to Nauruan officials: Philip Dorling, 'Nauru Officials' "Friendly Payoffs"', *Sydney Morning Herald* (29 August 2011).

'No nation is too tiny for China and Taiwan to squabble over':

Lindsey Hilsum, 'Why Beijing Cares about Tiny Nauru', *New Statesman* (20 September 2007).

The estimate of Muslims detained in Xinjiang comes from Adrian Zenz, 'New Evidence for China's Political Re-Education Campaign in Xinjiang', *China Brief* 10:18 (May 2018). Further on this issue, see Nathan VanderKlippe, 'UBC Student Uses Satellite Images to Track Suspected Chinese Re-education Centres where Uyghurs Imprisoned', *The Globe and Mail*, updated 9 July 2018. Shawn Zhang's findings can be found @ https://medium.com/@shawnwzhang/list-of-re-education-camps-in-xinjiang-新疆再教育集中营列表-99720372419c; accessed 15 August 2018.

'We have decided to separate altogether from them': quoted in Alex McKay, 'From Mandala to Modernity: The Breakdown of Imperial Orders', in Brook et al. (eds), *Sacred Mandates*, p. 181.

On 'national articulation', see Wang Lixiong and Tsering Shakya, *The Struggle for Tibet* (London: Verso, 2009), pp. 116, 223, 250.

Kwame Nkrumah, *Neo-Colonialism: The Last Stage of Imperialism* (London: Nelson, 1965).

On Chinese investment in Ecuador, see Juan José Lucci, 'Are China's Loans to Ecuador a Good Deal? The Case of the Sopladora Hydro Project', Leadership Academy for Development Case Study, Stanford University and Johns Hopkins University, 2014. On indigenous opposition to oil development, see Dan Collyns, 'Was This Indigenous Leader Killed Because He Sought to Save Ecuador's Land?', *The Guardian* (2 June 2015). For the position of the Ecuadorean government, see Joel Parshall, 'Ecuador Official Makes Case for Foreign Oil Investment', *Journal of Petroleum Technology* (12 October 2017). On recent Chinese drilling in the Amazon, see Jonathan Watts, 'New Round of Oil Drilling Goes Deeper into Ecuador's Yasuní National Park', *The Guardian* (10 January 2018).

On China's practice of writing off debt, see John Hurley, Scott Morris and Gailyn Portelance, 'Examining the Debt Implications of the Belt and Road Initiative from a Policy Perspective', Center for Global Development Policy Paper 121, March 2018, Appendix C, pp. 29–32.

For a recent summary of the state of play over Hambantota, see Maria Abl-Habib, 'How China Got Sri Lanka to Cough Up a Port', *New York Times* (25 June 2018).

On the use of *tianxia* philosophy of international relations, see Feng Zhang, 'Confucian Foreign Policy Traditions in Chinese History', *The Chinese Journal of International Politics* 8:2 (2015), pp. 197–218.

On Huseyin Celil, see Nathan VanderKlippe, 'Chinese Official Defends Jailing of Uyghur-Canadian Dissident Huseyin Celil', *The Globe and Mail* (31 October 2017).

Debt loads of the Maldives and others: Hurley et al., 'Examining the Debt Implications of the Belt and Road Initiative from a Policy Perspective', pp. 11–12.

Comment of Ruwan Siriwardane: quoted in Dinouk Colombage, 'The Hambantota Port Declared Open', *Sunday Reader*, undated [2010].

'Growing structural bipolarity of the world order': *China and the Age of Strategic Rivalry* (Canadian Security Intelligence Service, 2018), p. 17.

Owen Lattimore, 'Satellite Politics: The Mongolian Prototype', in his *Studies in Frontier History: Collected Papers, 1928–1958* (London: Oxford University Press, 1962), p. 297.

Index

Page numbers for notes are followed by n

A

Abdul Kadir 180, 181, 182
Abišqa 40, 41, 42
Abu Said 57–8
Aceh 47, 87
Acquaviva, Claudio 5
Acuña, Pedro de 192
Ada Azhe 84
Afonso, King 146
Africa 48, 146–7, 382–3
 see also South Africa
al-Maqrizi, Taqi al-Din 57, 70
Alagakkonara, Nissanka 80–82,
 99–100
Alagakkonara, Vira 81, 82, 97, 99
Albuquerque, Afonso de 147, 148
Albuquerque, Jorge de 166
Alcáçovas, Treaty of 142, 144
Aleni, Giulio 201, 202
Aleppo 58
Alexander VI, Pope 145–6
Alexander, William 339

All under Heaven (tianxia) 5, 86,
 125, 126, 132, 137, 207, 216, 222, 255,
 372
 as contemporary ideology 387,
 388, 426n
Altan Khan 266–7, 268
Álvares, Jorge 140, 149
An Lushan 206
Ananda 39–40, 42
Andaman Islands 47
Andes Petroleum 385
Andrade, Fernão Pires de 139–41,
 147, 149–52, 162–3, 164, 165
Andrade, Simão de 164
Arghun 40–41, 49
Ariq Böke 24, 25, 31
Austen, Jane 315
Avalokitesvara 266, 270, Pl. 13
Ayutthaya 87

B

Badoèr, Donata 52

Bantam 174–6, 178–9, 195, 196, Pl. 11
 EIC storehouse fire 171–4, 179–80,
 187–8, 197, 198–200
 justice 179–88
 silver 197–8
 trade and sovereignty 188–91
Barnes, Major A. A. S. 325–6, 331,
 332, 337
Barrada, Gratia 297
Batu Möngke 110
Behaim, Martin 141–2, Pl. 8
Beijing
 Ch'oe Pu 120–23
 Chongzhen's death 235–6
 Japanese invasion 351, 352, 355, 377
 Jesuits 232
 Khubilai Khan 22, 24–5, 28, 29–32
 Ming Great State 115, 116
 peasant rebellions 235–6, 249,
 254–5
 plague 65, 70
 public executions 341
 Qing Great State 256–7, 318, 320,
 321
 Toghon Temür 75
 Yellow Temple 14, 267
Belt and Road 390–1
Berger, Patricia 103
Bi Zhen 154–6
Black Death xiii, 10, 60, 63, 69, 72–3
 see also plague
bloodwit 182–5
bloody tanistry 23, 25, 54, 85, 270–1,
 273
Blue Princess 36–7, 41, 45–51
Boland, Frank 324–6, 331, 333, 342
Boniface III, Pope 51
Book of Changes 5, 30
Book of Poetry 355
Bos, Kirsten 69

Boxer Rebellion 320, 338, 340, 343,
 377
Brazil 146, 147, 330, 383
Brilliant 290
Britain
 1906 election 12, 333–4, 342
 East India Company 171–2, 190–
 91, 195, 196, 309–10
 free trade 377
 French Revolutionary Wars
 287–8
 Hong Kong 321, 386
 opium 313
 Opium Wars 39, 181, 377
 racism 334, 36, 338
 and South African coolie labour
 11–12, 330, 333–8
 Treaty of Nanking 321–22
Brue, Adrien Pl. 19
Bu Xiaolin 380
Buddha 265, 266
 tooth 101–5, 108
Buddhism
 Galle Stele 93–4, 95
 Ming Great State 207, 208, 209,
 213
 Mongol Great State 74–5
 reincarnation 272
 Yongle 91
 see also Dalai Lama
Buhe 380
Bulughan Khatun 41
Buqa 39–40, 42

C
Cabral, Pedro Álvares 147
Caffa 54–6, 66
Caishikou, Beijing 341
Camara 180, 182, 184, 186, 188,
 189–90

Canada 379, 389–90
Cantino, Alberto 146–7
Cantino Planisphere 146–7, Pl. 7
Canton 178
 Canton trade system 11, 294,
 298–9, 302–4, 316, 321
 Jesuits 231
 Portuguese 139–41, 150–52, 167
 Treaty of Nanking 321
Carte générale de l'empire Chinois
 (Brue) Pl. 19
Cattaneo, Lazaro 219
Celil, Huseyin 389–90
Ceylon
 Battle of 81–83, 98, 403n
 Buddha's tooth 101–5
 Galle Stele 91–7, 105–7
 Marco Polo 47–8
 Ming Great State 79–83, 91–101,
 105
 see also Sri Lanka
Chabi 18
Chagatai Khanate 41, 53, 72–3
Chamberlain, Joseph 333, 340, 420n
Champa 44, 45, 47, 84–5, 87, 139,
 147–8
Chang, T'ien-tsê 164
Charnock, Robert 289–90, 314
Chen Boxian 156–7, 158, 161, 162
Chen Jin 162–3
Chen Qide 237–40, 261
Chen Qun 358, 367
Chen Zuyi 80–81
Chenghua, Emperor 109, 125
Chiang Kai-shek 348, 350, 351, 352,
 356, 358, 359, 364, 373
Chinese Maritime Customs Service
 332–3, 422n
Chinese Republic see Republic of
 China

Chinggis Khan 7, 8, 22–3, 30, 270–1
 descendants 41–2, 53, 130
 and Tanguts 66
Ch'oe Pu 112–14, 116–24, 128, 132–3,
 136–7, 138
Chola 84
Chongqing 348
Chongzhen, Emperor 235–6, 246,
 248, 249, 255, 260, Pl. 12
Christianity
 and Ming Great State 201–17,
 221–32
 Yangzi Delta 237
Churchill, Winston 12, 335, 337, 342
Chwolson, Daniel 72
Cixi, Empress Dowager 320–1
Cleaves, Francis 39
Cochin China 147–8
coins, bronze 43, 197–8
Coleridge, Samuel Taylor 20, 22
collaboration 347–9, 359, 363–8
Colombo 80, 99
colonialism 106, 108, 191, 320, 374,
 375, 379, 391
 Chinese 379–82
 economics 323, 329
 Japanese 354
 neo-colonialism 382–86
 use of labour 325–9, 337–8
 see also decolonisation
Columbus, Christopher 141, 142–4,
 145, 146, 149, 263
Compagnie des Indes Orientales
 289, 295, 296–7, 300, 308–9
Compendium of Chronicles 39–40, 42,
 55–6
The Complete Map of the Ten
 Thousand Countries between
 Heaven and Earth (Liang Zhou)
 2–5, 7

*Confessions of an English Opium-
Eater* (de Quincey) 13, 14, 341
Confucianism 86, 116, 226
 and Buddhism 209, 213, 224
 Ch'oe Pu 116–17, 118, 121, 122,
 123–4
 hierarchy 128, 138, 388
 isolationism 124–8
Constant, Charles de 289, 294–7,
 299–200, 305–9, 316, 317
 Etrusco 289, 309, 313–15
 and Lum Akao 290, 292, 293, 297,
 308
 opium 311–12, 313
coolies 323–5, 330–32, 333–5
 South Africa 12, 323–8, 333–8,
 342–43
Coromandel 84, 87
Correa, Rafael 384–5
cotton 143, 217, 313, 323–4, 330
country trade 310–11
courier system 245
Cuba 143, 324, 330
Cui, Yujun 69, 72
The Costume of China (Alexander) 339

D
da Gama, Vasco 147
Da Rocha, João 220
Dadu *see* Beijing
Dai Li 362
Dai Viet 44, 83–4, 87
 see also Vietnam
Dalai Lama 102, 265–7, 285–6
Dalai Lama, Third 265, 266–7, 268,
 Pl. 13
Dalai Lama, Fifth 266, 272, 273, Pl.
 13
 Beijing meeting 13–14, 251–52, 253,
 268–70, 278

Dalai Lama, Sixth 273–5, 276
Dalai Lama, Seventh 265–6, 272–73,
 274–5, 280–2, 283–4, 285, Pl. 13
 and Prince Yinzhen 11, 268,
 277–80
 and Zunghars 276, 282
Dalai Lama, Eighth 285
Dalai Lama, Thirteenth 286, 381
Dalai Lama, Fourteenth 267, 286,
 381
Damascus 59
Danloux, Henri-Pierre 291–4, 316,
 Pl. 14
Daoguang, Emperor 321
Daoism 208, 213
Dashing Prince *see* Li Zicheng
De jure praedae (Grotius) 195–6
de' Mussis, Gabriele 55, 56–7, 59
de Quincey, Thomas 13, 14, 341
de Ursis, Sabatino 205, 226, 230, 231
death by a thousand cuts 155, 341,
 343–4
debt 383–6, 391, 392, 393
decolonisation 377–8, 382–3
Democratic Progressive Party
 (DPP) (Taiwan) 374
Desideri, Ippolito 275, 281, 282,
 417n
Devi, Sunetra 99
Dezhin Shekpa 102–3
Dias, Manuel 205
Dingmu 258–9
Djibouti 391
Doetecum, Baptista van Pl. 11
Dominican Republic 374
Dondra 91–2, 94–5, 106, 107
Dong Han 237–9, 261–4
Dongping 66
Dorgon 250–1, 254, 255, 256, 257,
 262, 271

drought 27, 28, 74, 227, 241, 242, 246,
 257–60
Dunstan, Helen 244
Dutch 177, 192
 Bantam 174, 180–81, 182–5, 189, 191
 Jakarta 191, 193
 and Portugal 193–6

E
Earthworks (Tumu) 130–31, 136
East India Company (EIC) 171–2,
 190–91, 195, 196
 and *Etrusco* 288, 309–10, 314–5
 Lady Hughes incident 308
 opium 310–1, 312
East Turkestan 275–7, 380–1, 391
Ecuador 383–5, 393
Elizabeth I 171, 190
environmental conditions 26–9,
 240–3, 244–5, 252, 257–60
equality 387
Eroshenko, Galina 72
Esen 130
Espinosa Garcés, María Fernanda
 385
Etrusco 287–90, 297, 309, 310, 313–5,
 316
Euclid 220
eunuchs 34, 84, 153–6, 159, 177, 228,
 240
 as slaves 88–90
Europe 6, 225–6
 environmental conditions 244
 Great Powers 377–8
 plague 10, 60–61, 69, 244
 Ricci 6, 212–14, 216–17, 221–8
 An Exact Discourse (Scott) 171–4, 175,
 178–80, 183–91, 193, 195, 197–200,
 409n, 411–12n
extraterritoriality 179–88, 307, 321–2

F
famine 27, 227, 242–3, 246
Fei Xin 83, 91, 97
Fengxiang 64, 66
Feodosia 54–6, 66
Ferdinand, King 142–3, 144–5
First World War 375
Fletcher, Joseph 23
floods 27, 28–9, 227, 240–1
folangji 150
France
 Compagnie des Indes Orientales
 289, 295, 296–7, 300, 308–9
 decolonisation 377
 post-war trials 366, 371
free trade 321–2, 333, 377
French Revolution 288, 292, 299,
 309
French Revolutionary Wars 287–8
Fu, Prince of *see* Hongguang,
 Emperor
Fu Rong 119
Fulin *see* Shunzhi, Emperor
Fuzhou 38, 64
Fuzhuli 341, 343

G
Galbert de Rochenoire, Jean-
 Charles-François 302–4
Galbi, General 281
Galileo Galilei 215
Galle 391
Galle Stele 91–7, 105–7, Pl. 6
Gampola 82
Gandhi, Mohandas 328–30
Ganglin 256–7
Gao Jie 258
Gaykhatu 49–50
Genghis Khan *see* Chinggis Khan
Genoa 20, 54

Geoffrey le Baker 57
George III 293, 306
Georgi, Balthazar 309, 314, 315, 316
Germany 353, 374
Ghazan 36, 37, 49–51, 53, Pl. 4
Gibson, William 103
Golden Horde 41, 53–6, 57, 58
Golden Khan 264–5, 268
goldsmith 187–8, 197–8, 411n
Gramsci, Antonio 388
Great Britain *see* Britain
The Great Compendium of the Yongle Reign 39–40, 42, 55–6
The Great Learning 125
Great Powers 376–9, 382
Great State 7–9, 11, 137, 376, 387
 see also Ming Great State; Qing Great State; Yuan Great State
Green, Monica 73, 398n
Greenblatt, Stephen 411–12n
Gregory X, Pope 191
Grotius, Hugo (Huig de Groot) 195–6, 322
Grozer, Joseph 293, 316–7, Pl. 14
Guangdong province 71, 153, 158–9, 161, 167
Guangxi province 153, 161, 167
Gushri Khan 266, 272, 273–4
Guy, Kent 301–2

H
Hainan Island 124
Hambantota 385–6, 391
Hangzhou 237
Harada Kumakichi 353
Hayot, Eric 411n
hegemony 388
 see also neo-hegemony
Heh Ao 167
Heh Ru 170, 408n

Henan province 70
Hengzhou 65
Heshen 300
Hirota Kōki 351–52, 355
Holland *see* Dutch
Hong Kong 61, 62, 63, 69, 321, 386
Hong Taiji 8, 251–3, 254, 268–9, 271
Hongguang, Emperor 249–50, 255, 256, 259
Hongwu, Emperor 8, 83–5, 271
Hongzhi, Emperor 109–10, 121–2, 271
 Confucianism 120
 and foreigners 136
 and Korea 115, 119–20, 121
 and Mongols 110–11, 130
 and Qiu Jun 125
Hopkins, L. 319
Hormuz 48
horses 128–9
How the Eunuch of the Three Jewels Sailed to the Western Ocean 104–5
How the Tartars Laid Waste to the Chinese Kingdom (Martini) 236–7
hua-yi distinction 2, 127–8, 387
Hymes, Robert 63, 65, 67

I
Ibn al-Wardi 58, 59, 72, 73
Ibn Battuta 58–9, 94
Il-khanate 37, 40–41, 49–51, 53
 plague 57–9, 73
Imperial Asiatic Company of Trieste 295–6
Imperial Household 17, 88, 90, 153, 155, 298, 301
India
 drought 244
 Hongwu 84

Khubilai Khan 41–2, 44–5
labourers in South Africa 329–30
Marco Polo 47–8
opium 310, 312, 313
plague 58
and PRC 385
and Tibet 381
Inner Mongolia 380
international law 145–6, 181–2, 193,
375, 388, 389–80, 392
see also extraterritoriality; law of
the sea
Isabel, Queen 142–3, 144–5
Islam 51, 96, 144, 145
see also Muslims
Issyk Kul 72

J
Jakarta 179, 193
Jamieson, J. W. 335–7
Janibeg 53–4
Japan 349
Behaim globe 141–2
extraterritoriality 181–2
Great State 377
Hongwu 84
invasion xvii, 12, 347–9, 350–71,
377, 389
Khubilai Khan 42–4
Meiji Restoration 355
piracy 118, 136, 217
Second World War 390–1
Yongle 87
Java 11, 45, 84, 87, 106, 156
see also Bantam
Jesuits 3, 6, 11, 201–17, 219, 220, 225–
6, 228–32, 237, 263–4
Ji Mingtai 1–2, 4, 5, 6–7, 376, 390,
Pl. 1
Jia Sidao 24

Jiajing, Emperor 166, 167, 170, 176,
217
Jiang Jieshi see Chiang Kai-shek
Jiangnan 240, 257–60
Jiangxi province 70
Jianwen, Emperor 85–6
Jiemian 123–4
Jin Great State 8, 65, 67, 141, 251,
256
Hong Taiji 252
Nurhaci 271
Jinan 64
João, King 146
Johannesburg 325, 326–8, 335–6
Johor 194, 196
Judt, Tony 370
Jurchens 8, 141, 236, 251, 256, 271
see also Manchus
justice
extraterritoriality 179–88, 307,
321–2
punishments 155, 184, 187–8,
340–1, 343–4
see also torture

K
Kaifeng 65–7, 70
Kaiping see Xanadu
kamikaze 43, 44
Kangxi, Emperor 271, 272, 300
Tibet 275, 276, 277, 280, 282, 285
Karmapa Lama 102–3
Kayal 44, 45, 47–8
Kelsang Gyatso see Dalai Lama,
Seventh
Kennedy, Paul 160
Kepler, Johannes 215
Khanbalik see Beijing
Khoshot Mongols 268, 273, 276, 281,
282–3, 284, 285

Khubilai Khan 8, 9–10
 and Altan Khan 266
 and Arghun 40–41
 Beijing 29–33
 Ceylon 101
 hunting 17–19, 20–1, 33, Pl. 2, Pl. 3
 India 41–2, 44–5
 Japan 42–4
 and Kökečin Khatun 37, 39–41,
 46–50
 Korea 114
 Little Ice Age 26–7
 memorial gate 74
 naval expeditions 44–5
 and Polos 19–22, 83
 portrait 17–19, 22, 29, 33–4
 and Šahab-al-Dīn 38–9
 State Foundation Edict 30–31
 Xanadu 23–6, 32–3
 Yuan Great State 38–9, 40
Kirke, C. 318–21, 332
Kökečin Khatun 36–7, 41, 45–51, Pl. 4
Kokonor 11, 66–7, 72, 266, 269, 275,
 277–80
Kollam 44–5
Konoe, Prince 352, 356–7
Korea
 Hongwu 84
 horses 129, 131–8
 and Japan 350
 Khubilai Khan 42–4, 114
 Korean War 373
 and Ming Great State 9, 10, 111–
 24, 128, 131–8, Pl. 9
 Yongle 87
 see also North Korea; South
 Korea
Kotte 80, 99
Kumbum Monastery, Kokonor
 277–80

Kyrgyzstan 41, 53, 58, 72–3

L
Lady Hughes 304–5, 308, 322
Lao Khita 131–8
Laos 371
Lattimore, Owen 391–2
law
 Chinese 198, 205–6, 209, 212, 285,
 304–5, 336, 367, 370
 English 179, 198, 305, 329, 410n
 Islamic 39, 188
 Tibetan 285
 see also international law; law of
 the sea; laws of war
law of the sea 193–6, 390
laws of war 289, 314
legitimacy 50, 83, 101, 273, 280, 351,
 351, 370, 376, 402n
 Yongle 85–6, 91, 100, 105
League of Nations 351
Lhasa 269, 274, 276–7, 280, 281–2, 381
Lhazang Khan 273–5, 276, 282
Li Gao 65, 66
Li Xiang 121–2
Li Zhiying 301, 302
Li Zicheng (the Dashing Prince)
 235, 236, 245, 248–9, 254–5
Liang Hongzhi 347, 350, Pl. 18
 arrest 358–60
 in Reformed Goverment 353–6,
 357, 358
 trial 347–8, 360–71
Liang Zhou 2–5, 7
Ligdan Khan 253
lightning 214–15
Lincoln, Abraham 356
Linqing 238
Lintin Island 106
Lithang 274

Little Ice Age 26–9
Liu, Judge 362
Liu Guandao 17–19, 22, 29, 33–4, Pl. 2
Liu Jin 154, 155–6, 159
Lloyd George, David 334
loans 383–6, 391, 392, 393
Lockhart, James 337
locusts 27, 28, 241, 242–3
Longobardo, Niccolò 201, 202, 230–31
Longqing, Emperor 176
Lum Akao 287, 290–4, 297, 299, 308, 316–17, Pl. 14

M
Ma He *see* Zheng He
Ma Huan 95, 100
Macao 218
 Constant 294–7
 Jesuits 231
 Portuguese 168, 174, 176–7, 194, 196
Macartney, George 306–7, 321
McCarthy, Alexander 331–2, 341
McCarthy, Joseph 391
McNeill, William 400n
Mahmud Shah, Sultan 148, 149
Malacca 87, 105, 106, 156
 Portuguese 106, 147–9, 164, 165, 166, 168
Maldives 391
Manchukuo 351
Manchuria 62–3, 69, 252, 350
Manchus 8, 11, 232
 invasion xvi, 250–7, 260–2
 succession 271–2
 Tibet 268–70, 280–2, 283–4, 285
 see also Qing Great State
Manila 174, 191–3
Manjusri 252, 270, 272, 277

Manuel, King 148
Mao Zedong 348, 373
maps 392
 Cantino Planisphere 146–7, Pl. 7
 Carte générale de l'empire Chinois et du Japon, Pl. 20
 eastern hemisphere Pl. 18, Pl. 19
 Haifang tu 372–3, 381, Pl. 20
 Ji Mingtai 1–2, 4, 5, 6–7, 376, 392, Pl. 1
 Liang Zhou 2–5, 7
 Ortelius 4–5
 Qing Great State 372–3, 381
 Ricci 3, 5, 203, 216–17, 372, 392
 Selden map 410n
Mare liberum (Grotius) 196, 322
Martin, William 330–1
Martini, Martino 236–7, Pl. 12
Mason, George 339–40
Ming Code 198, 208
Ming Great State xiv, 8, 10–11, 376
 and Ceylon 79–83, 91–108
 and Christianity 201–17, 221–32
 courier system 245
 environmental conditions 64, 257–60
 eunuchs 88–9
 and foreign trade xv, 139–41, 152–70, 176–7, 191–3
 horses 128–30, 131–8
 and Koreans 111–24, 128, 129–38
 Manchu invasion 220, 236, 250–7, 260–4
 maps of the world 1–5
 Ministry of Justice 109, 119
 Ministry of Personnel 109, 119, 159, 259
 Ministry of Rites 84, 86–7, 90, 97–8, 110–11, 121, 137, 153–60, 163, 165–6, 201–2, 205–6, 229–31, 256

Ministry of War 98, 109, 111, 119, 122, 153, 202
Ministry of Works 201
and Mongols 110–11, 129–31, 266
peasant rebellions 245, 247–50, 260
and Philippines 191–3
plague 64
succession 85–6, 271
Mitchell, John J. 107
Möngke 23, 24, 25
Mongolia 267, 280, 285, 379, 391
Mongols
Caffa 54–6
Chinggis Khan 22–3
and Dalai Lama 266, 268, 269
Great Code 253–4
Great State 7–8, 30–31
horses 128–9
invasion 7, 24, 25–6, 34–5
and Jurchens 251
Kaifeng, siege of 65–7
Khubilai Khan 9–10, 22–5, 33
Kökečin Khatun 36–7
and Ming Great State 110–11, 129–31
and plague 55, 65–7, 72, 73
succession 23, 25, 54, 85, 270–1
Take Off 32–3
and Tanguts 66–7
and Tibet 11, 266–7
trebuchet 55–6, Pl. 5
and Yongle 86–7
see also Golden Horde; Yuan Great State; Zunghars
monsoons 46, 47
Montenegro 391
Montesquieu 299
Moreno, Lénin 384–5

Morning Leader, The 326–8, 331, 333, 335, 338, Pl. 15
Mudaliar, Nacem 148, 149
Mudeng'e 302–4
Munkh-Erdene, Lhamsuren 252
Muslims 89, 207
in Spain 142, 145
Uyghurs 380–1
see also Islam
My Khitan Buddy 131–8

N
Nambui 18
Nanjing
Japanese invasion 348, 352, 355
Jesuits 201–4, 220, 228–31
Korean envoys 115–16, Pl. 9
Manchu invasion 257
maps 2, 3, 4
Ming Great State 2, 4, 86, 88, 102–3, 107, 168
Qing Great State 248, 249
Republic of China 350
world maps 216
Nanjing, Treaty of 321
Naquin, Susan 290–1
'national articulation' 381–2
Nationalist Party (Republic of China) 250, 348, 356, 361, 363, 371
Nationalist Party (Taiwan) 371, 374
Nauru 375–6, 382, 393
Neill, Michael 409n, 411n, 412n
neo-colonialism 382–86
neo-hegemony 386–92
Ngabehi 180, 187
Nicholas V, Pope 146
Nkrumah, Kwame 382–83, 384, 385, 386
North Korea 374
Nourse Deep 326, 331

Nurhaci 251, 271

O
Ögedei 23, 67, 271
oil 381–3, 390
Okinawa 87, 112
One Belt, One Road 390–1
one-China policy 374–6, 382
opium 13, 310–3, 327, 328
Opium Wars 39, 181, 313, 377
Ortelius 4–5
Outer Mongolia 380
Ozaki Hostumi 357

P
padrões 106, 149
Pakistan 58
Pakramabahu VI 97, 99–101, 104, 105
Pal, Radhabinod 370
Pan Youdu 308
Pan Zhong 159
Panama 374
Panama Papers 385
Panchen Lama 274, 276–7, 283, 285
pangeran 179–80, 188
Pantoja, Diego de 205, 206, 230, 231
Parameswara, King 87
Parker, Geoffrey 244–5
Pasteur, Louis 61
Pekar Dzinpa 274, 275, 276
Peking *see* Beijing
Peking Convention 323–4
People's Republic of China 12, 371,
 373, 392–3
 at United Nations 373, 374
 and Ecuador 383–5
 as Great Power 378, 379
 and Mongolia 378–80
 Nauru and Tuvalu 375–6
 neo-hegemony 386–92

and Sri Lanka 385–6
and Taiwan 374–5, 382
and Tibet 267–8, 286, 381–3
and Uyghurs 379, 380–9, 389–90
Perera, Edward 99–100
Perestrello, Rafael 140, 149
Persia 37, 45–51
PetroChina 384, 385
Phagpa 266
Philippines 174, 191–3, 390
photography 339–41
piracy 140, 193–6, 217–18
Pires, Tomé 148, 163, 164, 165, 197
Piron-Hayet, Jean-Baptiste 289, 308
plague xiii, 59–63, 244, 266
 in Caffa 54–6
 in China 58, 59, 61, 62, 63–7, 69–71,
 73
 in the East 56–9
 genomic research 59, 67–70, 71–2
 in Kaifeng 65–7
 in Yangzi Delta 242–4
Pless, Henry 318–21, 325, 329, 331–3,
 338, 339, 341–2, 343
Polhané 283–4
Polo, Maffeo 19–20, 21, 42, 50, 191
Polo, Marco 10, 19–20, 34, 54, 83,
 141, 142, 143, 191
 and Arghun 40, 41–2
 Beijing 31–2
 Ceylon 101
 and Khubilai Khan 20–2, Pl. 3
 and Kökečin Khatun 37, 46, 47–8
 return to Venice 50, 51–2
Polo, Niccolò 19–20, 21, 42, 50, 191
ponggawa 179–80, 187
Popham, Home 287, 288–90, 309,
 310, 313–15
Portugal 142, 144–7
 Ceylon 91–2

China 10, 139–41, 148, 149–52,
 160–8
and the Dutch 193–6
and Jesuits 203
Macao 168, 174, 176, 294, 295, 297
Malacca 147–9, 164, 165, 166, 168
padrões 106, 149
postwar 370–1
PRC *see* People's Republic of China
prices 1, 28, 129, 133–5, 309–10, 312,
 323, 384
primogeniture 2671
The Punishments of China (Mason)
 339–40
Puyi 351

Q
Qara Khitai 58
Qi Biaojia 245–51, 257–61
Qianlong, Emperor 284–5, 300, 301,
 302, 303, 306–7, 321
Qiao, General 239
Qin dynasty 6
Qing Code 338, 343
Qing Great State 8, 349, 372–3
 administration 301
 Boxer Rebellion 320, 338, 343
 Canton trade system 11–12, 298–
 9, 301–4, 316, 321
 collapse 350
 and Dalai Lama 13–14, 268–70,
 275, 277–80
 employment abroad 323–4
 extraterritoriality 321–2
 invasion of Ming 4, 8, 252–3, 254,
 255
 Japanese invasion 377
 Macao 294–5
 New Policies 320–21
 opium 310–3

Opium Wars 377
 punishments 328, 338–9, 340–1,
 342–4, Pl. 16, Pl. 17
 succession 271–2, 278
 Tibet 280–6, 381
 and Zunghars 276, 277
Qinghai *see* Kokonor
Qiu Daolong 164–5
Qiu Jun 124–8
Qoǰe 40, 41, 42, 49
Quanzhou 46, 58
Quilon 44–5
Quito 384

R
Raikes, C. T. 62–3
Rajapaksa, Mahinda 385, 386
Rashīd al-Dīn 49–50, 51, Pl. 4, Pl. 5
Reformed Government 355–6, 360–1
reincarnation 265, 272–3
Ren Yuandao 359
Reorganised National Government
 (RNG) 348, 357, 358
Republic of China 8, 12, 350
 Japanese invasion 347–9, 350–71
 Tibet 285–6
Republic of China (Taiwan) 373,
 374–6, 382
 see also Taiwan
Ricci, Matteo 6, 11, 203, 204, 210,
 230, Pl. 10
 conversations with Xu Guangqi
 221–8, 413n
 Europe 216–17
 and Great West 207–8, 212–13
 maps of the world 3, 5, 6, 203,
 216–17, 219, 372, 394n
 sciences 214–16, 220
Riggs, Charlie 356
Robert of Avesbury 57, 73

Robinson, Mark 314
Ruggieri, Michele 203
Russia 378, 379, 380
 see also Soviet Union
Rustichello da Pisa 20, 21, 54
Ryukyu Islands 87, 112

S
Šahab-al-Dīn 38–40, 42
Sakyamuni Buddha 266, Pl. 13
Sambiasi, Francesco 230
Sami, Widagama 99–100
Samudra 47, 87
Santa Catarina 194–5, 196
Scott, Edmund 171–4, 175, 178–80,
 183–91, 193, 195, 197–200, 409n,
 411–12n
Scotty, Ludwig 376
Second World War 348, 357, 358, 373,
 377, 390
 Nauru and Tuvalu 375
 post-war trials 366, 370–1
Semedo, Álvaro 201, 202, 203, 204,
 205, 231–2
Sending the Envoy to Heaven's Court
 Home to his Country 115–16, Pl. 9
Shandong 70–71, 350
Shangdu see Xanadu
Shanghai
 drought 258
 Japanese invasion 351, 352
 Jesuits 237
 Liang Hongzhi 347, 353, 358–60,
 361
 Ming Great State 217–8
 treaty port 321
 Yuan Great State 38
Shanxi province 70, 71
Shanyin 246, 247
Shaoxing 65, 71

Shaozhou 219
Shen Jiaben 342–3
Shen Que 203–13, 217, 228–31, 232
Shenyang 251
Shi Kefa 250
Shi Zhonghe 314
Shunzhi, Emperor 254, 257, 269–70,
 271, 272, 278
Siam 87, 154, 156
Silk Road 41, 64, 72, 390
silver 33, 94, 176, 178, 197–8
Sipsongpanna 87
Siriwardane, Ruwan 391
slavery 330, 334, 335–6, 342
 Javanese 180, 182–4
Smith, George 304–5, 308
Society of Jesus see Jesuits
sodomy 50, 337
Sonam Gyatso see Dalai Lama,
 Third
Song dynasty 7, 24, 26
Songjiang 237–9, 258, 261–2
Sorge, Rchard 357
South Africa 12, 325–30, 321–2, 333–8,
 342–3
South Korea 8, 374
South Sudan 378, 393
Soviet Union 348, 357, 383
 see also Russia
Spain 142–3, 144–7, 176
 Manila 174
 Philippines 191, 192
Sparta 222
Sri Lanka 385–6, 391, 393
 see also Ceylon
stele 91, 402n
 see also Galle Stele
Strabo 222
Stratford, Ralph 68–9
Sudan 378

sugar 309, 310

Sumpa Khanpo 285

Sun Yat-sen 348, 350, 356, 361, 418n

Superfluous Notes from Water-Mallow Village (Dong Han) 238–9, 262–3

A Supplement to Elaborations on the 'Great Learning' (Qiu) 125–8

Suzhou 243

Syria 378

T

Tabriz 37, 49

Taiwan 350, 371, 377
 see also Republic of China (Taiwan)

Taiyuan 66

Takaishi Shingorō 351, 352

Tana 54, 55

Tang Great State 7, 9, 112

Tanguts 66–7, 141

tanistry *see* bloody tanistry

Tartaria 141

Temüjin *see* Chinggis Khan

Temür 44, 51

Ten Talks of an Eccentric (Ricci) 221–5

'ten thousand countries' 5–7, 263, 372–3, 376
 maps of 3, 5, 394n

Tenavarai-Nayanar 94

Tenavaram *see* Dondra

Tenzin Gyatso *see* Dalai Lama, Fourteenth

Terrestrial map of the astral correspondences of the nine provinces (Ji Mingtai) 1–2, 4, 5, 6–7, 376, 392, Pl. 1

Tianjin 256, 319, 325, 333

tianxia see All under Heaven

Tibet 267–8, 285–6

Mongols 11, 66–7, 141, 266–7
 and PRC 267–8, 286, 379, 381–2
 Qing Great State 11, 280–6, 381
 Yongle 102–3, 104
 Zunghars 276–7
 see also Dalai Lama

Toghon Temür 74–5

Tokugawa Ieyasu 181–2

Tomalin, Henry 92, 106, 107, 108

Tongxiang 240–2

Tordesillas, Treaty of 146–7, 196

torture 263, 314, 339, Pl. 16, Pl. 17
 in Bantam 186–8, 411n
 in Johannesburg 326–32, 342, Pl. 15

Transvaal 325–30, 331–3, 335–8, 342–3

treaty ports 321–2, 325

trebuchet 55–6, Pl. 5

tribute system 45, 83, 84–5, 86–8, 110–11, 140, 148, 152
 Korea 114–16, 129
 missionaries 206
 Portugal 162–4

Tripitaka 101–2, 104–5

Tsai Ing-wen 374

Tsangyang Gyatso 273–4, 276

Tsering Dhondup 276, 281, 417n

Tsewang Rapten 276

Tumu *see* Earthworks

Turkestan 275–7, 380–1

Tuvalu 375, 382, 393

U

Ulanhu 380

ultimogeniture 270

Uludai 40, 41, 42

unification, as political ideal 6, 25, 209, 367, 376

United Nations 373, 374, 375, 376, 377–8, 382
 Charter 387

Convention on the Law of the Sea 390
member-states 373, 393
PRC and Taiwan 373, 374–5, 376
Special Committee on Decolonization 375, 377
Tibet 381
United States 378, 379
and Chiang Kai-shek 348
cotton 313, 330
Korean War 373
neo-colonialism 383
Usuda Kanzō 353, 354–5
Uyghurs 84, 379, 380–1, 389–90
Uzbekistan 58

V
Vagnone, Alfonso 201, 202, 205, 230, 231, 232
Vaisravana 75
Van Heemskerck, Jacob 193, 194–5
Van Neck, Jacob 194
Vancouver 1, 337
Venezuela 383, 385
Venice 19, 20, 50, 54
Victoria, Queen 321
Vietnam 139, 147–8
 see also Dai Viet
Vijayabahu VI see Alagakkonara, Vira
Vishnu 93, 94–5, 96
VOC (Vereenigde Oostindische Compagnie) 195–6
Voltaire 12–13, 299

W
Wakeman, Frederic 256
Walsingham, Thomas 57
Wang Hong 161, 166

Wang Jingwei 348, 357, 358, 361, 362, 363–4, 367, 369
Wang Kemin 361
Wang Linheng 177–8, 194, 197
Wang Lixiong 381–2
Wanli, Emperor 192, 193, 204, 205, 212, 217, 229–30, 232, 249–50
Western Learning (xixue) 214, 227
Westphalia, Peace of 254, 376–7, 387, 389
Whampoa 302, 304–5
WikiLeaks 375
Witwatersrand (the Rand) 325, 331
Wonogiri, Nyai Gee 180, 190
Wu Lien-teh 62–3, 64, 69
Wu Sangui 255
Wu Tingju 141, 149–52, 156–60, 161, 162, 163, 165, 169
Wu Youxing 243

X
Xanadu 20–2, 23–5, 29–30, 32–3, 74, 75
Xi Jinping 374
Xi'an 64
Xiangshan 293, 418n
Xinjiang 275–7, 380–1, 391
Xiong Xuan 154
Xu Guangqi (Paolo) 204–12, 213, 214, 217–24, 226–8, 229, 232, 253, 264, Pl. 10
Xu Shupi 243–4
Xu Xueju 192–3
Xuande, Emperor 98, 105
Xuanzang 101–2

Y
Yang Rong 97–8
Yang Tingbi 44–5
Yangzhou 250

Yangzi Delta xvi, 70, 237–42, 246,
 247, 257–60
Yanjing *see* Beijing
Yeke Mongqol ulus 8
Yellow Temple, Beijing 14, 269
Yersin, Alexandre 59–60, 61, 63, 69
Yersinia pestis see plague
Yi Sŏnggye 115
Yin Qing 87
Yingchang 75
Yinzhen, Prince 268, 271–2, 277–80,
 416n
Yongle, Emperor
 and Buddha's tooth 102–5
 and Indian Ocean 84, 86–8,
 90–105
 and Korea 129
 nepoticide 85–6, 271
 and Zheng He 89–90
Yongzheng, Emperor 271–2, 282–5
Yuan Great State 8, 9–10, 33, 34–5,
 53, 253, 376
 collapse 74–5
 Khubilai Khan 8, 24–5, 29–31
 Little Ice Age 26–9
 plague 64, 70–71, 73–4

succession 270–1
Yunnan 84, 89

Z
Zeno 221
Zhang Shizhao 364–7
Zheng He 10, 80–83, 88, 89–91,
 95–6, 97, 99, 101, 105, 107–8
 and Buddha's tooth 102, 103–5
Zhengde, Emperor
 death 165–6
 and foreign trade 153–5, 156–7, 163
 and Liu Jin 155
 and Mongols 149
Zhengtong, Emperor 130
Zhifu 325
Zhang Jirong 239
Zhongdu *see* Beijing
Zhou Peichun Pl. 16
Zhou dynasty 387
Zhu Di *see* Yongle, Emperor
Zhu Yuanzhang 8, 83–5, 271
Zicong 24, 28, 30
Zunghars 275–7, 284–5
 Tibet 280, 281–2, 283, 284
Zuo Maodi 256–7